THE STEINS COLLECT

THE STEINS COLLECT

Matisse, Picasso, and
the Parisian Avant-Garde

San Francisco Museum of Modern Art in association with Yale University Press, New Haven and London

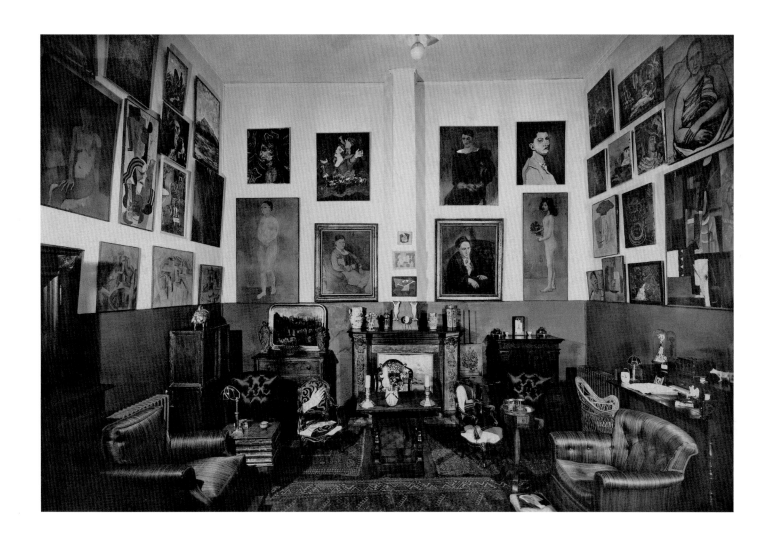

Edited by Janet Bishop, Cécile Debray, and Rebecca Rabinow

Contents

Sponsor's Statement

The Charles Schwab Corporation is honored to be the lead corporate sponsor of the San Francisco presentation of *The Steins Collect: Matisse, Picasso, and the Parisian Avant-Garde*, partnering with the San Francisco Museum of Modern Art (SFMOMA) to bring this remarkable exhibition to our city. We're particularly happy to help showcase the lasting contribution to modern art made by a family with ties to the Bay Area.

That family was the Steins: the writer Gertrude Stein, her brothers Leo and Michael, and Michael's wife, Sarah, whose patronage and salons helped launch the careers of some of the early twentieth century's most celebrated talents. This exhibition showcases landmark works from the Steins' collections, including pieces by Pablo Picasso, Henri Matisse, Paul Cézanne, and many others.

It's fitting that this touring exhibition follows the same journey as the Steins themselves: from the Bay Area, their childhood home, to Paris, their adopted home. A final stop in New York brings the collection to a diverse audience of Americans and visitors from around the world.

As a company founded and headquartered in San Francisco, we've always felt a special responsibility to help make this city's vast cultural resources available to everyone. For over twenty years, Schwab has proudly supported SFMOMA and its mission to make art meaningful and accessible. Our contribution to the KidstART program has enabled more than 275,000 children under the age of twelve to visit the museum at no charge. With this exhibition, we recommit ourselves to the important work of SFMOMA and celebrate the roles we each can play in fostering art that educates, enlightens, and endures.

Walt Bettinger
President and CEO
The Charles Schwab Corporation

Exhibition Tour

San Francisco Museum of Modern Art
 May 21 – September 6, 2011

Réunion des Musées Nationaux-Grand Palais, Paris
 October 3, 2011 – January 16, 2012

The Metropolitan Museum of Art, New York
 February 21 – June 3, 2012

The Steins Collect: Matisse, Picasso, and the Parisian Avant-Garde is organized by the San Francisco Museum of Modern Art; the Réunion des Musées Nationaux-Grand Palais, Paris; and The Metropolitan Museum of Art, New York.

The exhibition is supported by an indemnity from the Federal Council on the Arts and the Humanities.

At The Metropolitan Museum of Art, the exhibition is made possible by The Philip and Janice Levin Foundation and the Janice H. Levin Fund. Additional support provided by The Daniel and Estrellita Brodsky Foundation. Education programs are made possible by The Georges Lurcy Charitable and Educational Trust.

At the San Francisco Museum of Modern Art, the exhibition is made possible by the following:

Presenting Sponsor

MIMI AND PETER HAAS FUND

Lead Corporate Sponsor

charles SCHWAB

Premier Sponsors

Evelyn D. Haas
EXHIBITION FUND
 KORET
 FOUNDATION

Major Sponsors

evelyn & walter
HAAS JR. fund
 THE BERNARD
 OSHER
 FOUNDATION

Major support is provided by Martha and Bruce Atwater; Gerson and Barbara Bakar; the Evelyn and Walter Haas, Jr. Fund; the Helen Diller Family Foundation, a supporting foundation of the Jewish Community Endowment Fund; and The Bernard Osher Foundation. Generous support is provided by the National Endowment for the Arts; Gay-Lynn and Robert Blanding; Jean and James E. Douglas Jr.; Ann and Robert S. Fisher; Gretchen and Howard Leach; Elaine McKeon; Deborah and Kenneth Novack, Thelma and Gilbert Schnitzer, The Schnitzer Novack Foundation; and Lydia and Douglas Shorenstein. Additional support is provided by Dolly and George Chammas and Concepción and Irwin Federman.

Directors' Foreword

April 1, 2011

In the fall of 1905, a family of four American expatriates encountered Henri Matisse's *Woman with a Hat* at the Grand Palais in Paris. Gertrude, Leo, Michael, and Sarah Stein returned again and again to stare at the unusual painting; with its vigorous brushwork and remarkably vivid palette, the canvas was unlike anything they had ever seen. "It was what I was unknowingly waiting for," Leo recounted, "and I would have snatched it at once if I had not needed a few days to get over the unpleasantness of the putting on of the paint." Leo eventually purchased it from the exhibition, and over the ensuing decade the painting would pass to Gertrude and then to Sarah and Michael. Meanwhile, not long after the Steins first came upon *Woman with a Hat*, an ambitious young Spanish artist, Pablo Picasso, began painting portraits of the family. According to lore, Gertrude posed some ninety times for her portrait, and in the process, she and the artist became friends. It was only after Picasso returned to Paris from a summer in the Spanish Pyrenees that he hit upon the masklike, disjointed treatment of the face that would foretell the cubist revolution to come.

These two landmark works of modern art heralded the Steins' meteoric rise to prominence within the bustling cultural scene of Paris in the early twentieth century. They also evidence how the legacy of courageous art patronage can shape museum collections in fundamental ways. Gertrude Stein bequeathed her portrait by Picasso to The Metropolitan Museum of Art in 1946. Almost five decades later, Elise S. Haas, art patron and friend of Sarah Stein, bequeathed Matisse's *Woman with a Hat* to the San Francisco Museum of Modern Art, fulfilling Sarah's

long-standing wish for the work to be publicly displayed in the Bay Area. Each artwork is now a cornerstone of its respective museum collection.

It is often difficult in institutional contexts to remember that these masterpieces came out of a moment when championing an artist like Matisse or Picasso was not a foregone conclusion, when artists and patrons alike were trying to find their way amid the complex transition to the modern world. The Steins formed close bonds with the emerging artists they collected and promoted, and they played a pivotal role in creating markets for their work outside Paris. Along the way, the Steins covered their walls with cutting-edge paintings by the most controversial artists of the day. Leo and Gertrude were soon overwhelmed with requests to see the collections and eventually established regular visiting hours so that Gertrude could attend to her writing in peace. Sarah and Michael opened their apartment on the same night of the week, and thus began the celebrated Saturday evening salons, where artists, writers, musicians, and collectors convened to discuss the latest developments.

The Steins Collect: Matisse, Picasso, and the Parisian Avant-Garde represents the story of one family whose taste in and support of modern art shaped a generation. It also traces how their collections evolved significantly over the years. Difficulties inherent in World War I led to the sale of nineteen Matisses from Michael and Sarah's collection, but they later acquired several additional canvases by the artist before turning their support to modern architecture. Leo, who had led the family in championing modern art, forsook it in favor of Renoir paintings and, later, Native American art. Gertrude sold some of her pictures to finance the publication of her books but, unlike her siblings,

managed to keep an impressive part of her collection intact. Many years later, after the death of her lifelong companion Alice Toklas, their holdings were purchased by a consortium of trustees of the Museum of Modern Art, New York. The arrival of Gertrude's collection on American soil was celebrated in MoMA's groundbreaking 1970 exhibition *Four Americans in Paris: The Collections of Gertrude Stein and Her Family*, which in many ways has served as the starting point for the present exhibition.

A project of this scope and complexity would not be possible without the participation of numerous lenders, and we thank them for entrusting us with their artworks during the exhibition's international tour. Their willingness to make such a profound commitment testifies to the outstanding work of the curatorial team for the exhibition— Janet Bishop for the San Francisco Museum of Modern Art, Cécile Debray for the Réunion des Musées Nationaux- Grand Palais, and Rebecca Rabinow and Gary Tinterow for The Metropolitan Museum of Art—as well as to the care and professionalism of the curators' colleagues at the three organizing institutions. We congratulate them for their success in this exciting undertaking.

We are grateful for generous financial support from many sources, which has allowed us to realize our aspirations for this project. The exhibition is supported by an indemnity from the Federal Council on the Arts and the Humanities, and we particularly recognize Alice M. Whelihan, Indemnity Administrator, National Endowment for the Arts.

At the San Francisco Museum of Modern Art, presenting support is provided by the Mimi and Peter Haas Fund. Lead corporate support is provided by The Charles Schwab Corporation. Premier support is provided by the Evelyn D. Haas Exhibition Fund and the Koret Foundation. Major support is provided by Martha and Bruce Atwater; Gerson and Barbara Bakar; the Evelyn and Walter Haas, Jr. Fund; the Helen Diller Family Foundation, a supporting foundation of the Jewish Community Endowment Fund; and The Bernard Osher Foundation. Generous support is provided by the National Endowment for the Arts; Gay-Lynn and Robert Blanding; Jean and James E. Douglas Jr.; Ann and Robert S. Fisher; Gretchen and Howard Leach; Elaine McKeon; Deborah and Kenneth Novack, Thelma and Gilbert Schnitzer, The Schnitzer Novack Foundation; and Lydia and Douglas Shorenstein. Additional support is provided by Dolly and George Chammas and Concepción and Irwin Federman.

At the Metropolitan Museum of Art, we would like to recognize the outstanding generosity of The Philip and Janice Levin Foundation and the Janice H. Levin Fund. We are grateful to Esty and Dan Brodsky for their commitment to the Museum and for their continued support for special exhibition programming. Additionally we wish to thank The Georges Lurcy Charitable and Educational Trust for supporting the educational programs surrounding the project.

Neal Benezra
San Francisco Museum of Modern Art

Jean-Paul Cluzel
Réunion des Musées Nationaux-Grand Palais

Thomas P. Campbell
The Metropolitan Museum of Art

Acknowledgments

In the decades since the Steins assembled their ground-breaking collections of works by Henri Matisse, Pablo Picasso, and other modern masters, the art they owned has been scattered around the world. Our efforts to represent the depth and importance of their holdings in this exhibition and publication were aided by a great number of people who believed in the relevance and merit of this endeavor. The exhibition was launched in 2001 when the heirs of Elise S. Haas, particularly the late Peter E. Haas, granted SFMOMA one-time permission for Matisse's *Woman with a Hat* to travel. A decade later, we extend warm thanks to all of the institutions and private collectors who entrusted us with their works of art. First and foremost, we thank The Museum of Modern Art (MoMA), New York, and The Baltimore Museum of Art (BMA)—both of which own a great number of works that once belonged to the Steins. The cooperation and enthusiasm of Glenn Lowry, John Elderfield, Ann Temkin, Anne Umland, and Cora Rosevear at MoMA, and Doreen Bolger, Jay McKean Fisher, Katherine Rothkopf, and Ann Shafer at the BMA have been critical to the project's success.

We are deeply grateful to many other colleagues at museums and institutions throughout the United States for lending works to the exhibition: James Cuno, Douglas Druick, Stephanie D'Alessandro, Suzanne Folds McCullagh, Mark Pascale, and Jennifer Paoletti of The Art Institute of Chicago; Arnold Lehman and Kevin Stayton, Brooklyn Museum; Tom Seligman and Hilarie Faberman, Iris & B. Gerald Cantor Center for Visual Arts at Stanford University; Katherine Koperski and Kathleen Fraas, Castellani Art Museum of Niagara University; David Franklin and Heather Lemonedes, The Cleveland Museum of Art; Jennifer B. Lee and Alexis L. Hagadorn, Rare Book and Manuscript Library, Columbia University; Graham W. J. Beal and Salvador Salort-Pons, Detroit Institute of Arts; John Buchanan, Lynn Orr, and Melissa Buron of the Fine Arts Museums of San Francisco; Richard Armstrong, Tracey Bashkoff, Vivien Greene, and Megan Fontanella of the Solomon R. Guggenheim Museum; Richard Koshalek, Hirshhorn Museum and Sculpture Garden; Katherine Hart, Hood Museum of Art, Dartmouth College; Judy A. Greenberg, Kreeger Museum; Michael Govan and Stephanie Barron, Los Angeles County Museum of Art; Joseph Helfenstein, The Menil Collection; Stephanie Hanor and Stacie Daniels, Mills College Art Museum; Kaywin Feldman and Josh Lynn, Minneapolis Institute of Arts; Malcolm Rogers, Clifford Ackley, and Stephanie Loeb Stepanek of the Museum of Fine Arts, Boston; Gwendolyn H. Goffe and the late Peter Marzio, Museum of Fine Arts, Houston; Earl A. Powell III and Lisa MacDougall, National Gallery of Art, Washington, D.C.; Jeremy Strick and Jed Morse, the Raymond and Patsy Nasher Collection, Nasher Sculpture Center; Margaret Glover, Madeleine C. Viljoen, and Deborah Straussman of the New York Public Library; Timothy Rub and Kathryn Bloom Hiesinger, Philadelphia Museum of Art; John E. Mustain, Department of Special Collections, Stanford University Libraries; Genie Guerard, Octavio Olvera, and Gary E. Strong of the Charles E. Young Research Library, Department of Special Collections, UCLA; Adam D. Weinberg, Whitney Museum of American Art; and Jock Reynolds, Suzanne Boorsch, and Robert L. Solley of Yale University Art Gallery.

Numerous international museums generously shared their artwork with us, and we thank Matthew Teitelbaum, Art Gallery of Ontario, Toronto; Bruno Racine, Sylvie Aubenas, Céline Chicha-Castex, Valérie Sueur-Hermel, and

Françoise Simeray of the Bibliothèque Nationale de France; Ernst Vegelin, Barnaby Wright, and Julia Blanks of The Courtauld Gallery; Åsmund Thorkildsen and Nancy Nyrud, Drammens Museum; Michel Richard, Isabelle Godineau, and Arnaud Dercelles of the Fondation Le Corbusier; Hideki Kawazoe, Ikeda Museum of Twentieth-Century Art Foundation; Christoph Becker and Karin Marti, Kunsthaus Zürich; Isabella Fehle, Carmen McCoy, and Sabine Mertens of the Landesmuseum Mainz; Gérard Audinet, Dominique Gagneux, and Fabrice Hergott of the Musée d'Art Moderne de la Ville de Paris; Jean-Paul Monery, Musée de l'Annonciade; Marie-Paule Vial, Christine Poullain, and Olivier Cousinou of the Musée Cantini; Sylvie Ramond, Musée des Beaux-Arts, Lyon; Alain Seban and Alfred Pacquement, Musée National d'Art Moderne, Centre Georges Pompidou; Gilles Chazal, Petit Palais, Musée des Beaux-Arts de la Ville de Paris; Anne Baldassari, Musée National Picasso; Guy Cogeval and Stéphane Bayard, Musée d'Orsay; Guillermo Solana, Museo Thyssen-Bornemisza; Joao Vicente de Azevedo, J. Teixeira Coelho Netto, Eunice Sophia, and Eugênia Gorini Esmeraldo of MASP, Museu de Arte de São Paulo Assis Chateaubriand; Kasper König, Katia Baudin, Stephan Diederich, and Beatrix Schopp of the Museum Ludwig; Udo Kittelmann and Dieter Scholz, Nationalgalerie, Staatliche Museen, Berlin; Gerard Vaughan, National Gallery of Victoria, Melbourne; Ingar Pettersen and Øystein Ustvedt, National Museum of Art, Architecture, and Design, Oslo; Akira Tatehata and Azusa Hashimoto, National Museum of Art, Osaka; Melinda Géger and Ábrahám Levente, Rippl-Rónai Museum, Kaposvár, Hungary; Sean Rainbird, Ortrud Westheider, Peter Frei, and Frank-Thomas Ziegler of the Staatsgalerie Stuttgart; Mikhail Piotrovsky and Albert Kostenevich, The State Hermitage Museum; Karsten Ohrt, Kasper Monrad, and Dorthe Aagesen of the Statens Museum for Kunst, Copenhagen; Roger Fayet, Ariane Dannacher, and Sandra Maziere of the Museum zu Allerheiligen, Schaffhausen; and Nicholas Serota, Caroline Collier, and Nicole Simões Da Silva of Tate, London.

The success of this undertaking has further depended on the remarkable generosity of private collectors, foundations, and gallerists who made works available for our exhibition. In the U.S., we offer our very grateful thanks to William J. Ashton for granting us full access to materials in the Estate of Daniel M. Stein. We likewise extend our appreciation to Frances and Michael Baylson; Albert S. Bennett; Isabelle and Scott Black; Nancy and Robert Blank; David and Barbara Block; Sam Berkovitz, Concept Art Gallery, Pittsburgh; Mr. and Mrs. E. David Coolidge III; Dr. and Mrs. Maurice Galanté; Hans Gallas; Mildred Gaw; the Gecht Family Collection; Ann and Gordon Getty; Richard and Mary L. Gray; Katrina B. Heinrich-Steinberg; Morton and Linda Janklow; the Kaiserman Family; Mike Kelley; Alida and Christopher Latham; Cary and Jan Lochtenberg; the V. Madrigal Collection; The Henry and Rose Pearlman Foundation; Anne and Stephen Rader; Martha Parrish and James Reinish, James Reinish & Associates, Inc.; Michael Rosenfeld, Michael Rosenfeld Gallery, LLC, New York; Beverly and Raymond Sackler; Boris Stavrovski; Stanley Steinberg; Trina and Billy Steinberg; Michael and Judy Steinhardt; Mr. and Mrs. Eugene V. Thaw; Lily Downing Burke, the Estate of Max Weber/Gerald Peters Gallery; and the many private collectors who prefer to remain anonymous.

We are also deeply grateful to the collectors and gallerists based in Europe who lent or facilitated loans: the Collection Couturat; Jane England, England & Co. gallery, London; Waring Hopkins, Galerie Hopkins, Paris; Mr. and Mrs. Michel Ibre; Evelyne Ferlay, Aviel Krugier, Tzila Krugier, and Marie-Anne Krugier-Poniatowski, Galerie Krugier & Cie, Geneva; Quentin Laurens, Galerie Louise Leiris, Paris; Marc Domènech, Oriol Galeria d'Art, Barcelona; Carmen Thyssen-Bornemisza; Laszlo von Vertes, Galerie Salis & Vertes, Zurich; and additional private collectors.

We extend our thanks to the following individuals for their assistance or counsel regarding loans: Elodie Blanchet, Patricia Bonadei, Alice Bourgoin, Emily Braun, Michael Briggs, Philippe Buttner, Joan Chapman, Emmanuel Clavé, Ute Collinet, Alain Elkann, Moriah Evans, Claire Filhos-Petit, Susan Ginsburg, Deborah Hatch, Ira S. Hirschfield of the Evelyn and Walter Haas, Jr. Fund, Diana Howard, John Huszar, Mark Kernohan, Taddé Klossowski, Mark Krisco, Ann Marcus, Maureen McCormick, Julie

Muehleisen, Claudia Rice, Bertha Saunders, Patricia Tang, Francesca Volpe, and Steve Watson. Our colleagues at auction houses, both in the United States and Europe, were generous to us in a variety of ways. From Christie's, we thank Amy Albright, Guy Bennett, Olivier Camu, Sybille Fornas, Vanessa Fusco, Conor Jordan, Laura Paulson, Mary Phelps, and Nadja Scribante. From Sotheby's, we are grateful to Emily Bergland, Marion Bertagna, Aurelia Bolton, Alice Chubb, Deborah Hatch, Nina Kronauer, Bristol Maryott, Renata Mindlin, Charles S. Moffett, Scott Niichel, David C. Norman, Darrell Rocha, Liz Schroeder, Simon Shaw, Andrew Strauss, and John Tancock. We are also indebted to Anna-Karin Pusic of Bukowski Auktioner, Stockholm, and Constance Lemasson of Tajan, Paris.

Our work would not have been possible without the cooperation of the many libraries, archives, and institutions that facilitated our research and provided access to historical documents and photographs: Wanda de Guébriant, Georges Matisse, and Claude and Barbara Duthuit of the Archives Matisse, Paris, were indispensible to this endeavor, and were especially generous participants throughout the exhibition's development. We also thank Joy Weiner of the Archives of American Art; Amanda Hamilton, Catrina Hill, and Emily Rafferty of the BMA; the staff of The Bancroft Library, University of California, Berkeley, and Laura Michels of its Magnes Collection of Jewish Art and Life; Hungarian art historian Gergely Barki; Judith Dolkart, Deb Lenert, Martha Lucy, and Katy Rawdon of The Barnes Foundation; Joanna Ling and Katherine Marshall, the Cecil Beaton Studio Archive at Sotheby's, London; Graham Sherriff and the reading room staff of the Beinecke Rare Book and Manuscript Library, Yale University; Guy-Patrice Dauberville, Galerie Bernheim-Jeune; Philippe Büttner, Fondation Beyeler, Riehen; Laura Christiansen and Jeanne Noonan, Jean Outland Chrysler Library, Chrysler Museum of Art; Floramae McCarron-Cates, Cooper-Hewitt, National Design Museum; Alain Prévet, Direction des Musées de France; Paul-Louis Durand-Ruel and Flavie Durand-Ruel, Durand-Ruel Archives; Sébastien Gonnet, Fonds Municipal d'Art Contemporain; J. A. Lemire, Frick Art Reference Library, The Frick Collection; Agnès de Bretagne, Christian Derouet, Francine Delaigle, Véronique Borgeaud, Didier Schulmann, and Catherine Tiraby of the Bibliothèque Kandinsky, Musée National d'Art Moderne, Centre Georges Pompidou; Lauren Hinkson, Solomon R. Guggenheim Museum; Richard Workman and Caitlin Murray, the Harry Ransom Humanities Research Center, University of Texas, Austin; Jean-Pierre Manguin and Claude Holstein-Manguin; Clare Elliott and Mary Kadish, The Menil Collection; Peter Morrin of the University of Louisville; Ruth M. Alvarez, Special Collections, University of Maryland Libraries; Guite Masson and Martin Masson, the Comité André Masson; Ami Bouhassane, Lee Miller Archives; Gail Stavitzky and Andrea Cerbie, the Montclair Art Museum; Pierre Matisse Archives, the Morgan Library and Museum; Nicolas de Sainte-Fare Garnot, Musée Jacquemart-Andrés; Clément Chéroux and Camille Morando, Musée National d'Art Moderne, Centre Georges Pompidou; Isabelle Cahn, Isabelle Gaëtan, Sylvie Patry, Anne Roquebert, and Marie-Pierre Salé, Musée d'Orsay; Evelyne Cohen, Musée National Picasso; MacKenzie Bennett, Michelle Harvey, and Donald Prochera of the MoMA Archives; Beverly Calte, the Comité Picabia, Paris; Enrique Mallen, the Online Picasso Project; Christine Pinault and Stéphanie Monnet, Picasso Administration, Paris; Felix Billeter, the Hans Purrmann Archiv; Emily Peters, the Museum of Art, Rhode Island School of Design; Günter Schauerte, the Staatliche Museen zu Berlin–Preußischer Kulturbesitz; Marina Ducrey, the Fondation Félix Vallotton; Bruce Kellner, the Van Vechten Trust; and Claudia Defendi and Matt Wrbican, The Andy Warhol Foundation for the Visual Arts.

Our understanding of Gertrude Stein has been greatly enhanced through our dialogue with scholar Ulla E. Dydo. Likewise Edward Burns has generously shared his extensive knowledge of Gertrude Stein and Alice Toklas's art collection, opened his photographic archives to the organizers of the exhibition, and subsequently presented the images to The Metropolitan Museum of Art. Others who were helpful to us in our research and presentation of the exhibition were: Giovanni Agosti, Cynthia Altman, David Amar, Susan K. Anderson, Anny Aviram, Gilles

Barabant, Lawrence Becker, Rosa Berland, the late Donald Biggs, Irène Bizot, Emmanuel Bréon, Eric Browner, Karen K. Butler, Philippe Büttner, the late Françoise Cachin, Valentina Castellani, Alain Chaverebière de Sal, Tim Clifford, Wanda Corn, Kathy Curry, Marc Dachy, Janet Dafoe and Ronald Davis, Pierre Daix, Alex Danchev, Gitty Darugar, Gail S. Davidson, Marie Ducrocq, Françoise Ducros, Judith Durrer, Debra Earl, Elizabeth Easton, Alain Elkann, Richard Feigen, Claire Filhos-Petit, Jack Flam, Marcel Fleiss, Megan Fontanella, Dominique Fourcade, James Gaw, Léonard Gianadda, Derek Gillman, Franck Giraud, Lukas Gloor, Laura Golsan, the Grunspan family, Julie Guétard-Isoré, Phyllis Hattis, Françoise Heilbrun, Lauren Hinkson, Edward C. Hirschland, Erica Hirshler, Ay-Whang Hsia, Sara Kay, John Kerner, Michel Laclotte, Pierre and Mariel Lartigue, Tirza True Latimer, Nora Lawrence, Sébastien Lebrec, Adolf Leisen, Laurence Madeline, Ann Marcus, Laure de Margerie, Claire Markus, Stephen Mazoh, Diane Moore, Patrick Mullowney, Cynthia Nadelman, Francis Naumann, Jessica Nicoll, David Parry, Diana Widmaier Picasso, Christine Pinault, Marie-Victoire Poliakoff, Pierre Rainero, Nancy Ramage, Gérard Régnier, Philippe Renaud, Melissa Rinne, Cécile Rizenthaler, Marie Kroll Rose, Elaine Rosenberg, Pierre Rosenberg, Italo Rota, Dominique Saint-Pierre, Sarah Samuels, Sarah Suzuki, Gregory Selch, Mr. and Mrs. Jean Silvy-Leligois, Emöke Simon, Jan Lewis Slavid, Thomas A. Sos, Hilary Spurling, Denny Stein, Gertrude Stein, Julian Stein, Michael Stein, Agnès et Hiro Takahashi, Vérane Tasseau, Francesca Volpe, Jayne Warman, Nicholas Fox Weber, Shelley E. Wertheim, and Connie Wolf.

Our jointly organized exhibition would not have been possible without the oversight and diplomatic skills of Ruth Berson, SFMOMA Deputy Director, Curatorial Affairs, who was joined in its management by Exhibitions Co-Director Jessica Woznak. Others at SFMOMA who were deeply involved in the development of the exhibition are Project Assistant Curator Carrie Pilto, who we note, in particular, for her exceptional research skills and thoughtful essay on the Villa Stein-de Monzie, and Curatorial Project Manager Kate Mendillo, who graciously shared the considerable task of loan coordination with Ms. Pilto,

contributed to our application for United States government indemnity, and compiled the extensive chronology in this volume. The project has further benefited from the expertise, input, and support of curatorial colleagues Joseph Becker, Nadiah Fellah, Gary Garrels, Sarah Roberts, and John Zarobell. Registrars Olga Charyshyn and Laura Graziano expertly coordinated the transportation of artworks to San Francisco. We also thank Erica Gangsei, Morgan Levey, Peter Samis, Frank Smigiel, Suzanne Stein, Tim Svenonius, and Dominic Willsdon in Education and Public Programs and note, in particular, their program collaboration with the Contemporary Jewish Museum, the Yerba Buena Center for the Arts, and Ensemble Parallèle.

We extend our gratitude to the many other SFMOMA colleagues who contributed to this project in meaningful ways: Michelle Barger, Paula De Cristofaro, and Amanda Hunter Johnson in Conservation; Layna White, Susan Backman, Anne Bast, Don Ross, and Ron Scherl in Collections Information and Access; Robert Lasher, Elaine Asher, Cary Littlefield, Courtney McIlhenny, Jennifer Mewha, Andrea Morgan, Nicola Rees, and Misty Youmans in Development; Kent Roberts, Mia Patterson, Rico Solinas, Kimberly Walton, and Greg Wilson in Exhibitions; Jennifer Sonderby and Dan McKinley in Graphic Design; Leo Ballate in Information Systems; Barbara Rominski, Andrew Pierce, and Elka Weber in the Library; Libby Garrison, Mary Beth Smith, Apollonia Morrill, and Robyn Wise in Marketing and Communications; Jana Machin, Anne-Marie Conde, and Tobey Martin in the MuseumStore; Tina Garfinkel, Eliza Chiasson, and Kelly Parady in Registration; and Simon Blint in Visitor Services. Former employees Marnie Burke de Guzman, Lori Fogarty, Madeleine Grynsztejn, Emily Hage, Bonnie McLeskey, Andrea Nitsche, David A. Ross, Blair Winn, and intern Cynthia Jordens were helpful in earlier stages in the exhibition's development.

At the Réunion des Musées Nationaux-Grand Palais, the exhibition was enthusiastically supported by General Administrator Thomas Grenon and by his successor, President Jean-Paul Cluzel, and very capably overseen since its inception by Marion Mangon and Catherine

14

Chagneau. We offer additional thanks to Caroline Benzaria and Valérie Loth for their assistance with the research and development of the project; to Katia Cartacheff for her work with Ms. Chagneau on the loans for the exhibition; to Sylvia Linard for her work on the transport of artwork to and from Paris and on the application for French government indemnity; and to Véronique Leleu for overseeing the French language edition of our catalogue, as well as to Consuelo Crulci, Mélanie Gaunelle, and Sophie Prieto.

At The Metropolitan Museum of Art, the project was initially championed by former Director Philippe de Montebello and Associate Director for Exhibitions Mahrukh Tarapor. Their successors, Thomas P. Campbell and Jennifer Russell, embraced the exhibition, the complexities of which have been astutely navigated by Martha Deese, Senior Administrator for Exhibitions; Linda Sylling, Manager for Special Exhibitions, Installation, and Design; and Kirstie Howard, Assistant Counsel. Gary Tinterow, the Engelhard Chairman of the Department of Nineteenth-Century, Modern, and Contemporary Art is a valued co-curator of *The Steins Collect*; all aspects of the exhibition benefited from his keen intelligence and insight. Registrar Meryl Cohen arranged for all transportation related to the New York venue and advised in the preparation of the United States government indemnity application. Paintings Conservators Lucy Belloli, Isabelle Duvernois, and Charlotte Hale, along with Objects Conservator Kendra Roth, have spent months cleaning and restoring works, both from the Metropolitan's collection and elsewhere. Mellon fellow Luuk Hoogstede analyzed paint samples from the Steins' rue de Fleurus apartment, and Jenna Wainwright created mounts for dozens of objects on display at all venues.

We thank Marci Kwon for her meticulous research on Leo Stein and his philosophical influences for Gary Tinterow's essay on that topic. Mary Clare McKinley graciously and efficiently assisted with many aspects of the exhibition over the course of several years. We acknowledge additional research assistance from Camille Dorange, Holly Gover, Samantha Law, and Margaret Samu. Warm thanks are extended to many of our colleagues at the Metropolitan Museum: in the Department of Drawings and Prints, George Goldner, Cora Michael, Samantha Rippner, and David del Gaizo; in the Department of European Paintings, Lisa Cain, Andrew Caputo, Patrice Mattia; in the Department of Nineteenth-Century, Modern, and Contemporary Art, Anthony Askin, Kay Bearman, Catherine Brodsky, Mary Chan, Magdalena Dabrowski, Jeff Elliott, Christel Force, Cynthia Iavarone, Lisa Messinger, Asher Miller, Jessica Murphy, Nykia Omphroy, Sandie Peters, Faith Pleasanton, Sabine Rewald, Rachel Robinson, Brooks Shaver, Susan A. Stein, and Rebecca Tilghman; and in the Department of Photographs, Malcolm Daniel and Mia Fineman. The following also contributed to the exhibition in a meaningful way: Dita Amory, Carrie Rebora Barratt, Lawrence Becker, Barbara Bridgers, Paul Caro, Aileen Chuk, Sharon Cott, Christine Coulson, Willa Cox, Nina Diefenbach, Lisa Musco Doyle, Lizzie Fitzgerald, Robyn Fleming, Peggy Fogelman, Emily Foss, Michael Gallagher, Patricia Gilkison, Sarah Higby, Michael Langley, Carol Lekarew, Missy McHugh, Cynthia Moyer, Rachel Mustalish, Christopher Noey, Stella Paul, Emily Rafferty, Gwen Roginsky, Marjorie Shelley, Kenneth Soehner, Neal Stimler, Rachel Tofel, Elyse Topalian, Juan Trujillo, Romy M. Vreeland, and Masako Watanabe.

This complex publication would not have been possible without the deeply engaged oversight and editorial acumen of SFMOMA Director of Publications Chad Coerver and his team. Managing Editor Judy Bloch and Editorial Coordinator Amanda Glesmann brought unparalleled effort, intelligence, and consideration to every aspect of the book. Editorial Associate Erin Hyman and Research Assistants Jennifer De La Cruz and Jared Ledesma offered vital aid in bringing the project to fruition. The Publications team joins us in thanking Karen Jacobson for her astute editorial work, Alison Anderson for her thoughtful translations, Kathleen Preciado for her compilation of the index, and Juliet Clark for her proofreading. An outstanding group of outside authors contributed insightful essays; we are grateful to Isabelle Alfandary, Emily Braun, Edward Burns, Claudine Grammont, Hélène Klein, and Martha Lucy for their generous participation and dialogue

throughout. This catalogue required enormous amounts of research, and for this we acknowledge the contributions of the entire curatorial team. The indefatigable Robert McD. Parker dedicated himself to tracking every work of modern art known to have been owned by the Steins, and was ably assisted in this effort by Maxime Touillet and Hilary Floe. The distinctive design of the book was created with great care and good cheer by Tracey Shiffman, Alex Kohnke, and Deanne Oi of Shiffman & Kohnke. Patricia Fidler of Yale University Press offered early and enthusiastic support as the copublisher of this volume.

For their belief in this project from its outset and for their unfailing institutional commitment in seeing it to completion, we are deeply grateful to our respective directors: Neal Benezra at SFMOMA; Jean-Paul Cluzel at the Réunion des Musées Nationaux–Grand Palais; and Thomas P. Campbell at The Metropolitan Museum of Art.

Janet Bishop, Cécile Debray, Rebecca Rabinow

Contributors

CURATORS OF THE EXHIBITION

Janet Bishop
Curator of Painting and Sculpture
San Francisco Museum of Modern Art

Cécile Debray
Curator of Modern Collections
Museé National d'Art Moderne, Centre Georges
Pompidou, Paris

Rebecca Rabinow
Associate Curator, Nineteenth-Century, Modern, and
Contemporary Art
The Metropolitan Museum of Art, New York

Gary Tinterow
Engelhard Chairman, Nineteenth-Century, Modern,
and Contemporary Art
The Metropolitan Museum of Art, New York

ADDITIONAL CONTRIBUTORS

Isabelle Alfandary
Professor of American Literature
University of Paris-Est

Emily Braun
Distinguished Professor
Hunter College and the Graduate Center, City University
of New York

Edward Burns
Professor of English
William Paterson University of New Jersey

Claudine Grammont
Independent Scholar

Hélène Klein
Chief Curator, Professor of Art History
École du Louvre, Paris

Martha Lucy
Associate Curator
The Barnes Foundation, Merion, Pennsylvania

Kate Mendillo
Curatorial Project Manager
San Francisco Museum of Modern Art

Robert McD. Parker
Independent Scholar

Carrie Pilto
Project Assistant Curator
San Francisco Museum of Modern Art

Note to the Reader

This book is organized into four main parts: an introduction followed by three sections corresponding to each of the Stein siblings and his or her companion. In these sections devoted to the family members—Leo Stein; Sarah and Michael Stein; and Gertrude Stein and Alice Toklas—the essays are accompanied by a selection of plates illustrating artworks acquired by the relevant figures, or associated with them for other reasons. The descriptive captions for the plates were written by the curators of the exhibition.

The caption for each illustration in this publication includes a plate number and, where applicable, a catalogue (cat.) number. The latter indicates that the artwork was owned by a member of the Stein family and can be found within the Catalogue of the Stein Collections on pages 394-457. The presence of brackets around the catalogue number in the caption indicates that the Steins did not own this particular example of a sculpture or print produced in multiples.

Titles of artworks, with few exceptions, have been translated into English. Where possible, the preferred naming conventions of the current owner have been honored.

The medium and dimensions of artworks have been provided by the owners or custodians of the works, augmented in some cases by firsthand observation by members of the exhibition team. Dimensions of artworks are given in inches and centimeters, with height preceding width, followed by depth (for three-dimensional objects). Dimensions provided for works on paper correspond to the sheet size of the work.

References are cited in abbreviated form in the essay endnotes, descriptive captions for the artworks, and the Catalogue of the Stein Collections. The corresponding full citations for archives, exhibitions, and publications are found in the References section on pages 468-79.

Quotations from French archival documents and published works have been translated into English for this publication. When no source is named, the translation has been provided by the author and editors.

In order to construct a comprehensive visual record of the Stein collections, we have provided plate illustrations for a number of Stein-owned artworks that are not included in the accompanying exhibition. Please consult the list of works in the exhibition (pages 458-67) in order to determine which artworks are displayed at the San Francisco Museum of Modern Art and/or Metropolitan Museum of Art.

INTRODUCTION

Plate 1
The Steins in the courtyard at 27 rue de Fleurus, Paris, ca. 1905. From left:
Leo Stein, Allan Stein, Gertrude Stein, Theresa Ehrman, Sarah Stein, Michael
Stein. Theresa Ehrman papers and photographs, BANC MSS 2010/603, The
Magnes Collection of Jewish Art and Life, The Bancroft Library, University of
California, Berkeley. Transfer; Judah L. Magnes Museum; 2010

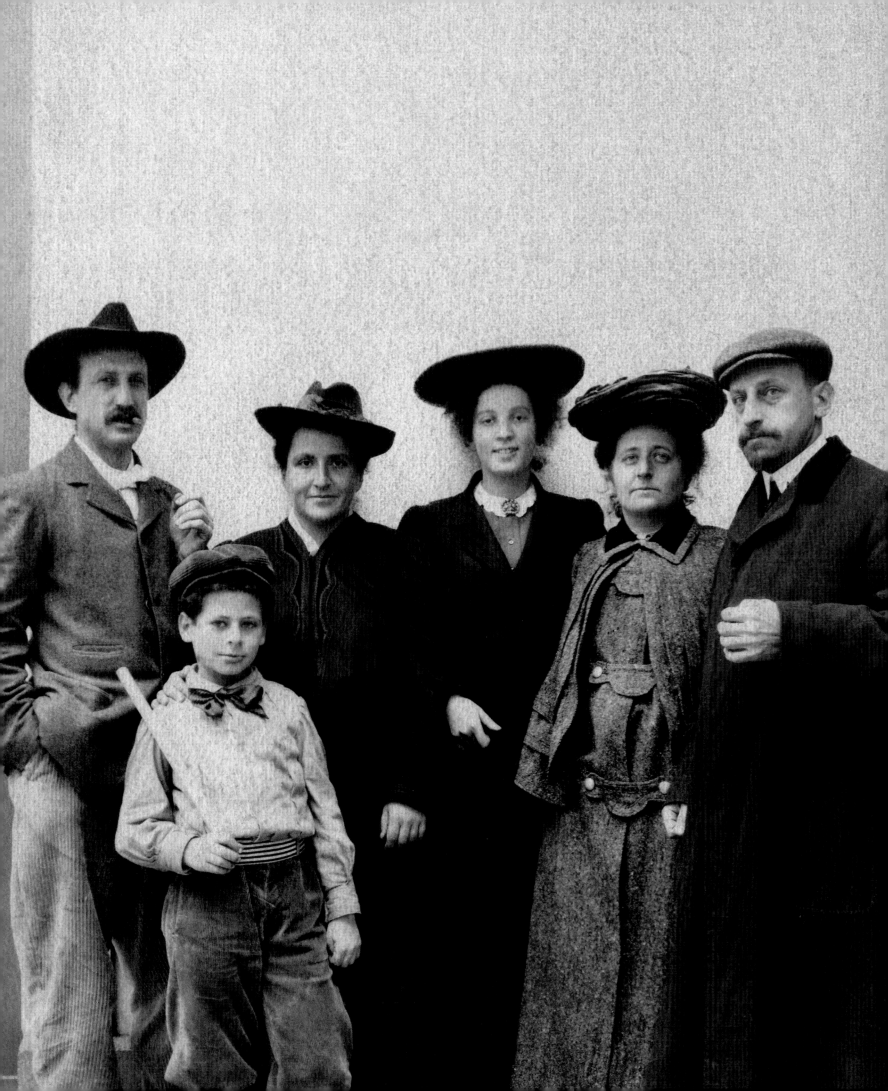

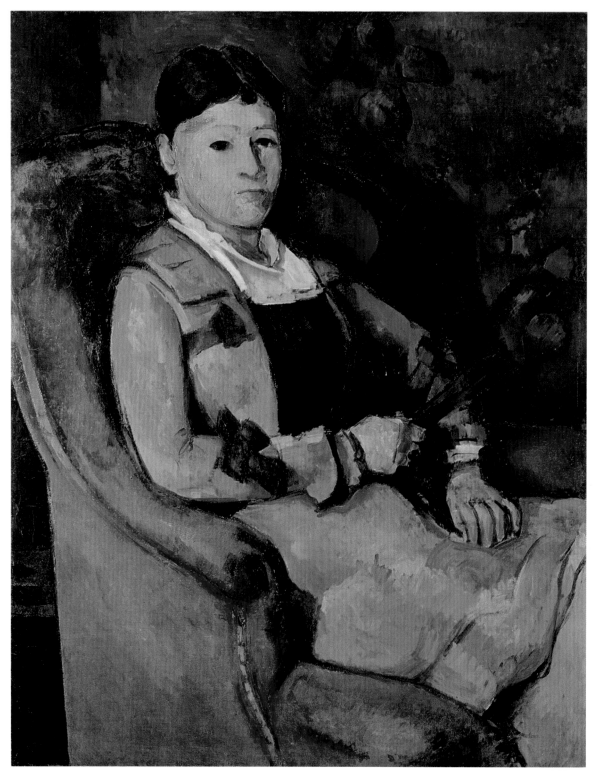

Plate 2

Discovering Modern Art: The Steins' Early Years in Paris, 1903-1907

Rebecca Rabinow

At the end of the nineteenth century, it seemed as if every wealthy American in France was hunting for art treasures. The Potter Palmers of Chicago, the H. O. Havemeyers of New York, and many others arrived in Paris with deep pockets, willing and able to purchase whatever caught their fancy. They filled their mansions in the States with thousands of contemporary paintings, ranging from canvases by medal winners at the annual Paris salon exhibitions (Alexandre Cabanel and Pierre Puvis de Chavannes, for example) to the controversial pictures of the Impressionists. During the first decade of the twentieth century, when the siblings Leo, Gertrude, and Michael Stein, together with Michael's wife, Sarah, began buying pictures by a younger generation of artists working in Paris, the Steins were assumed to be yet another millionaire family from America.[1] But the Steins were different. They were not particularly wealthy, and none of them had come to France with the goal of collecting paintings. Once they began purchasing contemporary art, they did not whisk the canvases back to America but instead chose to reside in Paris and open their apartments to anyone interested in seeing the pictures on their walls. Consequently their discovery of modern art—especially the work of Henri Matisse and Pablo Picasso—had an indelible impact on its development for years to come.

Leo and Gertrude were among the millions of tourists who traveled to Paris during the summer of 1900 to visit the World's Fair. Leo opted to remain in Europe. He was twenty-eight years old and highly intelligent, but having already rejected careers in law and zoology, he was at loose ends. He discovered that he enjoyed life in Florence, where he was surrounded by art, antiquities, and a welcoming erudite expatriate community. Leo became particularly friendly with the American art historian and connoisseur Bernard Berenson, who was seven years his senior. After a couple of years the novelty faded; Leo recognized that Florence was "not an ideal winter resort… nothin' doin' in the town and the sky one unvarying panorama of sodden gray.… Spring & summer in Italy and winter in the larger cities of the north, that is now my program."[2] He visited London in December 1902 and, on his way back to Florence, stopped in Paris for a few days. One night, after dining with a friend, Leo returned to his hotel room, made a roaring fire, disrobed, and drew his nude body's reflection in the wardrobe mirror.[3] The following weeks were a blur of sketching sessions at the Musée du Louvre and studio art classes. Leo had decided to become an artist.

Leo was free to do as he pleased. Both his parents were dead. Modest investments made on his behalf were managed in California by his eldest brother, Michael, ensuring that Leo did not have to work so long as he lived frugally. It is unlikely that his career choice upset any of his extended family. After all, his maternal uncle Ephraim Keyser was a successful sculptor in Baltimore who had spent years training in Munich, Berlin, and Rome.[4] Keyser's son, Ephie, was following in his father's footsteps and studying sculpture in Paris. He directed Leo to a newly constructed studio and adjacent apartment available for rent at 27 rue de Fleurus, just a few blocks from the Musée du Luxembourg, a small museum of contemporary art housed in a former orangery.

Like many art students in Paris, Leo repeatedly visited the local museums and exhibitions. He was interested in and extremely knowledgeable about art from a wide range of periods and cultures.[5] A collector by nature, he was always on the lookout for items that were intriguing and affordable. His first known acquisition in Paris was a picture of a woman in white walking her dog against a backdrop of a green lawn. It was painted by the Swiss-born artist Raoul du Gardier, whose works were featured in a January 1903 exhibition at Galerie Silberberg.[6] Critics singled out du Gardier as one of the most gifted of Gustave Moreau's students, a group that also included the as-yet-undiscovered Henri Matisse. "I had plunged into the water and picked up something more or less at random," Leo recalled.[7] At this point he had no collecting strategy, and it would be many months before he began assembling paintings in a methodical way.

Situated in the city's financial district, near the Opéra and around the corner from the auction house Hôtel Drouot, the short stretch of rue Laffitte (pl. 3) on either side of boulevard Haussmann was home to many of the city's best-known art galleries, including Vollard (no. 6),

Bernheim-Jeune (no. 8), Hessèle (no. 13), and Durand-Ruel (no. 16). Sometime in late February or early March 1903 Leo stopped by Durand-Ruel's gallery to see the fourth exhibition of the Société Nouvelle de Peintres et de Sculpteurs.[8] He was intrigued by the paintings of Jacques-Émile Blanche and Henri Martin, as well as those of Charles Cottet and Lucien Simon, both of whom specialized in views of Brittany. All four were well known, having exhibited regularly in the spring salons. Each year, representatives from the Ministry of Fine Arts purchased about fifty new paintings and sculptures from the salons for the Musée du Luxembourg, with the understanding that within ten years of the artist's death his work would be eligible for transfer to the Musée du Louvre.[9] Limited wall space at the Luxembourg necessitated annual reinstallations. Blanche, Cottet, Martin, and Simon were distinguished by having at least one canvas on view.[10] "Their work was fresh and vivid and momentarily exciting," Leo would later recall, "but its real value as form was nil."[11]

Frustrated that he had not yet found affordable paintings with long-lasting appeal, Leo discussed the matter with his friend Berenson, who suggested that Leo return to rue Laffitte, this time to Ambroise Vollard's gallery, and ask to see works by Paul Cézanne. Leo had often passed the gallery, but it looked so forbidding that he had never ventured inside.[12] Certainly the dealer's gruff demeanor and disorganized shop gave no hint of the treasures massed in his back rooms. Following his Cézanne retrospective of 1895, Vollard had purchased almost all the artist's unsold canvases and watercolors. Vollard was famous for refusing to show prospective clients whatever it was they requested, yet Leo persevered and acquired a landscape, the first of some twenty Cézanne oils, watercolors, and lithographs that he and his siblings would eventually own.[13]

That fall Leo was joined by Gertrude, who arrived in Paris in time for the first Salon d'Automne. Leo recalled repeated visits. "I looked again and again at every single picture, just as a botanist might at the flora of an unknown land."[14] The plans for this new salon had sparked opposition. Critics argued that artists had ample opportunities to present their work each spring, when thousands of recent

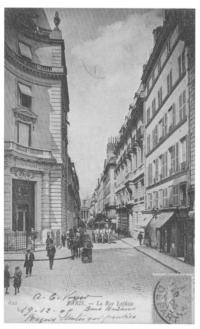

Plate 3

Plate 3
Postcard featuring a view of rue Laffitte, Paris, postmarked December 19, 1905.
Rue Laffitte was known as the "street of paintings" because of the numerous art galleries located there. Department of Nineteenth-Century, Modern, and Contemporary Art, The Metropolitan Museum of Art, New York

paintings, drawings, and sculptures went on view at the Salon des Artistes Indépendants, the Salon de la Société Nationale des Beaux-Arts, and the Salon des Artistes Français.[15] Nevertheless, when the Salon d'Automne debuted in the basement and ground-floor galleries of the Petit Palais on October 31, 1903, it was widely acclaimed—more youthful and lively than the spring salons—despite its awkward installation in small, poorly illuminated spaces: "You pass from a sunlit room, one that is too bright even, to a dark room where you can barely discern some frames."[16] Electric lighting was still a novelty. Frustrated critics at the crowded opening resorted to striking matches in an effort to see the canvases packed into dark corners.[17]

In January 1904, after retiring from his post as division superintendent of the Market Street Railway in San Francisco, Michael moved to Paris with his thirty-three-year-old wife, Sarah, and eight-year-old son, Allan. They also brought Theresa Ehrman, the twenty-year-old daughter of a family friend. She was a gifted pianist who looked after Allan in return for the opportunity to live and study in Europe. The family found suitable living quarters at 2 rue de Fleurus, across the street from the Jardin du Luxembourg and just a few blocks from the apartment that Leo and Gertrude shared.

The younger siblings quickly discovered that Michael's presence meant stricter fiscal oversight. Upon learning that Leo had recently spent more than he could easily afford on a group of Japanese prints, Michael chided him and insisted that the entire family attend the auction at which Leo put the prints back up for sale in an attempt to recover his investment.[18]

In March Gertrude embarked on a visit to the States. Leo, meanwhile, embraced his new persona as an artist. He attended classes at the Académie Julian from 8:00 a.m. until noon and spent the afternoons in his studio, where he sometimes painted from a model, before returning to the academy for the evening session, from 7:00 to 10:00 p.m.[19] It was once again the spring art season, and he reveled in all that the city had to offer. "The period of exhibitions is in full blast," he wrote a friend.[20] *French Primitives, 1292–1500*, an ambitious and enormously popular exhibition, opened

on April 5 at both the Louvre and the Bibliothèque Nationale. The following day, *Contemporary Masters*, a group of fifty-seven pictures from private collections, debuted at the Musée du Luxembourg.[21] Slightly more than half of the works were lent by members of the museum's friends group, established the previous year by the curator Léonce Bénédite.[22] In his review Roger Marx suggested that since the twenty-four artists featured—Carolus-Duran, Edgar Degas, Édouard Manet, Claude Monet, Camille Pissarro, Pierre-Auguste Renoir, Alfred Sisley, and others—were already much admired, the Luxembourg would do well to present a follow-up exhibition of equally talented but forgotten painters.[23] Nonetheless, for Leo and his peers, this exhibition provided a rare opportunity to see paintings such as Manet's *Soap Bubbles* (1867; Museu Calouste Gulbenkian, Lisbon), lent by the architect and archaeologist Emmanuel Pontremoli, and Puvis de Chavannes's *Prodigal Son* (ca. 1879; National Gallery of Art, Washington, D.C.), lent by the artist Henry Lerolle. Leo was looking forward to the Pissarro retrospective at Durand-Ruel's—the artist had died the previous November—which opened that week as well.

"Paris is garbing itself in Spring," Leo enthused. "I am having the time of my life [painting] a canvas 6½ x 4½ ft…, [and] Mike & Sarah are becoming more devotedly Parisian every day and are gradually burrowing deep into the museums!"[24] Michael and Sarah visited the Louvre regularly. They particularly enjoyed examining specimens of Chinese and Japanese art in Leo's company and attending the Tuesday afternoon open houses at Durand-Ruel's private residence. There they had the opportunity to admire the "superb collection of modern Frenchmen," including an ensemble of more than forty canvases that Monet had painted specifically for the dealer's drawing room in the mid-1880s.[25] Like Leo, Michael and Sarah spent a good deal of time in the art galleries. Sarah was just as intrigued by the annual display of the Société Nouvelle as her brother-in-law had been the previous year. "It is a good thing we have no spare cash, as we might have returned with a couple [of paintings], especially those of Henri Martin," she wrote a friend.[26] On April 16, Sarah and Michael accompanied Leo

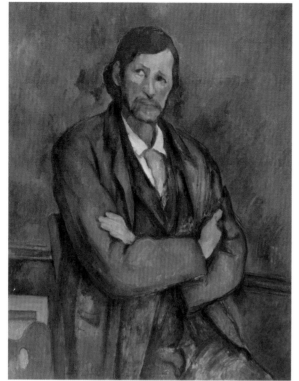

Plate 4

Plate 5

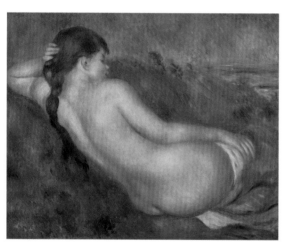

Plate 6

Plate 4
Paul Cézanne, *Man with Crossed Arms,* ca. 1899. Oil on canvas, 36¼ x 28⅝ in. (92 x 72.7 cm). Solomon R. Guggenheim Museum, New York

Plate 5
Henri de Toulouse-Lautrec, *Woman before a Mirror,* 1897. Oil on cardboard, 24½ x 18½ in. (62.2 x 47 cm). The Metropolitan Museum of Art, New York, The Walter H. and Leonore Annenberg Collection, bequest of Walter H. Annenberg, 2002

Plate 6
Pierre-Auguste Renoir, *Reclining Nude,* 1883. Oil on canvas, 25⅝ x 32 in. (65.1 x 81.3 cm). The Metropolitan Museum of Art, New York, The Walter H. and Leonore Annenberg Collection, bequest of Walter H. Annenberg, 2002

Plate 7
Pierre-Auguste Renoir, *Study. Torso, Effect of Sunlight,* ca. 1876. Oil on canvas, 31⅞ x 25⅝ in. (81 x 65 cm). Musée d'Orsay, Paris, bequest of Gustave Caillebotte, 1894

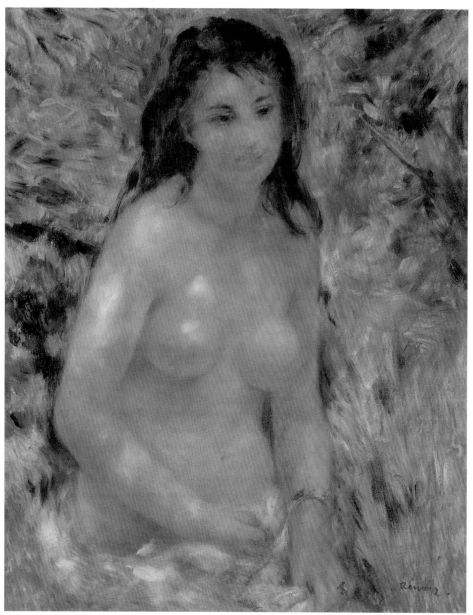

Plate 7

to the social highlight of the Paris art season, the opening (known as Varnishing Day) of the 1904 Champ de Mars Salon. The international papers breathlessly reported that "owing to the fine weather…all French and American smart society thronged the Grand Palais," where paintings by Louis Anquetin, Carolus-Duran, Jean-Paul Laurens, Martin, John Singer Sargent, and James McNeill Whistler were on display.[27]

In late May Michael and Sarah rented out their apartment and embarked on a lengthy trip to Switzerland, Germany, and Italy. They were not among the crowds who stopped by rue Laffitte during the first days of June to see the much-talked-about and highly successful Monet *Views of the Thames* exhibition at Durand-Ruel before it closed. A few doors away, an exhibition of paintings by a thirty-four-year-old artist had just opened at Vollard's gallery.[28] It was Matisse's first solo show.

On August 24 Leo and Gertrude paid Vollard 600 francs ($120, at the then-prevailing exchange rate of five francs to the dollar) for a portrait study of an old woman by Honoré Daumier (cat. 57). Daumier had long been esteemed for his lithographs, and his oil paintings had been rediscovered in May 1901 at a retrospective organized by the École des Beaux-Arts.[29] The panel was one of several minor works by prominent nineteenth-century artists that Leo and Gertrude purchased over the next few years. These acquisitions, including Eugène Delacroix's *Perseus and Andromeda* (1847; cat. 60) and Manet's *Ball Scene* (1873; pl. 48, cat. 81), serve as a reminder that while the Steins (particularly Leo) were extremely knowledgeable about art, they had a limited pocketbook. Even though Leo and Gertrude combined their funds for their purchases, they simply could not afford major works by established artists.

On October 15, 1904, the second Salon d'Automne was inaugurated at the Grand Palais. Included were retrospectives of Paul Cézanne, Henri de Toulouse-Lautrec, Pierre Puvis de Chavannes, Odilon Redon, and Pierre-Auguste Renoir, who were considered to be among the most relevant artists for the younger generation of painters (pls. 4–7). Impressed, Leo and Gertrude stopped

by Vollard's gallery two weeks later and spent 8,000 francs on seven colorful figurative canvases: two Cézannes, two Gauguins, two Renoirs, and a Maurice Denis. Both of the Cézannes were "bather" paintings, similar in composition and comparable in size to the one Matisse lent to the Salon d'Automne. (The Cézanne gallery at the Salon included two much larger Bathers as well.) The two works by Paul Gauguin chosen by the Steins had likely been included in Vollard's memorial tribute to the artist the previous November.[30] Gertrude remembered that she liked the "sun-flowers but not his figures [pl. 8] and her brother preferred the figures," so they bought both.[31] The Renoirs—a pastel of bathers and an oil of a woman's head—were the first manifestations of Leo's growing interest in the artist's work, which he had come to appreciate after repeated visits to the Caillebotte bequest on view in a small room at the Musée du Luxembourg (see pl. 7).[32] In the course of negotiating the sale, Vollard added a Denis painting of a nursing mother, a secular Madonna and child, in hope of enticing the Steins to collect works by an artist whom he had promoted for a decade (*Mother in Black*, 1895; pl. 40, cat. 61).

Cynics questioned whether the Salon d'Automne retrospectives had been organized for the benefit of the rue Laffitte art dealers.[33] Vollard's account books for 1904 reveal that he sold at least sixteen paintings by Cézanne, many at an enormous profit, between the time that the Salon opened in mid-October and the end of the year. The number of sales is all the more remarkable given that the artist was not yet particularly well known.[34]

Vollard saw Michael, Leo, and Gertrude—"the two brothers and the sister, seated on a bench"—in front of Cézanne's portrait of his wife every time he visited the Salon d'Automne.[35] Surely he was not surprised when Leo and Gertrude turned up at his gallery a few weeks later determined to purchase a portrait by the artist. Gertrude recalled that they began with eight possibilities before narrowing the choice to two, one of a woman and one of a man (probably *Man with Crossed Arms* [ca. 1899; pl. 4]), both of which they would have acquired if they could have afforded to do so. They ultimately selected *Madame*

Plate 8

Cézanne with a Fan (1878–88; pl. 2, cat. 10), which had just returned from the Grand Palais. It was an important painting with a price to match: 8,000 francs, exactly what they had spent the previous month on all seven of their pictures combined.[36]

Leo and Gertrude considered their paintings to be investments, which explains why, during these years, they always pooled their funds. Theresa Ehrman tended to repeat in her letters what she heard in the Stein household. She noted that the small Daumier painting that Leo and Gertrude acquired in August would "someday…be worth its weight in gold."[37] She also wrote her mother about Leo and Gertrude's October purchases from Vollard: "They found that they had not been spending their whole income and preferred to buy pictures with the surplus money, [rather] than bonds. They are truly characters."[38] The 16,000 francs that Leo and Gertrude spent at Vollard's gallery in October and November 1904 represented a princely sum for them. They would never again have the opportunity to spend so much money on paintings in such a short period.

Once the Vollard purchases were hung on the cream-and-terracotta-colored walls of the studio, Leo was able to reflect on the ensemble.[39] What had begun as a few incidental purchases was now a burgeoning collection. Leo's goal was to assemble pictures by modern masters, artists who were considered to have had the greatest influence on the new generation. His plan was to add examples by Pierre Bonnard, Edgar Degas, Vincent van Gogh, Édouard Manet, and Édouard Vuillard.[40] Aware that they needed to replenish their acquisition funds, Leo and Gertrude asked friends to sell artworks left behind in America.[41] In the meantime they made do with lithographs and color reproductions. A Degas bather selected from a portfolio of matted reproductions was framed and hung near one of the new Cézanne oils.[42]

Impressed by the Toulouse-Lautrec display at the 1904 Salon d'Automne—which was immediately followed by an exhibition of the artist's graphic work at the Musée du Luxembourg in December and a group show at Berthe Weill's gallery in late February 1905[43]—Leo decided to add a Toulouse-Lautrec as well. He probably mentioned his intention to Weill, "the funny little squinting near-sighted old lady who sympathized with revolutionaries."[44] She tried to entice him with "a superb Lautrec that I would like to show you if you care to stop in to see me. The subject is a bit risqué but careful framing could cover the shocking part without diminishing the artistic value of the piece."[45] Ultimately Leo and Gertrude purchased one of the artist's less provocative views of a brothel interior (*In the Salon: The Divan*, ca. 1892–93; pl. 28, cat. 437).

The influence of Toulouse-Lautrec, who had died in 1901, was apparent in the work of many young artists. It certainly could be seen in the pictures that the Spanish teenager Pablo Picasso included in his first Paris exhibition.[46] Unlike Matisse, Picasso did not participate in the annual salons; Leo supposed the reason was "partly diffidence, partly pride."[47] Instead Picasso's work could be seen in group shows, including one held in February–March 1905 at Serrurier et Cie, a modern furniture store on boulevard Haussmann, behind the Opéra.[48] This exhibition was organized by Charles Morice, the art critic for *Mercure de France*. It featured twenty-four watercolor scenes of Switzerland by Albert Trachsel, fifteen canvases by the painter and illustrator Auguste Gérardin, and thirty-four works by Picasso. It was reviewed by Morice himself, who did not seem bothered by the conflict of interest, and by Picasso's friend Guillaume Apollinaire.[49] The exhibition was also mentioned in a recently launched British periodical, the *Burlington Magazine for Connoisseurs*, which noted Picasso's "extraordinary perfection of manner."[50] Leo visited the exhibition in the company of Mahonri Young, a talented American artist he had met at the Académie Julian.[51] The store's regular staff seems to have lacked the authority to sell the pictures on display, because Leo's request to purchase some of Picasso's drawings languished.[52]

Undeterred, Leo returned to Clovis Sagot's nearby gallery—it was Sagot who had recommended that he stop by the Serrurier exhibition in the first place—and bought a sizable Picasso gouache, *The Acrobat Family* (1905; pl. 22, cat. 291). Leo's and Gertrude's reminiscences are famously contradictory, yet both agree that Gertrude heartily disliked the

second large Picasso that Leo proposed, *Girl with a Basket of Flowers* (1905; pl. 9, cat. 232), a muted, almost symbolist painting. Gertrude "found something rather appalling in the drawing of the legs and feet, something that repelled and shocked her."[53] At this point Leo was the driving force behind the acquisitions, and he purchased the canvas anyway. "That day I came home late to dinner, and Gertrude was already eating. When I told her I had bought the picture she threw down her knife and fork and said, 'Now you've spoiled my appetite.'"[54]

The 1905 Salon des Indépendants, an annual unjuried show open to any artist willing to pay a nominal handling fee, opened on March 24 at the Serres du Cours-la-Reine, the immense glass buildings constructed alongside the Seine for the 1900 World's Fair.[55] The German artist Paula Modersohn-Becker described it in a letter to her husband: "The walls are covered with burlap and there the pictures hang, with no jury in sight, alphabetically arranged in colorful confusion. Nobody can quite put a finger on exactly where the screw is loose, but one has a strange feeling that something is wrong somewhere. There are retrospective exhibitions of Van Gogh and Seurat, but one leaves them no better informed than when one went in. Again the Salon is Paris through and through, with its whims and fancies and childlike qualities. Stupid conventionality hangs next to eccentric attempts at *pointillisme*."[56]

Pointillisme—or as Morice mockingly called it, "Confetti-ism"—was enjoying a revival.[57] Galerie Druet's exhibition of Henri Edmond Cross was timed to coincide with the Seurat retrospective at the Indépendants, which featured *A Sunday on La Grande Jatte* (1884–86; Art Institute of Chicago) alongside other famous canvases by the artist.[58] A younger generation was experimenting with divided brushstrokes. Of the many examples on display, Matisse's *Luxe, calme et volupté* (1904; Musée National d'Art Moderne, Paris, on loan to Musée d'Orsay) was the most notable. This style did not yet appeal to any of the Steins; Leo recalls thinking it the ugliest technique ever invented.[59]

He and Gertrude instead acquired two comparatively conventional nudes from this exhibition: a reclining figure by the thirty-nine-year-old Swiss-born Félix Vallotton

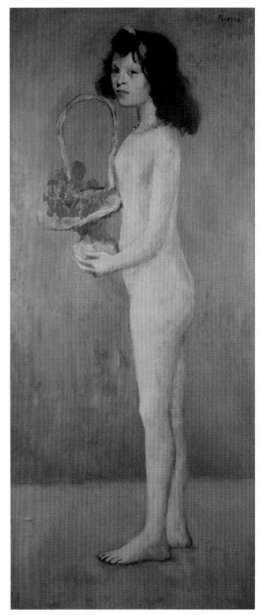

Plate 9

Plate 9, cat. 232
Pablo Picasso, *Girl with a Basket of Flowers,* 1905. Oil on canvas, 61 x 26 in. (154.9 x 66 cm). Fractional gift to The Museum of Modern Art, New York, by a private collector

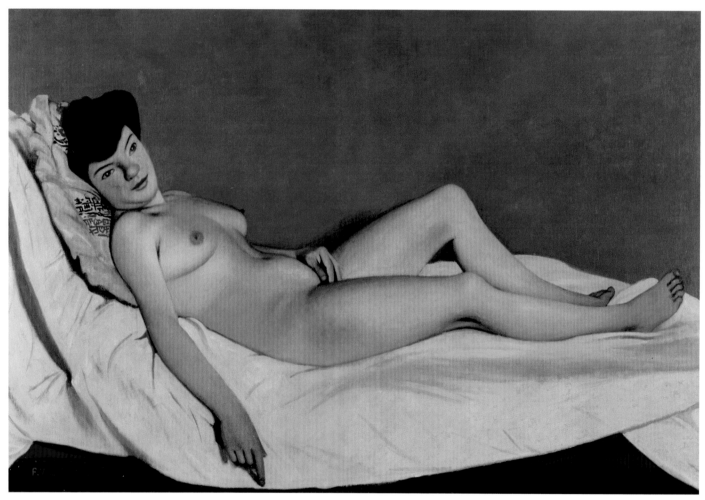

Plate 10

(pl. 10, cat. 438) and a standing one by the thirty-one-year-old French artist Henri Charles Manguin (pl. 55, cat. 82). Vallotton's five-foot painting simultaneously recalled Giorgione's *Venus of Dresden* (ca. 1510; Gemäldegalerie, Dresden)—a reproduction of which had hung in Gertrude's room at Johns Hopkins University—and Manet's *Olympia* (1863; pl. 11, then on view in the Musée du Luxembourg), to which it was unfavorably compared by critics.[60] Manguin's composition of a woman posing in a studio had been painted in the company of Albert Marquet and Matisse, friends from his student days at the École des Beaux-Arts.[61] The unexpected area of bright yellow brushstrokes behind the model's head was exactly the type of painterly bravura that would soon attract Leo to Matisse's work.

It was customary for prospective buyers to offer two-thirds of the asking price through the intermediary of the Salon secretary, and it was probably during these negotiations or shortly thereafter that the Steins met Manguin and Vallotton. Leo found Manguin "a man of the world who talked easily and fluently," and Vallotton "witty and cynical."[62] All four of the Steins became friendly with the artists and hung paintings by them on their apartment walls.

There was a sense in Paris that painting was changing dramatically. Long-held ideals taught at the École des Beaux-Arts were challenged from every direction. Some critics of contemporary art were overwhelmed by what they perceived as a chaotic swirl of styles, approaches, and inspirations. At the end of the summer of 1905, Charles Morice published a three-part article in which he tried to make sense of it. He recorded fifty-five artists' responses to a questionnaire that he had circulated. The questions included: "Is today's art moving in a new direction?" "Is Impressionism over?" and "What do you make of Cézanne?"[63] The replies were as varied as the artists he polled. Morice cautioned against the "fever to find the new at any price," although he was intrigued by Eugène Carrière's more optimistic point of view. Carrière, a fifty-six-year-old founding member of both the Société Nationale des Beaux-Arts and the Salon d'Automne, reminded him that artists had always combed earlier time periods for inspiration. He argued that rather than worry about the lack of a communal style, art lovers should feel great hope. Something remarkable was bound to rise from the crowd of artists feverishly at work in Paris.[64] Appreciating the new creations would require an open mind on the part of the public. The critic Élie Faure emphasized that audiences needed to be "willing to listen to an entirely new language…. Let us think before laughing."[65]

Michael and Sarah had initially planned to stay in France for a year and had consequently leased the apartment

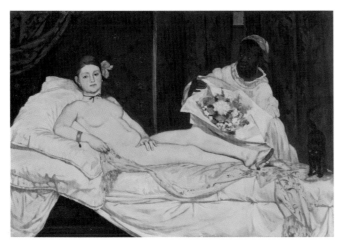

Plate 11

Plate 10, cat. 438
Félix Vallotton, *Reclining Nude on a Yellow Cushion,* 1904. Oil on canvas, 38³⁄₁₆ x 57½ in. (97 x 146 cm). Sturzenegger Foundation, Museum zu Allerheiligen Schaffhausen, Switzerland

Plate 11
Édouard Manet, *Olympia,* 1863. Oil on canvas, 51⅛ x 74¾ in. (130.5 x 190 cm). Musée d'Orsay, Paris

at 2 rue de Fleurus until April 1905. They had no desire to return to the States. "Paris is the world's mart, and here one can learn both artistic and commercial values as nowhere else," Sarah explained to a friend. "We read along aesthetic lines a great deal, and meet many nice, interesting people through Leo & Gertrude."[66] They found a nearby apartment at 58 rue Madame, located on the third floor of a building attached to a Protestant church. The living-dining room was a simple, white-walled, loftlike space with two thin columns in the middle.

Leo, Michael, and Sarah, avid collectors of Japanese art, must have been delighted to see Count Isaac de Camondo's famous collection of prints by Kitagawa Utamaro at the 1905 Salon d'Automne. Their tastes were evolving, however, and they found themselves drawn to the so-called Fauve room, the "Gallery of Dangerous Lunatics," according to one wag, who pinned the epithet to the entrance of gallery seven.[67] Displayed inside were paintings by the Steins' recent acquaintance Manguin, as well as Charles Camoin, André Derain, Albert Marquet, Maurice de Vlaminck, and Matisse. The Steins had not yet met Matisse, although they certainly knew of him. He was mentioned repeatedly in the press. The previous October his name had been spelled out in italics on the front page of *Gil Blas*, where he was touted as a leader of the new school of painting.[68] Vollard surely spoke of him to the Steins, as did Weill, who claims to have implored them to buy Matisse's work.[69] Now, because of Manguin and Vallotton, who were friendly with Matisse, they had acquaintances in common.

The 1905 Salon d'Automne also featured a large room devoted to retrospectives of Jean-Auguste-Dominique Ingres and Édouard Manet, who were presented as contradictory yet worthy role models. Anyone who spent significant time in front of Ingres's delicately modeled paintings and portrait drawings or Manet's pictures, especially his portrait of Berthe Morisot holding a fan (1874; pl. 12), would have been struck by Matisse's distortion of color and line in his depiction of his wife, Amélie, posing with a fan, *Woman with a Hat* (1905; pl. 13, cat. 113). Leo was not alone in thinking it "the nastiest smear of paint" that he had ever seen.[70] After five weeks in front of the picture, he and Gertrude

decided that it justified the asking price of 500 francs. Sarah, who is not known to have purchased any contemporary French paintings up to this point, regretted not buying the painting herself, particularly since she believed that it bore a striking resemblance to her mother.[71]

The purchase of *Woman with a Hat* altered the direction of Leo and Gertrude's collection. They were shifting away from their earlier emphasis on modern French masters in favor of more affordable ultracontemporary work. Four days after the Salon d'Automne closed, Leo wrote a friend about the latest purchases: the provocative *Woman with a*

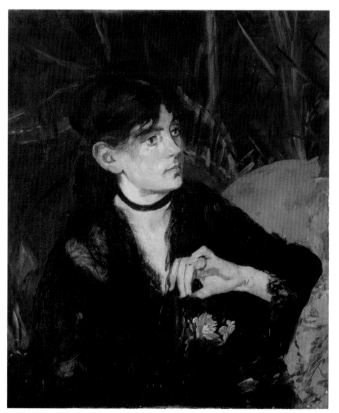

Plate 12

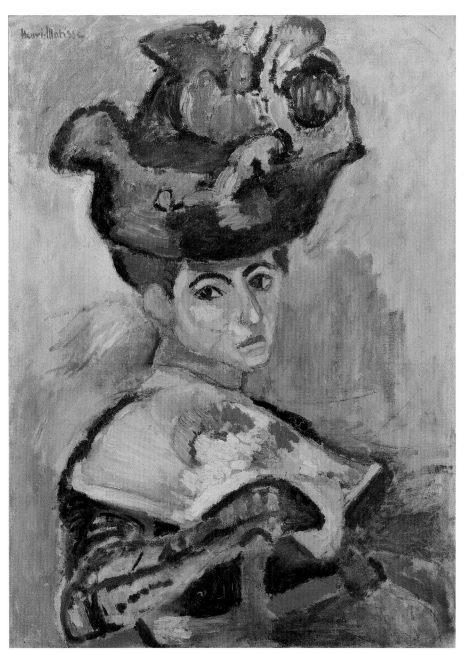

Plate 13

Plate 14

Hat, which "made everybody laugh except a few who got mad about it," and Bonnard's *Siesta* (1900; pl. 14, cat. 3), a large oil of a nude sprawled facedown on a bed, echoing the pose of the *Borghese Hermaphrodite*, a Roman sculpture on display at the Louvre.[72] Leo also boasted of earlier acquisitions, the two pictures "by a young Spaniard named Picasso whom I consider a genius of very considerable magnitude and one of the most notable draughtsmen living."[73]

Picasso, savvy and in need of money, recognized that the Stein family—both the rue de Fleurus and rue Madame households—could be helpful to him. Not only had they purchased two of his large paintings, but they encouraged friends such as the wealthy Cone sisters of Baltimore to do so as well.[74] Picasso presented casual portraits to the Steins, renderings of Leo (1906; pl. 33, cat. 325) and Allan (1906; pl. 179, cat. 324) painted in gouache on cardboard. Gertrude wanted something grander, and Picasso was happy to oblige. His companion Fernande Olivier noted that he had been "so attracted by Mlle Stein's physical presence that he suggested he should paint her portrait, without even waiting to get to know her better."[75] Picasso used oils on a canvas almost identical in size to *Madame Cézanne*, by far the most valuable painting hanging on the walls of rue de Fleurus at that time.

Much has been written about Gertrude's portrait (pl. 183). Because Picasso typically painted quickly and from memory, it is unlikely that he needed the eighty or ninety sittings that Gertrude recalled.[76] Early on, these sittings surely were a pretext for her to spend time with the artist and Fernande. The trio became friendly in spite of the language barriers. Gertrude savored these opportunities to dissociate herself from her upper-middle-class Jewish American background. Friends in California who received photographs of her garbed in unconventional brown corduroy dresses and sandals noticed her physical transformation as well. "For goodness sake Gertrude, what are you?…Are you a nun, a learned doctor, or are we ignorant as to the meaning of your unique costume?"[77] She particularly enjoyed surprising well-bred American acquaintances with visits to the ramshackle Bateau-Lavoir, where Picasso

resided and worked. A young woman from California, Annette Rosenshine, accompanied her one Sunday afternoon in the fall of 1906:

> [Gertrude] suddenly decided it would be interesting to drop in at Picasso's studio.… She turned the doorknob and pushed—there on the bare floor of a completely unfurnished room lay an attractive woman between two men—Picasso on one side.… They were fully clothed…lying there to rest from a Bohemian revelry the night before.… [Since] Picasso and his companions…were disinclined to get up or incapable of it and did nothing to detain us, we left. As we stepped into the dimly lighted hall, closing the door behind us, Gertrude gave me a quick quizzical look that told her interest in my response to our Bohemian foray. She obviously expected me to be shocked. I resolved to display nothing but complete aplomb.[78]

Leo's decision to pursue a career as an artist was validated during the winter of 1905-6, when he sold his first painting. Paris finally felt like home. "My artistic affiliation is over here, and in America, I fear, I should feel completely isolated and very lonely."[79] After six years abroad, he sent to Baltimore for his books, which soon lined the walls of the small dining room that he and Gertrude shared.[80] Gertrude was working on an ambitious new literary project, *The Making of Americans*; Sarah was involved with the Christian Science church and was studying painting; and Michael was contemplating opening an antiques store and was reading every art historical text in English, French, and German that he could find.

In February and March 1906 the Steins purchased several Cézanne and Renoir color lithographs from Vollard. At between fifty and eighty francs each, they were easily affordable.[81] More significant purchases came later that spring from Matisse's second solo exhibition, held at the gallery of the photographer and dealer Eugène Druet on rue Faubourg Saint-Honoré.[82] Critics cautioned that the fifty-five paintings displayed would interest only "those afraid to seem outdated."[83] Matisse's circle of admirers at the time

Plate 14, cat. 3
Pierre Bonnard, *Siesta*, 1900. Oil on canvas, 42⅞ x 52 in. (109 x 132 cm). National Gallery of Victoria, Melbourne, Australia, Felton Bequest, 1949

Plate 15

Plate 15, cat. 117
Henri Matisse, *Le Bonheur de vivre*, also called *The Joy of Life*, 1905-6. Oil on canvas,
69½ x 94¾ in. (176.5 x 240.7 cm). The Barnes Foundation, Merion, Pennsylvania

included the politician Olivier Sainsère; the businessman Robert Ellissen, who was a member of the Peau de l'Ours group, which speculated in contemporary art; and a merchant from Le Havre, Pieter van de Velde. Having already missed out on one impressive portrait of Amélie Matisse the preceding fall, Sarah and Michael were determined not to lose another. Around this time, probably from the Druet exhibition, they purchased a smaller but equally memorable image of Madame Matisse known as *Madame Matisse (The Green Line)* (1905; pl. 88, cat. 110).

The Matisse exhibition at Druet's opened on the eve of the Salon des Indépendants, which explains why Matisse sent only one painting to the 1906 Salon. With a staggering 5,552 works listed in the Salon catalogue, most worthy pictures were lost amid a sea of ridiculous daubings.[84] Two of these paintings—catalogue numbers 4717 and 4718, "Flowers" and "Portrait"—were submitted by Leo himself, to the great excitement of his friends and family.[85] Nonetheless, the most-talked-about canvases were Douanier Rousseau's *Liberty Inviting Artists to Take Part in the Twenty-Second Exhibition of the Société des Artistes Indépendants* (1905-6; National Museum of Modern Art, Tokyo) and Matisse's aggressively colored and highly stylized *Le Bonheur de vivre*, also called *The Joy of Life* (1905-6; pl. 15, cat. 117). The playwright Georges Courteline purchased the Rousseau for his "Musée des Horreurs," a collection of the most grotesque canvases he could find; *Le Bonheur de vivre* went unsold.[86]

The artist Paul Signac, who had acquired Matisse's *Luxe, calme et volupté* in the summer of 1905, had been disappointed by the unfinished *Bonheur de vivre* when he saw it in Matisse's studio in January 1906: "Matisse, whose attempts I have liked up to now, seems to me to have gone to the dogs. Upon a canvas of two and a half meters he has surrounded some strange characters with a line as thick as your thumb. Then he has covered the whole thing with flat, well-defined tints, which—however pure—seem disgusting," he groused to a mutual acquaintance.[87] Leo had also seen the painting in the artist's studio. Unlike Signac, he was intrigued by the finished canvas. He recognized references to various works of art, including Cézanne's

pastoral scenes of bathers in a forest, rendered in a colorful new visual vocabulary. Although Leo wanted the painting, he could not commit to its purchase due to his uncertain financial situation. A devastating earthquake had struck San Francisco on April 18, 1906, just weeks after the Salon had opened. Michael and Sarah rushed back to the States to check on their rental properties, an important source of income for the entire family. A week after the Indépendants closed, Leo wrote Matisse of his quandary. He was in luck: the artist no longer had room for such an enormous canvas. It was installed in the rue de Fleurus atelier by early June although not paid for until the following year.[88]

The earthquake resulted in a momentary lull in the Steins' collecting. Aware of their potentially changed financial situation, Leo and Gertrude cut back on their spending to the point that friends offered to send them money.[89] The paintings added to their walls at this time were simply borrowed from Michael and Sarah's vacant apartment. Gertrude's attention was focused on finding a publisher for her recently completed *Three Lives*. "I am very proud of it, nothing will discourage me. I think it a noble combination of Swift and Matisse."[90] After returning from their summer in Italy, the siblings undoubtedly attended the 1906 Salon d'Automne but are not known to have made any purchases.

Michael and Sarah returned from the United States in mid-November 1906 with increased resolve to remain in Paris. Their rental properties in San Francisco were more or less unscathed, and there was enough money to renovate the rue Madame apartment. Their principal living space was enlarged by removing a wall that bisected one of the two large arched windows that overlooked rue Jean Bart. Sarah invited Matisse to stop by and give his "opinion on our main room and our Japanese art objects—and we also hope to add some of your recent works to our collection, to make our installation/arrangement just right."[91]

Around this time the hanging rails installed along the perimeter supported Picasso's *The Acrobat Family*, which they either bought or borrowed from Leo and Gertrude, and the blue period canvas *Melancholy Woman* (1902; pl. 176, cat. 231); Vallotton's *Standing Nude* (1904; pl. 180, cat. 439); a Cézanne *Bathers* nearly identical to one owned by Leo and

Gertrude (ca. 1892; pl. 129, cat. 11); Japanese paintings; and increasing numbers of brightly colored canvases by Matisse. A few of Matisse's small sculptures were soon brought into the apartment as well. The Steins considered Matisse the greatest sculptor of their day, no small praise considering Auguste Rodin's renown.

The walls of the rue de Fleurus studio, similarly, were covered with paintings by Cézanne, Gauguin, Manguin, Matisse, Picasso, Renoir, Toulouse-Lautrec, and Vallotton. The displays at the Musée du Luxembourg looked outdated in comparison. Two years earlier, Paula Modersohn-Becker had been delighted by certain sections of the museum; now she was frustrated: "Considering the fact that it's the only official French museum for modern art, it's a bit pathetic."[92] The Steins' two apartments provided an alternative. Increasing requests to visit the collections led to frequent interruptions. Gertrude, who used the atelier as her writing studio, particularly resented the disturbances.[93] A decision was made to consolidate the visits and open both apartments on Saturday evenings to anyone who arrived with a reference in hand. The solution was successful, but since neither apartment was wired for electricity, visitors struggled to see. It was not unusual for interested newcomers to request a return visit in daylight.

Guests often found Leo pacing the studio or reclining on a daybed while extolling the individual merits of the pictures. He claims to have convinced Vollard to reconsider the artists whose works hung on his walls.[94] Certainly many factors influenced Vollard, not least of which was the avidity with which Druet was purchasing paintings by these artists. In the spring of 1906 Vollard made his move. On March 21 he paid Manguin 7,000 francs for 147 of his paintings and works on paper. One month later he acquired a group of twenty paintings and studies from Matisse for 2,200 francs, and in early May he offered Picasso 2,000 francs for twenty-seven of his paintings.[95] Only a few months later Bernheim-Jeune & Cie hired the writer and art critic Félix Fénéon to head up its contemporary art division at rue Richepanse, a move widely interpreted as a direct challenge to all the dealers of contemporary art in Paris, especially Druet.[96] Fénéon began wooing Matisse

almost immediately and, on March 11, 1907, scooped the competition by sending him an agreement. In return for rights of first refusal and a commitment to purchase the majority of Matisse's work, Bernheim-Jeune received 25 percent of every painting sold, regardless of whether the gallery was directly involved in the transaction.[97] The Steins could not have anticipated the consequences of their enthusiasm. Their promotion of modern art was rapidly contributing to their being priced out of the market.

Thanks to an extensive Gauguin retrospective at the 1906 Salon d'Automne, which featured loans from an impressive array of collectors, all of whom were prominently listed in the catalogue, the market for the artist's work had intensified. Leo recognized that it was a good time to sell.[98] On January 21, 1907, he and Gertrude traded their Gauguin *Three Tahitian Women against a Yellow Background* (1899; pl. 8, cat. 63), along with Bonnard's *Siesta*, to Vollard for a Renoir valued at 4,000 francs.[99] The new acquisition was probably *Girl in Gray-Blue* (ca. 1889; cat. 395), which they displayed as a pendant to Matisse's *Woman with a Hat* (see pl. 16). Once again Vollard threw in an additional work, this time a painting by Jean Puy, a Fauve artist whom he had represented for just over a year.[100] Presumably for both aesthetic and investment purposes, Leo was homing in on Renoir's work and was willing to trade two paintings in order to acquire a Renoir with striking visual similarities to the Matisse.

Plate 16

Plate 16
The atelier at 27 rue de Fleurus, Paris, ca. 1908–9. Henri Matisse's *Woman with a Hat* (1905; pl. 13) is at far left and Pierre-Auguste Renoir's *Girl in Gray-Blue* (ca. 1889; cat. 395) at far right. Dr. Claribel and Miss Etta Cone Papers, Archives and Manuscripts Collections, The Baltimore Museum of Art

Following Leo's lead, Sarah and Michael exchanged three of their paintings (by Denis, Henri Fantin-Latour, and Adolphe Monticelli) for six Matisses at Druet's.[101] Although canvases by Matisse increasingly dominated their walls, they were not yet collecting him to the exclusion of all others. In March 1907 Michael attended a widely anticipated auction of pictures owned by the dentist Georges Viau.[102] Rosenshine recalled the lively atmosphere: "I became so excited that I did not realize that Michael's last bid had been accepted. The next day a Paris newspaper commented upon the sale, speaking of 'the crazy American who paid one thousand francs for a Cézanne fragment [*Portrait of Paul, the Artist's Son* (ca. 1880; pl. 128, cat. 9)].'"[103]

The Steins undoubtedly were attracted to Renoir's lush paintings of bathers included in the Viau sale, but the prices were prohibitively high.[104] These types of reclining nudes were the talk of the town. On February 7, 1907, after much public debate, Manet's controversial *Olympia* was transferred from the Musée du Luxembourg to the bastion of high art, the Musée du Louvre, where it was installed as a pendant to Ingres's *Grande Odalisque* (1814; Musée du Louvre, Paris).[105] The display of Manet's painting in the Louvre was considered "a momentous event in the history of modern art" because it represented official sanction of an artistic style that had heretofore been considered an attack on the teachings of the École des Beaux-Arts.[106] It was against this backdrop that Matisse presented his rendition of the same motif, *Blue Nude: Memory of Biskra* (1907; pl. 27, cat. 139), at the spring Salon des Indépendants.[107] Leo and Gertrude purchased Matisse's aggressive, edgy canvas as a replacement for Bonnard's *Siesta*, which they had sold two months earlier. A wide variety of bathers had appeared on the walls of the rue de Fleurus studio over the previous two and a half years. *Blue Nude* was the most provocative addition to date.

Picasso saw *Blue Nude* both at the Salon des Indépendants and on the Steins' wall. His response was immediate. He began drawing and painting the figure of a woman with a bent upraised elbow and crooked knee, as if the model for *Blue Nude* was holding her pose after being rotated to a standing position.[108] The figure appears repeatedly in studies for *Les Demoiselles d'Avignon* (1907; Museum of Modern Art, New York), *Nude with Drapery* (1907; State Hermitage Museum, Saint Petersburg), and *Three Women* (1908; pl. 186, cat. 251). Picasso reportedly considered the composition of *Blue Nude* to be unresolved and felt that the figure was isolated from the background.[109] Inspired by additional elements from Matisse's painting— the dark contours, hatching on the palm fronds, and palette—he set out to do one better in *Nude with Drapery*, a painting that he referred to as "ma nue couchée" (my reclining nude).[110] Leo and Gertrude were delighted, and although they did not buy the painting, they acquired many of Picasso's studies for it.[111] Michael and Sarah added one to their collection as well.

A painting by Manguin proved equally stimulating. The Steins purchased his *La Coiffure* (1905; pl. 18, cat. 83) in February 1906. There is no doubt that Picasso saw it during his frequent visits and was inspired to paint a similar subject (*La Coiffure*, 1906; pl. 17).[112] Matisse took up the theme as well (*La Coiffure*, 1907; pl. 19, cat. 141). Art historians have interpreted his canvas as a direct response to Picasso's, which Matisse may have seen either in Picasso's studio or at Vollard's gallery. But it is the similarities between the

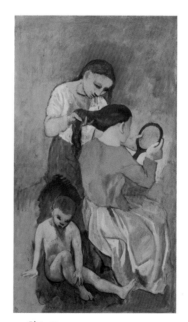

Plate 17

Plate 17
Pablo Picasso, *La Coiffure,* 1906. Oil on canvas, 68⅞ x 39¼ in. (174.9 x 99.7 cm). The Metropolitan Museum of Art, New York, Wolfe Fund, 1951; acquired from The Museum of Modern Art, New York, anonymous gift

Plate 18, cat. 83
Henri Charles Manguin, *La Coiffure,* 1905. Oil on canvas, 45⅝ x 35⅟₁₆ in. (116 x 89 cm). Collection Couturat

Plate 19, cat. 141
Henri Matisse, *La Coiffure,* 1907. Oil on canvas, 45⅝ x 35 in. (116 x 89 cm). Staatsgalerie Stuttgart

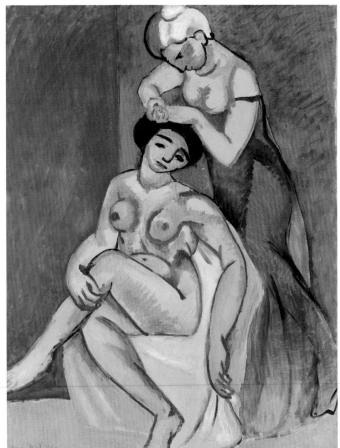

Plate 19

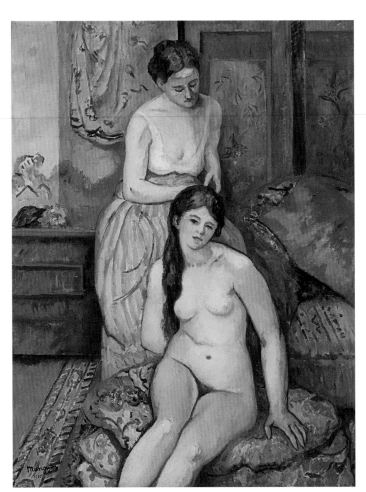

Plate 18

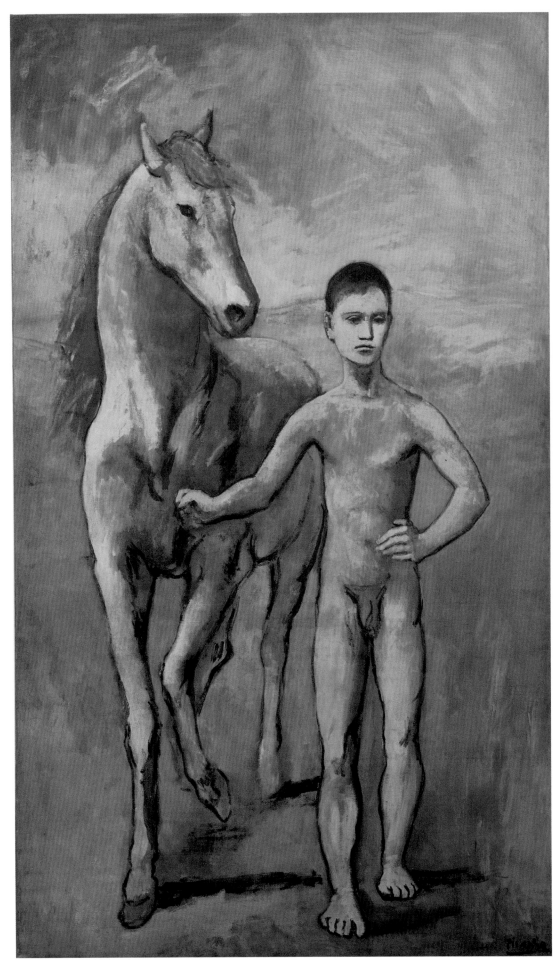

Plate 20

Matisse and the Manguin that are most compelling: the standing woman's pose, dress, and hairstyle; the contours of the upper portion of the nude model; even the way in which the background is divided with a vertical line. The two canvases are exactly the same size. Sarah and Michael were fascinated by Matisse's finished picture and, with the artist's help, were able to sell other paintings from their collection in order to finance its acquisition.[113]

During these years all four of the Steins were friendly with the artists whose works they collected. They dined on Madame Matisse's rabbit stew, sympathized with Fernande's complicated feelings for Picasso, and researched inexpensive Italian villa rentals for the Manguins. Letters from Picasso to Leo contain reports of his recent work, requests to see various paintings at rue de Fleurus, and pleas for money. Intrigued that Leo was lining paintings in his collection, Picasso supposedly adhered a second canvas to the back of a large work before starting it. The picture in question may be *Boy Leading a Horse* (1905-6; pl. 20, cat. 236), which Leo and presumably Gertrude considered one of the artist's "best things of the period" and promptly acquired.[114]

In July 1907 Matisse and his wife vacationed in northern Italy, where they spent time with Leo and Gertrude, visiting local museums and discussing art. Prior to the trip, Matisse had shipped six paintings to his dealer in Paris. In late August he learned that Bernheim-Jeune would not purchase any of these until a lawsuit filed against the gallery by Prince Alexandre de Wagram had been resolved.[115] The unexpected turn of events presented an ideal opportunity for the Steins. Within weeks of their return to Paris, Leo and Gertrude purchased the oil sketch *Music* (1907; pl. 62, cat. 143), and Sarah and Michael, a still life, a landscape, and a "large painting," probably *Le Luxe I* (1907; pl. 101, cat. 142).[116]

Le Luxe I was among the seven works that Matisse submitted to the 1907 Salon d'Automne. Also hanging on the walls of the Grand Palais that October was the first painted likeness of Gertrude to be publicly exhibited: Vallotton's *Gertrude Stein* (1907; pl. 206, cat. 441), which was reproduced in the Paris edition of the *New York Herald* and in *Studio*. "Has she really become as sour as Vallotton has painted her?"

joked Mahonri Young from his home in Utah.[117] Over the course of her life, Gertrude posed for various artists. She believed that modeling sessions were helpful to her as a writer, because they provided her with long, still hours in which to meditate and make sentences.[118] According to Rosenshine, Gertrude regretted that Matisse never asked her to sit for him.[119]

When Apollinaire's article on Matisse was published in the December 15, 1907, issue of *La Phalange*, it was illustrated with the three major canvases that the artist had painted that summer—*Red Madras Headdress* (1907; pl. 95, cat. 144), *La Coiffure*, and *Le Luxe I*—as well as with his self-portrait (1906; pl. 138, cat. 131). Three of the four were hanging on the walls of Michael and Sarah's apartment; the fourth was acquired soon thereafter. With the exception of the artist's studio, there was no better place to see Matisse's most recent work. It was a short-lived moment. That month, December 1907, the Russian textile merchant Sergei Shchukin paid the Steins a visit.[120] He soon began acquiring large and increasingly expensive paintings by Matisse. Unlike the Steins, with their modest budgets and small apartments, Shchukin had vast wealth and a palace in central Moscow. By the end of 1908 he had become the artist's most important patron, a role that he enjoyed until political conflict closed the borders in 1914.

The end of 1907 marked a turning point for the Steins. With Sarah's staunch encouragement and support, arrangements were under way to open an art academy led by Matisse. Michael helped with the effort while simultaneously establishing his new jewelry business.[121] Gertrude, meanwhile, was immersed in her next book, *The Making of Americans*. She drew inspiration from the paintings on her walls. Friends equated the unusual style of her prose to her pictures, and the comparison pleased her. In September, Gertrude had been introduced to Alice Toklas, who would remain her companion for the rest of her life. December 1907 also marked the fifth anniversary of Leo's move to Paris. He was still working toward his goal of becoming an artist. How gratifying it must have been for him to receive letters from Vollard, each addressed to "M. Stein, artiste-peintre." During this period, however, Leo was far more

Plate 20, cat. 236
Pablo Picasso, *Boy Leading a Horse*, 1905-6. Oil on canvas, 86⅞ x 51⅝ in. (220.6 x 131.2 cm). The Museum of Modern Art, New York, The William S. Paley Collection, 1964

important as the instigator and driving force behind the family collections.

Over the ensuing years, a rift between Leo and Gertrude would strain their relationship. Leo moved to Italy just as World War I cast its shadow over Europe. The famous rue de Fleurus collection was divided, and some pictures were sold. The war had a particularly devastating impact on Michael and Sarah's collection. At Matisse's request, they lent nineteen of their most important paintings by him to an exhibition in Berlin. The paintings were confiscated and ultimately sold; Michael and Sarah's collection never recovered its former glory.

As 1907 drew to a close, however, the dark days ahead were unimaginable. The walls of the apartments at rue de Fleurus and rue Madame were filled with colorful paintings, created in large part by the Steins' friends, who happened to be some of the most interesting artists of the day. Once a week the apartments overflowed with painters, sculptors, writers, collectors, and dealers who knew that there was no better way to keep up with recent artistic developments than to spend a Saturday evening at the Steins'.

Notes

1. Apollinaire 1907b, 29; L. Stein 1996, 151–52; L. Stein 1950, 195.

2. Leo Stein to Mabel Weeks, March 15, 1902, Yale Collection of American Literature, Beinecke Rare Book and Manuscript Library, Yale University (hereafter, Beinecke YCAL), MSS 78, box 3, folder 52.

3. L. Stein 1996, 151–52; L. Stein 1950, 203.

4. Anon., March and April 1905; Clement 1879, 23.

5. The sculptor Mahonri Young, a friend of Leo's from the Académie Julian in Paris, recalled, "I have only known one or two in my life as well informed as he, especially in art." Young 1940, 52.

6. *Tableaux de MM Hugues de Beaumont et Raoul du Gardier*, Galerie Silberberg, 29 rue Taitbout, through January 31, 1903. Earlier that winter in London, Leo purchased an as-yet-unidentified painting by the British Impressionist Philip Wilson Steer (1860–1942). L. Stein 1996, 150.

7. L. Stein 1950, 203.

8. The exhibition ran from February 14 to March 7, 1903. For Paula Modersohn-Becker's impressions of the exhibition, see Modersohn-Becker 1983, 293 (letter dated February 14, 1903).

9. Anon., June 1902, 339.

10. The 1904 edition of Karl Baedeker's *Handbook for Travellers, Paris and Environs* recommends that visitors to the Musée du Luxembourg see Blanche's *Flowers* (Musée d'Orsay); Cottet's *The Last Rays* and *Coast Scene* triptych (1892 and 1898; both Musée d'Orsay); Martin's *Inspiration, Serenity*, and *Effect of Sun*; and Simon's *Procession to Penmarch* (1900; Musée d'Orsay).

11. L. Stein 1950, 204.

12. Ibid.; L. Stein 1996, 154–55. Gertrude's impressions of Vollard are recorded in G. Stein 1971, 29–34.

13. The purchase of Cézanne's *The Spring House* (ca. 1879; pl. 35, cat. 8) has sometimes been dated to 1904 because Gertrude claimed to have been present (G. Stein 1971). In L. Stein 1996, 155, however, Leo clarifies that he bought the landscape from Vollard before going to Fiesole for the summer. To further support a 1903 acquisition date, the sale is conspicuously absent from Vollard's otherwise detailed 1904 account books. (His records from 1903 are unlocated.)

14. L. Stein 1996, 157.

15. Anon., March 7, 1903; see also Anon., August 8, 1903, and Joubert 1903. The Salon de la Société Nationale des Beaux-Arts was informally known as both the "Nationale" and the "Champ de Mars," after its former location near the Eiffel Tower. The Salon des Artistes Français was often referred to as the "Champs-Élysées" because the exhibition had been held at the Palais des Champs-Élysées before that building was replaced by the Grand Palais in 1900.

16. M.P.V. 1903, 1.

17. Pip 1903, 271. Complaints about the abysmal lighting were widespread and appear in most reviews of the exhibition.

18. Jelenko ca. 1965, 2.

19. Leo Stein to Mabel Weeks, April 12, [1904], Beinecke YCAL, MSS 78, box 3, folder 52; Holland 1904, 228. Leo attended various art schools while living in Paris, including the Académie Colarossi, located at 10 rue de la Grande-Chaumière, and the Académie Delécluse, located at 84 rue Notre-Dame-des-Champs, both an easy walk from his apartment. Rosenshine n.d., 100; Mikola 1972, 46–48, courtesy of Gergely Barki.

20. L. Stein to Weeks, April 12, [1904].

21. *Exposition temporaire de quelques chefs-d'œuvre de maîtres contemporains prêtés par des amateurs organisée avec le concours de la société de Amis du Luxembourg*, April–May 1904 (opening held on April 13).

22. In early April 1903, partly to compensate for his inadequate acquisition budget, the Luxembourg's curator, Léonce Bénédite, founded the Amis du Luxembourg. It was hoped that the group's donations and gifts would make up for what was widely perceived to be purchases of mediocre art by state representatives. Anon., April 4, 1903; Bénédite 1904, 107–8.

23. Marx 1904, 135.

24. Leo Stein to Mabel Weeks, April 12, [1904].

25. Sarah Stein to Jennie Rosenthal Ehrman, March 12, 1904, Theresa Ehrman papers and photographs, BANC MSS 2010/603, The Magnes Collection of Jewish Art and Life, The Bancroft Library, University of California, Berkeley. Transfer; Judah L. Magnes Museum; 2010.

26. Ibid.; *Exposition de la Société nouvelle de peintres et de sculpteurs*, Galerie Georges Petit, Paris, March 12– April 2, 1904.

27. Anon., April 17, 1904; Anon., May 21, 1904, 30.

28. *Claude Monet: Vues de la Tamise à Londres*, Galerie Durand-Ruel, May 9–June 4, 1904. *Exposition des œuvres du peintre Henri Matisse*, Galerie Vollard, June 1– 18, 1904. In a letter dictated by Sarah in the 1940s, she recalled that Leo attended the Matisse exhibition (Kimball 1948a, 37). Leo accompanied Michael and Sarah on the first part of their trip in early June, however, and it is not clear that he returned to Paris in time to see the exhibition.

29. *Exposition Daumier*, Palais de l'École des Beaux-Arts, May 1901. See also L. Stein 1996, 142.

30. Paul Gauguin, who had died in May 1903 in the Marquesas Islands, was the subject of a small retrospective at the 1903 Salon d'Automne and a concurrent and significantly larger tribute at Vollard's gallery, *Exposition Paul Gauguin*, November 4–28, 1903.

31. G. Stein 1971, 32.

32. Leo recalled: "There were many Renoirs in the Caillebotte collection, and I had looked at them a great deal without getting far with them until one day one of the pictures clicked and Renoir was understood. I remember how after this one had been seen I stood in the center of the room and swept my eye round over the seven or eight pictures by him in the room and they all came into line." L. Stein 1950, 204. State officials had hotly contested Caillebotte's 1894 bequest of sixty-five works by Cézanne, Degas, Manet, Millet, Monet, Pissarro, Renoir, and Sisley. Ultimately slightly fewer than two-thirds of the pictures were accepted and placed on view in a single gallery of the museum in February 1897.

33. Vauxcelles 1904b; also Bouyer 1904, 601.

34. In addition to the Steins, Paul Cassirer, Baron Denys Cochin, Harry Graf Kessler, and Auguste Pellerin purchased works by Cézanne from Vollard during this period. Vollard Archives, Bibliothèque des Musées Nationaux de France (hereafter, Vollard Archives), MS 421 (4, 10), folios 27, 30, 31, 34–35, 38, 42, 44.

35. Vollard 1936, 137.

36. The transaction is recorded on December 16 in Vollard's register, Vollard Archives, MS 421 (4, 10), folio 44. Vollard had purchased the painting (stock book no. 4061) from Cézanne for only 300 francs. Ibid., (4, 5), folio 77.

37. Theresa Ehrman to Jennie Rosenthal Ehrman, October 30, 1904, Theresa Ehrman papers and photographs, BANC MSS 2010/603.

38. Ibid.

39. The current residents of the studio at 27 rue de Fleurus kindly permitted us to remove paint samples, which were analyzed by Luuk Hoogstede, Andrew W. Mellon Fellow, Department of Paintings Conservation, Metropolitan Museum of Art, spring 2010.

40. Leo Stein to Mabel Weeks, undated, reprinted in L. Stein 1950, 15.

41. Leo and Gertrude Stein hoped to sell artwork by Hayden, Alexander Schilling, and Anders Zorn. The sale of works in America is mentioned in correspondence between Leo and Gertrude and Harriet Clark, Estelle Rumbold Kohn, and Mabel Weeks, Beinecke YCAL, MSS 76.

42. *Degas: Vingt dessins, 1861-1896* (Paris: Goupil & Co., 1897). The image, visible in archival photographs of the rue de Fleurus apartment, has been identified by Robert McD. Parker (see pl. 343; cat. 59).

43. *Exposition temporaire des lithographies en couleurs de Toulouse-Lautrec*, Musée du Luxembourg, Paris, December 12, 1904 – January 15, 1905; *Exposition de dessins, aquarelles, et peintures par MM. Beaufrère, Boudin, Dufy, Lautrec, Van Dongen*, Galerie B. Weill, Paris, February 25 – March 25, 1905.

44. L. Stein 1996, 159.

45. Berthe Weill's undated note to Leo is written on her gallery business card, Beinecke YCAL, MSS 76, box 130, file 2830.

46. *Exposition de tableaux de F. Iturrino et de P.-R. Picasso*, Galerie Vollard, Paris, June 25 – July 14, 1901.

47. L. Stein 1996, 172.

48. The shop, located at 37 boulevard Haussmann, was founded in 1903 by the Belgian furniture designer Gustave Serrurier-Bovy and the Parisian architect René Dulong. In 1905 it had branches in Paris, Brussels, Liège, and The Hague. The exhibition in question was on view from February 25 to March 6, 1905.

49. Morice 1905a; Apollinaire 1905a and 1905b.

50. Anon., April 1905.

51. Young 1940, 52. "Leo brought a friend of his to dinner the other night, a Mr. Young, a Mormon, who Leo says is the most talented American painter in Paris." Theresa Ehrman to Jennie Rosenthal Ehrman, March 31, 1904, Theresa Ehrman papers and photographs, BANC MSS 2010/603.

52. L. Stein 1996, 169. Gertrude remembers the events differently. She recalls that the prices of the paintings were too high, "almost as expensive as Cézanne." G. Stein 1990, 43.

53. G. Stein 1990, 43.

54. L. Stein 1996, 173.

55. These buildings were demolished in 1908.

56. Paula Modersohn-Becker to her husband, March 22, 1905, in Modersohn-Becker 1983, 363.

57. Morice 1905b, 542.

58. *Exposition Henri Edmond Cross*, March 21 – April 8, 1905.

59. Leo further remembers Matisse's efforts as "splotchy and messy…though both his drawing and his color had a decisive quality of energy." L. Stein 1996, 157.

60. Morice 1905b, 545. For contemporary interest in this type of composition, see Leclère 1905.

61. The versions by Matisse (*Marquet Painting a Nude in Manguin's Studio*) and Marquet (*Matisse in Manguin's Studio*) are both in the collection of the Musée National d'Art Moderne, Centre Georges Pompidou, Paris.

62. L. Stein 1996, 159.

63. Morice 1905c-e. Responses were published by Paul Artot, Alcide le Beau, Paterne Berrichon, Albert Besnard, Victor Binet, Jacques-Émile Blanche, Georges Bouche, Bernard Boutet de Monvel, Albert Braut, Charles Camoin, Henry Caro-Delvaille, Eugène Carrière, Claudio Castellucho, Ernest Ponthier de Chamaillard, Louis Dejean, Jean Delville, Lisbeth Delvolvé-Carrière, Maurice Denis, George Desvallières, Maxime Dethomas, Kees van Dongen, Raoul Dufy, Henri Duhem, Francisco Durio, Pierre Girieud, Charles Guérin, Henri Hamm, Charles Lacoste, Jacqueline Marval, Maxime Maufra, Charles Milcendeau, Tony Minartz, Lucien Hector Monod, M. Ouvré, Fernand Piet, René Piot, René Prinet, Gaston Prunier, Jean Puy, Léon de la Quintinie, Armand Rassenfosse, Dário de Regoyos, Gabriel Roby, Antoine de la Rochefoucauld, Georges Rouault, Émile Schuffenecker, Paul Sérusier, Henri Eugène Le Sidaner, Paul Signac, Marie Louis Süe, Gaston la Touche, Félix Vallotton, Paul Vernet, Ferdinand Willaert, Adolphe Willette, and Ignacio Zuloaga.

64. Morice 1905b, 550; Morice 1905e, 84-85.

65. Faure 1905, 24.

66. Sarah Stein to Jennie Rosenthal Ehrman, December 6, 1904, Theresa Ehrman papers and photographs, BANC MSS 2010/603.

67. Octave Maus, in a lecture given on November 15, 1906, at the time of the closing of the Salon d'Automne, published in Maus 1907, 61.

68. Vauxcelles 1904a.

69. Spurling 1998, 334.

70. L. Stein 1996, 158.

71. Kimball 1948a, 37. It is possible that Michael and Sarah had acquired a painting or two by Manguin and/or Vallotton earlier in the year.

72. Gide 1905, 482.

73. Leo Stein to Mabel Weeks, November 29, 1905, Beinecke YCAL, MSS 78, box 3, folder 52.

74. Sarah described the Cones: "Etta Cone, who is an especially nice Baltimore friend of Gertrude's, & her sister, Dr. Claribel Cone, rather a famous pathologist, now working at the Pasteur Institute." Sarah

Stein to Jennie Rosenthal Ehrman, October 29, 1904, Theresa Ehrman papers and photographs, BANC MSS 2010/603. A reference to Etta Cone's first Picasso purchases—"1 picture, 1 etching"—appears in her account books. Although there is no date on the page of the entry, the dates of the surrounding pages make it clear that the purchase was noted on November 2, 1905. Information courtesy Emily Rafferty, archivist, Baltimore Museum of Art.

75. Olivier 2001a, 178.

76. G. Stein 1990, 45. See Gary Tinterow, in Tinterow and S. Stein 2010, 108-10, and Belloli 1999.

77. Mathilda Brown to Gertrude Stein, October 22, 1907, Beinecke YCAL, MSS 76, box 99, folder 1916. The Steins' clothing (Leo's and Sarah's as well) seemed as odd to their European acquaintances as it did to the Americans. Apollinaire noted that when the Steins "want to relax on the terrace of a café on one of the boulevards, the waiters refuse to serve them and politely inform them that the drinks at that café are too expensive for people in sandals" (Apollinaire 1907b, 29). The Hungarian artist Lipót Herman wrote about a visit to the "Stein art collection" in a diary entry for September 16, 1911: "[Leo Stein] is a bearded vegetarian who goes about in sandals.…[H]is fat sister, with a cigar in her mouth and her reform clothes, seemed a somewhat droll figure." Archives of the Hungarian National Gallery; reference courtesy of Gergely Barki; translation by Patrick Mullowney.

78. Rosenshine n.d., 112-13.

79. Leo Stein to Horace A. Eaton, January 16, 1906, University of California, Los Angeles, Department of Special Collections, Miscellaneous manuscript collection, Collection 100, box 168. Sarah spread news of the sale of Leo's picture. See Miriam Price to Leo Stein, April 29, [1906], Beinecke YCAL, MSS 76, box 119, folder 2571. Also Hortense Moses to Gertrude Stein, March 17, 1906, ibid., box 117, folder 2488; and Mabel Weeks to Gertrude Stein, [May (?) 1906], ibid., box 130, folder 2834.

80. Rosenshine n.d., 118; Leo Stein to Mabel Weeks, undated [late spring 1906], Beinecke YCAL, MSS 77, box 12, folder 177.

81. February 6, 1906: "Vendu à Stein une litho de Cézanne 50 frs" and March 17, 1906: "Recu de Stein 160 frs pour 2 lithos en couleur (femmes aux chapeaux de Renoir)." Vollard Archives, MS 421 (5, 1), folios 23, 50.

82. *Tableaux de M. Henri Matisse*, Galerie Druet, March 19 - April 7, 1906.

83. Bouyer 1906, 110.

84. Morice 1906, 534.

85. Harriet Clark to Gertrude Stein, March 30, 1906, Beinecke YCAL, MSS 76, box 101, folder 1968. It appears that Leo tried in vain to exhibit at one of the Salons d'Automne as well. In response to Leo's request for assistance, Matisse writes that he will speak to Marcel Sembat, a member of the jury, about Leo's painting. Henri Matisse to Leo Stein, Beinecke YCAL, MSS 76, box 116, folder 2449.

86. Adriani 2001, 195.

87. Paul Signac to Charles Angrand, January 14, 1906 (Barr 1951, 82). Cachin 2000, 377, dates the letter January 16.

88. June 1906 letter from Henri Charles Manguin to Henri Matisse, in which he comments on the appearance of the painting in the Stein atelier. Archives Matisse, Paris (hereafter, AMP). See also Leo Stein's postscript in an undated letter from Gertrude Stein to Mabel Weeks, in L. Stein 1950, 18.

89. Etta Cone wrote Gertrude on May 16, 1906, with the offer of a loan. Potter 1970, 80.

90. Gertrude Stein to Mabel Weeks, undated [late spring 1906], Beinecke YCAL, MSS 77, box 12, folder 177.

91. Sarah Stein to Henri Matisse, January 25, 1907, AMP (translation by Carrie Pilto). Matisse provided the Steins with that very opportunity the following month, when he invited them to meet him at Perpignan. He was there to transfer his work from his in-laws' house to a newly rented storage facility in nearby Collioure, and it seems likely that he permitted the Steins to choose from the available canvases. Wanda de Guébriant at the Archives Matisse, Paris, kindly shared this hypothesis with me, based in part on the telegram the artist sent the Steins from Perpignan on February 27, 1907: "Will wait for you tomorrow one o'clock if possible. Be discrete [*sic*]. Matisse." Beinecke YCAL, MSS 76, box 116, folder 2449.

92. Paula Modersohn-Becker to her husband, February 27, 1906, in Modersohn-Becker 1983, 385.

93. G. Stein 1990, 41.

94. L. Stein 1996, 192-93.

95. Vollard Archives, MSS 421 (5, 1), folios 53, 77, 89. Leo Stein to Henri Matisse, May 8, 1906, AMP.

96. Henri Charles Manguin to Henri Matisse, December 30, 1906, AMP.

97. Félix Fénéon to Henri Matisse, February 23 and March 11, 1907, AMP.

98. Leo was not the only collector who felt this way. A few weeks later Gustave Fayet, an important lender to the Gauguin retrospective and an admirer of Matisse, sold eight of his Gauguins to Vollard for 24,000 francs. Bacou 1991, 28-29.

99. Vollard Archives, MSS 421 (5, 2), folio 8.

100. Vollard suggested that Leo choose between two Puy "heads." Ambroise Vollard to Leo Stein, letter postmarked February 23, 1907, Beinecke YCAL, MSS 76, box 130, folder 2828.

101. Sarah Stein to Henri Matisse, January 25, 1907, and Henri Charles Manguin to Henri Matisse, February 28, 1907, AMP.

102. "Tableaux, pastels, aquarelles, dessins & eaux-fortes…composant la collection de M. George Viau," Galeries Durand-Ruel, Paris, March 21-22, 1907 (second sale). Prior to the Viau sales, Durand-Ruel had tried to interest international collectors, including the Havemeyers of New York, in the Cézannes, Daumiers, Renoirs, Degases, and Manets (Frelinghuysen 1993, 245).

103. Rosenshine n.d., 98.

104. The winning bid on Renoir's *Reclining Nude* (1883; Metropolitan Museum of Art), for example, was 4,750 francs. S. Stein et al. 2009, 123.

105. The Musée du Luxembourg was considered the museum of living artists. A decade after an artist's death, his pieces were supposed to be transferred to either the Louvre or a museum elsewhere in France. By this logic, *Olympia* should have left the Luxembourg in 1893, but opposition from the director of the École des Beaux-Arts and others kept the painting out of the Louvre for an additional fourteen years (Marguillier 1907, 161-62). Benjamin (2001, 111) points out that thanks to the bequest of Étienne Moreau-Nelaton, Manet's *Déjeuner sur l'herbe* (1863; Musée d'Orsay) entered the Louvre one week before *Olympia*'s unveiling there.

106. Marguillier 1907, 161.

107. Twenty-third Salon des Indépendants, March 20 - April 30, 1907.

108. The source of Picasso's figure has also been traced further back, to Michelangelo's *Dying Slave*, a cast of the bust of which was owned by Leo.

109. Cowling 2002, 187.

110. Danchev 2005, 53.

111. Pierre Daix's assertion that Leo and Gertrude owned this painting (in Daix and Rosselet 1979, 208, no. 95) has not been substantiated.

112. Gary Tinterow (86) and Lucy Belloli (90) in Tinterow and S. Stein 2010.

113. In his introduction to Gertrude Stein's book *Painted Lace*, Daniel-Henry Kahnweiler recalls that Matisse approached him in 1907 in an effort to help the Steins. G. Stein 1955, ix-x. Matisse proposed that he sell *La Coiffure* to Kahnweiler, who would in turn sell it to Sarah and Michael for cash and their Gauguin *Head of a Tahitian Girl* (ca. 1892; cat. 62).

114. L. Stein 1996, 173, 175. Leo writes that the painting Picasso lined was *Les Demoiselles d'Avignon*, but conservators at the Museum of Modern Art disagree. See "Les Demoiselles d'Avignon, Conserving a Modern Masterpiece," http://www.moma.org/explore /conservation/demoiselles/analysis_2_a.html. The thin, unprimed canvas of Picasso's *Boy Leading a Horse* was lined early in its history. Brushstrokes passing from the main canvas onto the larger lining canvas are clearly visible. It is possible that Picasso lined *Boy Leading a Horse* before beginning it, but since Picasso is known to have returned to his paintings for retouching, visual examination is not conclusive. My thanks to Anny Aviram, conservator, Museum of Modern Art, for unframing the painting and sharing her expertise.

115. Félix Fénéon to Henri Matisse, August 28, 1907, AMP. According to a published report, several months after he invested six million francs in a partnership with Bernheim-Jeune et Cie, Prince Alexandre de Wagram sued the gallery, charging that it had overestimated the value of its stock. The gallery was eventually acquitted of all charges. Anon., January 12, 1908. For Apollinaire's staunch support of Wagram, see Apollinaire 1907a.

116. Henri Matisse to Henri Charles Manguin, September 15, 1907, Grammont 2005, 283.

117. Mahonri Young to Leo Stein, February 11, 1908, Beinecke YCAL, MSS 76, box 131, folder 2882. Also Mrs. Milton Eisner to Annette Rosenshine, October 19, 1907, Annette Rosenshine Papers, Bancroft Library, UC Berkeley.

118. G. Stein 1990, 43.

119. Rosenshine n.d., 81.

120. Kostenevich and Semyonova 1993, 11-12.

121. Sarah Stein to Gertrude Stein, undated ("Wed a.m." [1908] and "Sunday a.m." [1909]), Beinecke YCAL, MSS 76, box 126, folder 2731.

Plate 21

Saturday Evenings at the Steins'
Emily Braun

From 1906 until the outbreak of World War I, devotees and skeptics of modernism made pilgrimages to the Paris salons of the Stein families. "Some came to mock and remained to pray," wrote Leo of the not-uncommon conversions to the new religion, as it was aptly termed.[1] It is no exaggeration to state that the Steins did more to support avant-garde painting than any other collectors or institutions anywhere in the first decade of the twentieth century. They also came to epitomize the societal freak show of bohemia for cultural conservatives. At 27 rue de Fleurus, home of Leo and his sister Gertrude, and 58 rue Madame, that of their brother Michael and his wife, Sarah, thrill seekers and earnest amateurs hobnobbed with a cosmopolitan aggregation of insiders. The reactions to the paintings by Paul Cézanne, Henri Matisse, and Pablo Picasso ranged from disdain to incredulity, but the astonishment of neophytes served only to spread the word, and crowds soon flocked to gawk at the controversial art and the owners who had consecrated it.

The legacy of the Stein salons extended far beyond the many canvases now ensconced in major museums in Europe and North America. In the confines of their weekly "at homes," avant-garde artists were comforted and economically sustained, their reputations enhanced by in-house competition and their careers furthered by introductions to soon-to-be collectors and impresarios. Critics and art historians absorbed ideas in the making. For artists and laymen, rue de Fleurus and rue Madame offered concerted apprenticeships on how to see, not merely look. The personalities, as well as the pictures, inspired new works of art and literature. The Steins themselves were as unconven-

tional as the art on their walls, and they represented the possibility of self-discovery and reinvention. As Marsden Hartley confided to Gertrude, "I date much of my experience of freedom from those times at 27 which is itself peculiarly a place of freedom—a place where genuine ideas thrive and mediocrity walks away with discretion."[2]

The first documented visitors to rue de Fleurus were Leo's artist friends, whom he met while taking classes at the Académie Julian or playing billiards at the Café du Dôme. In August 1905 Alfred (Alfy) Maurer and Mahonri Young brought over some fellow Americans to see and be "shocked" by the pictures.[3] Leo used the atelier (attached to the ground-floor apartment where he and Gertrude lived) as his own studio, but it soon became an informal gallery where he displayed his Japanese prints and recently purchased works by Cézanne, Paul Gauguin, Pierre-Auguste Renoir, Henri Charles Manguin, and Félix Vallotton. With the acquisition of Matisse's *Woman with a Hat* (1905; pl. 13, cat. 113)—whose showing at the 1905 Salon d'Automne had achieved infamy in the press a few weeks earlier— the Steins' public profile as avant-garde collectors emerged. Simultaneously they began to favor late symbolist works by an unknown Spaniard, Pablo Picasso (see pl. 22). Sometime in 1906, likely after they acquired Matisse's even more controversial *Le Bonheur de vivre*, also called *The Joy of Life* (1905–6; pl. 15, cat. 117), from the Salon des Indépendants that spring, Leo and Gertrude decided to host regular Saturday evenings to accommodate the flow of visitors.

Michael and Sarah, who had advocated for *Woman with a Hat* and purchased their own works by Matisse soon thereafter, devotedly showcased the paintings and sculptures of the Fauve master. They too opened their doors on

Plate 21
Sarah Stein (left) hosts a visitor in the apartment at 58 rue Madame, Paris, ca. 1911–14. Henri Matisse's *Interior with Aubergines* (1911; pl. 162) hangs in the background. Estate of Daniel M. Stein

Plate 22

beyond the drawing room, they mixed the sexes and social classes, creating new elites based on talent rather than birthright. Salons had long served as clearinghouses for the visual arts: patrons changed the pictures on the walls according to their influential tastes, invited habitués to show new work, and sold to other collectors or dealers. Men did hold or cohost salons, but the social power traditionally resided with women and the ideal of feminine politesse. Such gatherings began as a means of self-education for women when universities and careers outside the home were denied them. The most powerful salon women, including Sarah Stein, derived their influence from personal charisma and the quotient of male celebrity in the drawing room. Only a very few, like Gertrude Stein, succeeded in becoming both a hostess and a "genius," a *maîtresse de maison* and a *cher maître*.[7]

Since the Enlightenment, salons had been a means of assimilation into mainstream culture for Jews, and they afforded Jewish women, as well as their Christian peers, an outlet for their intellectual ambitions.[8] Such was the case with Sarah, or "Sally," Samuels, valedictorian of her high school class at age fourteen, who made a very favorable marriage to Michael Stein in her native San Francisco in 1894. The Michael Steins entertained a great deal in their "handsome flat," which proudly contained a Steinway piano and Far Eastern art.[9] A budding woman of ideas, Sarah began to take appreciation courses on art, music, and comparative literature after the birth of their son, Allan. Yet the stereotypes of French sociability did not sit well with the mores of upper-middle-class America. As she wrote in 1899 to Gertrude, who was then studying medicine at Johns Hopkins, "I've thought very often of your advice concerning my Salon-lady propensities and although occasionally the temptation has been there, I have fought it and I can truly say that I am happier and gladder that I can turn to Mike and the dear baby with a clear conscience, for a woman cannot be a Salon-lady these days, I fear, without flirting a wee bit, can she?"[10]

Endowed with a formidable intellect rather than feminine seductiveness, Sarah found her métier in Paris, becoming a zealot for the cause of Matisse, increasing her status and authority in tandem with his success. Over

Saturdays, apparently receiving at an earlier hour, whereas the salon at rue de Fleurus started at nine and went on well into the night, enabling visitors who so chose to attend both.[4] The Steins perforce welcomed certain people, who wanted to see the art by daylight and without the hoi polloi, at other times during the week. No one was "at home" during the summers, when they vacationed in Italy or traveled elsewhere in Europe.

From the fall of 1910, when Alice Toklas moved in with Gertrude, the tenor changed at 27 rue de Fleurus. Leo's interest in both collecting and proselytizing started to wane, and he increasingly absented himself from the Saturday evenings during the course of 1911, barely attending in 1912–13 (though visitors could often find him upstairs in his private quarters).[5] Whereas the initial salon at rue de Fleurus had Leo "explaining and expounding" modernist aesthetics, under Gertrude's aegis after 1912 it became a center for her promotion of her own writing and Picasso's Cubism, both of which her brother disavowed.[6]

In hosting a salon on a *jour fixe*, the Steins followed a venerable institution for the marketing of high culture, which had originated in their adopted France in the seventeenth century. Many salons developed into exclusionary enclaves for the upper classes, but they also functioned as a social equalizer. Private spaces that wielded influence

Plate 22, cat. 291
Pablo Picasso, *The Acrobat Family,* 1905. Watercolor, gouache, and ink on paper, 41 x 29½ in. (104 x 75 cm). Gothenburg Museum of Art, Sweden

the years a whole cadre of women at the Stein salons, Alice Toklas and Etta and Dr. Claribel Cone among them, similarly came from comfortable American Jewish families that put a premium on education and appreciation of the arts. Several followed directly in Sarah's footsteps—or were "hypnotized," as her girlhood friend Harriet Lane Levy put it—and bought works by Matisse early on.[11] The Steins followed the usual salon protocol, in which the husband played the background role of financial supporter and took pleasure in his wife's social luster. Michael Stein, whom Sarah never took for granted, was known for his gentle hospitality and for guiding American visitors through Parisian museums and galleries—another pedagogical arm of the Stein salons.[12]

From 1905 at least until 1909, however, Leo led the way in aesthetics, using the Saturday evenings to explain the pictures, which he genuinely appreciated and understood in the context of art history and the nascent formalist theories of his time. "He believed that if the important people in the art world, art curators, authors, critics, were to unite in what he called a conspiracy, they could, in a few months, overturn public opinion completely," wrote a visiting American, the feminist Inez Haynes Irwin. "He talked everyone else out of the room, but we listened absorbed to his last word."[13] The dealer Ambroise Vollard favored the

Steins, it was said, because they were *not* rich, but he shrewdly recognized Leo's value as patron and spokesperson for an art that initially had no social or financial currency. According to Leo, Vollard once "expatiated on the conversation of French salons," in an attempt to prod him into the beau monde: "I assured him that this sort of thing was not at all in my line, and quite out of the question, but I was surprised by his speaking of it. Meeting Picasso the next day, I told him about this strange attack. Picasso laughed. Yes, he said, Vollard had already spoken to him of this, and what splendid publicity I could supply if I would go out into society and talk about painting. In fact however, I confined myself to 27 Rue de Fleurus."[14]

In a larger context, the Stein salons were but two in a city immortalized for many, including the aristocratic soirees of the Faubourg Saint-Germain, which were in eclipse, not only after the divisiveness of the Dreyfus Affair but also because of the new generation of bohemian social mores. The Steins were not the first to support renegades in the arts; already in the late nineteenth century, salon patrons fostered the assault against bourgeois norms and beaux-arts tastes. Wilhelm Uhde, for example, a rue de Fleurus habitué, hosted his own gatherings every Sunday. Nor were they the only expatriates to draw in fellow Americans. Natalie Barney held a contemporaneous literary

Plate 23

Plate 24

salon, feminist and lesbian-identified, while among artists, the Edward Steichens and the Patrick Henry Bruces were known for their hospitality. Others gathered at the American Art Club in Montparnasse. The writers and artists who frequented the Steins' also fraternized at the Café du Dôme and the Closerie des Lilas, or witnessed the latest work of colleagues in their studios. But nowhere else in the Western world except *chez les Steins* could one find the radically new in art—specifically, numerous examples by Cézanne and the best by upstarts Matisse and Picasso— on permanent display.

What we know of the Saturday evenings at the Steins' relies on the memoirs of the main protagonists and their guests. These recollections are often inaccurate and partisan, swayed by the internecine rivalry that eventually dissolved the relationship of Leo and Gertrude. Not infrequently, visitors confuse rue de Fleurus with rue Madame or conflate their original impressions with stories about the Steins that circulated long after. Because Sarah destroyed her letters from Matisse toward the end of her life and never immortalized her own account in print, we know much more about rue de Fleurus. Gertrude famously embellished *The Autobiography of Alice B. Toklas* to serve her self-aggrandizing purposes, eliminating Leo from the founding narrative in an act of literary fabrication that prompted him and many others to set the record straight upon its publication in 1933. More reliable, though smaller in number, are letters and diaries of the actual time and the reminiscences of lifelong American friends who were on the scene in the early years. Their testimonies lend more credence to Leo's version than to Gertrude's, demonstrating that he was not, at first, the pedant that he was later to become, his behavior exacerbated by the onset of deafness before the age of forty. Gertrude cannot be entirely condemned for her entertaining version of events: given the evanescence of salon conversation it was a long-standing tradition to re-create or even fictionalize the goings-on. Once a writer, she inscribed the address of rue de Fleurus, not rue Madame, in history; her popularizing story of the salon earned a far broader readership than any of her recondite literary tomes.

Visitors to the atelier at rue de Fleurus (pl. 25) entered a cluttered space with pictures at times skied four high, books everywhere, and portfolios of prints and drawings stacked against the wall. Gas lamps illuminated the pictures rather inadequately until electrical ceiling lights were installed a year or so before the war. At rue Madame, the paintings hung on picture rods in the aerie space of a former Protestant church. Massive Renaissance furniture with carved decorative details (purchased by the Steins in Florence) filled the public rooms of both apartments, with Islamic carpets underfoot. The Michael Steins shipped pieces of their Chinese collection from San Francisco. On his "junking trips" in Italy, Leo also purchased iron boxes, bronze mortars, terracotta saints, and carved wooden angels, even plaster casts of heads by Michelangelo and Donatello. The traditional, if eclectic, decor could not have been more of a contrast with the revolutionary art, but those of sharp mind intuited that the new would soon be valued like the old. For others, the patina of age offered reassurance and the curios something to look at if the pictures proved too overwhelming. When one visitor noted that he liked the Cézannes at rue de Fleurus and not those elsewhere, Leo explained that it was on account of the "exuberant milieu." He compared it favorably to the house of his neighbor, an American vegetarian millionaire. "We spent an evening there in a religious hush looking at

Plate 25

Rembrandts and Durers and Nanteuils. The walls were a cool grey, the carpet was cool, even the stove was cool—the esthetic chill as I called it."[15]

Extraordinary as the pictures were, the Steins needed more than shock value to accrue their cultural capital. The legacy of any salon drew from the brilliance of its guest list, both the habitués and a widening circle of newcomers. Gertrude knew this when she devoted the main of *The Autobiography of Alice B. Toklas* to documenting the accomplished and eccentric who streamed through the atelier. The expanding network depended on key "liaison officers," among them the Americans Alfy Maurer and the theater impresario Mildred Aldrich; the Frenchman Henri-Pierre Roché, a node for the Parisian *bohème* and, later, the author of *Jules and Jim*; and the English art historian Matthew Stewart Prichard.[16] The opening of the Académie Matisse in January 1908 produced a growing contingent of Germans (led by Hans Purrmann), Scandinavians, Russians, and Hungarians. Acquaintances from San Francisco flocked to both rue de Fleurus and rue Madame. Americans felt at ease with the informality of the Steins, but for foreigners, Lee Simonson remembered, it had the aura of a shrine: "Somber-suited or frock-coated Germans and Scandinavians, like pallbearers who had just interred the remains of traditional painting bowed at the courtyard door, murmuring '*Habe die Ehre*,' solemnly made the tour of the studio, and bowed themselves out with more murmurs of '*Besten Dank*.'"[17] The British—among them the critic Roger Fry and artists Jacob Epstein, Vanessa and Clive Bell, Duncan Grant, Augustus John, and Wyndham Lewis—were relative latecomers to the Stein abodes.[18] In 1911 Paris-based Gino Severini brought F. T. Marinetti and Umberto Boccioni, but there was no love lost between the belligerent Italian Futurists and the laid-back hosts of rue de Fleurus.

Much has been made of the seeming gender inequality of Gertrude's memoirs, in which men and women at rue de Fleurus are divided between "geniuses" and "wives of geniuses." Taking on Alice's third-person narrative voice in a clever literary device, Stein immodestly vaunted her own position as the singular female deity at the Saturdays. Closer reading, however, reveals that Gertrude acknowledged the key roles played by her domestic goddess, Toklas, and their loyal cook, Hélène.[19] And whereas Toklas chatted about perfumes, hats, and babies with several female habitués, Gertrude dutifully recorded the presence of professionals such as Mildred Aldrich and Dr. Claribel Cone. The Saturday evenings featured "New Women" such as the writers Mabel Dodge and Neith Boyce Hapgood, whose contacts were instrumental in furthering Gertrude's career. For every "femme décorative," as Gertrude characterized the habitué Fernande Olivier, Picasso's lover, there was a "femme d'intérieur," notably the strong-willed milliner Amélie Matisse, who worked hard to keep her family afloat economically and emotionally.

Artists' wives and mistresses of disparate backgrounds and personalities populated the Stein salons, among them Germaine Pichot, Alice Derain, Marcelle Braque, Dolly van Dongen, Josette Gris, Eva Gouel, Bridget Gibb, and Gabrielle Picabia, not to mention artists' mothers (Robert Delaunay brought his). Yet the Saturdays also attracted women who were artists in their own right, many of them unmarried, for whom the networking counted: Anne Goldthwaite, Achille Schille, Kathleen Bruce, Grace Gassette, Janet Scudder, Grace Mott Johnson, Ethel Mars, Maud Hunt Squire, Mina Loy, Marguerite Zorach, Georgette Agutte, the miniaturist Myra Edgerly, and the future Sonia Delaunay. The painter Marie Laurencin held her own amid the giant egos, including that of her lover Guillaume Apollinaire: her depiction of her coterie features women on a creative par with men and deliberately feminizes the male figures (pl. 26). Well-educated American ladies from the West Coast and alumnae of Johns Hopkins, Wellesley, Bryn Mawr, and the Harvard Annex added to the intellectual mix, while not a small number of them went on to purchase works by Picasso and Matisse as a result. Society figures and wealthy patrons such as Agnes Meyer, Lady Ottoline Morrell, Emily Chadbourne, and Elizabeth Montgomery Sears added to the variety of the gender difference at the Steins', countering any stereotype of a passive femininity that Gertrude's memoirs might have subsequently construed.

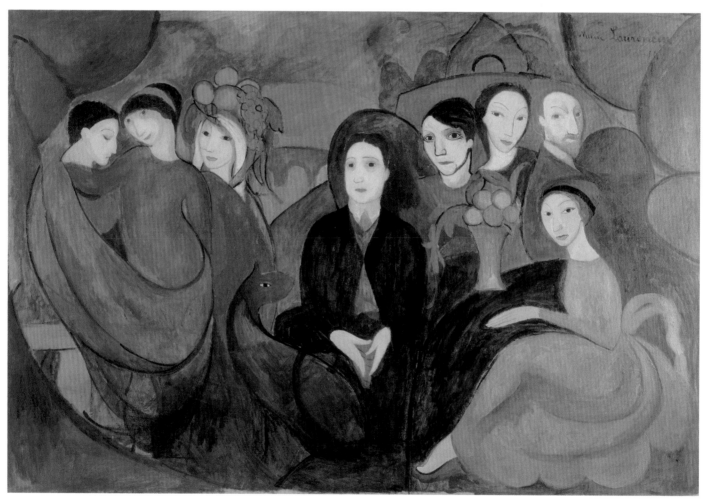

Plate 26

Both Stein households usually hosted a small group for dinner before other habitués and the strangers arrived, the latter customarily gaining entrance by dropping the name of someone who knew someone. "It was easy," Aldrich recalled telling an American concerned about protocol at rue de Fleurus. "The door was wide open. He had only to enter and look at the pictures as he would in a public gallery."[20] Already in 1908 Sarah wrote to Gertrude that she could not have a private conversation with Patrick Henry Bruce because of the crowds.[21] The insiders at the Michael Steins' often retreated to the back room, and Aldrich advised one American that Gertrude would not engage—she spoke only with her intimate friends. Max Weber remembered the early years of "lengthy and involved discussions," but Arthur Carles found it "all rather jumbled—the people and the pictures—confused impressions—complex."[22] Often the sheer spectacle overwhelmed the possibility of unobstructed viewing or intimate dialogue, let alone gossip. Instead people came to look and, eventually, to look at the lookers. "Last night we went to the Steins," wrote family friend Sylvia Salinger in 1912: "There were quite a number of people there. Some awfully funny ones, but we don't talk to that kind, just sit and watch while they look at the pictures. One very fantastic lady went all around the room with her lorgnette fastened first on one picture and then on another until finally they landed on me where they stuck…. I suppose if I am not there the next time she comes she'll take it for granted I've been sold."[23]

Topics of conversation ranged from lowbrow to highbrow: palmistry, boxing, and the Katzenjammer Kids interspersed with talk about the latest exhibitions, Otto Weininger, and Sigmund Freud. Prim Americans did not easily mingle with bohemians, and language barriers could inhibit rather than facilitate intellectual exchange. As Salinger exclaimed: "These artist people are the limit trying to hold a conversation with. It's the hardest work ever! They just sit all kind of sprawled out and let you do the talking. If you get tired and stop—there is dead silence until you begin again."[24] Harriet Levy, for her part, found the art talk "full of excitement, passion, anger, rebellion," but the professionals "used words whose meaning I did not understand."[25]

Regardless of their professional background, attendees at first visit experienced a similar reaction to the art: disbelief, revulsion, and for many, an eventual communion with the lines, forms, and colors about which Leo and Sarah spoke so convincingly. "It is very difficult now that everybody is accustomed to everything to give some idea of the kind of uneasiness one felt when one first looked at all these pictures on the walls," Gertrude affirmed.[26] Quite simply, people expected pictures to depict recognizable people and things, or at least to cohere stylistically. Typical was the description of a visit to the Michael Steins' apartment by the critic Lewis Hind in his 1911 book on Postimpressionism, one of the first in English on the subject. Initially horrified by the Matisse canvases—"that abortion of the female form so grotesquely naked!" as he described one—Hind told his readers that after an hour he felt compelled to stay: "I did not feel the 'tranquility' of which Mrs. Stein spoke, but I did feel a sense of excitement and stimulation. Here and there, as I waited and watched, an eccentricity seemed to start from the walls and say: 'I am alive. I am movement. I am rhythm. I exist.'"[27]

Raucous debunking of modern art had become commonplace at the public salons, but viewing the same in the confines of a private home was a different experience again: one was a guest, after all, and a modicum of decorum had to be maintained. Hence, legions pretended to admire the art, only to snicker and belittle their hosts once they departed. But those who stayed or returned to Saturday evenings had the possibility of unselfconscious contemplation, ready explication, and even the possibility of a tête-à-tête with Picasso and Matisse—who were not such madmen after all. Moreover, the hosts had put their money where their mouths were. As a result, different kinds of social pressures came to bear: that of being considered philistine or missing out on a shrewd investment. Nicknamed the "Stein Corporation," the hosts were often accused of being speculators.[28]

To be in the know or not to be in the know: that was the question raised by the reception of modernist aesthetics. Many people surrendered their convictions after visiting the Steins, recalled Harriet Levy: "They were afraid to buy

Plate 26

Marie Laurencin, *Apollinaire and His Friends*, 1909. From left: Gertrude Stein, Fernande Olivier, unidentified figure, Guillaume Apollinaire, Pablo Picasso, Marguerite Gillot, Maurice Cremnitz, Marie Laurencin. Oil on canvas, 51⅛ x 76⅜ in. (130 x 194 cm). Musée National d'Art Moderne, Centre Georges Pompidou, on loan to Musée National Picasso, Paris

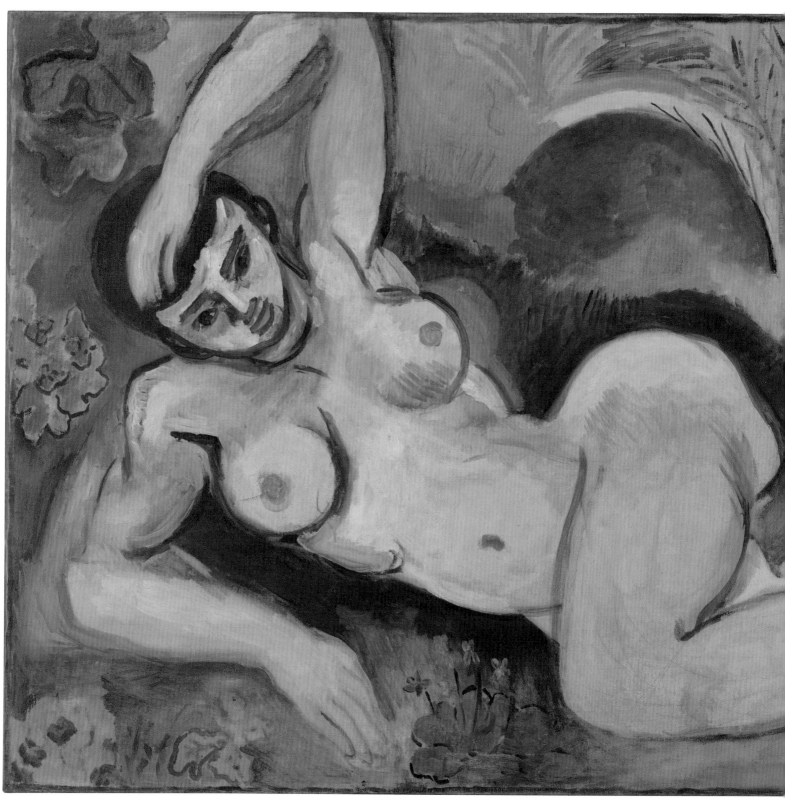

Plate 27

Plate 27, cat. 139
Henri Matisse, *Blue Nude: Memory of Biskra*, **1907.** Oil on canvas, 36¼ x 55¼ in.
(92.1 x 140.4 cm). The Baltimore Museum of Art: The Cone Collection, formed
by Dr. Claribel Cone and Miss Etta Cone of Baltimore, Maryland

them, they were afraid not to buy them. Afraid that they would turn out to be the important paintings the Stein's [*sic*] said they were."[29] For their part, the Steins were famously indifferent to novices and naysayers, and the sureness of their insights frequently came across as arrogant. "Leo Stein was a braggart American," opined the Hungarian sculptor Márk Vedres. "He'd crumple up the newspaper and declare it art."[30]

Lost to us are the animated conversations at the heart of the Stein soirees: those that addressed the pictures on the walls. From contemporary accounts we can surmise that Leo held forth in front of the canvases, emphasizing the visual tension between shifting planes and resolute mass, spatial illusionism and the flatness of the picture plane.[31] During his sojourns in Florence, Leo had been led to Cézanne and schooled in aesthetics by Bernard Berenson; both men, in turn, were influenced by the psychology of William James and the role of tactility in the cognition of three-dimensional objects.[32] Leo did not abide other contemporary theories that discussed the influence of the fourth dimension or Henri Bergson's élan vital on modernist abstraction. Instead he encouraged the salon guests to dwell on the apperception of purely pictorial qualities, on the nonreferential visual power of liberated form, line, and color. As a result of Leo's formalist insights, further propagated by Sarah, the Stein homes became the epicenter of a new language with a self-referential vocabulary all its own: "[Sarah] spoke for instance of a picture being plastic and solid at once. How that puzzled me!" exclaimed Irwin.[33] "People giggled and scoffed after they left," wrote Dodge, "not knowing all the same they were changed by seeing those pictures."[34] The concepts of pure form, color sensations, plasticity, and rhythmic expression soon made their way into the published criticism of Walter Pach and Willard Huntington Wright and the artists' statements of Max Weber, Morgan Russell, Andrew Dasburg, and many other habitués.

From the beginning, the stellar attractions at the Saturdays were Matisse and Picasso. Picasso sought to usurp Matisse as the leading figure of the avant-garde; he spurred his own creativity by competing against the number and notoriety of Matisse's canvases at the Steins. Leo was

the first, anywhere, to buy the work of both, but when he did so in 1905, the Fauve painter was way ahead in the game. Rue de Fleurus held the three most sensational paintings of the public exhibitions: *Woman with a Hat, Le Bonheur de vivre*, and, from the spring Salon des Indépendants in 1907, *Blue Nude: Memory of Biskra* (1907; pl. 27, cat. 139). Picasso's blue and rose period canvases seemed tame by comparison, and Gertrude herself conceded that initially people came to see the Matisses and Cézannes.[35] Only Picasso's *Gertrude Stein* (1905–6; pl. 183, cat. 238), on the wall by the end of 1906, contained an inkling of his radical primitivism. Even that was strategically conceived to gain his patrons' approbation and as a deliberate response to the daring images of real women that dominated the rue de Fleurus salon at its inception: Hortense Fiquet in Cézanne's *Madame Cézanne with a Fan* (1878–88; pl. 2, cat. 10) and Matisse's wife, Amélie, in *Woman with a Hat*. Picasso's breakthrough picture, *Les Demoiselles d'Avignon* (1907; Museum of Modern Art, New York), inspired by the corporeal violence of *Blue Nude*, was unsalable. He kept Leo and Gertrude abreast of his ambitious sequel, the monumental *Three Women* (1908; pl. 186, cat. 251), in order to coax their purchase and achieve parity with Matisse—at least at their house, for Sarah and Michael had thrown their full support behind his rival.[36]

Both artists, in turn, had to stake their position with regard to the most formidable presence at rue de Fleurus: Paul Cézanne. Most contemporary artists had not seen the work of the reclusive master until a series of exhibitions in 1905, 1906 (after his death), and 1907; even then, the Stein salons did more to promote his influence than any other venue in Paris. Leo championed Cézanne—the catalyst for his own aesthetic awakening—as the liberator of pure form. "Matisse said once that Cézanne is 'the father of us all,' but he did not reckon with the phoenix Picasso, who had no father," he wrote. Yet the Spaniard "had one rival who had to be met" and Leo watched with interest as Picasso pursued "the conflict" with Cezanne's bathers and watercolors, which could be seen aplenty at rue de Fleurus.[37] Leo intuited Picasso's debt to the earlier master when he purchased his Rue-des-Bois and Horta landscapes over

Plate 28, cat. 437
Henri de Toulouse-Lautrec, *In the Salon: The Divan*, ca. 1892–93. Oil on cardboard, 23⅝ x 31½ in. (60 x 80 cm). MASP, Museu de Arte de São Paulo Assis Chateaubriand, São Paulo, Brazil

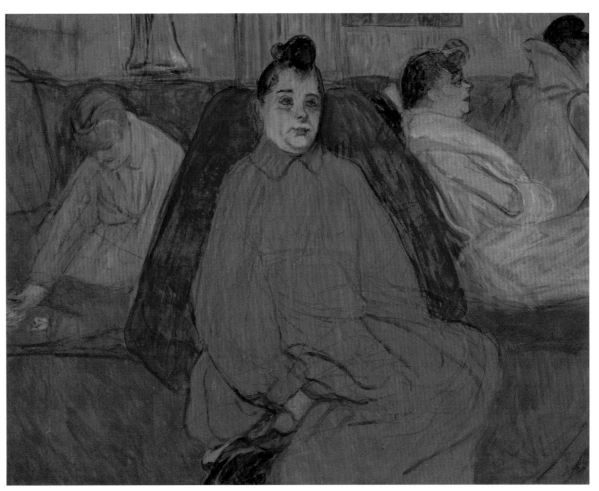

Plate 28

the course of 1909, paintings that were only later understood as founding moments in the history of Cubism. In hindsight, Leo's precocious connoisseurship of Matisse and Picasso made perfect sense in relationship to the painter whose works served as a linchpin for most everything on the walls of rue de Fleurus: he lost interest in them precisely when the seminal influence of Cézanne on their art had run its course.

The financial need to sell tough pictures also drove the parrying. The Saturday evening soirees proved the best advertisement for the artists' work—particularly that of Picasso, who chose not to show at the public exhibitions. At the Steins', the two artists were a study in opposites. "Matisse felt himself to be one of many, and Picasso stood apart, alone," observed Leo. Picasso's ambitions drove him to compare himself with everyone and everything. He scrutinized Henri de Toulouse-Lautrec's *In the Salon: The Divan* (ca. 1892–93; pl. 28, cat. 437), recounted Gertrude with some amusement, "and greatly daring said, 'but all the same I do paint better than he did.'"[38] Matisse dressed and conducted himself like a gentleman, holding his deep anxieties in check. "He was also witty, and capable of saying exactly what he meant when talking about art. This is a rare thing with painters," Leo added.[39] Picasso arrived "like a little bullfighter" surrounded by his often unruly *tertulia* of critics and poets: Apollinaire, Maurice Cremnitz, Max Jacob, and André Salmon.[40] André Derain and Georges Braque, no longer Fauves, left Matisse's side for the contender. Unsure of his French, and socially not yet at his ease, Picasso dressed down and liked to endear himself through clever asides. He left his entourage to bad-mouth Matisse, who had crossed a line by openly disparaging his emerging cubist style. The salon graces of old did not rule at rue de Fleurus, as Gabrielle Picabia recounted: "All those painters were *très méchants* towards each other. It used to shock me."[41]

The creative tensions between Picasso and Matisse abetted the other conflicts stoking at the Stein salons: those between Sarah and Gertrude, and Gertrude and Leo. Once Matisse opened his school, backed by Michael and Sarah, the camps divided between Matisseites and Picassoites,

as Gertrude gleefully dubbed them.[42] Gertrude had grown close to Picasso while she sat repeatedly for her portrait, but she competitively encouraged their alliance after Sarah became known as the high priestess of Matisse. Harriet Levy believed "that the two factions had identified their authority with the identity of the two painters," and she felt "impaled between two forces."[43] Showing interest in Picasso at the Michael Steins could be perceived as heresy, while Martin Birnbaum earned Gertrude's displeasure by mistaking one of the Spaniard's paintings for a Cézanne: "To discover influences in the work of Miss Stein's unapproachable master was almost a crime, and was in itself sufficient reason for being regarded as an unwelcome visitor."[44]

Leo remained nonpartisan, although in March 1908 one guest perceived a complicated situation of "two hungry families pouncing" on everything Matisse produced.[45] Sarah's role in promoting Matisse was hugely influential, even if Alice Toklas later cut her down as "a provincial Madame de Stael."[46] Sarah was intimidating to some women but not to men. Like Leo, she commanded respect for her knowledge of modern art, yet her delivery was tempered by a genuine interest in others that her introverted brother-in-law lacked. As a result, some preferred the more relaxed atmosphere of rue Madame to the bohemian antics of rue de Fleurus. Bernard Berenson had mentored Leo in art history, but it was Sarah who won over the esteemed authority on Italian Renaissance art. "If you can ever convince me of any beauty in that toad, I'll believe in Matisse," Berenson taunted her, referring to the bosomy spread of *The Gypsy* (1905–6; pl. 29, cat. 118)—and she did.[47]

Sarah's aide-de-camp at rue Madame was Matthew Stewart Prichard, a conduit to wealthy American society ladies and British cultural circles. His background in Asian and Byzantine studies, complemented by Sarah's appreciation for Chinese art, proved critical to Matisse's developing interest in flat, decorative abstraction. The intellectual exchange with these two kindred spirits was as valuable to Matisse as all the publicity that he garnered at rue de Fleurus.[48] After Gertrude's catty memoir, he defended Sarah as "the really intelligently sensitive member of the family," an opinion seconded by Walter Pach and others.[49]

The salon dynamic between Leo and Gertrude was less overt and more complex. Until Gertrude published *Three Lives* in 1909, her presence did not count for much, and few paid attention to her.[50] Indeed, she was noted mostly for her silence, a silence broken by a winning, deep-bellied laugh that left the most lasting impression upon visitors. When Alfred Stieglitz came to rue de Fleurus in June 1909, led by Steichen, he had no idea of the identity of the big, smiling woman in the corner. He was transfixed, instead, by the most marvelous explication on art he had ever heard—that of Leo Stein.[51] Their old friend Hutchins Hapgood believed that had Gertrude penned *The Autobiography of Alice B. Toklas* at the actual time of the salons, Leo would "have appeared, not only as the beloved and the important, but as the great spirit of twenty-seven rue de Fleurus, where Picasso and Matisse received material and spiritual nourishment, and she was vouchsafed the daily privilege of his presence."[52] Explicating visual images "with occasional

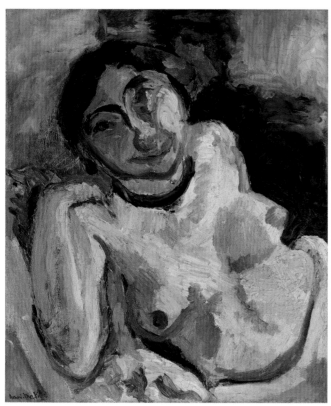

Plate 29

flashes of genius" proved to be Leo's great gift, one acknowledged by many, including his sister, who was determined little by little to surpass him, well aware of her brother's crippling writer's block and his abandoned enterprise as a painter.[53]

Both Gertrude and Leo had a personal investment in the notion of genius, and the Saturdays became both the test of their mettle and the contested field.[54] Leo's fluency with spoken language, the most evanescent skill of a salon, led him—for a time—to dominate a traditionally feminine domain. But Gertrude's quiet attention belied the creative gestation stimulated by the pictures, personalities, and conversations around her. Trained as a medical researcher, she set about using the salon as her laboratory.

Stieglitz had asked Leo to write about his views on art for the periodical *Camera Work*, but he demurred. In 1912, instead, Gertrude sent him her short texts on Matisse and Picasso, and he published her first character typologies, directly inspired by the careerism that she had witnessed at rue de Fleurus. They announced a new form of literary portraiture, a genre that originated in the French salons of old.[55] Gertrude's writing incited the contempt of Leo, who felt that the word portraits reduced sociability to the discourse of nursery rhymes.[56] With increasing confidence in her pursuit of "glory," Gertrude began to win over salon habitués and build her own following with her warmth and personal magnetism.[57] The last blow was her encroachment on Leo's realm of connoisseurship. Picasso's *The Architect's Table* (1912; pl. 197, cat. 260), her first independently purchased work (encouraged by the artist's sly trompe l'oeil depiction of her visiting card in the lower right of the composition), increased her stature as a pioneering collector. It was fitting that when their deep bond disintegrated, Gertrude, renowned for her physical bulk, identified with the disembodied facets of Cubism, while the emaciated Leo fell in love with Renoir's corporeal abundance.

The title of Gertrude's next book, *The Making of Americans* (1911), could have easily applied to her salon memoirs. Few American artists or mavens of high culture in Paris from 1905 to the outbreak of war failed to attend one of the Stein Saturdays. The influence of their network

Plate 29, cat. 118
Henri Matisse, *The Gypsy*, 1905-6. Oil on canvas, 21⅝ x 18⅛ in. (55 x 46 cm). Musée National d'Art Moderne, Centre Georges Pompidou, on loan to the Musée de l'Annonciade, Saint-Tropez

on individual American artists and cultural impresarios like Steichen, Stieglitz, Marius de Zayas, Robert J. Coady, and Michael Brenner has been well documented.[58] Circa 1905 James McNeill Whistler, William Merritt Chase, and Arthur Wesley Dow were the points of reference for those who had crossed the Atlantic. Many, such as Max Weber, saw their first Cézanne at rue de Fleurus; Maurer persuaded new arrivals that *Madame Cézanne with a Fan* was in fact a finished painting because it had a frame.[59] Although many of the Stein regulars exhibited at the Parisian salons, they tended not to assimilate or to socialize with other French vanguard artists outside the Stein "at homes." Rue de Fleurus and rue Madame offered the foremost seminars on modernism, an opportunity redoubled for some of the habitués who studied with Matisse; the master and his pupils sometimes went straight from the classroom to the Steins'.

The American contingent grew exponentially from a network that Leo established beginning in 1904 with Maurer, Young, and Maurice Sterne. He also gave several of them economic support by purchasing their works. Among the core group of early habitués were Bruce, Steichen, and Arthur B. Carles, who along with Maurer and Weber formed the New Society of American Artists in Paris in 1908. One introduction led to another in the close-knit community of expatriate practitioners: Samuel Halpert, Abraham Walkowitz, George Carlock, H. Lyman Saÿen (a scientist by training, who helped convert rue de Fleurus to electricity), the sculptors Arthur Lee, Jo Davidson, and Elie Nadelman. Weber and Bruce were founding students of the Académie Matisse, and others who joined the classes, like Arthur Burdett Frost Jr. and John Lyman, also made their way to the Steins'. Pach became a regular at both salons by 1907.[60] Another wave arrived in 1908–9, including Morgan Russell, Stanton Macdonald-Wright, Lee Simonson, Andrew Dasburg, Morton Livingston Schamberg, and Charles Sheeler. Between 1912 and 1914 Alvin Langdon Coburn, Manierre Dawson, Edward Fisk, Joseph Stella, Charles Demuth, and Marsden Hartley all visited rue de Fleurus, but they engaged with Gertrude, not the disaffected Leo.

Although words and camaraderie helped, the real apprenticeship for the American artists took place with pen and brush. High-quality reproductions of contemporary art were rare, rarer still from private collections, and only in black and white.[61] To see them in the flesh, one had to go to the Steins'—and a lot of flesh there was. Weber created a small painting of figures in a landscape (pl. 30) inspired by *Le Bonheur de vivre*, while Russell and Macdonald-Wright grafted the contorted pose and impossible skin tones of *Blue Nude: Memory of Biskra* onto their studies of Michelangelo's sculptures.

Overall, the influence of Cézanne and Matisse for American artists (as opposed to American collectors) outweighed that of Picasso at the Stein salons: the theme of the socially marginalized in the blue period canvases and brooding expressions of the harlequins and other early work did not render a following; undoubtedly the monochromatic palette and symbolist interiority seemed too redolent of Whistler. At that time, rue de Fleurus did not contain any paintings by Braque to illustrate his invention of Cubism alongside Picasso; there were other opportunities for that, notably Daniel-Henry Kahnweiler's gallery. In 1910 *Three Women* and *Les Demoiselles d'Avignon* were reproduced in Gelett Burgess's sensationalist article "The Wild Men of Paris," which publicized the Spaniard's work directly overseas.[62] Further, the moment of collage represented in Gertrude's collection was all too brief before war

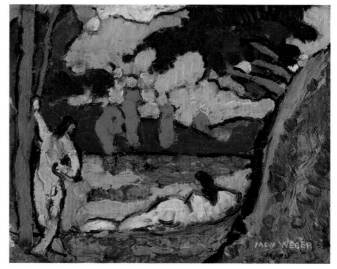

Plate 30

Plate 30
Max Weber, Sketch, 1906. Oil on canvas, 7½ x 9½ in. (19.1 x 24.1 cm). Galerie Salis & Vertes, Zurich

put a temporary end to her salon: when she resumed it in 1918, Picasso's cubist phase was over. Certainly Gertrude promoted Picasso's style, especially with regard to her own writing, and the cubist pictures on the wall as of 1909 influenced the credibility of the movement. But one may surmise that without Sarah's patronage, and lacking Leo's support (let alone his acumen in explicating pictures as one artist to another) in the years 1909 to 1914, the Stein Saturdays did not have the same role in the dissemination of Cubism as they did for Postimpressionism and Fauvism.

The panoply of unconventional artistic styles seen at the Steins' accompanied a pervasive sense of social freedom and countercultural bohemia at their weekly gatherings. Americans from different classes commingled with locals, foreigners, Jews, homosexuals, and the occasional aristocrat, following a pattern of expatriate salons that eroded differences of background and behavior. Europe provided the opportunity for the high-culture careers of the Steins, but their Saturdays, in turn, left their mark on the cosmopolitan character of Parisian modernity.[63] Their lack of convention extended to the social protocol of the evenings, which was so unstructured as to be almost nonexistent. "It was a world to be in ease in. No consequence hung upon what you told, upon what you said," Harriet Levy insisted, while Vollard admired the reversals of hierarchy: "People who came there out of snobbery soon felt a sort of discomfort at being allowed so much liberty in another man's house, and did not come again."[64]

They gave one "the feeling of independence," recalled Max Weber of the Steins, "they were free economically." "We were free," affirmed Leo, who claimed that they spent everything they had on art, books, and travel and took on no debts.[65] They stood out for donning comfortable sandals (specially designed by Raymond Duncan, brother of Isadora) and corduroy, a favorite of bohemian artists because it wore well and did not show the dirt. Sarah and Gertrude greeted guests in loose-fitting robes, and Leo sometimes wore a kimono. Typical of other salons, however, those of the Steins also established new demarcations between insiders and mere hangers-on, conscious of the authority that the Steins wielded as tastemakers and power brokers.

The Steins cultivated their sense of superior otherness in Paris as Americans and supporters of radical art. At rue de Fleurus and rue Madame, the hosts performed their newfound identities as the culturally eminent: having started out as middle-class natives of Allegheny, Pennsylvania, they were themselves as creative an invention as the pictures on the walls. Indifference to what others thought made the Steins a magnet for the similarly irreverent, nomadic, and reborn. Herein their Saturdays became "the cathedral of the international vanguard," in the words of society painter Jacques-Emile Blanche, but it was a decidedly ecumenical house of worship.[66]

Though unreligious, the Steins maintained strong Jewish identities, which added to their exotic appeal or, conversely, their disrepute. Mary Cassatt, indignant that new elites in the art world should be replacing the old, lashed out against the Steins with an anti-Semitic refrain: "They are not Jews for nothing…and the pose was, if you don't admire these daubs then I am sorry for you; you are not one of the chosen few."[67] Typical of many reform Jews, the Michael Steins assimilated to the point of celebrating Christmas, while Sarah became an advocate of Christian Science. Yet they drew the line at intermarriage, as did Gertrude, who chose a Jewish lesbian partner. Though Leo did not (he married Nina Auzias in 1921), his self-conscious identity as an outsider was grounded in his experience of growing up a non-Christian, from his close association with fellow Jews in the minority at Harvard and elsewhere, to his cultivation of the look and sound of a prophet in the wilderness of modernism. Gertrude was known to be proudly Jewish and, like Leo, criticized those who denied their origins as the price of entrée into genteel society.[68]

At the Saturdays, however, it was Gertrude who represented the ultimate figure of difference, the one whose open personality and sexuality produced a social aura all its own. Be they men or women, Americans or Europeans, visitors were taken by her fatness, earthy persona, and unconstrained appetite, which far exceeded the norms of femininity and upright Protestant comportment. Most described her calm demeanor and swathed physique as Buddha-like or compared her to a Hindu idol or Cambodian

caryatid.[69] The blatant orientalism of the allusions under-scored her Jewishness or what some less flatteringly termed her primeval Semitic features, while Alice Toklas, for some detractors, wore a concubine's attire, "draped in some semi-Oriental gauze of sorts, with clinking bracelets, tinkling chains."[70] Given the additional presence of numerous Hungarians—and "Turks, Armenians and other Jews," as Leo sarcastically noted—Saturdays at the Steins appeared to confirm the influx of the East into the West.[71]

Gertrude's sexual identity was equally threatening to the status quo for some: Agnes Meyer was repelled by her "masculine attributes."[72] By contrast, the Swedish-born American sculptor and habitué David Edstrom found her "precious and lovely"—impossible to love romantically, he added, but attractive nonetheless.[73] Other heterosexual men similarly found her intensity alluring, notably Picasso, who captured her "unfeminine beauty" in his series of monumental primitivizing nudes, with hints of lesbianism in the pairs of touching female bodies.[74] *Three Women*—with its triad of male, female, and androgynous bodies—epitomized the multiple identities tolerated at rue de Fleurus, while his *Gertrude Stein* captured the ambiguous sexuality of the sitter for all to see. Gertrude and Alice never advertised their same-sex relationship, as did other salon guests, such as the outré Ethel Mars, with her flaming orange hair and the exaggerated makeup that she shared with her companion, Maud Hunt Squire.[75] Instead, their rather traditional domestic arrangement was enough to reassure the reticent and comfort the similarly oriented. Like other salons, the Steins' provided a secure space in which to be oneself, without fear of surveillance or prosecution. They attracted a number of homosexuals and bisexuals, including the coterie of the German dealer Wilhelm Uhde, the young Oxford men brought by Matthew Prichard, Marsden Hartley and the German sculptor Arnold Rönnebeck, and Gertrude's own group of female cohorts.

The racial and sexual fluidity exhibited by the Steins and their guests was reinforced by the display of outlandish bodies in the art. When it was first shown at the public salon, Matisse's *Le Bonheur de vivre* caused a furor with its provocative mix of arcadian idyll and orientalist debauch. The Michaels Steins' collection of Far Eastern art added to the ascent of the non-Western implicit in Matisse's decorative style. Nudity in high art was nothing new, but *The Gypsy* incarnated an ugly beauty, threatening in its miscegenation of the European and the atavistic. With its masklike features and muscular anatomy, the *Blue Nude* wavered between male and female, black and pink skin, as did Picasso's numerous studies for *Les Demoiselles d'Avignon* and *Nude with Drapery*, several of which Leo and Gertrude had dared to acquire.[76] Gertrude's writing, inspired by the modernist fragmentation of the paintings, with their lack of differentiation and structure, also stood for the "peaceful Oriental penetration into European culture," as she phrased it, "or rather the tendency for this generation that is for the twentieth century to be no longer European because perhaps Europe is finished."[77] In *The Autobiography of Alice B. Toklas*, Gertrude tellingly banned the term *salon*, with its feminine and class connotations. Instead the "Saturdays" had a more casual ring, the "atelier" a more professional tone, and both suited the open-door, nondiscriminatory policy of the hosts.

Between 1906 and 1910, evenings at the Steins' promised novel and liberating discoveries, but as Gertrude intuited, "once everybody knows they are good the adventure is over." By the end of the decade, Matisse and Picasso had major dealers and financial security, making their appearances less critical at rue de Fleurus and rue Madame. With the opening of the Armory Show in New York in 1913, modernism officially came to America. The character of the soirees changed with Gertrude's celebrity and Leo's definite departure in the spring of 1914, at which point they divided their collection. Michael and Sarah lost the bulk of their Matisses in Germany while they were on exhibit there at the outbreak of war. "And everybody came and no one made any difference," recounted Gertrude of the shift. "There were the friends who sat around the stove and talked and there were the endless strangers who came and went."[78] In the 1920s Gertrude continued to receive visitors

at rue de Fleurus, but she presided over a literary salon, and the acolytes came to worship her.

Saturdays at the Steins' marked a transition from the intimate salons of a previous generation to a more public spectacle, edging toward diversion as much as edification. They ushered in a new form of sociability that took hold back in the United States after World War II: that of the private collection tour, in which a vetted group of strangers enter a home to gawk at the art and accrue insider information on cutting-edge acquisitions. The Stein salons had become "one of the sights of Paris," in Leo's words, and something authentic was lost in the birth of art tourism.[79]

Part voluble institution, part unrepeatable performance, salons were by nature transitory, although their influence, as in the case of the Steins', could be enduring. Despite the rift in their relationship, Gertrude and Leo could agree on the Stein legacy: for a brief moment in time, four Americans in Paris "happened to be in the heart of an art movement of which the outside world at that time knew nothing."[80] Long after the first cathedrals of the international vanguard shut their portals on rue Madame and rue de Fleurus, the disciples of the new religion, whom the Steins had inspired, continued to spread the word, the celebrity, and the marketing of modernism.

Plate 31

Notes

1. Leo Stein, Notebook 2, "Notes for Chapters on Matisse and Picasso," ca.1937, unpaged, Yale Collection of American Literature, Beinecke Rare Book and Manuscript Library, Yale University (hereafter, Beinecke YCAL), Leo Stein Papers, MSS 78, box 6, folder 170. The passages in this notebook served as drafts for Stein's 1947 book *Appreciation: Painting, Poetry, and Prose* (L. Stein 1996).

2. Gallup 1948, 258-59. The notable studies of the Stein Saturdays are James R. Mellow, *Charmed Circle: Gertrude Stein and Company* (Mellow 1974); Margaret Potter, Irene Gordon, and Leon Katz, *Four Americans in Paris: The Collection of Gertrude Stein and Her Family* (Potter 1970); and Brenda Wineapple's revisionist appraisal, which gave Leo his due, *Sister Brother: Gertrude and Leo Stein* (Wineapple 1996).

3. "Am to meet your friends tomorrow night and have dinner with them. And will take them to see your pictures. Young and I shocked some Americans the other day with them. The lady wanted to know if I was in earnest." Alfred Maurer to Leo Stein, August 2, 1905, Gertrude Stein and Alice B. Toklas Papers, Beinecke YCAL, MSS 76, box 116, folder 2452.

4. Vollard 1936, 136; Saarinen 1958, 187. Saturday evenings at the Michael Steins' were interrupted for a year beginning in the summer of 1910 when they returned to San Francisco to be with Sarah's dying father.

5. Family friend Sylvia Salinger wrote home in October 1912: "After supper we sat around and talked, Leo flitting in and out as if we weren't there at all, after the first greeting and introduction," and "Leo lives alone, mostly in this room—he does not eat with Gertrude and Alice at all." Salinger 1987, 12, 14; see also Wineapple 1996, 379.

6. L. Stein 1996, 200-201. As Leo wrote to Alfred Stieglitz from Settignano on April 10, 1911: "I can't abide cubism of Picasso or the Walkowitz order.... Well I'm out of it all. Goodbye, good luck." Alfred Stieglitz and Georgia O'Keeffe Archive, Beinecke YCAL, MSS 85, box 46a, folder 1108. On February 4, 1913, Leo wrote to Mabel Weeks, referring to himself as a "rank outsider...however I'm a cheerful one, and take my deposing good-humoredly, like the soon-to-be late President" (L. Stein 1950, 49). On his disaffection with Gertrude and Cubism, see Wineapple 1996, 327-30.

7. See, for example, Fisher 2000, chap. 4, "The Maîtresse de Maison Americanized: Art Hostesses and Women's High-Cultural Authority, 1880-1932," 173-226.

8. Bilski and Braun 2005, especially 1-21, and on Gertrude Stein, 113-25.

9. Jelenko ca.1965, 1-2. A pianist, Theresa Ehrman (later Jelenko) arrived with the Michael Steins in January 1904 to work as the au pair for their son, Allan, and returned to the United States two years later; she came back to Paris on her own in 1912.

10. Sarah Stein to Gertrude Stein, October 20 [or 30], 1899, Gertrude Stein and Alice B. Toklas Papers, Beinecke YCAL, MSS 76, box 126, folder 2731.

11. Levy n.d., 10.

12. Rosenshine n.d., 97-98.

13. Irwin n.d., 264. Irwin traveled to Paris in the spring of 1908 and accompanied the journalist Gelett Burgess to the Steins' and to artists' studios as he researched his article "The Wild Men of Paris," which appeared in *Architectural Record* in May 1910 (Burgess 1910). Her memoirs were written later but based on notes from her diary.

14. L. Stein 1996, 193. Leo also admitted in a letter to Mabel Weeks dated February 7, 1913, "For conversation as an art I have no talent...the aesthetic and philosophical attitudes that I myself hold are too much the attitudes of the intellectual superman to be available as yet for the general profit." L. Stein 1950, 55.

15. Leo Stein, Notebook 2, unpaged.

16. L. Stein 1996, 169; G. Stein 1990, 44, 121, 123.

17. Simonson 1943, 14.

18. Roger Fry and Duncan Grant first visited in 1909, Clive and Vanessa Bell in 1914; see Shone 1993, 480n6, and Shone 1976, 57, 135. In July 1913 Lady Ottoline Morrell viewed the Matisses at the Michael Steins'. Gathorne-Hardy 1963, 191.

19. For a revisionist account of Gertrude's gender politics, see Norris 1997.

20. Aldrich 1926, "Part Third/IV," 141-49.

21. Sarah Stein to Gertrude Stein, Friday, [likely late spring, early summer] 1908, Gertrude Stein and Alice B. Toklas Papers, Beinecke YCAL, MSS 76, box 126, 2732.

22. Weber 1958, 73-74; Mielziner 1928, 32; see also Wolanin 1983, 33-39.

23. Sylvia Salinger, December 8, 1912, in Salinger 1987, 40.

24. Sylvia Salinger, November 25, 1912, ibid., 35.

25. Levy n.d., 30.

26. G. Stein 1990, 10

27. Hind 1911, 45. See also the detailed accounts by Irwin (n.d., 260); Levy (n.d., 28); and Salinger (1987, 10).

28. Sterne 1965, 53; Blanche 1938, 276; Levy n.d., 8, 59.

29. Levy n.d., 59.

30. Archives of the Hungarian National Gallery, reference courtesy of Gergely Barki; translation by Patrick Mullowney.

31. "People were beginning to go to their apartment to hear Leo talk about two new painters he had 'discovered' at the Indépéndants exhibition—Matisse and Picasso. Earlier still he had come upon the Cézannes—and holding forth night after night in his big living room, he had forced people to see their value"; "Leo stood patiently night after night wrestling with the inertia of his guests, expounding, teaching, interpreting, always the advocate of tension in art!" Luhan 1999, 88, 89. See also Rewald 1989, 68-71.

32. Kyle 2001, 104-7. Mahonri Young recalled of his friendship with Leo in 1903-5 that Berenson's name "occurred constantly in their talk." Davis 1999, 81.

33. Irwin n.d., 262.

34. Luhan 1999, 89, and the account of Nina Auzias in L. Stein 1950, 26.

35. G. Stein 1990, 41.

36. On the relationship between Matisse, Picasso, and the Steins, see J. Richardson 1991, 411-19, and J. Richardson 1996, 90-91, 106; Spurling 1998, 380-84, 403-5; and Flam 2003, 9-65.

37. L. Stein 1996, 174, and L. Stein 1924, 230.

38. G. Stein 1990, 10.

39. L. Stein 1996, 159.

40. J. Richardson 1996, 3-9, for *la bande à Picasso*.

41. Gabrielle Picabia (who met Gertrude Stein in 1911) to Elizabeth Sprigge, in Sprigge 1954, 69.

42. G. Stein 1990, 64.

43. Levy n.d., 11, 12.

44. Birnbaum 1960, 40.

45. Irwin n.d., 267.

46. Wineapple 1996, 212, citing the Aline Saarinen interview with Alice Toklas (1956), Aline Saarinen Papers, Archives of American Art, Smithsonian Institution, Washington, D.C. In her memoir, *What Is Remembered*, Toklas remarked: "Mrs. Stein followed Matisse blindly. Mr. Stein believed in his wife and whatever she believed in" (Toklas 1963, 18). More accurate are the statements by the eyewitness Hans Purrmann (quoted in Göpel 1961, 92), who emphasized how much Matisse valued "her remarkable standpoint regarding his artistic worries and moods," and Rosenshine n.d., 97.

47. Levy n.d., 29.

48. Rosenshine n.d., 97; Spurling 1998, 44-47. Prichard's role is downplayed in *The Autobiography of Alice B. Toklas*, though he is referred to as having "brought a great many young Oxford men." G. Stein 1990, 123.

49. Braque et al. 1935, 3; Pach 1957, 72.

50. Jelenko ca. 1965, 4; Rosenshine n.d., 86; Young 1958, 63; Meyer 1953, 80; Luhan 1999, 90; Sterne 1965, 48; Picabia, in Sprigge 1954, 69. Accounts written decades later by those who had more investment in Gertrude undercut Leo's role, notably, Daniel-Henry Kahnweiler, introduction to G. Stein 1955, ix-xviii.

51. Stieglitz ca. 1922, 1.

52. Hapgood 1939, 247; see also 215.

53. W. H. Wright 1915, 284; Mellquist 1942, 252; Simonson 1943, 14-15. Gertrude's deep admiration for her brother's talents is documented in Wineapple 1996, 225, 278.

54. The competition between Leo and Gertrude and their "personal stake in the definition of genius" is discussed at length by Brenda Wineapple in her definitive study of their relationship, Wineapple 1996, 174-75.

55. G. Stein 1912, 23-25, 29-30. The portraits were written between 1909 and 1910; see Haselstein 2003, 723-27, 730.

56. Leo's parodies of Gertrude's "Portrait of Mabel Dodge at the Villa Curonia" (1913) are found in L. Stein 1950, 48-49, and especially 50. He expresses his disdain for the same literary portrait in another letter to Mabel Weeks, February 7, 1913, in which he opines that it was directly influenced by Picasso's "latest form," and that both were "Godalmighty rubbish." Ibid., 53.

57. Mabel Weeks, foreword to L. Stein 1950, viii, and Sterne 1965, 48-49.

58. Greenough 2000; Stavitsky 1990; Morrin et al. 1986; Levin 1978; and Rewald 1989, 76-82. As Morrin writes in "An Overview: Post-Impressionism and North American Art" (Morrin et al. 1986, 19), "If there is a key figure in the dissemination of Post-Impressionist aesthetics for Americans, Leo Stein would be the prime candidate."

59. Weber 1958, 58; G. Stein 1990, 11, 33-34.

60. McCarthy 1996, 71; Phillips 1983, 108-9.

61. Two important exceptions are the four paintings by Matisse in the Michael Steins' collection reproduced in *La Phalange*, December 15, 1907, with an article by Apollinaire; and Burgess 1910, which featured Picasso's *Three Women* (as well as the first reproduction of *Les Demoiselles d'Avignon*).

62. Fitzgerald 2006, 22-23.

63. Fisher 2000, 207.

64. Levy n.d., 4; Vollard 1936, 137.

65. Weber 1958, 59; L. Stein 1996, 196.

66. Blanche 1938, 275.

67. Mary Cassatt to Mary Ellen Cassatt, March 26, 1913(?), in Mathews 1984, 130.

68. Wineapple 1996, 37, 56-58, 132, 183-84; Hapgood 1939, 535-36.

69. Stimpson 1986, 30-35. See, for example, Fisk 1912 and Davidson 1951, 174.

70. Draper 1929, 152.

71. Leo Stein to Gertrude Stein, February 3, 1913, Gertrude Stein and Alice B. Toklas Papers, Beinecke YCAL, MSS 76, box 124, folder 2714.

72. Meyer 1953, 81.

73. Edstrom 1937, 239.

74. J. Richardson 1996, 55-57.

75. The description of Mars and Squires, memorialized by Gertrude in her word portraits "Miss Furr and Miss Skene," is that of Anne Goldthwaite in Breeskin 1982, 23.

76. A. Wright 2004, 93-99, 163-91; Garb 2001.

77. G. Stein 1971, 21.

78. G. Stein 1990, 123-24.

79. L. Stein 1996, 195.

80. G. Stein 1990, 28.

LEO STEIN

Plate 32
Leo Stein in the atelier at 27 rue de Fleurus, Paris, ca. 1904 (detail of pl. 345). Yale
Collection of American Literature, Beinecke Rare Book and Manuscript Library,
Yale University, New Haven

Plate 33

Leo Stein before 1914

Gary Tinterow, assisted by Marci Kwon

Leo Stein was one of the most fascinating and frustrating men of his generation. "My great trouble," Leo confided in his notebook, "was that I never could take myself seriously."[1] But he was accustomed to superlatives from an early age, and he never failed to dazzle, whether as a schoolboy, as a houseguest, or as a host at 27 rue de Fleurus, the Paris studio and apartment he shared with his sister Gertrude from 1903 until 1914. It was there that he made his reputation, equally as a collector and as an intellectual. As Alfred Barr, Jr., the first director of New York's Museum of Modern Art, saw it, "For the two brief years between 1905 and 1907 he was possibly the most discerning connoisseur and collector of 20th-century painting in the world."[2] The Stein studio was the crossroads of the modern art world, and it is impossible to overstate the impact of those encounters: it was there that Pablo Picasso would find Henri Matisse, American artists would meet Europeans, and dealers would meet collectors, and they all would discover the work of Picasso and Matisse and often the men themselves. Also hanging in the Stein studio were paintings by the artists of the "Generation of 1870": Paul Cézanne, Paul Gauguin, Pierre-Auguste Renoir, and their younger colleague Henri de Toulouse-Lautrec. This unique intergenerational hanging was experienced as a canon of aesthetic merit that was in time duplicated by collectors from Moscow to Berlin, from London to Paris, and up and down the Eastern Seaboard of the United States.

It was Leo, and not Gertrude, who dominated the scene at rue de Fleurus during the early years. "People came," Leo wrote, "and so I explained, because it was my nature to explain."[3] "Of course," Gabrielle Picabia said, "Gertrude knew nothing about painting."[4] Recalling her visits to rue de Fleurus in 1909, Agnes Meyer, the American journalist and art collector, astutely summed up the situation: "The center of attraction was Leo's brilliant conversation on modern French art and the remarkable collection mostly of contemporary paintings which he made at little cost with the aid of his independent and exacting judgment. Leo was cruelly shut off from easy communication with others by his inner conflicts. But his extreme sensitivity, introspection and overly severe self-criticism aroused sympathy rather than aversion. When we looked at his collection together, he spoke little, but his occasional words and the intensity of his feeling revealed the modern paintings one saw with him in their highest significance."[5]

In autobiographical notes, Leo traced the development of his aesthetic sensibility to decisive moments during his childhood and early adolescence. Born in 1872, the fourth of five siblings, he was shuttled about as if he were a character living out of a steamer trunk in a Henry James novel: from Vienna and Paris to Baltimore and Oakland before attending college at Berkeley, Johns Hopkins, and Harvard, which he left in 1895 to sail literally around the world. Often accompanied by his younger sister, Gertrude, if not his older brother Michael, who served in loco parentis after the death of their parents, Leo was not wanting for company; the rootless nature of his early life forged close ties with Gertrude while discouraging external relationships. (Leo, a heterosexual, had few lovers and settled down to marriage only in 1921, at age forty-nine, with Eugénie "Nina" Auzias, whom he first courted in 1908.) When he was a young man, his aesthetic epiphanies usually occurred in a family setting or while he was alone:

Plate 33, cat. 325
Pablo Picasso, *Leo Stein*, **1906.** Opaque watercolor on cardboard, 9¾ x 6¾ in. (24.8 x 17.2 cm). The Baltimore Museum of Art: The Cone Collection, formed by Dr. Claribel Cone and Miss Etta Cone of Baltimore, Maryland

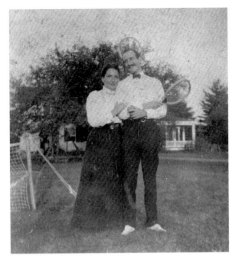

Plate 34

taking an etching out to an orchard to compare it with the real thing;[6] studying reproductions such as Jean-François Millet's *Man with a Hoe* (1860-62) in the *Century Magazine*;[7] analyzing why a poppy next to a boulder looked more beautiful than others in a field.[8] All his recorded memories revolve around his recognition of heightened visual perception: "I improvised a definition of art: that it is nature seen in the light of its significance."[9]

At Harvard, the sensitive aesthete should have, like his sister Gertrude, found favor and fatherly encouragement from William James, the brilliant psychologist and philosopher.[10] James's ideas on perception and his philosophical approach, called pragmatism, would mark Leo profoundly. But when Leo first arrived in Cambridge, James was on sabbatical, visiting Bernard Berenson, the Lithuanian-American art historian, in Florence; later Leo dropped out of James's philosophy class.[11] One can well imagine that James's almost relentless vitality and optimism might have threatened the feckless young man. Yet it probably was in discussions with Berenson, another Harvard-trained intellectual, that Leo began to test the application of Jamesian thinking to aesthetics. Leo met Berenson in 1900 while residing in Florence.[12] "During those two winters I did the work I spoke of on seeing; I became really intimate with quattrocento Italian art—the art of Piero della Francesca, Paolo Uccello, Domenico Veneziano, Andrea del Castagno,

and the early Siennese—and I discovered pragmatism. I was not the first to discover it. Charles Peirce had discovered it twenty years earlier; William James had given his California lecture two years before. At any rate, James says that pragmatism is just a new name for an old way of thinking; so it would seem that nobody really discovered it."[13] As Leo's biographer Brenda Wineapple wrote of his mature thought: "Leo was interested in…the process of seeing, or more loosely, the psychology of vision—that is, what people perceived and how these perceptions translated into aesthetic values."[14]

During his many visits to Florence, where he lived from 1900 to 1902 and summers thereafter, Leo had occasion to study the impressive group of Cézannes assembled by two American expatriates: Egisto Fabbri (1866-1933), a painter and heir to an immense banking fortune, and Charles A. Loeser (1864-1928),[15] whom Berenson considered "my most fierce enemy-friend, as well as a really fine collector."[16] After Leo moved to Paris, Berenson prompted him to visit the Parisian dealer Ambroise Vollard, from whom he bought his first Cézanne landscape in 1903 (pl. 35, cat. 8).[17] This odd conclave of Anglophones who convened in Florence (which also included the English art historian and critic Roger Fry) were fascinated equally by early Italian painting, modern American philosophy, and contemporary

Plate 35

Plate 34
Gertrude and Leo Stein, ca. 1894. Yale Collection of American Literature, Beinecke Rare Book and Manuscript Library, Yale University, New Haven

Plate 35, cat. 8
Paul Cézanne, *The Spring House,* ca. 1879. Oil on canvas, 23⅝ x 19¹¹⁄₁₆ in. (60 x 50 cm). The Barnes Foundation, Merion, Pennsylvania

Plate 36, cat. 14
Paul Cézanne, *Bathers,* 1898-1900. Oil on canvas, 10⅝ x 18⅛ in. (27 x 46 cm). The Baltimore Museum of Art: The Cone Collection, formed by Dr. Claribel Cone and Miss Etta Cone of Baltimore, Maryland

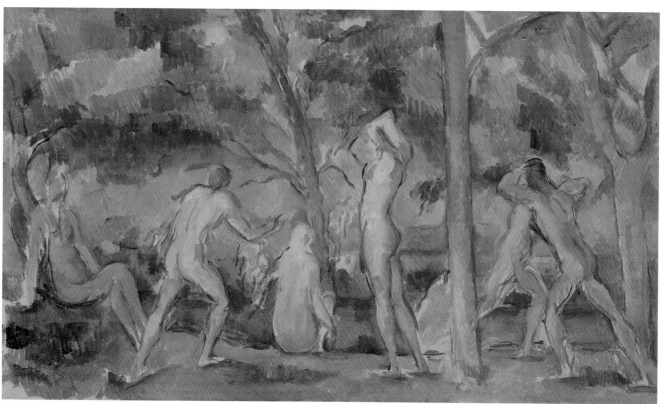

Plate 36

French painting as represented by Cézanne and others in his circle; these interests gave rise to the thoughts that soon would transfix visitors to 27 rue de Fleurus. As William Rothenstein recalled: "The cognoscenti of Florence had just discovered Cézanne; Loeser had bought several of his smaller landscapes, and there was already a large collection of Cézanne's work in Florence, that of Signor Fabbri.... I was thankful to see anything so fresh and vital as a Cézanne painting in an Anglo-American-Italian interior."[18] Writing about his discovery of Cézanne in his autobiography, *Appreciation*, Leo noted: "I have already said that for me Mantegna's Crucifixion was a sort of Cézanne precursor 'with the color running all through it.' Also the Tuscan quattrocentisti, especially Piero della Francesca and Domenico Veneziano, were an excellent preparation. I was quite ready for Cézanne."[19]

Plate 37

Leo's literary projects in the years before World War I might well be called unfinished sketches for an unrealized composition: writing a never-completed monograph on Mantegna in Florence (1900–1902), drafting an unpublished essay on aesthetics in London (1902)[20] and again in Florence (1904), composing and then abandoning a grand unified theory on visual perception and art appreciation in Paris. "Many wanted to know why I didn't write. I said I couldn't

write. This was before I knew of Freud, so I could not tell them about inhibitions."[21] After definitively leaving Paris for Florence, Leo did write during the war years—producing fine, lucid articles for the *New Republic*—and he finally published *The A-B-C of Aesthetics*, a masterful synthesis of his ideas, in 1927.[22]

Prior to his life-changing rupture with Gertrude in 1913–14, he could nevertheless count some notable successes, if not publications. For one, he learned, at the Académie Julian, how to paint (see pl. 37). Using his considerable analytical skills, he overcame his lack of innate talent to make competent pictures in the manner of late Renoir. An understanding of composition and color theory bought him some small credibility among the painters whom he collected, although they were indubitably more impressed by his willingness to purchase work and his recommendations to dealers like Vollard and collectors like Claribel and Etta Cone. His greatest achievement was surely his collection. He was the first significant collector to recognize the promise of Picasso and Matisse, and he and his siblings would come to own more than 180 examples by each artist—the most extensive collections of Picasso and Matisse in the world, until they were surpassed just before 1914 by the infinitely richer Russians Sergei Shchukin and Ivan Morosov. Leo's collection, and his brilliant conversation, made him a figure of importance and fascination in Paris. As his friend Mabel Dodge recounted: "People were beginning to go to their apartment to hear Leo talk about the two new painters he had 'discovered' at the 'Independents' exhibition—Matisse and Picasso. Earlier still, he had come upon the Cézannes—and holding forth night after night in his big living room, he had forced people to see their value."[23]

Nevertheless, Leo's mind was restless; his opinions of artists and their work constantly evolved and frequently took an about-face. He famously turned first on Matisse, around 1908, and then on Picasso, by 1912. And just as he rejected Picasso and Matisse, he turned on himself. Throughout his adult life, Leo had maintained a posture of unrelenting self-criticism. The journalist Hutchins Hapgood, who accompanied Leo on his trip around the world in 1895, characterized him as follows:

Plate 37
Leo Stein (attributed to), *Self-Portrait*, ca. 1906–8. Oil on canvas, 31¹³⁄₁₆ x 17⅝ in. (80.8 x 44.7 cm). Mr. and Mrs. Michel Ibre, Paris

Plate 38
Leo Stein and friends at the Café du Dôme in Montparnasse, Paris, 1910. From left: Leo Stein, Nina Auzias, Max Weber, unidentified woman. Yale Collection of American Literature, Beinecke Rare Book and Manuscript Library, Yale University, New Haven

Whenever I think of Leo Stein, I like him better than when I am with him. He couldn't leave the slightest subject without critical analysis. He and I argued the livelong days.… He was almost always mentally irritated. The slightest flaw, real or imaginary, in his companion's statements, caused in him intellectual indignation of the most intense kind. And there seemed to be something in him which took it for granted that anything said by anybody except himself needed immediate denial or at least substantial modification. He seemed to need constant reinforcement of his ego, in order to be certain that all was well with the world and that God was in his heaven.… But, as I have suggested, there was something singularly pure, highminded, and noble about him. Had it not been for the shadow of himself, his constant need of feeling superior to all others, he would have been a great man.[24]

Alfred Stieglitz, the American photographer and champion of the avant-garde, recalled visiting the Steins in summer 1909, in the company of Edward Steichen. By that time Leo had already decoupled his car from Matisse's train: "'Now we shall go to Leo Stein,' [Steichen said]. 'His place is the real center. All the American artists, students who are up to date and many others go there. He has special evenings…' Leo Stein began to talk. I quickly realized I had never heard more beautiful English nor anything clearer.

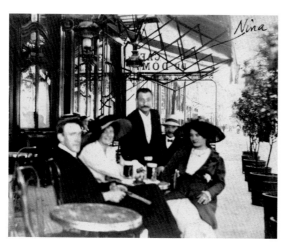

Plate 38

He held forth on art. He described Whistler as decidedly second-rate and Matisse, whom he had championed a few years before, also as second class—a better sculptor than painter, even better than Rodin." Stieglitz asked Leo to contribute an article to *Camera Work*, and Leo responded, "'But Mr. Stieglitz…you see I am trying to evolve a philosophy of art, and I have not entirely succeeded in closing the circle. Until I have done so, I shall not write.' Just before leaving, I asked, 'Will you please tell me where you place Rubens and Renoir?' He was taken by surprise. 'That is the rub,' he answered. 'I like them both. They are great favorites of mine. But they seem not to fit into the philosophy of art I have thus far evolved. That worries me.' He bade us goodbye. I thought to myself, 'Stein will not be able to solve his problem about Renoir and Rubens until he has fallen in love.'"[25]

"The Big Four"

What precisely did Leo say to his guests at rue de Fleurus? Since he did not publish his aesthetic until 1927, one must use eyewitness accounts and his letters to convey the discourse and to suggest an outline of his thought in the first years of the twentieth century.[26] The most cogent document of his early writing on contemporary painting is a letter of 1905 to his close friend Mabel Weeks. In it he articulates in strikingly vivid language the qualities of the men he called the Big Four—Édouard Manet, Pierre-Auguste Renoir, Edgar Degas, and Paul Cézanne—along with Pierre Puvis de Chavannes, who, for reasons unknown, did not merit inclusion as the "big fifth."

> My dear Mabel,
>
> There is so much to be said and since I have taken to the brush I have a greater aversion than ever to the pen so that I am doubtful if even a small portion of it will come to utterance. At all events, I will make a beginning and if this proves to be a treatise, not a letter, the responsibility will lie with the obligation that I have been under ever since the [1904] Autumn Salon of expounding L'Art Moderne (you will observe that this is not the same thing as L'Art Nouveau). The men whose pictures we have bought—Renoir, Cézanne, Gauguin,

Maurice [Denis]—and others whose pictures we have not bought but would like to—Manet, Degas, Vuillard, Bonnard, and Van Gogh for example—all belong. To make the subject clear requires a discussion of the qualities of the men of '70 of whom the Big Four and Puvis de Chavannes are the great men and the inspirers in the main of the vital art of today. The Big Four are Manet, Renoir, Degas, and Cézanne.

Of these Manet is the painter par excellence. He is not the great colorist that is Renoir but in sheer power of handling he has perhaps not had his equal in modern times. He had a great conception of art but few great conceptions. Almost all his work is largely haphazard because with all his splendid qualities he had not great intellect. He rarely realized a thing completely yet everything he did was superb. There is a limpid purity in his color and feeling for effect, a realization of form and vitality in rendering, all of which are most admirable, but that power of conception which could fuse all this and cast it into the form of stabile equilibrium, that perfect poise of the completely achieved—all that was beyond his range of mental grasp.

Renoir [pl. 39] was the colorist of the group. He again was a man of limited intellectuality but he has the gift of color as no one perhaps since Rubens except perhaps Fragonard has had it—what you might call the feeling for absolute color, color handled not as the medium but as the stuff of art. Sometimes his realization of a theme is complete but only rarely, at least as far as composition and mass go. But his color carries every bit of his work splendidly just as texture and mass carry Manet so that nothing of his is worthless.

Degas, the third of the quartet, is the most distinctively intellectual. Scarcely anything that he has done is unachieved either in part or in whole. He is incomparably the greatest master of composition of our time, the greatest master probably of movement of line, with a colossal feeling for form and superb color. And all his qualities are held together and brought to a focus by a perfection of control that only the finest mentality could give.

Fourth comes Cézanne [pl. 36] and here again is great mind, a perfect concentration, and great control. Cézanne's essential problem is mass and he has succeeded in rendering mass with a vital intensity that is unparalleled in the whole history of painting. No matter what his subject is—the figure, landscape, still life—there is always this remorseless intensity, this endless upending gripping of the form, the unceasing effort to force it to reveal its absolute self-existing quality of mass. There can scarcely be such a thing as a completed Cézanne. Every canvas is a battlefield and victory an unattainable ideal. Cézanne rarely does more than one thing at a time and when he turns to composition he brings to bear the same intensity, keying his composition up till it sings like a harp string. His color also, though as harsh as his forms, is almost as vibrant. In brief, his is the most robust, the most intense, and in a fine sense the most ideal of the four.

The work of these four men is exceedingly diverse; in fact there is in general aspect no resemblance whatever. They do not constitute a school in any sense in which that word can be reasonably used and yet they have something in common. Their work is all nondramatic. When figures are composed in a group their relations are merely spatial. At most they are relations of movement concurrent or opposite. This fact is intimately related to another, that the work is done in the main direct from life. This is in a sense not true of Degas, for though he makes elaborate studies, his compositions are not painted from life; yet even with him the model remains dominant. The consequences of this are enormous and in Cézanne we find their logical working out. They mean that the path of pictorial accomplishment lies in the reaching to the last drop the virtue which lies in the model. The roots of this procedure lie far back. Holbein did it with his line, Velasquez did it with his values, but never till this recent time was the conception fundamentally worked out. Velasquez is, in fact, to me a man more of Monet's type, only ten thousand times finer—for the things that Monet does not badly, nor too well either, Velasquez

Plate 39, cat. 393
Pierre-Auguste Renoir, *Seated Bather*, ca. 1882. Oil on canvas, 21½ x 16½ in. (54.5 x 41.9 cm). Private collection

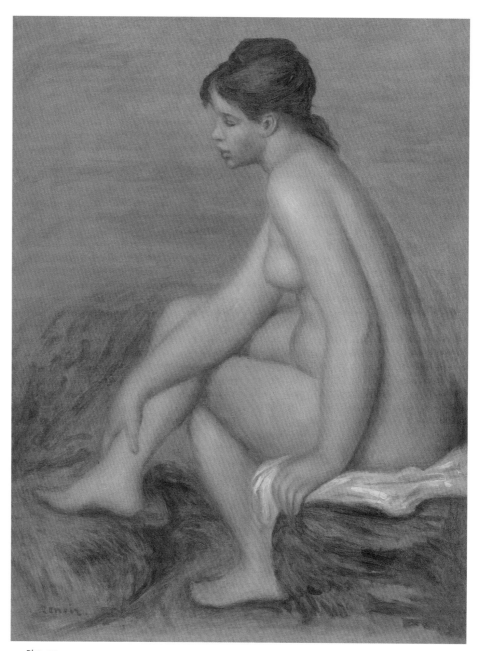

Plate 39

did magnificently. Both of them are what might fairly be called naturalists with the addition of a sense for composition both in color and form. Renoir, Manet and Cézanne substitute for that the abstraction of the quality of color, and form from the model. Manet pushed the thing through to the bitter end, for he was continually experimenting, but Renoir succeeded with his color and Cézanne with the form or rather with what is the essence of form—mass. Degas most perfectly combined both things, adding composition and movement, but losing perhaps a trifle of the pure virgin force that the other three have. Whistler lost it almost completely, substituting for it an artifice so brilliant in its accomplishment as almost to succeed in disguising the loss.

The loss of dramatic quality was a necessary consequence of this devotion to the model and we have an art that is full of ideas and personality, but which does not attempt to render ideas of personality. This was its great limitation, its element of "materialism" that made it caviare to the general. This other side was ministered to most adequately among contemporaries by Puvis de Chavannes, Gustave Moreau and Fantin-Latour. Moreau, though not a great artist, seems to have been a remarkable teacher and had a wide influence. The other two you know well enough for the purposes in hand.[27]

Nothing like this had yet been published in English. Although he barely mentioned Van Gogh, Leo identified many artists who still rank as the most important of their generation, and his influence unquestionably helped establish a canon that persists today. His approach to the art and his definition of the essential characteristics of the works also still ring true. Yet he did not generate his ideas in a vacuum. Each of the "Big Four"—and others such as Van Gogh, Gauguin, and Maurice Denis (pl. 40)—had ties to the dealer Ambroise Vollard, whom Leo patronized; the younger artists whom Leo championed all admired and claimed these forebears, although it is difficult to determine whether Leo directed attention to the Big Four or, more

likely, whether he himself was led to them through discussion with the artists whom he knew. Regardless, one can now see that his thinking in 1905 was not only a reflection of his experiences at exhibitions and art galleries in Paris, as Rebecca Rabinow recounts in these pages, but also a result of his reading of Giovanni Morelli, William James, Julius Meier-Graefe, and most importantly, Bernard Berenson. Art history was in its infancy, and Leo was an early convert; the instability of his allegiances and thought is a natural result of the shifting terrain of a newly developing intellectual discipline.

Giovanni Morelli

Trained as a doctor and scientist, Giovanni Morelli (1816–1891) turned to art history when he was nearly sixty years old. Hoping to overturn a corpus of inaccurate biographical studies and wishful attributions, Morelli attempted to establish a methodical system for examining works of art, which he first published in 1874-76 in the German periodical *Zeitschrift für bildende Kunst*.[28] A few years later Morelli returned to the same issues in *Die Werke italienischer Meister in den Galerien von München, Dresden und Berlin* (1880), published under the pseudonym "Ivan Lermolieff." The book is a fictive

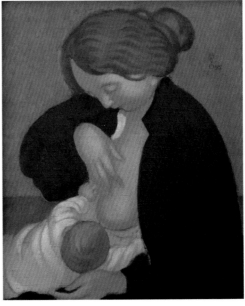

Plate 40

Plate 40, cat. 61
Maurice Denis, *Mother in Black*, 1895. Oil on canvas, 18½ x 15¼ in. (47 x 38.7 cm). Private collection

dialogue between "Lermolieff" (a Russianized anagram of Morelli) and "Dr. Johannes Schwarze" (a Germanized version of his name), treating the most famous artworks of the museums in Munich, Dresden, and Berlin. Leo carried around the "Lermolieff" on his trip to Dresden in 1895, and called it "level-headed" in a letter to his cousin Bird Stein: "I don't do much reading nowadays outside of books on Art. I read a couple in French and am now reading a good deal of Lermollieff."[29] As Brenda Wineapple wrote: "His volume was more stimulating to Leo than any other book on art he read at the time. He was elated whenever he found in it some confirmation of his own perceptions and was delighted with Morelli's praise of Giorgione's languorous *Sleeping Venus*. Of all the paintings in Dresden, this sensually reclining goddess affected Leo the most."[30] Although he would soon lose interest in Morelli's and, especially, Berenson's insistence on identifying authentic works as the primary task of the art historian, the criteria for quality in art that Leo would subsequently develop have their roots in Morellian methodology.

William James

Leo would soon turn from Morelli toward different models, particularly William James (1842–1910; pl. 41). Brother of the novelist Henry James and the noted diarist Alice James, William James was an enormously important psychologist and philosopher; although many scholars have noted his influence on modernist literature, his impact on art history and aesthetics remains a relatively unexplored topic.

James studied painting with William Morris Hunt in Newport, Rhode Island, in 1860 and enrolled in Harvard Medical School in 1864. He never practiced medicine but taught physiology, anatomy, psychology, and philosophy at Harvard, counting among his pupils Theodore Roosevelt, W. E. B. Du Bois, and Walter Lippmann. Today James is most associated with the philosophical concept of pragmatism, which questions the notion of objective truth and instead looks at the relative impact of an idea or fact in order to assess its validity. According to historian Bruce Kuklick, James "would seek the meaning of 'true' by examining how the idea functioned in our lives. A belief was true, he said,

Plate 41

if in the long run it worked for all of us, and guided us expeditiously through our semi-hospitable world."[31] James was equally skeptical of the idea of a singular, objective aesthetic experience.[32]

Leo was strongly affected by James's *The Varieties of Religious Experience: A Study in Human Nature*, published in London in 1902.[33] The last chapter of this book, "Philosophy," is devoted primarily to pragmatism. In the fall of 1902, when Leo was living in England with Gertrude (Berenson was nearby at Green Hill), he turned to James's treatise. In a letter to Mabel Weeks of September 19, 1902, he wrote: "Have you read James's new book on religion? It's a splendidly broad-minded sane treatment of the theme and ought to have a very considerable influence on the study of the subject. It was eminently desirable that fresh air should be allowed to blow in on that theme and thanks are due to James for opening the window."[34]

Leo's correspondence after 1902 is threaded with Jamesian thought. After spending a summer in Florence in 1904 trying yet again to write his own book, he wrote to Mabel Weeks on August 28 with language that rings of James: "I envy the Buddhist his seeking for a purely disembodied ideal which needs form only to render it to sense and then the finer the sense the more reticent though yet more trumpet tongued the expression. This is something which sounds like yet is so different from the economy of means that one

Plate 41
William James, n.d. Photograph by Notman Studio. Houghton Library, Harvard University, *2002M-44. Purchase, Amy Lowell Trust. Louis J. Appell Jr. Fund for British Civilization in the Harvard College Library; James Duncan Phillips fund; and the Charles Warren fund

hears so much of in the discussion of Whistlers and other etchings. One in method is so much more the construction of essentials, the other so much more the elimination of inessentials."[35] In contrast, James wrote in *The Principles of Psychology* (1890): "The artist notoriously selects his items, rejecting all tones, colors, shapes, which do not harmonize with each other and with the main purpose of his work. That unity, harmony, 'convergence of characters,' as M. Taine calls it, which gives to works of art their superiority over works of nature, is wholly due to elimination."[36] True to character, Leo adopted a typical observation from James and then amended it to his liking.

The publication of James's tract on pragmatism in 1907 was pivotal for Leo. As he wrote in a letter of 1909,

> James is a wonder. The genuine coherent grip of his mind and his marvelous power of expression delight me more and more in every reading and rereading of his books and the crass incapacity of brilliant thinkers but unimaginatives has led me to much reflection on the subject of criticism. It has not led me to anything radically new in the way of ideas on the subject, but has simply intensified my conviction that the pragmatic power required for valid critical work is very great, and that most critics fail helplessly because, leaving the question of their talents aside they do not start with this implicit proposition…that in order to criticize a work you have to see all that the insider—whether it be author or advocate—does, and then see beyond.[37]

James also had a great impact on Berenson, whom he taught at Harvard. The two men became close when James came to Florence for six months in October 1892, immediately after the publication of *The Principles of Psychology*.[38] Berenson subsequently privileged perceptual analysis in his book *Florentine Painters of the Renaissance* (1896), in which he introduced his concept of "tactile values," or the sensation of touch derived from a painting.[39] As Berenson said in 1957: "'Tactile values' was really James's phrase, not mine, although he never knew he had invented it."[40] Indeed, according to Berenson's biographer Ernest Samuels, "James emphasized the psychological/physiological implications

of the study of art, and talked of 'ideation,' the derivation of ideas from physical percepts, and of the 'tactile' sensations that might accompany those ideas. Berenson marked these passages in pencil."[41]

Finally, Stein's later tendency to consider art and aesthetics from the position of individual perception (stressing the importance of stereoscopic vision to the formation of consciousness, for instance) has its roots in James's work. Yet Leo's concurrent insistence on formal aspects such as composition, texture, and color was also rooted in James. Jill Anderson Kyle writes: "Indeed, a line can be traced from James through Berenson and Stein, and in the last-named's cogent aesthetic perceptions of Cézanne's pictorial achievements, the line extends directly to American artists who gathered at the Steins' rue de Fleurus apartment in Paris and absorbed perceptions of 'tactility' and 'plasticity' in the way Cézanne depicted form."[42]

Julius Meier-Graefe

Julius Meier-Graefe (1867–1935) was born in Banat, Hungary. After moving to Berlin in 1890, he studied art history at the university and associated with the Ferkel Kreis, a German literary avant-garde group. He helped found the periodical *Pan* in 1894 and started his own avant-garde journal, *Dekorative Kunst*, in 1895. Leo must have read his book *Die Entwicklungsgeschichte der modernen Kunst*, now considered a landmark of early modern art history, soon after it was published in German in 1904 (the English edition, *Modern Art: Being a Contribution to a New System of Aesthetics*, appeared in 1908).

Biographical, historical, and iconographic facts are for the most part ignored by Meier-Graefe: he has been described as "the first to conceive the modern era as a series of formal problems solved on canvas."[43] Accordingly, he organized the art of the nineteenth century "not vertically according to chronology and movements, but horizontally according to formal-artistic tendencies which he calls 'Potenzen' (line, color, composition, etc.)."[44] This structure recalls the organization of Berenson's *Florentine Painters of the Renaissance*, a "protoformalist view that visual images can be analyzed and broken down into experimental components such as sensations, touch, movement, and space,

and a loose understanding of the empathy principle, the projection of human feeling into an object or situation."[45] Meier-Graefe considered great art to have certain unvarying qualities and hence to belong to a universal continuum that escaped time and place.

Perhaps the most influential section of *Die Entwicklungsgeschichte* was book 2, "The Pillars of Modern Painting." In the chapter "The Generation of 1870," Meier-Graefe wrote: "All the more glorious therefore is the house which modern reverence has built up round them, the sanctuary to which the best artists of our own day rest to collect their strength for future works. Four mighty columns bear it aloft: Manet, Degas, Cézanne, and Renoir. They do not stand alone. Ought we not perhaps to add to these four cornerstones of modern painting several others, notably that of the most vital of contemporary masters, Monet, we should not hesitate, but that the four are all-sufficient for the structure."[46] Meier-Graefe then devoted a chapter to each of these artists.

Leo's "Big Four" letter of early 1905 is essentially an abridged and revised version of the aforementioned Meier-Graefe chapter: "To make the subject clear requires a discussion of the qualities of the men of '70 of whom the Big Four and Puvis de Chavannes are the great men and the inspirers in the main of the vital art of today. The Big Four are Manet, Renoir, Degas, and Cezanne…"[47] Naturally, there are many differences as well as similarities, since Meier-Graefe and Leo had read the same books and seen many of the same pictures. Meier-Graefe's chapter on Cézanne indicates that he was aware of Berenson, for example, and perhaps James too. When writing about the "sensation" of looking at art, he notes the role of the "latent tactile impulse," although he says that this "cannot be reckoned with here."[48] (Of course, lurking behind all late nineteenth- and early twentieth-century discussion of perception and tactility is Hippolyte Taine, whom Pepe Karmel called "the most influential critic" of the second half of the nineteenth century.[49] Taine posited that all visual perception engages memory of muscular and tactile associations: "Our pure visual sensations are nothing more than signs. Experience alone acquaints us with their meanings, in other words,

experience alone associates with each of them the image of the tactile and muscular sensation corresponding to it."[50])

Unlike Leo, Meier-Graefe found in Cézanne a decided decorative flatness. He noted that when numerous canvases hang together, they "combine to produce an effect of Gobelin tapestry," and he compared Cézanne's color system to a "kind of kaleidoscope, in which what we see has been shaken together, and so shaken that mosaic-pictures are produced, amazing in their vigorous contrasts in color."[51] Yet, he notes, "This is the most amazing part of the whole thing; this mosaic impresses us by its minute fidelity to nature."[52] This stands in sharp contrast to Leo's analysis of Cézanne, which finds that, in addition to color, Cézanne emphasized mass.[53] "Cézanne's essential problem is mass and he has succeeded in rendering mass with a vital intensity that is unparalleled in the whole history of painting."[54] But both insist on the importance of "minute fidelity to nature" (Meier-Graefe) and work done "direct from life" (Leo).[55] Indeed, as Kenworth Moffett wrote: "Meier-Graefe looked for a strongly expressive, sensual unity; questions of authenticity, 'hands' were secondary. His way of seeing was fundamentally unlike that of a connoisseur such as Morelli. The emphasis and focus of his aesthetic regard was on the organic totality, not the details; he did not seek to visually take a picture apart but tried to imaginatively recreate its wholeness. Thus he was less disturbed by historical seams than by artistic ones."[56] This empathetic, rather Jamesian approach resembles Leo's desire to completely understand a work of art from the perspective of the maker before criticizing it.

Bernard Berenson

Of all Leo's predecessors, Bernard Berenson (1865–1959; pl. 42) may well have had the greatest impact in the years before 1914. As a practicing and publishing art historian, he provided an immediate role model. Berenson's assimilation first of Morelli and then of James likewise set a precedent that Leo followed. It was Berenson who introduced Leo to the joys of early Italian painting and likely to Cézanne and the Impressionists as well. Although Leo was from the beginning wary of Berenson's ego—"there's simply that

Plate 42

authentic oeuvre on which a more accurate artistic identity could be built.[61]

With the publication of *Florentine Painters of the Renaissance* in 1896, Berenson signaled a departure from Morelli toward a more psychologically based analysis derived in part from the writing of William James.[62] As a contemporary art critic, Kenyon Cox, noted, "There are two men in Mr. Berenson: the ingenious promulgator of certain broad views of art based on psychology, the inventor of 'tactile values,' and 'space-composition'; and the modern connoisseur, the follower of Morelli, the readjuster of attributions."[63] This new emphasis on formal values as opposed to attribution, as well as his interest in the aesthetic experience (once again influenced by James), undoubtedly had an impact on Leo, whose own aesthetic theories would become increasingly based on psychological models of perception.

Berenson was an early champion of Cézanne and the Impressionists. In his *Painters of the Central Italian Renaissance* (1897), he daringly compared Cézanne with Michelangelo: "In spite of the exquisite modeling of Cézanne, who gives the sky its tactile values as perfectly as Michelangelo has given them to the human figure, in spite of all Monet's communication of the very pulse-beat of the sun's warmth over fields and trees, we are still waiting for a real art of landscape. And this will come only when some artist, modeling skies like Cézanne's, able to communicate light and heat as Monet does, will have a feeling for space rivaling Perugino's or even Raphael's."[64] (In later writings, Leo often mentioned Michelangelo when discussing Cézanne.)[65]

tremendous excess of the I"—his admiration tempered any scorn.[57] As he wrote in 1900: "He's thoroughly intelligent in general; as he expressed it, his art studies are the least of his intellectual interests. For metaphysics he doesn't care and he knows little or nothing about physical science, but he is widely and well read in literature, is an enthusiastic Grecian, and rather specially interested in Kulturgeschichte problems of all kinds…[he] has, too, much common sense though his manner tends to disguise this…. It's like a cold bath. After the first plunge you don't mind it."[58] By the end of the decade, however, Leo would turn on Berenson; Berenson and his wife subsequently dismissed the Steins with great vehemence.

Berenson was born in Lithuania and immigrated to Boston in 1875. He attended Harvard, where he was a student of William James and tutored Charles Loeser and George Santayana. Berenson moved to Florence around 1889 and began to write art criticism and history, often with his companion, Mary Costelloe (whom Berenson married in 1900). Berenson met Morelli in mid-January of 1890.[59] He considered Morelli's "services to the science of pictures…greater than Winckelmann's to antique sculpture or Darwin's to biology."[60] Berenson used Morelli's methodology of connoisseurship for much of his own work, especially his famous lists of attributions, and he wrote *Lorenzo Lotto: An Essay in Constructive Art Criticism* (1895) as a demonstration of the potential of Morellian connoisseurship to identify an

Leo was twenty-eight years old when he met Berenson in Florence in October 1900. It was clear from the start that each had met his match. "He has sense, there's no doubt about that," wrote Leo. "He's rather younger than I thought him—only thirty-five, but he's been in Florence since he was twenty. His house is filled with beautiful old Italian furniture and hangings and he has really a magnificent art library.… He says that almost all recent writers on Italian art were not only fools but thieves as well, for they take everything that they have from him and almost never acknowledged their indebtedness. The anti-Morellians

Plate 42
Bernard Berenson at Villa I Tatti, Florence, Italy, 1903. The Berenson Archive, The Harvard University Center for Italian Renaissance Studies, Villa I Tatti, courtesy of the President and Fellows of Harvard College

hate him because he's a Morellian and the Morellians hate him because he isn't Morellian enough."[66]

The frequency of mentions in Leo's letters indicates that they quickly established a strong friendship. In a letter dated April 6, 1901, he gives his return address as Berenson's villa, I Tatti, and says that he is staying with "B.B." until the latter's wife returns from London. Berenson clearly enjoyed Leo's company; he wrote Mary ten days later: "I got violent neuralgia…which left late in the evening in an exciting discussion with Stein. It was about tactile values & …it was such a pleasure to discuss with a man who thinks so clearly & knows what I mean."[67] In the fall of 1902 Leo accompanied Berenson to England, where they were joined by Gertrude. In his letters, Leo described the many conversations he had at "B.B.'s": "The more I see of him the better I like him. There is something robust about his delicate sensitive organization that gives his thought and conversation a vitality that is rare. He has the great advantage over most people of being able to dig his stuff out of himself without turning it up crude. With many men of strong mind one occasionally has the feeling almost of intrusion, of surprising them in their thought dressing rooms, and one feels quite ashamed at spying on their intellectual nakedness, and tries to pretend that one didn't notice, but with him that has, I believe, never occurred. And then there is no pretentiousness even though he will tell you for example that 'Roger Fry is the only man writing decent criticism in England chiefly because he has managed to get my ideas reasonably straight instead of mangling them as all the rest who try to take them up do.' But then this is quite true and truth is its own excuse for being."[68]

Although Leo and Berenson were never as close as they were when they were both living in Florence, Leo would visit Berenson during subsequent summers, and Berenson would often see Leo when he went to London to see his wife's family. However, after Leo moved to Paris, learned to paint, failed to publish, and began to listen to his sister Gertrude, who disliked Berenson, the relationship suffered. When the Berensons visited 27 rue de Fleurus in 1907, "their hosts gave Berenson 'a very unflattering portrait of his character.' Sally Stein later explained that Leo's

critical attitude was prompted by Gertrude and that until two years before he had 'perfectly worshiped him.'"[69] Indeed, Gertrude once said of Berenson: "[Berenson] thinks he is great all the time but it isn't his mind; it is his moments of exquisite creative perception that completely expressed themselves."[70]

In 1908 Gertrude and Leo took Berenson to task in an affair regarding a journalist's vicious review of the Salon d'Automne and especially Matisse.[71] By 1909 Leo's relationship with Berenson had certainly soured; Berenson wrote Isabella Gardner describing the Steins as "a tribe of queer, conceited, unworldly, bookish, rude, touchy, brutal, hypersensitive people" and Gertrude as "a sort of Semitic primeval female straight from the desert…. They come often to forage in the library and sit in our midst disapprovingly saying nothing. They all have power and brains… but I am getting so frivolous I begin to be bored by them."[72]

Leo's unremitting attempts to posit a unified aesthetic theory that could bind the art of the past that he loved with the contemporary art that he admired proved frustrating to almost everyone in his circle, especially Berenson. As Peter Morrin sees it, "If one compares [Leo's] earlier formulations to his later ones, one senses that Stein's criteria were increasingly cerebral, unrealized, and unrealizable."[73] However, when Agnes Meyer, a nonpartisan observer, weighed the personal impact of Leo against Berenson, she was certain that Leo came out on top: "Leo Stein was the only one of the many contemporary art critics I have known, not excepting Berenson, Roger Fry, or Meier-Graefe, who achieved complete integrity in his relationship to aesthetic values."[74] As Leo himself said late in life, "Aesthetics had to be brought into relation with all other things in a way that made me feel that living was not altogether silly."[75]

Notes

1. L. Stein 1950, 109.

2. Barr 1951, 57.

3. L. Stein 1996, 201.

4. Sprigge 1954, 69; quoted in Wineapple 1996, 244.

5. Meyer 1953, 81. It should be noted that Meyer herself admits a prejudice against Gertrude: "I was hampered in my relations with Leo because I conceived an immediate antipathy for his sister Gertrude. It is no doubt one of my limitations that I have always distrusted masculine women, and found their self-assertion distasteful." Ibid.

6. L. Stein 1996, 102.

7. Leo writes in *Appreciation*: "In the eighties the *Century Magazine* was noted for its excellent illustrations.... The Millet was the first picture I had seen that was done by a Famous Painter, and the local intellectuals were much exercised. We talked about nothing else for days." L. Stein 1996, 141.

8. Leo writes in *Journey into the Self*: "Some years later when I was a freshman at the University of California I was once lying on a hillside and about me grew an abundance of golden poppies. One that I noticed was more beautiful than any other and I got up to look at it. But nearer to my view it was no different from any other, so I went back to my former position and looked at it again. Then I saw that it grew at the foot of a boulder and had been enhanced by becoming part of a composition. This was an important moment in the growth of my aesthetic experience because after that looking for a composition became a natural diversion." L. Stein 1950, 205.

9. L. Stein 1996, 102.

10. Gertrude wrote in 1895: "Is life worth living? Yes, a thousand times yes when the world still holds such spirits as Prof. James." Gertrude Stein, composition, April 25, 1895, quoted in Miller 1949, 146. In *The Autobiography of Alice B. Toklas*, Gertrude describes how one spring she wrote at the top of her final exam, "Dear Professor James, I am so sorry but really I do not feel a bit like an examination paper in philosophy to-day" (G. Stein 1990, 79). According to Gertrude, James agreed and gave her the highest mark in the class—no doubt typical Gertrudian hyperbole.

11. Wineapple 1996, 62.

12. Leo wrote Gertrude from Florence on October 9, 1900, describing a recent lunch he had with Berenson (L. Stein 1950, 3). Hutchins Hapgood, Leo's traveling companion for part of his 1895 world tour, wrote him a letter of introduction dated July 24, 1900 (Wineapple 1996, 444).

13. L. Stein 1996, 147.

14. Wineapple 1996, 308.

15. It appears that Leo did not see the numerous Cézannes owned by Charles Loeser until summer 1903. He recalls in *Appreciation*: "I thought that strange, as I had often been at Loeser's house, but Berenson explained that the Cézannes were not mixed with the other pictures which filled his house, but were all in his bedroom and dressing room." He called this visit to Loeser's "a Cézanne debauch" (L. Stein 1996, 155). Loeser owned eight small landscapes, a portrait, two scenes with figures, a Bathers painting, and three still lifes, all dating from the early 1870s to the end of Cézanne's life (Bardazzi 2007, 90). John Rewald (1989, 53-55) notes that Loeser's Cézannes "ran the gamut from some still hesitant work of the Auvers period, when Cézanne had first begun to paint directly from nature (the scene of the bathers is somewhat related to that phase), to a confidently brushed view of a house on a hill near Aix, executed during the artist's very last years.... In addition, Loeser owned a number of smaller paintings, among them some with figures, yet did not possess a single important portrait or figure piece." Rewald also notes that the wealthy Italian American artist Egisto Fabbri owned several major works by Cézanne, although he finds no evidence that Leo saw these. Rewald seemingly ignored a letter from Fabbri to Leo dated November 3, 1909, which proves that Leo did. Fabbri writes to Stein: "I shall be delighted to see you again and to show you my Cezannes if you wish—as well as to any of your friends. Will you come any day next week except Tuesday and Saturday?" (Bardazzi 2007, 275).

16. Bernard Berenson to Mrs. Alfred H. Barr, Jr., April 22, 1941, in Berenson 1964, 182.

17. Both Leo in *Appreciation* and Gertrude in the *Autobiography* date their first Cézanne purchase, and the events that precipitated it, to 1904 (see L. Stein 1996, 154); however, Wineapple is fairly certain that Berenson's mention of Cézanne to Leo (and therefore his "Cézanne debauch") must have occurred in 1903. The traditional dating of this event to 1904 is based on an undated letter Gertrude wrote to Mabel Weeks noting that they were trying to sell Japanese prints in order to buy a Cézanne, taken along with Leo's account in *Appreciation*, which also dates his encounter with Cézanne to 1904. Wineapple (1996, 452), however, dates Gertrude's letter to the fall of 1903, based on Gertrude's mention of Michael and Sarah's brief visit to New York and of her own upcoming trip to New York.

18. Rothenstein 1932, 125.

19. L. Stein 1996, 155.

20. As Brenda Wineapple (1996, 191) recounts, this unfinished work would have been based on a book by Alfred Hodder, *The Adversaries of the Skeptic; or, The Specious Present: A New Inquiry into Human Knowledge* (1901): "Reading William James's *The Varieties of Religious Experience* for a breath of fresh air, he began to compare aesthetic and religious experience. But it was Hodder's book and their talks together that Stein seemed to savor most." Wineapple goes on to note

that "Hodder's idea of the specious present helped Leo distinguish, in the first place, between aesthetic and emotional experience," as illustrated by Leo's 1906 letter to Horace Eaton.

21. L. Stein 1996, 201.

22. George Boas, a philosophy professor at Johns Hopkins University, noted in a review of *The A-B-C of Aesthetics*: "Those of us in America who grew conscious of modern art during and after the famous Armory Show found that consciousness awakened for the most part by his various articles in *New Republic*, which almost alone among the papers written on the subject seemed clear and intelligible." G. Boas 1928, 287.

23. Luhan 1999, 88.

24. Hapgood 1939, 120-22.

25. Alfred Stieglitz, quoted in Norman 1973, 110-11.

26. In "Adventures of Yesterday," an unpublished memoir, Inez Haynes Irwin describes her six-week trip to Paris in March 1908: "One of the great adventures of my life…was my experience with the 'wild men' in art." Irwin gives a detailed account of one of Leo Stein's speeches at 27 rue de Fleurus, in which he discussed everything from connoisseurship to nineteenth-century French artists, and the changing relationship of art to society: "We had a long talk with Leo Stein, in which he instructed us in regard to this new art. He said first that it was impossible to define the artistic. Some people are born so that they can tell the difference between Keats and Tennyson and others never can. He admitted that almost anyone could pick out a better picture for the Albany State House than he. There were two copies of Holbein's famous altar-piece, one at Darmstardt [*sic*] and the other at Dresden. For years, war waged among critics as to which was the original. He said that anybody, who had the true artistic instinct, could sit before these pictures for a morning and then be able to tell which came first. He spoke of the group of French artists Cézanne, Manet, Monet, Degas. Of them all, Cézanne was the most bourgois [*sic*]. Cézanne wanted to exhibit in the Salon, he wanted the Legion of Honor. But he never achieved either ambition. The other members of the group did not want either of these honors. Yet Cézanne's influence lived and theirs had died. Matisse and his crowd were trying to get that impalpable something which constituted the difference between a work of art and a photograph or an engraving of it. Photographs stopped working after a while. (Note: I do not believe that Arnold Genthe or Alvin Coburn's great photographs have stopped working.) As for this new school of art, he was not yet sure. He had only known these pictures for four years. But after ten years.… He talked everyone else out of the room, but we listened, absorbed to his last word." Irwin n.d., 258, 263-64.

27. Leo Stein to Mabel Weeks, undated [1905], in L. Stein 1950, 15-18.

28. "Die Galerien Roms: Ein kritischer Versuch von Iwan Lermolieff" appeared in installments in *Zeitschrift für bildende Kunst* 9 (1874), 10 (1875), and 11 (1876).

29. Leo Stein to Bird Stein Sternberger, August 30, 1895, Yale Collection of American Literature, Beinecke Rare Book and Manuscript Library, Yale University (hereafter referred to as Beinecke YCAL), MSS 78, box 1, folder 6.

30. Wineapple 1996, 87.

31. Kuklick 1981, xiv.

32. In an illuminating passage in *Principles of Psychology*, vol. 1, James writes: "What is got twice is the same OBJECT. We hear the same *note* over and over again, we see the same *quality* of green or smell the same objective perfume, or experience the same *species* of pain. The realities, concrete and abstract, physical and ideal, whose permanent existence we believe in, seem to be constantly coming up again before our thought, and lead us, in our carelessness, to suppose that our 'ideas' of them are the same ideas…. The grass out of the window now looks to me of the same green in the sun as in the shade, and yet a painter would have to paint one part of it dark brown, another part bright yellow, to give its real sensational effect. We take no heed, as a rule, of the different way in which the same things look and sound and smell at different distances and under different circumstances. The sameness of the *things* is what we are concerned to ascertain; and any sensations that assure of that will probably be considered in a rough way to be the same with each other." James 1890, 231.

33. James 1902.

34. L. Stein 1950, 12.

35. Beinecke YCAL, MSS 78, box 3, folder 52.

36. James 1890, 287.

37. Leo Stein to Mabel Weeks, October 6, 1909, in L. Stein 1950, 20.

38. Ernest Samuels (1979, 162) writes that Berenson and James "took long strolls up the walled lanes toward Fiesole. James vigorously objected to the high walls which shut out the view of the countryside. Berenson, attuned to a more subtle aesthetic, declared that the view was all the more delightful 'for not having it constantly before one.'"

39. Berenson (1930a, 64) writes: "Now, painting is an art which aims at giving an abiding impression of artistic reality with only two dimensions. The painter must, therefore, do consciously what we all do unconsciously—construct his third dimension. And he can accomplish his task only as we accomplish ours, by giving tactile values to retinal impressions. His first business, therefore, is to rouse the tactile sense…so that the picture shall have at least as much power as the object represented, to appeal to our tactile imagination."

40. Quoted in Taylor 1957, 124.

41. Samuels 1979, 152.

42. Kyle 2009, 70. Kyle may be correct on the latter point, but no published recollection of Leo's lectures at rue de Fleurus mentions James by name.

43. "Julius Meier-Graefe," *The Dictionary of Art Historians*, entry available at http://www.dictionaryofarthistorians.org/meiergraefej.htm.

44. Moffett 1973, 41.

45. Calo 1994, 57.

46. Meier-Graefe 1908, 252.

47. The similarities between Leo's 1905 letter to Mabel Weeks and Meier-Graefe were first noted by Anne E. Dawson (1996, 49).

48. Meier-Graefe 1908, 267.

49. Karmel 2003, 4.

50. Taine 1875, 69.

51. Meier-Graefe 1908, 267.

52. Ibid., 268.

53. In an unpublished paper, Peter Morrin notes that Stein's emphasis on the internal formal logic of a composition is related to Meier-Graefe's insistence that "if art is to have its true value, it must give its first rapture in a sphere that is particularly its own, reacting from this on the intellectual, not vice-versa." Meier-Graefe 1908, vol. 1, 13; quoted in Morrin n.d., 25–26.

54. Leo Stein to Mabel Weeks, undated (early 1905), in L. Stein 1950, 16.

55. Dawson 1996, 49.

56. Moffett 1973, 97.

57. Leo Stein to Gertrude Stein, October 11, 1900: "I saw Berenson again on Wednesday evening [October 10]. He's certainly very conversable and in the main I find him very sensible. There's simply that tremendous excess of the I. For example when we were talking about Yiddish literature he spoke of the numerous myths that were current in his Lithuanian home, many of them of great interest and which he declared ought to be garnered up and saved. 'But there's no one can do it except myself and I'm forgetting them.' Why he should suppose that the preservation of the myths of a large community should be dependent on his sole activity rather puzzled me but I didn't ask an explanation." L. Stein 1950, 4.

58. Leo Stein to Mabel Weeks, November 7, 1900, Beinecke YCAL, MSS 78, box 3, folder 51.

59. Samuels 1979, 103.

60. Bernard Berenson in an essay on Morelli included in his miscellaneous papers at Villa I Tatti, the Harvard University Center for Italian Renaissance Studies; quoted in Samuels 1979, 101.

61. Berenson 1895. For a detailed analysis of Bernard Berenson's critical oeuvre, see Calo 1994.

62. Berenson 1930a.

63. Cox 1901, 362.

64. Berenson 1930b, 201.

65. In a letter from Leo Stein to the American painter Morgan Russell, dated June 26, 1910, Leo wrote: "I noticed at Rome that nowhere on the ceiling has Michelangelo attained to the sheer expression of form that is often achieved in his drawings. I believe that nowhere is it as complete as in those apples of Cézanne." Morgan Russell Archives and Collection, Montclair Art Museum, Montclair, N.J., Series 1.1, folder 74.

66. Leo Stein to Gertrude Stein, October 9, 1900, in L. Stein 1950, 3.

67. Bernard Berenson to Mary Berenson, April 16, 1901, Villa I Tatti; quoted in Wineapple 1996, 162.

68. Leo Stein to Mabel Weeks, September 19, 1902, in L. Stein 1950, 11–12.

69. Samuels 1987, 50, citing a September 1907 letter from Bernard Berenson to Mary Berenson.

70. Samuels 1987, 61, citing Gertrude's unpublished, undated notebooks.

71. Alfred Barr in *Matisse: His Art and His Public* discusses the scathing review in the *Nation* of Matisse's 1908 exhibition at the Salon d'Automne, in which an unnamed journalist wrote: "Some of the younger artists have surprisingly good and new work, along with direct insults to eyes and understanding. Such is Henri Matisse, who forgets that beholders are not all fools" (Barr 1951, 111–12). The review of the Salon d'Automne appeared in the *Nation*, October 29, 1908, 422. Berenson (1908) was moved to write a response to this review. Berenson later told Van Wyck Brooks that the Steins were hostile to him because of his unwillingness to follow this letter and become a full-blown critic of modern art, which they took as a "great refusal" (Brooks 1958, 255).

72. Samuels 1987, 66. Mary Berenson wrote her friend Hannah Smith in June 1910 that Gertrude was "fat beyond imagination" and was accompanied by "an awful Jewess, dressed in a window curtain, with her hair completely hiding her forehead and even her eyebrows. She was called Toklas…. Neither Gertrude nor her brother Leo stood on ceremony, and they came over whenever the spirit moved. They were easily accommodated with a 'free meal' at tea time, hardly an expense at this period since their new fad was to eat almost nothing." Ibid., 106.

73. Morrin n.d., 6.

74. Meyer 1953, 80, 81.

75. Leo Stein to Maurice Sterne, undated, in L. Stein 1950, 177.

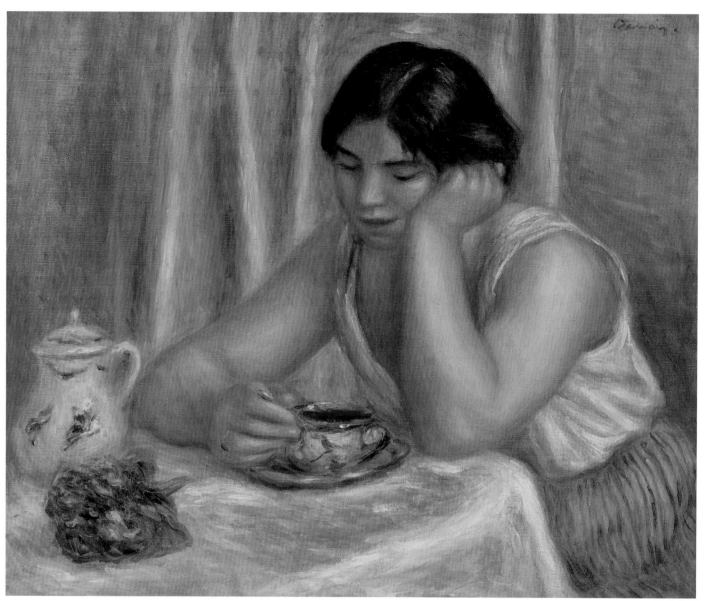

Plate 43

Leo without Gertrude

Martha Lucy

In the spring of 1914 Leo Stein moved his belongings out of 27 rue de Fleurus. The long, devoted partnership with Gertrude had come to an end, and on April 3, after packing up his books and what remained of his art collection, he set off for his villa in Settignano, Italy.[1] Tension between Gertrude and Leo had been mounting for years. While the strain was certainly aggravated by the presence of Alice Toklas, its roots were deeper and more intractable. Leo and Gertrude had absolutely diverged intellectually—"there is practically nothing under the heavens that we don't…disagree about," Leo explained in February 1913—and one of the main points of contention was the new direction of Pablo Picasso's art.[2] Where Gertrude was an enthusiastic supporter of Cubism, Leo found the new style to be an "utter abomination": it was all surface and no substance, a vacant attempt at intellectualism, and he railed against it to anyone who would listen.[3]

That Picasso's new style should infuriate Leo so intensely was, on the one hand, a matter of taste: committed to certain aesthetic principles, he simply couldn't abide this sudden abandonment of solid form by an artist he had so admired. But Leo's hostility was, on the other hand, also bound up with his faltering status at the siblings' famous Saturday evening salons. For Gertrude to support Cubism against Leo's passionate recommendations was a direct challenge to the authority that he had enjoyed for years at rue de Fleurus, where he was known as a kind of "prophet" of modern art, and he wrote candidly about having been "deposed" in a letter to Mabel Weeks. "I'm a rank outsider," he told her in early 1913. "However, I'm a cheerful one,

and take my deposing good-humoredly, like the soon-to-be late President."[4]

Gertrude's writing supplied another major point of tension. To Leo, a work like the recent "Portrait of Mabel Dodge at the Villa Curonia" (1913) was "utter nonsense," the prose equivalent of Picasso's fatuous play with pictorial structure. Gertrude resented her brother's disapproval, and by the end of 1913 the siblings began making arrangements to divvy up the collection.[5] The news tore through Paris and New York: "You have seen it for the last time together," the *New York Sun* reported.[6] Interestingly, this was the one part of the split that was amicable, for their difference of opinion on Cubism made the lines of division quite clear. "I shall…insist with happy cheerfulness that you make as clean a sweep of the Picassos as I have of the Renoirs," Leo wrote to his sister.[7]

If Leo's departure from 27 rue de Fleurus has a certain mythic status in the art historical literature, this is largely because of the choices that he made when selecting his share of the collection. It seems unfathomable that this passionate orator on modernism could become "a simple minded person of the 'Old School,'" as Leo himself put it, leaving Paris "without a single Picasso hardly any Matisses only 2 Cézanne paintings…and 16 Renoirs."[8] In the months leading up to the split, Leo had actually sold several paintings to finance the purchase of Renoir's *Cup of Chocolate* (ca. 1912; pl. 43, cat. 411)—a work that he regarded as "the quintessence of pictorial art."[9]

For writers like John Rewald, Leo's abandonment of the painters that he and Gertrude had championed could only signal a loss of enthusiasm for art in general, and his move to America the following year is simply further proof that he had given up, taken himself "out of the game."

Plate 43, cat. 411

Pierre-Auguste Renoir, *Cup of Chocolate*, ca. 1912. Oil on canvas, 21⅜ x 25½ in. (54.3 x 64.8 cm). The Barnes Foundation, Merion, Pennsylvania

Leaving Europe was an "exit" from his own life, or an "early retirement," as Brenda Wineapple calls it.[10] To be sure, Leo's tastes became less adventurous after the rue de Fleurus years, and his self-described neuroses could render him utterly debilitated at times. But he certainly did not lose interest in art. Indeed, it was only after his move to America that he began publishing his art criticism—something that he had struggled his whole life to do—and in later decades he continued collecting and took up painting. In many ways, Leo's life post-Gertrude was as much an arrival as it was an exit.

Leo's "Exit" to America

When Leo sailed into New York on May 10, 1915, he was immediately swept up in the social circles of the city's literary and artistic avant-garde. "It's a thrilling life," he wrote to Nina Auzias just a week after his arrival. "At the moment I'm running like the devil…every day is divided between a throng of dinners.…It's amusing, it's exciting, and I find myself feeling good."[11] Mentions of various social engagements fill his letters—visits to Alfred Stieglitz's gallery, dinner with the journalist Paul Rosenfeld, meetings with leading art critics like Willard Huntington Wright and Henry McBride, and with Walter Pach, the artist, writer, and great champion of modernism. Indeed many artists moved in and out of Leo's New York circle, and this he proudly reported in a letter to Gertrude from February 1916, listing Jules Pascin, Francis Picabia, Marcel Duchamp, and Albert Gleizes.[12] His old friends Florine and Ettie Stettheimer held fashionable gatherings attended by "the celebrities of the world of art and literature," as Rosenfeld put it, a circle that included Carl Van Vechten and Gaston Lachaise among many others.[13]

While a constant stream of personalities moved in and out of Leo's sphere, there was also a core group that formed a kind of home base. Among them were Leo's cousins Howard and Bird Gans, who invited him to stay for long stretches at 401 West End Avenue; the writer Hutchins Hapgood, an old Harvard friend; the painter Maurice Sterne, with whom Leo would spend hours arguing about art and psychology; and perhaps most importantly, Mabel Dodge.

Dodge was an enormous personality in avant-garde circles, her salon at 23 Fifth Avenue a legendary gathering place in the years around the Armory Show. Leo had first met Dodge in Europe, with Gertrude, but it wasn't until his return to America that the friendship really blossomed. As Dodge later reflected: "Leo meant a great deal more to me in America than he had in Europe.… I needed people of solid worth, people with ideas and character."[14] Through Dodge, Leo found himself constantly surrounded by artists and writers, including Sterne, John Reed, and Marsden Hartley. After the start of the war Dodge's group gathered outside the city—during the winters at Finney Farm, Dodge's home in Croton-on-Hudson, New York, which Leo first visited in October 1915.[15] He was a regular guest there into the spring of 1916, telling Gertrude that he was "spending as much as possible of my week-ends at Croton"—so much so that Dodge let him take over one of the stone houses on the property.[16] During the summers Leo joined the group in Provincetown, Massachusetts, spending a month there with Dodge and Sterne in late August 1915, and again in 1916; Hapgood was a Provincetown regular too.

Another of Leo's regular contacts was the collector Albert Barnes, whom he had first met in Paris in 1912, when Barnes visited the rue de Fleurus apartment. The two became fast friends, sharing a love of modern painting and sparring continually in letters about aesthetics and philosophy. Since their first meeting in Paris, Barnes's collection had grown considerably, and Leo traveled to see it for the first time in June 1915, stopping at Barnes's home in Merion, Pennsylvania, on his way from Boston to Baltimore.[17] More visits followed in 1918, and there were several over the winter of 1919.[18] The two would spend hours studying Barnes's collection of works by Matisse, Renoir, Cézanne, and Picasso—it must have felt to Leo like being at rue de Fleurus—and often they were joined by artists. It is clear that Leo's desire to surround himself with art, and with people interested in art, did not end when he left Europe.

Yet it was a rather fragmented existence. Leo was no longer the one with the collection, to whom everybody flocked; he had to go to them. On top of his trips to Provincetown, Croton-on-Hudson, and Philadelphia, Leo

Plate 44

traveled frequently to Boston (June 1915, fall 1916); to Nantucket, Massachusetts (October 1917); to Washington, D.C. (December 1915); and to Baltimore, where he had relatives (June 1915, November 1915, June 1917, 1918, February 1919, summer 1919). He even traveled west, to Taos, New Mexico, to visit Dodge at her new home there from August to November of 1918.[19] A photograph shows Leo, Mabel, and a few others cooking a makeshift dinner in the desert, an image that swiftly sums up his nomadic existence during his years in America (pl. 44).

"Nothing Left but Literature"

Leo may have left his collection behind, but he brought plenty of ambitions with him to New York, telling Nina that he felt for the first time "truly…anxious to accomplish something."[20] He was deeply immersed in the study of psychology, continuing the intensive analysis begun in Settignano and reading voraciously. And he was hardly alone in his interest: Freud was all the rage among New York's intellectual elite, and psychoanalytic terms crept into everyday conversation. Hapgood wrote in his memoirs, "Psychoanalysis had been overdone to such an extent that nobody could say anything about a dream…without his friends' winking at one another and wondering how he could have been so indiscreet."[21] Leo was right at the head of the pack: known within the Provincetown group as an "authority on psychoanalysis," he dispensed his diagnoses

freely.[22] In 1915, enjoying his renewed role as expert, he toyed with the idea of becoming a psychoanalyst, but his rapidly deteriorating hearing proved a major impediment. "A psychoanalyst without ears would be like a violinist without a violin," he wrote to Nina. "There is nothing left but literature."[23] In the fall of 1915 Leo resigned himself to writing, and Barnes, who had endless respect for his knowledge, encouraged him: "I thought last night…what a sin it is for you not to put down in print what you carry in your head on the subject of paintings."[24]

Leo published his first article in the *New Republic* on January 22, 1916. The subject was Paul Cézanne, whom he called "perhaps the most important figure in the history of modern painting" before going on to articulate the significance of his contribution. But it is the first three paragraphs, in which Cézanne is not mentioned at all, that are of particular interest, for in them we get a glimpse of the direction that Leo's writing about art would eventually take. Addressing the question of how aesthetic feeling is produced, Leo offers a theory hinging on the Freudian idea of sublimation: "In ordinary life feeling is an accompaniment of action, whereas in aesthetic contemplation it is the product of frustrated action and is felt as belonging to the thing that we regard."[25] The article set off a friendly quarrel between Stein and Barnes, carried out in the pages of the *New Republic*; Barnes liked the discussion of Cézanne but disagreed with Leo's application of Freud.

Despite Barnes's criticisms, Leo was energized. He began lecturing—giving talks in New York and Baltimore, and at Bryn Mawr College—and in 1919 he participated in a panel discussion on modern art at the Civic Club, with Pach and other critics.[26] His essays appeared in the *Dial* and in *Seven Arts*, alongside pieces by Robert Frost, Theodore Dreiser, Willard Huntington Wright, and John Dewey. From 1916 to 1919 he published about three articles a year in the *New Republic*—including a 1916 review of Wright's book *Modern Painting* and essays on Ignacio Zuloaga, Edgar Degas, Arthur B. Davies, and Pierre-Auguste Renoir—a body of work that the *New York Times* would later praise as "the best of his written work."[27] Following the initial Cézanne piece, Leo backed away from such direct

engagement in psychological principles. What emerged instead in these essays was a broader argument for what makes a good painting—an argument in which Renoir ranked above Picasso.

Although Leo would not explicitly take on Picasso until years later, his disapproval of Cubism is certainly at the core of his thinking in many of these early articles; occasionally it bubbles to the surface, as in his review of Davies, a good artist who fell under the spell of Cubism's "intellectual formulations."[28] For Rewald, the preference for Renoir over Picasso was untenable and simply more evidence that Leo had lost interest in art.[29] Yet Leo was hardly alone in his reverence for late Renoir; many critics, including Wright and Barnes, placed the artist's late work at the forefront of developments in modern painting. Indeed, what Leo's shift in taste reflects is not a loss of interest but rather an adherence to a particular theoretical position about the path on which modern art ought to be headed. If Cubism, for Leo, was the mark of the wrong direction—it was too cynically disinterested in form—Renoir, by contrast, showed a "devotion to things in the visible world."[30] In Leo's opinion Renoir had achieved an understanding of plastic form that was so advanced that his paintings could function as complete systems unto themselves. To be sure, Leo admired the artist's classicism, but his admiration was also firmly lodged in the principles of early modernist thinking—in the ideal of the artwork as a self-reflective, autonomous system.

Although Leo had curtailed his use of Freudian principles after the Cézanne article, he continued to be absorbed in questions of subjectivity—his own especially. His notebooks and letters are filled with interrogations into the nature of self, his every desire subject to pages of analysis. It is not surprising, then, that questions of the self would begin to reemerge in his art criticism, and by 1919 he had drifted away from "objective" formal analysis, prompting a series of outbursts from Barnes. "For the love of Mike," Barnes wrote in February, "cut out the amicable blather you've started in the New Republic.... It's not aesthetics—it's esoteric raving."[31] His approach had become far too subjective, Barnes said, and he advised Leo to

ground his writing in the actual artwork: "go look at some pictures, living or reproduced, with more vision and less self." But Leo ignored the advice, and by the 1920s his writing would move entirely away from visual analysis of the object to a wholesale interrogation of the ways one *experiences* that object—perceptually, physically, and psychologically.

Leo's self-reflectivity also affected his relationship to his work. Despite his many articles and speaking engagements, his letters abound with anxious confessions about his inability to produce, and it sent him into long flights of despair and self-loathing. As Dodge described his mood one summer, "Leo perched on a rock in Provincetown, and with eyes turned inward, spun a web of thought and wrapped it round and round him so that very little outside life could touch him."[32] Paralyzed by fear of failure, Leo grew resentful of those who opined freely about the subjects that he knew so well. His loss of hearing could sometimes be deployed to his advantage; he did not like to listen as much as he liked to profess, and in 1919 an exasperated Barnes diagnosed him with "a case of psychic deafness."[33]

Turning ever more inward, Leo occupied the center of the art world in an increasingly tenuous way toward the end of his New York years, and nothing makes this more plain than Florine Stettheimer's 1917-19 portrayal of one of her gatherings (pl. 45). *Soirée*, like most of Stettheimer's paintings, is a study of the social identities of the New York art elite; gestures, poses, locations within the room are all rife with meaning. Ettie Stettheimer, Isabelle Lachaise, and Maurice Sterne form a gossiping trio at top left; Gaston Lachaise and Albert Gleizes stand examining the canvas; and on the red carpet, next to the melancholic figure of Avery Hopwood, sits Leo. Though positioned at the center of the room, Leo is hardly the center of attention. He is not engaged in discussion, and this is underlined by the position of the hearing aid lying unused in his palm. What is most significant is his relationship to the painting on view: unlike the standing figures before the easel, who are actively engaged in looking, Leo sits at a significant distance from it, his curled-up posture reflecting an entanglement in the self rather than in the world of objects.

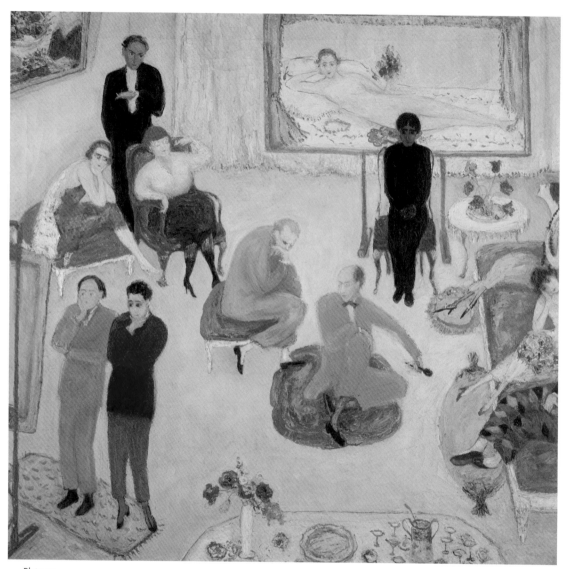

Plate 45

Plate 45
Florine Stettheimer, *Soirée,* **1917–19.** Oil on canvas, 32 x 33½ in. (81 x 85 cm).
Yale Collection of American Literature, Beinecke Rare Book and Manuscript
Library, Yale University, New Haven

"More Vision and Less Self": The Later Years in Europe

In November 1919 Leo returned to Europe, where he would live the rest of his life. He and Nina married in 1921, spending winters in Paris at their apartment at 42 rue du Parc Montsouris and summers in Settignano at the Villino Rossa. To finance their lifestyle, Leo sold off most of his collection—including several Matisses and all sixteen of his beloved Renoirs—to Barnes and Durand-Ruel in 1921.[34] One can imagine the sense of loss that Leo must have experienced. Years earlier he had expressed "a feeling very like sacrilege about selling a Renoir," and during the course of his negotiations with Barnes he made several attempts to hold on to his favorite pictures, but to no avail.[35]

Leo continued writing, venturing more directly into psychology with articles such as "Dr. Lutoslawski's 'Theory of Personality'" in 1922 and "Dr. Drever on Psycho-Analysis" in 1924. He returned to art criticism as well, and his contempt for Cubism came bursting forth in his 1924 essay "Pablo Picasso" in the *New Republic*. In 1925 he became embroiled in another epistolary dispute—this time with Dewey on the subject of Barnes's recently published tome *The Art in Painting*. While Leo praised Barnes's analysis of form, he took issue with the extent to which Barnes simply imposed his method of seeing. This is the wrong way to teach about art, Leo insisted, to which Dewey, defending Barnes, finally replied, "As far as I can make out you are comparing the book with something in your own head."[36]

Dewey was right on target: Leo's reaction to Barnes's book was entirely enmeshed in the anguish of writing his own treatise on aesthetics, a goal that he had mentioned as early as 1916 in a letter to Barnes. "One of the things that I want to do is to write a book…about painting in general with an insistence on appreciation in the largest possible way."[37] This was to be his definitive work, and he fixated on it, describing the project in letters and at social gatherings, swinging wildly from excitement to despair at his lack of progress; by the mid-1920s Mabel Dodge said to him, "I wish also you'd write your book so we'd see what it's all about."[38] Barnes, too, encouraged him to get his ideas down: "You owe it to yourself to do that book."[39] But Leo was paralyzed by the intense pressure that he was putting on himself and by his fear of not meeting the expectations that he imagined people had for him. As he noted, "If you are assailed with the statement: 'You know all about these matters. Tell me so and so,' you have greater difficulty in letting yourself down. You generally do your best to remain in the character that has been imposed upon you."[40]

After laboring on the project in stops and starts for a decade, Leo finally published *The A-B-C of Aesthetics* in 1927. It is an ambitious volume addressing philosophical questions such as the relationship between the self and the object in the production of aesthetic feeling. The reviews were almost uniformly negative. In the *Dial*, Horace Kallen critiqued the inaccessibility of Leo's language and his solipsistic approach: "you are asked to take his review of his own experiences and meditations as a prospectus for the unfolding of yours."[41] Leo was devastated: "I am going out of the author business," he announced to his friend George Boas.[42] One rare supporter was Stieglitz, who told Leo that he felt the work to be "of unusual value and significance" but also noted that he found himself constantly "fighting with critics and others about it."[43] Sterne gently ventured an explanation for the negative reaction: "Forgive me for writing this to you but I thought it might be of interest to you as it probably reflects the general attitude toward your book…it makes me mad to have to make such an effort to get your meaning."[44] Perhaps Leo should consider doing some lectures in America, Sterne offered, suggesting that this might help him clarify his ideas.

Reluctantly Leo followed Sterne's advice and traveled to New York in 1929 to deliver a series of twelve lectures at the New School. Held on Friday evenings from January through March, the lectures included "How I Look at a Picture" and "Why Art Appreciation Should Not Be Taught"—this last one perhaps a jab at Barnes. The New School gave Leo top billing, and the *New York Times* published a long excerpt of Leo's text from the promotional pamphlet; meandering, vaguely incoherent, and infused with psychology, the text hints at what the talks must have been like. "I suppose you heard of Leo's lectures," McBride reported to Gertrude. "He had his difficulties they tell me, and in one of them broke down completely. Mabel Dodge

felt guilty that she might have been to blame for she whispered to her neighbour, just before the debacle, 'Why this is all in Jung.'"[45] Public understanding of his aesthetic philosophy became even more muddled.

 If in the late 1920s Leo was foundering in a formless abyss of ideas, he was also beginning to reconnect to the tangibility of objects, finding an anchor especially in the work of the Czech painter Othone (Otakar) Coubine (pl. 46). Leo admired Coubine's sense of composition and the solidity of his form; this he expressed in a 1926 article on the artist, a straightforward piece of formal analysis. So inspired was Leo that he began collecting again, buying his first Coubine—a landscape—out of an exhibition that Adolph Basler had mounted in June 1926. "This artist could not dream of a more esteemed consideration of his talent," Basler wrote to him.[46] Leo's interest in Coubine soon grew into a serious passion: from the late 1920s into the 1930s he purchased at least forty works by the artist, though not purely out of aesthetic inspiration. As he explained to his cousin Fred Stein, "When I got these things it was due to two interests—(1) Coubine's were the first after the early days of Matisse and Picasso that interested me and (2) I was trying to create a market for him."[47]

 During the 1930s Leo kept up his contacts in America, making another trip in 1937 to New York, where he was photographed by Van Vechten; to Washington, D.C.; and to Philadelphia to see Barnes, with Leon Kroll.[48] In Settignano, Leo had a close-knit group that included Coubine,

Basler, and Sterne, who often came to visit, as well as the painter Edward Bruce, who owned a villa nearby and whose art Leo greatly admired; he kept dozens of photographs of Bruce's paintings and wrote an introduction to one of his exhibition catalogues. Coubine would spend weeks at a time in Settignano, where he would stay with Leo and occasionally with Bruce, and Leo in turn traveled to Coubine's home in Simiane-la-Rotonde, in the Basse-Alpes region of France, spending at least a month there in 1936.[49] As in the rue de Fleurus days, Leo was surrounded by artists, and discussions within the group often focused on the newest developments in their painting, with Leo acting as critic.

 But Leo's greatest reconnection with the art object was through his own painting, which he took up seriously around 1930. Throwing himself into his work, he painted the landscape around Settignano and brought his canvas out into the open air: "I work all day long and each day I make real progress," he told Coubine.[50] Frequently he and Coubine painted together. Leo was struggling financially— he gave up the Paris apartment in 1933 and sold off more of his collection throughout the 1930s—and he would send batches of canvases to Bruce, Gans, and Fred Stein in the States, who would try to find buyers.[51] "Howard [Gans] has undertaken to get some friendly disposed people to take a picture a year for $100 to help tide over," he wrote to Etta Cone. Among the "friendly disposed people" were Cone, Bruce, Gans, and Sterne.[52] But if painting brought Leo some money, it also brought him great personal satisfaction, and he wrote enthusiastically to many friends about his progress. "So far as the painting goes I feel just on the threshold," he told Sterne.[53] Painting was a balm for his neuroses and helped to stave off the "feeling of almost non-existence" that he often complained about.[54]

 The appearance of Gertrude's autobiography in 1933 certainly did nothing to assuage Leo's lingering existential anxieties. For in its pages, the great orator of the rue de Fleurus salon, the self that loomed so large in Leo's mind, was essentially erased. In Gertrude's account, it was she who had discovered Matisse and Picasso; Leo was barely mentioned. "Practically everything that she says of our

Plate 46

Plate 46
Othone Coubine and Leo Stein, Simiane-la-Rotonde, France, ca. 1930s.
Yale Collection of American Literature, Beinecke Rare Book and Manuscript
Library, Yale University, New Haven

activities before 1911 is false both in fact and implication," Leo wrote to Mabel Weeks; he complained that his sister had found it necessary "practically to eliminate me."[55] Leo was infuriated by the book's falsehoods but perhaps even more so by Gertrude's success as a writer. He was the one who understood language, he insisted; she, in contrast, had never used words well, a deficiency she "tried to circumvent…by novel inventions of form" and through the force of her own enormous personality.[56]

Leo and Nina remained in Settignano during the war. His letters describe the bombers flying overhead and the scarcity of food; friends in the United States sent coffee, sugar, clothing, and batteries for his hearing aid. Toward the end of the war Leo began work on a kind of memoir combining his thoughts on aesthetics with his experiences collecting art. Fred Stein encouraged him toward the latter: "write more about your recollections of your contacts with the art world and the various painters that you knew. That would be really making a contribution to art history."[57] *Appreciation: Painting, Poetry, and Prose* was published in 1947, and in it Leo reaffirmed his place as a critic, a theorist, and the driving force behind the rue de Fleurus collection. Taking Fred Stein's advice, Leo discussed painting in an accessible way, articulating his views on the artists he felt were most important to the development of modern art. The book is at times philosophical—art is part of society, he argues, to be found in ordinary things—and at times deeply personal. But rather than being merely solipsistic, the personal passages are packed with crucial bits of history. Leo describes certain acquisitions and reminisces about the artists he knew so well—Matisse and Picasso especially—detailing their working methods and their views on art. Such passages have become key documents in the art historical literature.

Reviews of *Appreciation* were positive, but the one that mattered most to Leo came from Barnes, in a personal letter. "Appreciation is a knockout," Barnes told him. And Nina replied: "thank you so much for your good letter to Leo—he felt so proud about it."[58] When Leo died a few weeks later, on July 29, 1947, Barnes was moved to tell Nina of her husband's profound influence on him: "It is safe to say that my talks with him in the early days were the most

important factor in determining my activities in the art world.…I feel deep sorrow now that just when he was coming into the enjoyment of the recognition of the value of his work he should pass away." Barnes continues, "It is a parody, as well as a great shame, that when Leo's name appears in books or journals he is mentioned as 'the brother of Gertrude.'"[59] Indeed, this was how the *New York Times* described Leo in his obituary: "Brother of Gertrude Is Dead." But that was just the subhead. In larger print above was the identity toward which he had strived his whole life: "Leo Stein, Author and Art Critic."[60]

Plate 47

Notes

1. "I leave tomorrow [for Italy]," Leo wrote to Mabel Weeks on April 2, 1914. Yale Collection of American Literature, Beinecke Rare Book and Manuscript Library, Yale University (hereafter, Beinecke YCAL), MSS 78, box 3, folder 55.

2. Leo Stein to Mabel Weeks, February 7, 1913, in L. Stein 1950, 52.

3. Leo Stein to Mabel Weeks, February 4, 1913, in L. Stein 1950, 49.

4. Ibid.

5. Brenda Wineapple (1996, 358) provides the best account of the split, noting, "That he refused to see any merit in his sister's recent work drove a final cutting wedge between them."

6. Cited ibid., 374.

7. Leo Stein to Gertrude Stein, undated, in L. Stein 1950, 57.

8. Leo Stein to Mabel Weeks, April 2, 1914, Beinecke YCAL, MSS 78, box 3, folder 55.

9. Leo Stein to Nina Auzias, undated [probably spring 1914], Beinecke YCAL, MSS 78, box 2, folder 31 (my translation).

10. Rewald 1989; Wineapple 1996, 394.

11. Leo Stein to Nina Auzias, May 16-17, 1915, Beinecke YCAL, MSS 78, box 2, folder 31 (my translation).

12. Leo Stein to Gertrude Stein, February 15, 1916, in L. Stein 1950, 72.

13. Rosenfeld's description of the Stettheimer circle is cited in Bloemink 1993, 5.

14. Luhan 1999, 167.

15. Leo Stein to Nina Auzias, October 26, 1915, Beinecke YCAL, MSS 78, box 2, folder 31.

16. Leo Stein to Gertrude Stein, February 15, 1916, in L. Stein 1950, 71.

17. Albert Barnes to Leo Stein, June 6, 1915, Barnes Foundation Archives (hereafter, BFA).

18. Albert Barnes to Leo Stein, March 27, 1918, and February 22, 1919; and Leo Stein to Albert Barnes, [probably February 8 or 9,] 1919, BFA.

19. Leo toyed with the idea of settling in Taos. See Michael Stein to Gertrude Stein, undated, Beinecke YCAL, MSS 76, box 125, folder 2721.

20. Leo Stein to Nina Auzias, September 19, 1915, in L. Stein 1950, 64.

21. Hapgood 1939, 382.

22. Leo Stein to Nina Auzias, undated (probably early October 1915), Beinecke YCAL, MSS 78, box 2, folder 31 (my translation).

23. Leo Stein to Nina Auzias, November 6, 1915, Beinecke YCAL, MSS 78, box 2, folder 31 (my translation).

24. Albert Barnes to Leo Stein, January 21, 1916, BFA.

25. L. Stein 1916, 297.

26. Anon., January 12, 1919.

27. Anon., July 31, 1947. For the most complete list of Leo's articles and books, see the Beinecke YCAL finding aid "Guide to the Leo Stein Collection: Series III. Writings."

28. L. Stein 1918a.

29. Rewald 1989, 258-59.

30. L. Stein 1918b, 260.

31. Albert Barnes to Leo Stein, February 5, 1919, BFA.

32. Luhan 1999, 167.

33. Albert Barnes to Leo Stein, February 7, 1919, BFA.

34. See Lucy 2010.

35. See ibid.

36. John Dewey to Leo Stein, May 27, 1926, Beinecke YCAL, MSS 78, box 4, folder 79.

37. Leo Stein to Albert Barnes, 1916, BFA.

38. Mabel Dodge to Leo Stein, 1924 or 1925, Beinecke YCAL, MSS 78, box 4, folder 100.

39. Albert Barnes to Leo Stein, April 27, 1925, BFA.

40. Leo Stein to Trigant Burrow, June 20, 1933, in L. Stein 1950, 132.

41. Kallen 1928, 147.

42. Leo Stein to George Boas, March 3, 1928, in L. Stein 1950, 102.

43. Alfred Stieglitz to Leo Stein, February 2, 1938, Beinecke YCAL, MSS 78, box 3, folder 129.

44. Maurice Sterne to Leo Stein, August 5, 1928, Beinecke YCAL, MSS 78, box 5, folder 126.

45. Henry McBride to Gertrude Stein, May 10, 1929, Beinecke YCAL, MSS 76, box 115, folder 2413.

46. Adolph Basler to Leo Stein, June 26, 1926, Beinecke YCAL, MSS 78, box 3, folder 68 (my translation).

47. Leo Stein to Fred Stein, February 17, 1938, Beinecke YCAL, MSS 78, box 1, folder 22. Many of Leo's Coubines are now in a private collection in New York.

48. Leo Stein to Albert Barnes, 1937, undated, BFA; Edward Bruce to Leo Stein, November 9, 1937, Beinecke YCAL, MSS 78, box 3, folder 72.

49. Edward Bruce to Leo Stein, July 28, 1933, Beinecke YCAL, MSS 78, box 3, folder 72; Leo Stein to Maurice Sterne, Sept 7, 8, 9, 1936, in L. Stein 1950, 163.

50. Leo Stein to Othone (Otakar) Coubine, October 11, 1930, in L. Stein 1950, 118.

51. In November 1930 he consigned his Delacroix to J. B. Neumann, and in January 1931 he added four Picasso drawings and Henri de Toulouse-Lautrec lithographs. J. B. Neumann to Leo Stein, November 1930, Beinecke YCAL, MSS 78, folder 104.

52. Leo Stein to Etta Cone, November 19, 1938, Dr. Claribel and Miss Etta Cone Papers, Archives and Manuscripts Collections, The Baltimore Museum of Art.

53. Leo Stein to Maurice Sterne, undated (probably 1938 or 1939), Beinecke YCAL, MSS 78, box 3, folder 49.

54. Extract from Leo Stein's journals, September 20, 1941, in L. Stein 1950, 218.

55. Leo Stein to Mabel Weeks, December 28, 1933, in L. Stein 1950, 134.

56. Leo Stein to Mabel Weeks, undated, in L. Stein 1950, 141.

57. Fred Stein to Leo Stein, May 9, 1946, Beinecke YCAL, MSS 78, box 5, folder 122.

58. Albert Barnes to Leo Stein, July 3, 1947, BFA; Leo Stein to Albert Barnes (with note appended by Nina Stein), July 8, 1947, BFA.

59. Albert Barnes to Nina Stein, August 1, 1947, BFA.

60. Anon., July 31, 1947.

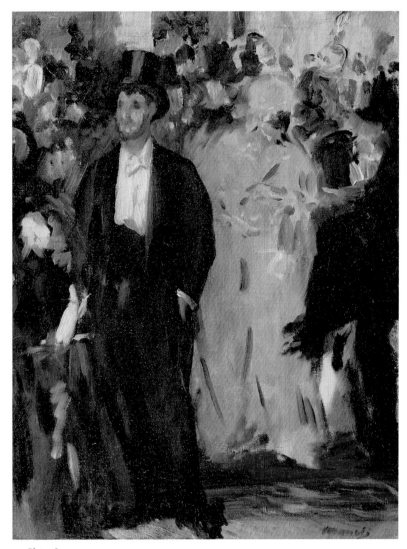

Plate 48

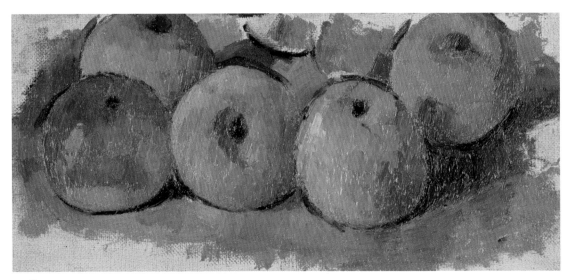

Plate 49

Plate 48, cat. 81
Édouard Manet, *Ball Scene*, **1873.** Oil on canvas, 13¾ x 10⅝ in. (34.9 x 27 cm). Private collection

In late 1904 Leo Stein explained to a friend that contemporary artists in Paris were drawing inspiration from the work of Paul Cézanne, Edgar Degas, Édouard Manet, Pierre-Auguste Renoir, and Pierre Puvis de Chavannes—artists whose work Leo was also attempting to collect. "Manet is the painter par excellence," wrote Leo. "He is not the great colorist that is Renoir but in sheer power of handling he has perhaps not had his equal in modern times" (L. Stein 1950, 15). Gertrude recalled that she and Leo found this "very very small Manet painted in black and white with [the artist Jean Louis] Forain in the foreground" at Ambroise Vollard's art gallery (G. Stein 1990, 32).

Plate 49, cat. 7
Paul Cézanne, *Five Apples*, **1877-78.** Oil on canvas, 4⅞ x 10¼ in. (12.4 x 26 cm). Mr. and Mrs. Eugene V. Thaw

Acquired by Leo and Gertrude in 1907, *Five Apples* was a favorite of visitors to rue de Fleurus. The siblings allowed the American artist Morgan Russell to borrow the painting for study, which resulted in his oil *Three Apples* (1910; Museum of Modern Art, New York). When the Steins divided their collection in 1914, Leo wrote to his sister, "The Cézanne apples have a unique importance to me that nothing can replace…. I'm afraid you'll have to look upon the loss of the apples as an act of God" (quoted in Mellow 1974, 207-8). In consolation for Gertrude's loss, Picasso painted a watercolor of a single apple (pl. 238), which he offered to Gertrude and Alice Toklas as a Christmas gift in 1914.

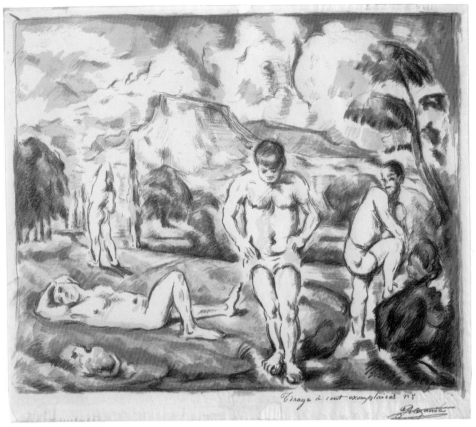

Plate 50

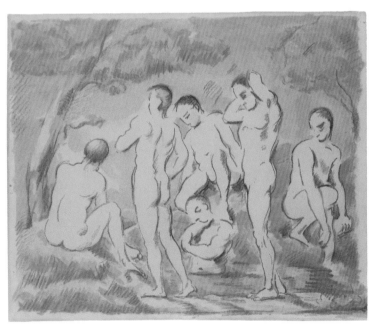

Plate 51

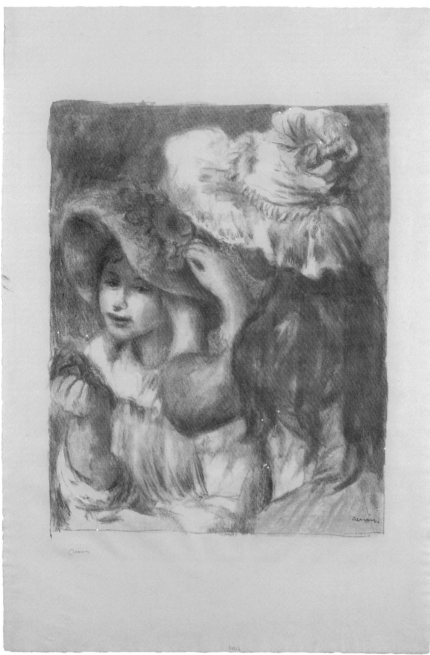

Plate 52

Plate 50 [cat. 26]
Paul Cézanne, *Large Bathers,* **1896–97.** Color lithograph, 16¾ x 20¼ in. (42.6 x 51.5 cm). San Francisco
Museum of Modern Art, bequest of Harriet Lane Levy

Plate 51 [cat. 27]
Paul Cézanne, *Bathers,* **1897.** Color lithograph, 9½ x 11⅜ in. (24.1 x 28.9 cm). San Francisco Museum of
Modern Art, bequest of Harriet Lane Levy

Plate 52 [cat. 413]
Pierre-Auguste Renoir, *The Hat Pinned with Flowers,* **1898.** Color lithograph, 35⅝ x 24¹⁵⁄₁₆ in. (90.5 x 63.3 cm).
The Metropolitan Museum of Art, New York, Harris Brisbane Dick Fund, 1931

Given the high prices commanded by Cézanne's and Renoir's canvases after their critically
acclaimed retrospectives at the 1904 Salon d'Automne, the Steins could not afford to purchase
many large oils by these artists. The family supplemented their collections with several of the
deluxe color lithographs that Ambroise Vollard had published during the second half of the
1890s. Visible in photographs of both Leo and Gertrude's atelier and Michael and Sarah's living
room, prints by Cézanne and Renoir were framed and integrated into the painting displays.

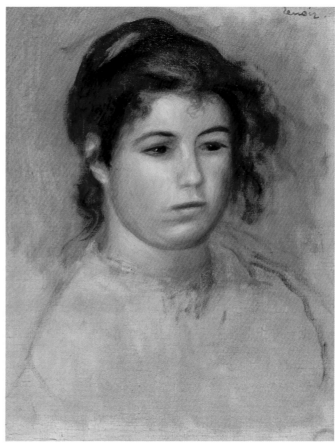

Plate 53

Plate 53, cat. 396
Pierre-Auguste Renoir, *Head of a Young Woman*, 1890. Oil on canvas, 16¼ x 12¾ in. (41.3 x 32.4 cm).
Private collection

Two weeks after the 1904 Salon d'Automne opened, Leo and Gertrude purchased their first
Renoirs: this oil and a pastel of two nudes (cat. 412). Though Leo would eventually turn away
from the work of both Matisse and Picasso, his enthusiasm for Renoir remained constant
throughout his life. Leo appreciated in the master colorist's work "the serene graciousness of
his pure and noble joy" (quoted in Wineapple 1996, 348).

Plate 54, cat. 394
Pierre-Auguste Renoir, *Washerwoman and Child*, 1887. Oil on canvas, 32 x 25¾ in. (81.3 x 65.4 cm). The Barnes
Foundation, Merion, Pennsylvania

Leo recounted his first impression of this painting in his memoirs: "It was a winter evening [in
1908] and already dark. The picture of a mother and child with some clothes hanging on a line
behind them was brilliantly lighted [in the window of a gallery]. I looked and looked, and after
a long while, I started toward home. But after a few hundred yards, I thought that the picture
couldn't really be as beautiful as that—I must go back and look at it again. [He inquired the price
and found it quite expensive.] When I got to the house Gertrude was finishing her dinner and
she started up in some alarm—'Why what's the matter? What's happened?' I said, 'I've been
looking at the picture Pablo [Picasso] and Braque talked about last Saturday. I want you and Mike
…to look at it tomorrow and if you like it, buy it, and if not I don't want to hear anything more
about it.' 'But you're crazy,' she said. I never before had suggested that anyone should decide
about a picture for me" (L. Stein 1950, 19). Leo purchased the painting soon thereafter.

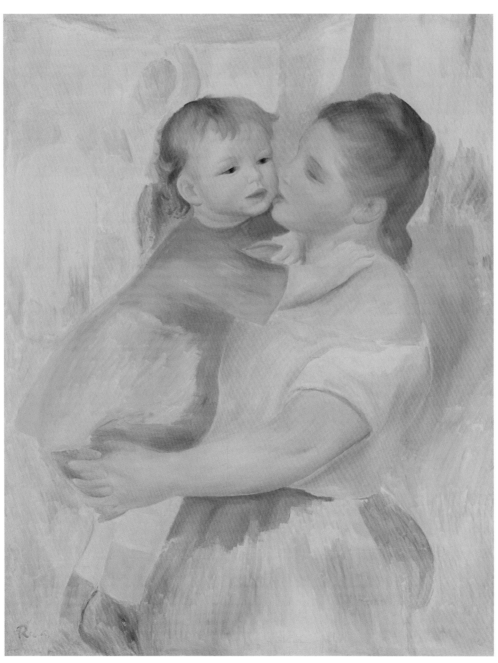

Plate 54

Plate 55

Plate 56

Plate 56

Plate 55, cat. 82
Henri Charles Manguin, *The Studio, the Nude Model*, 1904-5. Oil on canvas, 24¾ x 21 in. (65 x 54 cm).
Collection of Mr. and Mrs. E. David Coolidge III

Leo moved to Paris in order to become an artist, and once he rented his atelier at 27 rue de
Fleurus, he began hiring models to pose for him. He was particularly taken with Manguin's
colorful rendition of a studio nude when he saw it displayed at the 1905 Salon des Indépendants.
Manguin painted the canvas in his own studio in the company of his friends Albert Marquet
and Henri Matisse, each of whom created a version of the same scene from a slightly different
vantage point.

Plate 56, cat. 84
Henri Charles Manguin, *Study of Reclining Nude*, 1905. Oil on panel, 13 x 16⅛ in. (33 x 41 cm). Private
collection, France

Extremely knowledgeable about the history of art, Leo clearly was intrigued by contemporary
reinterpretations of the traditional motif of the reclining nude. Between spring 1905 and spring
1907, he and Gertrude purchased at least four versions of this theme, including works by Félix
Vallotton (pl. 10) and Pierre Bonnard (pl. 14). This painting was purchased in February 1907, just
a few months before the Steins acquired Matisse's *Blue Nude: Memory of Biskra* (1907; pl. 27).

Plate 57

Plate 57, cat. 91
Henri Matisse, *Canal du Midi*, **1898.** Oil on cardboard, 9½ x 14⅛ in. (24 x 36 cm). Collection of Carmen
Thyssen-Bornemisza, on loan to the Museo Thyssen-Bornemisza, Madrid

Five months after Leo and Gertrude purchased their first painting by Matisse—the controversial
Woman with a Hat (1905; pl. 13) from the 1905 Salon d'Automne—they attended his solo
exhibition at Galerie Druet. Both Stein households made purchases from the show, and it is
thought that Leo acquired *Canal du Midi* at that time. His choice of an early landscape was a
vote of confidence for the largely unknown artist. This canvas, painted by Matisse in Toulouse,
depicts part of a canal system that was built in the seventeenth century to connect the Atlantic
Ocean to the Mediterranean Sea.

Plate 58 [cat. 198]
Henri Matisse, *The Serf*, **1900-1903.** Bronze, 36⅛ x 14⅞ x 13 in. (91.8 x 37.8 x 33 cm). San Francisco Museum
of Modern Art, bequest of Harriet Lane Levy

Each of the Stein households owned a selection of sculptures by Matisse, including casts of
the large-scale *Serf*. Leo was convinced that the artist was the most talented sculptor of his
generation. Given the importance of Leo's support as a collector, Matisse was eager to ensure
that he was pleased with his purchases. In an undated letter to Leo, the artist writes: "Here is
your bronze! If you do not care for the patina, return [it].... It is very easy to give it a more
golden patina if you prefer that" (Beinecke YCAL, MSS 76, box 116, folder 2449).

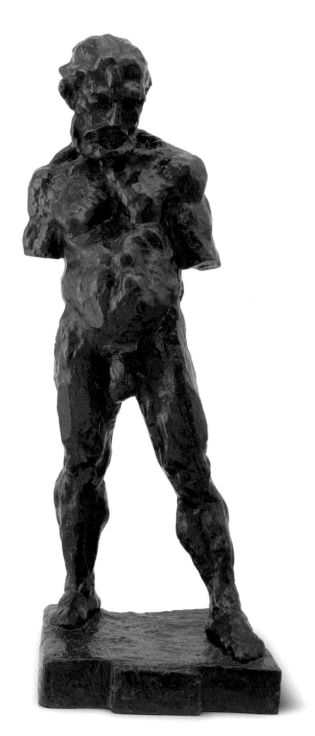

Plate 58

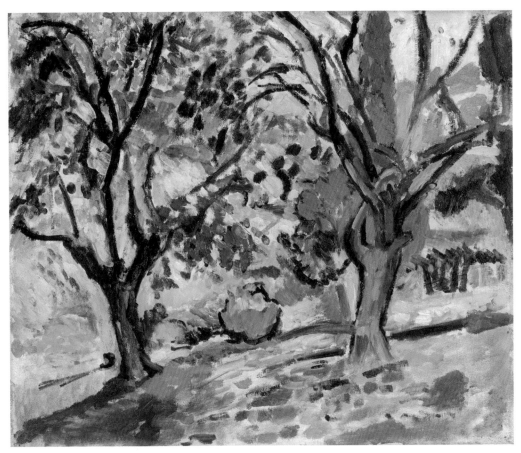

Plate 59

Plate 59, cat. 134
Henri Matisse, *Olive Trees at Collioure,* ca. 1906. Oil on canvas, 17½ x 21¾ in. (44.5 x 55.2 cm).
The Metropolitan Museum of Art, New York, Robert Lehman Collection, 1975

In May 1905 Matisse began spending time in Collioure, a small fishing village in southern France
near the Spanish border. He interpreted his surroundings in bright, non-naturalistic colors
and broken brushstrokes. When Leo first saw some of these canvases at the 1905 Salon d'Automne,
he was intrigued but hesitant. Soon, though, he grew convinced that Matisse "was by far the
most important and essentially vital of the younger…painters. He did something new with
colors—bold, brilliant, subtle" (L. Stein 1996, 160). Over the next few years Leo and his siblings
acquired many of the landscapes that Matisse painted at Collioure, including this
view of olive trees.

Plate 60, cat. 136
Henri Matisse, *Dishes and Melon,* 1906-7. Oil on canvas, 25⁹⁄₁₆ x 31⅞ in. (65 x 81 cm). The Barnes Foundation,
Merion, Pennsylvania

Leo and Gertrude purchased this painting soon after it was finished and for a time displayed
it next to Paul Gauguin's similarly sized *Sunflowers on an Armchair* (1901; cat. 64). In a photograph
taken in the atelier at 27 rue de Fleurus (pl. 349), the background of *Dishes and Melon* is clearly
enlivened with the decorative, sinuous lines of a textile design. Matisse later made a number of
changes to the Steins' canvas, most notably overpainting the upper right quadrant with
insistent diagonal brushstrokes.

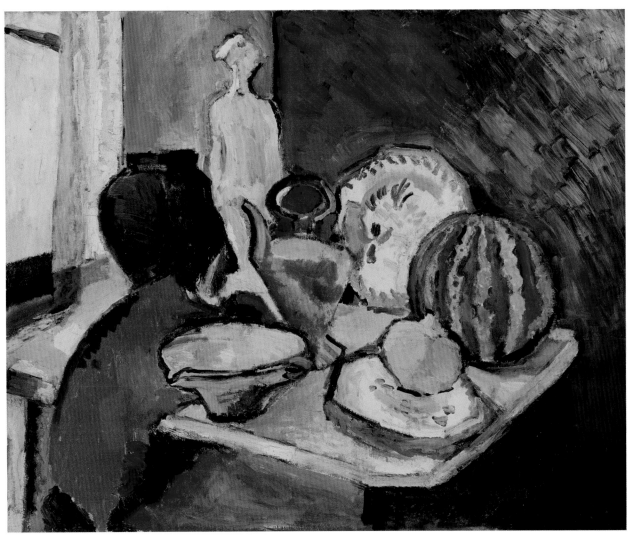

Plate 60

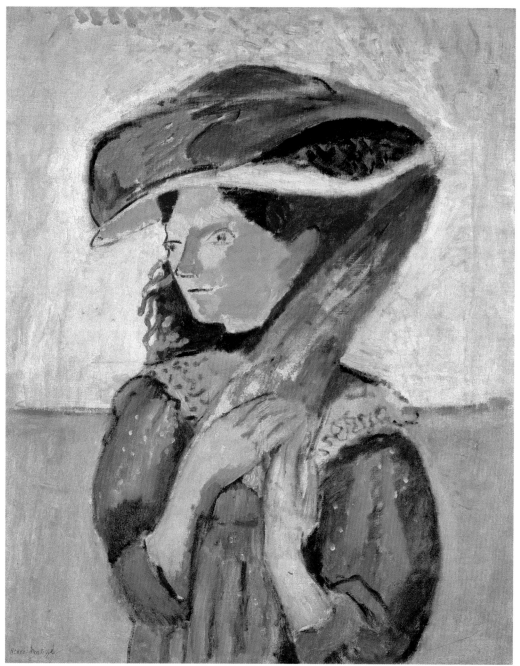

Plate 61

Plate 61, cat. 122
Henri Matisse, *Margot*, **1906.** Oil on canvas, 31⅞ x 25⅝ in. (81 x 65 cm). Kunsthaus Zürich

The year after purchasing *Woman with a Hat* (1905; pl. 13), Leo acquired a second Matisse canvas
of similar size and subject matter. The model here is not Matisse's wife, Amélie, however,
but rather his eldest child and only daughter, Marguerite (or Margot, as she was also known).
Leo recalled that it was the hat that most intrigued him: "I never could make out why those
yellows [in the brim] did what they did. Renoir, colorist as he was, could not understand how
Matisse controlled his intense colors and made them keep their places—foreground, middle
ground, background—just as he wanted them" (L. Stein 1996, 161).

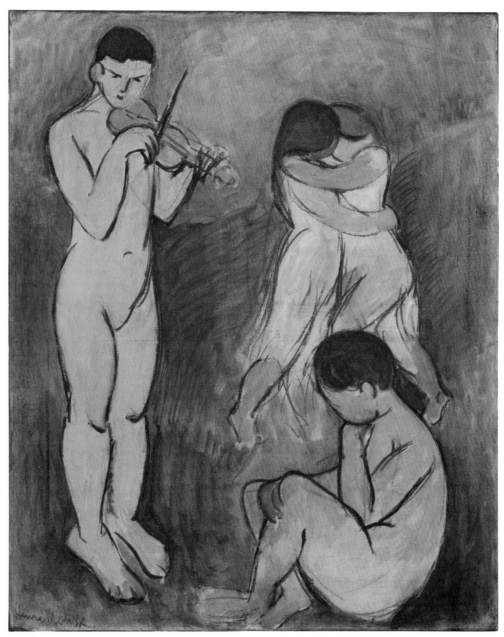

Plate 62

Plate 62, cat. 143
Henri Matisse, *Music* (Sketch), **1907.** Oil and charcoal on canvas, 29 x 24 in. (73.7 x 61 cm). The Museum of
Modern Art, New York, gift of A. Conger Goodyear in honor of Alfred H. Barr, Jr., 1962

The Matisses joined Leo and Gertrude in Italy in July 1907, just after the artist had shipped this
large-scale canvas to his dealer. It seems likely that Matisse showed the collectors a photograph
or sketch of the work while they were away together, as the Steins purchased it soon after
their return to Paris. *Music* is among the last Matisse canvases acquired by Leo and Gertrude,
ending a three-year period of intensive patronage. Leo explained that after that time "I was
always interested to see what he was doing because he always kept moving and generally moving
forward; but it was enough for me to see his pictures at exhibitions" (L. Stein 1996, 166). It was
not until Leo returned to Paris after World War I that he found himself newly intrigued by the
artist's recent paintings; by that point, however, he could no longer afford them.

Plate 63

Plate 63, cat. 214
Elie Nadelman, *Head of a Woman,* **ca. 1906.** Ink on paper, 11¾ x 7½ in. (29.9 x 19.1 cm). Private collection, courtesy James Reinish & Associates, Inc.

Leo was a great enthusiast of the work of sculptor Elie Nadelman, and he both lent to and purchased from the artist's solo exhibition at Galerie Druet in the spring of 1909. As author André Gide noted in his journal, "The Nadelman show had hardly opened when he [Stein] had already bought up two-thirds or three-quarter of the [approximately one hundred] drawings" (excerpted in Kirstein 1973, 272). While most of Leo's purchases cannot be identified, this sepia-toned study is known to have been one of them. Gertrude befriended Nadelman as well and wrote a word portrait of him in 1927.

Plate 64 [cat. 215]
Elie Nadelman, *Standing Female Figure,* **ca. 1907.** Bronze, 29½ x 10½ x 9½ in. (74.9 x 26.7 x 24.1 cm). Whitney Museum of American Art, New York, gift of the Estate of Elie Nadelman

In June 1909 Fernande Olivier wrote to Alice Toklas about the plaster version of this sculpture, which was prominently displayed in the atelier at 27 rue de Fleurus. "Did I tell you in an earlier letter that the landlady of the inn where we're living is very beautiful? She looks exactly like a sculpture by Monsieur Nadelman. You know the first one Monsieur Leo Stein bought, the one that isn't very big and depicts a large woman with a very thick neck and a fine head" (Olivier 2001a, 238). Olivier was not the only observer to associate the sculpture, one of a series of *venus pudica* types executed by Nadelman, with the identity of a particular person. Ever since Lincoln Kirstein noted that the work "embodies the face and form of Gertrude Stein" (Kirstein 1973, 177), it has been inaccurately described as a portrait of Gertrude.

Plate 64

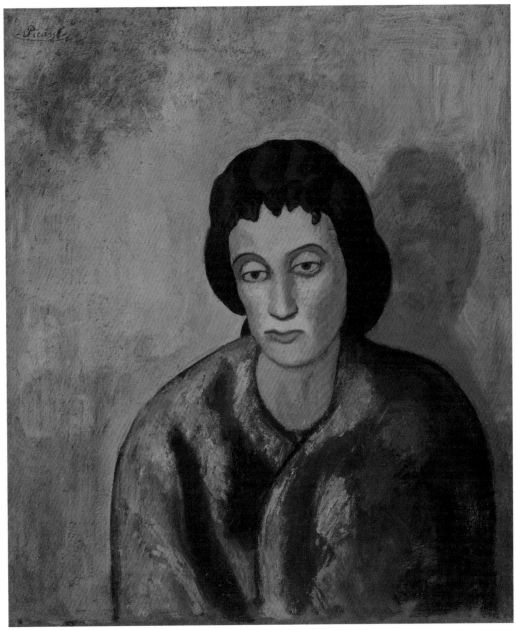

Plate 65

Plate 65, cat. 225

Pablo Picasso, *Woman with Bangs,* **1902.** Oil on canvas, 24⅛ x 20¼ in. (61.3 x 51.4 cm). The Baltimore Museum of Art: The Cone Collection, formed by Dr. Claribel Cone and Miss Etta Cone of Baltimore, Maryland

The Steins had not yet met Picasso when he painted his blue period works, but it was a style that resonated with Leo when he first encountered it in 1905. He and his sister subsequently purchased several paintings—among them, this haunting portrait of a Parisian prostitute—and displayed them as a group in the southeast corner of the rue de Fleurus atelier, where they must have been quite striking against the room's terracotta-colored wainscoting. The natural illumination from the atelier's north-facing windows would have enhanced the dramatic play of light in this work.

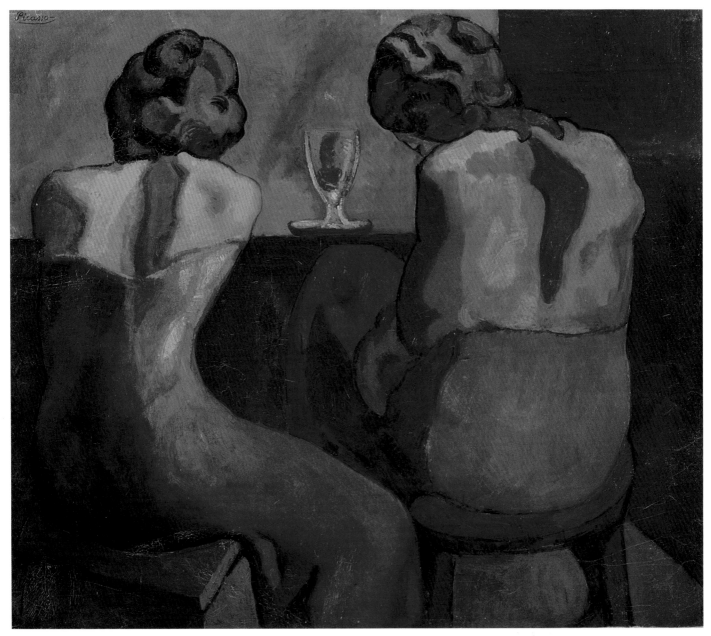

Plate 66

Plate 66, cat. 229

Pablo Picasso, *Two Women Seated at a Bar,* 1902. Oil on canvas, 31½ x 36 in. (80 x 91.4 cm).
Hiroshima Museum of Art

The theme of women in a café was considered quite modern at the turn of the century, and Leo was familiar with interpretations by Edgar Degas, Édouard Manet, Henri de Toulouse-Lautrec, and others. With their moody blue tonalities, Picasso's *Dozing Drinker* (1902; cat. 227) and *Two Women Seated at a Bar*—both owned by the Steins—are far more emotive than their precedents. Here, Picasso's emphasis on the figures' sharp shoulder blades seems to have particularly intrigued Leo. Though the collector often rearranged the pictures in the rue de Fleurus atelier, he frequently displayed his own painting of a figure's naked back near this canvas.

Plate 67

Plate 67, cat. 289
Pablo Picasso, *The Milk Bottle*, **1905.** Gouache on cardboard, 24⅝ x 17¾ in. (62.5 x 45.1 cm). The Museum of Fine Arts, Houston, gift of Oveta Culp Hobby

Leo and Gertrude acquired *The Milk Bottle* within a year or so of meeting the artist. It seems likely that Leo recognized the picture's affinities with a painting he admired at the Musée du Luxembourg: Pierre Puvis de Chavanne's *The Poor Fisherman* (1881; Musée d'Orsay, Paris). *The Milk Bottle* hung in the rue de Fleurus atelier near Gauguin's painting *Three Tahitian Women against a Yellow Background* (1899; pl. 8), which also includes a full-length figure shown frontally, barefoot and clutching her loose garments. The religious overtones of Picasso's beggar boy resonated as well with a similarly sized *Madonna and Child with Saint John the Baptist* in the atelier (see pl. 347).

Plate 68

Plate 68, cat. 235
Pablo Picasso, *Lady with a Fan,* **1905.** Oil on canvas, 39½ x 31⅞ in. (100.3 x 81 cm). National Gallery of Art, Washington, D.C., gift of the W. Averell Harriman Foundation in memory of Marie N. Harriman

Picasso painted *Lady with a Fan* in the fall of 1905, a period during which he was inspired by a variety of works on display in Paris. The position of this sitter's right arm, with its bent elbow and outward facing palm, recalls the *abhaya* mudra gesture of peace and protection commonly found in Buddhist sculpture—examples of which could be found in local museums. Another source of inspiration may have been Paul Cézanne's portrait of his wife (pl. 2). Both canvases feature three-quarter-length depictions of women holding folded fans, and they share a similar palette of reds and blues. The Cézanne had been publicly exhibited at the 1904 Salon d'Automne and afterward hung in Leo and Gertrude's studio. It was the star of their collection, and Picasso undoubtedly saw it when he visited the siblings the year this painting was made.

Plate 69

Plate 69, cat. 287
Pablo Picasso, Study for *The Actor*, 1904-5. Graphite on paper, 19 x 12½ in. (48.3 x 31.8 cm). Private collection

Leo and Gertrude avidly collected drawings by Picasso. This particular sheet contains studies for *The Actor* (1904-5; Metropolitan Museum of Art, New York), a large painting then owned by the Franco-American painter Frank Burty Haviland. On the right side of the sheet are two sketched portraits of Fernande Olivier, the artist's model and lover. Fernande, whom Gertrude recalled as "very large, very beautiful and very gracious," was friendly with all of the Steins during her years with Picasso (G. Stein 1990, 46).

Plate 70, cat. 234
Pablo Picasso, *Young Acrobat on a Ball*, 1905. Oil on canvas, 57⅝ x 37⅜ in. (146.4 x 94.9 cm). Pushkin State Museum of Fine Arts, Moscow

Leo's early enthusiasm for Picasso's work inspired him to invite guests to 27 rue de Fleurus, where the pictures made a strong impression on visitors. The Hungarian painter András Mikola remembers arriving at the atelier one Saturday evening around nine o'clock. Leo had invited him, but Mikola did not know what to expect. "There was Renoir, Cézanne, Picasso, Matisse, Bonnard, Degas, and so on. Along the walls there were also carved, antique Renaissance chests teeming with Chinese and Japanese silk paintings, woodcuts, prints, and drawings. At that time, Picasso had not yet turned to Cubism, and I especially enjoyed a picture of his painted with pale, pleasant pink in mild blue tones. It depicted a female circus performer balancing on a ball, while another circus performer, a giant of a man, [sat] in the foreground with his back to us" (Mikola 1972, 46-48; reference courtesy Gergely Barki, translation by Patrick Mullowney).

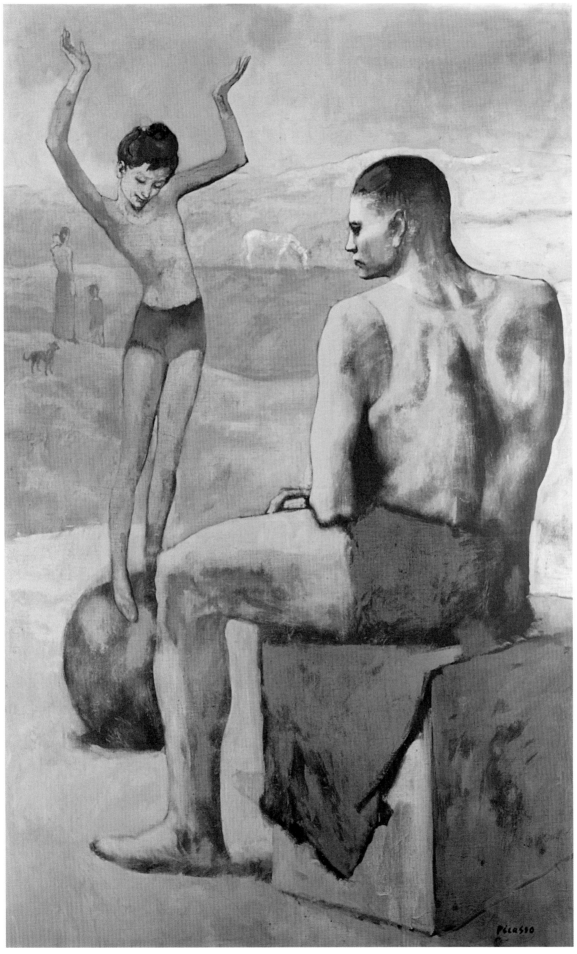

Plate 70

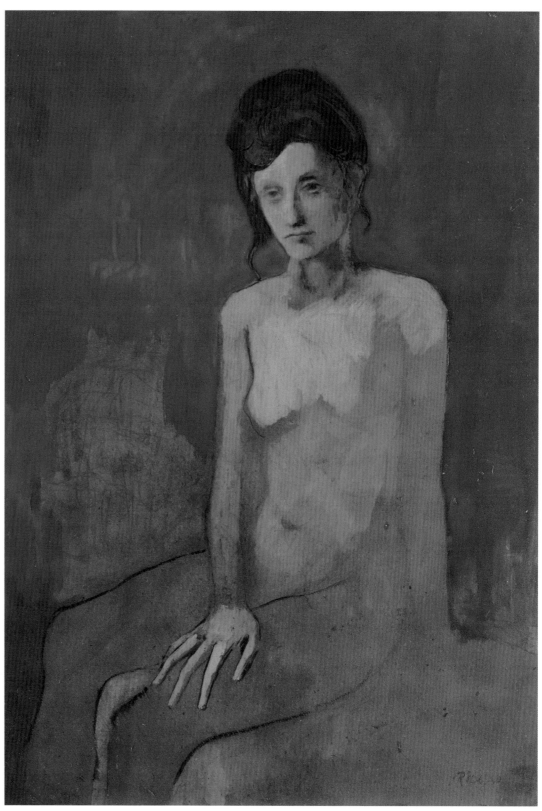

Plate 71

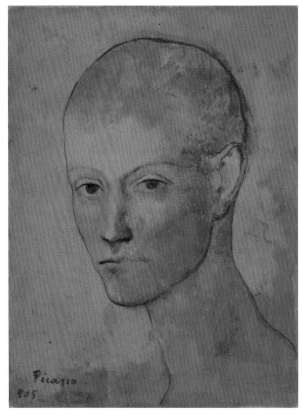

Plate 72

Plate 71, cat. 233
Pablo Picasso, *Seated Nude*, 1905. Oil on cardboard mounted on panel, 41¾ x 30 in. (106 x 76 cm).
Musée National d'Art Moderne, Centre Georges Pompidou, on loan to Musée National Picasso, Paris

The model for this painting is thought to have been Madeleine, a young woman with whom
Picasso had a relationship after he returned to Paris from Barcelona in 1904. As in *Woman with
Bangs* (1902; pl. 65), Picasso emphasizes the bright light that streams across the model from an
unseen source at upper left. The sketchlike quality of the work is underscored by the inclusion
of a small rendering of the same seated woman to the left of the central figure.

Plate 72, cat. 294
Pablo Picasso, *Head of a Boy*, 1905. Opaque matte paint on composition board, 9⅝ x 7⁵⁄₁₆ in. (24.6 x 18.6 cm).
The Cleveland Museum of Art, bequest of Leonard C. Hanna, Jr.

Drawings like this elegant rose period work convinced Leo that Picasso was one of the most
gifted draftsmen of his generation. The sheer number of Picasso drawings that Leo and
Gertrude came to own necessitated that most remained hidden away in portfolios, but this
early acquisition was framed and displayed against the wainscoting of the atelier walls.
The poignant quality of the adolescent figure evidently appealed to Leo and Gertrude, as it
is similar in mood and style to other Picassos they acquired during the early years.

Plate 73

Plate 73, cat. 353
Pablo Picasso, *Two Nudes,* **1906.** Charcoal on paper, 24½ x 18 in. (62.2 x 45.7 cm). The Museum of Fine Arts, Houston, gift of Oveta Culp Hobby

In 1906 Picasso created numerous studies of two standing female figures, clothed and unclothed. Leo and Gertrude acquired this example, which is closely related to a painting owned by Ambroise Vollard (now private collection, Switzerland) and to a watercolor purchased by the Steins' close friends the Cone sisters and now in the Baltimore Museum of Art.

Plate 74, cat. 237
Pablo Picasso, *Nude with Joined Hands,* **1906.** Oil on canvas, 60½ x 37⅛ in. (153.7 x 94.3 cm). The Museum of Modern Art, New York, The William S. Paley Collection, 1990

Picasso painted *Nude with Joined Hands* in Gósol, a remote village in the Spanish Pyrenees, in summer 1906. This large canvas is the same height as, but a bit wider than, the artist's *Girl with a Basket of Flowers* (1905; pl. 9), which also hung in the atelier at rue de Fleurus. Relative to its earlier counterpart, *Nude with Joined Hands* is a more classical depiction of a serene, confident nude. Leo and Gertrude also acquired several drawings related to this composition (see cat. 332, 333).

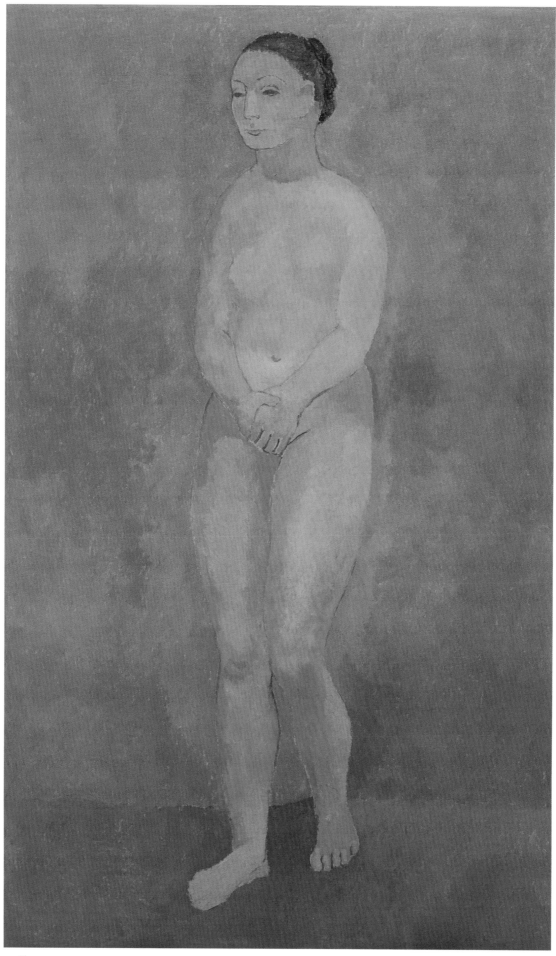

Plate 74

Plate 75

Plate 76

Plate 75, cat. 350
Pablo Picasso, *Standing Nude and Head in Profile*, 1906. Graphite on paper, 12¼ x 9⅛ in. (31.5 x 23.5 cm). Richard and Mary L. Gray, Chicago

Plate 76, cat. 331
Pablo Picasso, Study for *Woman Combing Her Hair*, 1906. Graphite and charcoal on paper, 11⅞ x 8⅝ in. (30.2 x 21.9 cm). Hegewisch Collection at the Hamburger Kunsthalle, Hamburg, Germany

Plate 77, cat. 357
Pablo Picasso, *Head and Figure Studies*, 1906. Conté crayon on paper, 24 x 17¾ in. (61 x 45.1 cm). Museum of Fine Arts, Boston, Arthur Tracy Cabot Fund

Leo and Gertrude owned more than one hundred drawings by Picasso, and it was not unusual for them to purchase groups of sketches directly from the artist soon after they were made. Some were exhibited by the siblings, but the majority were kept in portfolios and brought out for interested guests. When Leo and Gertrude divided their collection in 1914, *Head and Figure Studies* (at right) was one of the nineteen Picasso drawings that remained with Leo.

Plate 77

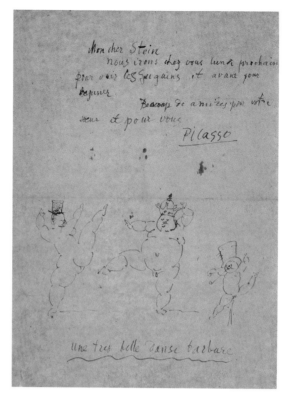

Plate 79

Plate 78

Plate 80

Plate 78, cat. 310
Pablo Picasso, *Leo Stein*, **1905.** Ink on paper, 12½ x 9⅜ in. (31.8 x 23.8 cm). Castellani Art Museum of Niagara
University Collection, gift of Dr. and Mrs. Armand J. Castellani, 1998

Plate 79, cat. 281
Pablo Picasso, *Une très belle danse barbare*, **1904 (letter ca. 1905).** Ink on paper, 11¼ x 15⅞ in. (28.6 x 40.3 cm).
Private collection

Plate 80, cat. 308
Pablo Picasso, *Leo Stein*, **1905.** Ink on tracing paper, 6¼ x 4½ in. (15.9 x 11.4 cm). Philadelphia Museum of Art:
The Louis E. Stern Collection, 1963

In the division of Leo and Gertrude's collection, Gertrude kept all of the Picasso paintings
that the two siblings had purchased. These three works are among the few drawings by the
artist that Leo took for sentimental reasons. In addition to the sketches of himself, Leo
opted to retain a letter that Picasso had sent in response to an invitation to have lunch and
view artworks by Paul Gauguin.

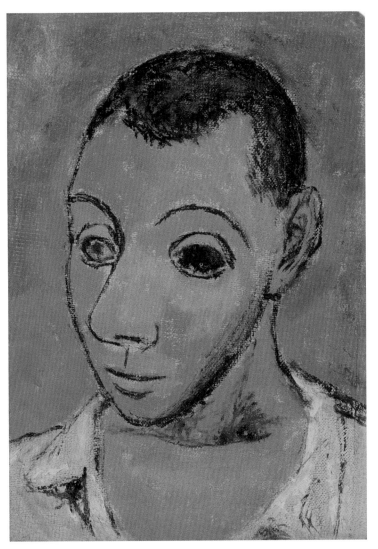

Plate 81

Plate 81, cat. 239

Pablo Picasso, *Self-Portrait*, 1906. Oil on canvas mounted on honeycomb panel, 10½ x 7¾ in. (26.7 x 19.7 cm). The Metropolitan Museum of Art, New York, Jacques and Natasha Gelman Collection, 1998

Upon Picasso's return to Paris from Gósol in August 1906, the twenty-four-year-old artist wrote Leo, who as usual was summering in Italy, to request a loan of "50 or 100 francs" in exchange for a picture (G. Stein and Picasso 2008, 16). Leo obliged. It is possible that this diminutive self-portrait, painted that autumn, was used to repay this debt and others incurred at the time. The painting remained with Gertrude after Leo moved to Italy in 1914. She treasured it throughout her life and prominently displayed it in each of her homes (see pl. 198).

SARAH AND MICHAEL STEIN

Plate 82
Henri Matisse (center) and Hans Purrmann (right) dining with Michael, Sarah, and Allan
Stein in the apartment at 58 rue Madame, Paris, ca. 1908. Estate of Daniel M. Stein

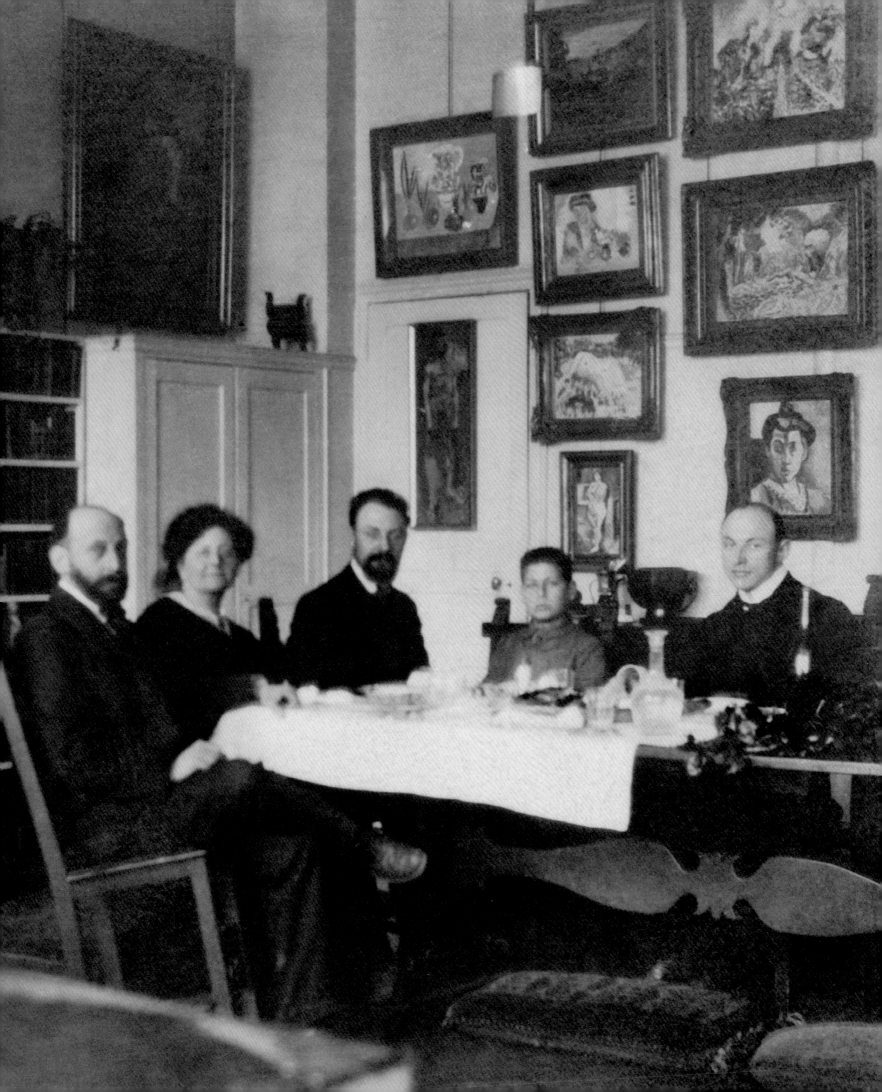

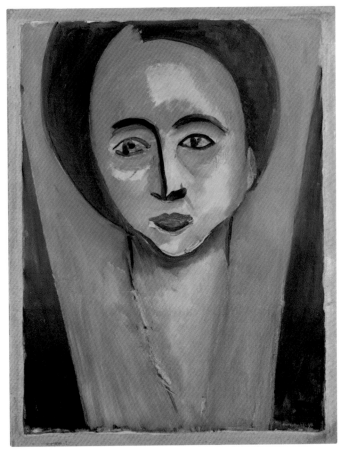

Plate 83

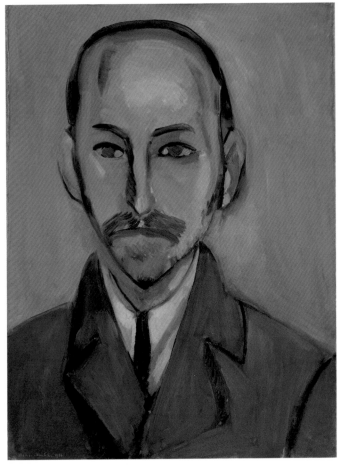

Plate 84

Sarah and Michael Stein, Matisse, and America
Janet Bishop

It seems the best part of my audience has departed with you.
—HENRI MATISSE TO SARAH STEIN, AUGUST 5, 1935[1]

Sarah and Michael Stein's return to California after more than thirty years in Paris prompted a particularly poignant exchange between Henri Matisse and his American patron. Sarah was up early on July 6, 1935, writing to the artist that they were to sail that morning on the *Statendam* and thanking him for "the joy that you have brought me these many years through your beautiful journey and your beautiful results."[2] The long draft that he wrote in reply suggests that he was unprepared for her to go:

> I had hoped…I could have spoken again with you of the past, to tell you how vivid my memories remain of my ardent years of work…during which you and Mr. Stein supported me so much, with tireless devotion—, and since, of the pleasure that I had in showing you my work…how much I valued your wise judgments, guided by your exceptional sensibility, and full knowledge of the road I have traveled…. True friends are so rare that it is painful to see them move away.[3]

The two would not see each other again. They would no longer share meals and vacations, watch each other's children grow and marry, or spend countless hours looking at and discussing Matisse's work. But by that point Sarah and her husband, Michael, had played an inestimable role in building a lasting audience for the artist. As Alfred H. Barr, Jr., documented in *Matisse: His Art and His Public* (1951), Matisse had endured an inordinate amount of enmity over the course of his career.[4] From the very beginning, his work commanded attention, inciting passion among the few and skepticism, if not ire, among the masses. Yet for such a gifted artist Matisse was, by and large, overlooked or dismissed by the French, especially early on. Claude Duthuit, the artist's grandson, remarked of those days, "Without the Americans and the Russians, he would have starved."[5] Foremost among those Americans were the members of the Stein family, especially Sarah and Michael, who bolstered the artist's career not only via their own patronage and friendship but also by building a critical network of support for him stateside. They welcomed countless visitors at their salons in Paris to see and discuss his work, facilitated transactions, lent to international exhibitions, and made introductions, all of which contributed to the artist's initial and sustained exposure in the United States. Sarah and Michael made only two trips back to the States during their three decades abroad. Their infectious enthusiasm for Matisse had a far-reaching ripple effect across the Atlantic during that period, however, and once home for good, they actively continued to further his cause.

Before moving to Paris in early 1904, Sarah and Michael Stein found their peers among San Francisco's cultured and educated "Jewish money-aristocracy."[6] Sarah Samuels was a native, and Michael had moved with his peripatetic family to Oakland in 1879, when he was fourteen. The two were married in 1894, and their son, Allan, was born the following year. With Michael assuming the role of family banker after his parents' deaths, he and his four younger siblings—Leo and Gertrude the two germane to our story—enjoyed a steady if not substantial income. Michael also worked in the management of the burgeoning streetcar business, as had his father before him, and owned

Plate 83, cat. 152
Henri Matisse, *Sarah Stein*, 1916. Oil on canvas, 28½ x 22¼ in. (72.4 x 56.5 cm). San Francisco Museum of Modern Art, Sarah and Michael Stein Memorial Collection, gift of Elise S. Haas

Plate 84, cat. 151
Henri Matisse, *Michael Stein*, 1916. Oil on canvas, 26½ x 19⅞ in. (67.3 x 50.5 cm). San Francisco Museum of Modern Art, Sarah and Michael Stein Memorial Collection, gift of Nathan Cummings

rental properties in town. Sarah's early interests included psychology and art. She drew and painted, particularly portraits of family and friends. Her keen mind is evident in her early letters; in one written to Gertrude, probably in the year the future sisters-in-law met, Sarah relayed having finished reading Theodore Child's *Art and Criticism*, a recently published collection of essays devoted primarily to French art, and indicated that she "enjoyed it and the illustrations immeasurably."[7]

From the beginning of their shared lives, Sarah and Michael surrounded themselves with beautiful things. They counted among their possessions paintings by leading Northern California artists William Keith, known for his luminous landscapes; Arthur Mathews, the tonalist painter and leader of the local Arts and Crafts movement; and Francis McComas, a Mathews follower. (Michael hired Mathews's architect brother Edgar to design rental flats.) The two also owned Japanese prints (for example, pls. 85–87) and other decorative Asian objects that were available through strong Pacific Rim trade at the turn of the century. Michael boasted to Gertrude, who was studying medicine at Johns Hopkins in 1900, of the "wonderful art treasures being brought back from China."[8] A 1901 *San Francisco Chronicle* article on the going "craze for things Japanesque" noted that "Mrs. Michael Stein, a very modest collector, has some of the best bits of pottery in the city, among them a piece of very old and genuine Satsuma unequaled in color and shape,"[9] thus singling out the thirty-year-old Sarah for her discerning eye.

Plate 86

Plate 85

Plate 87

Plate 85
Katsushika Hokusai, *Watermill at Onden*, from the series *Thirty-Six Views of Mt. Fuji*, between 1826 and 1833. Color woodblock print, 9¼ x 12¾ in. (23.5 x 32.4 cm). Stanley Steinberg, San Francisco

Plate 86
Kitagawa Utamaro, *Kayoi* [Komachi], from the series *Fashionable Renditions of the Seven Tales of Ono Komachi*, 1795. Color woodblock print, 14⅜ x 9½ in. (36.5 x 24.1 cm). Stanley Steinberg, San Francisco

Plate 87
Kitagawa Hidemaro, *Two Beauties and an Attendant by the Sea*, ca. 1801–18. Color woodblock print, 14½ x 9½ in. (36.8 x 24.1 cm). Stanley Steinberg, San Francisco

Fed up with business in San Francisco and intrigued by reports of Paris from Leo and Gertrude, who were living together on the Left Bank at 27 rue de Fleurus by the fall of 1903 (Leo had arrived the year prior), Sarah and Michael showed up in Paris in January 1904 with their eight-year-old son and his teenage piano teacher, Theresa Ehrman. They soon settled a few short blocks from Gertrude and Leo, at 58 rue Madame, intending to stay for perhaps a couple of years.[10] Following Leo's lead, they immersed themselves in art—visiting galleries, museums, and the periodic salon exhibitions of art fresh out of the academies and studios.

The experience of the Salon d'Automne of 1905— where Matisse's brightly colored and almost chaotically painted *Woman with a Hat* (1905; pl. 13, cat. 113) was the centerpiece of the succès de scandale that gave the Fauves their name—marked the beginning of a profound relationship between the Steins and Matisse. The Americans had attended the vernissage with sisters Claribel and Etta Cone, friends of Gertrude's and Leo's from Baltimore, as well as Ehrman, who remembered the Steins' quiet admiration for *Woman with a Hat* while "the young painters were just laughing themselves sick about it."[11] With the whole family fascinated by Matisse's most controversial contribution and Leo and Gertrude buying it by the show's end, the Steins were out on a limb—staking a claim for modern art that would be both baffling and powerfully seductive to their peers.

Sometime shortly after the salon concluded, Leo met Matisse though Henri Charles Manguin, whose work he had already collected. Leo, in turn, brought Sarah and Michael to Matisse's studio, where they selected their first work— thought to be a drawing of a nude leaning back on one arm (pl. 146). If Michael and Sarah wished that they had been the ones to take the plunge with *Woman with a Hat*, by spring 1906 they were in deep, having purchased Matisse paintings as radical and confrontational as *Madame Matisse (The Green Line)* (1905; pl. 88, cat. 110), *The Gypsy* (1905–6; pl. 29, cat. 118), and others shown at Galerie Druet from March 19 to April 7 of that year.

The couple would barely have had time to take possession of their new paintings before the San Francisco earthquake and fire of April 18, 1906, prompted them to make immediate plans for a trip home. (Save for a few fallen chimneys, their properties proved to be unscathed.) The Steins set sail for New York on April 28, taking with them three paintings and a drawing by Matisse—the first of his works to be seen in the United States. The American artist-dealer-curator Walter Pach recalled the Steins' transport scenario, including "a burlesque scheme they evolved for avoiding the customs-tax on paintings that was then in force. Mr. Stein was to tell the customs man that Matisse was the greatest painter in the world and that his works were priceless. Mrs. Stein was then to walk quietly around in back of her husband, point to his head, and tap her own forehead," indicating that she considered her husband of less than sound mind.[12] All parties (including the hypothetical customs man) would have been well aware that Matisse's painting, circa 1906, was not going to "look" important to most eyes.

During their stay in San Francisco, the Steins showed off their Matisses to a flurry of friends and art enthusiasts who had caught wind of their astounding cargo. Painter Anne Bremer sent the arts patron Albert Bender to pay a visit. As Sarah summed up the hubbub to Gertrude, back in Paris:

> I have had a pretty hot time with some of the artists.... You see, Mikey sprang the Matisses on one just for fun, and since the startling news that there was such stuff in town has been communicated I have been a very popular lady.... Oh, Albert Bender has been our most[?] faithful & devoted—as always—he runs in to see us every few days—but his devotion hardly stood the test of the "femme au nez vert"—Anne Bremer, (his cousin), insisted upon his seeing it,—she had told him of it, & he had said "if Sarah Stein says it's great—it must be"— & Anne said "But just wait until you see it"—Upon his demand, I assured him that perhaps he'd better spare himself this test, as I knew his belief in my infallibility was something very dear to him. "No," he said, "I shall never, never, never say, as others have, that you are crazy." Well—he saw it—for two minutes he was speechless—then he meekly inquired—"But don't you think you're crazy?"[13]

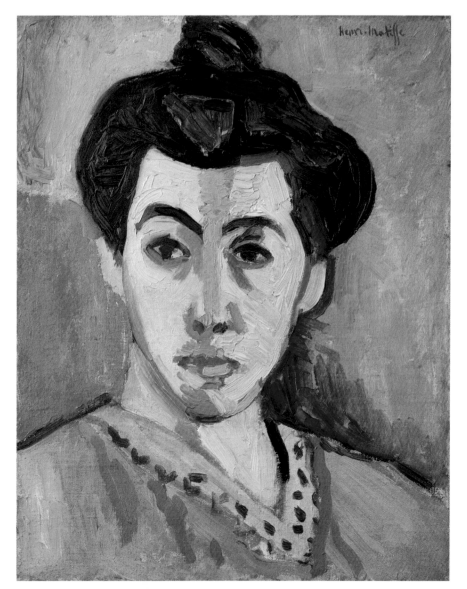

Plate 88

Annette Rosenshine, another Bay Area artist friend, vividly remembered her visit to the Steins with Alice Toklas:

> Mrs. Stein received Alice and me graciously and seemed pleased to introduce us to French art and to show the three paintings she had brought with her…. Our initiation was a portrait painted on a splotchy background. On the right side of the head was a green daub and on the opposite side a splash of crimson and mauve. But the crowning affront was a green streak running from the center of the forehead down the nose, lips and chin. It was grotesque—and to me, conditioned by my training at Mark Hopkins Institute of Art in San Francisco, it seemed a demented caricature of a portrait. Another picture showed a fat distorted little nude who struck me as a gross un-esthetic monster, a far cry from the nude paintings in our life class. The last horror was a small head painted with dots, with spotty bits of the canvas left uncovered by paint.[14]

Rosenshine went on to describe the canvases—*Madame Matisse (The Green Line)*, *Nude before a Screen* (1905; cat. 112), and an unconfirmed third, quite possibly *Woman in a Kimono* (ca. 1906; pl. 90, cat. 135)[15]—as leaving her "speechless and non-plussed," though she was clearly engaged. As remote as Matisse's raw, high-keyed painting was from the Barbizon and Whistlerian art in which Rosenshine had been schooled, she was, as Sarah wrote Gertrude, "a girl who 'saw' the Matisse things at once."[16]

Potent and memorable as those three small canvases proved for those who saw them in San Francisco, the Steins didn't win over any artists or collectors there just yet. Residents of the recently devastated city were focusing their energies on rebuilding rather than revolutionizing; the shift toward modern art came later.[17] When the Steins showed the pieces in New York en route to Paris in November 1906, however, they impressed painter and master framer George Of, who wrote to Leo: "I am grateful to your brother & Mrs. for looking me up in passing through NY for the opportunity of seeing some real painting, which has given me some hope…. I can understand how they are all 'Matisse-stuck' over there. Can poor people buy one? Maybe a very little one for about $25.00 or is he

too swell?"[18] Records from Galerie Druet register the June 21, 1907, sale to "Michael and Sarah Stein pour le compte de George F. Of" of the artist's *Nude in a Wood* (1906; pl. 92), a more fully realized variant of *Nude in a Landscape* (1906; pl. 91, cat. 124), which the Steins had purchased for themselves.[19] The first Matisse painting to take up permanent residence in the United States, *Nude in a Wood* had an active public life in Of's shop, where it was displayed alongside Matisse prints that Sarah also purchased for him.

Sarah and Michael's promotion of Matisse in the United States so soon after meeting him is testament to how invested they were in his work. Letters also make clear how much the couple and the artist meant to each other personally. While his brother and sister-in-law were away, Leo shared news of the situation in San Francisco with a concerned Matisse, and the trip launched a lifelong correspondence between the two families. Matisse even wrote Allan, then ten, sending a postcard with a sketch of his family—himself, Amélie, and three children—with an inscription identifying little Pierre as "le plus méchant," the naughtiest (pl. 89). Allan responded: "Dear Mr. Matisse, A thousand thanks for the kind souvenir of the Matisse family. We were very happy to receive it. I'm having lots of fun here, but haven't forgotten Paris or our good friends there."[20] The Steins were back in France by mid-November 1906, when Sarah wrote to Amélie that she wanted to see her and Marguerite right away (Matisse was apparently out of town) but was "so overwhelmed by the installation of our apartment that for the moment I cannot leave the

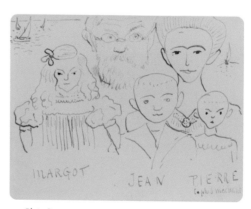

Plate 89

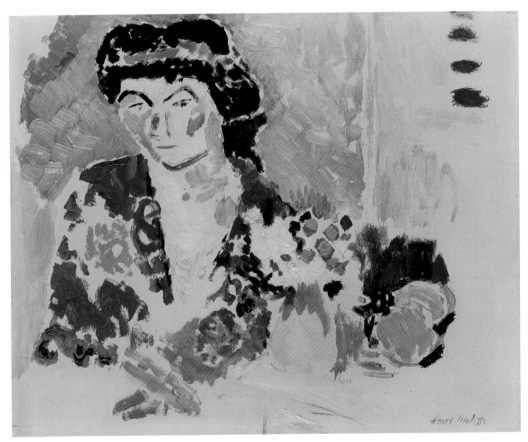

Plate 90

Plate 92

Plate 91

Plate 90, cat. 135
Henri Matisse, *Woman in a Kimono,* ca. 1906. Oil on panel, 12⅜ x 15½ in.
(31.5 x 39.5 cm). Private collection, on loan to The Courtauld Gallery, London

Plate 91, cat. 124
Henri Matisse, *Nude in a Landscape,* 1906. Oil on panel, 15¾ x 12⅝ in. (40 x 32 cm).
V. Madrigal Collection, New York

Plate 92
Henri Matisse, *Nude in a Wood,* 1906. Oil on board mounted on panel, 16 x 12¾ in.
(40.6 x 32.4 cm). Brooklyn Museum, gift of George F. Of

house."[21] Sarah was no doubt eager to have guests to rue Madame.

The couple entered into a period of fervently acquiring works by Matisse, both old and new,[22] while at the same time steering their visitors toward modern art. The Steins' cousin Bird Gans visited in September 1907 and purchased a still life from Druet—*Flowers* (1906; pl. 93)— thus making two Matisse paintings in New York by the end of the year thanks to Sarah and Michael.[23]

From California, Sarah and Michael had brought Annette Rosenshine, who moved into an apartment above them, worked as Gertrude's secretary, and was among the first group of students at the Académie Matisse, the art school that the artist established with the Steins' encouragement and backing in early 1908.[24] Rosenshine made her art purchases carefully: "Influenced by Mike's practicality, I learned not to squander my trifles," she remembered. "With the saved francs I bought three Matisses"—a drawing, a watercolor, and an oil (like Gans's, a 1906 flower picture), purchased for thirty-five dollars.[25] "Another occasion, on quite a different mission, I was to accompany Gertrude and Sarah Stein to Picasso's studio to select one of his drawings in exchange for a Chinese gown of mine which he had admired and wanted to give to Fernande…. Bowing to the superior tastes of the Stein ladies, I let them do the selecting, and merely nodded my head at their choice. Picasso was most generous and gave me two ink drawings and a watercolor entitled *Cocks*."[26]

San Franciscans Harriet Lane Levy and Alice Toklas arrived in the fall of 1907, settling together on the rue Notre Dame des Champs. Toklas made an immediate connection with Gertrude and became her secretary after Rosenshine headed back home the following year. Levy recalls an intense indoctrination into modern art and artists.[27] She had her portrait bust made by Swedish-born sculptor David Edstrom and accompanied the Steins to a party for Henri Rousseau hosted by Picasso, where she recited to the cheers of the raucous guests the "Oski Wow-Wow," a University of California, Berkeley, spirit yell. Like Rosenshine, she spoke of the power of the Steins, particularly Sarah, as tastemakers. Levy's letters from

the period reflect her enthusiasm for that chapter in her life, whereas her corresponding memoirs, dating from much later, reveal fraught relationships with both Sarah and Gertrude.

Levy especially valued the connection with Matisse, with whom she too would long stay in touch, and whom she would host in San Francisco during his one visit to California, in 1930. Levy's most significant acquisition of the artist's work was *The Girl with Green Eyes* (1908; pl. 94), a startlingly frontal view of a woman in a Chinese robe that Michael purchased on her behalf on November 22, 1908. Levy remembered Michael presenting the acquisition "as my opportunity to possess myself of a Matisse before it had been purchased by them," and barely before Sergei Shchukin, the Russian Matisse collector of fast-growing importance, could snap it up.[28] She returned to San Francisco in 1910, joined by her painting early in 1911, after its display in Roger Fry's influential *Manet and the Post-Impressionists* show at London's Grafton Galleries. In February 1911 Levy proudly wrote Toklas that *The Girl with Green Eyes* was "certainly getting sufficient advertisement"—it had just appeared in one of the San Francisco newspapers. She spared Toklas the context and caption: "Matisse paints faces crazed by absinthe drinking."[29] Even Levy's more modest collection additions would continue to provoke, among them a controversial portrait drawing

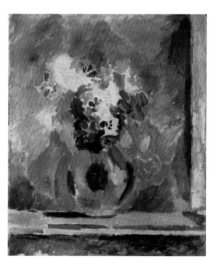

Plate 93

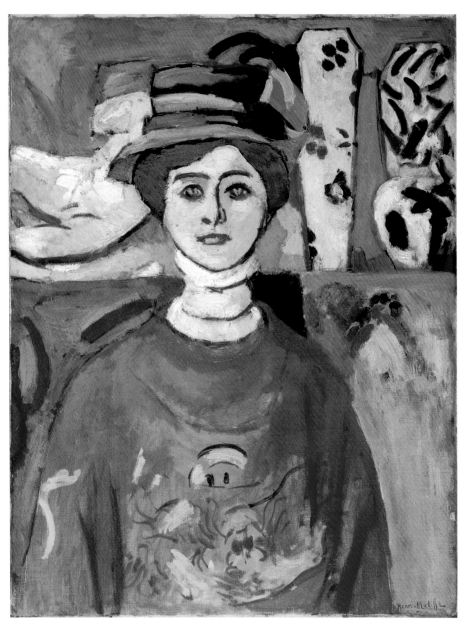

Plate 94

that she brought back from her 1913 Paris trip.[30] Matisse's work would be publicly displayed in San Francisco for the first time in the Panama-Pacific Exposition of 1915 and the Post-Exposition Exhibition of 1916, which would be turning points in the city's appreciation for modern art.

The Steins found especially ready collectors in Claribel and Etta Cone, who had long held their own Saturday night salons in Baltimore and, like the Steins, surrounded themselves, Victorian-style, with an abundance of antiques, curiosities, decorative objects, and artworks. The sisters had traveled with Gertrude and Leo in Europe before any of the Steins settled in Paris. After sharing the experience of the 1905 Salon d'Automne, Etta visited Matisse's studio with Sarah in January 1906, at which point Etta purchased two of the artist's works on paper and two more the following month. The Cone sisters' first Matisse painting was *Yellow Pottery from Provence* (1905; cat. 114), which hung on the walls at rue de Fleurus before it was sent to Baltimore (see pl. 350). As early as 1907, Etta began writing Michael from Baltimore to enlist his help in making purchases both for them and for their Baltimore friends, and by 1911 the sisters were gaining a reputation for their Matisse collection. Baltimore's April 8 *Evening Sun* described a modest Dr. Claribel as being "willing to discuss Matisse, the French artist, leader of the school of independents, at length; she brought out specimens of his work to show us, but she was as wary as one of the germs with which she is so familiar of having the light of publicity thrown upon her."[31]

In addition to welcoming friends and relatives from home, whose travels to Paris often proved transformative, the Steins also hosted many other guests, from blatant curiosity seekers to serious artists and art enthusiasts who were profoundly affected by their experiences.[32] American photographer Edward Steichen, who moved to Paris in the autumn of 1906 and frequented both Stein salons, noted that "Mrs. Michael Stein, a painter herself, bought nothing but Matisses, and her whole apartment was filled with them."[33] Sarah facilitated an introduction of Steichen to Matisse early in 1907—a meeting that would lead directly to the painter's first solo exhibitions in the United States.

Steichen wrote to photographer and New York gallerist Alfred Stieglitz: "I have another crackerjack exhibition for you that is going to be as fine in its way as the Rodins are. Drawing by Henri Matisse the most modern of the moderns—his drawings are the same to him & his painting as Rodin's are to his sculpture. Ask young Of about him.— I'll bring them with me, and we can show them right after mine, if you can arrange it."[34]

Stieglitz would present a succession of three Matisse exhibitions at his 291 Fifth Avenue gallery. The 1908 show, the artist's first solo exhibition outside Paris, consisted of prints, drawings, and watercolors—mostly female nudes— and one painting, probably George Of's landscape, since Steichen had specifically sent Stieglitz his way. The 1910 show again featured works on paper as well as black-and-white photographs of Matisse's paintings, and the 1912 show, his sculpture and drawings.[35] These form-based glimpses of Matisse were derided in the press—the drawings perceived as ugly and the sculpture as abominable—and resulted in a tiny number of sales, most to Stieglitz himself.[36]

Matisse's work was presented in the States in full color and to a massive audience in 1913 as part of the International Exhibition of Modern Art, popularly known as the Armory Show (for its New York venue). The show's organizers—Arthur B. Davies, Walt Kuhn, and Walter Pach— made reconnaissance visits to both Stein households in late 1912. Pach had seen Matisse's work in Paris, including his submissions to the 1905 Salon d'Automne, but it had not yet registered. With more exposure, however, and after meeting the artist through Sarah and Michael in 1907 in Fiesole, Italy, where they all vacationed together, Pach was well on his way to becoming a true compatriot in the cause of Matisse.[37] Of his pre-Armory visit to Sarah and Michael's home, he wrote:

> I remember how, in 1912, when I had left the Steins'
> apartment in the rue Madame with Arthur B. Davies,
> that extraordinary appreciator made a respectful bow
> to them—on the other side of the door. And it was
> an immense service they rendered—not so much to
> Matisse and Picasso—as to the innumerable visitors
> who came to know the work of those artists at the

Saturday-night gatherings in both the Stein households.
If Gertrude and Leo have since gained fame by their
writings, it is to the other side of the family that go
some of the most grateful memories of those days.[38]

By the time of the Armory Show, Pach had surpassed
Stieglitz as Matisse's chief promoter in the United States.

In order to arrange for as strong a representation
as possible, the Armory team borrowed works from
Matisse and his dealer, as well as from the Steins and their
friends. Among some thirteen hundred works by three
hundred artists, the show included thirteen paintings, one
plaster, and a group of eight drawings by Matisse. Sarah
and Michael lent *Red Madras Headdress* (1907; pl. 95, cat. 144)
and *La Coiffure* (1907; pl. 19, cat. 141); Leo and Gertrude,
Blue Nude: Memory of Biskra (1907; pl. 27, cat. 139); George
Of, *Nude in a Wood*; and Bird Gans, *Flowers*.

Not a single Matisse (or Picasso) painting sold in
New York. Yet Pach, undeterred, wrote to Michael Stein
from Chicago, where the next iteration of the show
had just opened: "We are going to put a mark on American
thought that will be simply indelible. We have done it
already." Pach noted the vast audience and mostly inane
but attendance-driving press that the show continued to
generate, and the pride of place that Matisse had been given
in Chicago: "Matisse, I really believe, awakens more inter-
est than any one else in the show and I do not have to
work hard to keep up my hopes of a sale or two from the
splendid long wall he has to himself here, the first thing
you see as you enter."[39] Although Marcel Duchamp's *Nude
Descending a Staircase (No. 2)* (1912) has endured as the most
memorably radical painting of the show, Matisse's *Red
Madras Headdress*, on loan from rue Madame, finished a
close second in receiving scandalized callouts in the press.[40]
Blue Nude: Memory of Biskra, from rue de Fleurus, was
burned in effigy by art students in Chicago. Pach contin-
ued, "Oh how the academic rotters will feel that they are
hit." And indeed a Boston critic wrote of Sarah and
Michael's other canvas making the three-city tour of the
States, "It is impossible to accept such offensive presenta-
tions of the human form divine as those which appear
in *La Coiffeuse* [*La Coiffure*]."[41]

In the spring of 1914 Pach sought Michael's aid in
tracking down Matisse to deliver a request to exhibit his
work at New York's Montross Gallery. Ever optimistic, he
wrote to Matisse via Michael of the importance of the
show, stressing how much things had changed in the United
States since the Armory.[42] Michael was more than sympa-
thetic to Pach's wish to expand Matisse's client base
stateside, as the war in Europe had complicated the potential
for sales to Russian and German collectors, who had pro-
vided a dependable source of income for the artist. Michael
wrote to Pach on October 19, 1914, echoing the potential
benefit of the New York show for Matisse, whose home out-
side Paris, in Issy-les-Moulineaux, was then occupied by
French soldiers:

> Should you get in communication with [Matisse], don't
> fail to impress on him that he must now look to America
> for a market for his art for sometime to come, and he
> might as well send all the things that are at Issy, spec-
> ifically the older & smaller things, black & whites etc.
> etc. and not to put the prices too high, as now is the time
> to have the Americans begin to own Matisse. They have
> read about him, discussed him, seen him in exhibitions
> ad infinitum. It is about time he were ranked among
> the accepted classics & bought freely.[43]

With seventy-four paintings, sculptures, and works
on paper, the Montross exhibition, which opened in
January 1915, amounted to a much larger, if tamer, selection
than had been at the Armory. The critical response was
mixed but more favorable than not, with only two of the ten
reviews dismissing the work entirely,[44] and the show was
an unequivocal popular success. Traffic among buyers had
picked up considerably since the 291 and Armory shows.
Pach may have taken Michael's cue in pricing: prints could
be had for as little as eight dollars and were, according to
Vanity Fair, "simply gobbled up by the general public."[45]
Louise and Walter Arensberg, who had begun collecting in
earnest at the Armory Show, bought a handful of them.
John Quinn bought what he described to Ezra Pound as "two
important Matisses"—*Purple Cyclamen* and *Hat with Roses*,
both of 1914—as well as a large number of works on paper:

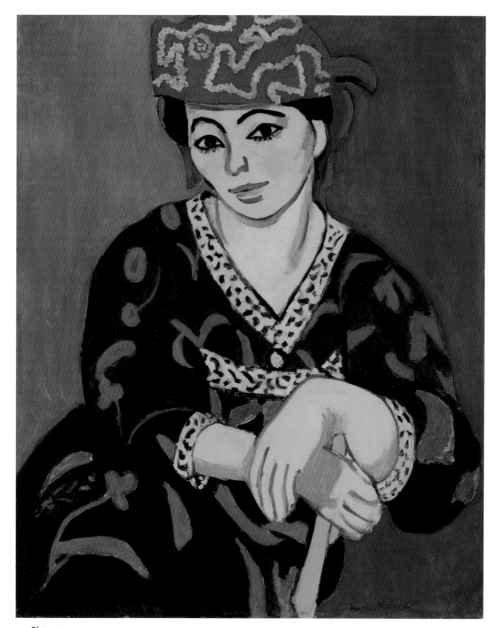

Plate 95

two drawings, two etchings, two woodcuts, and thirteen lithographs, these works marking just the beginning of the Matisse collection that he would develop over the next decade. Pach himself wrote an article concurrent with the presentation in which he shared the artist's perspective on his practice alongside reproductions of two paintings: *The Young Sailor II* (1906; Metropolitan Museum of Art, New York), a variant of Sarah and Michael's *Young Sailor I* (1906; pl. 157, cat. 133), and *Blue Still Life* (1907; cat. 140), from their collection (though not in the Montross show).[46]

At the same time that Michael was facilitating Pach's work with Matisse on the Montross show, he and Sarah lent to an exhibition of the artist's work in Berlin that would mark the great tragedy of their lives as collectors: the staggering loss of nineteen paintings that Matisse and Hans Purrmann had urged them to send in July 1914 to an exhibition at the Kunstsalon Fritz Gurlitt in Berlin. With the outbreak of war, the paintings were at risk of being seized as enemy property, and the Steins felt they had no choice but to sell them. These major works from 1897 to 1909— including their two submissions to the Armory, *Red Madras Headdress* and *La Coiffure*, as well as *The Young Sailor I*, *Blue Still Life*, *Madame Matisse (The Green Line)*, *Pink Onions* (1906–7; pl. 117, cat. 138), and the artist's 1906 self-portrait (pl. 138, cat. 131)—would never be reclaimed.[47]

Matisse made companion portraits—the only such works of his that exist—of Sarah and Michael (pls. 83, 84) in the fall of 1916, while the loans to Berlin were still in limbo. No records exist to confirm how the portraits came about—whether the Steins commissioned them or the artist invited them to sit for him. (Matisse was deeply interested in portraiture, as close to the Steins as to anyone, and without a professional model until late that year.)[48] When Matisse wrote to Pach that the Steins were packed up and poised to return to America in response to the war,[49] he would have been acutely aware that they would be leaving without the core of their collection. For an artist with a great sense of moral rectitude, the portraits may have been made as a gesture of consolation for the Steins' loss—a parting tribute to his loyal supporters and friends.[50]

No matter their genesis, it is clear is that Matisse labored over these two works. A snapshot of Michael's taken during a studio sitting (pl. 96) suggests that the final portrait might have lost something of its potency in its final form, in which facial lines have been smoothed over. A glass-plate negative showing an earlier state of the painting of Sarah (pl. 97) reveals just how much special attention Matisse lent to his image of the woman who loved his paintings as much as he did. In raising her eyes and her forehead, dropping her neckline, abstracting her gown, and encompassing the whole composition in gold, to name just a few of the painterly decisions that the artist made en route to the finished piece, Matisse transformed Sarah from a woman of very human physiognomy into the icon that she was to him.

Sarah and Michael ultimately decided not to flee to America, choosing instead to wait out the war in the French countryside while Allan was on the ground as part of the American army. After the war the couple moved into a home in Passy with their friend Gabrielle Colaço-Osorio, whom Sarah had met through the Christian Science church, and her daughter, Jacqueline. The Steins and Colaço-Osorio would commission Le Corbusier to design and build a new duplex home outside Paris in 1926 (they moved in 1928),[51] and they would share their domestic lives for decades.

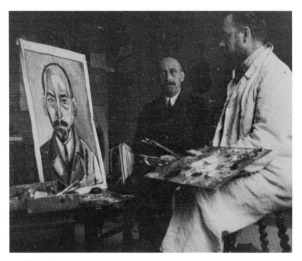

Plate 96

Plate 95, cat. 144
Henri Matisse, *Red Madras Headdress,* **1907.** Oil on canvas, 39⅜ x 31¼ in. (100 x 80.6 cm). The Barnes Foundation, Merion, Pennsylvania

Plate 96
Henri Matisse at work on his portrait of Michael Stein (1916; pl. 84), Paris, 1916. Estate of Daniel M. Stein

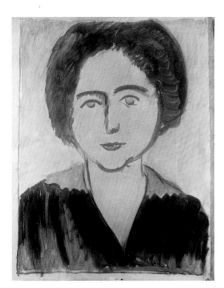

Plate 97

The first significant additions to the Steins' second, post-Gurlitt collection were their own portraits, and the piece that had launched their journey with Matisse nearly a decade earlier, *Woman with a Hat*, purchased from Gertrude in 1915. They continued to buy modestly from time to time, and Matisse is known to have made gifts of his prints and books to the Steins. Major acquisitions included the dramatic, sun-soaked *Bay of Nice* (1918; pl. 98, cat. 153) and the panoramic Issy garden scene, *Tea* (1919; pl. 99, cat. 155). But many more of Sarah and Michael's transactions involved obtaining works of art for the Cone sisters, whose spike in fortune in the 1920s left them undaunted by the concurrent jump in Matisse's prices.

Michael's letters to Etta throughout the 1920s confirm news of art (and furniture) purchases, his tracking of their accounts, and transport arrangements—seven cases slated for a steamer to Baltimore in 1922, a Louis XVI table joining the art in 1923, five cases in 1925, six in 1926.[52] Some two dozen of the works by various artists retained by Gertrude after her split with Leo in 1914 were sold directly to the Cones as the writer's priorities shifted toward financing her publications. Michael often served as trusted intermediary between his sister and the Cones, discussing with Gertrude the works of art from her collection that they could make available to their wealthier friends.[53] When it came to

Matisse's works, the sisters generally tended toward more conservative examples than had the Steins (excepting, most notably, *Blue Nude: Memory of Biskra,* formerly of Leo and Gertrude's collection, which the Cones bought at the John Quinn estate sale in Paris on October 28, 1926, and which Michael arranged for Matisse to sign for them).[54] The Cones would go on to amass some sixty Matisse paintings and sculptures and a great number of works on paper, all the while crediting the Steins for awakening them to such pleasures.[55]

* * *

Most accounts of Sarah and Michael's role in the story of Matisse and his reception trail off with the couple's 1935 return to California, if not significantly earlier.[56] Yet on the West Coast, the Steins' homecoming with their magnificent cargo was news and offered unprecedented opportunities to experience Matisse's work, both publicly and at their rambling new quarters in Palo Alto. Matisse had passed through San Francisco en route to Tahiti in March 1930, spending four days touring the California School of Fine Arts, visiting artists' studios, and being whisked around by Harriet Levy. And Gertrude had made stops in the Bay Area during her nine-month American lecture tour in 1934. According to the *Oakland Tribune,* Sarah and Michael were finally persuaded to return to California after Gertrude reported to them from Oakland: "I like it here. Don't tell me I don't like it here"— at which point Sarah and Michael "sold their home in Paris, rendezvous of many famous artists, including Matisse," and headed home.[57]

Grace McCann Morley, director of the newly opened San Francisco Museum of Art (now SFMOMA), didn't miss a beat in seeking an introduction to the Steins. She wrote to Albert Bender: "I have heard that Mr. and Mrs. Michael Stein have returned to California to live, bringing with them a remarkably fine collection of paintings by contemporary artists, principally French artists, no doubt."[58] The Steins had yet to settle in at 433 Kingsley Avenue in Palo Alto (with Allan's son Daniel, along with Colaço-Osorio and her daughter, in tow) before Morley planned Matisse's first solo museum exhibition on the West Coast. "Our paintings have

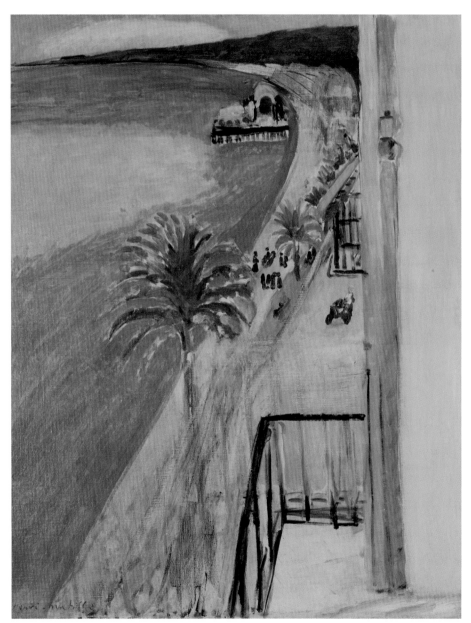

Plate 98

Plate 99, cat. 155
Henri Matisse, *Tea,* **1919.** Oil on canvas, 55¼ x 83¼ in.
(140.3 x 211.3 cm). Los Angeles County Museum of Art, bequest
of David L. Loew in memory of his father, Marcus Loew

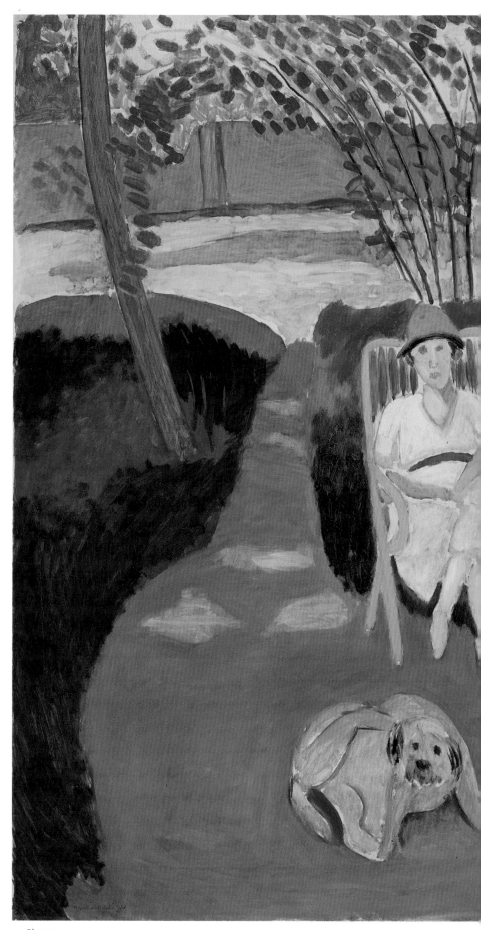

Plate 99

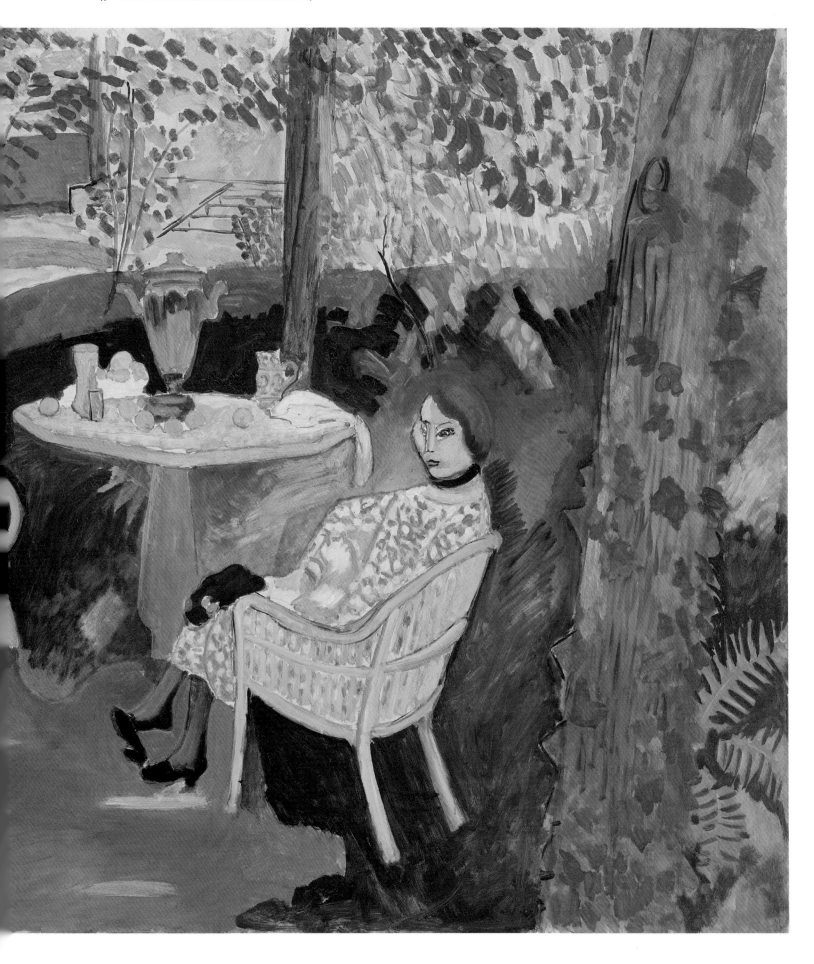

been hung for two weeks now and we were finally feeling at home," wrote Sarah to Matisse on January 7, 1936, "when today a large part of them (eleven canvases) are leaving for an exhibition of your work in San Francisco. The house will be a bit sad but the exhibition will be superb."[59] Within the same season, four paintings went to the English Club at the University of California, Berkeley, and two were sent to the Museum of Modern Art in New York. When *Girl Reading* (ca. 1925; pl. 170, cat. 156) went to the Mills College Art Gallery in Oakland in 1937, along with eleven other Matisses from their holdings, Sarah joked that "she was sure [Alfred] Neumeyer [the director] there had slept with it in his bed to keep it safe."[60] She hardly exaggerated in reporting to Matisse that "our paintings are traveling," though she and Michael remained skittish about sending them far, especially back to Europe. In any case, as Sarah explained to the artist, "the best propaganda we can make for modern art is to show your paintings in America."[61]

This final California chapter lasted just three years for Michael. He died in September 1938, remembered by Leo in a condolence letter to Sarah for how responsible he was, and for "all the excitements in Paris…when we were helping to create a new epoch."[62] Until the late 1940s, when her own deteriorating health precluded entertaining, Sarah continued to host a steady stream of culturally engaged guests—university professors, museum people, artists, writers, and the like—reviving something of the salon culture that she had fostered on rue Madame, but on Thursdays instead of Saturdays. Stanley Steinberg, one of the Stanford students she befriended, remembers seeing Morley and Barr, Italian art writer Lionello Venturi (who taught at Berkeley during the war), and local artists William Gaw and Daniel Mendelowitz.[63] Mendelowitz, the head of Stanford's art department, in turn arranged tea with Sarah for his student Richard Diebenkorn, who recalled seeing *Woman with a Hat*, *Bay of Nice*, and *Tea*, and whose work from the mid-1950s forward resonates with his connection to Matisse.[64] Robert Motherwell, also studying at Stanford, was invited to tag along with his tennis partner to a cocktail party, as he recounted: "'I heard you are interested in pictures,' he said. 'Well these people have some pictures.'

I said, 'In that case, I'll come,' because in San Francisco in those days there were no pictures at all. Behold it turned out to be the Michael Stein collection. I saw Matisses and they went through me like an arrow and from that moment, I knew exactly what I wanted to do."[65]

Guests at the home recognized the privilege of seeing the collection in the company of the woman who had been in the right place at the right time and had chosen an extraordinary talent to champion. Her continued passion for Matisse galvanized local collectors. Sarah's lawyer Tevis Jacobs recalled that "Sarah must have said the right things," and he went on to develop his own collection and helped found Berkeley's University Art Museum.[66] Elise S. Haas, like Sarah a sometime artist herself, became one of the regular guests with whom Sarah shared Matisse's letters.[67] They also discussed eventual plans for the collection, which Sarah hoped to keep intact and donate to a local public institution. Haas would play a key role in the fate of the Matisses when Sarah began selling art to support the addiction that her *enfant terrible* grandson Daniel, now grown, had to raising and racing horses. Sarah was known to be inordinately generous, often sending friends home with gifts of photographs, brochures, her own artworks, or sometimes even Matisse's, and inscribing them with appreciative notes. But to friends who knew her in her later years, her enabling of her grandson's habits represented a blind spot in her judgment. When, in the late 1940s, Haas caught wind of representatives from the retailer Gump's visiting Kingsley Avenue, followed by a Los Angeles dealer scooping up a group of bronzes at fire-sale prices, she offered to place works locally, acquiring *Woman with a Hat*, a sketch for *Le Bonheur de vivre* (1905–6; pl. 142, cat. 116), and other pieces with her husband, Walter, and using her network of friends and family to acquire yet more. Relative to what she had once dreamed of, the direct gifts that Sarah made to institutions were modest: a dozen Matisse prints and his *Jazz* portfolio (1947) to Stanford, six prints to Mills, and two to the San Francisco Museum of Art. Another friend, the Stanford dean of humanities John Dodds, worked with Sarah on a lasting gift to Matisse scholarship: the sharing of her notes (pls. 296–342) from the

artist's academy with Barr, who published them in *Matisse: His Art and His Public.*[68]

Shortly before Sarah died in September 1953, Haas made a pilgrimage to Vence, in the south of France, to meet Matisse, who himself would die soon thereafter, in November 1954. The artist sent Haas home with an illustrated book bearing the inscription: "A Madame Sarah Stein, qui m'a si souvent soutenu dans mes faiblesses." (To Madame Sarah Stein, who so often aided me through my weaknesses.)[69] One could hardly overstate the depth of the connection between Matisse and Sarah.

For nearly half a century—from Michael and Sarah's early days on rue Madame, through World War I, their move outside Paris, and their eventual return to what Matisse called "your splendid California"—the relationship between Matisse and the Steins was fundamental to who each of them was. The artist was the first to acknowledge the couple's impact on him, his work, and its reception. Sarah, married into a family of brilliant minds and self-mythologizers, was the one who stood out to Matisse as "the really intelligently sensitive member of the family"—a patron in every sense of the word.[70]

Plate 100

Notes

1. Henri Matisse to Sarah Stein, draft, August 5, 1935, Archives Matisse, Paris (hereafter, AMP; translation of Archives Matisse letters by Carrie Pilto and the author).

2. Sarah Stein to Henri Matisse, July 6, 1935, AMP.

3. Matisse to S. Stein, draft, August 5, 1935, AMP.

4. In addition to Barr 1951, research in this field is especially indebted to the work of John Cauman. See, in particular, his dissertation (Cauman 2000a).

5. Claude Duthuit to the lenders to the exhibition *Matisse: Radical Invention*, Art Institute of Chicago, March 18, 2010.

6. Sarah Stein to Gertrude Stein, [1893?], Yale Collection of American Literature, Beinecke Rare Book and Manuscript Library, Yale University (hereafter, Beinecke YCAL), MSS 76, box 126, folder 2730.

7. Sarah Stein to Gertrude Stein, October 11 [1893?], Beinecke YCAL, MSS 76, box 126, folder 2730. The reference is to Child 1892. The book, incidentally, is dedicated "To the cultivated women of North America …in grateful recognition of their unfailing sympathy."

8. Michael Stein to Gertrude Stein, December 21, 1900, Beinecke YCAL, MSS 76, box 126, folder 2731.

9. Anon., April 28, 1901, 30.

10. Haas 1972, 100–101, notes their planned length of stay.

11. Jelenko ca. 1965.

12. Pach 1956, 38.

13. Sarah Stein to Gertrude Stein, October 8, 1906, Beinecke YCAL, MSS 76, box 126, folder 2732. Bender would go on to include Matisse in his own collection, which focused primarily on new art from California and Mexico, and West Coast photography. Bender gave two Matisse lithographs to Mills College in Oakland in 1926.

14. Rosenshine n.d., 61–62.

15. In his 1951 account of the first works in the United States, Barr speaks of *Nude before a Screen* and a drawing of a woman leaning on her elbow, which is consistent with Sarah's late-in-life recollections as communicated by Stanford professor Jeffrey Smith to Philadelphia Museum of Art director Fiske Kimball, February 8, 1948, Philadelphia Museum of Art Archives (hereafter, PMA Kimball Papers). Sarah's October 8, 1906, letter to Gertrude and Rosenshine's recollection clearly point to *Madame Matisse (The Green Line)* as another. The third piece Rosenshine described is unconfirmed. *Red Madras Headdress* (1907; pl. 95, cat. 144) has been posited by more than one scholar as a possibility. Per recent provenance work at the Barnes

by Kate Butler and Claudine Grammont, it was first purchased by Oskar and Greta Moll and never owned by the Steins (though it could have been borrowed for the journey). Stein-owned works from the period that most closely match the description are the small *Marguerite Reading* (1906; pl. 152, cat. 123) and *Woman in a Kimono*, the latter much more distinct for its areas of bare canvas.

16. Sarah Stein to Gertrude Stein, October 8, 1906, Beinecke YCAL, MSS 76, box 126, folder 2732.

17. N. Boas 1988, 22. In a letter to Sarah from San Francisco in 1907, Etta Cone noted the American public's lack of art knowledge, joking that if she were ever low on funds, "by saying a few things that sounded like 'art talk' [I] might replenish empty coffers." Etta Cone to Sarah Stein, 1907, Beinecke YCAL, MSS 76, box 102, folder 1981.

18. George Of to Leo Stein, November 25, 1906, Beinecke YCAL, MSS 76, box 117, folder 2516.

19. Flam 2005, 40.

20. Allan Stein to Matisse, n.d. [after receipt of July 4, 1906, postcard], AMP.

21. Sarah Stein to Amélie Matisse, n.d. [shortly after Sarah and Michael's return to Paris, ca. November 17, 1906], AMP. Sarah Stein to Gertrude Stein, October 8, 1906: "We have decided to sail on the Ryndam[?] on November 7th & this will bring us to Paris on the 17th—or thereabouts." Beinecke YCAL, MSS 76, box 126, folder 2732.

22. See Rebecca Rabinow in this volume.

23. Druet records indicate that *Flowers* (1906) was sold on September 13, 1907. "At last I have received the Matisse," wrote Bird [Mrs. Howard] Gans from New York to Michael Stein on November 7, 1907. "I hear Mr. Off [sic] has his on exhibition and I am going down to see it. Perhaps he may want to exhibit mine too." Beinecke YCAL, MSS, box 107, folder 2140.

24. See Claudine Grammont in this volume.

25. Rosenshine n.d. Rosenshine's Matisse drawing and painting were eventually sold to Levy and bequeathed to SFMOMA, acc. nos. 50.6090 and 50.6084, respectively.

26. Rosenshine n.d. Rosenshine's three Picasso works on paper were also sold to Levy and left to SFMOMA: acc. nos. 50.6098, D.50.6100, and 50.6103.

27. Levy n.d.

28. In her "Recollections" (Levy n.d., 33), Levy describes her exchange with Shchukin, he claiming that *The Girl with the Green Eyes* would make the perfect addition to the thirteen Matisse paintings he

already owned, and her standing her ground in refusing to relinquish her first.

29. Harriet Levy to Alice Toklas, February 11, 1911, Beinecke YCAL, MSS 76, box 114, folder 2369. The article Levy refers to is "Do Deadly Diseases Inspire Art's Masterpieces?" (Anon., February 5, 1911).

30. Of this drawing (SFMOMA acc. no. 50.6087), Levy wrote: "Everybody is muchly interested in it, finding it young, immature, depressing, serene, perturbed, calm, resembling, unresembling, pathetic, lovely, penetrating, lived, etc., etc., according to the taste and fancy of the onlooker. Anne Bremer passed through rapid stages of surprise, reproach—interest and passionate wonder." Harriet Levy probably to Alice Toklas [quoted sheet is separated from beginning of letter; most Levy letters in this file are to Alice and this letter references Gertrude, so was not addressed to her], [dated "1910?" (probably 1913)], Beinecke YCAL, MSS 76, box 114, folder 2369. The sour expression on Levy's face recorded by Matisse may have had to do with his reluctance to make her portrait until she offered him an unprecedented $100. Albert S. Bennett e-mail message to Carrie Pilto, November 15, 2010.

31. Anon., April 8, 1911.

32. "No American visitor to this city thought his visit complete unless he had mixed with the decidedly mixed crowd of long-haired 'nuts' who gathered in rapturous throngs before the Matisse puzzles in paint," wrote the author of "Have the Steins Deserted the 'Genius' Whom They Discovered?" (Anon., August 23, 1914). On the Stein salons at 27 rue de Fleurus and 58 rue Madame, see Emily Braun in this volume.

33. Steichen 1963, chap. 4, unpaged.

34. Image of first page and transcription appear in Barr 1951, 112–13.

35. For a detailed history of these three exhibitions and their reception, see Cauman 2000b.

36. John Quinn, who would go on to be an important Matisse collector, was one buyer. The most positive critical voice for Matisse during this period was Leo's friend Bernard Berenson (see Gary Tinterow in this volume), who, after meeting the artist through Sarah, became for a short time his chief public defender. See Berenson 1908, 461; reprinted in full in Barr 1951, 114, in which the author stakes a claim for Matisse as one of the great masters of the last sixty centuries. The piece circulated among the Steins' peers. An unidentified "F.G." wrote to Rosenshine: "This week's 'Nation' has a short appreciation of Matisse drawings now on exhibition in New York. I thought you might wish to see what the art critic of the 'most authoritative journal in the English language' has to say of them & so I'm forwarding you my copy….—But may I ask

you to mail it back after you've read it? —I'd like then to send it on to Miss Bremer." Rosenshine added a note to the top of the letter that "every other mail brings me something like this." "F.G." to Annette Rosenshine, n.d., Beinecke YCAL, MSS 76, box 135, folder 2993.

37. Walter Pach to Henri Matisse, AMP. Pach fondly remembers the introduction via the Steins to Matisse in at least three of his letters to the artist: March 30, 1916; March 24, 1946; and May 3, 1951.

38. Pach 1938, 118.

39. Walter Pach to Michael Stein, March 30, 1913, Beinecke YCAL, MSS 76, box 118, folder 2529.

40. Per Cauman 2000a, 193, the collected press clippings featuring *Red Madras Headdress* appear in Press Scrapbook, vol. 1, Walt Kuhn Papers, Archives of American Art, Smithsonian Institution, Washington, D.C. (hereafter, Archives of American Art).

41. William Howe Downes in the *Boston Transcript*, as quoted by Brown 1963, 136.

42. Walter Pach to Matisse, April 27, 1914, AMP: "I have at present a subject that is so important to discuss that I prefer to send the letter via Mr. Stein, who will certainly know how to get in contact with you." The letter cited in note 43 below mentions the occupation of Issy.

43. Michael Stein to Walter Pach, October 19, 1914, Walter Pach Papers, Archives of American Art Series 2: Professional Correspondence.

44. Cauman 2000a, 262, summarizes the ten reviews (nine in daily papers, one in *American Art News*) of Matisse's Montross show as two negative, five mixed, and three positive.

45. Gregg 1915, 31.

46. Pach 1915.

47. See Claudine Grammont in this volume.

48. Wanda de Guébriant suggests this possibility. Conversation with the author, July 8, 2010.

49. Matisse to Walter Pach, November 6, 1916, Walter Pach Papers, Archives of American Art. The Steins had gone so far as to give notice on their apartment: "I have given congé for my apartment for January 1917." Michael Stein to Gertrude Stein, August 6, 1916, Beinecke YCAL, MSS 76, box 125, folder 2719.

50. The insight into Matisse's character is John Elderfield's. Conversation with the author, August 23, 2010.

51. See Carrie Pilto in this volume.

52. Michael Stein to Etta Cone, November 19, 1922; December 17, 1923; October 24, 1925; December 8, 1926, Dr. Claribel and Miss Etta Cone Papers, Archives and Manuscripts Collections, The Baltimore Museum of Art (hereafter, BMA Cone Papers).

53. For a detailed summary of these transactions, see B. Richardson 1985, especially 82–85.

54. Michael Stein to Etta Cone, December 8, 1926, BMA Cone Papers.

55. In an early letter to Michael, for example, Etta referred to "the real inspiration & interest in things that without you, I should never have been able to regard more than superficially." Etta Cone to Michael Stein, June 15, 1908, Beinecke YCAL, MSS 76, box 102, folder 1981. Owing to the number of works sold by the Steins to the Cones and the sisters' bequests of their respective collections to the Baltimore Museum of Art, that museum is one of the most important repositories of works formerly in the Stein collections.

56. Among significant texts, Golson 1970 devotes one paragraph to the Steins' Palo Alto years; Cauman's dissertation (Cauman 2000a), and thus his treatment of our protagonists, ends in 1933; and Barr 1951 mentions the Steins post-1935 only with regard to the dispersal of their collection. Contemporaneous articles by Philadelphia Museum of Art director Fiske Kimball (1948a and 1948b) offer the most detailed accounts of Sarah at home in Palo Alto.

57. Anon., July 28, 1935.

58. Grace McCann Morley to Albert Bender, September 17, 1935, SFMOMA Archives, *Paintings, Drawings, and Sculpture by Henri Matisse*, January 11–February 24, 1936, Exhibition Records.

59. Sarah Stein to Henri Matisse, January 7, 1936, AMP.

60. Fiske Kimball to R. Sturgis Ingersoll, February 25, 1947, PMA Kimball Papers.

61. Sarah Stein to Henri Matisse, May 26, 1937, AMP; Sarah was explaining her reasons for not lending *Woman with a Hat* to an exhibition of his work that year at the Petit Palais.

62. Leo Stein to Sarah Stein, September 9, 1938, Estate of Daniel M. Stein.

63. Steinberg 2010, 24.

64. Nordland 1978, 12, and Gerald Nordland, conversation with the author, March 18, 2009.

65. Motherwell delighted in this story and told it many times. The quoted version comes from Enright 1989, courtesy Tim Clifford of the Dedalus Foundation.

66. Morch 1971.

67. Haas 1972. Sarah corresponded with both Henri and Amélie Matisse until the late 1940s. Her letters to them, as well as drafts of letters from Matisse to Sarah, are preserved at the Archives Matisse, Paris. Aside from a few leaves in the estate of Daniel M. Stein, very little of Matisse's sent correspondence to her has survived, though we know that he wrote her regularly, as her letters reference his, and in addition to Haas, friends Stanley Steinberg, Maurice Galanté, Donald Biggs, and Fiske Kimball also recall the pleasure she took in reading letters from "Maître" aloud. Annette Rosenshine recounts being "shocked when she told me that she destroyed his letters, fearing in her provincialism that her relations with Matisse might be misconstrued" (Rosenshine n.d., 97).

68. Dodds sent a transcription of the notes to Barr on July 30, 1950. Alfred H. Barr, Jr. Papers, Museum of Modern Art, New York. See Bishop and Pilto in this volume.

69. Haas 1972, 107. When Sarah died in 1953, Elise Haas ensured that the portraits of Sarah and Michael would be preserved at the San Francisco Museum of Art and did what Sarah could not by leaving her own collection to a museum. Haas's 1990 bequest to the San Francisco Museum of Modern Art, as it was known by then, included one Picasso and eight Matisses once owned by Sarah and Michael; another Matisse, the painted portrait of Sarah, was given in 1954.

70. Braque et al. 1935, 3.

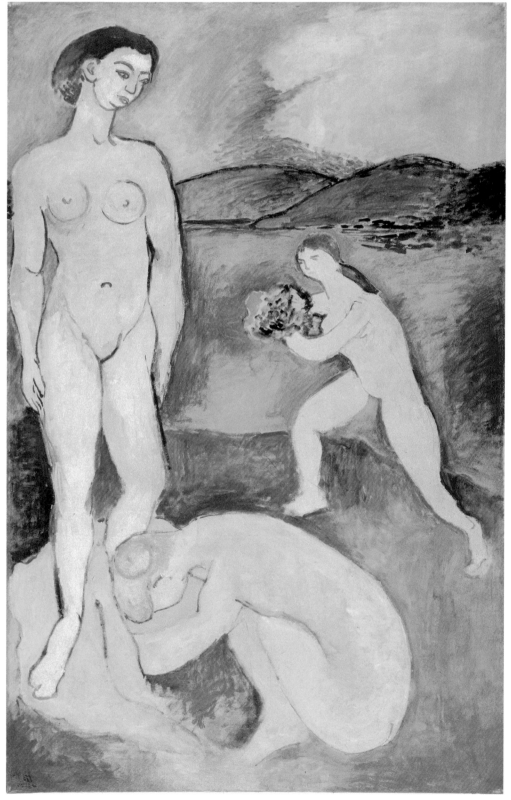

Plate 101

Matisse as Religion: The "Mike Steins" and Matisse, 1908–1918
Claudine Grammont

The art collections assembled by the Stein family were among the first to be informed by a current of Anglo-Saxon aesthetic thought that emerged around 1905. Psychological aesthetics—which gave rise to the formalism of Bernard Berenson, Roger Fry, and Clive Bell, among others—considered the work of art in its formal reality no longer as an object of contemplation, but rather as the framework of an experience: "We have ceased to ask 'What does this picture represent?' and ask instead, 'What does it make us feel?'" wrote Bell.[1] The Steins became part of this community of ideas through their studies (Gertrude and Leo Stein were William James's students at Harvard); their interests, which were very much focused on psychological analysis; their reading, which included the most recent publications in the field; and their intellectual milieu, which was close to this sphere of thought or even directly in contact with it.[2] As a result, they conceived and developed their collections as a psychological vector. For them, collecting went far beyond the activity of acquiring works of art and became an endeavor that was directly linked to the construction of their personal and family identities.

Leo Stein's collection provided a basis for his formulation of a method for the formal analysis of artworks, which would be given concrete expression later on in *The A-B-C of Aesthetics* (1927).[3] It was in the context of the work of Paul Cézanne, Henri Matisse, and Pablo Picasso that Gertrude would develop her literary style, writing *Three Lives, The Making of Americans*, and her first word portraits between 1905 and 1911. (The earliest word portraits to be published

were those devoted to Matisse and Picasso, in Alfred Stieglitz's *Camera Work* in 1912.) In the case of Sarah Stein, her enthusiasm for Matisse was a near-religion, one aspect of a spiritual quest that would culminate in her joining the Christian Science church in Paris around 1909. As of 1907 Sarah and her husband, Michael Stein, were buying works by Matisse almost exclusively.[4] In the fall of that year, the American couple purchased the most important pieces from the artist's summer production—major paintings including *The Young Sailor I* (1906; pl. 157, cat. 133), *Pink Onions* (1906–7; pl. 117, cat. 138), *La Coiffure* (1907; pl. 19, cat. 141), *Red Madras Headdress* (1907; pl. 95, cat. 144), *Le Luxe I* (1907; pl. 101, cat. 142), and *View of Collioure* (1907; pl. 158, cat. 145). These were followed, in all probability, by the purchase of *Blue Still Life* (1907; cat. 140) in the winter of 1907–8.[5] With the exception of *Pink Onions*, most were large canvases, thus complementing the dozen or so small and medium-size Matisses that were in their possession at the end of 1906.[6] Four more Matisse paintings would be added in 1909, including two older canvases, *Pot of Flowers* (ca. 1901; cat. 103) and *Woman with Black Hair* (ca. 1900; cat. 99). After that they would buy considerably fewer works from Matisse, with the exception of the major canvas *Interior with Aubergines* (1911; pl. 162, cat. 149) in late 1911, which Matisse himself bought back in November 1917.[7] One reason that they bought less was simply a lack of space in which to hang art at rue Madame (see pls. 362–74).[8] Subsequently the price Matisse could command for a picture increased dramatically and was no longer negotiable: the Bernheim-Jeune contract signed in September 1909 set fixed prices, and demand from the Russians and Germans who would become his next wave of collectors did not make things any easier for the Steins.

Plate 101, cat. 142

Henri Matisse, *Le Luxe I,* 1907. Oil on canvas, 82⅝ x 54⅜ in. (209.9 x 138.1 cm). Musée National d'Art Moderne, Centre Georges Pompidou, Paris

At rue Madame, Matisse's paintings covered the walls, accompanied by a few ceramics.[9] Prominently displayed in the space, too, was *The Serf* (1900-1903; pl. 58, cat. 198), acquired in 1908 (Matisse apparently cast it in bronze especially for them),[10] as well as *Reclining Nude I (Aurora)* (1907; pl. 150, cat. 204). The apartment was "medieval-like,"[11] located on the third floor of a former Protestant church that had been furnished with Italian Renaissance furniture,[12] and was decorated with a number of artifacts, most of them Chinese, and Persian carpets.[13] Sarah and Michael received visitors on Saturday evenings, and Sarah would explain Matisse to their guests. It was a ritual of sorts. Stretched out on her sofa, she enthusiastically proclaimed him a great artist, with such conviction that some of the guests would leave utterly hypnotized or, in any case, as converts.[14] Harriet Lane Levy, for example, spoke of having a revelation of "universal love" through Matisse's paintings during an evening at the Steins'.[15]

The physical presence of Matisse's paintings, their capacity to exude a force that was soothing and joyful at the same time, counted for a great deal.[16] Matisse attributed therapeutic virtues to his art, and Sarah shared this belief, in parallel with her faith in Christian Science, a church espousing the curative virtues of prayer. The Steins were drawn to the materiality of a painting, in particular the subjective power of its presence, and this must have intrigued Matisse and helped him to develop his pictorial conception of the decorative by 1907-8, as set forth for the first time in his "Notes d'un peintre" (Notes of a Painter), published in *La grande revue* in December 1908.[17]

Matisse's decorative orientation was also founded on his discovery of Asian and Byzantine art.[18] The Steins, as it happens, were connoisseurs and collectors of the art of China and Japan, and their tastes and aesthetic interests were formed according to the standards of Asian art. According to Matisse, it was actually their knowledge of Chinese art that brought them to his painting: "Michel Stein was interested in Chinese cloisonné. He had noticed my canvases for the purity of color deployed in spots, and their rich texture; he liked them first and foremost as objects."[19] Inez Haynes Irwin told the story of how Sarah,

when commenting on Matisse's paintings, would hang pieces of Chinese and Persian fabric next to them; Walter Pach, meanwhile, related that he did not understand how she could see a connection between Matisse's use of color and that of Byzantine enamels.[20]

The importance granted to objects and their evocative power—an abiding feature of Matisse's aesthetic approach—would be confirmed in the major still lifes painted between 1906 and 1910.[21] Here color is associated with the presence of one object or another, each of them acquiring an emphasis or a particular meaning, as in the red of the pieces of Catalan cloth in *The Red Carpet* (1906; Musée de Grenoble) or the blue toile de Jouy fabric in *Blue Still Life*. Similarly, in *The Red Studio* of 1911 (Museum of Modern Art, New York), Matisse set a piece of Persian, or more likely Ottoman, cloth at the center of his composition, right next to his own paintings and sculptures, as if the better to affirm, as Sarah had done, how very close they were indeed.[22] This attention to the object and its resonance goes some way toward explaining the presence of the Japanese cloisonné pot (pl. 102) from Sarah and Michael's collection in *Still Life with Geraniums* from 1910 (pl. 103), which may well be a discreet nod on the part of Matisse to the Steins' taste.[23]

During the years preceding the war, the Matisses were devoted friends of Sarah and Michael. They saw one another regularly in Paris, then in Issy-les-Moulineaux, as well as during the summer of 1909 while the two families were staying on the coast in the Var. Matisse, who was often prey to self-doubt, took Sarah's opinion of his work quite seriously. He regularly brought his latest production to rue Madame or invited her to come and see it in Issy. Theresa Ehrman recalled: "She was the one who fascinated him with her sense of appreciation of values among all who came to see his paintings.... Sarah would tell him what she thought of things, sometimes rather bluntly. He'd seem to always listen and always argue about it, and I must say, I was sometimes quite bored because the conversations were very lengthy and very philosophical and sort of beyond me."[24] Matisse placed so much importance on Sarah's judgment that he used her as a reference with the Russian collector Sergei Shchukin.[25] In a letter to Matisse

Plate 102

Plate 103

from October 1911, Sarah, who went to Issy while the artist was in Russia, gave a long critique of *The Pink Studio* (1911; Pushkin Museum, Moscow) and *The Painter's Family* (1911; State Hermitage Museum, Saint Petersburg). Her analysis is formulated in precise terms that also provide some insight into the tenor of the theoretical debate underlying Matisse's research into decorative aesthetics. About *The Painter's Family*, she wrote: "As for the family portrait, this one did not convince me. I had to think too much to like it a little. For me, there are contradictions in the treatment—which take away from its sincerity of expression; it's neither family portrait nor pure decoration. The profusion and dominance of the ornamentation undermine its status as portrait, while a certain intensity in some of the figures undermines its status as decoration—but I see by your letter that we'll speak of all this."[26]

The Académie Matisse, January 1908 – Spring 1910

The year 1908 was pivotal in Matisse's career, particularly for his reputation as the leading light among modernist painters. It was precisely his status as a painter-theoretician that Sarah and Michael helped promote through the Académie Matisse, the art school Matisse opened in January of that year.[27] The prior December he had published his artistic credo, "Notes d'un peintre." By then the artist's reputation had already spread worldwide, thanks in large part to the circulation of his works via exhibitions organized throughout Europe and largely supported by Matisse's first art dealers, Druet and Bernheim-Jeune.[28] The Steins, as Americans and collectors of Matisse's work, had contributed from their very first purchases to the establishment of his reputation, and they were soon followed by two major Russian patrons of the arts, Shchukin and Ivan Morosov, and German collectors such as Karl Ernst Osthaus, Kurt Glaser, and Hugo von Tschudi.

From the moment Matisse began to exhibit regularly in the major Parisian salons, he had attributed a great deal of importance to the grooming of his public image. The scandal of *Woman with a Hat* (1905; pl. 13, cat. 113) at the 1905 Salon d'Automne had positioned him as the leader of the group referred to as the Fauves, and critics constantly mocked him for going to extremes and for his pictorial incoherence. By 1907-8 Matisse found it necessary to make his artistic beliefs known in order to shake off the label of charlatan-painter, which certain conservative critics persisted in applying to him, and to differentiate himself from the many artists who had begun to emulate him. Matisse, in spite of himself, seemed to be the precursor of a school, attracting more and more followers, particularly among a young generation of European artists who saw reflected in him their hopes of artistic renewal through color.[29] For an artist who carefully managed his own career, this could quite naturally turn out to be unfavorable. His involvement in the Académie Matisse grew in part out of his desire to avoid the appearance of clones at any cost and to refute any presuppositions of artistic extravagance. The time had come to take control of his public image, and to firmly establish his status as "Maître."[30]

Plate 102
Cloisonné pot, once in the collection of Sarah and Michael Stein, depicted in Henri Matisse's *Still Life with Geraniums* (1910; pl. 103). Mildred Gaw, San Francisco

Plate 103
Henri Matisse, *Still Life with Geraniums*, 1910. Oil on canvas, 36⅝ x 45¼ in. (93 x 115 cm). Pinakothek der Moderne, Bayerische Staatsgemäldesammlungen, Munich

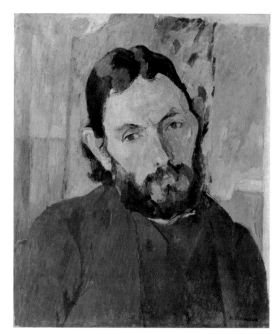

Plate 105

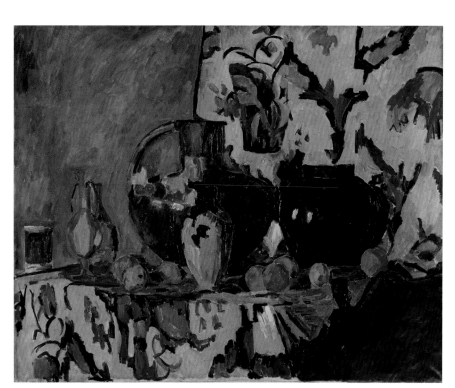

Plate 104

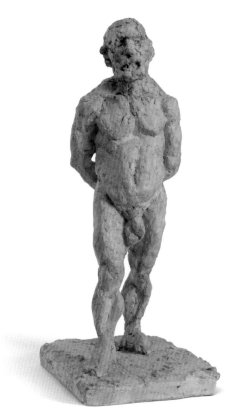

Plate 106

Plate 104
Hans Purrmann, *Still Life with Vases, Oranges, and Lemons,* **1908.** Oil on canvas,
31½ x 39⅛ in. (80 x 99.5 cm). Nationalgalerie, Staatliche Museen, Berlin

Plate 105
Hans Purrmann, *Model in Matisse's Studio,* **1908.** Oil on canvas, 21⅞ x 18¼ in.
(55.5 x 46.5 cm). Private collection

Plate 106
Hans Purrmann, *Striding Man,* **1909.** Plaster of Paris, 26 x 10⅝ x 13 in.
(66 x 27 x 33 cm). Private collection

The Académie Matisse also allowed Matisse to promulgate his theories at a time when his prestige was beginning to be rivaled by that of Cubism. The competition between the "Picassoites" and the "Matisseites"[31] began in earnest around the time of the 1908 Salon d'Automne, when Matisse served on the jury that rejected the cubist L'Estaque paintings submitted to the exhibition by Georges Braque. Where the Steins were concerned, the artistic rivalry became a family issue: rue de Fleurus versus rue Madame. Leo and Gertrude were becoming closer to Picasso, and in the fall of 1909 they bought a series of his cubist landscapes from Horta de Ebro, asserting moreover that neither one of them liked the way Matisse was evolving toward his decorative style.[32] "I felt that the two factions had identified their authority with the identity of the two painters.... Their own status was affected by the status they created for these two artists by publicizing so enthusiastically their opinions," recalls Harriet Lane Levy.[33]

For Sarah and Michael, the creation of the academy was yet another gesture in support of Matisse. The projected program also fell squarely within the bounds of an aesthetic conception founded on the notion of experience and direct contact with the work of art—an idea that must have appealed to Sarah and Leo as painters.[34] In fact, Sarah had already benefited from Matisse's instruction.

That is how it all started: Sarah found Matisse's suggestions for her own painting very useful and proposed that he do the same for others. So Sarah and Michael decided to organize a little "coup d'état" and submit drawings by Hans Purrmann to Matisse. Purrmann, a German artist and former student of Franz von Stuck, had recently arrived in Paris and had been introduced to the Steins by Maurice Sterne.[35] Soon he would be joined by two Americans, Patrick Henry Bruce[36] and Max Weber,[37] as well as the Germans Oskar and Greta Moll,[38] the Swede Carl Palme (who was brought in by Leo Stein, himself a brief participant in the academy),[39] and Jean Biette, a former friend of Matisse's from Gustave Moreau's studio.[40] Together they got organized and rented a studio not far from Matisse's in the convent of Les Oiseaux on rue de Sèvres. The academy opened in the early days of 1908 with no more

than a dozen participants.[41] There were lessons devoted to drawing, painting, and sculpture. Costs were shared among the founding members and managed by Purrmann, who had become the academy's treasurer. Each Saturday, Matisse would critique the work of these students, many of whom were already quite experienced.

In the spring of 1908 the academy, along with Matisse and his family, was obliged to move, as the convent was being put up for sale by the state. They then settled in the former convent of the Sacré-Cœur at 33 boulevard des Invalides. Matisse had his own apartment and a pavilion divided into his painting studio and a studio for sculpture, which is where the academy was held (pl. 107). Purrmann and Bruce (who was now the treasurer) settled in the same building, just above the Matisses' apartment. The class was fairly quiet until the autumn, when there was an influx of new recruits. According to the Swedish painter and Matisse pupil Isaac Grünewald, no fewer than 120 students would study at the Académie.[42] They were of various nationalities, for the most part Scandinavians, Germans, and Hungarians; only two were Frenchmen.

The Steins' role seems to have been decreasing in importance at this time, and in all likelihood the students came from the artists' community that gravitated around the Café du Dôme (which the Steins also frequented).[43] There

Plate 107

Plate 107
The model Bevilaqua posing for a sculpture class at the Académie Matisse, located in the former convent of the Sacré-Cœur, Paris, ca. 1909. Left to right: Jean Heiberg, unidentified woman, Sarah Stein, Hans Purrmann, Henri Matisse, Patrick Henry Bruce. Archives Matisse, Paris

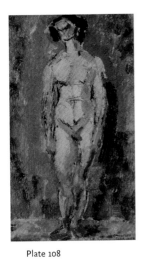

Plate 108

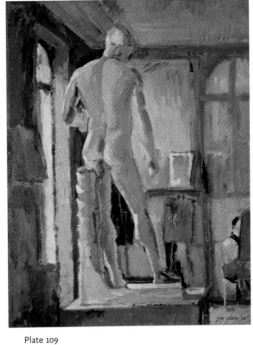

Plate 109

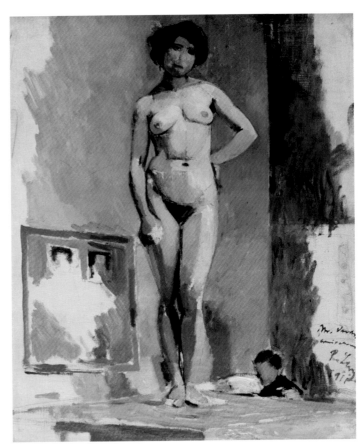

Plate 110

Plate 108
Max Weber, *Standing Nude,* 1908. Oil on board, 8¼ x 5⅛ in. (21 x 13 cm).
Estate of Max Weber, courtesy Gerald Peters Gallery, New York

Plate 109
Max Weber, *Apollo in Matisse's Studio,* 1908. Oil on canvas, 23 x 18 in.
(58.4 x 45.7 cm). Estate of Max Weber, courtesy Gerald Peters Gallery, New York

Plate 110
Rudolf Levy, *Nude on a Table,* 1911. Oil on canvas, 31¾ x 27½ in. (80.5 x 69.8 cm).
Generaldirektion Kulturelles Erbe Rheinland-Pfalz, Landesmuseum Mainz,
Germany

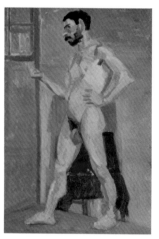

Plate 111

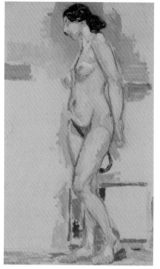

Plate 112

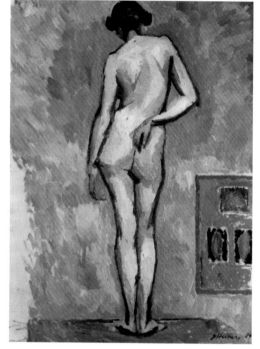

Plate 113

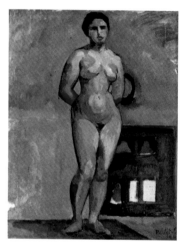

Plate 114

Plate 111
Sarah Stein, *Standing Male Nude,* ca. 1908–11. Oil on canvas, 19 x 13 in.
(48.3 x 33 cm). Dr. and Mrs. Maurice Galanté, San Francisco

Plate 112
Sarah Stein, *Standing Female Nude,* ca. 1908–11. Oil on canvas, 22¼ x 13¼ in.
(56.5 x 33.7 cm). Dr. and Mrs. Maurice Galanté, San Francisco

Plate 113
Jean Heiberg, *Nude,* 1909. Oil on canvas, 28⅜ x 21¼ in. (72 x 54 cm).
Drammens Museum, Norway

Plate 114
Vilmos Perlrott-Csaba, *Female Nude,* 1910. Oil on canvas mounted on board,
20⅛ x 16⅛ in. (51 x 41 cm). Rippl-Rónai Museum, Kaposvár, Hungary, bequest
of Ödön Rippl-Rónai

were a number of women present (mixed classes were fairly exceptional for the era), including not only Sarah Stein but Olga Meerson, Marie Vassiliev, Mathilde Vollmoeller, and Sigrid Hjertén.[44] After a few months the first arrivals departed: Leo Stein dropped in only occasionally, the Molls went back to Germany in May 1908, and Weber left the academy in July 1908, ceding his place to another American, Morgan Russell, who had arrived in the spring.[45] It is not clear exactly when Sarah Stein stopped going to the academy. According to Levy, she was there for only a year, working assiduously, "from eight in the morning to six at night," and after a summer spent in the south, she stopped painting to devote herself entirely to Christian Science.[46] This must have been at the end of the summer of 1909.[47]

From the summer of 1908 to May 1909, Matisse hardly left Paris, except in June 1908 for a brief trip to Germany with Purrmann. Beyond his sessions with the students, he devoted himself almost entirely to the large-scale paintings commissioned by Shchukin. In June 1909 the convent of the Sacré-Cœur was put up for sale, and after their vacation in the south the Matisses settled in Issy-les-Moulineaux. From then on, Matisse would have to go into Paris to give his instruction at the academy. The burden began to weigh too heavily, and in the spring of 1910 he finally decided to put an end to the venture. He wrote to Biette that it had been a difficult winter: "The studio with the students was a great burden.... I forgot to tell you that I've dropped the studio altogether, my last session will be on Saturday. What a relief! I took my role far too seriously."[48]

Matisse considered the experience a failure. There had been too many students (from that point of view, it was a resounding success), and above all a persistent misunderstanding had taken hold between master and students. Some of them had come solely to *paint like Matisse*, and they even thought he must be concealing some secret recipe: "They were (with exceptions) a bad lot, the wild-eyed type— largely non-Frenchmen—who apparently looked on Matisse as crazy, and who wanted to be the same way."[49] In the end Purrmann, who along with Bruce was one of the most committed to the project, had to concede: "There was nothing of a schoolmaster about him.... He was nearly like

one of his students; ... Matisse was always attempting to analyze his pictures."[50]

According to Gertrude Stein, it was precisely that absolute need for clarity that best characterized Matisse's personality: "His emotion is clear, and is pressed through obstacles, but his emotion always remains a clear thing, his emotion is not muggy or earthy or quivering.... Matisse is clear in his emotional power."[51] The need to give precise definition to his goal and find the means to attain it, along with its corollary—his aptitude for self-criticism— were no doubt among the dominant features of his teaching.[52]

Matisse's curriculum generally followed the model set by the École des Beaux-Arts, where students were expected to master the fundamentals—studying anatomy, making drawings after classical sculptures and works by the great masters, and drawing live models—before progressing to one of the academies of painting. That there was nothing terribly original or innovative about the apprenticeship must have disappointed those students who expected a new or radical regime. More interesting and unusual was the constant comparison Matisse would make between drawing and sculpture in the search for harmony of form, referring not only to sculpture from antiquity but also to the Gothic era and to African art. Certain basic principles can be found in one testimony after another. First of all, there was the fact that Matisse's instruction was based less on individual instruction than on a number of general, concise rules to which the student must always refer. Among them was the belief that visual elements should be considered not separately but within the logic of their relation to the whole, the search for unity on the basis of the construction of parts,[53] and the concept of form as a mass rather than a contour.

It would seem that the necessity of conceptualizing the human form in space was at the foundation of Matisse's teaching. Evidence of this is the importance given to voids as well as solids, in the teaching of drawing as well as sculpture.[54] With sculpture—during the final year, the only truly active studio—Matisse refused to use the method of the silhouette, which consists of copying the model's

Plate 115
Paul Cézanne, *Three Bathers*, 1879-82. Oil on canvas, 20½ x 21⅝ in. (52 x 55 cm). Petit Palais, Musée des Beaux-Arts de la Ville de Paris

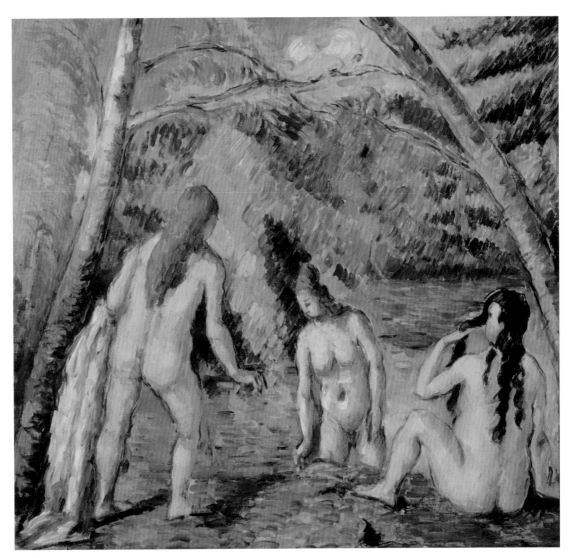

Plate 115

various profiles as he or she rotates; he advocated, rather, moving around or even looking away from the model, the better to grasp the organization of form.[55] He also recommended considering sculpture as an object that can be manipulated.[56]

His teaching was also marked by constant references to Cézanne's work (on Friday nights he would gather some of his students in his studio and show them his own Cézanne painting, *Three Bathers* [1879–82; pl. 115]).[57] Matisse underscored Cézanne's "unexcelled meticulous execution"; the architectonic plasticity of his painting was considered to be on a level with that of ancient Greece.[58] In addition, Matisse explained the scientific theories behind color as advanced by Michel Eugène Chevreul, Hermann von Helmholtz, and Ogden Rood, compared with the neoimpressionist method, as well as "what influence the basic principles of design and color in the great ancient arabesque of the Far-Eastern art, the Chinese, Persian and Hindu, had upon Western art."[59] Matisse often illustrated his discourse about painting with references to music, and he did not hesitate, during the sessions, to play classical pieces on the little harmonium that was in the studio.[60] The later evolution of Russell, Bruce, and even Léopold Survage (who was also one of Matisse's students) toward Synchromism no doubt found an initial impulse in Matisse's teaching of color.[61] Finally, even if Matisse did not resort a great deal to individual critique, the general principles of his instruction were developed through contact with works of art (or reproductions), whether they were the students', his own (he showed them *The Red Room (Harmony in Red)* from 1908 [State Hermitage Museum, Saint Petersburg] and explained how he went about modifying the colors),[62] or works from his private collection. Like the Steins, he thrived on the exchange of opinions, and as Weber has pointed out, discussions often continued at rue Madame or in Matisse's own studio.

World War I and the Gurlitt Affair

In 1914 nineteen of Matisse's paintings from Michael and Sarah Stein's collection were shipped to Berlin. The Berlin art dealer Fritz Gurlitt had already successfully organized an exhibition of Matisse's Moroccan works in May 1913,[63] after one that was held at Galerie Bernheim-Jeune in Paris. The next month, Gurlitt informed Matisse of his plan to organize another solo exhibition in the fall, as he had obtained the support of one of the painter's German collectors, Kurt Glaser.[64] In the end the exhibition was not held until the summer of 1914. According to Matisse, Glaser contacted the Steins about lending works, knowing that the family would be going to Italy, as they did every summer: "Out of kindness to me, the Steins agreed to my request."[65]

The Matisse exhibition at the Kunstsalon Fritz Gurlitt opened in July with only the Steins' nineteen paintings on view. Ranging in date between 1897 and 1909, the works were among the largest and most significant canvases in their collection, including *The Young Sailor I, Madame Matisse (The Green Line)* (1905; pl. 88, cat. 110), *Pink Onions, Blue Still Life, Red Madras Headdress, Self-Portrait* (1906; pl. 138, cat. 131), and *La Coiffure*. One can only wonder whether Sarah and Michael were unaware of the imminence of war or whether they simply did not want to admit the possibility of all-out conflict. As Gertrude Stein wrote in her *Autobiography of Alice B. Toklas*, "Americans living in Europe before the war never really believed that there was going to be war."[66] Following the German declaration of war against France on August 3, 1914, the exhibition had to shut down. The Steins decided at that point that, rather than try to repatriate the works, which could be risky, they would leave them where they were.[67] In all likelihood the canvases were still at the gallery in November 1916, when Michael drew up an inventory and appraisal of the lost works (pl. 116). The situation became even more complicated with the United States' entry into the war in 1917. From then on, the possibility loomed that paintings would be seized and confiscated as enemy property by the German authorities.

What happened next is very difficult to know for certain. In order to obtain title to the paintings, Gurlitt organized a fictitious auction. Purrmann, who was in Berlin, was notified by the artist Emil Orlik that he had seen *Pink Onions* in the home of E. R. Weiss in Berlin; Weiss had apparently just bought the painting, because Orlik's wife said that she had seen the notice of sale by auction in

Matisse pgs. (Michael Stein Coll. – sent to Gurlitt, art dealer, Berlin in June 1914. List compiled in 1916

	Size in cm.	Date	Value
Arbres fruitiers Corse (fruit trees in blossom)	46x38	1897	$150.00
Nature Morte cafetiere (still life coffe pot)	73x60	1899	350.00
Pont Saint Michel (Saint Michel bridge Paris)	55x46	1902	400.00
Primevere (pot de fleur) (Pot of flowers)	73X60	1902	900.00
Paysage du Midi (landscape trees)	55X46	1905	600.00
Portrait de femme (female head)	41X33	1905	600.00
Portrain d'homme (male head)	39X28	1905	300.00
Oliviers (olive trees)	55x46	1905	400.00
La gitane (female torse)	55x46	1906	400.00
Paysage de Collioure (landscape)	55x46	1906	600.00
Nature morte bleue (still life with table)	116x89	1907	2000.00
Portrait d'un Marin (portrait of sailor)	100x81	1907	1000.00
Portrait de l'artiste (portrait of the artist)	55x46	1907	600.00
Les Oignons (onions on a table)	55x46	1907	600.00
Portrait au Madras rouge (portrait with red head dress)	100x81	1907	1200.00
Collioure a travers les arbres (landscape foliage)	92x65	1907	800.00
La Coiffeuse (two female figures)	116x89	1907	1200.00
Nature Morte Le Bronze (Still life with bronze)	73x60	1908	800.00
Paysage d'automne (landscape autumn effect)	73x60	1909	800.00
			$13,700.00

Plate 116

Plate 116
Michael Stein's November 1916 inventory (annotated later by another hand) of
the nineteen Henri Matisse paintings that he and Sarah Stein lent to the Berlin
art dealer Fritz Gurlitt in June 1914. The works would never return to the Steins.
Dr. Claribel and Miss Etta Cone Papers, Archives and Manuscripts Collections,
The Baltimore Museum of Art

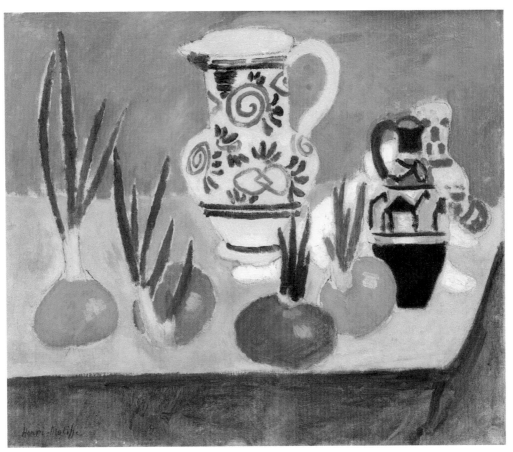

Plate 117

the newspaper. Purrmann tried to intervene, asking for help from the art dealer Paul Cassirer, but Cassirer refused and sided with Gurlitt.[68] In addition, at least one of the other Stein paintings, *Madame Matisse (The Green Line)*, apparently hung for a time in Oskar and Greta Moll's apartment in Berlin. We do not know, however, whether the Molls had had it in their possession since 1914 or whether they acquired it at the time of the fictitious auction in 1917.[69]

After the end of the war Purrmann, at the Steins' request, allegedly secured the return of the works and planned to have them repatriated to Paris. This seems improbable, however, given that shipping goods between France and Germany was still forbidden.[70] Perhaps Purrmann managed to obtain permission on paper, but in any case his efforts were for naught. He subsequently learned that "the Steins, in a moment of panic, had secretly sold all [the paintings] long before to the Norwegian [collector Christian] Tetzen-Lund."[71]

The circumstances behind this transaction remain murky. The sale probably took place in Germany in December 1917, after the artworks noted on Michael's 1916 inventory were revalued upward, with Matisse's approval.[72] In January 1918 the Danish art dealer Walter Halvorsen, who was heavily involved in the commerce of Matisse paintings, wrote a furious letter to Madame Matisse when he learned that the transaction had taken place without his knowledge.[73] It appears that the terms of the deal were not finalized for quite some time: the nineteen paintings did not arrive in Copenhagen until October 1920, and they were purchased jointly by Tetzen-Lund and the Norwegian shipowner Tryggve Sagen.[74] Soon thereafter the two owners divided up the works, with eleven going to Tetzen-Lund and eight to Sagen. Ultimately, the great mystery remains why the Steins decided to part with the bulk of their collection in the first place. Was it panic, as Purrmann implied? Or were they misled about the fate of the works? According to Matisse, Tetzen-Lund had promised to sell the paintings back to the Steins for the same price once the war was over.[75]

Whatever the case, the dispersal of the collection was, for Sarah, "the tragedy of her life."[76] She and Michael would continue to acquire the painter's works both during the war and afterward, though never at the pace of the preceding decade.[77] Their friendship with Matisse would remain on solid footing, and the two families would continue to socialize regularly until the Steins' departure from Paris in 1935.[78] Yet it is impossible not to view the Gurlitt affair as the conclusion of a period of remarkable intensity and idealism for the Steins—one with far-ranging implications for Matisse's career and the development of modern art.

Translated from the French by Alison Anderson

Plate 117, cat. 138
Henri Matisse, *Pink Onions*, 1906-7. Oil on canvas, 18⅛ x 21⅝ in. (46 x 55 cm). Statens Museum for Kunst, Copenhagen, gift of Johannes Rump, 1928

Notes

1. Bell 1912. See also Gary Tinterow in this volume.

2. The Steins were acquainted with Fry, Berenson, and the British Byzantinist Matthew Stewart Prichard.

3. L. Stein 1927.

4. In a January 1907 transaction with Galerie Druet, Sarah exchanged paintings by Adolphe Monticelli, Maurice Denis, and Henri Fantin-Latour for six works by Matisse (see page 47n101 in this volume). Photographs of rue Madame taken 1907 or after (pls. 365-74) show that Sarah and Michael still owned and displayed a relatively modest number of works by artists other than Matisse. These include Félix Vallotton's *Standing Nude Holding Her Chemise with Two Hands* (1904; pl. 180, cat. 439); Pablo Picasso's *Allan Stein* (1906; pl. 179, cat. 324), *The Acrobat Family* (1905; pl. 22, cat. 291), and *Melancholy Woman* (1902; pl. 176, cat. 231); and two works by Paul Cézanne, *Portrait of Paul, the Artist's Son* (ca. 1880; pl. 128, cat. 9) and *Bathers* (ca. 1892; pl. 129, cat. 11).

5. For the date of this acquisition, see Bois forthcoming.

6. See Rebecca Rabinow in this volume.

7. Matisse told Pierre Courthion that he bought the painting for the purchase price (Courthion 1941). The date of November 1917 was given by Wanda de Guébriant, Archives Matisse, Paris (hereafter, AMP; see Stein and Picasso 2008, 204n2).

8. According to Purrmann, the Steins wanted to buy *Bathers with a Turtle* (1908; Saint Louis Art Museum) in 1908 but did not have room for a painting that size. Hans Purrmann to Karl Ernst Osthaus, quoted in L. A. Stein 1998, 53-54.

9. Matisse gave his very first ceramic production to Sarah Stein at the beginning of 1908 (see Fourcade and Monod-Fontaine 1993, 79).

10. Kimball 1948a.

11. Levy n.d., 27.

12. The Steins had bought furniture during their stay in Italy, and for a time Michael had considered opening an antique shop. See Jelenko ca. 1965, 7.

13. For a description of the interior of the Steins' home at rue Madame, see in particular Rosenshine n.d., 95.

14. Levy (n.d., 10) gives the example of Mr. and Mrs. Sears, American art collectors.

15. Ibid., 28-29.

16. Matisse speaks of the painting as having "a calming influence on the mind," in "Notes of a Painter" (1908), reprinted in Flam 1995, 43. Regarding Sarah Stein, Harriet Levy (n.d., 9) stated: "She seems to receive joy from the painting."

17. Matisse 1908, reprinted in Matisse 1972, 40-58. *Red Madras Headdress* (1907; pl. 95, cat. 144), from the collection of Sarah and Michael Stein, is in this regard one of the inaugural paintings reflecting Matisse's conception of decorative aesthetics.

18. Sarah and Michael Stein introduced Matisse to Prichard in early 1909. See Labrusse 1996, 175.

19. Matisse, in Courthion 1941. Michael often signed "Michel" in his letters to the Matisses.

20. Irwin n.d., 261 (Inez Haynes Irwin's visit to the Steins with the journalist Gelett Burgess took place in spring 1908); Pach 1938, 117.

21. In Sarah Stein's notes: "To copy the object in a still-life is nothing; one must render the emotion they awaken in oneself. The emotion of the ensemble, the interrelation of the objects, the specific character of every object—modified by its relation to the others—all interlaced like a cord or a serpent." Cited in Barr 1951, 552.

22. My thanks to Rémi Labrusse for pointing out the piece of cloth that is in this painting.

23. *Still Life with Geraniums* was bought in June 1910 by Hugo von Tschudi, the director of the Neue Staatsgalerie in Munich. In a letter dated Monday the 24th [January 1910?], Michael Stein wrote to Gertrude: "Matisse has made a #50 Still life with our Cloisonné Jar and is sending it to Munich." Gertrude Stein Papers, Yale Collection of American Literature, Beinecke Rare Book and Manuscript Library, Yale University (hereafter, Beinecke YCAL), MSS 76, box 125, folder 2717.

24. Jelenko ca. 1965, 5. Theresa Erhman (later Jelenko) came to Europe with Sarah and Michael Stein in 1904; she was Allan's piano teacher.

25. Shchukin actually replied to Matisse that Sarah Stein's opinion mattered a great deal to him. Shchukin to Matisse, February 2-15, 1911, quoted in Kostenevich and Semyonova 1993, 169.

26. Sarah Stein to Henri Matisse, October 1911 ["dimanche"], AMP.

27. In addition to Sarah Stein's notes, the most complete testimonies regarding the Académie Matisse are those of Hans Purrmann (1922), Greta Moll (Salzmann 1975, 43-49), and Max Weber, in the text of a lecture given on October 22, 1951 (Archives of American Art). Several other sources mention the Académie Matisse, principally Barr 1951, 116-17 (based on original testimonies); Flam 1986, 220-23; Seckel 1991; and Cauman 2000a, 75-100.

28. Sarah and Michael regularly lent their Matisse paintings to exhibitions abroad, particularly *La Coiffure* and *Red Madras Headdress*, first to the Second Post-Impressionist Exhibition, organized by Roger Fry in London in January 1912, then to the International Exhibition of Modern Art (popularly known as the Armory Show) in New York, which traveled to Chicago and Boston between February and May 1913.

29. The press made mention of this situation several times. For example, the critic Louis Vauxcelles, in his report on the Salon des Indépendants in 1908, wrote, "MM. Matisse and Picasso have wrought havoc within the naïve brains of their little successors." Vauxcelles 1908.

30. Gertrude Stein would sarcastically call Matisse "Cher Maître." Stein, Notebook B, Beinecke YCAL, quoted in Wineapple 1996, 279.

31. Gertrude Stein wrote: "Derain and Braque became followers of Picasso…. The feeling between the Picassoites and the Matisseites became bitter." G. Stein, 1990, 63-64.

32. *Blue Nude: Memory of Biskra* (1907; pl. 27, cat. 139) was their last purchase of Matisse's work, in the spring of 1907. Leo Stein wrote, "The static quality of Matisse left me more and more stranded" ("Autobiographical Notes and Fragments," quoted in Wineapple 1996, 232). Gertrude shared his opinion (see ibid., 233).

33. Levy n.d., 11.

34. Leo Stein knew this only too well: after his successive attempts, and failures, to write down his theory, he finally had to conclude that he was good at talking about works only when he was actually in their presence.

35. Purrmann 1922, 33.

36. Patrick Henry Bruce (1881-1936) was a student of William Merritt Chase and Robert Henri at the New York School of Art. He arrived in Paris at the beginning of 1904 and began to visit the Steins in 1907. It was at their home that he met Matisse (see Agee and Rose 1979, 44-45).

37. Max Weber (1881-1961) arrived in Paris in 1905 and stayed until December 1908. He visited a number of free studios—the Académie Julian, the Académie Colarossi, and the Académie de la Grande-Chaumière—before taking part in the Académie Matisse (see Cauman 2000a, 32-33). Weber tells the story of how Purrmann, whom he met at Colarossi's, suggested joining him for the Académie Matisse project (Weber 1951).

38. Oskar Moll (1885-1947), a student of Lovis Corinth in Berlin and member of the Berlin Secession, and his wife, Greta Moll, a sculptor, arrived in Paris at the end of 1907.

39. Carl Palme met Leo Stein through the sculptor David Edstrom, and Stein introduced him to Matisse. Barr 1951, 536n6.

40. Palme, Weber, Bruce, and Purrmann met regularly at the Café du Dôme on boulevard du Montparnasse (Klüver and Martin 1989, 73). The list of the founding members of the academy varies. Barr (1951, 536n6) includes Sarah Stein, Oskar and Greta Moll, and Jean Biette, as well as Annette Rosenshine, based on Purrmann's letter of March 3, 1951. According to Greta Moll in 1958, those who were present at the beginning were Sarah Stein, Bruce, and Weber, as well as her

husband, Oskar Moll, and herself (see Salzmann 1975, 46). Carl Palme lists Sarah Stein, Purrmann, Weber, Bruce, Leo Stein, and himself (see Barr 1951, 536n6).

41. Ibid., 9. In a letter to Abraham Walkowitz on January 5, 1908, Weber wrote: "We have organized a little class—including Mr. Stein and his sister-in-law who paints—& two Germans—who know something—we begin to work tomorrow—mornings only—from the model–nude." Quoted in Cauman 2000a, 80.

42. Barr 1951, 117. Marit Werenskiold counted eighty-three students in all (see Werenskiold 1972, 197-98). But this figure remains a very rough estimate, as there was no register of students, and some of them were not really enrolled but came only on an occasional basis.

43. "When the studio had become well known the Dôme crowd renewed its alliances, and some of them even came to the classes." Purrmann 1922, 33.

44. In one of the photographs of the academy one can count thirty-five students, a third of whom were women. According to Barr (1951, 117), this photograph, published by Mathias Grünewald in 1944, belonged at the time to Palme.

45. Kushner 1990, 33.

46. Levy n.d., 11.

47. Ibid., 10.

48. Henri Matisse to Jean Biette, spring 1910, AMP. Matisse wrote to him that he had almost finished *Music*. Prior to this it was believed that the academy had closed during the summer of 1911 (see in particular Barr 1951, 117 [based on the testimonies of Grünewald and Palme]; Flam 1986, 264; and Seckel 1991, 317).

49. Pach 1938, 119. Walter Pach, who nevertheless admired Matisse, refrained from enrolling for that reason.

50. Purrmann 1922, 35.

51. Gertrude Stein's Notebook, Beinecke YCAL, quoted in Wineapple 1996, 333. The idea recurs in her word portrait of Matisse.

52. Regarding the content and organization of instruction, the primary testimony remains the notes taken by Sarah Stein in 1908, published by Barr in 1951 (550-52). For Sarah Stein's notebook of transcriptions of Matisse's teachings and a discussion of its relationship to Barr's published version, see "Sarah Stein's Notebook from the Académie Matisse" in this volume. Weber's testimony, although it came much later, also gives a very good idea (Weber 1951), as does that of Jean Heiberg, translated into English in New York 2001, 28-29.

53. "Matisse felt that a human body was composed of units that had to be understood separately before one could grasp the construction of the whole."

Russell Notebooks, Montclair Art Museum, quoted in Kushner 1990, 33.

54. See in particular "Notes of Sarah Stein" (1908), in Matisse 1972, 67.

55. See Heiberg's testimony in this regard, in New York 2001.

56. For example, when showing his collection of African figurines: "He will take a figurine in his hands and point out to us the authentic and instinctive sculpturesque qualities." Weber 1951, 14. See also "Notes of Sarah Stein" (1908), in Matisse 1972, 70.

57. Weber recalls that Matisse's "silence in front of it was more evocative and eloquent than words." Weber 1951, 14.

58. Ibid., 10.

59. Ibid., 11.

60. According to Weber, the harmonium also worked with rolls, and on one occasion Matisse even played Beethoven's Third Symphony for them himself. Russell would later perfect a music machine that produced immaterial colors (see Rousseau 2001).

61. This remains to be explored, in the archives of the various artists.

62. This episode occurred during a visit to Redon's studio, probably in the early days of the academy, in 1908 (see Weber 1951, 15).

63. There was no catalogue of the exhibition, and it was open for just over a week, from May 2 to 11, 1913 (see Kropmanns 2000, 260).

64. Fritz Gurlitt to Henri Matisse, June 5, 1913, AMP.

65. Courthion 1941, unpublished manuscript, AMP. This was not the case for Marcel Sembat, who was also approached and who knew that the war was imminent (see Barr 1951, 177).

66. G. Stein 1990, 143.

67. "There was a whole year where the Steins could have gotten their paintings out, but because they were very cautious, they asked around and concluded that it would be better to leave their canvases in Berlin rather than subject them to the danger of an ocean crossing." Henri Matisse, in Courthion 1941.

68. Purrmann 1946. Barr gives a very similar account of the facts based on this article and on the letter that he received from Purrmann (Hans Purrmann to Alfred H. Barr, Jr., September 20, 1950, Alfred H. Barr, Jr. Papers, Museum of Modern Art Archives; see Barr 1951, 177). It also tallies with the version of events related by Kaspar Monrad (1999b).

69. Kropmanns 1997. Kropmanns also includes *Olive Trees at Collioure* (ca. 1906; pl. 59, cat. 134) among the paintings exhibited at Gurlitt's and also found at the Molls'. What is more plausible is that the Molls bought the canvas from Galerie Bernheim-Jeune at the same time as *Margot* (1906; pl. 61, cat. 122). These two paint-

ings did in fact belong to Leo Stein, who had placed them with Galerie Bernheim-Jeune in November 1914 (see letter from Félix Fénéon, of the Galerie Bernheim-Jeune, to Gertrude Stein, November 26, 1914, Beinecke YCAL).

70. Ibid., also reprinted in Barr 1951, 177. In a footnote, Pierre Matisse has this to say: "I always thought Tetzen-Lund had acquired the Stein Matisses in Germany." Miscellaneous Correspondence, MoMA Barr Papers.

71. Purrmann 1946.

72. Jacob Moses wrote to Etta Cone: "The list was compiled in November 1916, but when the power of attorney was sent to me in December 1917, Mike increased the valuation to $20,000.00 and said valuation was supported by an affidavit made by Matisse." Jacob Moses to Etta Cone, February 27, 1923, Dr. Claribel and Miss Etta Cone Papers, Archives and Manuscripts Collections, The Baltimore Museum of Art (hereafter, BMA Cone Papers). Jacob Moses was a lawyer and friend of the Steins. I am grateful to Rebecca Rabinow for passing on this information to me.

73. "M. Stein sold his collection to the very people who had asked me to buy it. Because they were Jewish, I could see why, if they had had an enormous offer with very little time to think about it. But that was not the case." Walter Halvorsen to Amélie Matisse, January 23, 1918, AMP. The letter was published with several mistakes in the transcription and erroneously dated November-December 1918 in Monrad 1999b, 154.

74. This information is based on an article announcing the purchase, as well as the arrival of the pictures in Copenhagen. Petersen 1920; reprinted in Gottlieb 1984, 25.

75. Matisse, in Courthion 1941.

76. Kimball 1948a, 35.

77. Sarah and Michael Stein's wartime acquisitions of Matisse's art included at least seven etchings in 1914, *Woman with a Hat* from Gertrude in February 1915, and in October 1916, *Nude in a Forest* (1909-12; cat. 150), as well as their pair of portraits (pls. 83, 84; cat. 151, 152), created in the fall of 1916.

78. For example, at the time of Marguerite Matisse's marriage to Georges Duthuit in December 1923, Sarah and Michael were the only guests, apart from the witnesses, who were not family members (see the letter from Michael Stein to Etta Cone, December 17, 1923, BMA Cone Papers). I am grateful to Rebecca Rabinow for passing on this information to me. See also the essay by Janet Bishop in this volume, which details the Steins' relationship with Matisse and their promotion of his work through the 1940s.

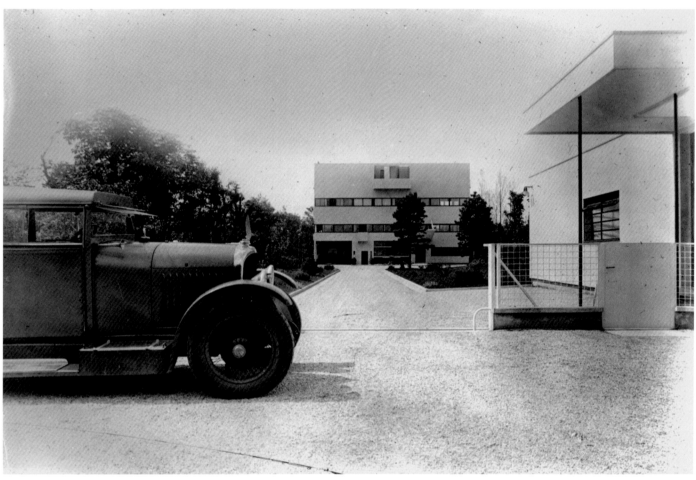

Plate 118

The Steins Build: Le Corbusier's Villa Stein-de Monzie, Les Terrasses
Carrie Pilto

After having been in the vanguard of the modern movement in painting in the early years of the century, we are now doing the same for modern architecture. —MICHAEL STEIN[1]

In the years following World War I, Michael and Sarah Stein, champions of modern art, commissioned one of the most innovative architects of the century, Le Corbusier (Charles Édouard Jeanneret), to design a home in Vaucresson, west of Paris. The villa Les Terrasses was built for the Steins and their friend Gabrielle Colaço-Osorio, the estranged wife of Count Anatole de Monzie. For Le Corbusier, the Steins and de Monzies were not only splendid clients but also strategic allies in the cause of modern architecture. Completed in 1928, Les Terrasses was a turning point in the architect's career, demonstrating his conviction that a house, which he called a "machine for living," could be both supremely efficient and an aesthetic tour de force. This house was an experiment in the ideals of the future: harnessing technology and industrial materials, wedding indoors to outdoors, opening and shaping interior space, eliminating decorative excess, and rationalizing form and function—all on a grand scale. The result set a new standard for modern luxury: air and light, sculpted to poetic proportions.

Gabrielle entered the Steins' lives when she met Sarah through the Christian Science church around 1912.[2] In time the two women would each take on the role of Christian Science practitioner, or healer, for the other. Unlike the Steins, Gabrielle did not collect art; a spiritual woman with a talent for languages and a passion for literature, she preferred what she considered to be the more immaterial arts.[3] She was, however, independently wealthy, from a family of Sephardic Jewish descent, and her banker father leveraged the family fortune with a business investment that itself had a connection to modernism: backing the inventor of Ripolin paint. The fast-drying, washable enamel popular in industry and hospitals was the same Ripolin paint that Picasso appropriated for his canvases and that Le Corbusier used for his walls. Gabrielle's husband, an influential politician of the radical socialist party, was to become an important government supporter of Le Corbusier.[4] Although Gabrielle and de Monzie appear to have been compatible in matters of culture, their marriage was undermined by his philandering.[5] She found a surrogate family in the Steins, to their mutual benefit.

The Steins began spending vacations with Gabrielle at her sisters' country estates, and during World War I, the de Monzie château near Cahors, in the south of France, served as their refuge. By 1922 the Steins had settled together with Gabrielle and her adopted daughter, Jacqueline,[6] into a spacious apartment at 59 rue de la Tour, in the Passy district of Paris's sixteenth arrondissement. They all longed for the healthy lifestyle of the country, and they toured the south of France extensively without finding an existing house that suited them. Now they envisioned a residence outside Paris on the same scale as Gabrielle's family villas and châteaux.

The friends were in the midst of looking for property when they attended the 1925 International Exposition of Modern Decorative and Industrial Arts and visited Le Corbusier's exhibit of a cubic housing unit, part of his controversial Pavillon de l'Esprit Nouveau (Pavilion of the New Spirit). The pavilion was Le Corbusier's first major

architectural manifesto, a grand summation of purist aesthetics and a radical departure from most of the exposition's primarily Art Deco offerings.[7] His polemical publication, *The Decorative Art of Today*, written to protest the exposition, excoriated superfluous ornament and the crafts tradition as decadent offerings of a darker age. He praised the clean lines and functional beauty of industrially manufactured furniture and objects. In lieu of damasks, wallpapers, or moldings inspired by decorative Cubism, he proposed to whitewash the home of every citizen with a coat of Ripolin paint—thus providing the background for an aesthetic revolution intended to foster moral, social, and intellectual renewal.

Le Corbusier was by this time emerging as an important contributor to artistic and architectural thought. *After Cubism* (with Amédée Ozenfant), published in 1918, replaced the fractured, "troubled" forms of Cubism associated with a shattered Europe with whole forms and precise geometries. Le Corbusier's 1923 anthology of writings, *Towards a New Architecture*, argued for buildings that satisfied function through form while elevating the human spirit. In it he juxtaposed photographs of Greek temples with those of automobiles, proposing a twofold standard for the postwar reconstruction period: a return to classicism, and the machine aesthetic. The Villa Stein-de Monzie would embody the perfect synthesis of these values.

Le Corbusier's theoretical works and projects considered mass housing and urban planning, but his built work consisted primarily of private houses for his family and friends. Michael, who had commissioned apartment buildings in San Francisco,[8] would likely have studied Le Corbusier's proposition for a universal dwelling at the Salon d'Automne in 1922 and was familiar with the studio-residence that he designed in 1923-24 for Jacques Lipchitz in Boulogne.[9] In the Steins' Paris neighborhood, the Swiss banker Raoul La Roche, also a prolific collector of modern art, was just moving into the home that he had commissioned from Le Corbusier in 1923.[10]

There were of course many other modern architects in the Steins' purview: Robert Mallet-Stevens, another Art Deco exhibitor, had built a home for couturier Paul Poiret and was constructing a villa for the count and countess

of Noailles; Adolf Loos would soon complete a house for Tristan Tzara; and Auguste Perret designed a new studio for Georges Braque. With the exposition of 1925, much as with the Salon d'Automne of 1905, aesthetic territory was laid out and battle lines were drawn, with the Steins, much as they had done for Henri Matisse at a crucial moment in his career, deciding to invest on the side of the most visionary. The Stein-de Monzie commission followed soon after the exposition, along with those of fellow American expatriates from the Stein circle William Cook and Henry and Barbara Church, giving a significant boost to Le Corbusier's activity. Michael also tried to enlist Pablo Picasso in their new architectural adventure, suggesting he buy the lot next to Cook's when it became available.[11] In the spring of 1926 Sarah wrote to Matisse to share the news (without divulging the name of the architect, whose sensibilities diverged from his): "We have decided, Madame de Monzie and ourselves, to settle in the vicinity of Paris.... For lack of a house already built, we have found a plot of land in the Plaine de Garches and we will build."[12]

Le Corbusier's records indicate that the design process began with a call from Sarah on May 7, 1926, which produced a first brief.[13] It was Michael, however, who would eventually oversee all the details of the villa's construction, while Gabrielle was the legal owner.[14] From the beginning the plans suggest a shared lifestyle around a single living room-library, dining room, and kitchen, with separate apartments for the Steins, Gabrielle, and Jacqueline (pl. 119). Part of the architect's challenge was to give equal weight to each family's private spaces while accommodating rooms for guests, quarters for live-in staff, and the Steins' art collection. The villa went through several phases of substantial redesign over the following year.[15] The collaboration process appears to have been so successful that in the spring of 1927 Le Corbusier wrote to his mother:

> The villa [Stein] de Monzie...will be a masterpiece of purity, elegance, and science.... Our clients, Mr. and Mrs. Stein and Mrs. de Monzie, are the best we have had, having a carefully established program, many requirements, but these being satisfied, having a total respect for the artist, and better still, being people who

know what an artist's sensibility is made of and how much can be gained from it if it is well treated. They are the people who bought the first Matisses, and they seem to consider that their contact with Le Corbusier is also a special moment in their lives.

Papa Stein has been spending hours on-site *every day* observing everything. The house is clean and pure, far beyond anything we have done: a kind of obvious, indisputable manifesto … against which so many others struggle, denying and accusing.[16]

The house was constructed according to Le Corbusier's "five points," which became a credo of modern architecture: (1) pillars supporting concrete slabs; (2) roof gardens; (3) the open plan; (4) ribbon windows, designed to give maximal light to each room; and (5) the free facade, relieved of structural functions. Taking full advantage of the unique requirements of a two-family house and his clients' considerable resources, the architect was able to produce an elegant adaptation of this system and to implement his full vocabulary.

Seen from the street, or the north side, the house is what Le Corbusier called a pure prism,[17] with alternating bands of whitewashed concrete and glass providing a vertical rhythm.[18] Important to the success of the final design, the pillars are set back from the facade, allowing for long, unbroken rows of windows (pl. 118). When the house is viewed from the garden behind, or the south side, the proportion of concrete to glass is inverted, and the prism opens to a vast cube of air—the suspended terrace, which connects to the garden via an exterior staircase (pls. 122, 127).

The south half of the top floor is a roof garden, protected at either end by windscreens, one of which incorporates a picture window. Le Corbusier added an unusual freestanding picture window cum planter to create yet another framed view of the landscape. "We pause," he explained, "struck by such interrelation in nature, and we gaze, moved by this harmonious orchestration of space."[19] The roof's most sculptural element is a spiral staircase that ascends to an elliptical observation deck (pl. 125). It stands at the summit of the house like a captain's bridge on

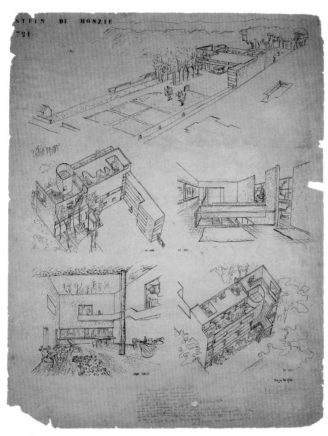

Plate 119

Plate 119
Le Corbusier, Preliminary studies for the Villa Stein-de Monzie, 1926.
Ink and graphite on tracing paper, 32¹¹⁄₁₆ x 25⁹⁄₁₆ in. (83 cm x 65 cm).
Fondation Le Corbusier, Paris (FLC 31480)

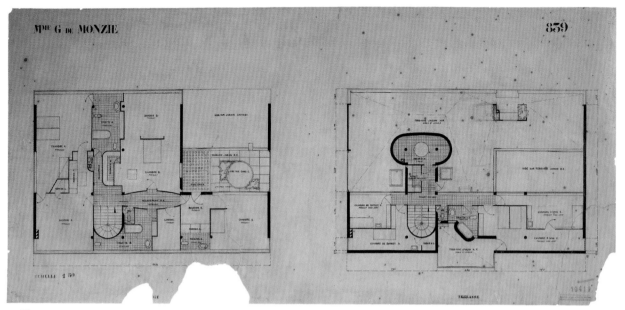

Plate 120

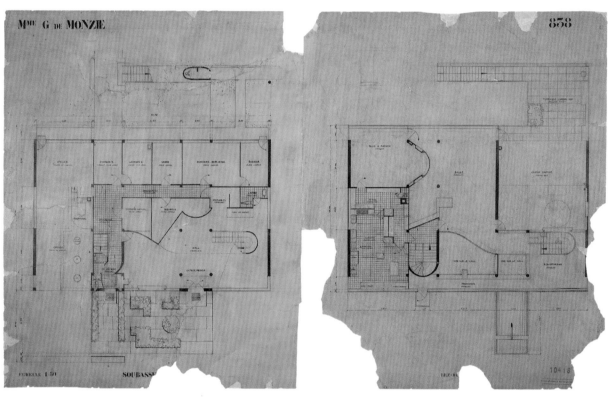

Plate 121

Plate 120

Le Corbusier and Pierre Jeanneret, Plans of the third floor and fourth floor with roof terrace of Villa Stein-de Monzie, 1927. Ink and graphite on tracing paper, 20$\frac{1}{16}$ x 41$\frac{3}{4}$ in. (51 x 106 cm). Fondation Le Corbusier, Paris (FLC 10419)

Plate 121

Le Corbusier and Pierre Jeanneret, Plans of the ground floor and main (second) floor of Villa Stein-de Monzie, 1927. Ink and graphite on tracing paper, 25$\frac{3}{16}$ x 41$\frac{5}{16}$ in. (64 x 105 cm). Fondation Le Corbusier, Paris (FLC 10418)

Le Corbusier and Pierre Jeanneret, Axonometric projection of the rear of Villa
Stein-de Monzie (southeast), 1927. Graphite and colored pencil on gelatin print mounted
on paper, 45¼ x 36⅝ in. (115 x 93 cm). Fondation Le Corbusier, Paris (FLC 10445)

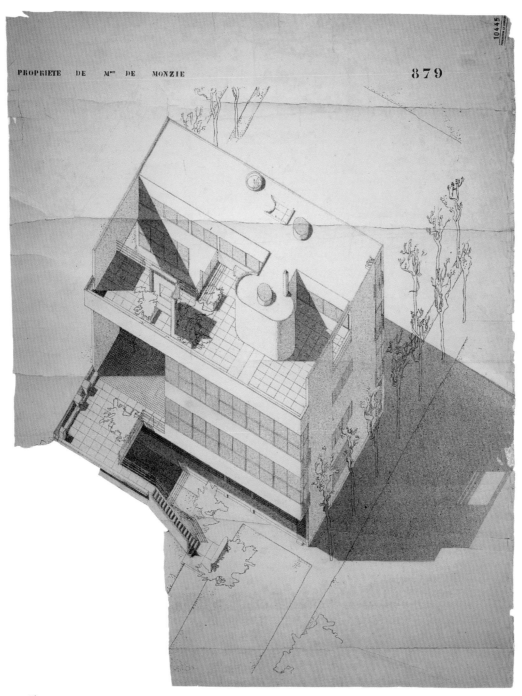

Plate 122

an ocean liner, reinforcing the nautical imagery of the streamlined facades and the gangplank-like stairway to the back garden. The room below the deck, originally intended to hold a water tank, served as a painting studio for Sarah. Planes of color in green and gray articulated many of the features and completed the exterior.[20]

Le Corbusier's use of the open plan inside the house allowed him to experiment freely with room partitions. The dining room wall evolved into a bow, and the void over the entrance hall acquired a shape reminiscent of a grand piano. Details such as curved and perforated walls; double-height ceilings and voids; rounded skylights; and the subtle use of clear, translucent, and opaque glass produced transitions, transparencies, and spatial ambiguities similar to those of Cubism and Le Corbusier's own purist paintings. Add to this the architect's color detailing of the interior, and it becomes clear that the Steins and Gabrielle inhabited an exploded purist painting framed within a rigid outer shell.

The house is but one part of an intricate composition that organizes the long, narrow lot, beginning with a gatehouse lodge that James Ward called "perhaps the finest worker's dwelling designed during the heyday of the International Style."[21] Le Corbusier placed the main house as a single block across the lot, thus dividing the property into two nearly equal sections, with the residence acting as a

node: in front, the realm of the automobile, with its straight driveway leading to the garage, and behind, the loose formality of the garden. As Dorothée Imbert observes, "Front and rear were balanced as if equal importance were accorded to driving and strolling."[22] Gertrude, who followed the process, wrote, "He decided she decided they decided that the house is not to be divided but to face out both ways."[23]

Costing nearly 1.5 million francs, Les Terrasses was the largest and most costly of Le Corbusier's private homes of the 1920s. An ultramodern house with the grandeur of a palace, it altered notions not only of luxury but also of openness, expanding what was permissible to see and share. Christian Zervos, reviewing the house for *Les cahiers d'art*, commented on "the realization of a plan that can surprise at first sight, but that introduces into architecture new elements and freedoms to which we will grow accustomed little by little."[24] Critic Sigfried Giedion pronounced, "The luxury of the villa is a luxury of the volume of air"; British architect Howard Robertson concluded that "the dominant impression…is that of light, and its play on harmonious form."[25]

While the edifice itself was significant as a consolidation of his research over the past ten years, the architect's promotion of the house had an even greater influence on contemporary work. He wrote a book about it, *A House—a Palace* (1928); devoted the lavishly illustrated spring-summer

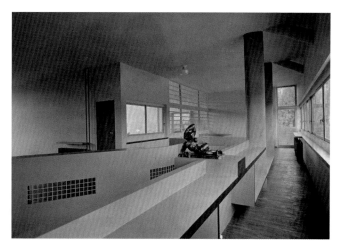
Plate 123

Plate 124

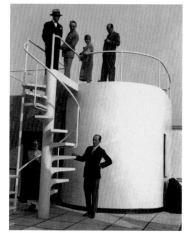
Plate 125

Plate 123
Interior of Villa Stein-de Monzie, Vaucresson, France, ca. 1927-28. Henri Matisse's *Reclining Nude I (Aurora)* (1907; pl. 150, cat. 204) is cantilevered over the void on a concrete base. Fondation Le Corbusier, Paris

Plate 124
Interior of Villa Stein-de Monzie with artworks by Henri Matisse, Vaucresson, France, ca. 1928. From left: *La Japonaise: Woman beside the Water* (1905; pl. 140), *Madeleine I* (1901; pl. 134, cat. 197), *Woman Leaning on Her Hands* (1905; cat. 201), *Small Head with Comb* (1907; cat. 205). David and Barbara Block family archives

Plate 125
Visitors tour the observation deck on the roof terrace of Villa Stein-de Monzie, Vaucresson, France, 1928. Top, from left: two unidentified men, Sophie Küppers, El Lissitzky. Bottom: Sarah Stein, Piet Mondrian. Fondation Le Corbusier, Paris

1929 issue of *L'architecture vivante* to the project; and collaborated on a documentary film featuring the villa, *Architecture d'aujourd'hui*, by Pierre Chenal (1930). In one scene, Le Corbusier drives up to the house in his state-of-the-art Voisin automobile and bounds inside, creating the "definitive image…of the modern spirit."[26]

In the early summer of 1928 the families began their new life at Les Terrasses. Michael was by this time sixty-three, Sarah fifty-eight, Gabrielle forty-six, and Jacqueline ten. "We love the house," wrote Sarah to Gertrude.[27] "We are resting and haven't hung a single picture. Last workman left today. The Cones [Claribel and Etta Cone] are here." "The air here is simply fine and smells like real country," enthused Michael.[28] Grandson Daniel Stein (b. 1927) and his nanny unexpectedly joined the household around 1930; Daniel's photo albums, which Michael had been methodically preparing since his birth, give a heretofore unpublished view of family life at Les Terrasses (pls. 126, 127).[29]

Visitors and critics flowed in from around the world, and Sarah and Michael were again at the center of a new movement. As Sarah had promoted Matisse, now Michael extolled the virtues of modern architecture. Among the first to tour the property were the artists Piet Mondrian and El Lissitzky, who were photographed with Sarah on the roof terrace (pl. 125). Gertrude sent the art critic Henry McBride, who relayed his personal impressions to Georgia O'Keeffe in America:

> It looks like a factory at first glance, with windows that go clear across like this [drawing]…and a facade that hides the sense of structure. The facade in fact is like a thin curtain, that is let down, for the real supports of the roof are the concrete pillars, that are well inside the house. There are queer things on the roof, which I find I forget and can't draw. The interior has many pleasing, novel, clean, hygienic hospital effects, but they are ruined, to my mind, because the Michael Steins would not part with their Louise Quinze [*sic*] furniture and it looks shabby and wrong. They have a lot of grand Matisses, however, which look right. It is a house for America, of course, as one such bit of modernity cannot do much for Paris.[30]

The villa showcased a mixture of both the Steins' antiques and Le Corbusier's built-in furnishings. Kitchen and bedrooms were outfitted with the most efficient integrated shelving and cabinets, while the living areas were designed to display the Steins' collection of books and bronze sculpture (pls. 123–24).

The Steins' Renaissance-style furniture was a point of debate, the only snag, it seems, in the architect-client relationship. Gertrude poked fun at Le Corbusier's attempts to persuade them to integrate the furnishings that he was beginning to develop with a talented new designer, Charlotte Perriand: "It is his wish that it should be furnished in that way as well. It is his wish that nothing that is not as long should be as short…. It is his wish that they would like to have it too."[31] Sarah felt that juxtaposing traditional objects with avant-garde paintings helped the viewer to see the paintings, which she knew could be disorienting.[32] The villa's revolutionary space could likewise be disorienting. Their antiques gave continuity to their lives and must have anchored them both visually and emotionally as they went about daily living in their futuristic architectural utopia.

Matisse dominated the surroundings. His portraits of Michael and Sarah (1916; pls. 83, 84, cat. 151, 152) graced the entrance hall, where antique *cassoni* held the latest phonograph records. The brightly dappled *Woman in a Kimono* (ca. 1906; pl. 90, cat. 135) leaned over the Aeolian player piano, which played *The Rite of Spring* on the original Stravinsky piano rolls.[33] The large bronze *Serf* (1900–1903; pl. 58, cat. 198) was positioned in a specially conceived niche by the stairway; *The Bay of Nice* (pl. 98, cat. 153) and *Landscape with Cypresses and Olive Trees near Nice* (pl. 165, cat. 154), both of 1918, completed the ground floor.

Upstairs in the salon and library, *Woman with a Hat* (1905; pl. 13, cat. 113) and *Tea* (1919; pl. 99, cat. 155) hung near several small Fauve landscapes and a recent acquisition, *Girl Reading* (ca. 1925; pl. 170, cat. 156). *La Pudeur (L'Italienne)* (1906; cat. 26) and *Faith, the Model* (ca. 1901; pl. 135, cat. 102) enlivened an area near the stairwell and radio post; *Interior with Dog* (1934; Baltimore Museum of Art), Matisse's latest masterpiece, which the Steins handled for the Cone sisters,

reigned over the dining room on its way to America. Sarah reserved her own paintings for the private spaces of the upstairs bedrooms.

The families inhabited their masterpiece for only seven years. Pushed by Hitler's rise to power and Michael's longing for his native country, they set their sights on California. In 1935 they sold Les Terrasses to a Danish banker, and the entire household—including Gabrielle, Jacqueline, and Daniel—moved to Palo Alto, "leaving bewildered friends and family behind," as Alice T. Friedman recounts.[34] Gertrude explained in *Everybody's Autobiography*, published two years later:

> Let me tell you about my brother.... About five years ago he said he wanted to go back to California but why I said what's the matter...oh he said you don't understand he said I want to say in English to the man who brings the letters and does the gardening I want to say things to them and have them say it to me in American. ...And he has sold his house, it was a bad time to sell and nobody could sell anything but he wandered around until he saw a man who looked as if he was looking for a house and he was and my brother said why not buy mine and he did and in a week they were gone.[35]

Les Terrasses was praised upon its completion as an audacious act of patronage and a milestone in the development of modern architecture. In 1932 it became a central example of the International Style when photographs of it were exhibited (along with Walter Gropius's Bauhaus buildings and Ludwig Mies van der Rohe's Barcelona Pavilion) at the Museum of Modern Art, New York.[36] After World War II, Le Corbusier negotiated with the United States government to acquire it as a "special embassy where Franco-American modern art would be shown to its advantage."[37] His attempts having failed, the house was subdivided into apartments in 1959. Even so, in 1975 Les Terrasses was declared a historical monument. It stands today at 17 rue du Professor Victor Pauchet in Vaucresson.

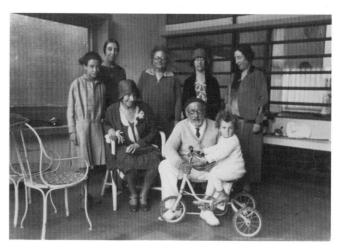

Plate 126

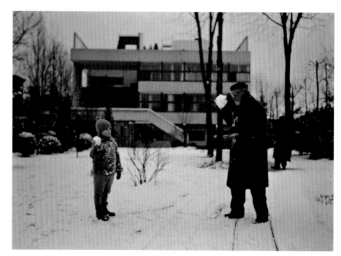

Plate 127

Plate 126
On the covered terrace of Villa Stein-de Monzie, Vaucresson, France, ca. 1930. Standing, from left: Jacqueline Colaço-Osorio, Yvonne Daunt Stein, Sarah Stein, unidentified woman, Gabrielle Colaço-Osorio. Sitting: unidentified woman, Michael Stein, Daniel Stein. Estate of Daniel M. Stein

Plate 127
Daniel and Michael Stein throwing snowballs in the backyard of Villa Stein-de Monzie, Vaucresson, France, 1933. Estate of Daniel M. Stein

Notes

1. Michael Stein to P. G. Byrne [1934], Yale Collection of American Literature, Beinecke Rare Book and Manuscript Library, Yale University (hereafter, Beinecke YCAL), MSS 76, box 135, folder 3047.

2. For accounts of Gabrielle and the Steins' history together, see Ward 1984, Dennis 1984, and Friedman 1998.

3. "The late Gabrielle Colaço-Osorio…used to say: 'Painting is an inferior art, mainly because it can be bought and sold, bartered and coveted. That is its taint. Literature and music are free from this commercialization.'" Daniel M. Stein to Alfred Frankenstein, draft, 1962, Estate of Daniel M. Stein.

4. Gertrude Stein introduced Le Corbusier to de Monzie in 1925. As minister of education and fine arts, he presided over the official inauguration of the Pavillon de l'Esprit Nouveau, arranging the removal of a high fence that exposition organizers had built around the pavilion to hide it from visitors. He also came to the rescue of the Cité Frugès, the architect's fraught workers' housing project in Pessac, near Bordeaux.

5. David Block (Gabrielle's grandson), interviews with the author, 2009-10, and Ward 1984, 84n67.

6. Jacqueline, a war orphan, was born January 13, 1918, to Georgette Coral, Gabrielle's young seamstress. Gabrielle's decision to adopt the child provoked a definitive rupture in the de Monzie marriage. Colaço-Osorio family history and records, provided by David Block.

7. For a detailed history of the pavilion, see Eliel 2001. The pavilion incorporated works of art by mutual Stein friends Juan Gris and Jacques Lipchitz, as well as those of Fernand Léger, Amédée Ozenfant, and Le Corbusier himself. Gris contributed *The Green Cloth* (1925; cat. 72), a new still-life painting that belonged to Gertrude Stein. Many of the pavilion's architectural innovations, such as roof terraces and built-in furniture, as well as provisions for the dramatic display of sculpture, would make their way into the Stein-de Monzie home.

8. The apartment buildings, both by local architect Edgar Mathews (1866-1946), were constructed in what was then a new residential section of the city. One of these—a spectacular block of three-story duplex houses at the corner of Washington and Lyon, completed in 1901—is described by James Ward (1984, 23) as an "innovational structure" in the shingle style novel to the West Coast and "an act of advanced urbanism." Ward, however, attributes the flats to Arthur Mathews, Edgar's brother. Biographical information on the Mathews family kindly provided by David Parry.

9. Lipchitz remembers recommending the architect to Michael Stein; see Patai 1961, 228.

10. La Roche's home was designed as a showplace for his collection of cubist and purist paintings, the cream of which he had acquired from auctions of works confiscated during the war from the Kahnweiler gallery. Le Corbusier and Ozenfant advised La Roche on his selection from these auctions, which the Steins also attended. The adjoining Jeanneret-Raaf house now houses the Fondation Le Corbusier, whose archives and collection informed this research and exhibition.

11. He wrote: "My Dear Gertrude, Jeanneret (the architect of Cook) told me that the corner lot next to Cooks is for sale and he is awfully afraid some ugly house will be plumbed up against Cook. You told me that Picasso had some thought of building. Could you perhaps suggest that he see Cook's house and perhaps the lot would suit him…Mike." Michael Stein to Gertrude Stein, n.d. [1926 or 1927, sent from 59 rue de la Tour, Paris 16e], Beinecke YCAL, MSS 76, box 125, folder 2722.

12. Sarah Stein to Henri Matisse, May 16, 1926, Archives Matisse, Paris.

13. Fondation Le Corbusier Archives, H1-4-159.

14. The architect's plans and drawings variously bear the names "De Monzie," "Stein," or "Stein-de Monzie," indicating the fluidity and interchangeability of the villa's ownership in the eyes of Le Corbusier's studio.

15. For in-depth studies of the evolution of the villa's design, see Dennis 1984, Ward 1984, and Benton 2007.

16. Le Corbusier to his mother, Marie-Charlotte-Amélie Jeanneret, March 5, 1927, Fondation Le Corbusier Archives, ELM R1 6 151. Indeed, for Le Corbusier the Stein-de Monzie commission couldn't have been better timed. His studio was then involved in the heated, highly publicized competition for the commission to build the League of Nations in Geneva, a symbolic combat pitting modern architecture against the academy. Les Terrasses served as a concrete example of his theories.

17. Unlike Le Corbusier's contemporaneous residences the Villa Cook (1926) or the Villa Savoye (1929-30), whose pillars are exposed on the ground floor, the Stein-de Monzie residence featured an enclosed facade that accommodated a garage, lodgings for staff, and a grand entry hall.

18. Le Corbusier used regulating lines and the section d'or, or golden rectangle, to bring mathematical precision to his composition of the house. See Le Corbusier 1929, 15-16.

19. Le Corbusier 1948, 7, as cited in Dennis 1984, 18.

20. See Hitchcock and Johnson 1966, 117, and *L'Architecture vivante*, Spring-Summer 1929, 15.

21. Ward 1984, 109.

22. Imbert 1993, 156.

23. G. Stein 1928; cited in Dusapin and Turrell 1997, 35-36.

24. Zervos 1928, 256.

25. Giedion 1928, 255; Robertson and Yerbury 1929, 83.

26. Benton 2007, 111. In this scene the Steins' grandson Daniel even pedals his own little car on the roof terrace.

27. Sarah Stein to Gertrude Stein, n.d. [late spring-early summer 1928], Beinecke YCAL, MSS 76, box 126, folder 2733.

28. Michael Stein to Gertrude Stein, n.d. [late spring-early summer 1928], Beinecke YCAL MSS 76, box 125, folder 2723.

29. "I first lived with my parents Allan and Yvonne Stein at their apartment on Rue Copernic in Paris, and then later in a house in the suburb of La Celle St. Cloud, and when they were divorced about 1930, I went to live with my paternal grandparents at Les Terrasses until 1935 when we returned to the United States." Daniel Stein to Irene Gordon, July 22, 1974, Estate of Daniel M. Stein. Gabrielle accommodated by moving into the penthouse suite designed for guests, leaving her spacious bedroom to the *enfant roi* of the house.

30. Henry McBride to Georgia O'Keeffe, July 19, 1928, published in Watson 2000, 176-77.

31. From "Hurlbut," published in G. Stein 1955, 308-9, as indicated in Dydo and Rice 2003, 137.

32. Dr. Stanley Steinberg (friend of Sarah Stein), interview with the author, 2009.

33. E. T. Cone 1973, 453.

34. Friedman 1998, 119.

35. G. Stein 1971, 13-14.

36. The *International Exhibition of Modern Architecture*, organized by Henry-Russell Hitchcock and Philip Johnson, identified characteristics common to Modernism across the world and presented examples of its finest achievements. The author's inventory of Daniel Stein's library brought to light a copy of Hitchcock's *Modern Architecture: Romanticism and Reintegration* (1929), dedicated "With profound respect and admiration to the builders and owners of Les Terrasses/Henry-Russell Hitchcock Jr./September 1931."

37. Le Corbusier to V. Chabas, July 26, 1948, Fondation Le Corbusier Archives, H1-4-194 (my translation).

Plate 128

Plate 128, cat. 9
Paul Cézanne, *Portrait of Paul, the Artist's Son*, ca. 1880. Oil on canvas, 6¾ x 6 in. (17.1 x 15.2 cm). The Henry and Rose Pearlman Foundation; on long-term loan to Princeton University Art Museum

Sarah and Michael Stein were the top bidders for this tiny Cézanne at a spring 1907 auction of pictures owned by the dentist Georges Viau. Years later, when the couple considered buying a house on the French Riviera, they offered to sell it and a similarly petite Renoir (cat. 403) to the Cone sisters. In 1924 Claribel wrote to Etta Cone: "Did you see the house 'villa' the Steins want… and is it worth the 'Renoir' and the 'Cézanne' baby head? Which would you rather have, a villa or a picture?" (in Rewald 1996, 312).

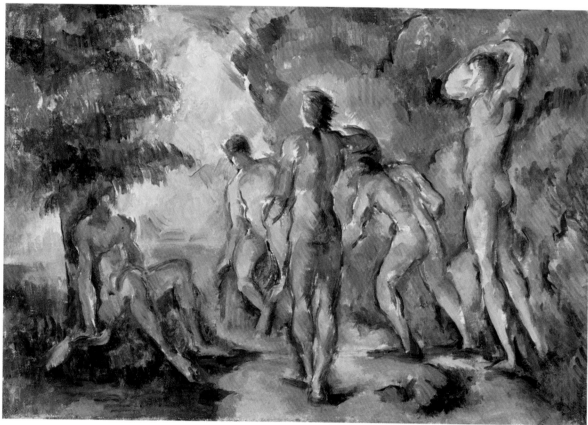

Plate 129

Plate 129, cat. 11
Paul Cézanne, *Bathers*, ca. 1892. Oil on canvas, 8¹¹⁄₁₆ x 13 in. (22 x 33 cm). Musée d'Orsay, Paris, on deposit at
the Musée des Beaux-Arts, Lyon

In October 1904 Leo and Gertrude purchased two of Cézanne's Bathers paintings. Sometime
during the next few years, Sarah and Michael acquired this version for themselves. Matisse also
owned a Bathers picture (pl. 115), which the Steins first saw at the 1904 Salon d'Automne and
subsequently encountered at Matisse's home and school. Max Weber, one of the students at the
Académie Matisse, recalled that "with great modesty and deep inner pride he showed us his
painting [*Three*] *Bathers* by Cézanne. His silence before it was more evocative and eloquent than
words" (Weber 1951, 14).

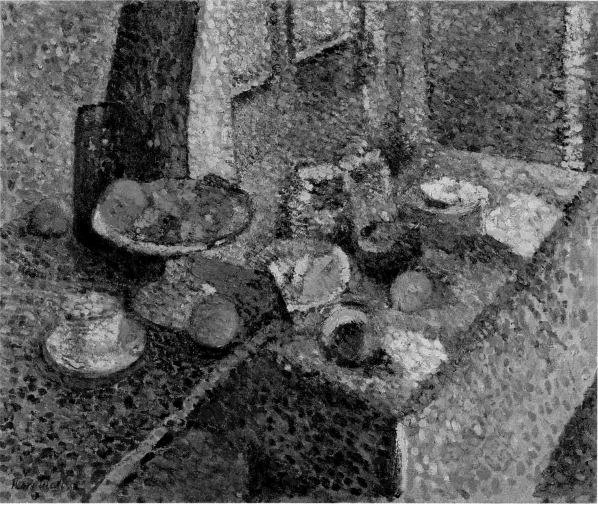

Plate 130

Plate 130, cat. 98
Henri Matisse, *Sideboard and Table,* **1899.** Oil on canvas, 26⅝ x 32½ in. (67.5 x 82.5 cm). Kunsthaus Zürich, gift of the Holenia Trust in memory of Joseph H. Hirshhorn with support from Rolf and Margit Weinberg

Sideboard and Table begins to appear in photographs of rue Madame around 1910 (see pl. 369). Sarah and Michael's acquisition of this early canvas suggests that they were attempting to collect the full range of the artist's work, as his style had already evolved in a different direction by the time he met the couple in 1905. Sarah remembered from a conversation with Matisse that he felt that the pointillist technique "was not his vein, not only because there was no line… but because he did not represent color but created color" (Fiske Kimball to R. Sturgis Ingersoll, February 25, 1947, PMA Kimball Papers).

Plate 131, cat. 106
Henri Matisse, *Still Life with Blue Jug,* **ca. 1900-1903.** Oil on canvas, 23 x 25 in. (58.4 x 63.5 cm). San Francisco Museum of Modern Art, bequest of Matilda B. Wilbur in honor of her daughter, Mary W. Thacher

Matisse's still lifes were of particular interest to Sarah and Michael, and they owned at least seven of them. This early composition, acquired around 1907, would have appealed to Sarah as a student of painting. Featuring a simple tabletop arrangement of earthenware vessels and fruit, the canvas shows Matisse assimilating the lessons of Cézanne: solidly rendered objects in primary colors and paint applied in diagonal, parallel brushstrokes. Cézanne was fundamental to Matisse's teaching. As Sarah recorded in her notes from the Académie Matisse, "Cézanne used blue to make his yellow tell, but he used it with the discrimination, as he did in all other cases, that no one else has shown" ("Sarah Stein's Notes, 1908," in Flam 1995, 52).

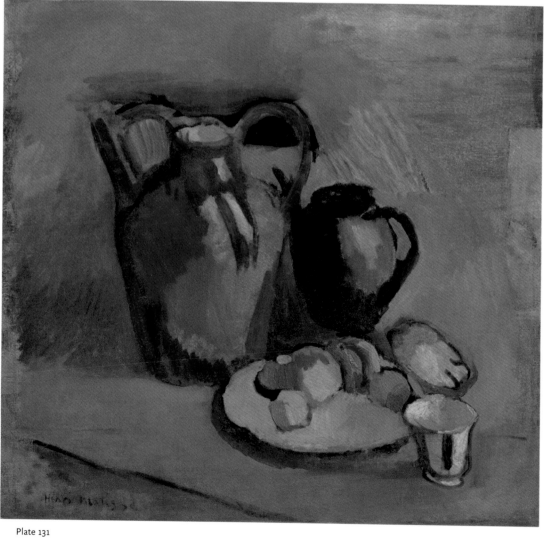

Plate 131

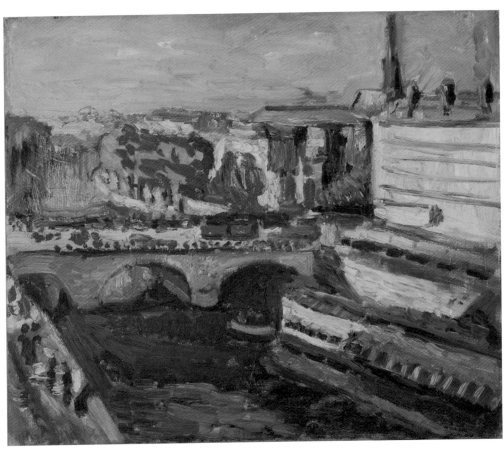

Plate 132

Plate 132, cat. 105
Henri Matisse, *Pont Saint-Michel*, 1901–2. Oil on canvas, 18¼ x 22 in. (46.7 x 55.9 cm). Isabelle and Scott Black Collection

Matisse and his family moved to 19 quai Saint-Michel in early 1899. From his perch above the Seine, the artist made several paintings of the views east toward Notre Dame and west toward Pont Saint-Michel. Matisse would continue working in his Saint-Michel studio until the fall of 1905, when he rented space in a former convent at 56 rue de Sèvres. Soon after the 1905 Salon d'Automne ended in November, Leo brought Sarah and Michael to rue de Sèvres to meet the artist for the first time.

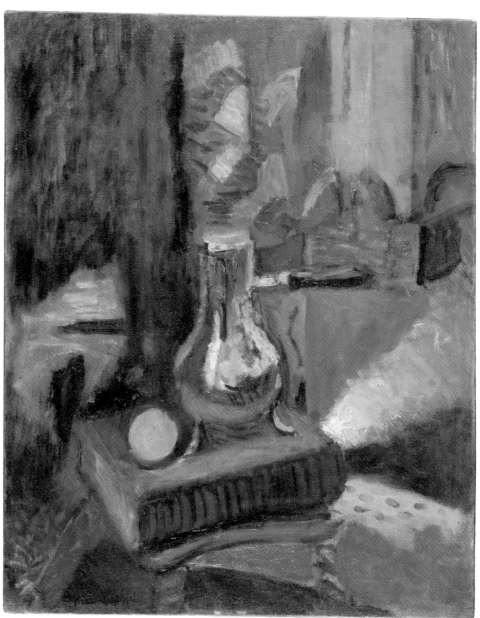

Plate 133

Plate 133, cat. 104

Henri Matisse, *Still Life with Chocolate Pot*, 1900-1902. Oil on canvas, 28¾ x 23⅜ in. (73 x 59.4 cm). Musée National d'Art Moderne, Centre Georges Pompidou, Paris, gift of Alex Maguy-Glass, 2002

Matisse explained to his students that the quality and interrelations of color are particularly important when painting a still life. "When the eyes become tired and the rapports seem all wrong, just look at an object. 'But this brass is yellow!' Frankly put a yellow ochre, for instance on a light spot, and start out from there freshly again to reconcile the various parts. To copy the objects in a still life is nothing; one must render the emotion they awaken in him" ("Sarah Stein's Notes, 1908," in Flam 1995, 51).

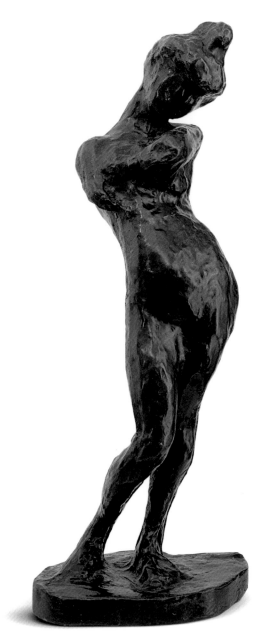

Plate 134

Plate 134 [cat. 197B]
Henri Matisse, *Madeleine I*, **1901.** Bronze, 21½ x 7⅝ in. (54.6 x 17.2 cm). San Francisco Museum of Modern
Art, bequest of Harriet Lane Levy

Although Matisse had no formal training as a sculptor, he created approximately eighty bronzes
during his lifetime. *The Serf* (1900–1903; pl. 58) and *Madeleine I* were the first to be completed, and
Sarah and Michael owned examples of both (cat. 197, 198). They acquired the plaster of *Madeleine I*
by 1908, and a bronze cast by 1925. In one early photo of the rue Madame apartment (pl. 365),
the plaster of the sinuous nude with her exaggerated *contrapposto* stance is perched atop a built-
in wardrobe, just above a *Bathers* lithograph by Paul Cézanne (1897; pl. 51) and adjacent to
Matisse's monumental painting *Le Luxe I* (1907; pl. 101).

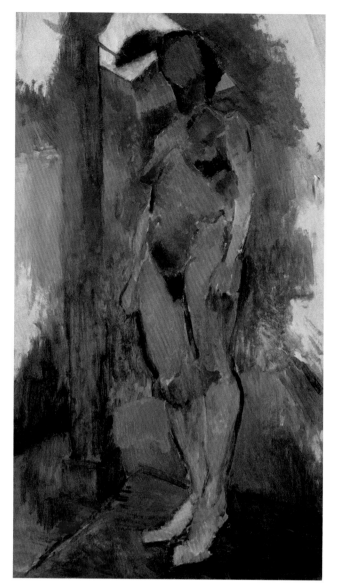

Plate 135

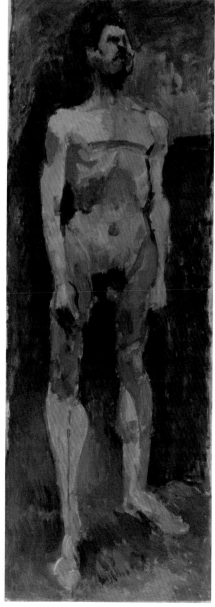

Plate 136

Plate 135, cat. 102

Henri Matisse, *Faith, the Model,* **ca. 1901.** Oil on canvas, 31 x 17½ in. (78.7 x 44.5 cm). Fine Arts Museums of San Francisco, bequest of Aurelie Henwood to the de Young Museum in memory of Lucille and Gardner Dailey

Studying the human figure and painting from life were fundamental to Matisse's practice. When Sarah and Michael first hung this study of a nude model at 58 rue Madame in 1906, the canvas included unpainted areas at left and right (see pl. 362). Sometime between 1916 (Dauberville 1995, no. 36) and the end of 1930 (photograph of Villa Stein-de Monzie by F. Yerbury), these side areas were cropped from the painting, resulting in a more "finished" work of art.

Plate 136, cat. 100

Henri Matisse, *Male Nude,* **1900-1901.** Oil on canvas, 32⁵⁄₁₆ x 11⁷⁄₁₆ in. (82 x 29 cm). Musée Cantini, Marseille

Matisse first gave this rendering of the model Bevilaqua to the artist Jean Biette, who later recalled: "Around 1906, Mrs. Stein, having seen the canvas *chez moi* in Boulogne, desired to acquire it; it's then that Matisse, having found the N. Dame canvas and judging it a good thing, had it relined and gave it to me in exchange" (Jean Biette to Marguerite Matisse, August 20, 1931, Archives Matisse, Paris). Sarah subsequently described the model as embodying "determination" (Stanley Steinberg to Carrie Pilto and Janet Bishop, August 16, 2010).

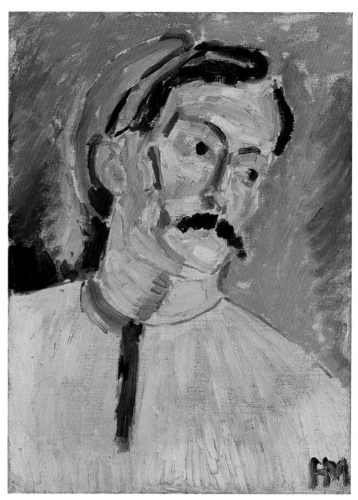

Plate 137

Plate 137, cat. 107
Henri Matisse, *André Derain*, **1905.** Oil on canvas, 15½ x 11⅜ in. (39.4 x 29 cm). Tate, London, purchased with assistance from the Knapping Fund, the Art Fund and the Contemporary Art Society and private subscribers, 1954

Matisse and Derain painted each other's portraits with brilliant colors and "affectionate violence" in the summer of 1905 (Raymond Escholier, in Klein 2001, 122). Gertrude recalled that "Derain was a very young man at that time, he enormously admired Matisse, he went away to the country with them to Collioure near Perpignan, and he was a great comfort to them all" (G. Stein 1990, 38). Although Sarah and Michael never purchased any of Derain's work, they acquired this portrait of him through Galerie Druet in late October 1908.

Plate 138, cat. 131
Henri Matisse, *Self-Portrait*, **1906.** Oil on canvas, 21⅝ x 18⅛ in. (55 x 46 cm). Statens Museum for Kunst, Copenhagen, gift of Johannes Rump, 1928

Sarah and Michael purchased this work in late 1906, soon after its creation. While Gertrude Stein found the informal portrait "too intimate to be shown publicly" (Golson 1970, 43), Sarah and Michael likely considered it an example of Matisse's newfound self-assurance as leader of the Fauve movement. In 1907 Matisse borrowed it back from the Steins for a group exhibition, *Portraits d'hommes*, at Galerie Bernheim-Jeune.

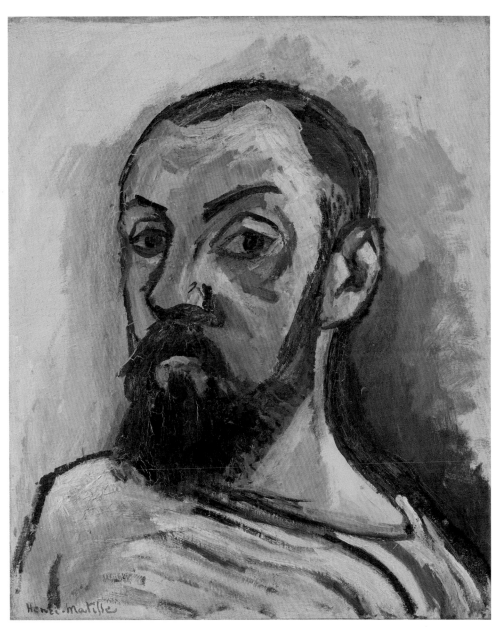

Plate 138

Plate 139

Plate 139, cat. 161
Henri Matisse, *Madame Matisse in the Olive Grove,* **1905.** Ink and graphite on paper, 8⅛ x 10⅝ in.
(20.6 x 26.6 cm). Frances and Michael Baylson, Philadelphia

After the Philadelphia Museum of Art's director, Fiske Kimball, visited Sarah in 1947, he
described this work to a friend as "a beautiful little drawing, like Van Gogh, but delicate, of
Mme. Matisse walking in the garden, a special favorite of his, which she [Sarah] selected
when he begged her to give him the samovar [depicted] in *Le Thé* [*Tea*, pl. 99], in return for a
drawing" (Fiske Kimball to R. Sturgis Ingersoll, February 25, 1947, PMA Kimball Papers).
This drawing features the same subject and composition as an oil that the Steins had purchased
in spring 1906 (cat. 111).

Plate 140, cat. 108
Henri Matisse, *La Japonaise: Woman beside the Water,* **1905.** Oil and graphite on canvas. 13⅞ x 11⅛ in.
(35.2 x 28.2 cm). The Museum of Modern Art, New York, purchase and partial anonymous gift, 1983

Matisse's wife, Amélie, posed for this work in the summer of 1905. The canvas was one of
ten that Matisse exhibited a few months later at the Salon d'Automne, where the Steins first saw
another image of his wife, *Woman with a Hat* (1905; pl. 13). In a published retort to Gertrude
Stein's *Autobiography of Alice B. Toklas*, Matisse described his wife as "a very lovely Toulousaine,
erect, with a good carriage and the possessor of beautiful dark hair, that grew charmingly,
especially at the nape of the neck. She had a pretty throat and very handsome shoulders. She
gave the impression, despite the fact that she was timid and reserved, of a person of great
kindness, force and gentleness" (Braque et al., 1935, 3).

Plate 140

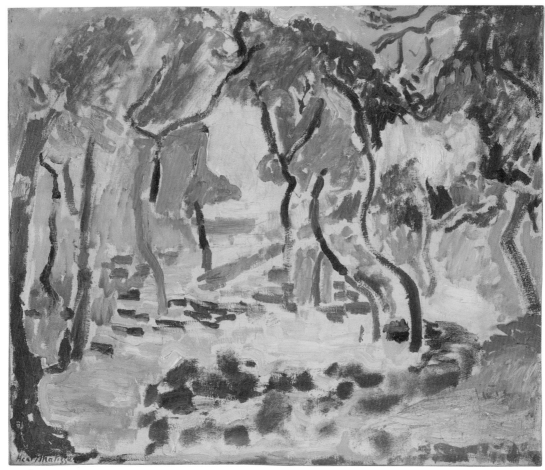

Plate 141

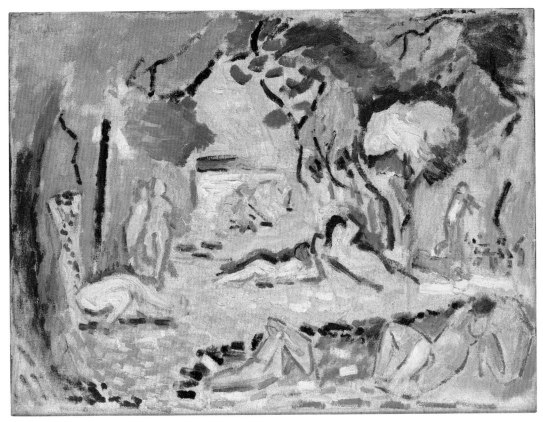

Plate 142

Plate 141, cat. 109
Henri Matisse, *Landscape near Collioure* [Study for *Le Bonheur de vivre*], 1905. Oil on canvas, 18⅛ x 21⅝ in.
(46 x 54.9 cm). Statens Museum for Kunst, Copenhagen, gift of Johannes Rump, 1928

Plate 142, cat. 116
Henri Matisse, Sketch for *Le Bonheur de vivre*, 1905-6. Oil on canvas, 16 x 21½ in. (40.6 x 54.6 cm).
San Francisco Museum of Modern Art, bequest of Elise S. Haas

Sarah and Michael owned a number of oil sketches for *Le Bonheur de vivre*, also called *The Joy
of Life* (1905-6; pl. 15). The example at left was purchased from Matisse's solo exhibition at Galerie
Druet in Paris in the spring of 1906—a moment when the monumental painting was under
critical attack at the Salon des Indépendants. Soon afterward, in late April, the couple sailed for
America in order to assess the property damage caused by the San Francisco earthquake.
When they returned to Paris in mid-November, *Le Bonheur de vivre* was hanging in Leo and
Gertrude's atelier at 27 rue de Fleurus.

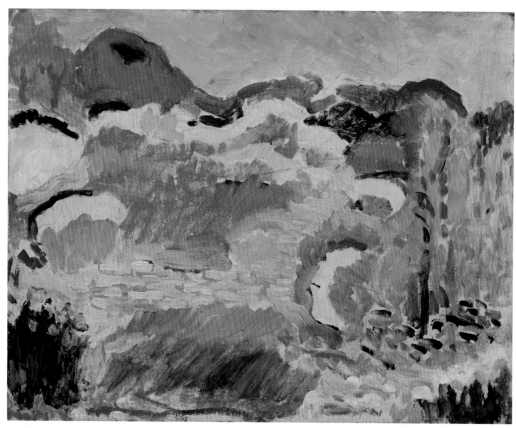

Plate 143

Plate 143, cat. 119

Henri Matisse, *Landscape: Broom,* **1906.** Oil on panel, 12 x 15⅝ in. (30.5 x 39.7 cm). San Francisco Museum of Modern Art, bequest of Elise S. Haas

Like the seascapes on the facing page, *Landscape: Broom* dates from Matisse's second summer in Collioure. The painting began as a pencil sketch on a wooden panel but was freely recast as the artist applied pigment. The finished work is a result of Matisse's enthusiastic experimentation with different ways of constructing form with color, revealing the artist's rapport with the landscape based on emotional and visual primacy. As Matisse shared with his students, a landscape was to be selected "for certain beauties—spots of color, suggestions of composition. Close your eyes and visualize the picture; then go to work, always keeping these characteristics the important features of the picture" ("Sarah Stein's Notes, 1908," in Flam 1995, 50).

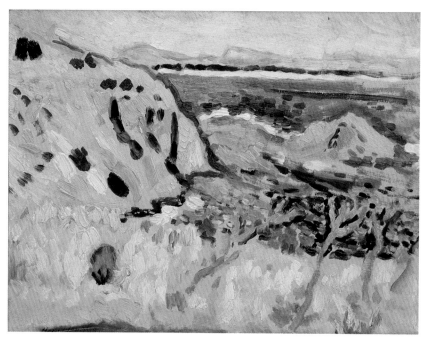

Plate 144

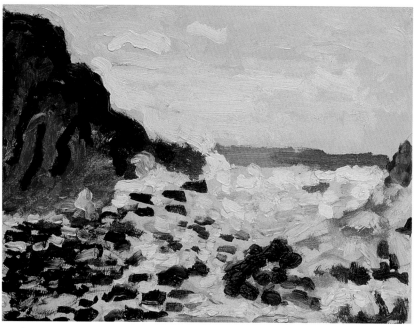

Plate 145

Plate 144, cat. 129
Henri Matisse, *Seascape (La Moulade)*, **1906.** Oil on cardboard mounted on panel, 10¼ x 13¼ in. (26 x 33.7 cm).
San Francisco Museum of Modern Art, bequest of Mildred B. Bliss

Plate 145, cat. 128
Henri Matisse, *Seascape (Beside the Sea)*, **1906.** Oil on cardboard mounted on panel, 9⅝ x 12¾ in. (24.5 x 32.4 cm).
San Francisco Museum of Modern Art, bequest of Mildred B. Bliss

These two paintings feature the Mediterranean coastline's characteristic *moulades*, or rocky
protrusions, and were likely made *en plein air* atop the artist's paint box (Freeman 1990, 22). Sarah
and Michael acquired them in the winter of 1908-9, often hung them as a pair, and even lent
them out for study purposes. In April 1910 Georgette Agutte, whose politician husband Marcel
Sembat was then Matisse's principal French supporter, wrote to the artist: "I brought back the little
seascape and please thank Mr. and Mrs. Stein for me most warmly for having so graciously lent
it to me. I believe that you will like my copy [location unknown], Marcel is very pleased with it—
I am looking for a frame" (Georgette Agutte to Henri Matisse, April 2, 1910, in Phéline and Baréty
2004, 88-89).

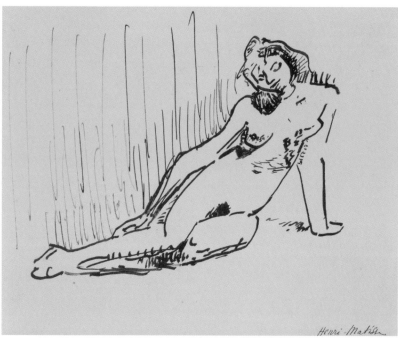

Plate 146

Plate 147

Plate 146, cat. 167
Henri Matisse, *Reclining Nude,* **ca. 1906.** Ink on paper, 12¾ x 15½ in. (32.4 x 39.4 cm). Anne and Stephen Rader, USA

In the winter of 1905-6 Leo brought Sarah and Michael to Matisse's studio for the first time, at which point the couple met the Matisse family and purchased this drawing. According to Sarah, who shared the story with her friend Jeffrey Smith, Matisse was "pleased with her selection and with her understanding of his work, and from that day their friendship was established" (Jeffrey Smith to Fiske Kimball, February 8, 1948, PMA Kimball Papers). *Reclining Nude* was one of several works by Matisse that Sarah and Michael took to America on their 1906 visit.

Plate 147, cat. 169
Henri Matisse, *Woman Leaning on Her Elbow,* **1906-7.** Ink on paper, 10¼ x 8¼ in. (26 x 21 cm). San Francisco Museum of Modern Art, bequest of Elise S. Haas

Matisse often inscribed his drawings to friends and patrons, generously acknowledging those who supported him. In this case Sarah, in turn, wrote directly on the artist's drawing, "To Elise from Sarah with love," when she gave it to her friend Elise Haas in the 1940s.

Plate 148, cat. 168
Henri Matisse, *Seated Nude,* **ca. 1906.** Pastel and ink on vellum, 29⅜ x 21½ in. (74.3 x 54.6 cm). Collection Jan Krugier

Matisse is thought to have exchanged this dynamic figure drawing for a paisley-patterned shawl owned by Sarah (Janet Bishop, conversation with Diane Jacobs Moore, July 16, 2009). The Steins acquired the piece close to the time it was made, and Sarah kept it throughout her life, eventually displaying it in the foyer of her Palo Alto home.

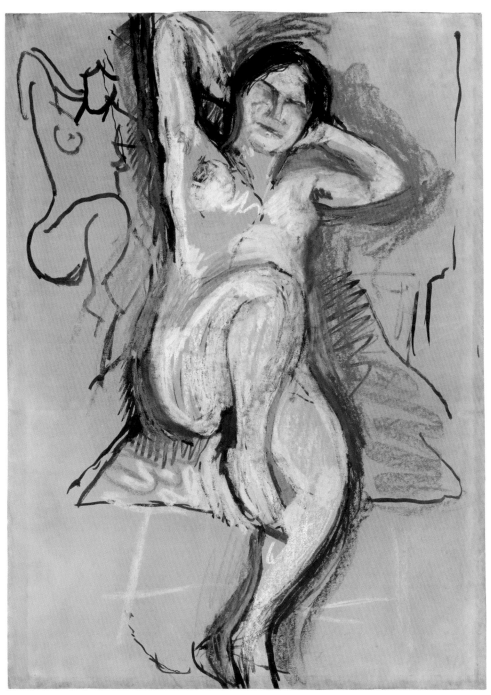

Plate 148

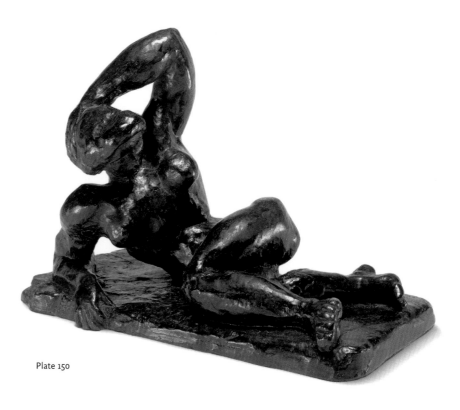

Plate 150

Plate 149

Plate 149, cat. 207
Henri Matisse, *Study of a Foot*, ca. 1909. Plaster, 13½ in. (34.3 cm) high. Dr. and Mrs. Maurice Galanté

Matisse taught his students that feet count enormously, urging them to think of the foot as "a bridge." The artist advised that when making sculpture, "the joints, like wrists, ankles, knees and elbows must show that they can support the limbs.... Above all, one must be careful not to cut the limb at the joints, but to have the joints an inherent part of the limb" ("Sarah Stein's Notes, 1908," in Flam 1995, 46, 49). Sarah treasured this plaster cast and in the 1940s presented it to her friend Maurice Galanté.

Plate 150 [cat. 204]
Henri Matisse, *Reclining Nude I (Aurora)*, 1907. Bronze, 13¹⁄₁₆ x 19¾ x 11 in. (34.4 x 49.9 x 27.9 cm). Raymond and Patsy Nasher Collection, Nasher Sculpture Center, Dallas

In 1926, Sarah and Michael hired Le Corbusier to design the Villa Stein-de Monzie, a large modern home outside Paris. The progressive architect was dismissive of the Steins' antique Italian furniture and oriental rugs, and indifferent to their paintings. Le Corbusier was inspired, however, by their collection of Matisse sculpture. He not only designed special display spaces for it within the house but also featured their cast of *Reclining Nude I* (cat. 204) in architectural renderings and official photographs of the villa's interior (pl. 123).

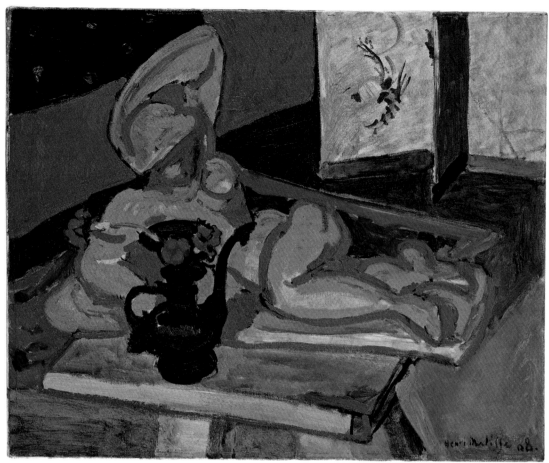

Plate 151

Plate 151, cat. 146

Henri Matisse, *Sculpture and Persian Vase,* **1908.** Oil on canvas, 23⅞ x 29 in. (60.6 x 73.7 cm). The National Museum of Art, Architecture, and Design, Oslo

Sarah and Michael purchased this canvas from Galerie Bernheim-Jeune in early October 1908. Matisse moved fluidly between two and three dimensions: the same figure appears in both the sculpted *Reclining Nude I (Aurora)* opposite and the monumental painting *Blue Nude: Memory of Biskra* (1907; pl. 27), owned by Leo and Gertrude. Matisse also regularly depicted his sculpture in his paintings. In *Sculpture and Persian Vase,* the bronze functions as both a female nude and a still-life prop in dialogue with the curved vessel in the foreground.

Plate 152

Plate 153

Plate 152, cat. 123
Henri Matisse, Sketch for *Marguerite Reading*, **1906.** Oil on canvas, 5¼ x 5½ in. (13.3 x 14 cm).
Private collection

Plate 153, cat. 165
Henri Matisse, *Marguerite in Three Poses*, **1906.** Ink on paper, 10 x 15⅝ in. (25.4 x 39.7 cm). San Francisco
Museum of Modern Art, bequest of Elise S. Haas

Sarah and Michael were close to the entire Matisse family. The artist's daughter Marguerite
was a little more than a year older than their son, Allan, and the two children were regular
playmates around this time—making it especially meaningful for the Steins to own works with
Marguerite as a subject. The image of *Marguerite Reading* is a relatively raw, tiny study for a
1906 canvas now at the Musée de Grenoble, while the sinuous line drawing *Marguerite in Three
Poses* shows the girl with the black ribbon she often wore to hide a scar on her throat.

Plate 154

Plate 154, cat. 101

Henri Matisse, *Marguerite,* **1901.** Oil on cardboard, 28 x 21¾ in. (71.1 x 55.3 cm). Private collection, San Francisco

Matisse was a struggling artist when he began this portrait of his daughter Marguerite around the time of her seventh birthday. After falling ill in July 1901, she suffered through an emergency tracheotomy and soon afterward a bout of typhoid fever. Marguerite is thought to have posed for her father while convalescing. Sarah Stein purchased this canvas within a year or two of meeting Matisse and displayed it prominently in each of her residences before selling it to her friend Lionel Steinberg in the late 1940s.

Plate 155

Plate 155
Henri Matisse, *Allan Stein*, ca. 1907. Oil on canvas, 21⅝ x 18⅛ in. (55 x 46 cm). Kaiserman Family

Plate 156
Henri Matisse, *Boy with Butterfly Net*, 1907. Oil on canvas, 69¾ x 45¹⁵⁄₁₆ in. (177.2 x 116.7 cm).
Minneapolis Institute of Arts, The Ethel Morrison Van Derlip Fund

Matisse and the young Allan Stein shared a mutual affection, and the artist portrayed the boy in
a number of pictures. Allan is depicted wearing a sailor sweater in the painting above, while
at right he is shown with a butterfly net given to him by his uncle Leo. A contemporaneous letter
from Sarah to Amélie Matisse, sent from Fiesole while on holiday, captures the warm tenor
of the families' friendship: "Allan is collecting butterflies; my sister-in-law is baking her skin to
well done in the sun; my dear husband is playing father of the family, and is very well" (undated
[summer 1907], Archives Matisse, Paris).

Plate 156

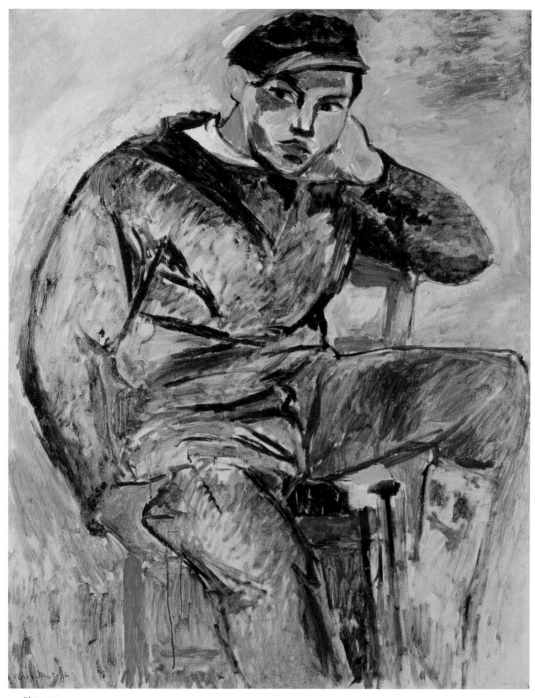

Plate 157

Plate 157, cat. 133
Henri Matisse, *The Young Sailor I,* **1906.** Oil on canvas, 39¼ x 32¼ in. (100 x 78.5 cm). Private collection

In the summer of 1906 Matisse painted two canvases representing a young fisherman he had
met in Collioure. Leo recalled that Matisse brought both canvases back to Paris with him: "At
first he pretended that [the second version] had been made by the letter-carrier of Collioure,
but finally admitted that it was an experiment of his own. It was the first thing he did with forced
deformations" (L. Stein 1996, 192). After Matisse showed both versions to the Steins, Sarah
and Michael chose to acquire the sketchy and fairly realistic *Young Sailor I* (above) rather than the
more stylized *Young Sailor II* (1906; Metropolitan Museum of Art, New York).

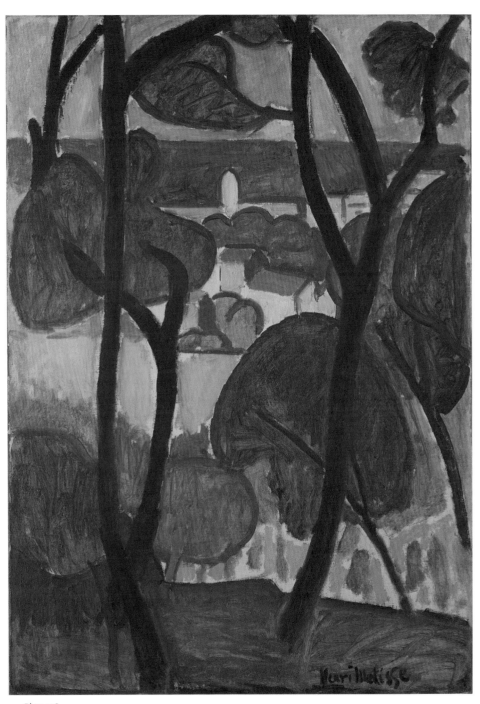

Plate 158

Plate 158, cat. 145

Henri Matisse, *View of Collioure*, **1907.** Oil on canvas, 36¼ x 25⅞ in. (92 x 65.5 cm). The Metropolitan
Museum of Art, New York, Jacques and Natasha Gelman Collection, 1998

Matisse is thought to have painted this work from a rocky lookout point near his rented
studio in Collioure. The canvas was one of several he submitted to the 1907 Salon d'Automne,
where critics praised him for his use of color and the "serene beauty" of his simplified
landscapes (Jean-Aubry 1907, 340; Fourcade and Monod-Fontaine 1993, 444). *View of Collioure*
was soon acquired by Sarah and Michael, who were then in their heyday as collectors of
Matisse's work. Seven years later, they loaned nineteen paintings—including this canvas—to
a Matisse exhibition at Kunstsalon Fritz Gurlitt in Berlin. The pictures remained in Germany
when war was declared, and ultimately the Steins opted to sell the works.

Plate 159

Plate 160

Plate 159, cat. 212
Henri Matisse, Painted ceramic plate, ca. 1908. 9¼ in. (23.5 cm) diameter. Philadelphia Museum of Art: purchased with Museum funds, 1949

Plate 160, cat. 211
Henri Matisse, Painted ceramic vase, ca. 1907. 9⁷⁄₁₆ x 7⁷⁄₈ in. (24 x 20 cm). Trina and Billy Steinberg, Los Angeles

Matisse was one of many artists who decorated ceramics that André Methey (later spelled "Metthey") made at his studio in Asnières, northwest of Paris. Methey helped revive the art form and exhibited some one hundred of these colorful, tin-glazed works in the 1907 Salon d'Automne. Sarah and Michael Stein owned several figure-painted ceramics by Matisse, and typically displayed them with their Asian ceramics. Sarah later wrote to a friend of "an afternoon when Monsieur Matisse came in on his way home from the Céramiste full of ideas for other plates. He picked up a few sheets of Allan's school paper and made some sketches of what he had in mind" (Sarah Stein to Charles Lindstrom, April 4, 1941, SFMOMA Permanent Collection Object File: 62.429). In 1949 Sarah gave the vase as a wedding present to her friends Louise and Lionel Steinberg.

Plate 161, cat. 147
Henri Matisse, *Fontainebleau Forest (Autumn Landscape)*, 1909. Oil on canvas, 23⅝ x 29 in. (60 x 73.5 cm). Private collection

Matisse made this painting, which depicts a clearing in the vast Fontainebleau forest southeast of Paris, during the period when he was teaching hundreds of young artists at his Académie Matisse. He shared his inspiration for such subjects: "Nature excites the imagination to representation. But one must add to this the spirit of the landscape in order to help its pictorial quality. Your composition should indicate the more or less entire character of these trees, even though the exact number you have chosen would not accurately express the landscape" ("Sarah Stein's Notes, 1908," in Flam 1995, 50–51).

Plate 161

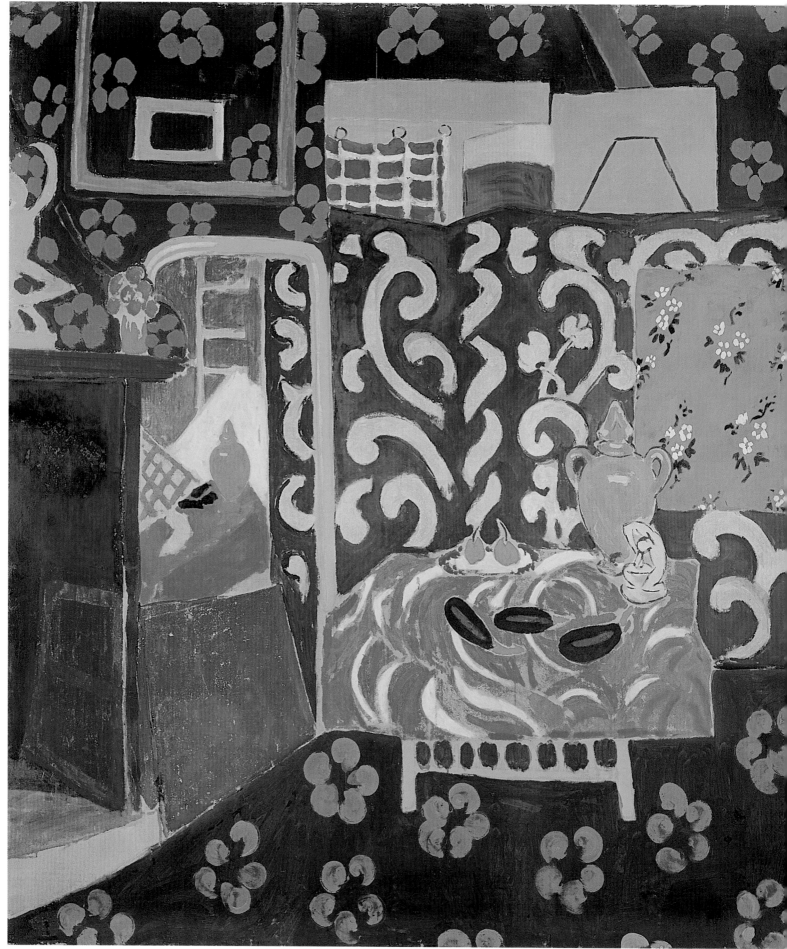

Plate 162

Plate 162, cat. 149

Henri Matisse, *Interior with Aubergines,* **1911.** Distemper on canvas, 82⅜ x 96⅞ in. (212 x 246 cm).
Musée Grenoble, gift of the artist, 1922

In a letter written in late 1911, Michael announced to Claribel Cone that "we have a great big
new Matisse decoration about 8 x 10 feet which has necessitated our rearranging our
room entirely" (Michael Stein to Claribel Cone, received January 5, 1912, BMA Cone Papers).
Photographs of their rue Madame apartment show *Interior with Aubergines* displayed in
the artist's original flower-patterned painted frame (see pl. 21). In late 1916, when Sarah and
Michael contemplated returning to the United States during the war and their collection
was sought after by dealers and collectors, Matisse offered to buy back the painting for the
original purchase price. He reacquired it in November 1917 and presented it to the Musée
de Grenoble in 1922.

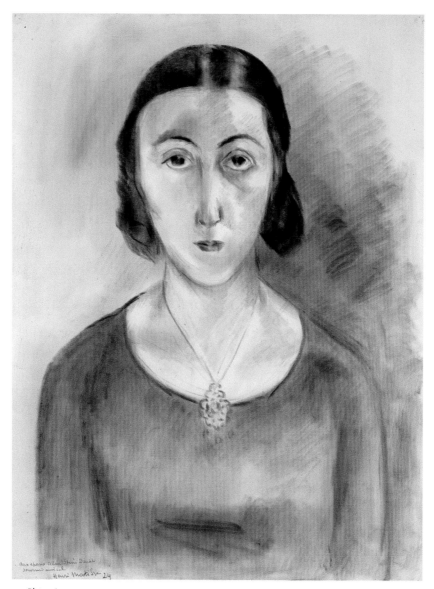

Plate 163

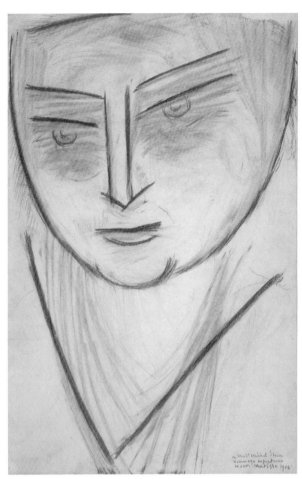

Plate 164

Plate 163, cat. 178
Henri Matisse, *Mrs. Allan Stein (Yvonne Daunt),* **1924.** Charcoal on paper, 25 x 19 in. (63.5 x 48.3 cm). Trina and Billy Steinberg, Los Angeles

In 1924 Allan Stein married the dancer and choreographer Yvonne Daunt, who was known for her barefoot performances. In 1922 she starred with the Paris Opera Ballet, and the following year she performed her own choreography to the music of Henry Cowell at the Salon d'Automne. Matisse made this portrait on the occasion of Allan and Yvonne's marriage, dedicating it "aux epoux Allan Stein Daunt/souvenir amical/Henri Matisse 24."

Plate 164, cat. 175
Henri Matisse, *Study of Sarah Stein,* **1916.** Graphite on paper, 19⅛ x 12⅝ in. (48.6 x 32.1 cm). San Francisco Museum of Modern Art, gift of Mr. and Mrs. Walter A. Haas

Around the time that Matisse undertook his painted portraits of Sarah and Michael Stein (1916; pls. 83, 84), he produced this carefully worked drawing with an inscription to Sarah that reads: "a Mad.e Michel Stein/hommage respectueux/Henri Matisse 1916." In the summer of 1914 the couple had lent nineteen paintings to a solo exhibition of the artist's work at the Kunstsalon Fritz Gurlitt in Berlin. War broke out shortly thereafter, and the loans could not be retrieved. Matisse was aware of how devastating it was for the Steins to be without their pictures, which they would never recover, and likely tried to make amends with this drawing and the painted portraits.

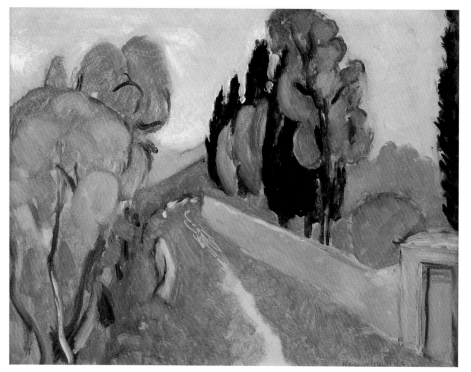

Plate 165

Plate 165, cat. 154

Henri Matisse, *Landscape with Cypresses and Olive Trees near Nice,* **1918.** Oil on board, 10⅝ x 13½ in. (27 x 34.3 cm).
Ann and Gordon Getty, San Francisco

Sarah and Michael's first purchases after the trauma of World War I included two landscapes painted
by Matisse shortly after his 1917 move to Nice: *The Bay of Nice* (1918; pl. 98) and this work. *Landscape
with Cypresses and Olive Trees near Nice* was made while Matisse was living in the hills above the
city in the Villa des Alliés, which offered views of the sea and the bucolic landscape. Matisse wrote
of the countryside to the painter Charles Camoin: "A little while ago, I took my nap under an
olive tree and what I saw was of a color and a softness of relationships that was truly moving....
Here [the light] is silvered. Even the objects that it touches are very colored, such as the greens
for example" (quoted in Cowart and Fourcade, 1986, 23).

Plate 166, cat. 157

Henri Matisse, *Cap d'Antibes Road,* **1926.** Oil on canvas, 19⅞ x 24 in. (50.5 x 61 cm). Private collection

Cap d'Antibes Road, painted near Nice, is thought to be the last Matisse canvas that Sarah and
Michael acquired for their collection. They remained devoted to the artist throughout their lives
and assisted their friends the Cone sisters of Baltimore in acquiring his works into the 1930s.
The year this painting was made, however, they began to focus their resources on a new cause—
modern architecture—with the commission of an extraordinary home by Le Corbusier.
The painting was included in the important 1937 exhibition *Les Maîtres de l'art indépendant,
1895-1937* (Masters of Independent Art, 1895-1937) at the Petit Palais.

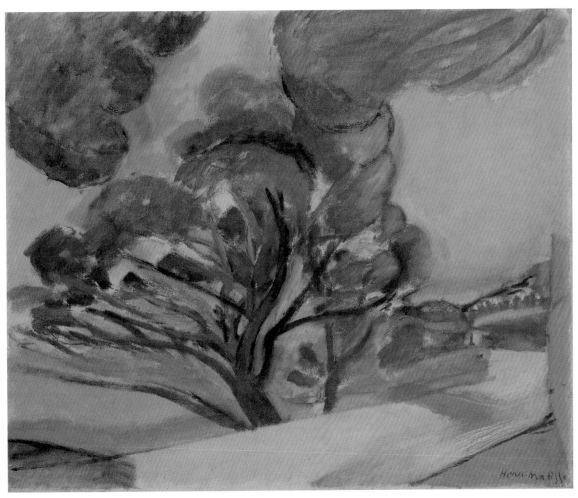

Plate 166

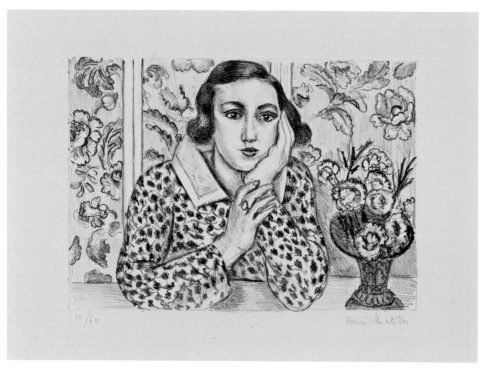

Plate 167

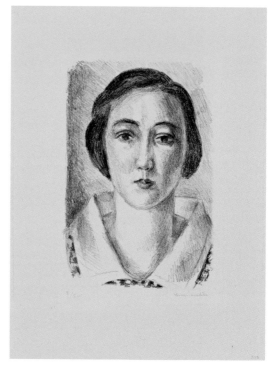

Plate 168

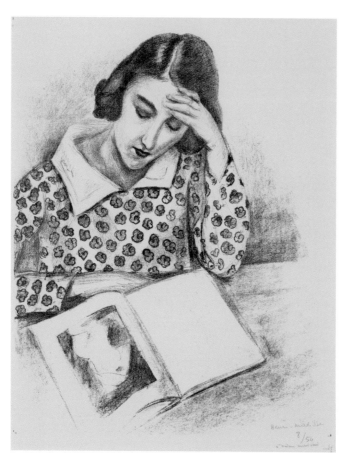

Plate 169

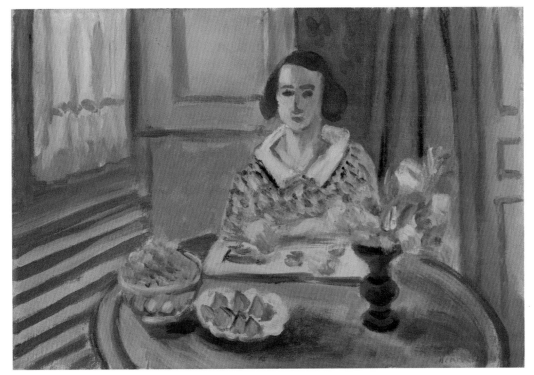

Plate 170

Plate 167, cat. 185
Henri Matisse, *Girl Seated at a Table with Vase of Flowers*, **1923.** Lithograph, 11⁹⁄₁₆ x 14¼ in. (29.4 x 36.2 cm).
Iris & B. Gerald Cantor Center for Visual Arts at Stanford University, gift of Mrs. Michael Stein, 1953

Plate 168, cat. 186
Henri Matisse, *Girl with an Organdy Collar, No. 2*, **1923.** Lithograph, 13½ x 10⅛ in. (34.3 x 25.7 cm). Iris & B.
Gerald Cantor Center for Visual Arts at Stanford University, gift of Mrs. Michael Stein, 1953

Plate 169, cat. 188
Henri Matisse, *Woman Reading*, **1923.** Lithograph, 25¼ x 19¾ in. (64.1 x 50.2 cm). Mills College Art Museum,
gift of Mrs. Michael Stein, 1945

Plate 170, cat. 156
Henri Matisse, *Girl Reading*, **ca. 1925.** Oil on canvas, 14 x 19½ in. (35.6 x 49.5 cm). Private collection

Matisse's favorite model in the early 1920s, the musician and ballerina Henriette Darricarrère,
posed for the painting and lithographs seen here. Matisse dedicated the small canvas "a Madame
Michel Stein, Juillet 1925" on a small piece of cloth adhered to the back. In the 1940s Sarah felt
obliged to sell works from her collection to help pay off her grandson Daniel's debts. When
Sarah decided to part with this painting, her friend Maurice Galanté called Elise Haas to help
find Sarah a buyer. Haas, in turn, contacted Brayton Wilbur, then the president of the San
Francisco Museum of Art, who purchased *Girl Reading* along with *Still Life with Blue Jug* (ca.
1900-1903; pl. 131). "I'm still annoyed that I didn't buy the girl behind the tablecloth…" recalled
Haas. "How foolish! I should have bought the whole collection" (Haas 1972, 104).

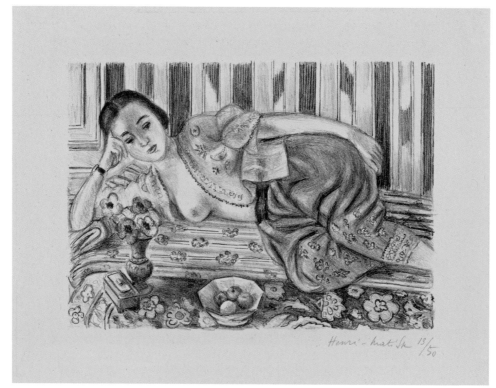

Plate 171

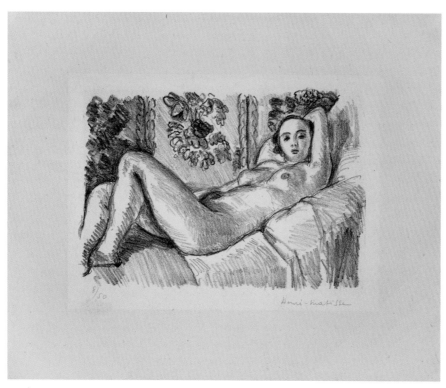

Plate 172

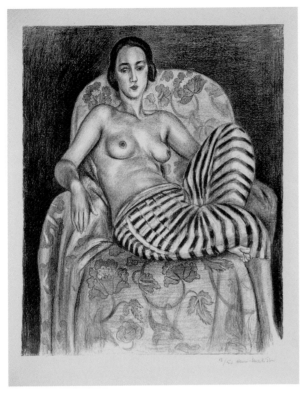

Plate 173

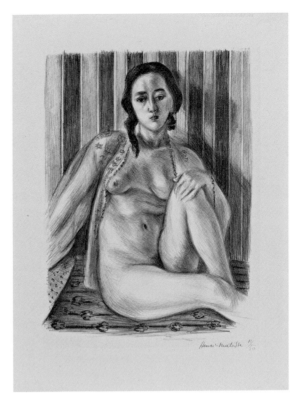

Plate 174

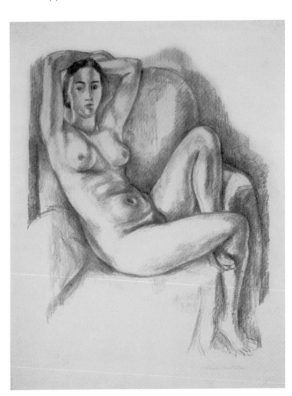

Plate 175

Plate 171, cat. 191
Henri Matisse, *Reclining Odalisque (with Red Satin Culottes),* **1925.** Lithograph, 11¹⁄₁₆ x 13¹³⁄₁₆ in. (28.1 x 35.8 cm). Iris & B. Gerald Cantor Center for Visual Arts at Stanford University, gift of Mrs. Michael Stein, 1953

Plate 172, cat. 187
Henri Matisse, *Little Aurore,* **1923.** Lithograph, 10¼ x 12¼ in. (26 x 31.1 cm). Stanley Steinberg, San Francisco

Plate 173, cat. 190
Henri Matisse, *Odalisque in Striped Pantaloons,* **1925.** Lithograph, 24¾ x 19¾ in. (62.9 x 50.2 cm). Mills College Art Museum, gift of Mrs. Michael Stein, 1945

Plate 174, cat. 192
Henri Matisse, *Seated Nude with Tulle Jacket,* **1925.** Lithograph, 19¹⁄₁₆ x 14⁷⁄₁₆ in. (48.1 x 37.4 cm). Iris & B. Gerald Cantor Center for Visual Arts at Stanford University, gift of Mrs. Michael Stein, 1953

Plate 175, cat. 189
Henri Matisse, *Nude with Blue Cushion,* **1924.** Lithograph, 29¼ x 21⅞ in. (74.3 x 55.5 cm). Iris & B. Gerald Cantor Center for Visual Arts at Stanford University, gift of Mrs. Michael Stein, 1953

A 1937 inventory of Sarah and Michael's collection includes seventy lithographs and seven etchings by Matisse. In Palo Alto, where the couple moved from Paris in 1935, Sarah stored the prints in a large wooden chest and brought them out to share with interested visitors. Her friend Stanley Steinberg recalls that Matisse's ongoing gifts of prints to the couple were connected to his distress over the loss of their artworks in the Gurlitt affair (Steinberg 2010, 23), and in 1922 Sarah wrote to a friend that Matisse had presented them with a suite of lithographs as "a peace offering" (Michael Stein to Theresa [Ehrman] Jelenko c/o Mrs. S. Bauer, July 31, 1922, Bancroft Library, University of California, Berkeley, BANC MSS 71/222c).

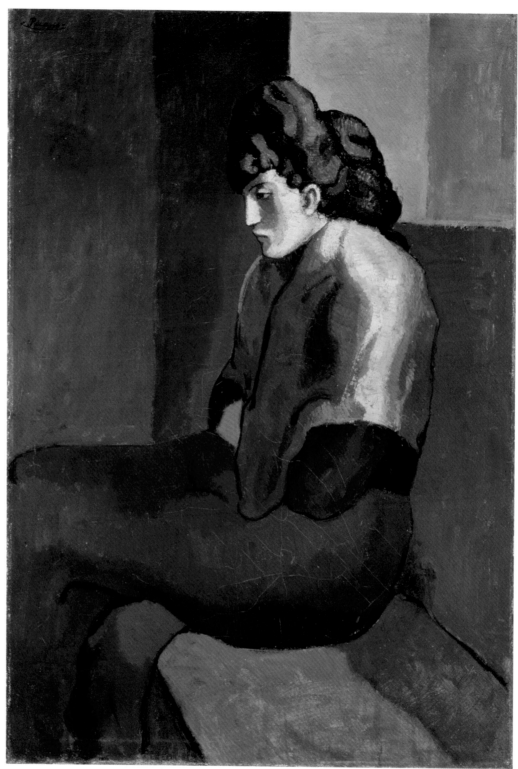

Plate 176

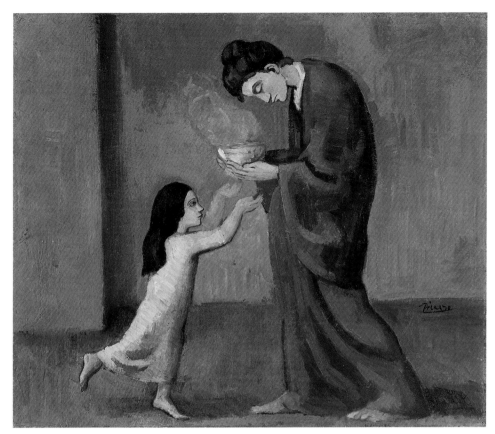

Plate 177

Plate 176, cat. 231
Pablo Picasso, *Melancholy Woman*, 1902. Oil on canvas, 39⅜ x 27¼ in. (100 x 69.2 cm). Detroit Institute of Arts, bequest of Robert H. Tannahill

Sarah and Michael owned relatively few paintings by Picasso, and most of their purchases were made soon after meeting the artist. Although Picasso painted his blue period canvases prior to encountering the Steins, Leo considered these early pictures—profound, monochromatic meditations on the subjects of poverty, charity, mental illness, and despair—to be among the artist's finest. *Melancholy Woman* is a moonlit portrait of a prostitute incarcerated in the Saint-Lazare women's prison and hospital, which Picasso first visited in 1901.

Plate 177, cat. 228
Pablo Picasso, *Soup*, 1902. Oil on canvas, 15⅛ x 18⅛ in. (38.4 x 46 cm). Art Gallery of Ontario, gift of Margaret Dunlap Crang, 1983

Pierre Puvis de Chavannes's frescoes in the Panthéon in Paris have been cited as Picasso's inspiration for this work (J. Richardson 1991, 256-57), but Sarah and Michael surely were aware of the painting's affinity with Japanese prints. The woman's draped robes, stooped pose, and bent neck—as well as the use of flat, monochromatic planes of color—have much in common with the work of Suzuki Harunobu and other Japanese artists whose prints Sarah and Michael admired and collected. When the couple redecorated their Paris apartment in late 1906, they segregated *Soup* from their other contemporary paintings and juxtaposed it with Asian bronzes and painted landscapes (see pl. 364).

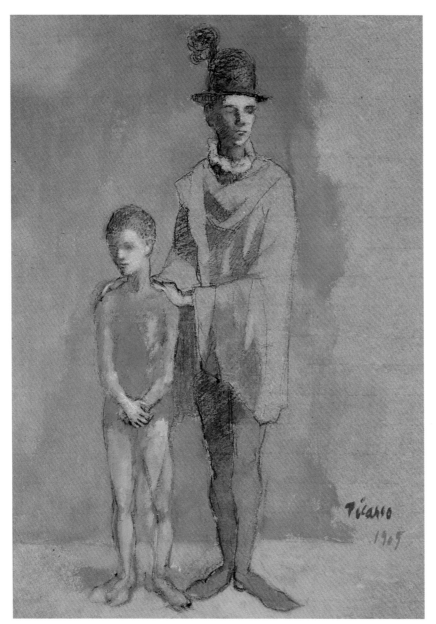

Plate 178

Plate 178, cat. 290

Pablo Picasso, *Strolling Player and Child*, 1905. Gouache and pastel on cardboard, 27¾ x 20½ in. (70.5 x 52 cm). The National Museum of Art, Osaka

When the Steins first encountered Picasso, actors and circus performers were among the artist's chief subjects. In 1907 Sarah and Michael displayed *Strolling Player and Child* near *The Acrobat Family* (1905; pl. 22)—Leo's very first Picasso purchase—in their rue Madame apartment (see pls. 363, 364). With the boy in blue and the adult in pink, *Strolling Player and Child* has been described as a transitional work between the artist's blue period and the tender melancholy of the rose period (Palau i Fabre 1981, 404).

Plate 179

Plate 179, cat. 324

Pablo Picasso, *Allan Stein*, 1906. Gouache on cardboard, 29⅛ x 23½ in. (74 x 59.7 cm). The Baltimore Museum of Art: The Cone Collection, formed by Dr. Claribel Cone and Miss Etta Cone of Baltimore, Maryland

The Steins treasured Picasso's depiction of their ten-year-old son, which is thought to have been commissioned by Michael as a birthday gift for Sarah. In August 1949, when the fifty-four-year-old Allan was ill and in need of money, he sold the portrait from his mother's collection to their family friend Etta Cone. Over the years, when the Steins (especially Gertrude) needed an influx of cash, they turned to Etta and occasionally to her older sister Claribel. The Cone sisters ultimately purchased more than thirty works from the Steins.

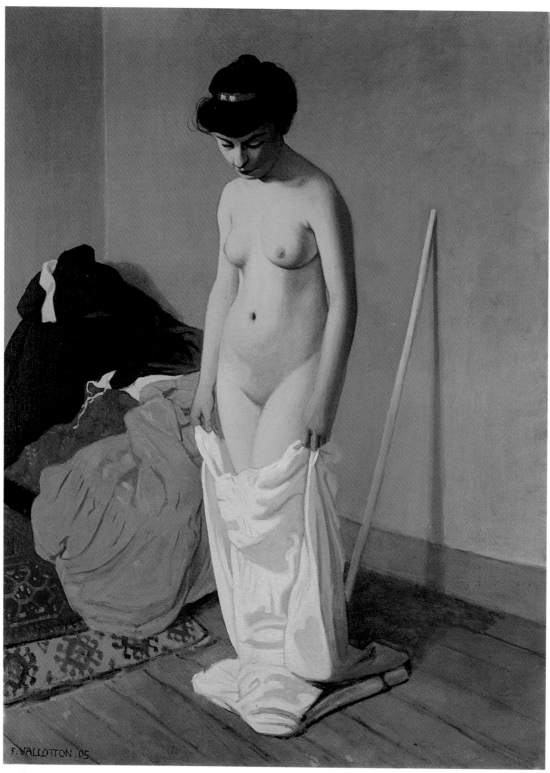

Plate 180

Plate 181

Plate 180, cat. 439
Félix Vallotton, *Standing Nude Holding Her Chemise with Two Hands*, 1904. Oil on canvas, 50¾ x 37⅜ in.
(129 x 95 cm). Private collection, Switzerland

In spring 1905 Leo boldly acquired *Reclining Nude on a Yellow Cushion* (1904; pl. 10) by Vallotton, whom he described as "a talented and essentially witty painter" (L. Stein 1996, 158). Gertrude, on the other hand, christened the Swiss artist "Manet for the impecunious" (G. Stein 1990, 50). The Stein family bought this more demure painting of the same model the following year. Although the purchase has been attributed to Leo (Ducrey 2005, no. 537), archival photographs dated as early as 1907 show the work at Michael and Sarah's rue Madame residence (see pl. 363). In these early years, the Stein family often made purchases in concert, befriending and supporting the same artists.

Plate 181, cat. 442
Mathilde Vollmoeller-Purrmann, *Still Life with Fruit*, ca. 1906-7. Oil on canvas, 18 x 24 in. (45.7 x 60.1 cm).
San Francisco Museum of Modern Art, bequest of Esther Pollack

The German painter Mathilde Vollmoeller arrived in Paris in 1906 and quickly fell under the spell of Cézanne. After Vollmoeller began studying at the Académie Matisse, Sarah wrote of her to Gertrude: "The girl Purrmann is seen with a great deal is Fräulein Vollmüller, an atelier comrade. I know that they are very great friends. Mikey likes her very much, she is very pretty, most 'chicer,' extremely aristocratic, of good family & rich, besides. I shall have to tease Purrmann and watch him wriggle" (Sarah Stein to Gertrude Stein, undated [ca. 1908], Beinecke YCAL MSS 76, box 126, folder 2731). Vollmoeller and Purrman married in 1912 and resided in Paris until the war broke out. When she returned to Paris in 1919 to clear out their studio, she was a guest of the Steins (Hans Purrmann to Augustus Pollack, March 1, 1961, SFMOMA Permanent Collection Object File: 92.136), and gave *Still Life with Fruit* to Sarah.

GERTRUDE STEIN AND ALICE TOKLAS

Plate 182
Gertrude Stein (seated) and Alice Toklas in the atelier at 27 rue de Fleurus,
Paris, 1922. Photograph by Man Ray (detail of pl. 360). Musée National d'Art
Moderne, Centre Georges Pompidou, Paris

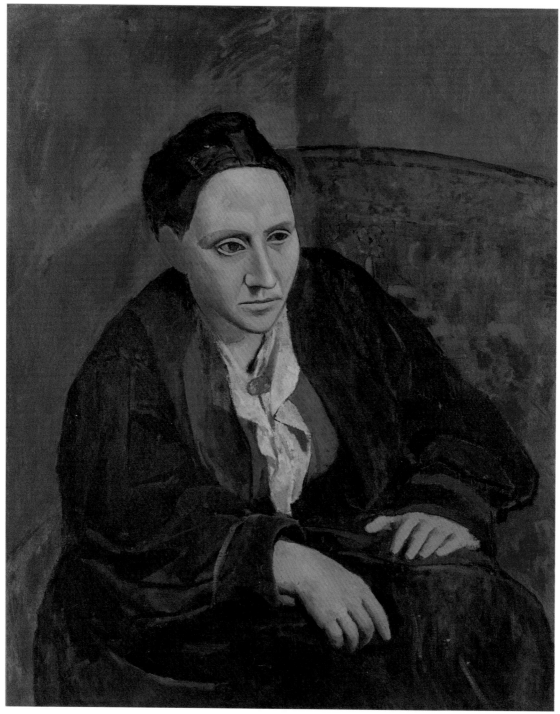

Plate 183

Gertrude Stein and Painting: From Picasso to Picabia
Cécile Debray

TO PIERRE LARTIGUE

During a 1934 lecture, Gertrude Stein attributed the beginnings of her writing to the contemplation of Paul Cézanne's paintings: "Finished or unfinished [a Cézanne painting] always was what it looked like the very essence of an oil painting because everything was always there, really there…. This then was a great relief to me and I began my writing."[1] In this passage, Stein—a former student of William James, father of cognitive sciences—addresses the issue of perception, which played a prominent role in the research carried out by the artistic avant-garde in the early twentieth century. By linking her experience of visual art to her vocation as a writer, she was insisting upon her need to become familiar with paintings, whence the size and significance of the collection that she began to assemble at her home in Paris in 1904, first with her brother Leo, then, beginning around 1910-13, with her companion Alice Toklas. This particular, intertwining connection between writing and painting would accompany the creation of an incomparable, changing, and sometimes disparate collection; it would also provide the framework for the numerous exchanges with artists that became the substance of Gertrude Stein's written "portraits."

Ever since the 1933 publication of *The Autobiography of Alice B. Toklas*—Gertrude Stein's deliberately distant and arbitrary rendition of her memories as filtered through the fictional device of Alice's point of view—there has been considerable debate as to how much is owed to Gertrude and how much to Leo (or even to their sister-in-law Sarah Stein) for the pre-World War I creation of such an exceptional and avant-garde collection, consisting primarily of works by Henri Matisse and Pablo Picasso.[2] It has become common knowledge—something even Gertrude herself admitted—that Leo initially was the driving force behind the collection. He was the one who showed the Cézanne paintings owned by the collector Charles A. Loeser in Florence to his younger sister, and who bought Cézanne's *Madame Cézanne with a Fan* (1878-88; pl. 2, cat. 10) and works by Paul Gauguin from Ambroise Vollard. It was also Leo who discovered works by Pablo Picasso at Clovis Sagot's gallery and at the Serrurier gallery's exhibition in early 1905, and in all likelihood it was Leo who was behind the spectacular, emblematic purchase of Matisse's *Woman with a Hat* (1905; pl. 13, cat. 113) at the 1905 Salon d'Automne. What is important to remember where Gertrude is concerned is that she would embrace her calling as a writer thanks to the presence in her life of these works, especially the tutelary paintings *Madame Cézanne with a Fan* and *Woman with a Hat*.[3]

The Portrait of Gertrude

Gertrude Stein's role as collector and patron of the arts would develop through her friendship with Picasso, and his famous portrait of her from 1905-6 (pl. 183, cat. 238) would prove decisive for this evolution. Stein refers to the beginnings of their passionate friendship in a passage in the *Autobiography*. With a perfect sense of detail, she relates the first time he came to dinner: "He was thin dark, alive with big pools of eyes and a violent but not rough way. He was sitting next to Gertrude Stein at dinner and she took up a piece of bread. This, said Picasso, snatching it back with violence, this piece of bread is mine. She laughed and he looked sheepish. That

Plate 183, cat. 238
Pablo Picasso, *Gertrude Stein,* 1905-6. Oil on canvas, 39⅜ x 32 in. (100 x 81.3 cm).
The Metropolitan Museum of Art, New York, bequest of Gertrude Stein, 1946

was the beginning of their intimacy."[4] The two were very close but also capable of petty quarreling, like siblings, and their friendship would be at the center of the life story that Gertrude wrote nearly thirty years after they came to know each other. There are several pages devoted to the portrait of Gertrude that Picasso offered to paint only shortly after they met, and her account confers a veritable mythology upon this seminal work.[5] Brazenly exaggerating the number of sessions—claiming that there were between eighty and ninety[6]—at Picasso's Bateau-Lavoir studio in Montmartre, Stein enhances the heroic dimension of the work's genesis, implying a veritable combat. She also emphasizes the decisive nature of the formal solution that Picasso adopted for the depiction of her face upon his return from Gósol, presaging his radical work in *Les Demoiselles d'Avignon* (1907; Museum of Modern Art, New York). The portrait was indeed a turning point in Picasso's development as an artist.

We will never know what they said to each other during these sessions, full of the sound of poetry (Picasso's companion Fernande read aloud from the fables of La Fontaine), but it would seem that something momentous occurred for both of them, with repercussions for their pictorial and literary endeavors. Stein, at the time of the portrait, was working on "Melanctha," a piece about a black servant that was published in the collection *Three Lives*, a work that would be foundational for her particular style of writing.[7] Picasso, stimulated in part by Matisse's paintings hanging at rue de Fleurus, particularly *Le Bonheur de vivre* (1905-6; pl. 15, cat. 117), and by the Romanesque Virgin of Gósol in Catalonia—and in all probability by his conversations with Gertrude—was in the crucial first stages of his exploration of the style that would lead to Cubism.

Thus their meeting in 1905 was a tremendous stimulant to both Stein and Picasso, and it also paved the way for a discreet interplay of identification. A few years later, in 1911-12, Stein would have no qualms about situating herself among a triad of geniuses whose other members were Picasso and Matisse.[8] Picasso, for his part, was more circumspect and never contradicted his friend's often-fantastical memories. Unlike Leo Stein, Picasso was full of respect and admiration for Gertrude's work and her status as a writer:

in March 1911, on the envelope of a letter he sent her, he wrote: "To Mademoiselle Gertrude Stein, Man of Letters."[9] Oddly enough, his finely wrought portrait of her shares a similar style with and even closely resembles his own *Self-Portrait with Palette* (1906; Philadelphia Museum of Art), and one wonders whether he might have given Gertrude another little self-portrait from the same era (pl. 81, cat. 239) on the occasion of her portrait, as if to seal their nascent friendship.

Picasso's portrait of Gertrude Stein magnifies the model, makes her into a monument, enhancing her face and her intelligence. For her, this portrait would always be a sort of disturbing double with which the other portraits she inspired—and they would be numerous—would be compared. Toklas, after her companion's death, would recall with melancholy Gertrude and the portrait: "Gertrude always sat on the sofa and the picture hung over the fireplace opposite and I used to say in the old happy days that they looked at each other and that possibly when they were alone they talked to each other."[10]

James Lord has correctly pinpointed the sort of transubstantiation that is at work in this painting, somewhere between the myth of Pygmalion and *The Picture of Dorian Gray.* During one of his visits to Toklas after Gertrude's death, he noticed that the portrait was gone, for in keeping with Gertrude's will it had left for the Metropolitan Museum of Art: "Gertrude was gone. And not only Gertrude herself but also the ideal, immutable image and symbol of her was gone; the one reproduction of her that had always been Gertrude for Gertrude, and consequently for Alice as well, was gone. They were separated in the mind as well as in the flesh. Gertrude had gone to join the immortals, and in substance she had taken with her the all-embracing evidence of her immortality."[11]

The Studio of the "Demoiselles"

As her friendship with Picasso grew stronger, Gertrude played an ever more significant role in her family's art collecting. It is quite conceivable that Gertrude and Leo's acquisition of coherent bodies of Picasso's work reflects the depth of her relationship with the painter as well as her interest, shared with her brother, in increasingly radical

ventures in art. Thus between 1906 and 1909 they bought, directly from the studio, several older works from the blue and rose periods, which seemed to confirm Leo's taste in postimpressionist art or work inspired by Cézanne. They also bought very recent paintings and drawings, contemporaneous with the genesis of *Les Demoiselles d'Avignon*: two major canvases produced immediately after *Les Demoiselles—Nude with a Towel* (1907; pl. 184, cat. 242)[12] and *Three Women* (1908; pl. 186, cat. 251)—as well as preparatory works such as *Head of a Sailor* from 1907 (cat. 240); the studies for *Les Demoiselles d'Avignon* and *Nude with Drapery* (all 1907; pls. 208-17, cat. 362-75) included in the sketchbook known as Carnet 10;[13] and a study in gouache for *The Dryad* (1908; pl. 219, cat. 252).

The Steins' acquisitions of Picasso's recent work were exceptionally bold, especially when viewed in light of the negative reception of his art during this period: poorly understood, *Les Demoiselles d'Avignon* would be left in the studio for several years and not exhibited until 1916. For Leo, the influence of *art nègre* in Picasso's early cubist works must have resonated with his own interest in tribal art and Gauguin's work. And as for Gertrude, in this multiplicity of studies, in the repetition of the same themes—faces or bodies simplified by the use of hachure, curves, and countercurves on the sheets of Carnet 10—she must have identified a conceptual research into form that was like her own in the realm of writing and syntax. The nucleus of works by Picasso in their collection was taking shape.

Gertrude and Leo's patronage made it possible for Picasso to stay outside Paris during the summer months. In the summer heat wave of 1908, the artist left for the village of La Rue-des-Bois, in Ile-de-France. When he returned to Paris in September, he hung his new work in his studio for the Steins' visit.[14] Leo and Gertrude, back from Italy, chose three landscapes from La Rue-des-Bois (pl. 226; cat. 245-47), to which they would subsequently add *Landscape with Two Figures* (1908; pl. 185, cat. 244).[15] Three of the little wooden panels on which Picasso, in early summer, had painted superb still lifes with fruit and stemmed glasses (cat. 248, 249, 253) complemented the Cézannesque landscapes in the Stein collection.

In June of the following year, Picasso went to Horta de Ebro (now Horta de Sant Joan), in Catalonia, after a brief stay in Barcelona. His correspondence with the Steins was intensifying and constitutes one of the most accurate sources we have about his activity of this period. By reporting regularly to his patrons on his work,[16] Picasso was sharing the groundbreaking research into form that would result in Cubism: his inversions of perspective, geometric rendering of the Catalan landscape, and faceted treatment of the volumes of the head in his portraits of Fernande.

Hoping to persuade Gertrude and Leo to join them, Fernande described in her letters the monotonous passage of the days: Picasso shut up in his makeshift studio above a bakery, with its windows opening onto the stark mountain of Santa Bárbara; the villagers; the beauty of the surrounding countryside.[17] With the letters there were occasionally examples of the photographic reportage Picasso was preparing of the village and its inhabitants, the landscape, and his studio; a dozen or so prints played on the contrast between the images and the effects of double exposure obtained during development using superimposition and layers of multiple negatives.[18] Picasso also sent the Steins photographs of four of his paintings in order to show them the formal leap he had made.

As soon as Picasso was back in Paris, he wrote to Gertrude and Leo, on September 13: "Dear friends, the pictures will not be put up until the day after tomorrow. you are invited to the vernissage Wednesday after noon."[19] On that day Gertrude—and, to a lesser degree, Leo, who would begin to distance himself from Picasso as the artist's Cubism became more dominant—selected three more paintings: two landscapes—*The Reservoir, Horta de Ebro* (1909; pl. 229, cat. 256) and *Houses on a Hill, Horta de Ebro* (1909; pl. 230, cat. 257)—and a portrait of Fernande (1909; pl. 228, cat. 258). Of the three landscapes that Picasso brought back from Horta, Gertrude and Leo declined the *Factory at Horta de Ebro* (also known as *Brick Factory at Tortosa*, 1909; State Hermitage Museum, Saint Petersburg), an imaginary landscape unrelated to Picasso's photographs but reminiscent of Cézanne's *Factories near Le Cengle* (1869-70; private collection).

Plate 184

Plate 185

Plate 184, cat. 242
Pablo Picasso, *Nude with a Towel*, 1907. Oil on canvas, 45⅝ x 35 in. (116 x 89 cm).
Private collection

Plate 185, cat. 244
Pablo Picasso, *Landscape with Two Figures*, 1908. Oil on canvas, 23⅝ x 28¾ in.
(60 x 73 cm). Musée National Picasso, Paris

Plate 186, cat. 251
Pablo Picasso, *Three Women*, 1908. Oil on canvas, 78¾ x 70⅛ in.
(200 x 178 cm). The State Hermitage Museum, Saint Petersburg

Plate 186

Gertrude had been struck by the relationship between Picasso's Horta paintings and photographs, which to her underscored both a visual resemblance and an outright syntactical equivalency between photographic and painted reality—a destabilization of the perception of the real that she associated with her very first aesthetic experience of painting. One imagines that she often showed Picasso's photographs to visitors to rue de Fleurus in order to compare them with the paintings. In 1928 Elliot Paul—a close collaborator of Eugène Jolas, the founder of the French-American journal *Transition*—convinced her to publish a reproduction of *Houses on a Hill, Horta de Ebro* side by side with Picasso's photograph of the same landscape (pl. 187). The didactic presentation bears the credit "By courtesy of Miss Gertrude Stein."[20] In her 1938 essay devoted to Picasso, Stein would once again refer to his painting's connection with photography, a critical angle that, as we shall see, also proved productive for her in approaching Francis Picabia's work.

Cubism, 1912–1920

Gertrude Stein established a dialogue with Picasso's work that is reflected in her personal notebooks from 1908 to 1911—the laboratory for her writing. Cubism provided a foundation for her literary pursuits; it gave legitimacy to her research into the object, the flatness of the continuous present, and a syntax that was taken apart and deconstructed as she played with the oral nature of repetition.[21] As Claude Grimal has noted, "Stein's texts offer a surface of resistance comparable to that of the cubist painters, for they are composed on the basis of an identical questioning of the phenomena of perception and interpretation, and an identical refusal to abandon the succulence of the sensory."[22]

By 1909 Gertrude Stein was fully immersed in her major fresco, *The Making of Americans*, and had begun composing her word portraits, particularly those devoted to Matisse and Picasso, which were first published in 1912 in Alfred Stieglitz's journal *Camera Work*. Gertrude never mentions either artist's name but injects the portraits with leitmotifs, that of work for Picasso and that of struggle for Matisse. With the publication of "Portrait of Mabel Dodge at the Villa Curonia" in *Camera Work* at the time of the Armory Show in June 1913, an exhibition to which Leo and Gertrude lent a painting by Picasso—*Vase, Gourd, and Fruit on a Table* (1908; pl. 227, cat. 254)—Gertrude's repetitive style would quickly be associated and compared with Picasso's Cubism. Adopting categories from painting, her collection *Tender Buttons*, as Donald Sutherland has explained, "corresponds to the 'still life,' the familiar objects on a table top, that were used as basic subject matter by

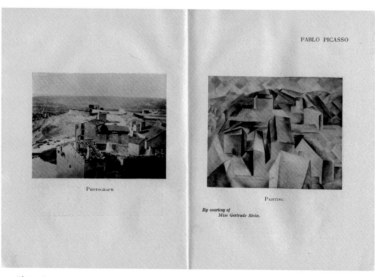

Plate 187

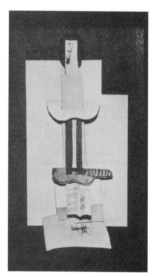

Plate 188

the cubists. As the created reality and not the original reality had to be everything in the cubist picture, the original reality had to be as simple and familiar as possible, to contain nothing but a visual interest and even that visual interest as unprejudiced as possible by tradition."[23] At the same time, Gertrude was closely observing Picasso's use of photography in the composition of objects in his studio at boulevard de Clichy in 1911 and at boulevard Raspail somewhat later, in 1912-13. There he produced constructions in paper such as *Guitarist with Sheet Music* (1913; pl. 188, cat. 390),[24] which he would give to her, as well as astonishing collages and assemblages with objects, papers, and canvases.[25]

Leo, who must have been vexed by the succès de scandale that greeted his sister's first publications, now professed outright hostility toward Cubism. Gertrude undertook the purchase of Picasso's paintings on her own. The first transaction took place in 1912 with the help of the art dealer Daniel-Henry Kahnweiler, with whom Picasso was not yet under contract, for a painting that contains a tribute to Gertrude's friendship, *The Architect's Table* (1912; pl. 197, cat. 260).[26] Gertrude would provide the key to the work in *The Autobiography of Alice B. Toklas*: "One day we went to see [Picasso at his new studio]. He was not in and Gertrude Stein as a joke left her visiting card. In a few days we went again and Picasso was at work on a picture on which was written ma jolie and at the lower corner painted in was Gertrude Stein's visiting card.... This was in the spring."[27]

Then in May Gertrude chose two exquisite still lifes exemplifying a very refined and difficult strand of Cubism, *The Small Glass* (1912; cat. 261) and *Le Journal* (1912; cat. 259), a choice that Picasso welcomed.[28] Somewhat later she would acquire a striking ensemble of two paintings created using sand, *Violin* (1912; pl. 231, cat. 262) and *Guitar on a Table* (1912; pl. 232, cat. 263), with two large related drawings (cat. 377, 378). Over the next two years she bought a pair of significant works, *Man with a Guitar* (1913; pl. 234, cat. 264) and *Woman with a Guitar* (1914; pl. 235, cat. 266); a major collage from 1913-14, *Student with a Pipe* (1914; pl. 233, cat. 265); and a series of still lifes from 1914.

The collection began to change, reflecting Gertrude's individual preferences as she emerged from the shadow of her brother. Progressively excluded once Alice Toklas moved in at rue de Fleurus in 1910, Leo definitively left Paris for Italy in early 1914. He and Gertrude divided the collection at that point. Leo took the works by Renoir, while Gertrude kept the Picassos; Matisse's *Woman with a Hat* (which she would sell shortly afterward, in 1915, to her brother Michael); and the Cézannes, except for *Five Apples* (1877-78; pl. 49, cat. 7), which she found very hard to part with.[29] To console her, as a Christmas present in 1914 Picasso painted a watercolor with a single apple (pl. 238, cat. 382). The walls at rue de Fleurus were no longer as crowded, and a tidier, more systematic way of hanging the works took over, as evidenced by photographs taken after the split (pls. 355-61): groups of related artworks were closer together, and the studies from the 1907 notebook were displayed in a row (pl. 355). The changes reflected a more modern sensibility, far removed from the dense, "cabinet of curiosities" character that typified the early days of the collection.

After the war, Gertrude could no longer afford Picasso's work. The last painting she acquired, *Still Life*, from 1922 (cat. 269), became part of her collection thanks to an exchange for an older canvas by Picasso.[30]

The Kahnweiler Stable

Daniel-Henry Kahnweiler, the gallery owner who championed Picasso during his cubist period and the theoretical and critical interpreter of Cubism, had a lively relationship with Gertrude in her capacities as writer and collector, as witnessed by their uninterrupted correspondence from 1912 until the 1940s. The art dealer could not help but admire her for her long friendship with Picasso and for her radical writing. In the various texts that he wrote in tribute at the time of her death, he returned to his first impression: "I must say that from the very first days, Gertrude seemed to me to be 'the great man' in her family. Her calm certainty impressed me far more than Leo's peremptory affirmations, which frequently varied, moreover."[31] Kahnweiler sensed early on the revolutionary dimension of Gertrude's writing, positioning her, for literature, alongside Picasso for painting and Arnold Schoenberg for music.

First as Gertrude's reader, then progressively as her friend, flattering or sincerely admiring, Kahnweiler quickly took on the role of art adviser and supplier. He provided appraisals at the time that the collection was divided in 1914, and he bought several historical masterpieces by Picasso: *Young Acrobat on a Ball* (1905; pl. 70, cat. 234), *Nude with a Towel,* and *Three Women.*[32] Gertrude, meanwhile, began to buy works by Juan Gris and André Masson from Kahnweiler. The war years would end up being, however, a turning point for both the writer and the art merchant: for Gertrude, the end of a period of formal exploration shared with Picasso, and for Kahnweiler, the dispersal of an unparalleled collection from the Braque-Picasso *cordée*—a heroic time followed by a disillusioned morning after.

Their shared interest in Juan Gris would lead Stein and Kahnweiler to an attempt to revive something of that earlier era—here was a new Picasso, Spanish, cubist, working at the Bateau-Lavoir, and dependent upon their patronage. Gris's death in 1927, at the age of forty, would bring them closer, in sorrow.

Gertrude had met Gris in 1910, probably at the Bateau-Lavoir or through their mutual friend Picasso. But she began to buy his paintings relatively late, in 1914, two years after his first exhibition at Sagot's (January 1912), and after his noted appearance at the Salon de la Section d'Or in October 1912.[33] According to both Kahnweiler's and Gris's letters, Gertrude bought four cubist still lifes from the dealer, colorful and rigorous works of fine quality: *Glass of Beer and Playing Cards* (1913; cat. 66), *Glasses on a Table* (1913–14; pl. 241, cat. 67), *Flowers* (1914; pl. 189, cat. 69), and *Book and Glasses* (1914; pl. 242, cat. 68).[34] These purchases on the part of the woman who "invented" Picasso were a very encouraging sign for Gris. But the brutal disruption caused by the outbreak of the war turned out to be catastrophic, leading to Kahnweiler's departure from France, the sequestration of the assets of his gallery, and a falling-out with Gertrude. At Picasso's request, Gertrude had sent money to Gris, who had taken refuge in Collioure when he was cut off from subsidies from his art dealer. Gertrude had hoped to help him out, particularly in a time of war, through the good offices of the art dealer Michael Brenner, in exchange

for a few paintings. She eventually gave up on the idea due to Gris's hesitation and Kahnweiler's opposition, as the latter was bitterly defending his exclusive agreement.

Their relations did not recover until 1920, when Kahnweiler returned to Paris and reopened his gallery under the name of his friend and business associate, André Simon. (Kahnweiler ran the operation, with Simon serving as a silent partner.) Over the ensuing decade Gertrude bought from Galerie Simon a number of Gris artworks in a more classical vein, characterized by linear, sinuous draftsmanship: *The Table in Front of the Window* (1921; pl. 244, cat. 70), *Woman with Clasped Hands* (1924; pl. 246, cat. 71), *The Green Cloth* (1925; cat. 72), and *Dish of Pears* (1926; cat. 73).

Gertrude's friendship with Gris deepened thanks to numerous visits. In 1921 she and Alice went to see the artist in Monte Carlo, where he was working on costumes and scenery for the Ballets Russes. In the fall 1924 issue of the *Little Review,* Gertrude published a word portrait of Gris, illustrated with reproductions of his paintings:

> Juan Gris is a Spaniard. He says that his pictures remind him of the school of Fontainebleau. The school of Fontainebleau is a nice school Diana and others. In this he makes no mistake but he never does make a mistake.... He is a perfect painter, all right he might be right....
>
> Juan Gris is one is the one who combines perfection with transubstantiation. By this he lives to say to-day yesterday and to find a day.
>
> Let me tell all I know about Juan Gris.
>
> To begin with he has black thoughts but he is not sad.... To begin with he is necessary and not destroyed.[35]

As is often the case, Gertrude Stein's words, beneath an appearance of innocuous simplicity, ring true. Juan Gris's oeuvre, shaped by the rigor that he learned in engineering school, is characterized by balance, clarity, and the elegance of the school of Fontainebleau. These very qualities—perfection, Cubism, a Spanish essence offset by the irresistible appeal of a Gallic touch—would be mentioned in Stein's tribute to Gris at the time of his death in May 1927, "The Life and Death of Juan Gris."[36]

Plate 189, cat. 69
Juan Gris, *Flowers,* 1914. Oil, pasted paper, and graphite on canvas, 21¾ x 18¼ in. (55.3 x 46.4 cm). Private collection

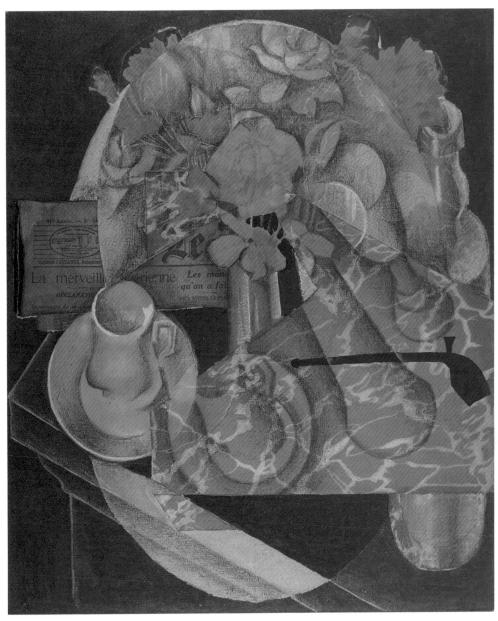

Plate 189

Gris expressed his allegiance in a multitude of ways. In April 1924 he shared with his friend the aesthetic declaration "On the Possibilities of Painting," a text that he wrote for a lecture at the Sorbonne. He gave Alice and Gertrude two of his original drawings for an illustrated book by Armand Salacrou, *Le Casseur d'assiettes* (The Plate Breaker; pl. 245, cat. 74, 75), published by Galerie Simon in December 1924. Gris also presented them with a watercolor of a ship's deck (1924; cat. 76), a set design for a "little ballet lasting not more than fifteen minutes, with decors and costumes," commissioned in September 1924 by Henri Varna.[37] In the summer of 1925 the artist chose *The Green Cloth* from Gertrude's collection to decorate the Pavillon de l'Esprit Nouveau (Pavilion of the New Spirit), created by Le Corbusier for the International Exposition of Modern Decorative and Industrial Arts, and he designed tapestry cartoons for Alice. Under Kahnweiler's guidance he conceived a book project with Gertrude titled *A Book Concluding with As a Wife Has a Cow a Love Story*, published in December 1926, with text by Gertrude and four of his own illustrations (pl. 243).[38]

Although it was more fleeting, Gertrude Stein's interest in André Masson—she would buy several of his canvases (pls. 247, 248) from Galerie Simon[39]—paralleled her taste for elements of Gris's work in the 1920s: a freer, postcubist use of representation and a playful brushstroke that intrigued her and that she also found in Picasso's work, particularly in the *Still Life* that she bought in 1922. With regard to Masson she refers to this use of line condescendingly in *The Autobiography of Alice B. Toklas*: "She was interested in André Masson as a painter particularly as a painter of white and she was interested in his composition in the wandering line in his compositions."[40] She would return to this theme when, in *Everybody's Autobiography* (1937), she described one of her first airplane rides, at a time when the issue of automatic writing was at the heart of the Surrealists' production and was being both exploited and distorted by Picabia in his Transparencies: "Quarter sections make a picture and going over America like that made any one know why the post-cubist painting was what it was. The wandering line of Masson was there the mixed line of Picasso coming and coming again and following itself into a

beginning was there, the simple solution of Braque was there and I suppose Leger might be there but I did not see it not over there. Particularly the track of a wagon making a perfect circle and then going back to the corner from where they had come."[41] Resemblance, elements of syntax, line— these were the recurrent arguments used to valorize in whatever way possible these "post-cubist" paintings.

Gertrude could not, however, follow the dissolution of form as advocated by the Surrealists. Stubbornly opposed to the sectarian propensity of the movement as led by André Breton—just as she supremely ignored the bond between Picasso and Braque—she would turn away from Masson already in 1925, as he recounted: "I was so in love with freedom that after I broke with surrealism, Gertrude Stein, who had stopped seeing me the moment I joined the group, came to visit, and asked me, 'What came over you to go and join a group, you're not at all a gregarious person.'"[42]

Stein, wearing her halo as patron of the arts and friend of Picasso during the heroic years, had been surrounded since the war by young American writers and artists who came to learn their trade in Paris, and now she was waiting, without a great deal of conviction, for the appearance of a young artist "to create an idea," a new Picasso. After 1925

Plate 190

Plate 190, cat. 433
Pavel Tchelitchew, *Three Heads (Portrait of René Crevel)*, 1925. Oil on canvas, 18¾ x 14½ in. (47.6 x 36.8 cm). Professor Boris Stavrovski, New York

and her last purchases of works by Kahnweiler's artists—Gris, Masson, Braque[43]—her choices would seem less clairvoyant, more tentative, and indisputably reflect a break in the history of her collection. According to Gertrude, this was also a reflection of a decline in art; in 1932 she would assert that "painting now after its great period has come back to be a minor art."[44]

There may have been economic reasons for this as well, and there was most definitely a certain loss of interest on her part. Painting, once a laboratory for form, had now become for Gertrude a banal diversion secondary to writing: "Just as one needs two civilizations so one needs two occupations the thing one does and the thing that has nothing to do with what one does. Writing and reading is to me synonymous with existing, but painting well looking at paintings is something that can occupy me and so relieve me from being existing. And anybody has to have that happen."[45]

The "Autobiographical" Break

It was during an exhibition at Galerie Druet in the winter of 1926 that Gertrude became infatuated with the young painters whom the critic Waldemar George grouped together under the banner of "Neo-Romantics" and whom she would refer to as "the Russians": Pavel Tchelitchew, Eugene Berman and his brother Leonid, the Frenchman Christian Bérard, and the Dutchman Kristians Tonny.[46] Part of a movement advocating the return to more classical forms of representation, albeit with vaguely surrealist or dreamlike touches, these artists worked for the Ballets Russes or the Ballets Suédois and were close to Jean Cocteau's set, which included the musician Allen Tanner and composer Virgil Thomson. Gertrude played a significant role in the artistic and social life of Paris in the 1920s: She was present at the premieres of *The Rite of Spring* and *Parade*, and her collection *Tender Buttons* was jubilantly praised by Cocteau for her abrupt changes of subject and the concision of her poems, which he christened "radiotelegrams." She was also courted by young artists or poets who came to admire her Cézannes and Picassos and to try to obtain her precious patronage.

At the Salon d'Automne in 1925 Stein took notice of Tchelitchew's *Basket of Strawberries* (1925; private collection), a still life in distorted perspective that the critics had praised unanimously.[47] Although she characterized the artist somewhat maliciously as "the leader of [a minor] art,"[48] she bought several of his paintings, including a portrait of the poet René Crevel (1925; pl. 190, cat. 433), with whom Gertrude maintained a friendship until Crevel's suicide in 1935. It was one of a series of simultaneous portraits with a multitude of heads or limbs, influenced by the palette of Picasso's canvases of the blue and rose periods, as well as the formal experimentation of his 1905–6 portrait of Gertrude, all of which Tchelitchew had discovered at rue de Fleurus. Gertrude was fascinated by the Russian's procedure of simultaneous reproduction, reminiscent of cubist pictorial strategies, even though the technique was applied in a quite tame way in the picture of Crevel. At the same time that she took an interest in the richly psychological works of Tchelitchew and his neoromantic peers, Stein resumed her own writing of portraits, which she collected in the volume *Dix Portraits*, published in Paris in 1930 in English and French (thanks to the poet Georges Hugnet).[49] The book was intended to be a side-by-side presentation of writing and art, and each word portrait was illustrated by one of the artists who served as Gertrude's models. Thus her portrait of Picasso, "If I Told Him. A Completed Portrait of Picasso," was set next to a self-portrait by Picasso, who also provided the visual portraits of Apollinaire and Erik Satie; "Pavlik Tchelitchef or Adrian Arthur" was illustrated by the artists themselves; Virgil Thomson by Bérard; Bérard by himself; the historian Bernard Faÿ by Tonny; Tonny by himself; Georges Hugnet by Berman; and "More Grammar Genia Berman" by the artist himself.

All these young artists—including the English painter Francis Rose, a close friend of Bérard's and Cocteau's who met Gertrude in 1931 and immediately brought out both her and Alice's maternal instincts—enjoyed a degree of support. Yet Gertrude was not easily taken in, and her interest never lasted very long. She justified her inconstancy by the trial of a painting's performance on her wall: "It is not I that change my mind about the pictures, but the paintings

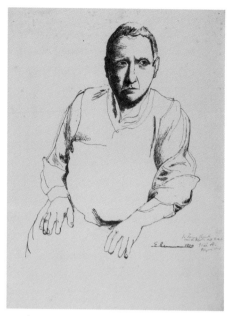

Plate 191

very stylized head (1920; pl. 253), which inspired Matisse's sculpture *Henriette* in 1927. Man Ray—who would make his first series of photographs of rue de Fleurus in 1922, not long after his arrival in Paris—endeavored to suggest a new iconic formula: he had Gertrude pose next to the portrait by Picasso, and later, in 1927, he photographed her in profile, looking strict and inspired, with short hair. Cecil Beaton staged her in his studio in 1936 with Alice in a play of hieratic and modern silhouettes. There was even a patriotic version, also in profile, with an American flag in the background, by the photographer Carl Van Vechten (pl. 193). Louis Marcoussis played up the poet's imperious character in a series of medallion etchings of her profile crowned with a laurel wreath (pls. 256–58). Bérard, Berman (pl. 191), Tchelitchew (pls. 259–60), Rose (pl. 263), Picabia (pls. 250, 252), and Pierre Tal-Coat (pl. 262) have left us numerous projects for portraits—ink drawings, charcoal sketches, or paintings, executed with varying degrees of success. The one by Picabia from 1933 is without doubt one of the strongest, evoking an old photograph of Gertrude in Italy sitting cross-legged on a stone table like a Buddha (pl. 31).

disappear into the wall, I do not see them any more and then they go out of the door naturally."[50] In addition to her purchases of these artists' works—Berman's landscapes in the style of antiquity, a multitude of naive canvases by Rose, genre scenes by Bérard, a *Bateau ivre* with Rimbaldian overtones by Tonny, and so on—she helped them gain exhibitions in France (thanks to her friendship with Marie Cuttoli, owner of Galerie de Beaune) and even in the United States. She put forth the names of a number of artists for exhibitions held at the Chicago Arts Club, whose president, Bobsy Goodspeed, she knew well and whom she hosted in Paris during her visits.[51] She also demonstrated her patronage by writing prefaces for their catalogues.

Obliged to play the role of artist to her role as patron, forever trying to measure up to the unequalled standard of Picasso's portrait, most of the artists who regularly visited rue de Fleurus would perform the task expected of them: depicting Gertrude. Félix Vallotton was the first, in 1907 (pl. 206, cat. 441), taking up the challenge set by Picasso by accentuating his model's mass and including a nod to Jean-Auguste-Dominique Ingres's *Louis-François Bertin* (1832). Jo Davidson's sculpture from ca. 1920–22 (pl. 254) adopts a similarly realistic approach. Jacques Lipchitz sculpted a

The sudden increase in the number of portraits in the 1920s was a sign of Gertrude's growing notoriety: her aura was indisputable, but there was also an obvious narcissism, and this rise in fame was concomitant with a turning point in her work exemplified by the production of her own self-portrait, the famous *Autobiography of Alice B. Toklas*, in 1932.[52] Claude Grimal views it as the expression of a break in her work that began in the 1920s, between the period of hermetic literary invention, during which she wrote the majority of her most difficult (largely unpublished) pieces, and her autobiographical and journalistic period, when she continued to write fine but no longer innovative texts.[53] Jacques Roubaud refers to "an autobiographical rupture," a perilous exhibitionism that annihilates her writing system: "This abolishes the protective membrane of nocturnal silence where the internal ruminates over the diurnal daily words that were heard as external."[54]

Stein's memoirs, often vitriolic, would earn her the enmity of many of her former friends,[55] and after her lecture tour of North America in 1934—nine months spent

Plate 191
Eugene Berman, *Gertrude Stein in Bilignin*, 1929. Ink on paper, 15¾ x 23⅝ in. (40 x 60 cm). Private collection, Paris

explaining her literary output, and her taste in painting and literature—she went through a crisis in her writing: "I did no writing. I had written and was writing nothing. Nothing inside me needed to be written. Nothing needed any word and there was no word inside me that could not be spoken and so there was no word inside me."[56] Her block might explain the violence with which she greeted Picasso's efforts at writing poetry (which he published in 1936 in the *Cahiers d'art*), for he too was in a period of reevaluating everything in the wake of his separation from his wife Olga in 1935. Gertrude flung at him: "You are extraordinary within your limits but your limits are extraordinarily there."[57]

Gertrude Stein's myth was built on the accumulation of autobiographical texts written in a Steinian but accessible style (*The Autobiography of Alice B. Toklas*, *Lectures in America*, *Everybody's Autobiography*, *Wars I Have Seen*, *Paris France*), and on an ever-more-abundant iconography. The effectiveness of these texts in establishing her cultural authority could be measured by the number of tributes, some of them ambivalent, that artists addressed to her. Picasso's deliberately humorous and affectionate painting from 1909, *Homage to Gertrude Stein* (pl. 192, cat. 255), a scroll surrounded by angels with trumpets, was in keeping with their friendly exchanges around birthdays and anniversaries, but it did knowingly target a certain trait of Gertrude's character. Rose prepared an allegorical tribute to Gertrude using the baroque vocabulary of beatification—clouds, angels—and after her death he painted, in 1949, a large symbolist portrait of her in the gowns of a priestess, with the blind, or hallucinatory, omniscient gaze of a poet (pl. 263, cat. 431). Thomson composed a musical poem, a portrait for voice and instruments, *Miss Gertrude Stein as a Young Girl* (1928), and Hugnet wrote a poem, "Le berceau de Gertrude Stein" (1927).

On occasion these tributes became a means of getting even, a caricature. After he had fallen out with Gertrude, Tchelitchew embarked on a major programmatic painting, *Phenomena* (1936-38; State Tretyakov Gallery, Moscow), a sort of modern apocalypse in three movements: hell, purgatory, and paradise (this last movement was never completed). The work displays a number of visual influences, including

artworks by Lorenzo Ghiberti and Hieronymus Bosch, as well as Tod Browning's classic horror film *Freaks* (1932)—all by way of William Blake. At center left of the canvas, Gertrude and Alice are portrayed as incarnations of evil sitting atop piles of destroyed paintings (see the preparatory sketch for the work, pl. 261).

Balthus saw Gertrude and Alice during the war years he spent in Champrovent, not far from their country house in Bilignin, and he was then their neighbor in the Parisian *quartier* of rue Christine. Gertrude's role in his life is reflected in a 1949 painting, *Moroccan Horseman and His Horse* (pl. 194). Pierre Klossowski, Balthus's brother, described the mood of the composition as somewhere between nightmare and comedy: "the spahi is dwarfed by an enormous horse head, whose deep-socketed eyes have a certain je ne sais quoi that reminds one of Gertrude Stein's gaze."[58] Such a hidden, humorous tribute seems very probable on the part of Balthus, who found Gertrude's eccentricity amusing but enjoyed her conversation. He wrote to his wife in 1940: "It's winter here at the moment, but the weather is magnificent. On Sunday I went to Bilignin by bicycle. The two good aunties were kind and more witch-like than ever. What a pity I can't see them more often. It was a very quick and easy ride to get there, but I had to leave too early because of the ferry. Very good lunch and we had a great discussion, Gertrude

Plate 192

Plate 192, cat. 255
Pablo Picasso, *Homage to Gertrude Stein*, 1909. Tempera on panel, 8¼ x 10¾ in. (21 x 27.3 cm). Charles E. Young Research Library, UCLA Special Collections

and I. She is truly very reassuring and intelligent despite all her faults, and I for one like her a great deal."[59]

Picabia, the Cerebral Painter

In *Everybody's Autobiography*, which picked up the story of her life where *The Autobiography of Alice B. Toklas* left off in 1933, Gertrude Stein often spoke of Picabia. His painting, his conversation, and his friendship seem to have given new life to her interest in painting.

Although they met before World War I at rue de Fleurus, they really became friends only in 1930, and their correspondence between 1930 and 1945 is a particularly good indicator of the painter's activity.[60] Gertrude was impressed by the large Transparencies that Picabia exhibited from 1928 on; she saw them as a mixture of mimetic representation and elements of structure and syntax based on line, which together brought painting back into an ambiguous relationship to figuration. She observed, "Picabia had conceived and is struggling with the problem that a line should have the vibration of a musical sound and that this vibration should be the result of conceiving the human form and the human face in so tenuous a fashion that it would induce such vibration in the line forming it."[61]

Very quickly Gertrude identified a connection between Picabia's work and photography, as she had for Picasso. In the preface to the catalogue of his exhibition at the Valentine Gallery in New York, which she helped to arrange, she wrote: "Picabia got from the constant contact with photography... something which did give him the idea of transparence and four-dimensional painting, and this through him certainly has a great deal to do with everything. Even now in his later painting and his drawing he has achieved a transparence which is peculiarly a thing which has nothing to do with the surface seen."[62]

The work's indebtedness to photographic practice would not go unnoticed by Picabia's peers, particularly the photographers. Jacques-Henri Lartigue mocked Picabia's artistic process in 1927, seeing it merely as a "trick": "Picabia, 'the most intelligent of painters' (is that a compliment?), seems to me, above all, to be clever. Photographers and filmmakers have found a new thing called a 'means of expression' to impress the spectator's imagination. They superimpose, the way I—because I am small—sometimes forget to change the plate in my camera.... For Picabia this isn't complicated, he does two or three paintings which are colored drawings on the same panel."[63] Others professed more esoteric interpretations: the synarchic occultist Vivian Du Mas, for example, saw the work as the representation of astral visions filtered through the painter's consciousness.[64]

Gertrude Stein's comparison with photography is more interesting. She seems to sense, in Picabia, a connection to the image that is postmodern or neo-Dada, a connection that comes to undermine her own perception of painting with its roots in Cézanne and Picasso. When speaking of Picabia, she concedes:

> Anyway he was certain that anything should not look like anything even if it did and that really it did not. That was the influence of photography upon him it certainly was.
>
> That is where photography is different from painting, painting looks like something and photography does not.
>
> And Cezanne and Picasso have nothing to do with photography but Picabia has. Well. [...]
>
> I begin to see what Picabia means about Cezanne. Not that I do not like Cezanne best but I begin to see what he means. [...]

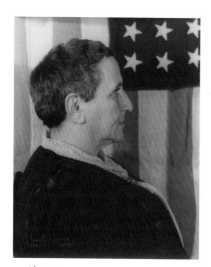

Plate 193

Plate 194

I thought I understood all about what we had done and now understanding Picabia made me start all over again. And suddenly with the Seurat show it came. Besides then there is the question of photography in painting.[65]

Gertrude is sensitive to the work's use of collage and manipulation of the image, its irony and "cerebral" nature. As a member of the organizing committee for the 1937 exhibition *Les Maîtres de l'art indépendant, 1895-1937* (Masters of Independent Art, 1895-1937), she proposed that Picabia's paintings be included in the show. With a great deal of humor, she evokes the debate that ensued: "Then of course I tried to introduce Picabia but to that there was no exception he was greeted by a universal no, why not I asked them because he cannot paint, they said, but neither everybody said could Cezanne, ah they said that is a different matter. Furthermore he is too cerebral they said…but to be cerebral and not abstract that is wrong I said oh yes they said."[66]

Gertrude and Picabia had a great deal in common: their love of dogs, their "open tomb" style of driving, the abundance and fluidity of their artistic and literary production—as well as a shared political conservatism and blindness all through World War II. More specifically, they had a mutual admiration for Marshal Pétain, head of the Vichy regime, and ties with Bernard Faÿ, director of the Bibliothèque Nationale during the occupation. Faÿ was a notorious collaborator, but he also protected Gertrude and Alice, two Jewish lesbians in Nazi-occupied France.[67]

Gertrude's friendship with Picabia, which was her last true close connection with an artist, is also reflected in the number of prefaces that she agreed to provide for his exhibition catalogues—exhibitions that she often helped to arrange.[68] At the time of the *Maîtres de l'art indépendant* exhibition in 1937, there were plans to produce a play together, with a script by Gertrude and decor by Picabia: "Picabia and I will perhaps do one for the exposition the play called Listen To Me, perhaps it is the son of Renoir who will put it on for us and it is all about how the world is covered all over with people and so nobody can get lost any more and the dogs do not bark at the moon any more because there are so many lights everywhere that they do not notice the moon any more."[69] Their plans came to nothing, for lack of a producer. Yet a stage set by Picabia, the organizer of memorable costumed fêtes on the Riviera, would undoubtedly have lent a very different aura than that which the young American artist Florine Stettheimer created for the 1934 production of *Four Saints in Three Acts* (pl. 195), the opera written by Stein with music by Virgil Thomson.[70] Performed on Broadway with African American voices, the production was a major event on the American stage of the 1930s—akin to the success of the 1917 musical ballet *Parade* in Paris, which featured music by Satie and decor by Picasso and was based on an idea by Cocteau. *Four Saints in Three Acts* was characterized by simplified, modern formal expression drawn from popular art forms, and it employed techniques of collage and assemblage that combined very successfully with Stein's rhythmic, abstract, concrete writing.

Gertrude Stein's last years would enable her, guided by Picabia, to see the establishment of postwar artistic trends such as Concrete art and Art Informel. The veterans of the Dada group—Hans Arp with his torn watercolors, Picabia, and Marcel Duchamp—were associated with the tendencies of Informel. By the time of the liberation, Picabia was once again spending time in Parisian art circles with the new generation—Henri Goetz, Christine Boumeester,

Plate 195

Plate 195
Florine Stettheimer's set for Act I of the 1934 production of *Four Saints in Three Acts*, composed by Virgil Thomson with libretto by Gertrude Stein. Photograph by Harold Swahn. Yale Collection of American Literature, Beinecke Rare Book and Manuscript Library, Yale University, New Haven

Jean-Michel Atlan, and Hans Hartung—at a time when one of his major abstract canvases from 1913, *Udnie*, was on view at the Musée National d'Art Moderne in Paris, and another, *Edtaonisl*, restored by Boumeester, was bought by James Johnson Sweeney for the Art Institute of Chicago in 1949. Now producing abstract paintings, Picabia drew Gertrude's attention to a young abstract artist, Atlan (pl. 196). Shortly before her death in July 1946, Gertrude Stein bought the informel canvases that Atlan presented at the Salon des Surindépendants in 1945[71] and wrote one last unexpected text on abstract art:

> And then one day I saw Atlan's paintings. And I was struck by the fact that he did not paint with what his eyes saw; he had an abstract conception and if there was something concrete it had crept in as emotion but fundamentally it was abstract, like writing [or] music and nonetheless it satisfied the eye, not his but mine.
>
> It was abstract and concrete in terms of emotion.[72]

Regardless of her professed lack of interest in all forms of abstract art (she was far too absorbed in the infinite possibilities, however radical, of the description of a fleeting reality), Stein had by this point finally broached the notion of abstraction, drawing a distinction with the idea of the concrete. And this new interest, in the end, was not unlike her own research into the typographical, sonorous, and poetic matter of words.

It was here that Gertrude ended her astonishing trajectory, from Cézanne to Atlan. She was convinced of the autonomy of painting, its capacity to question one's perception of reality, and every time she came across a new canvas, she would experience, to a greater or lesser degree of intensity, the initial jubilation of her visual encounters from childhood: at age eight, the experience of an illusory panorama of the battle of Waterloo, her first troubling encounter with verisimilitude, and, years later, the dizzying mise en abyme of a poster depicting a painter painting a poster that reproduces the same scene ad infinitum.[73] Each moment pointed to a vicious circle of representation that she evoked in her own circular emblem: *a rose is a rose is a rose is a rose…*

Plate 196

Plate 196
Jean-Michel Atlan, *Untitled*, 1945. Oil on panel, 39⅜ x 28¾ in. (100 x 73 cm).
Private collection

Notes

1. "Pictures" (1934), in G. Stein 1957, 77.

2. See Matisse's bitter testimony—"Testimony against Gertrude Stein" (Braque et al., 1935)—and the version that Leo published in 1947 in L. Stein 1996.

3. She writes: "It was an important purchase because in looking and looking at this picture Gertrude Stein wrote Three Lives.

"She had begun not long before as an exercise in literature to translate Flaubert's Trois Contes and then she had this Cézanne and she looked at it and under its stimulus she wrote Three Lives." G. Stein 1990, 34.

4. Ibid., 46.

5. See Giroud 2007.

6. Picasso worked very quickly; already by the first sitting he had finished a complete sketch, which Leo, Michael, and Sarah, as well as their friend Andrew Green, saw at the end of the day and which was clearly similar to the gouache portraits Picasso had made of Leo and Allan in 1906.

7. The first of her texts, published in 1909 by Grafton Press, New York.

8. In 1912 she wrote a long text, *A Long Gay Book*—published twenty years later under the title "G.M.P." (for "Gertrude Matisse Picasso")—a hermetic prose poem opposing the Matisse group (Delaunay, Derain, Manguin, Marquet, Puy) to the solitary genius of Picasso. "G.M.P. 1911-1912," in G. Stein 1933.

9. G. Stein and Picasso 2008, 81.

10. Toklas 1973, 49-50.

11. Lord 1994, 19.

12. Last shown at Jean Cassou's famous 1961 exhibition *The Sources of the Twentieth Century*, Picasso's *Nude with a Towel* is not well known today. This is the canvas bought by the Steins and not *Nude with Drapery* (1907; State Hermitage Museum, Saint Petersburg), as indicated in the exhibition catalogue *Four Americans in Paris* (Potter 1970). Margaret Potter was the first to point out the error in the catalogue of the David and Peggy Rockefeller collection (Potter 1984, no. 98, 262-64). She bases her argument on a letter from Kahnweiler to Gertrude dated October 17, 1913, which confirms the gallerist's purchase from her of three paintings by Picasso—*Young Acrobat on a Ball* ("La jeune fille sur la boule"), *Three Women* ("La grande composition rouge"), and *Nude with a Towel* ("La femme avec le linge")—in exchange for 20,000 francs and Picasso's recent painting *Man with a Guitar*. Working from a 1913 catalogue of the Shchukin collection, Potter also demonstrates that *Nude with Drapery* came from the Fonds Vollard (no.

126) and not from Kahnweiler. According to Kahnweiler's letter, the three paintings bought from Gertrude Stein in 1913 all entered the gallery at the same time. This is supported by the Kahnweiler gallery's stock numbers on the back of the works: *Three Women*, "n° 1490," and *Young Acrobat on a Ball*, "n° 1491" (information kindly provided by Albert Kostenevich, curator at the Hermitage in Saint Petersburg). We were able to examine the back of the painting *Nude with a Towel*, which carries the label "n° 1492." This confirms that the three paintings entered the Kahnweiler gallery stock simultaneously and came from the same source, Gertrude Stein.

13. The notebook of Picasso sketches now known as Carnet 10 was mentioned for the first time by John Richardson (1964), then partially reconstituted in the catalogue *Four Americans in Paris* (Potter 1970). Ten studies were subsequently recorded in *Le cubisme de Picasso* (Daix and Rosselet 1979): the still life (sheet 1) and nine studies of heads (sheets 2-10). The full ensemble was then published in the catalogue *Les Demoiselles d'Avignon* (Daix 1988, 521), including (via deductions based on similarities in size and subject) the four studies of figures for *Nude with Drapery* (sheets 11-14).

Bought from Picasso by Leo and Gertrude Stein around 1907-8, Carnet 10 was taken apart, and one of the sheets (cat. 370) ended up in Sarah and Michael Stein's collection. Of the fourteen sheets, four never appear in the photographs of rue de Fleurus, rue Madame, or rue Christine: two female heads acquired by the Seligmanns in 1947 from Alice Toklas (cat. 363, 364); the gouache that went to Sarah and Michael (cat. 370); and the sketch for *Nude with Drapery* now at the Baltimore Museum of Art (cat. 373). The other ten are all visible in a photograph of rue de Fleurus taken around 1914-15 (pl. 355); it shows a row of nine studies of female faces and nudes (cat. 365-69, 371, 372, 374, 375), with the still life (cat. 362) on the row below. This supports the contention that they all belonged to the same notebook.

14. He sent them a letter upon his return in September, and disappointed that they had not yet returned, he sent another card on September 13, 1908: "Studio tidied up, am only waiting for your visit," to show them his newest works. Stein and Picasso 2008, 42.

15. *Landscape with Two Figures* is visible in photographs of rue de Fleurus (pls. 351, 355, 360). Since the work is now in the Picasso collection, he must have bought it back from Gertrude or exchanged another work for it in the 1930s.

16. G. Stein and Picasso 2008, 55-65.

17. Ibid., 73-74.

18. On this topic, see Tucker 1982; Baldassari 1994, 156-75; and Baldassari 2007.

19. G. Stein and Picasso 2008, 62.

20. The two images were published on facing pages; on the back, a text by Elliot Paul explains the words, presenting Picasso's painting as the first cubist painting to which, given the attacks by critics, Gertrude Stein responded by asserting that "the painting is practically photographic." Transition 1928.

21. See Sutherland 1951; Grimal 1996; Dydo and Rice 2003. Excerpts from the notebooks concerning Picasso have been published in G. Stein 1970.

22. Grimal 1981, 42.

23. Sutherland 1951, 85-86.

24. "Picasso commenced to amuse himself with making pictures out of zinc, tin, pasted paper…. There is only one left of those made of paper and that he gave me one day and I had it framed inside a box." G. Stein 1984, 26. The work was reproduced after page 26, and although it is not the only vestige of this series of fragile sculptures made of cardboard, it is still one of the only ones that is on display, along with the two *Guitars* (Spies 2000, no. 29, 30) at the Musée National Picasso or the one that is at the Museum of Modern Art, New York (Spies 27A), and the little *Violin* (Spies 35).

25. See Baldassari 1994, 126-33, 213-43.

26. Daniel-Henry Kahnweiler to Gertrude Stein, March 28, 1912, Yale Collection of American Literature, Beinecke Rare Book and Manuscript Library, Yale University (hereafter, Beinecke YCAL), Gertrude Stein and Alice B. Toklas Papers, MSS 76, series II, box 112, folder 2310.

27. G. Stein 1990, 111.

28. Letter from May 8, 1912, in G. Stein and Picasso 2008, 103.

29. Leo Stein to Gertrude Stein, in L. Stein 1950, 56-57.

30. See letter from Gertrude Stein to Henry McBride in 1923: "I have a new Picasso I traded for an old and two new Masson's." Beinecke YCAL, MSS 31, box 11, folder 307, 13r.

31. Afterword to *Autobiographie d'Alice Toklas* (Kahnweiler 1965, 185). See also his introduction to volume 5 of the *Unpublished Writings of Gertrude Stein* (G. Stein 1955, ix-xvii) and his preface to *Picasso: Dessins, 1903-1907* (Kahnweiler 1954, unpaged).

32. See note 12 above.

33. See Cooper 1971, unpaged.

34. In a letter to Léonce Rosenberg on August 10, 1917, Gris mentions four still lifes bought by Gertrude Stein from Kahnweiler (Léonce Rosenberg Archives, Bibliothèque Kandinsky, Centre Georges Pompidou,

Paris, 9600-438, ms 20): nos. 48, 68, 83, 95 of the catalogue raisonné by Cooper (1977). See Kahnweiler's letter to Gertrude Stein on June 3, 1914, Beinecke YCAL, MSS 76, series II, box 112, folder 2310.

35. A portrait that was republished in a revised and corrected edition under the title "Pictures of Juan Gris" in *Portraits and Prayers* (G. Stein 1934), 46, 47, quoted here.

36. Transition 1927, 159-62.

37. Cooper 1971, unpaged.

38. See Kahnweiler's testimony about a project that never saw completion, the *Gertrude Stein Birthday Book*, written for Picasso's son Paulo, who was born in February 1921. The text was to be published with etchings by Picasso, which he constantly promised to finish the next day; according to Kahnweiler, he put up the passive resistance that was typical for any commission he was given. G. Stein 1955, ix-xviii.

39. In 1923 she bought three paintings: *The Meal* (1922), *The Cardplayers* (1923), and the major canvas *The Snack* (1922-23); she may have also influenced Hemingway when in May 1923 he bought *The Throw of the Dice* (ca. 1920). My thanks to Camille Morando for passing on to me her research for the publication of the catalogue raisonné (Masson et al. 2010).

40. G. Stein 1990, 210.

41. G. Stein 1971, 191.

42. Masson 1975, 32.

43. We know from the lists of paintings attached to insurance contracts entered into with Lloyd's in 1934 and 1937 that Gertrude owned three still lifes by Braque from the 1920s, bought no doubt from Kahnweiler and only just visible in a photograph taken in 1922 by Man Ray (pl. 359). The insurance contracts can now be found in the Stein Archives, Harry Ransom Humanities Research Center, University of Texas, Austin.

44. G. Stein 1990, 225.

45. Excerpt from "What Are Masterpieces," quoted in New Haven and Baltimore 1951, 8; cited in Grimal 1981, 383.

46. See G. Stein 1990, 230.

47. On this artist, see Soby 1942, New Haven and Baltimore 1951, Kirstein 1964, and Ford 1993. On his ties with Gertrude Stein, see Simon 1984, 153-54.

48. G. Stein 1990, 225.

49. G. Stein 1930.

50. G. Stein 1990, 227.

51. Bobsy Goodspeed came to Paris regularly to visit the studios before organizing her exhibitions. Gertrude Stein would advise her and invite her to her home. When Stein in turn was invited to America on a lecture tour, she lived at the Goodspeeds' for an entire month. The Arts Club would play a decisive role, as would Katherine Dreier's Société Anonyme in New York, in the introduction of modern art: staging exhibitions, concerts, lectures, and readings. In this way, a number of Gertrude's protégés were exhibited in Chicago: Francis Rose (1934), Tchelitchew (1935), Picabia (1936), Élie Lascaux (1936), and Balthus (1936), to mention only a few.

52. Before it was published in 1933 by Harcourt Brace, New York, excerpts appeared in the *Atlantic Monthly* and *Harper's Bazaar*.

53. Grimal 1981.

54. Roubaud 1983, 46.

55. See "Testimony against Gertrude Stein" (Braque et al., 1935).

56. G. Stein 1971, 64.

57. Ibid., 37.

58. Pierre Klossowski, "Du tableau vivant dans la peinture de Balthus," in Klossowski 2001, 116. I am grateful to Thadée Klossowski for having drawn my attention to this work and this text.

59. Balthus to Antoinette Klossowska de Rola, Champrovent, December 3, 1940, courtesy of Thadée Klossowski.

60. See Camfield 1979; and the correspondence between Gertrude Stein and Picabia, Beinecke YCAL, MSS 76, series II, box 118, folder 2548.

61. G. Stein 1990, 210.

62. G. Stein 1934a; an idea renewed in G. Stein 1971, 59.

63. Lartigue 1981, 255 (September 12 1927). I am grateful to Clément Chéroux for having drawn my attention to this text.

64. Du Mas 1932.

65. G. Stein 1971, 58-59.

66. Ibid., 313. She lent several works to the exhibition: twelve paintings by Picasso, two by Picabia (*Le Mandoliniste*, *Le Jeune Homme*), two by Gris, and an earthenware tile by Matisse. Raymond Escholier to Gertrude Stein, May 3, 1937, Beinecke YCAL, MSS 76, box 105, file 2085.

67. Regarding this issue, see Malcolm 2007; Compagnon 2009.

68. *Exposition de dessins par Francis Picabia*, Galerie Léonce Rosenberg, Paris, December 1-24, 1932 (poem and preface by Gertrude Stein, translated by Marcel Duchamp); *Recent Paintings by Francis Picabia*, Valentine Gallery, New York, November 5-24, 1934; *Picabia*, January 3-25, 1936, Arts Club, Chicago (poem by Gertrude Stein: "Stanza LXXI"); *Peintures Dada— Paysages récents de Francis Picabia*, Galerie de Beaune, Paris, November 19-December 2, 1937 (text by Gertrude Stein—November 1937—included in an ensemble of short texts by several authors: Marcel Duchamp, Breton, Cocteau, Ribemont-Dessaignes, and others); *Francis Picabia*, Galerie Serguy, Cannes, April 1941 (long preface by Gertrude Stein, in which she emphasizes the abundance of his production).

69. G. Stein 1971, 314. See also Picabia's letters from April 27, May 14, June 10, and July 1, 1936, Beinecke YCAL, MSS 76, box 118, folder 2549; and Burns and Dydo 2004-5.

70. *Four Saints in Three Acts* premiered on February 7, 1934, in Hartford, Connecticut, then played in New York and Chicago, with costumes by Florine Stettheimer, choreography by Frederick Ashton, and a black church choir from Brooklyn and Harlem. Another opera based on a text by Gertrude, *A Wedding Bouquet*, with music by Lord Berners, was produced at Sadler's Wells theater in London on April 27, 1937.

71. In the catalogue raisonné of Atlan's work, only one painting is said to come from the Gertrude Stein collection: Polieri 1996, no. 45 (no title), 175. A letter from Gertrude to Atlan, in which she expressed her joy at owning a major work by him and acts as intermediary for a purchase by Cecil Beaton, has been reproduced in the catalogue *Atlan: Premières périodes, 1940-1954* (Cousseau 1989), 224-25.

72. G. Stein 1978, 93 (translation by Erin Hyman). In a letter of January 4, 1946, Picabia thanked her for writing a preface to the catalogue of an exhibition devoted to Atlan, most probably the one that was held in February 1946 at the very new Galerie Denise René. Beinecke YCAL, MSS 76, box 118, folder 2549. The preface was not used, in fact, and would be published much later in *Lectures en Amérique* as "La peinture abstraite" (G. Stein 1978, 92-93).

73. "Pictures" (1934), in G. Stein 1957, 62-67.

Plate 197

Gertrude Stein and Pablo Picasso: In Their Own Words
Hélène Klein

The purpose here is not to discuss the ways in which Gertrude Stein's and Pablo Picasso's lives intersected. Nor is it to analyze the writer's remarks about the painter's work or the ways in which her writing may have been related to his painting, although the discussion, taking their own words as a point of departure, will be about life, writing, and painting. There will, naturally, be a certain imbalance, since her profession was that of a writer, using words abundantly, whereas he used a paintbrush and was a rather taciturn individual. With the exception of his letters and public statements, Picasso's words have generally come to us secondhand. In contrast, Gertrude Stein, who at a very young age "hunger[ed] and thirst[ed] for *gloire*," has left texts in which she is always seen in a favorable light.[1] In each case, their words are more or less unreliable. Their correspondence nevertheless contains flashes of indisputable sincerity.[2] What are we hoping to find in these words? Perhaps other ways—ways that are bound to be fragmented—to approach, cautiously, the reality of their relationship if not the truth…a truth that, fortunately, will escape our indiscretion.

Picasso is, along with the author, the hero of three of Gertrude Stein's books, in which he plays a more or less supporting role: *The Autobiography of Alice B. Toklas* (pl. 287), published in 1933; *Everybody's Autobiography*, published in 1937; and finally, *Picasso*, which was written in French in 1938.[3] Each of these three texts has a very different purpose: the first was written by Gertrude Stein in response to requests from people close to her who considered her to be *the* witness to the extraordinary quarter century that

they had just experienced. It is cleverly written, as if by another person altogether, someone who was reluctant to write—a challenge on the part of the writer as well as a coy writerly device, resulting in a disturbing story told by two voices, one that carries better than the other.[4] The second book picks up the narration of the author's life precisely where the 1933 text leaves off (recounting "what happened after *The Autobiography of Alice B. Toklas*"[5]), at which point it had become obvious that it was not so unpleasant to write an autobiography after all.[6] And the final volume—which, at least in the French edition, looks very much like a traditional, even rather serious monograph with footnotes—was commissioned by a publisher hoping to capitalize on the success of the 1933 book, which was no doubt due in part to Picasso's presence in the work, with a volume featuring two prestigious names on the cover.[7] A text in French was a challenge for a writer whose use of the language was eccentric, to say the least, but it was also an undertaking that ran counter to something that she had always claimed, namely that, in her opinion, there was only one language that suited her and that was English.[8]

In all three of these texts, which are fundamentally autobiographical, Gertrude Stein tells us a story, not the History that she no doubt would have liked to have lived and perhaps even believed that she had lived. "But God what a liar she is!" protested her brother Leo Stein on reading the *Autobiography* in 1933.[9] Naturally, her openly hagiographic narrative is not the least bit bothered with historical truth; the author's serene indifference to the corrections that Daniel-Henry Kahnweiler patiently and courteously suggested is proof that this was hardly her main concern. As he noted, "Gertrude didn't like reality."[10]

Plate 197, cat. 260
Pablo Picasso, *The Architect's Table*, 1912. Oil on canvas mounted on panel, 28⅝ x 23½ in. (72.7 x 59.7 cm). The Museum of Modern Art, New York, The William S. Paley Collection, 1971

Intimacy: "knee to knee"[11]

The story of Gertrude Stein and Picasso exists thanks to the words of a koine that belonged to them alone, the rough French that they spoke together, in 1905 at any rate: "I talk French badly and write it worse but so does Pablo he says we write and talk our French."[12] And while Gertrude Stein was always at ease, Picasso was less so: "People were bothering him, they wanted to make him speak, and that was hard for him, especially in French."[13] They were on a first-name basis, with "simple affection and confidence."[14]

There was an unusual physical closeness between the two. From the beginning, each of them found the other's appearance striking: Picasso was impressed by her massive body, her sculpted head, and her masculine side—"in her voice, in her entire bearing"—so much so that he immediately asked to paint her portrait.[15] She was struck by his beauty: "he was remarkably beautiful then,…he was illuminated as if he wore a halo"; "thin dark, alive with big pools of eyes."[16] There were details that they shared: small hands, loud laughter, and mutatis mutandis, even their clothes, if one remembers that Picasso, on his first trip to Paris, had a velvet suit made.[17] She also noticed a certain coarseness in his behavior: "a violent but not rough way," which she certainly found somewhat charming.[18] There are reports of several instances of physical confrontation. The earliest episode of this nature occurred the first time Picasso came to dinner at rue de Fleurus. He took a piece of bread from her, "snatching it back with violence," an event that would inaugurate "their intimacy."[19] Gertrude Stein describes another notably violent scene—and this time she was the perpetrator—that took place in the 1930s at Paul Rosenberg's: a discussion full of barbed remarks about Picasso's poems culminated in her grabbing him by the lapels and shaking him violently, then finally kissing him twice before taking her leave.[20]

Life's vicissitudes also brought them closer. Picasso came to her to explain why he had left Fernande Olivier: "He and Gertrude Stein had a long talk alone…he said a marvelous thing about Fernande, he said her beauty always held him."[21] There are also several moving passages in their correspondence: on May 5, 1913, after the death of his father,

Picasso wrote, "I love you very much my dear friend," and on January 8, 1916, upon the death of Eva Gouel, "I would have been very happy to speak with a friend like you." As for Gertrude Stein herself, when in 1935 Kahnweiler informed her of Picasso's "divorce," in a moment of sincere effusiveness she wrote, on August 8: "So Pablo do please come down and spend a few days with us. After all we're friends nothing can change that, and we can talk and empty ourselves of everything…send us a telegram and I'll fetch you at Culoz whenever you want, and perhaps it's all for the best it is difficult to know how, but perhaps."[22] Such authentic empathy in a private exchange gives legitimacy to what appears in print, reaffirming their friendship loud and clear.

There were, of course, times when they drifted apart—much changed after the war—and there were some serious conflicts. Gertrude Stein had no fear of describing them, but her manner is singular, detached: it is often difficult to determine exactly when, why, and for how long they were estranged.[23] Between the end of 1919 and the early summer of 1922, for example: "Gertrude Stein and Picasso quarreled. They neither of them ever quite knew about what. Anyway they did not see each other for a year." And after a meeting that did nothing to reconcile them, "they did not see each other for another year."[24] The onset of the 1940s and World War II would exacerbate their estrangement; the Spanish Civil War was an unspeakable torment for the artist, and he must have heard, if not directly at least through others, about Gertrude Stein's staunch anticommunist position, as set out in *Everybody's Autobiography* (which Picasso, who did not know English, could not have read). She mentions only the violent acts committed by the anarchists at the beginning of the conflict and seems to know nothing about what was actually at stake: "Well anyway the Spanish revolution obtrudes itself because I know Spaniards so well and all the things they are destroying… I would worry about them if I did not remember that they are always that they always have been destroying works of art."[25] He must have known, too, that in Bilignin (near Belley, in the Ain), where she spent the war years, she began in 1942 to translate Pétain's *Paroles aux français, messages et écrits, 1934-1941* for an American edition that in the end

was never published.[26] This was the basis, to some extent, for Picasso's remarks regarding Gertrude Stein, as related by James Lord: "A real fascist, what's more. She always had a weakness for Franco…. For Pétain, too."[27]

Painting: "It's all very hard to express with words"[28]

Picasso painted Gertrude Stein's portrait (pl.183) in 1905-6. She tells us the story of that portrait, a marvelously mythical narrative of an unbelievably long gestation period (one cannot help but question the purported eighty or ninety sessions), of a brutal interruption when Picasso destroyed his work on the face by covering it with a layer of paint (an iconoclastic gesture if ever there was one, all the more violent for the fact that he made it in the model's presence);[29] of his resumption of work on the canvas in the absence of the model following the summer he spent in Gósol. All of this leads us to a clearer understanding, given everything that the artist had invested in the portrait, of the essential contribution of his stay in Spain, for it led him to renounce resemblance in favor of a radically simplified treatment of the face, a major innovation. The mask that now replaced Gertrude Stein's face would become her likeness for all eternity and, as a result, consecrate the eternity of the "model."[30]

Gertrude Stein was a sharp customer, and it was easy for her to say later on that she had discovered her first true style, that of *Three Lives*, at the very same moment and thus to establish the story of their parallel creative lives, based on what she would invariably refer to as "struggle." We will not go into the legendary remarks that accompanied the history of that painting in Gertrude Stein's and Picasso's lives,[31] apart from this: just as the causes of their arguments have been forgotten, so too was the gestation of the portrait. Neither Gertrude Stein herself nor Picasso, she says, could remember what happened during the long period between the proposal and the completion of the portrait: "just how that came about is a little vague in everybody's mind…they neither of them can remember…how it came about they do not know…they do not either of them know how it came about." Between the first dinner at rue de Fleurus and the first sitting "there is a blank."[32] Similarly, according to her, they would lose all recollection of the initial portrait that

lay beneath the mask: "Neither can remember at all what the head looked like when he painted it out."[33] To what end such a singular suppression? And why did she feel the need to insist upon it so? This confers something of a sacred mystery of origins on the episode. And one might also see in it something of a fairy tale, in which the marvelous inevitably is followed by forgetting.

To what degree should we take Gertrude Stein at her word when she tells us about Picasso's life as a painter? Many of the details are colored by experience, which makes her often-exasperating texts so engaging. Was she present at the hilarious exchange between Braque and Picasso, "in their newest and roughest clothes," in Wilhelm Uhde's shop, behaving like clowns "and in their best Cirque Médrano fashion [keeping] up a constant fire of introducing each other to him and asking each other to introduce each other"?[34] It would seem so. And through her words we can see the artist's work as it is being performed—a precious legacy. We are with her in the studio when he begins her portrait: "Picasso sat very tight on his chair and very close to his canvas and on a very small palette which was of a uniform brown grey colour, mixed some more brown grey and the painting began."[35]

In the midst of the unbearable confusion—not only chronological—of her text for *Picasso*, there are many penetrating observations: for example, no doubt at the time that he was creating *Les Demoiselles d'Avignon* (1907; Museum of Modern Art, New York): "when Picasso wanted to express heads and bodies,…he had a tendency to take them as a block, the way sculptors do, or in profile, the way children paint."[36] After the summer of 1910, when the "homogeneous form burst forth":[37] "a child sees the mother's face up close, and sees only part of it, and knows one detail but not another, one side and not the other…;Picasso knows faces the way a child knows its mother's face."[38] Gertrude Stein makes note of his use of an unusual material, Ripolin enamel ("for him these paints were, as he often went on to say later, the health of color"[39]), and of papier collé. According to Picasso (who was grossly mistaken in fact), "*Paper lasts as long as paint and if it all ages together afterward, why not?*"[40] Gertrude Stein owned a photograph that Picasso had taken

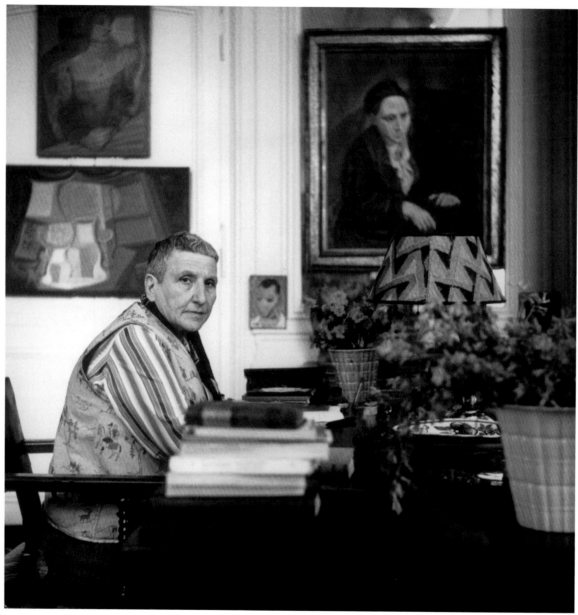

Plate 198

in his studio on boulevard de Clichy in 1911 of a still life on a coffee table, and because of this photograph, she would write: "I was astonished by the way Picasso could gather objects together and make a photograph with them. I kept one of them. The force of his composition was so great that he did not even need to paint the picture."[41] But one must remain circumspect: if it is true that Sergei Shchukin, in tears over *Les Demoiselles d'Avignon*, said to her that he felt it was "a loss for French art," the episode could not have taken place in 1907 because the painter and the Russian collector did not meet until 1908.[42]

Writing: "I like the life of a literary man"

Whose words were these? The artist's, in 1935, as quoted by the writer.[43] Gertrude Stein was not at all pleased to see Picasso taking up poetry (see pl. 199), for she felt that he should never use a pen for anything other than drawing. She speaks at length and with great interest in *Picasso* about the "calligraphy" that he used in his paintings and drawings in the mid-1920s and reproduces one of them, with the title "Lines and stars. Drawing of pure calligraphy."[44] One should not misinterpret the formula: "For Picasso, a Spaniard, writing is an art."[45]

It was moreover this ambiguity that led to their misunderstanding when Gertrude Stein went to Picasso's place to read his poems for the first time.[46] Both put on their glasses, Picasso to read and Gertrude Stein to "look on while he was reading." Picasso questioned her. "I drew a long breath," she wrote, "and I said it is very interesting."[47] Picasso was somewhat worried, all the same, and went to visit her in turn, to renew the attack: after discussing the egotism of painters and writers, she said once again—this was a formula she used in every situation—"it's extremely interesting." At that point Picasso did not mince his words in talking about the painters that Gertrude Stein had recently adopted: Francis Rose "had not come to anything," and Francis Picabia "is the worst painter of anyone…because he cannot paint at all." Her response: "Well I said his writing does not interest me and he did not answer. Then for a little while we did not meet."[48] It was during the confrontation mentioned above, at Galerie Paul Rosenberg, that she

would have it out with him, not without a certain soundness of judgment, although there was some jealousy involved, as she argued that they should each stick with what their true talent destined them for: "somebody who can really do something very well when he does something else which he cannot do and in which he cannot live it is particularly repellent."[49] In a stroke of genius, she backed up her argument by referring to the way Picasso despised Cocteau's drawings. She advised the artist to hurry and put an end to his writing therapy (since this was how he treated his depression, in Paris cafés) and get back to painting.

How, in turn, might Picasso have evaluated Gertrude Stein's writing? Obviously he was flattered when he received the portrait published by Stieglitz, but he pointed out that he could not read it. Kahnweiler translated it for him.[50] He was surely also sensitive to the remarkable quality of the special issue of *Camera Work* in which "Picasso" was published, along with seven superb photographic reproductions of his work and in the company of an artist of whom he already knew himself to be the equal, Matisse. But when he was urgently summoned in the fall of 1932—as soon as Gertrude Stein came back from Bilignin, where she had

Plate 199

written the book in six weeks—to hear *The Autobiography of Alice B. Toklas* read out loud to him in translation, things took a dramatic turn. There are two versions of the episode. The first one (official, published in *Everybody's Autobiography*) states that it was Olga Picasso who was offended to hear Fernande Olivier mentioned and who left the premises in the company of a husband who was reluctant to follow.[51] The second, infinitely more probable version, from 1934 and unpublished at the time, holds that Picasso was the one who got "very excited and pleased…went home and then he was furious and we have never seen each other again and now we never will."[52] It was better to blame explicitly the jealous wife rather than the hero of the story, whom Janet Scudder referred to in 1938 as the writer's "pet artist."[53] It is a well-known fact that Picasso could get very annoyed when anything was published about his life—not only his "family business"—and he had just been confronted with the publication in the press of an excerpt from Fernande Olivier's memoirs.[54]

As for what Picasso might have thought of Gertrude Stein's poetry, Leo Stein's testimony—for he was exasperated by his sister's style and had fallen out with Picasso already in 1907 when he confronted *Les Demoiselles d'Avignon*—must be taken with a grain of salt, because his satisfaction is only too obvious. One day in the early 1930s Leo ran into the artist on the street, and their encounter was anything but affable. When the question of what his sister was writing came up, the exchange was as follows: "'I can't read English [said the artist]. What does she write?' I said she used words cubistically [replied the American], and that most people couldn't understand at all. 'That sounds rather silly to me. With lines and colors, one can make patterns, but if one doesn't use words according to their meanings, they aren't words at all.'"[55] Picasso hardly seemed inclined to subscribe to the osmosis between literature and painting that the writer incessantly upheld with the most ardent conviction.

There is one word missing here, an absolutely crucial one: *genius*. It is used over and over by Alice Toklas in the *Autobiography* when referring to Gertrude Stein, Picasso, and, for good measure, Alfred Whitehead. And it is used again, even more unashamedly and without a trace of humor, by

Gertrude Stein about herself in *Everybody's Autobiography*. We come across it yet again in the fierce words of Leo Stein: just before the passage quoted above, Picasso related with a shrug of his shoulders a puzzling thing that Gertrude Stein had just said to him: "there are two geniuses in art today, you in painting, and I in literature."[56] We have seen what he thought of the edifice that the writer had patiently constructed over a lifetime.

Throughout this history, we are left wondering who made whom. When the affectionate William Cook, upon reading *Picasso*, wrote to Gertrude Stein, "you have done the Picasso legend and it will stay that way…without you he would have melted off somewhere, into something else, you have kept him and made him Picasso,"[57] Picasso himself could not hide his annoyance, if we are to believe the often unreliable James Lord.[58] But what might his fate have been had there not, at the side of Leo Stein, been the sister whose enthusiasm was unshakable? And without Picasso in his supporting role in the *Autobiography*, the book that truly launched Gertrude Stein, paving the way for her triumphant lecture tour in the United States in 1934, what might the writer's future have been? The fact remains that they cared deeply for each other, as best they knew how. She wrote about it at length in the pages of her books, and he wrote about it in his paintings: in *The Architect's Table* (1912; pl. 197, cat. 260), one can read "Ma Jolie"—an allusion to his beloved Eva Gouel that not many people could grasp in 1912[59]—as well as, perfectly legible on the little white rectangle painted in the lower right-hand corner, like a visiting card: "Gertrude Stein."[60]

Translated by Alison Anderson

Notes

My thanks to Cécile Debray for generously sharing her documentation with me, and to Edward Burns for doing likewise with his inexhaustible knowledge.

1. L. Stein 1950, 52.

2. G. Stein and Picasso 2008.

3. But Picasso had been mentioned before 1933 in Gertrude Stein's literary work: already in 1909, with "Picasso," which appeared in *Camera Work* in 1912 (G. Stein 1912); more secretly in "G.M.P.," written in 1911-12 and not published until 1933 in *Matisse, Picasso, and Gertrude Stein* (G. Stein 1933); and "If I Told Him. A Completed Portrait of Picasso," written in 1923, which would be published in *Dix Portraits* (G. Stein 1930) and *Portraits and Prayers* (G. Stein 1934). Obviously Picasso was present (mentioned or quoted) in other texts.

4. Which was not, as the author claimed, the equivalent of Robinson Crusoe's story as told by Defoe (G. Stein 1990, 252). Her Robinson had been living by her side for twenty-five years! Obviously she was writing *her* autobiography and was not as fierce in the telling as she would have people think; Henri-Pierre Roché guessed as much when he said to her, although she was speaking about herself: "that is very important for your biography" (ibid., 45). At the very end of "Portraits and Repetitions," in *Lectures in America*, she says: "And so I wrote the Autobiography of Alice B. Toklas and told what happened as it happened" (G. Stein 1957, 205). In the *Interview transatlantique* in 1946, she would add that she began to write it "as a joke" (G. Stein 1987, 16), in order to lead the reader astray as to the narrator's identity (and her literary agent was very worried about it!).

5. G. Stein 1971, 9.

6. Initially she refused to undertake this sort of project: "not possibly." G. Stein 1990, 251.

7. In 1970 Edward Burns published the invaluable *Gertrude Stein on Picasso* (G. Stein 1970), which contains the newly established text in English (it first appeared in October 1938 and differs markedly from the French); he quotes, on page 118, a letter from Gertrude Stein to W. G. Rogers: "there are going to be lots of dates and foot-notes just like a real book. Escholier insisting upon that, so I am letting them put them in not having the habit." According to Burns, it would have been Raymond Escholier, director of the Musée du Petit Palais and in charge of the Les Arts collection at the Floury publishing house, who approached Gertrude Stein and took on the task of providing the footnotes that she referred to so casually. According to Vincent Giroud (2007), it was Kahnweiler who actually provided the notes (in the book, only one is attributed to him by name, on page 37). There is noth-

ing on the subject in Kahnweiler's letters (which I have read), or in Escholier's, which Timothy Young kindly went over for me. They are preserved at the Yale Collection of American Literature, Beinecke Rare Book and Manuscript Library, Yale University (hereafter, Beinecke YCAL), MSS 76, series II, box 112, folders 2310-11, and box 105, folder 2085.

8. "There is for me only one language and that is English" (G. Stein 1990, 70). The text of *Picasso* (G. Stein 1938) was written in two school notebooks and typed up by Alice Toklas, then corrected by the two ladies and submitted for kindly review by the baronne Pierlot (a neighbor in Bilignin) and Kahnweiler (who was probably discouraged by the immeasurable task that would have been his if he had displayed his usual rigor). Beinecke YCAL, MSS 76, series I, box 65, folders 1161-64. Gertrude Stein describes how hard Toklas worked "to reduce tenses grammar spelling and genders into some kind of order." Gertrude Stein to Thornton Wilder, December 8, 1937, in G. Stein and Wilder 1996, 199. The manuscript, in rather clumsy French, already bears corrections; the typed version, which also contains handwritten corrections, differs considerably from the printed text, which has lost much of the authenticity of expression present in the earlier drafts. (It is in the English text that the language reasserts its rights.)

9. Leo Stein to Mabel Weeks, December 28, 1933, in L. Stein 1950, 134. Weeks was a patient correspondent who for years listened to Leo as he bitterly rehashed his multiple reproaches against his sister, who is said to have "eliminated" him (ibid.).

10. Kahnweiler 1965, 186. One can find distinct traces of the thirty-three corrections that Kahnweiler proposed for the *Autobiography* in his correspondence with Gertrude Stein, conserved at Yale. Beinecke YCAL, MSS 76, series II, box 112, folder 2311, n.d. Although he had corrected only factual errors, she paid no attention to his suggestions. Nevertheless, in the afterword from 1965, in which he reveals without the least bitterness Gertrude Stein's disdain for the proposed corrections, he strongly defended Wilhelm Uhde, saying that she was spreading "odious rumors." Clearly there was a constant distortion of reality in her autobiographical writings, to different degrees and in diverse ways.

11. G. Stein 1990, 77: "These two [Picasso and Gertrude Stein], even to-day have long solitary conversations. They sit in two little low chairs up in his apartment studio, knee to knee and Picasso says, expliquez-moi cela."

12. G. Stein 1971, 14. And it must have been quite a colorful idiom!

13. Fernande Olivier's words, in *Picasso and His Friends* (Olivier 1964, 139). Picasso "couldn't explain what he felt needed no explanation," added his companion. But

if we are to believe Leo Stein, the day he actually did begin explaining, it was a disaster, "childishly silly": "With Picasso as a thinker there's nothing doing.… Picasso may have given up 'thinking!'" Leo pointed out that Picasso was "more convivial than social… stood apart, alone." L. Stein 1996, 176, 182, 171.

14. "I wish I could convey something of the simple affection and confidence with which he always pronounced her name and with which she always said, Pablo." Matisse called her "Mademoiselle Gertrude." G. Stein 1990, 15.

15. Olivier 1988, 211. Naturally Picasso did not say anything about this model who so tempted him; it was Fernande Olivier who later wrote that he was "attracted by the woman's physical personality" and that he suggested doing her portrait "before he really knew her," when they met at Sagot's, a meeting that apparently took place before Leo Stein's first visit to the studio in the spring of 1905 in the company of Roché; Picasso made a return visit to rue de Fleurus on the same day. See L. Stein 1996, 171; Olivier 1988, 211 (a text that probably dates from 1906 and that she used again, in part, in *Picasso et ses amis* [Olivier 1933, 101n12]); Olivier 1964, 83. As for Gertrude Stein, she was aware of the virility of the men she encountered, Matisse and Picasso in particular. In notebooks that have for the most part remained unpublished, one can read: "Pablo & Matisse have a maleness that belongs to genius. Moi aussi, perhaps" (G. Stein 1970, 97). Vincent Giroud's very complete text (Giroud 2007) describes scene by scene the story of the portrait from 1905 right up to its donation, after the model's death, to the Metropolitan Museum of Art in New York.

16. G. Stein 1990, 221; 46. One of Alice Toklas's friends described Picasso as "a good-looking bootblack," no doubt for the somewhat exotic ring to the term (ibid., 46). In the 1909 portrait Gertrude Stein used the word *charming* over and over in the first paragraph to describe the painter (G. Stein 1912, 29; G. Stein 1934, 17).

17. J. Richardson 1991, 162. Picasso was still wearing the velvet suit in the photos taken in 1901 at 130 boulevard de Clichy and in *Self-Portrait in Front of the Moulin Rouge* (Daix and Boudaille 1966, no. IV 23), completed that same year. In 1905, however, he wore workers' overalls more often—"what the french call the singe or monkey costume" as Gertrude Stein wrote (1990, 22). Their close relationship could even be found in their pockets, in which they both accumulated the same little objects: "horseshoe nails and pebbles and little pipe cigarette holders" (ibid., 9).

18. Ibid., 46.

19. Ibid. Their intimacy was also based on aesthetic standards that Picasso very quickly voiced, *mezza voce*: he did not like Japanese etchings. And the text goes on

to say, "[they] immediately understood each other" (ibid., 46). Gertrude Stein also stated, with regard to Gris, "we were intimate" (1927, 161). She likes the word; it is flattering.

20. G. Stein 1971, 37. Three times over she says, in a few lines, that she shook him: this stylistic habit gives the "scene"—for it is a scene—a particular vehemence. But if we were to imagine these two episodes in another context—pairing Lauren Bacall with Humphrey Bogart, for example—we might interpret them quite differently. In 1955 Alice Toklas was amused to hear some fairly significant gossip, through Dilkusha de Rohan, alleging that Gertrude Stein and Picasso had been lovers (Toklas 1973, 319). It is unlikely that Picasso was ever troubled in the same way as Hemingway, who confessed in a letter to Gertrude Stein that "he had always had an urge to fuck her" (Mellow 1974, 458).

21. G. Stein 1990, 112. If it is true (and it does ring true), however, did Picasso expect the matter would be dragged into the public eye? In his "Testimony against Gertrude Stein" (Braque et al. 1935, 7), Matisse vehemently reproached her for the "sans-gêne" and "irresponsibility" that she displayed in *The Autobiography of Alice B. Toklas*. And it was no doubt because of indiscretions of this kind (for example, the feelings that she ascribed to him regarding Gris) that Picasso was upset by her book.

22. G. Stein and Picasso 2008, 350. Kahnweiler, upset, had written to her in French (and not in English), momentarily overwhelmed by emotion, no doubt, on August 7: "I'm sure he'd be glad of a letter from you" (ibid., 350n3). Picasso was not actually getting "divorced" but separating from his wife. Beinecke YCAL, MSS 76, box 112, folder 2311. There were other rough passages during their lives when they were reunited, such as an alert during World War I and Gris's death.

23. Although it is not an infallible indicator, the fact that their correspondence was interrupted is a sign.

24. G. Stein 1990, 190; note the repetition. Somewhat later on, as we will see, in 1935, they would have a serious falling out (both of them were angry). They also argued, probably in 1906, about some paintings that had ill-advisedly been varnished by the Steins (Olivier 1964, 139-40) and about the purchase of an automobile after the war: "They never saw each other again," concluded Alice (Toklas 2000, 210).

25. G. Stein 1971, 90-91. One year later, on July 18, 1937, in the *Springfield Republican*—did she even know about it?—Picasso issued a declaration against fascist propaganda, "Picasso, Statement rejecting the fascist position on the Franco rebels," addressing his "friends in America": "the world must know that the Spanish people have saved Spanish art." Picasso 1998, 38.

26. On this subject, see the edifying study published by Edward Burns and Ulla Dydo, which leaves one speechless: "Appendix IX, Gertrude Stein: September 1942 to September 1944" in G. Stein and Wilder 1996, 401-21. The introduction to her translation, written by Gertrude Stein herself, is published here in full: she praises the signing of the armistice, considering that "the Maréchal…achieved a miracle," and advising others "to have faith in him" (ibid., 408, 406). The loyal Kahnweiler had written to her on July 10, 1940, regarding the armistice: "you can imagine my feelings, just as I can imagine yours." Beinecke YCAL, MSS 76, series II, box 112, folder 2311. How, in his introduction to *Painted Lace* in 1955, could he write that the two of them both found themselves living "dans la clandestinité" (Kahnweiler 1955, 27)? Picasso nevertheless kept an eye from a distance on the preservation of the collection that was at rue Christine during the war, and he would hurry to Gertrude Stein's place the moment he returned in December 1944 (see Toklas 2000, 206).

27. Lord 1994, 15. She did not, however, write a speech for Pétain, although Lord implied that Picasso said she had. Lord recounts Picasso's words, which are remarkably vulgar, with obvious relish.

28. G. Stein 1938, 159.

29. A model he could easily do without, and his famous words are an eloquent expression of his exasperation: "I can't see you any longer when I look." G. Stein 1990, 53.

30. See Giroud 2007. Edward Burns brings to our attention that the little head of a man (1906; pl. 81, cat. 239), no doubt a self-portrait, which Gertrude Stein had in her possession, was a reversed picture of her own portrait (this has also been said about *Self-Portrait with Palette* [1906; Philadelphia Museum of Art]); however, at rue Christine, one can see in a photograph by Cecil Beaton (pl. 198) the little painting hanging just to the left of the portrait of Gertrude Stein, as if to echo it, and probably this was no coincidence.

31. Picasso went to rue Christine one last time to see the portrait before it left for the United States in 1947: "ni vous—ni moi le reverra jamais," he said. Toklas 1973, 57. It was a farewell to youth as much as to a work that he knew was decisive in his career and that had continued, given its geographical proximity, to be a part of his life.

32. All of this repeated in a few lines in the same paragraph (G. Stein 1990, 45). The episode came up again in *Everybody's Autobiography* (G. Stein 1971, 73) and elsewhere no doubt. To whom did it belong, the expression Picasso used regarding the portrait, "mais, quand même tout y est, all the same it is all there" (G. Stein 1990, 57), an expression that she had already suggested to him regarding a painting that was "not finishable"

(G. Stein 1990, 22)? She would use it again regarding Cézanne, whose canvases were "the very essence of an oil painting because everything was always there, really there," in her lecture "Pictures," in G. Stein 1957, 77.

33. G. Stein 1990, 57.

34. Ibid., 97.

35. Ibid., 47.

36. G. Stein 1938, 64.

37. The formula was Kahnweiler's (1963, 29).

38. G. Stein 1938, 51. The Russian writer Ivan Aksenov had also noticed how closely Picasso observed things; he wrote in 1917, in *Picasso i okrestnosti*: "Picasso looks at the objects he represents very closely—staring at them, not allowing himself to be distracted by anything, the way *lovers* look at each other." From the German translation, in Picasso 1973, 56.

39. G. Stein 1938, 78.

40. Ibid. Gertrude Stein's use of italics in the text suggests that she did not want anyone to question this statement by Picasso. Worthy of mention, on page 77, she discusses the cubist still lifes and constructions, including the one in paper that he had given her, *Man with a Guitar* (1913; pl. 234, cat. 264), an exquisite work that she reproduced on page 78.

41. Ibid., 63-64. This photograph has been reproduced by Anne Baldassari (1994, 131), who quotes the same text.

42. G. Stein 1938, 64. It is of little importance, moreover, whether the episode, with all its fine drama, is apocryphal (there are any number of points that could be improved or corrected in the book): it shows the distress the painting caused, about which Gertrude Stein herself says nothing.

43. G. Stein 1971, 18. These words could also be applied to the woman to whom Picasso wrote so wittily on March 31, 1911: "To Mademoiselle Gertrude Stein / man of letters." G. Stein and Picasso 2008, 81.

44. G. Stein 1938, 125. This same drawing was reproduced as a full page in *La révolution surréaliste*, no. 2 (January 1925).

45. G. Stein 1938, 106.

46. She had been informed by Kahnweiler, who wrote in September 1935: "Did I tell you that he *writes*…. He has showed me the manuscript, but he never lets me read it…it's a very serious matter with him." Beinecke YCAL, MSS 76, series II, box 112, folder 2311. In *Everybody's Autobiography*, this letter, or a later verbal exchange, would become: "just poetry he said you know poetry like everybody writes." G. Stein 1971, 15.

47. G. Stein 1971, 17. Here she says, about Picasso's handwriting, "whenever it puts itself down he makes a picture of it." In 1955 Toklas, who had grasped the misunderstanding, would recall in a letter to Dilkusha de Rohan: "she looking down at the page said—*Que c'est beau* and repeated it—*Que c'est beau*—as was her habit. I knew what she meant but didnt think P. did. It was the disposal of the written words on the sheet!" Toklas 1973, 319. See the manuscripts of the poems reproduced in Picasso 1989.

48. G. Stein 1971, 19.

49. Ibid., 37. This discussion is deserving of further exploration. For example: "No matter how certain you are about anything about anything belonging to you if you hear that somebody says it belongs to them it gives you a funny feeling." Ibid., 15.

50. Pablo Picasso to Gertrude Stein, September 18 and October 7, 1912, in G. Stein and Picasso 2008, 108, 111. Was it really about this, as has been said, that he wrote to her on December 23, "You will be the glory of America"? Ibid., 115.

51. G. Stein 1971, 14.

52. Unearthed by Ulla E. Dydo (Dydo and Rice 2003, 543), who notes that the lines quoted in part here are in the manuscript for "And Now And so the time comes when I can tell the story of my life," an essay published in *Vanity Fair* in September 1934, but they did not appear in the published version.

53. Janet Scudder to Gertrude Stein, April 3, 1938, in Gallup 1953, 328.

54. Apparently he thought of trying to prevent the publication of Fernande Olivier's book *Picasso et ses amis* (Olivier 1933), as he had interrupted its partial publication in *Le Soir* in 1930. The book came out several weeks after the English edition of *The Autobiography of Alice B. Toklas* (see Hélène Klein, "Temps perdu, temps retrouvé," in Olivier 2001b, 7–17). Already in 1913, following Guillaume Apollinaire's courageous *Méditations esthétiques*, in which he defends the "new painting," the Cubism that Picasso had initiated, Picasso wrote to Kahnweiler, on April 11: "I am really sorry about all this gossip." See Monod-Fontaine 1984, 170.

55. L. Stein 1996, 190. Leo Stein believed that there was an equivalent process in literature and writing from 1913 on, but only for the worst: "cubism whether in paint or in ink is tommyrot" (L. Stein 1950, 48). This is not the place to expand on the subject of "cubist poetry," which, from 1917 on, was the subject of much debate and the source of much quarreling in Paris among poets such as Apollinaire, Max Jacob, and Pierre Reverdy, with the publication of the book by Frédéric Lefèvre, *La jeune poésie française: Hommes et tendances* (Lefèvre 1917), in which for the first time he used the unfortunate expression "literary cubism." Gertrude Stein constantly reminds us that Picasso sought his friends among poets, and she even viewed this as a necessity. In her French book *Picasso* (G. Stein 1938, 6), she wrote, "Picasso, who was a man who expressed himself only through his painting, had a need, therefore, for friends who were writers." In English it was even worse: she wrote "had only writers as friends" (G. Stein 1984, 4). And while the Bateau-Lavoir studio was called "the rendezvous of poets," it was certainly not because she went there.

56. L. Stein 1996, 190.

57. William Cook to Gertrude Stein, March 27, 1938, in Gallup 1953, 327.

58. "To hear her, everyone might think she'd made me, piece by piece." Lord 1994, 178.

59. Picasso is known to have written to Kahnweiler about Eva Gouel on June 12, 1912: "I love her very much and I will write it on my paintings." Monod-Fontaine 1984, 168.

60. A very real dog-eared visiting card with the names of both Gertrude Stein and Alice Toklas, marking their passage at the painter's home, was found on a papier collé of 1914 that the painter left at their house in return. G. Stein 1970, 137n6.

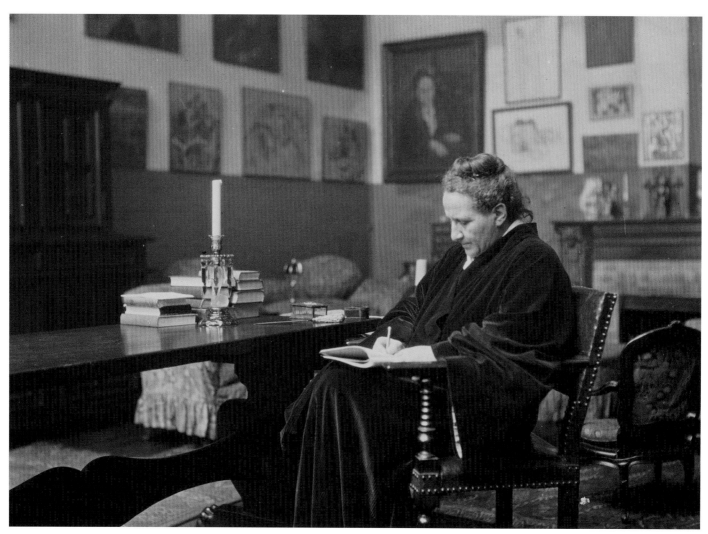

Plate 200

Gertrude Stein as Portrait Painter

Isabelle Alfandary

In the book *Portraits and Prayers*, published in 1934, Gertrude Stein compiled a series of word portraits composed between 1909 and 1933, arranged neither chronologically nor thematically. Included in the volume are portraits of artists (Paul Cézanne, Henri Matisse, Pablo Picasso, Juan Gris, Henri Charles Manguin, Christian Bérard), composers (Erik Satie, Virgil Thomson), writers (Georges Hugnet, Edith Sitwell, Jean Cocteau), poets (Guillaume Apollinaire, T. S. Eliot, Max Jacob), and close friends (Bernard Faÿ, Mabel Dodge, Mildred Aldrich, Carl Van Vechten), as well as fourteen anonymous portraits. There is even a portrait of her poodle, Basket.

The portrait, for Stein, was anything but a pastime: it was a literary form in its own right and one that she practiced in a rational, experimental way at a turning point in her poetic work. She had developed a totally new means of interpreting this pictorial and literary topos. Her portraits do not describe, depict, or represent their subjects in the manner that one might expect. Through her writing, she seeks to portray, if not her subject as a whole, then at least what it is that makes that subject unique. Her play with grammar is one way of expressing an individual's particularity. What the portrait offers to our vision and hearing is not an image of a subject on the page, a representation as if in a mirror, but rather something that emanates from the person in question. The dedication to Van Vechten, the American writer and photographer, informs us of the meaning that Stein attributes to the portrait: "To Carl Who knows what a portrait is because he makes and is them."[1]

In *Portraits and Prayers*, Stein does not seek to compete with painting. She does not aim to accomplish with words and language what painting does with colors and brushes. She is acutely aware of what divides the two arts and does not attempt to translate one practice to another. Ezra Pound, founder of the imagist movement, had already warned his contemporaries against this pitfall: "Don't be descriptive; remember that the painter can describe a landscape much better than you can and that he has to know a deal more about it."[2] Painting has at its disposal certain representational tools to which writing can never lay claim. But Stein explored the possibilities inherent in language to convey a dimension that her subjects were still unaware of: their way of being in the world. Her dedication to Van Vechten is far more than a jest, as it contains the most serious of intuitions: the portrait must be not the image of the man, but the man himself.

"Cézanne" (1923), the first portrait in the book, sets the tone for the collection and places it under the sign of a historical triad of painters, since the portraits of Matisse and Picasso—which were actually composed prior to this one, in 1909—follow immediately after. There is not a single mention of Cézanne in the first paragraph, which loftily ignores the expectations aroused by the title: "The Irish lady can say, that to-day is every day. Caesar can say that every day is to-day and they say that every day is as they say."[3] The portrait seems to be missing its subject, unless the reader consents to refrain from reading the text and instead focuses on listening to it. Stein is actually playing with onomastics. The name Cézanne as it is pronounced— not without some difficulty, moreover, in the language of Shakespeare—becomes the object of free association and is sectioned in various ways. The portrait takes shape like a sort of waking, sonorous dream about the name of the painter, rhyming it, subsequently, with *Caesar* or *say*. The

painter is undeniably present but invisible to the naked eye, encrypted in a string of wordplay on his name.

Names occupy a singular place in *Portraits and Prayers*. The portrait "Guillaume Apollinaire" (1913) begins with a statement that seems like utter nonsense: "Give known or pin ware."[4] The name Apollinaire evokes mystery, containing as it does varied, inimitable sounds; it triggers one's linguistic imagination, and for Stein it became the object of playful transcriptions and appropriations.

Something similar happens in "Cézanne," the second paragraph of which is constructed via a series of echoes. The play with the painter's name continues and grows progressively stronger. The sound effects increase: Stein plays on little words with Anglo-Saxon roots that harmonize endlessly: "say," "day," "way," "stay." These monosyllables are used as primary colors to create monochromes for the ear. In the flow of sparkling sounds, sense supplants meaning. Words call to one another and seem to reply in an extraordinary concert. The paragraph grows ever broader as it is padded with phrases that inflate with each successive utterance: "When I said settled I meant settled to stay. When I said settled to stay I meant settled to stay Saturday."[5] One monochrome leads to another: the layers of sonorous colors are swept up into a farandole.

In "Matisse" (1909), by contrast, the author's voice conveys reflections that are actually views of the painter. The first sentence is a model of the genre since it depicts Matisse in a moment of doubt and anxiety, followed by the happy outcome once the inner crisis has been overcome: "One was quite certain that for a long part of his being one being living he had been trying to be certain that he was wrong in doing what he was doing and then when he could not come to be certain that he had been wrong in doing what he had been doing, when he had completely convinced himself that he would not come to be certain that he had been wrong in doing what he had been doing he was really certain then that he was a great one and he certainly was a great one."[6]

The poetic voice enhances and supports the self-affirmation of Matisse's genius, at the same time expressing the arguments of his many detractors. This stormy aesthetic polemic is constructed exclusively around the theme of *on-dit*—rumor and hearsay—which is in no way irrelevant to the painter's personality if we are to believe *The Autobiography of Alice B. Toklas*: "Gertrude Stein enjoyed all these complications immensely. Matisse was a good gossip and so was she and at this time they delighted in telling tales to each other."[7]

The question of genius and its recognition suffuses the Matisse portrait, just as it never ceased to haunt Stein herself, precociously convinced of her poetic genius but at pains to persuade her contemporaries to accept it. For Stein, genius is immediately apparent to those it inhabits but is recognized by others only over time. It is not always easy to appreciate genius. Something of a struggle is required, and *struggling* is the recurring participle with which she designates all that the creative act implies in the way of perseverance and violence: "And certainly he was one not greatly expressing something being struggling, he was a great one, he was clearly expressing something."[8] In the *Autobiography*, Matisse is characterized as a "combatant" and a man of "antagonisms," qualities that Stein linked to his penchant for certitude when Matisse accused her of losing interest in his painting: "there is nothing within you that fights itself and hitherto you have had the instinct to produce antagonism in others which stimulated you to attack. But now they follow."[9]

Matisse's internal struggle is felt in the language of the portrait, in the grammatical endurance, the ability of the sentence to turn upon itself, to stretch, expand, and begin again, ad infinitum. Much like the artist himself, in "Matisse" the language does not let go of its subject, and it grapples with a rival as dreaded as it is imaginary—itself. The two concluding sentences are remarkable because they repeat a semantic and musical theme heard throughout the four pages of the portrait: "This one was one, some were quite certain, one greatly expressing something being struggling. This one was one, some were quite certain, one not greatly expressing something being struggling."[10]

In discovering and defending the work of painters like Cézanne and Matisse, Gertrude Stein was discovering and defending herself. At the time of the third Salon

d'Automne, she came upon Matisse's *Woman with a Hat* (1905; pl. 13, cat. 113): "She then went back to look at it and it upset her to see them all mocking at it. It bothered her and angered her because she did not understand why because to her it was so alright, just as later she did not understand why since the writing was all so clear and natural they mocked at and were enraged by her work."[11]

* * *

The two portraits of Picasso are the masterworks of *Portraits and Prayers*. Picasso is a special case in the series: not only did Stein have closer ties with him than with any other painter, but she claimed to be one of the first to grasp the significance of his art, which reminded her of her own. ("I was alone at this time in understanding him, perhaps because I was expressing the same thing in literature.")[12] In addition, by composing the portrait "Picasso" (1909) and the supplement to it, "If I Told Him. A Completed Portrait of Picasso" (1923), she was returning a favor to the artist. Stein had in fact posed for a famous portrait that Picasso painted of her in 1905-6:

> I posed for him all that winter, eighty times and in the end he painted out the head, he told me that he could not look at me any more and then he left once more for Spain. It was the first time since the blue period and immediately upon his return from Spain he painted in the head without having seen me again and he gave me the picture and I was and I am still satisfied with my portrait, for me, it is I, and it is the only representation of me which is always I, for me.[13]

The word portraits of Picasso, to which we can add the extended portrait from the *Autobiography* (1933) as well as a book titled *Picasso* (1938), are not meant to be read as simple gifts but are caught up in the logic of an intellectual exchange with Picasso that proved decisive for Stein and to which she would constantly return. The first portrait of Picasso was written using the same technique used for the Matisse portrait, composed the same year. It takes shape gradually; in increments, a syntactical and sonorous environment is created in which a few singular features stand out, repeated in the mode of a litany: "One whom some were

certainly following was one who was completely charming. One whom some were certainly following was one who was charming. One whom some were following was one who was completely charming. One whom some were following was one who was certainly completely charming."[14]

Stein was working with a limited series of intuitive terms declined in rhythmic motifs. This technique is not unlike what she called, in a lecture given in the United States, a "landscape," a rival genre also borrowed from painting. "A landscape does not move nothing really moves in a landscape but things are there, and I put in…the things that were there."[15] Her portraits are striking for what she called *insistence*, a term that she used to replace *repetition* and that she defended tooth and nail in another lecture.[16] The notion of insistence takes on all its meaning in a portrait: a subject's singularity and subtle way of being in the world are rendered in a vibratile, stabilized syntax. This explains why the portrait is situated at the limits of any evocation of the subject: "If I Told Him. A Completed Portrait of Picasso" is an echolalic poem in which—as in Stein's "Cézanne" of the same year—the painter's name is not once mentioned, other than in the subtitle, and it merely recalls the painter by default: "As a resemblance to him," says one verse.[17]

In the first portrait of Picasso, however, the artist is shown in succession to be a charmer and a hard worker. The impact of his art is dealt with head-on:

> Some were certainly following and were certain that the one they were then following was one working and was one bringing out of himself then something. Some were certainly following and were certain that the one they were then following was one bringing out of himself then something that was coming to be a heavy thing, a solid thing and a complete thing.

> * * *

> Something had been coming out of him, certainly it had been coming out of him, certainly it was something, certainly it had been coming out of him and it had meaning, a charming meaning, a solid meaning, a struggling meaning, a clear meaning.[18]

Given the personal and cultural ties that bound Stein to the Spanish painter—ties evoked on several occasions in the *Autobiography* and in *Picasso*—the portrait of Picasso can also be read as a self-portrait: "This one was always having something that was coming out of this one that was a solid thing…an interesting thing, a disturbing thing, a repellant thing, a very pretty thing."[19] In several portraits, Stein signs and signals to herself, for example, in the one devoted to the other Spanish cubist painter: "Juan Gris formally knows me. Juan Gris and I. Juan Gris and I and formally and knows me. When this you see remember me, remember him to me. When this you see."[20] As she did for Picasso, Stein created two portraits: "Pictures of Juan Gris" (1924) and "The Life and Death of Juan Gris" (1927), composed at the time of Gris's death in the guise of a literary epitaph. One formula in the first portrait is worth closer examination, particularly as it appears in other portraits as well: "Remember me, remember him to me."[21] The portrait is a memorial form. It is intended for the person who composes it: the gift that is implied is also—if not first and foremost—a gift to oneself and an aide-mémoire. It is inseparable from an injunction to remember.

The writing of the portrait must not, however, in Stein's opinion, rely on the faculty of memory, as stated in "Portraits and Repetition": "In other words the making of a portrait of any one is as they are existing and as they are existing has nothing to do with remembering any one or anything."[22] The paradox that underlies Stein's enterprise is unveiled in passing. The portrait causes absence to exist in the form of immediate presence. The writer points to the fact that early cinema had been able to thwart the very trap of repetition that she in her writing of portraits has been seeking to avoid: "In a cinema picture no two pictures are exactly alike each one is just that much different from the one before, and so in those early portraits there was as I am sure you will realize as I read them to you…no repetition."[23] The formula behind the Steinian portrait is contrary to the memento mori of antiquity ("remember you must die") and is based instead on "remember life," "remember a living person."

The portraits are an attempt to capture the singularity that each individual carries within, and it is up to the portraitist to determine how to seize, and translate, that singularity: "There are many of them. Each one is one being that one. Each one is one. There are many of them."[24] In one of her American lectures, Stein referred again to her motivation: "I had been enormously interested all my life in finding out what made each one that one and so I had written a great many portraits."[25] Her interest in portraits was part of a larger project of writing about singularity and partakes of her will to understand what makes us human. Grammatical landscapes were created so that others could see and hear in the echo chamber and the visual mass of the paragraph the subject's singular feature, his or her discrete and insistent way of being. The "portraits" would lead, moreover, in Stein's oeuvre, to her dramatic production ("plays"), the form that she found the most natural and appropriate for rendering singularity as it is played out in relationships, in confrontations with others.

If in the portraits Stein chose to overlook description and avoid any sort of narration ("But in my portraits I had tried to tell what each one is without telling stories"), deliberately eschewing any mimetic representation of her subjects, this is because she was seeking a different angle.[26] It was not that she was purely and simply giving up on the idea of resemblance—if for no other reason than that she knew what a human weakness resemblance can be ("And then everybody almost everybody likes a resemblance even when there is none")—but that it was not a priority for her.[27] She intended whenever possible to attain resemblance by other, unprecedented means. Her angle is a certain way of using language. Like the canvases in oil that so moved her when she first arrived in Paris, a portrait must have, according to Stein, its own life, independent of its subject: "There it is the oil painting in its frame, *a thing in itself*. There it is and it has to look like people or objects or landscapes. Besides that it must not completely only exist in its frame. It must have *its own life*."[28]

Translated from the French by Alison Anderson

Notes

1. G. Stein 1934.

2. "A Retrospect," in Pound 1954, 6.

3. "Cezanne," in G. Stein 1934, 11.

4. "Guillaume Apollinaire," in G. Stein 1934, 26.

5. "Cezanne," in G. Stein 1934, 11.

6. "Matisse," in G. Stein 1934, 12.

7. G. Stein 1990, 67.

8. "Matisse," in G. Stein 1934, 13.

9. G. Stein 1990, 65.

10. "Matisse," in G. Stein 1934, 16.

11. G. Stein 1990, 35.

12. G. Stein 1984, 16.

13. Ibid., 502.

14. "Picasso," in G. Stein 1934, 17.

15. "Plays," in G. Stein 1957, 129.

16 "Portraits and Repetition," in G. Stein 1957, 165-209.

17. "If I Told Him. A Completed Portrait of Picasso," in G. Stein 1934, 22.

18. "Picasso," in G. Stein 1934, 17.

19. Ibid., 18.

20. "Pictures of Juan Gris," in G. Stein 1934, 47.

21. The same formula can be found, notably, in "Mildred Aldrich Saturday": "The first effect of it was this, as when this you see remember me" (G. Stein 1934, 115-16), and in "Three Sitting Here" (ibid., 139).

22. "Portraits and Repetition," in G. Stein 1957, 175.

23. Ibid., 294.

24. "Galeries Lafayettes," in G. Stein 1934, 171.

25. "Plays," in G. Stein 1957, 119.

26. Ibid., 262.

27. "Pictures," in G. Stein 1957, 85.

28. Ibid., 87 (my italics).

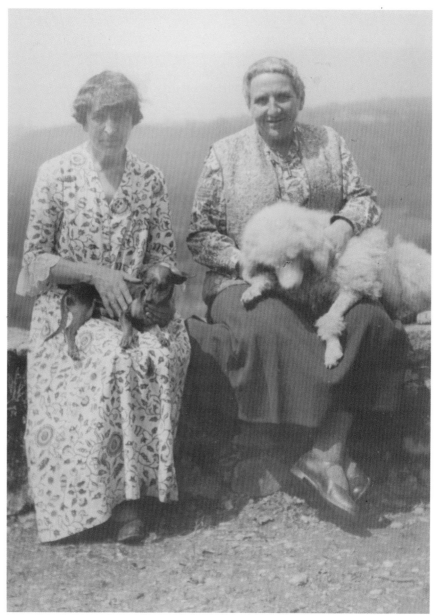

Plate 201

Alice Toklas and the Gertrude Stein Collection, 1946–1967
Edward Burns

Gertrude Stein died in the early evening of July 27, 1946, during an operation for cancer of the uterus. Four days later Alice Toklas wrote to their friends Carl and Fania Van Vechten: "I'm here alone. And nothing more—only what was. You will know that nothing is very clear with me—everything is empty and blurred."[1] A quiet sadness pervaded the rest of her life. Gertrude had been the center of her world from the day they met in September 1907, at the rue Madame apartment of Michael and Sarah Stein. Toklas recounts this first encounter in her memoir, *What Is Remembered*:

> In the room were Mr. and Mrs. Stein and Gertrude Stein. It was Gertrude Stein who held my complete attention, as she did for all the many years I knew her until her death, and all these empty ones since then. She was a golden brown presence, burned by the Tuscan sun and with a golden glint in her warm brown hair. She was dressed in a warm brown corduroy suit. She wore a large round coral brooch and when she talked, very little, or laughed, a good deal, I thought her voice came from this brooch. It was unlike anyone else's voice—deep, full, velvety like a great contralto's, like two voices. She was large and heavy with delicate small hands and a beautifully modeled and unique head. It was often compared to a Roman emperor's, but later Donald Sutherland said that her eyes made her a primitive Greek.[2]

Alice Toklas entered Gertrude Stein's life at a critical moment. In 1907–8 Stein's work on her novel *The Making of Americans* changed direction because of her discovery of Otto Weininger's book *Sex and Character* (1906). She had started tentative work on the novel in 1902, while living in England, and during her first years in Paris, she made notes for the book and wrote a draft that resembles a traditional nineteenth-century novel. But in 1908 the project began to take a different shape as she explored Weininger's systematization of psychology. She filled notebooks exploring the relationship of her friends to various psychological types—one notebook was labeled "The Diagram Book." From surviving notebooks, we know that Leo questioned the direction of her writing. His failure to believe in her was perhaps the primary factor in the permanent break between brother and sister.[3] The affirmation Alice gave to Gertrude's writing and their commitment to each other were thus crucial to Stein's life as a writer. In *The Making of Americans*, she writes:

> You write a book and while you write it you are ashamed for every one must think you are a silly or a crazy one and yet you write it and you are ashamed, you know you will be laughed at or pitied by every one and you have a queer feeling and you are not very certain and you go on writing. Then some one says yes to it, to something you are liking, or doing or making and then never again can you have completely such a feeling of being afraid and ashamed that you had then when you were writing or liking the thing and not any one had said yes about the thing.[4]

Stein's writings convey her perceptions about people, landscapes, and emotions. "A Sonatina Followed by Another" (1921) is but one of many texts in which her life with Alice becomes an emblem of ecstasy:

I caught sight of a splendid Misses. She had handker-
chiefs and kisses. She had eyes and yellow shoes she
had everything to choose and she chose me. In passing
through France she wore a Chinese hat and so did I. In
looking at the sun she read a map. And so did I. In eating
fish and pork she just grew fat. And so did I. In loving
a blue sea she had a pain. And so did I. In loving me she
of necessity thought first. And so did I. How prettily
we swim. Not in water. Not on land. But in love.[5]

In July 1946 Stein and Toklas planned a vacation at
the family home of Bernard Faÿ in Luceau, in the department
of Sarthe, but Stein became ill almost immediately after
they arrived. A local doctor urged her to return to Paris. From
the train station, she went immediately to the American
Hospital in Neuilly. On July 23 she signed her will, which
had been prepared by Charles D. Morgan, an American
attorney practicing in France. She declared herself an
American citizen living in France but "legally domiciled" in
Baltimore and appointed Toklas and her nephew Allan
Stein her executors. She bequeathed her portrait by Pablo
Picasso to the Metropolitan Museum of Art in New York. A
relationship with the Yale University Library had been

forged in 1937 through the efforts of Thornton Wilder, and
in her will she donated her papers and manuscripts to the
library. She instructed her executors to provide Carl Van
Vechten, whom she named her literary executor, with the
funds necessary to publish her unpublished writings.

The rest of Stein's estate was bequeathed to Toklas
for use in her lifetime with instructions that "insofar as
it may become necessary for her proper maintenance and
support" her executors were authorized "to make pay-
ments to her from the principal of my Estate, and for that
purpose to reduce to cash any paintings or other personal
property belonging to my estate." Upon Toklas's death,
Stein bequeathed the residue of her estate to Allan Stein,
the only child of her oldest brother, Michael. After his
death the estate was to pass in equal shares to his children.
Allan died in January 1951; he was survived by three chil-
dren. Daniel, his son by his first wife, the dancer Yvonne
Daunt, lived in California near his grandmother Sarah Stein.
His second family's children, Michael and Gabrielle, at
the time minors, lived with their mother, Roubina, in Paris.

To pay Gertrude Stein's medical bills and estate
taxes in France and the United States, Toklas and Allan
Stein sold pictures by Pavel Tchelitchew, Kristians Tonny,

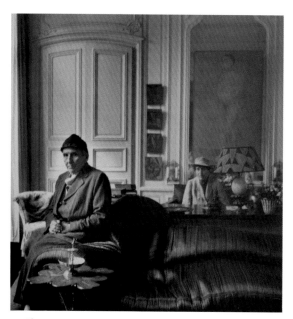

Plate 202

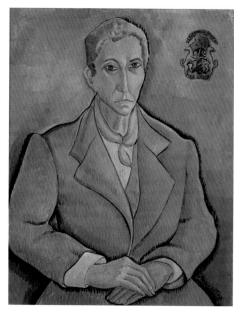

Plate 203

Plate 202
Gertrude Stein and Alice Toklas in the apartment at 5 rue Christine, Paris,
ca. 1938. Photograph by Cecil Beaton. Department of Nineteenth-Century,
Modern, and Contemporary Art, The Metropolitan Museum of Art, New York,
gift of Edward Burns, 2011

Plate 203, cat. 414
Francisco Riba-Rovira, *Gertrude Stein*, 1945. Oil on canvas, 35⅝ x 28¼ in
(90.5 x 71.8 cm). Collection of Alida and Christopher Latham

and Francisco Riba-Rovira (pl. 203). To provide Van Vechten with initial money to publish Stein's unpublished works, they sold Picasso's *Still Life* (1922; cat. 269).[6] Toklas, the loyal companion, was tenacious in her efforts to ensure recognition of Stein's literary achievement, and she understood that her most important task was to publish the unpublished works. As Ulla Dydo notes: "Always one Stein piece engenders the next, so that each becomes a context for the next. Her life's work is not only a series of discrete pieces but also a single continuous work. Personal commentary is not separate from literary composition but is used, as she uses everything, for composing."[7]

The building of the Stein Archive at the Yale Library was also central to Toklas's plans to ensure Stein's posthumous literary reputation. She assisted Van Vechten and Donald Gallup, then curator of American literature at the library, in persuading recipients of Stein's letters to donate them to the collection. To give visibility to the archive, Toklas and Allan Stein gave a number of artworks to the library. Among these were a 1906 drawing by Henri Matisse; a portrait of Stein by Francis Picabia from 1933; and works by Christian Bérard, Eugene Berman, Jo Davidson, Marie Laurencin, and Francis Rose. Shortly after Toklas's arrival in Paris, Stein had taken her to Picasso's studio. As Stein had done with other friends, she encouraged Toklas to buy works. During one visit (1907–8), Toklas purchased *Café Scene* (1900; cat. 224), a painting in the style of Henri de Toulouse-Lautrec. She gave this also to the growing Gertrude Stein Collection in the Yale Library. In the mid-1950s she would donate two armchairs for which she had made cushions in needlepoint after designs by Picasso[8] (pl. 204) and two paintings by Dora Maar: a portrait of Toklas and a landscape. Toklas hoped that Allan could be convinced to donate to the Yale Library most of the pictures in Stein's estate during his lifetime, but this never happened.

Before Allan Stein's death, he and Toklas had cooperated to ensure that Gertrude's wishes were fulfilled. After his death, Toklas's relationship with his widow, Roubina, hardened. Toklas saw the paintings in the estate, which were increasing in value, as a resource to fulfill her promises to Gertrude if it became necessary. She did everything

to preserve the integrity of the collection; the pictures had been companions in their life, and she understood the role that they played in Stein's aesthetic. To Roubina Stein they were a source of money for her two children, and she became increasingly impatient with Alice—fearful that she would squander the estate. Their relationship became so venomous that, as Toklas's letters reveal, no compromise was possible.[9]

When Stein's will was probated in Baltimore in 1946, Toklas and Allan Stein, because they were not residents of Baltimore, had to step down as executors. The court appointed lawyer Edgar Allan Poe, the poet's eponymous great-nephew, as administrator of the estate. He saw his role as providing an income for Toklas ($400 per month) and preserving the value of the estate for the eventual heirs. Toklas believed that within the guidelines of the will she had the right to sell works, and on two occasions she did this without consulting Poe. The first time was in 1950–51, when she sold a 1905 Picasso drawing of a woman on horseback (cat. 295), which she herself had bought during a visit to his studio, and a 1904 gouache from Stein's estate. These sales were to raise money to help Bernard Faÿ, administrator of the Bibliothèque Nationale during the occupation, break out of prison following his trial and conviction as a collaborator. Before her death, Stein had written a letter in support of him, citing among other things his aid in saving her art collection in the last days of the war and his deep attachment to the United States. In providing funds for his escape to Switzerland, Toklas felt that she was doing what Stein would have done had she lived.[10]

Yale University Press began publishing Stein's unpublished works in 1951 (eventually the series would comprise eight volumes, with the final one published in 1958). Toklas was pragmatic, and she knew that continued subventions were necessary to assure publication. Again without consulting Poe, in 1953 she approached Daniel-Henry Kahnweiler, director of the Galerie Louise Leiris, to sell a group of forty-two Picasso drawings. Kahnweiler arranged for Picasso to sign them for an exhibition, *Picasso Dessins, 1903–1907*, to be held at the Galerie Berggruen, May to July 1954. In the same year *The Alice B. Toklas Cook Book*

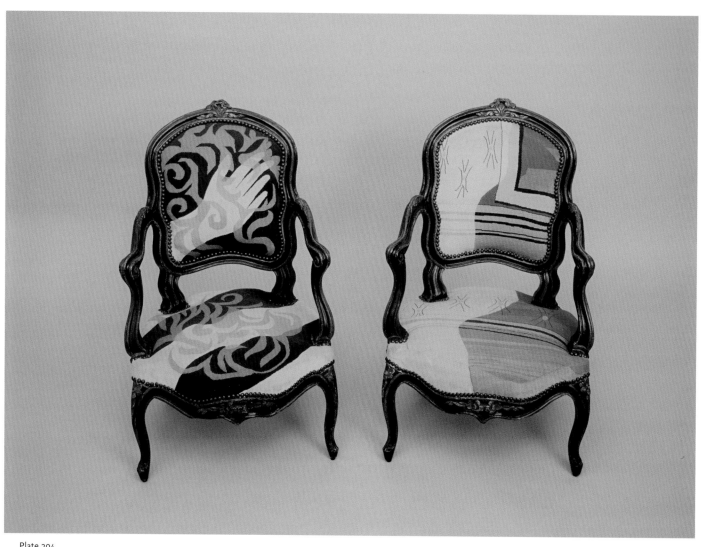

Plate 204

was published. This culinary memoir is rich in keen observations about food, servants, and the life Alice had spent with Gertrude in France during two wars.

The investments that Stein had in the United States did not provide an adequate income for Toklas's needs. (She continued to receive $400 checks from the Baltimore lawyer, though they were often late in coming.) By 1957 she was in a straitened financial situation. After much discussion between her lawyer in Paris and the lawyers representing the Stein estate, an agreement was reached to sell through Kahnweiler Picasso's *La Rue-des-Bois* (1908; cat. 247) to an Italian collector. At the same time Toklas sold to Kahnweiler Picasso's unique sculpture *Mask of a Woman* (1908; pl. 221, cat. 389). After paying lawyers' fees in France and the United States and insurance on the paintings, she lived on the proceeds from these sales for several years.

By the early 1960s Toklas, now in her eighties, was becoming frail. Her financial needs exceeded the income that the Stein administrator was willing to give her. In 1961 she became embroiled in two legal wrangles. Needing money, she sold two Picassos: *Head*, a painted bronze and iron sculpture from 1928 (pl. 240, cat. 391), and a 1913 paper construction, *Guitarist with Sheet Music* (pl. 188, cat. 390).

When she proposed selling one of two Picasso paintings to provide her with long-term financial stability, the Stein heirs impeded the sale. Through her lawyers, Roubina Stein insisted that her children, as remaindermen of the will, were entitled to be consulted on sales and to share in any income. Toklas at this time was arthritic and going blind, and she avoided the rigors of the Paris winter by going to Rome, where she stayed in a pension run by Canadian nuns.

During her absence, Roubina obtained a court's permission to enter the apartment at 5 rue Christine, where Toklas and Stein had lived since 1938, and inventory the works of art. When she found several works, including the drawings from the Galerie Berggruen exhibition, not in the apartment, she petitioned to have the works by Picasso and Juan Gris impounded, claiming that they were under-insured and endangered; these would eventually be sold to a syndicate, organized by David Rockefeller, of trustees and friends of the Museum of Modern Art, New York. Works by Picabia, Rose, and other painters were put into storage. Toklas returned in June 1961 to an empty apartment. She wrote a friend: "The pictures are gone permanently. My dim sight could not see them now. Happily a vivid memory does."[11] Urged by friends, she agreed to write a memoir,

Plate 205

Plate 204
Louis XV-style children's armchairs upholstered with petit point sewn by Alice Toklas over designs by Pablo Picasso, ca. 1930. Yale Collection of American Literature, Beinecke Rare Book and Manuscript Library, Yale University, New Haven

Plate 205
Alice Toklas receives a visit from the Italian writer and translator Fernanda Pivano in the apartment at 5 rue Christine, Paris, 1951. Photograph by Ettore Sottsass. Department of Nineteenth-Century, Modern, and Contemporary Art, The Metropolitan Museum of Art, New York, gift of Edward Burns, 2011

What Is Remembered (1963), in the hope of earning money to supplement the income provided by the Stein estate.

Sometime in the early 1960s the apartment building on rue Christine had been sold, and the tenants were offered the opportunity to buy their apartments. Toklas, believing that her age would protect her, told no one. The new owner sued for possession of the apartment, and after losing a series of lawsuits, Toklas was evicted in late 1964. Janet Flanner (Genêt) of the *New Yorker* and Doda Conrad, a cultural attaché at the American Embassy in Paris, found her an apartment in a modern building in the fifteenth arrondissement. Alice was by now bedridden, partially deaf, and almost blind. On April 10, 1965, she authorized her Paris lawyer to negotiate with the Stein lawyers for an annuity if she agreed to sell her life interest in the estate (no agreement was reached). Wearied by age, and yearning only to join Gertrude, she did not follow the legal battles that surrounded her. Her financial situation was so precarious that friends in Paris and the United States contributed to a fund to help her survive.

Alice Toklas died on March 7, 1967, a month before her ninetieth birthday. She was buried in the Père Lachaise cemetery in the tomb that she had purchased for Gertrude and herself.[12] Through fierce determination and stoic self-denial she fulfilled her promises to Gertrude. The Yale Edition of the Unpublished Writings of Gertrude Stein and the archive in the Beinecke Library at Yale are the monuments to Gertrude Stein's creative life.

Notes

1. Toklas 1973, 4.

2. Toklas 1963, 23.

3. See Katz 1978, 8–26.

4. G. Stein 1925, 485.

5. G. Stein 1953, 12.

6. For details on these sales, see Toklas 1973, letter to Church, April 9, 1947, 61; and letter to Gallup, October 6, 1947, 79–82.

7. Dydo and Rice 2003, 78.

8. On the origins and dating of the embroidery, see Dydo 2002–3, 16.

9. See Toklas 1973.

10. Stein had met Faÿ, a specialist in American history, in the early 1920s, and from 1927 on a personal friendship had developed. He translated her writings into French, and through lectures and writings he promoted her as a central figure in American literature. During the war his contact with the Vichy government helped protect Stein and Toklas. In July 1944, when German police entered Stein's rue Christine apartment, Faÿ used his influence to help save the paintings there. For details on Stein's relations with Faÿ, see G. Stein and Wilder 1996, appendix 9, "Stein: September 1942 to September 1944," 401–21. See also Malcolm 2007 and Will 2011.

11. Toklas 1973, 403.

12. It was Alice's decision to have her name and dates carved on the back, as opposed to the front, of the headstone.

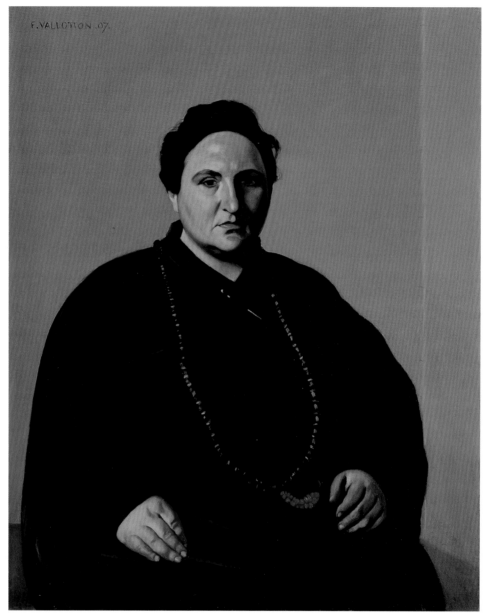

Plate 206

Plate 206, cat. 441
Félix Vallotton, *Gertrude Stein*, **1907.** Oil on canvas, 39½ x 32 in. (100.3 x 81.3 cm). The Baltimore Museum of
Art: The Cone Collection, formed by Dr. Claribel Cone and Miss Etta Cone of Baltimore, Maryland

This 1907 portrait was likely made in response to Picasso's iconic image of Gertrude from the
prior year (pl. 183). Gertrude described Vallotton's painstaking process in *The Autobiography of
Alice B. Toklas*: "When he painted a portrait he made a crayon sketch and then began painting at
the top of the canvas straight across. Gertrude Stein said it was like pulling down a curtain as
slowly moving as one of his Swiss glaciers" (G. Stein 1990, 51). Vallotton gave the portrait to Leo
and Gertrude and presented it publicly afterward. "I want to tell you that I would gladly exhibit
the portrait of your sister at the [1907] Salon d'Automne," he wrote to Leo. "And in any case
this will be the pièce de résistance" (translated and reprinted in Newman 1991, 316).

Plate 207

Plate 207, cat. 77
Marie Laurencin, *Group of Artists*, **1908.** Oil on canvas, 25½ x 31⅞ in. (64.8 x 81 cm). The Baltimore Museum
of Art: The Cone Collection, formed by Dr. Claribel Cone and Miss Etta Cone of Baltimore, Maryland

Gertrude recalled that she first met Laurencin when Guillaume Apollinaire brought her to the
rue de Fleurus atelier: "Marie Laurencin was terribly near-sighted and of course she never wore
eye-glasses, no french woman and few frenchmen did in those days. She used a lorgnette. She
looked at each picture carefully that is, every picture on the line, bringing her eye close and
moving over the whole of it with her lorgnette, an inch at a time. The pictures out of reach she
ignored. Finally she remarked, as for myself, I prefer portraits" (G. Stein 1990, 60). Gertrude and
Laurencin continued to see each other socially. "In the early days Marie Laurencin painted
a strange picture, portraits of Guillaume, Picasso, Fernande and herself. Fernande told Gertrude
Stein about it. Gertrude Stein bought it and Marie Laurencin was so pleased. It was the first
picture of hers anyone had ever bought" (ibid., 62). In a second canvas, *Apollinaire and His Friends*
(pl. 26), painted the following year, Laurencin included Gertrude among the poet's entourage.

Plate 208

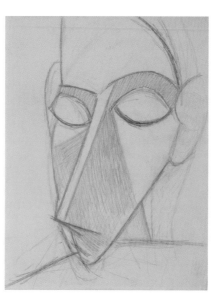

Plate 209

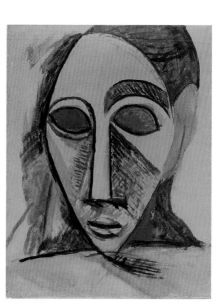

Plate 210

Plate 208, cat. 362
Pablo Picasso, *Pitcher, Jar, and Lemon*, 1907. Gouache on paper, 11⅞ x 9⅜ in. (31.2 x 24.3 cm). Gecht Family Collection

Plate 209, cat. 363
Pablo Picasso, *Nez quart de Brie* (Study for *Les Demoiselles d'Avignon* or *Nude with Drapery*), 1907. Graphite on paper, 11⅞ x 9⅜ in. (31.2 x 24 cm). Hegewisch Collection at the Hamburger Kunsthalle, Hamburg, Germany

Plate 210, cat. 365
Pablo Picasso, *Head of a Woman in Brown and Black*, 1907. Watercolor and gouache on paper mounted on panel, 12⅛ x 9⅜ in. (30.8 x 23.8 cm). Private collection

Leo and Gertrude avidly followed Picasso's artistic development in 1907. They watched as Picasso grappled with African, Iberian, and Oceanic art, and they surely were aware that his repeated depictions of a standing nude with a bent upraised arm were partly inspired by Matisse's *Blue Nude* (1907; pl. 27), which hung on the walls of their rue de Fleurus studio. Together the siblings purchased Carnet 10, a notebook containing some of these drawings and watercolors by Picasso. After Leo moved back to Italy and the collection was divided, Gertrude was able to fully demonstrate her support of Picasso by disassembling the notebook and displaying the pages on her walls. These images include a still life, a series of heads, and the standing nudes pictured on the following pages. (The drawing known as *Head in Three-Quarter View*, shown here, became part of Michael and Sarah's collection.)

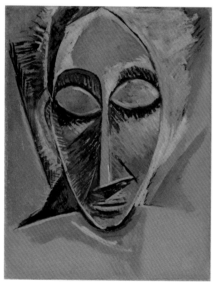

Plate 211

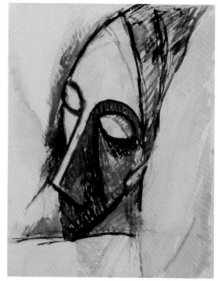

Plate 212

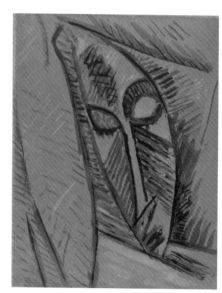

Plate 213

Plate 211, cat. 366

Pablo Picasso, Study for *Nude with Drapery*, 1907. Tempera and watercolor on paper mounted on board, 12³⁄₁₆ x 9⁷⁄₁₆ in. (31 x 24 cm). Private collection

Plate 212, cat. 370

Pablo Picasso, *Head in Three-Quarter View*, 1907. Gouache and watercolor on paper, 11¾ x 9¼ in. (29.9 x 23.5 cm). San Francisco Museum of Modern Art, bequest of Elise S. Haas

Plate 213, cat. 371

Pablo Picasso, Study for *Nude with Drapery*, 1907. Watercolor and gouache on paper, 12³⁄₁₆ x 9⅝ in. (31 x 24.5 cm). Museo Thyssen-Bornemisza, Madrid

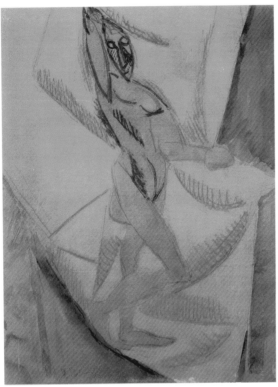

Plate 214

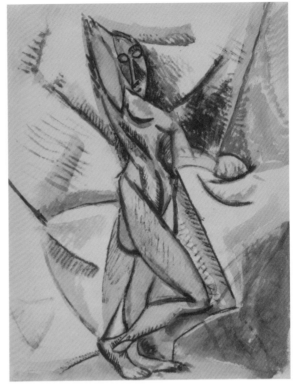

Plate 215

Plate 214, cat. 372
Pablo Picasso, Study for *Nude with Drapery*, 1907. Watercolor and graphite on paper mounted on canvas,
12 x 9¼ in. (30.5 x 23.5 cm). Collection Morton and Linda Janklow, New York

Plate 215, cat. 373
Pablo Picasso, Study for *Nude with Drapery*, 1907. Watercolor and conté crayon on cardboard, 12³⁄₁₆ x 9⁹⁄₁₆ in.
(30.9 x 24.3 cm). The Baltimore Museum of Art: The Cone Collection, formed by Dr. Claribel Cone and
Miss Etta Cone of Baltimore, Maryland

Plate 216, cat. 374
Pablo Picasso, Study for *Nude with Drapery*, 1907. Gouache on paper mounted on canvas, 12 x 9¼ in.
(30.5 x 23.5 cm). Private collection

Plate 217, cat. 375
Pablo Picasso, Study for *Nude with Drapery*, 1907. Oil wash on paper mounted on canvas, 12¾ x 9¾ in.
(32.4 x 24.8 cm). Collection Michael and Judy Steinhardt, New York

Plate 216

Plate 217

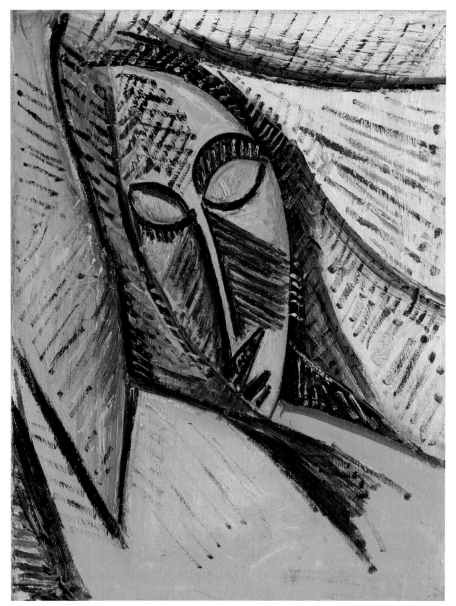

Plate 218

Plate 218, cat. 241

Pablo Picasso, *Head of a Sleeping Woman* (Study for *Nude with Drapery*), **1907.** Oil on canvas, 24¼ x 18¾ in. (61.4 x 47.6 cm). The Museum of Modern Art, New York, Estate of John Hay Whitney, 1983

It has long been believed that Leo and Gertrude owned *Nude with Drapery* (1907; State Hermitage Museum, Saint Petersburg), a large canvas depicting a full-length standing woman with her arm bent over her head. More recent research has shown that the siblings did not acquire the finished painting, notable for its elaborate pattern of hatch marks, but they did possess a number of studies for it—including the Carnet 10 images (pls. 208-17, cat. 362-75) and this oil sketch of the model's head and upraised arm. Gertrude treasured all of them and kept them throughout her life.

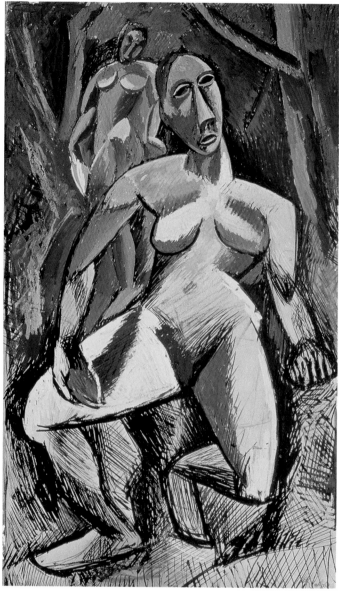

Plate 219

Plate 219, cat. 252

Pablo Picasso, Study for *The Dryad (Nude in a Forest)*, 1908. Gouache, ink, and graphite on card laid on cradled panel, 24⅝ x 14½ in. (62.5 x 37 cm). Private collection

The Steins were quite close to Picasso during the period in which he worked on *Les Demoiselles d'Avignon* (1907; Museum of Modern Art, New York). Although they did not purchase that monumental painting, they owned studies for it, as well as canvases that were created in its wake, such as *Three Women* (1908; pl. 186). Another related painting, *The Dryad* (1908; State Hermitage Museum, Saint Petersburg), was purchased by the Russian industrialist Sergei Shchukin. Leo and Gertrude acquired this study for *The Dryad*, the background of which includes a second nymph not present in the larger canvas.

Plate 220

Plate 221

Plate 220, cat. 360
Pablo Picasso, *Untitled (Head in Profile)*, 1907. Graphite on paper, 5⅛ x 7⅛ in. (13 x 18 cm). The Menil Collection, Houston

Plate 221, cat. 389
Pablo Picasso, *Mask of a Woman*, 1908. Terracotta, 7 x 6⅝ x 7⅞ in. (17.8 x 16 x 12 cm). Musée National d'Art Moderne, Centre Georges Pompidou, Paris, gift of Daniel-Henri Kahnweiler, 1957

Picasso's interest in non-Western art can be seen in this powerful 1907 drawing of a head in profile and petite 1908 terracotta sculpture, which was later cast in bronze. "Picasso having made a prodigious effort to create painting by his understanding of African sculpture was seduced a short time after 1908 by his interest in the sculptural form rather than by the vision in African sculpture," wrote Gertrude, "but even so in the end it was an intermediate step toward cubism" (G. Stein 1984, 23). Photographs of rue de Fleurus after Leo's departure (see pl. 355) show the sculpture on Gertrude's work table.

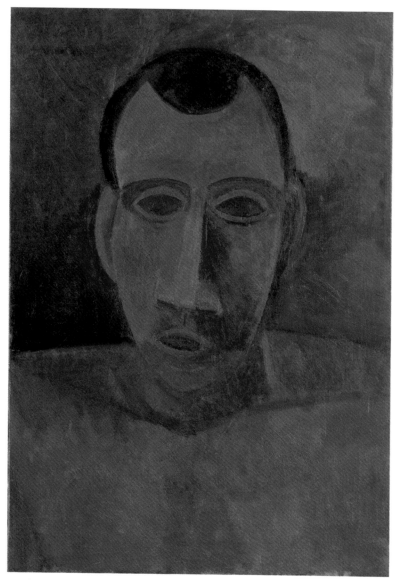

Plate 222

Plate 222, cat. 243

Pablo Picasso, *Bust of a Man,* **1908.** Oil on canvas, 24½ x 17⅛ in. (62.2 x 43.5 cm). The Metropolitan Museum of Art, New York, bequest of Florene M. Schoenborn, 1995

Picasso repeatedly invited Leo and Gertrude to his studio during 1908 to show them his most recent paintings. When the Steins spent the summer months in Fiesole, Picasso sent them news of his progress. It is likely that they were shown *Bust of a Man* sometime after they returned to Paris that autumn. Recent technical examination of this canvas reveals that Picasso painted the bust over several earlier compositions, among them a portrait of a man and a floral still life (see Lucy Belloli in Tinterow and S. Stein 2010, 133).

Plate 223

Plate 223, cat. 248
Pablo Picasso, *Green Bowl and Black Bottle*, **1908.** Oil on canvas, 24 x 19⅞ in. (61 x 50.5 cm). The State
Hermitage Museum, Saint Petersburg

Picasso's distilled, almost severe *Green Bowl and Black Bottle* extends his interest in non-Western
art to still life. It has a palette resembling that of *Bust of a Man* (1908; pl. 222) and, like the figure
painting, emphasizes the voids exposed by lozenge-shaped openings. Gertrude and Leo lent the
picture to the Grafton Galleries' important Second Post-Impressionist Exhibition in London in
January 1912, and that same year sold it to the Moscow collector Sergei Shchukin, who had
become passionately interested in the work of both Matisse and Picasso.

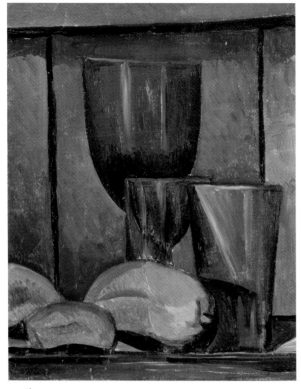

Plate 224

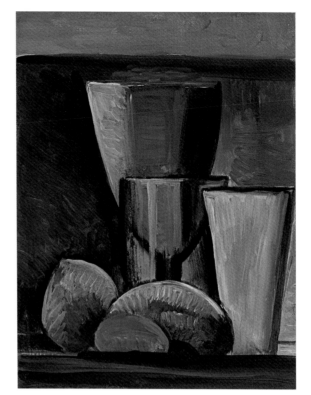

Plate 225

Plate 224, cat. 249
Pablo Picasso, *Glasses and Fruit,* 1908. Oil on cradled panel, 10⅝ x 8⅜ in. (27 x 21 cm). Museum Ludwig, Cologne

Plate 225, cat. 250
Pablo Picasso, *Glasses and Fruit,* 1908. Oil on panel, 10⅝ x 8½ in. (27 x 21.6 cm). Museo Thyssen-Bornemisza, Madrid

These small explorations of shape, volume, and spatial relationships are part of a group of at least ten closely related paintings on panel that Picasso is thought to have made during the fall of 1908. Leo and Gertrude purchased two of these still lifes and likely inspired the American artist Max Weber to purchase a third (Fitzgerald 2006, 16–17). Weber had arrived in Paris in 1905 and quickly become part of the Steins' milieu, immersing himself in the salon culture of rue de Fleurus and studying under Matisse. When Weber returned to New York in January 1909, he brought along his newly acquired still life—the first painting by Picasso to be seen in America.

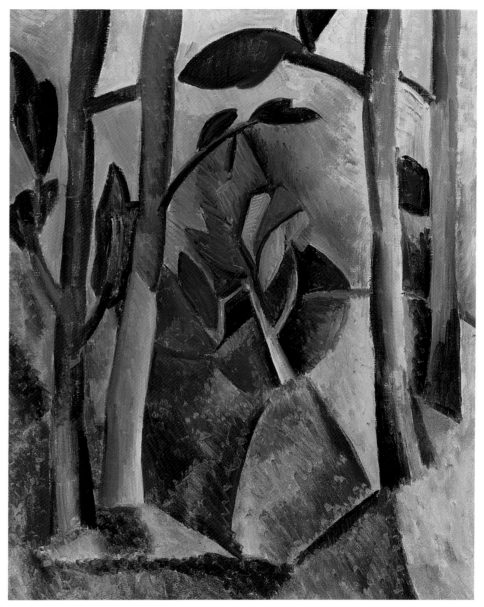

Plate 226

Plate 226, cat. 245
Pablo Picasso, *La Rue-des-Bois*, **1908.** Oil on canvas, 28¾ x 23⅝ in. (73 x 60 cm). Private collection

Taking refuge from the heat of Paris in August 1908, Picasso relocated to the small, wooded
village of La Rue-des-Bois, in the Oise region, not far from the city. The artist wrote to Gertrude
and Leo on August 14, 1908: "Dear friends I'm in the country I was ill very nervous and the
doctor told me to go and spend some time here.… I am working here and very content" (G. Stein
and Picasso 2008, 40). Upon his return in September, Picasso was eager to show his paintings
to the Steins, who had already purchased a large number of his works that year and had enabled
his summer trip. He wrote them again on September 14: "Studio tidied up am only waiting
for your visit" (ibid., 42). Leo and Gertrude selected at least three landscapes from this period,
including this one.

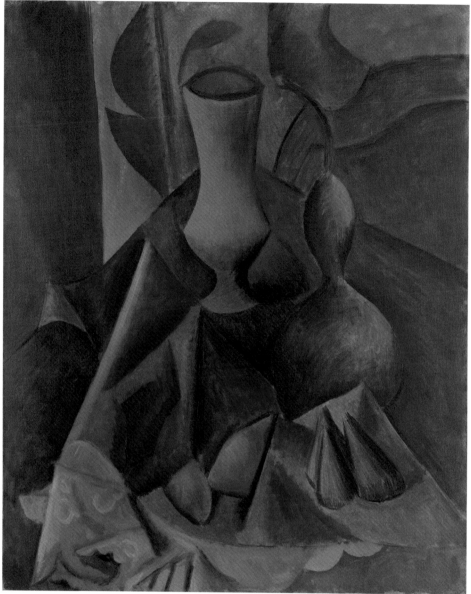

Plate 227

Plate 227, cat. 254
Pablo Picasso, *Vase, Gourd, and Fruit on a Table,* **1908.** Oil on canvas, 28¾ x 23⅝ in. (73 x 60 cm).
Yale University Art Gallery, John Hay Whitney, B.A. 1926, M.A. (Hon.) 1956, Collection

This work is one of several tabletop still lifes—nearly identical in size and featuring a vase, fruit,
and dramatic stemmed gourd—that Picasso made in 1908-9. While the overall palette resonates
with the artist's Rue-des-Bois pictures, the patterned wallpaper is a possible nod to the
landscapes of Henri Rousseau (Boggs 1992, 66). Picasso hosted a memorably raucous party for
Rousseau in 1908, an event that Gertrude vividly described in her *Autobiography of Alice B. Toklas*
(G. Stein 1990, 103-7). The Steins lent this painting to the International Exhibition of Modern Art,
popularly known as the Armory Show, held in New York, Chicago, and Boston in 1913.

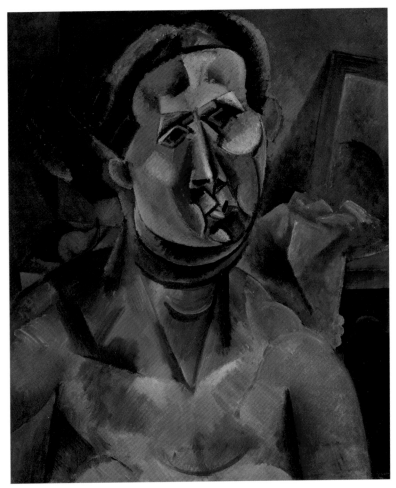

Plate 228

Plate 228, cat. 258
Pablo Picasso, *Head of a Woman (Fernande),* **1909.** Oil on canvas, 23⅞ x 20¼ in. (60.6 x 51.3 cm). The Art
Institute of Chicago, Joseph Winterbotham Collection

Plate 229, cat. 256
Pablo Picasso, *The Reservoir, Horta de Ebro,* **1909.** Oil on canvas, 24⅛ x 20⅛ in. (61.5 x 51.1 cm). Promised gift
of Mr. and Mrs. David Rockefeller to The Museum of Modern Art, New York

Plate 230, cat. 257
Pablo Picasso, *Houses on a Hill, Horta de Ebro,* **1909.** Oil on canvas, 25⅝ x 31⅞ in. (65 x 81 cm).
Nationalgalerie, Museum Berggruen, Staatliche Museen, Berlin

In 1909 Picasso spent a productive summer in the Catalan village of Horta de Ebro. The art he
made there, which includes these three paintings, proved fundamental to his cubist development.
Gertrude and Leo knew of Picasso's advances even before they saw the works in Paris in the
fall, as Picasso wrote to them regularly that summer. He sent photographs of the countryside
and of his new paintings. Gertrude later wrote: "But the essential thing, the treatment of the
houses was essentially Spanish and therefore essentially Picasso.... When they were first put up
on the wall naturally everybody objected.... And [Gertrude Stein] would show them the
photographs and really the pictures as she rightly said might be declared to be too photographic
a copy of nature.... This then was the beginning of cubism" (G. Stein 1990, 91). These would be
the last Picasso paintings purchased jointly by Leo and Gertrude.

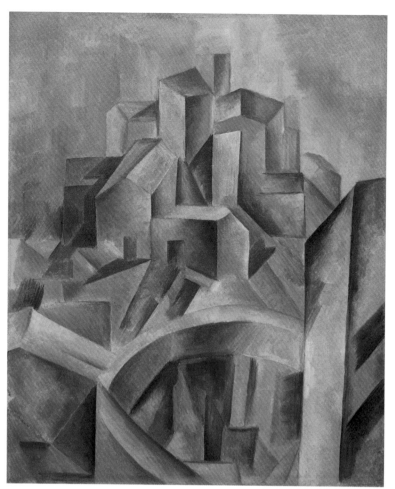

Plate 229

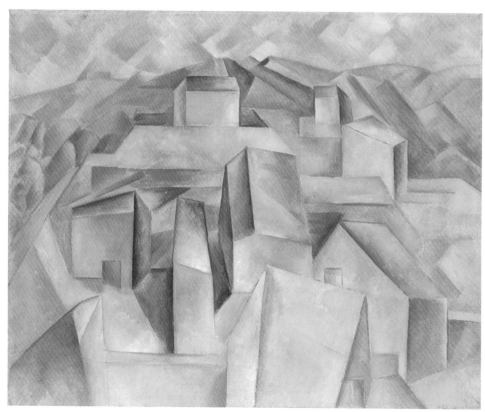

Plate 230

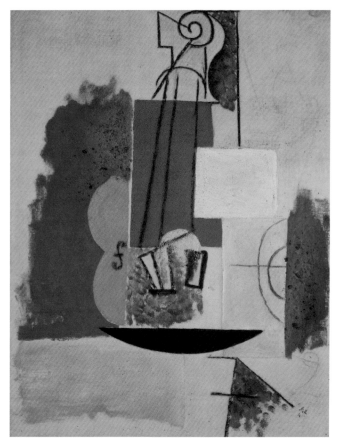

Plate 231

Plate 231, cat. 262
Pablo Picasso, *Violin*, 1912. Oil, sand, and charcoal on canvas, 21½ x 17 in. (54.6 x 43.2 cm). Private collection

In 1912 Gertrude came into her own as a collector. Increased tension between her and Leo, who had by this point renounced Cubism, led her to independently acquire pictures such as *Violin*, one of Picasso's first to incorporate sand. Gertrude remembered, "I was alone at this time in understanding [Picasso], perhaps because I was expressing the same thing in literature, perhaps because I was an American and, as I say, Spaniards and Americans have a kind of understanding of things which is the same" (G. Stein 1970, 23). It was also in 1912 that Alfred Stieglitz published Gertrude's word portrait of Picasso in his influential journal *Camera Work*.

Plate 232, cat. 263
Pablo Picasso, *Guitar on a Table*, 1912. Oil, sand, and charcoal on canvas, 20⅛ x 24¼ in. (51.1 x 61.6 cm). Hood Museum of Art, Dartmouth College, Hanover, New Hampshire; gift of Nelson A. Rockefeller, Class of 1930

Picasso offered *Guitar on a Table* as a gift to Gertrude in 1913, and despite two world wars and occasional financial difficulties, she kept the painting throughout her life. The guitar was central to Picasso's subject matter between 1912 and 1914, and Gertrude also owned a large study for the piece (cat. 377). For the final work, Picasso added sand to his paint—a technique that he shared with Georges Braque, his partner in developing Cubism.

Plate 233, cat. 265
Pablo Picasso, *Student with a Pipe*, 1914. Gesso, sand, pasted paper, oil, and charcoal on canvas, 28¾ x 23⅛ in. (73 x 58.7 cm). The Museum of Modern Art, New York, Nelson A. Rockefeller Bequest, 1979

Gertrude was particularly intrigued by papier collé. She is thought to have acquired this work in 1914, possibly around the time she purchased several pictures in the same medium by Juan Gris. In a photograph from 1922 (pl. 360), *Student with a Pipe* hangs near the atelier entrance, where raking light from the windows could accentuate the three-dimensional quality of the crumpled paper hat and pipe.

Plate 232

Plate 233

Plate 234

Plate 234, cat. 264
Pablo Picasso, *Man with a Guitar,* **1913.** Oil and encaustic on canvas, 51¼ x 35 in. (130.2 x 88.9 cm).
Private collection

In the fall of 1933 Gertrude traded art dealer Daniel-Henry Kahnweiler three Picassos—*Young Acrobat on a Ball* (1905; pl. 70), *Nude with a Towel* (1907; pl. 184), and *Three Women* (1908; pl. 186)—for this painting and 20,000 francs. The transaction allowed her to renew her commitment to Picasso's work and to finance the publication of her writings. Once the deal was concluded, Gertrude proudly informed Mabel Dodge, "I have a new one of his that interests everybody very much" (quoted in Luhan and Stein 1996, 209).

Plate 235

Plate 235, cat. 266
Pablo Picasso, *Woman with a Guitar,* 1914. Oil, sand, and charcoal on canvas, 45½ x 18⅝ in. (115.6 x 47.3 cm).
The Museum of Modern Art, New York, gift of Mr. and Mrs. David Rockefeller, 1975

Gertrude continued to purchase works by Picasso for as long as she could afford to do so,
and her acquisition of this painting, in addition to *Student with a Pipe* (1914; pl. 233) and *Man with
a Guitar*, marks the culmination of her identification with cubist portraiture. *Woman with a
Guitar* contains an inscription in Russian that translates roughly as "Grand Concert." Gertrude
Stein offers a clue to the inscription in *The Autobiography of Alice B. Toklas*, in which she
indicates that Picasso learned the Russian alphabet from his friend and fellow artist Serge Férat
and began "putting it in some of his pictures" (G. Stein 1990, 158). She must have had *Woman
with a Guitar* in mind since it is, in fact, the only Picasso with Russian lettering.

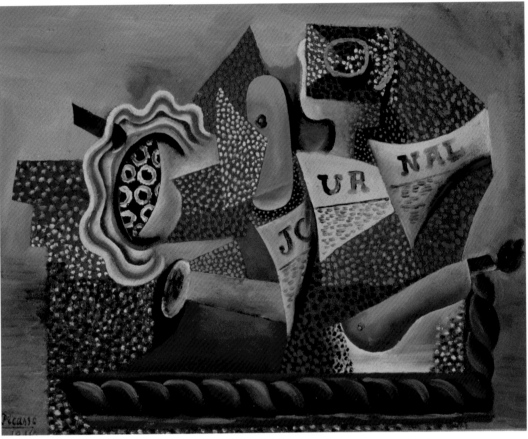

Plate 236

Plate 236, cat. 267
Pablo Picasso, *Still Life with Fruit, Glass, and Newspaper,* 1914. Oil and sand on canvas, 13⅝ x 16½ in.
(34.5 x 42 cm). Kreeger Museum, Washington, D.C.

Plate 237, cat. 268
Pablo Picasso, *Still Life with Bottle of Rum,* 1914. Oil and charcoal on canvas, 15 x 18⅛ in. (38.1 x 46 cm).
Nancy and Robert Blank, New York

In the summer before World War I broke out, Picasso lived in Avignon. On June 23, 1914, his
companion Eva Gouel wrote to Alice and Gertrude: "this morning Pablo found a quite Spanish-
looking house in the town proper, he is going to see the owner…who thought Pablo was a
house painter and was all ready to find him some work" (G. Stein and Picasso 2008, 145). In these
two particularly animated still lifes from the period, Picasso moves adeptly between flatness
and volume, darkness and light, solids and patterns, neutral tones and bursts of saturated color.
He borrowed *Still Life with Bottle of Rum* back from Gertrude for his 1932 Paris retrospective
at the Petit Palais.

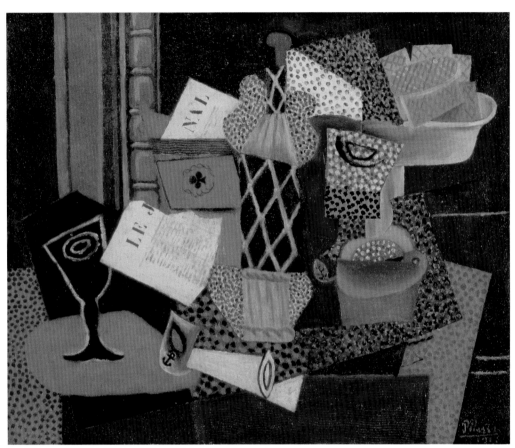

Plate 237

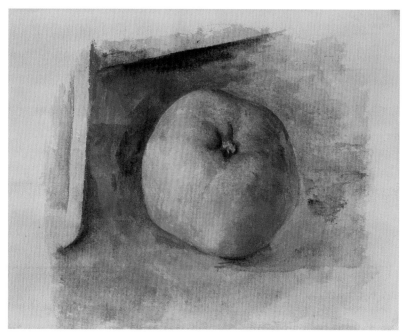

Plate 238

Plate 238, cat. 382
Pablo Picasso, *Apple*, 1914. Watercolor on paper, 5⅜ x 6⅞ in. (13.7 x 17.5 cm). Private collection

When Gertrude and Leo parted ways in 1914, their divergent tastes made the division of their collection relatively straightforward. According to Leo, his sister had become "sufficiently indifferent" to Renoir, for instance, whereas he had become "sufficiently indifferent" to Picasso (Leo Stein to Gertrude Stein, undated note, quoted in G. Stein and Picasso 2008, 173n1). Leo's success in claiming Cézanne's *Five Apples* (1877-78: pl. 49), however, was a source of great anguish for Gertrude. According to Alice, who helped negotiate the allocation of artworks, Picasso made this watercolor of a single apple to console his friend (Lord 1994, 24). The inscription on the verso reads: "Souvenir pour Gertrude et Alice / Picasso / Noel 1914."

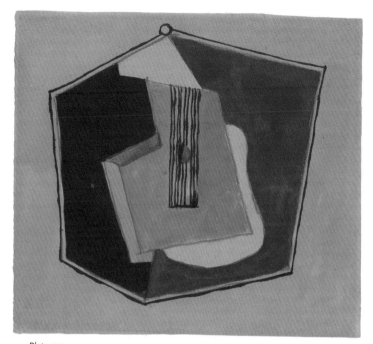

Plate 239

Plate 240

Plate 239, cat. 383
Pablo Picasso, *Guitar*, 1918. Graphite, watercolor, and ink on paper, 6¾ x 7½ in. (17.4 x 19.1 cm).
Private collection

Gertrude and Picasso saw each other far less frequently during the war years, though they
continued to correspond. The artist wrote in spring 1918, enclosing photographs of recent work
and this watercolor of a guitar, which bears a dedication on its verso: "Pour Gertrude Stein/
son ami Picasso/Montrouge 26 avril 1918." On May 9, 1918, Gertrude responded: "I was quite
delighted to get those photos and the drawing. I have lately begun feeling such a great nostalgia
for all my pictures and all your works, and longing to see something and just then your envelope
arrived.… I want to have the little sketch [*Guitar*] framed for hanging on the wall it might
console me a little" (G. Stein and Picasso 2008, 221). The piece was cherished by both Gertrude
and Alice, and the artist later copied the image onto a piece of tapestry canvas for Alice to
embroider (G. Stein 1990, 185-86).

Plate 240, cat. 391
Pablo Picasso, *Head*, 1928. Brass and iron, painted, 7 x 4⁵⁄₁₆ x 3 in. (17.8 x 10.9 x 7.6 cm).
Private collection, courtesy Diana Widmaier Picasso

This small sculpture is believed to be the last work by Picasso to enter Gertrude's collection.
Archival photographs from rue Christine testify to the place of honor Gertrude and Alice
accorded the piece in their home. One view (Widmaier Picasso 2003, 16) shows Gertrude posing
with *Head* on the mantelpiece directly below her portrait by Picasso (1905-6; pl. 183).

Plate 241

Plate 241, cat. 67
Juan Gris, *Glasses on a Table*, 1913-14. Oil and pasted paper on canvas, 24⅛ x 15⅛ in. (61.3 x 38.4 cm).
Private collection

Around 1907 the Spanish artist Juan Gris rented a studio at the Bateau-Lavoir, a rundown
complex of artist spaces in Montmartre. His ground-floor windows opened onto the street, and
the art dealer Daniel-Henry Kahnweiler noticed him by chance while visiting Picasso. Gris
worked primarily as an illustrator during this period, but around 1910 he took up oil painting.
In late 1912 Kahnweiler offered to buy the contents of Gris's studio as well as his future
production. Gris's work of 1913-14 is dominated by cubist still lifes such as this one, which
is thought to be one of the first pictures by the artist that Gertrude purchased. According to her,
"cubism is a purely spanish conception and only spaniards can be cubists and…the only real
cubism is that of Picasso and Juan Gris. Picasso created it and Juan Gris permeated it with his
clarity and his exaltation" (G. Stein 1990, 91).

Plate 242, cat. 68
Juan Gris, *Book and Glasses*, 1914. Oil, pasted paper, and wax crayon on canvas mounted on panel,
25¹¹⁄₁₆ x 19¹³⁄₁₆ in. (65.3 x 50.3 cm). Private collection, New York

Gertrude acquired *Book and Glasses* in July 1914, just before World War I erupted. When the
artist found himself stranded in the south of France soon thereafter, Gertrude tried to help him
by sending money. The understanding that Gris would repay his debts to her with artworks
angered Kahnweiler, who had secured the rights to Gris's artistic production. As a result of
these complicated circumstances, Gertrude held a grudge against Gris for the next five years,
but she renewed her friendship with him after admiring his contributions to the 1920 Salon
d'Automne.

Plate 242

Plate 243

Plate 243
Juan Gris, Illustration from Gertrude Stein's *A Book Concluding with As a Wife Has a Cow a Love Story*, 1926.
Offset lithography, 9¹⁵⁄₁₆ x 7¹¹⁄₁₆ in. (25.2 x 19.5 cm). The Metropolitan Museum of Art, New York, Harris
Brisbane Dick Fund, 1930

During the second half of the 1920s the art dealer Daniel-Henry Kahnweiler undertook several
publishing projects with Gertrude under his Galerie Simon imprint. Among these was
A Book Concluding with As a Wife Has a Cow a Love Story (1926), for which Juan Gris created four
illustrations. In a letter dated January 20, 1927, Kahnweiler admitted to Gertrude, "The print-
ing of the book is not as good as it could be. Still, I believe that in half a year's time, the ink
being then quite dry, it is going to improve and to be quite a nice little book" (Beinecke YCAL,
MSS 76, box 112, folder 2310).

Plate 244

Plate 244, cat. 70

Juan Gris, *The Table in Front of the Window,* **1921.** Oil on canvas, 25⅝ x 39½ in. (65 x 100 cm). Beverly and Raymond Sackler

On April 9, 1921, Gris informed Kahnweiler that he had just finished *The Table in Front of the Window.* "It is much looser in execution and has a sort of popular look which I rather like, but which is not due to using popular means. It has, if I'm not mistaken, a sort of Derain air. As soon as it is dry I will send it to you" (Gris 1956, 108). After visiting Gris at the seaside town of Bandol a few weeks later, Gertrude and Alice purchased this canvas from Kahnweiler. In mid-June the artist informed his dealer that Gertrude had written him "a very nice letter about the picture with which she says she is very pleased. I am delighted" (ibid., 122).

Plate 245

Plate 245, cat. 74

Juan Gris, *The Clown,* drawing for Armand Salacrou's *Le Casseur d'assiettes* (The Plate Breaker), 1924. Ink and graphite on paper, 9⅞ x 7½ in. (25.1 x 19.1 cm). Katrina B. Heinrich-Steinberg, Rancho Mirage, California

In February 1924 Gris began working on drawings for Armand Salacrou's recent one-act play, *Le Casseur d'assiettes* (The Plate Breaker). Gris had reportedly offered to illustrate the as-yet-unknown author's text after hearing Daniel-Henry Kahnweiler read it aloud to a group of friends (Hahn 1951, 2). The book included five illustrations by Gris when it was published under Kahnweiler's Galerie Simon imprint in December. Earlier that year Gertrude had submitted a flattering essay about Gris for an edition of the *Little Review* devoted to the artist. Possibly in thanks, Gris inscribed a dedication to her on this ink drawing, which was the basis for one of his illustrations for Salacrou's text. Gris inscribed a related drawing, *Man with Hat* (1924; cat. 75), to Alice at the same time.

Plate 246, cat. 71

Juan Gris, *Woman with Clasped Hands,* 1924. Oil on canvas, 32 x 23⅝ in. (81.3 x 60 cm). Ikeda Museum of Twentieth-Century Art Foundation, Shizuoka, Japan

Demand for Gris's work began to rise during the early 1920s. Gertrude and Alice visited the artist during the fall of 1923, when he was in Monte Carlo designing decor for Sergei Diaghilev's Ballets Russes. It is thought that Gertrude purchased *Woman with Clasped Hands* the following year. When he was invited to speak at the Sorbonne in May 1924, the artist presented a paper titled "On the Possibilities of Painting." Some of the lecture can be understood as a defense of his recent work, which included this painting: "A picture with no representational purpose is to my mind always an incomplete exercise, for the only purpose of any picture is to achieve representation. Nor is a painting which is merely the faithful copy of an object a picture.... It will only be the copy of an object and never a subject" (reprinted in Kahnweiler 1969, 200–201).

Plate 246

Plate 247

Plate 247, cat. 85
André Masson, *The Meal,* **1922.** Oil on canvas, 32¼ x 26⅜ in. (82 x 67 cm). Private collection, Madrid

Impressed by the Masson works exhibited at Galerie Simon in 1923, Gertrude wrote to Henry
McBride that she had acquired "a new Picasso" and "two new Massons," *The Cardplayers* (cat. 87)
and *The Meal* (undated [April 1923?], Beinecke YCAL, MSS 31, box 11, folder 307, 13 r). When
Ernest Hemingway expressed his frustration at not being able to afford Picasso's work, Gertrude
instructed him to "buy the people of your own age…there are always good new serious
painters" (Hemingway 2009, 26). After seeing Gertrude's Massons at rue de Fleurus, Hemingway
purchased his own, *The Throw of the Dice* (ca. 1920; John F. Kennedy Presidential Library and
Museum, Boston).

Plate 248

Plate 248, cat. 88
André Masson, *Man in a Tower,* **1924.** Oil on canvas, 37⅛ x 24 in. (95 x 60.8 cm). Solomon R. Guggenheim Museum, New York, Estate of Karl Nierendorf, by purchase

Man in a Tower represents a composite portrait of three regular visitors to Masson's studio: the surrealist authors Michel Leiris, Georges Limbour, and Roland Tual. The painting is rife with symbolism. The rope and tower stairs allude to escape, while the three dice are a nod to Stéphane Mallarmé's 1897 poem *Un coup de dés jamais n'abolira le hasard* (A Throw of the Dice Will Never Abolish Chance). At far left appears a bilboquet, a toy in which the user attempts to catch a small tethered ball in a cup at the end of a stick (Rudenstine 1976, 506).

Plate 249

Plate 249, cat. 219
Francis Picabia, *Pa*, **1932.** Oil on canvas, 25⁹⁄₁₆ x 21¼ in. (65 x 54 cm). Mike Kelley, Los Angeles

Gertrude Stein and Picabia met around 1913 at the suggestion of Mabel Dodge but did not become
particularly close until many years later. In December 1932, the year *Pa* was painted, Picabia
had a solo exhibition at Léonce Rosenberg's gallery in Paris. Gertrude wrote the preface for the
catalogue, which was translated into French by Marcel Duchamp. Her text took the form of a
stanza, one of many Stein wrote in 1932 that were posthumously published as *Stanzas in
Meditation* (G. Stein 1993, 568-69).

Plate 250

Plate 250, cat. 221

Francis Picabia, *Gertrude Stein,* **1933.** Oil on canvas, 45¾ x 23¾ in. (116.2 x 60.3 cm). Yale Collection of American Literature, Beinecke Rare Book and Manuscript Library, Yale University, New Haven

On June 18, 1933, Picabia's wife, Olga, wrote to Gertrude and Alice from Cannes: "We have rediscovered our little boat; Francis works all day long, the portrait of Gertrude is developing admirably, the composition is magnificent. You cannot imagine what marvelous memories Francis and I have of our stay at Bilignin. Picabia told me upon our return that his nearly constant feeling of loneliness had completely disappeared" (Beinecke YCAL, MSS 76, box 118, folder 2548). Picabia himself wrote on June 27 to let Gertrude know that he had finished the portrait, and he delivered it to her in July, just days after having been awarded the Legion of Honor.

Plate 251

Plate 251
Francis Picabia, *The Acrobats,* **1935.** Oil on panel, 59 x 34⅝ in. (150 x 88 cm). Private collection

Picabia was experiencing a series of personal difficulties in the mid-1930s, when Gertrude offered
to help him by organizing a show of his work at the Arts Club of Chicago. Gertrude was by
that point close friends with Bobsy Goodspeed, the director of the club, and she had lectured
there in 1934. Picabia responded enthusiastically to his friend's proposal: "I have just received
your letter on the subject of the exhibition. I thank you and accept with pleasure to do the
exhibition in Chicago" (Francis Picabia to Gertrude Stein, August 7, 1935, quoted in Camfield
1979, 248n17). The resulting 1936 show, which included *The Acrobats* among its thirty-three
works, proved to be a flop, as Picabia sold only one painting (Arts Club of Chicago to Francis
Picabia, July 2, 1936, Arts Club of Chicago archives).

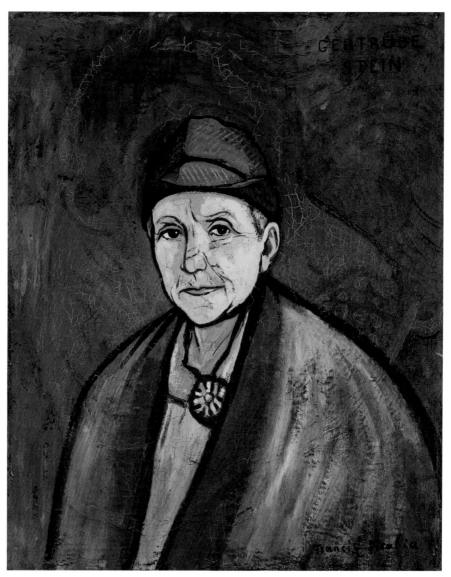

Plate 252

Plate 252, cat. 221

Francis Picabia, *Gertrude Stein*, **1937 or later.** Oil on canvas, 29½ x 24 in. (74.9 x 61 cm). Private collection, courtesy Concept Art Gallery, Pittsburgh

Picabia remained close to Gertrude and Alice throughout the 1930s. He and his wife, Olga, frequently visited them at Bilignin, where they discussed painting and played with Byron and his successor, Pépé, the chihuahuas the Picabias had given as gifts. This portrait is based on a 1937 photograph by Cecil Beaton, in which Gertrude is pictured in a shapeless brown jacket and favorite coral brooch. That same year, Picabia wrote: "For Gertrude Stein a work of art is the intimate expression of a being's personality, its exact projection, of the same dimensions" (draft, dated February 12, 1937, of an article about Gertrude Stein for *Des Feuilles*, Beinecke YCAL, MSS 76, box 118, folder 2549).

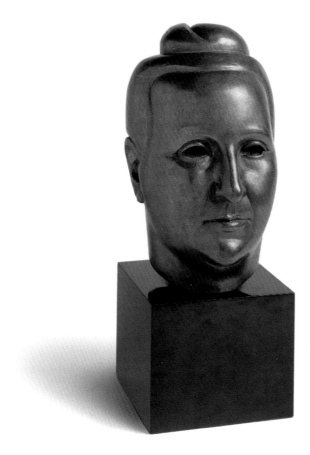

Plate 253

Plate 253
Jacques Lipchitz, *Gertrude Stein,* **1920.** Bronze, 13 x 7⅞ x 7½ in. (33 x 20 x 19 cm). Musée National d'Art
Moderne, Centre Georges Pompidou, Paris

Gertrude reminisced about the creation of this bust in *The Autobiography of Alice B. Toklas*:
"[Gertrude] never minds posing, she likes the calm of it and although she does not like
sculpture and told Lipchitz so, she began to pose. I remember it was a very hot spring and
Lipchitz's studio was appallingly hot and they spent hours there. Lipchitz is an excellent
gossip and Gertrude Stein adores the beginning and middle and end of a story and Lipchitz
was able to supply several missing parts of several stories. And then they talked about art
and Gertrude Stein rather liked her portrait and they were very good friends and the sittings
were over" (G. Stein 1990, 249).

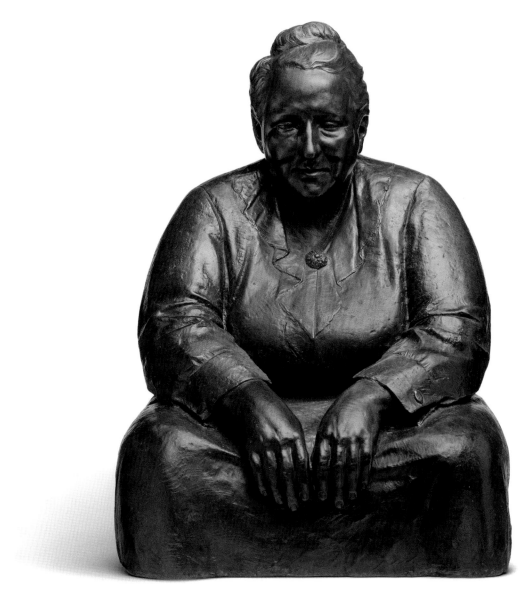

Plate 254

Plate 254
Jo Davidson, *Gertrude Stein*, ca. 1920-22. Bronze, 33 x 22 x 24 in. (83.8 x 55.9 x 61 cm). The Metropolitan
Museum of Art, New York, gift of Dr. Maury P. Leibovitz, 1982

The American sculptor Jo Davidson was drawn to Gertrude after meeting her on his first visit
to France in 1907. "Her wit and her laughter were contagious," he recalled. He realized that
"to [sculpt] a head of Gertrude was not enough—there was so much more of her than that. So
I did a seated figure of her—a sort of modern Buddha" (Davidson 1951, 174). After the sculpture
was completed, Gertrude sent a photograph of it to her friend the journalist Kate Buss, who
responded, "It is a remarkable piece of work I think, it is a good deal of your spirit and pretty
much your body. The hands and mouth are marvelous" (Kate Buss to Gertrude Stein, undated,
Beinecke YCAL, MSS 76, box 100, folder 1928).

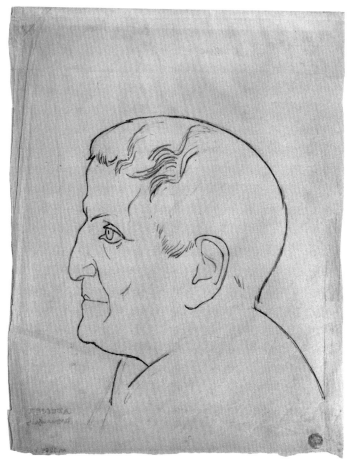

Plate 255

Plate 255
Louis Marcoussis, *Gertrude Stein,* **ca. 1936.** Graphite on paper, 14⁹⁄₁₆ x 10½ in. (37 x 26.7 cm). Musée National d'Art Moderne, Centre Georges Pompidou, Paris, purchased in 1964

Louis Marcoussis was a French painter of Polish birth who may have first come to Gertrude's attention when his wife, the illustrator Marcelle Humbert (also known as Eva Gouel), ran off with Picasso in 1912. The Stein family correspondence contains several breathless accounts of the event. Some twenty years later, Gertrude and Alice both posed for Marcoussis, resulting in a group of drawings and prints. In an undated letter to Gertrude written around Christmas 1933, the artist reported on his progress: "It's time now to stop the modeling sessions and attack the copper plate…. I am almost certain that with these two finished drawings I have what I need to work from now until Friday without bothering you. May I come Saturday at 1:30 to resume my work from life and our passionate conversations about old times?" (Beinecke YCAL, MSS 76, box 116, folder 2437)

Plate 256

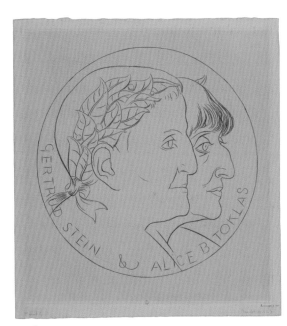

Plate 257

Plate 258

Plate 256
Louis Marcoussis, *Gertrude Stein and Alice Toklas,* **1934.** Engraving, third state, 14⁹/₁₆ x 13⁹/₁₆ in. (37.5 x 34.5 cm). Bibliothèque Nationale de France, Paris

Plate 257
Louis Marcoussis, *Gertrude Stein and Alice Toklas,* **1934.** Color engraving mounted on paper, fifth state, 13⁷/₁₆ x 12¹¹/₁₆ in. (33.5 x 32.5 cm). Bibliothèque Nationale de France, Paris

Plate 258
Louis Marcoussis, *Gertrude Stein,* **1934.** Drypoint and engraving, ninth state, 14¹/₁₆ x 10¹³/₁₆ in. (35.7 x 27.8 cm). Bibliothèque Nationale de France, Paris

Plate 259

Plate 260

Plate 259

Pavel Tchelitchew, *Gertrude Stein*, **1930.** Ink on paper, 16¾ x 11⅜ in. (42.7 x 28.8 cm). The Art Institute of Chicago, given in memory of Charles Barnett Goodspeed by Mrs. Charles B. Goodspeed

Plate 260

Pavel Tchelitchew, *Gertrude Stein*, **1931.** Sepia and wash on paper, 17⅝ x 10⁹⁄₁₆ in. (44.7 x 26.8 cm). Yale University Art Gallery, New Haven, University Purchase Fund

The Russian-born artist Pavel Tchelitchew moved to Paris in 1923. Gertrude recalled meeting him around the time that she had discovered his paintings at the 1925 Salon d'Automne. As she and Alice were driving across the Pont Royale in their car, which was nicknamed Godiva, "we saw Jane Heap and the young Russian. We saw his pictures and Gertrude Stein too was interested. He of course came to see us" (G. Stein 1990, 225). Over the next decade, Gertrude counted him among her inner circle. She also included a flattering word portrait of him in her book *Dix Portraits*, for which he was one of the illustrators. Tchelitchew, in turn, created numerous representations of Gertrude, including these two ink drawings.

Plate 261

Plate 261
Pavel Tchelitchew, Final sketch for *Phenomena*, **1938.** Oil on canvas, 35 x 45¾ in. (89 x 116.2 cm).
Hirshhorn Museum and Sculpture Garden, Smithsonian Institution, Washington, D.C., The Joseph H.
Hirshhorn Bequest, 1981

Gertrude had a falling out with Tchelitchew in early 1932. A few years later he began working
on a monumental painting, *Phenomena* (1936-38; State Tretyakov Gallery, Moscow). Both
the final canvas and this sketch for it portray the horrors of the time. Alice and Gertrude are
included in the apocalyptic vision. They sit at the feet of the shrouded figure at left as per-
sonifications of evil, huddled atop a pile of damaged canvases. The artist caustically referred
to these depictions of Gertrude and Alice as "Sitting Bull" and "The Knitting Maniac"
(Tyler 1967, 308).

Plate 262

Plate 262
Pierre Tal-Coat, *Gertrude Stein,* **1934–35.** Oil on plaster, transferred to particle board, 66½ x 35⅜ in.
(169 x 90 cm). Musée d'Art Moderne de la Ville de Paris

Pierre Jacob, or Pierre Tal-Coat, as he was professionally known, apprenticed as a blacksmith
and worked as a painter of ceramics before devoting himself to easel painting and printmaking.
He was in his late twenties when he met Gertrude and used her as a subject for several of his
paintings, one of which was awarded the Prix Paul Guillaume in 1935. From the early 1930s Tal-
Coat paid regular visits to the doctor Charles Flandin at his family's residence, the tenth-century
abbey of Cure near Vézelay, France. This portrait of Gertrude with her dog, painted on plaster,
originally adorned a garden wall at the abbey.

Plate 263

Plate 263, cat. 431
Francis Rose, *Homage to Gertrude Stein*, 1949. Oil, tempera, watercolor, and wax on paper, 80¼ x 56¼ in.
(203.8 x 142.9 cm). England & Co. gallery, London

Gertrude first purchased pictures by the British artist Francis Rose in late 1929 or early 1930,
almost a year before she met him. They soon became quite friendly, and Gertrude actively
promoted his work. She wrote a preface for one of Rose's exhibition brochures and solicited
illustrations from him for her books *The World Is Round* and *The Gertrude Stein First Reader*
(G. Stein and Wilder 1996, 215n4). In December 1946, five months after Gertrude's death, Alice
mentioned in a letter to a friend that Rose had begun "a big picture, an *Hommage à Gertrude*"
(quoted in G. Stein 1977, 158). The resulting painting shows Alice peering out a window behind
an enthroned Gertrude. The couple's two dogs, Basket II and Pépé, appear at Gertrude's feet.

SOURCES AND DOCUMENTS

Plate 264
The Steins in Fiesole, Italy, 1904. From left: Gertrude Stein; unidentified woman; Leo, Michael, and Sarah Stein; Theresa Ehrman; Allan Stein. Yale Collection of American Literature, Beinecke Rare Book and Manuscript Library, Yale University, New Haven

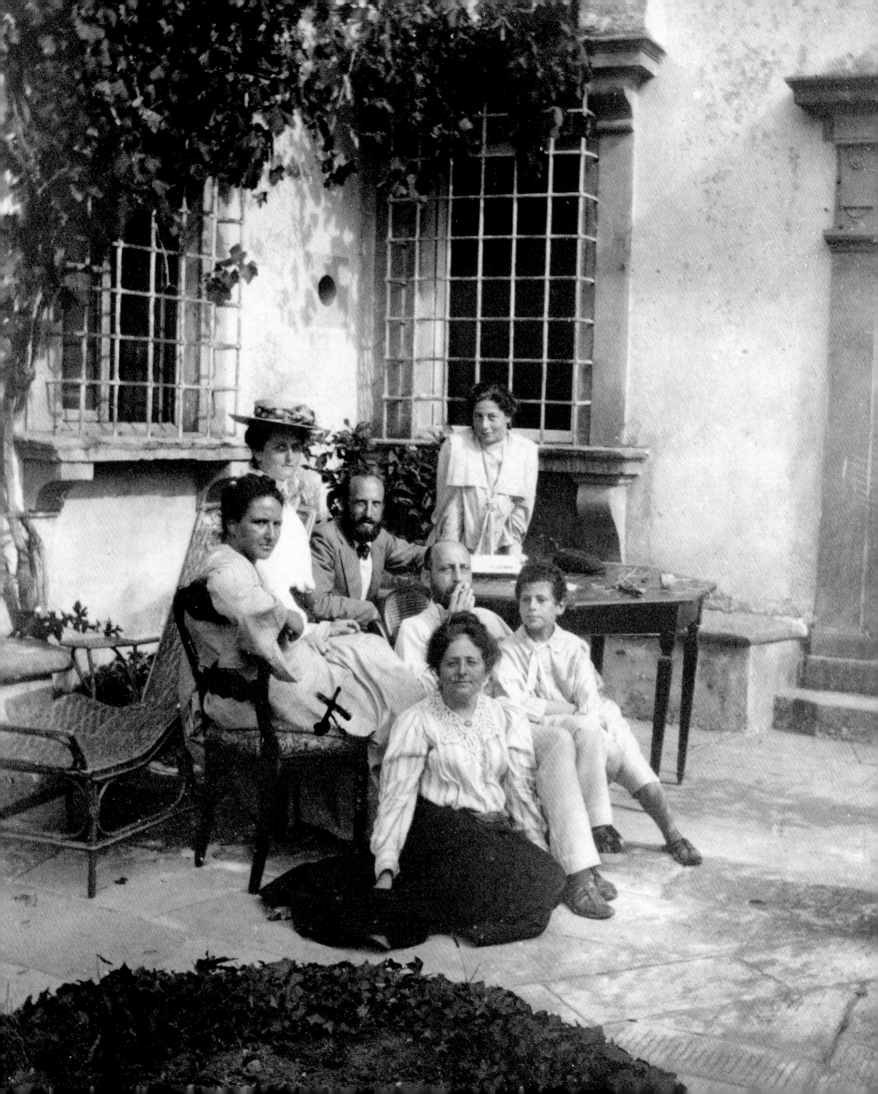

Chronology
Kate Mendillo

Plate 265

1864
Amelia "Milly" Keyser (1842-1888) of Maryland marries German-born Daniel Stein (1832-1891) on March 23 in Baltimore. The couple moves to Pittsburgh, where Daniel and his brother Solomon have recently established a branch of Stein Brothers, the family's Baltimore manufacturing and wholesale clothing firm.

1865
Michael Daniel Stein (1865-1938), Milly and Daniel's first child, is born in Pittsburgh on March 26. After the death of their second son, Harry, Simon (1868-1913) is born. A fourth child dies in infancy in October 1869; their daughter Bertha (1870-1924) is born the following year.

1869
Henri Matisse (1869-1954) is born at Le Cateau-Cambrésis, in the north of France, on December 31.

1870
Sarah Anne Samuels (1870-1953) is born on July 26 in San Francisco, the second of six children born to Esther (Blackman) Samuels (1849-1930) and Julius Samuels (1840-1910), a dry goods retailer.[1]

1872
Leo Daniel Stein (1872-1947) is born to Milly and Daniel at the family's new home on Western Avenue in Allegheny, Pennsylvania, on May 11.

1874
After the family moves to a redbrick house at 71 Beech Street in Allegheny, Milly and Daniel's youngest child, Gertrude Stein (1874-1946), is born on February 3. Gertrude would later write, "I was born in Allegheny Penn., a fact Alice [Toklas] always wants me to keep dark but you have to be born somewhere and I was born there."[2]

1875
Milly and Daniel Stein sail to Vienna with their five children after Daniel and Solomon shut down the Pittsburgh division of Stein Brothers. In Vienna the children receive instruction in a variety of disciplines, including German, French, music, and science.

1877
Alice Babette Toklas (1877-1967) is born in San Francisco on April 30 to Emma (Levinsky) Toklas (1856-1897) and Ferdinand Toklas (1845-1924). While living in San Francisco, Ferdinand opens a dry goods business in Seattle.

1878
The Stein family moves to Paris in the fall, establishing a residence in the Passy neighborhood, where the children continue their studies.

1879
The Steins return to North America. After a brief time in Baltimore, the family moves to Oakland. Daniel works in various fields, including mining, the stock market, and eventually cable cars.

1881
Pablo Picasso (1881-1973) is born in Málaga, Spain, on October 25.

1885
Sarah Samuels graduates from Girls' High School in San Francisco in May, valedictorian of her class. She goes on to study studio art.

1888
Milly Stein dies of cancer on July 29 at age 45, leaving behind children Michael (23), Simon (20), Bertha (17), Leo (16), and Gertrude (14). According to Alice Toklas, even as a child Gertrude was "fond of…Leo and Mike, and the other two [siblings] she ignored completely."[3]

Plate 265
The Stein children with their governess and tutor, Vienna, ca. 1875-78. From left: Gertrude, Bertha, Leo, Simon, and Michael Stein. Yale Collection of American Literature, Beinecke Rare Book and Manuscript Library, Yale University, New Haven

Plate 266

Plate 267

Plate 268

1889

In the fall Leo enrolls at the University of California, Berkeley, in the College of Letters and Political Science. It appears that Gertrude stops attending Oakland High School later that school year, perhaps after a fire destroys much of the building in November.

1890

The Toklas family moves to Seattle, where Alice studies music at the University of Washington. She would later say, "I was going to be a musician and then I found out that everything I did was absolutely fifth rate, and so I gave it up."[4] The family returns to San Francisco in 1895 so that Emma Toklas, who is suffering from cancer, can receive treatment.

1891

Daniel Stein dies in January, leaving Michael, age 25, to administer the family estate. Michael, who worked under his father as first assistant superintendent of the Omnibus Cable Company, moves the family to 834 Turk Street in San Francisco. His management of the estate provides his siblings with financial independence.

1892

After being diagnosed with typhoid fever and withdrawing from UC Berkeley in January, Leo transfers to Harvard in the fall. Gertrude and Bertha move to Baltimore to live with their maternal aunt Fanny Bachrach on Linden Boulevard. Many years later, Alice would describe Gertrude as "so Californian that when she went East she found it very strange. And the people she met found her strange. She was almost a foreigner."[5] In Baltimore, Gertrude and Leo meet the Cone sisters, Claribel (1864-1929) and Etta (1870-1949).

1893

Michael is instrumental in merging San Francisco cable car lines; two years later he will become division superintendent of this system, the Market Street Railway Company. While Leo and Gertrude are visiting Michael during the summer, he introduces them to Sarah Samuels.

In the fall, Gertrude enrolls at the Harvard Annex (which becomes Radcliffe College by 1894), and moves into a boarding house at 64 Buckingham Street, Cambridge. "She was bored with just doing nothing," Alice would later recall, and knew "that she had to have some schooling at some time, and she might as well get it over with."[6] As a philosophy and psychology major, Gertrude works under Hugo Münsterberg and William James in the Harvard Psychological Laboratory.

1894

Michael Stein and Sarah Samuels are married in San Francisco on March 1.

1895

After one semester at Harvard Law School, where he had been admitted without an undergraduate degree, Leo decides that he is "tired of law" and withdraws.[7] Leo travels to Europe with his friend Ben Oppenheimer in June. In August, Leo accepts an offer to accompany his uncle Solomon's son Fred on a yearlong trip around the world. They travel to Europe, Japan, China, Singapore, Ceylon (now Sri Lanka), and Egypt.

Sarah and Michael's only child, Allan Daniel Stein (1895-1951), is born on November 7.

Plate 266
Sarah Samuels (later Stein), San Francisco, ca. 1875. Estate of Daniel M. Stein

Plate 267
Sarah Samuels (later Stein), San Francisco, 1885. Estate of Daniel M. Stein

Plate 268
Michael Stein, San Francisco, ca. 1885. Estate of Daniel M. Stein

1896

In the summer, Gertrude travels to Europe to meet Leo, whom she has not seen in a year. They visit Belgium, the Netherlands, Germany, France, and England. That fall, they both return to Cambridge for Gertrude's senior year at Radcliffe; Leo is not enrolled in school.

1897

After failing a Latin exam, a Radcliffe graduation requirement, Gertrude cannot graduate with her class. Friends would later recall that she had "put off the real study of Latin until the last moment, carrying a Latin grammar under her arm and apparently hoping she might absorb it through her pores."[8]

Gertrude passes her Latin exam in late September. Although she won't receive her degree from Radcliffe until the following spring, in October she is allowed to enroll at Johns Hopkins Medical School, where she plans to study the nervous diseases of women. Leo is also admitted to Johns Hopkins to finish his undergraduate studies; the siblings live together at 215 East Biddle Street, Baltimore.

In Baltimore, Leo and Gertrude spend time with the Cone sisters, who entertain guests at their family home on Saturday evenings, providing a model of salon culture to the young Steins.

1898

Leo receives his diploma from Johns Hopkins on June 14. He enters the doctoral program in zoology but quits after a year.

1899

Enrolled in courses in music, comparative literature, and early Italian art, Sarah writes to Gertrude: "I had no idea that one could have so fair an appreciation [of art] without going abroad and seeing the originals.... I think of Leo very often these days. He certainly did a great deal for me in that first summer of our acquaintance, and when the class marvels at my poetical insight, I grin and charge it up to *his* credit account."[9]

1900

Leo, Gertrude, and their friend Mabel Weeks sail to Europe from Baltimore aboard the *H. H. Meier* on June 6. They spend the summer together in Italy and France, where they see the World's Fair in Paris. That fall, Gertrude returns

to Baltimore for her final year of medical school; Leo moves to Florence, where he soon meets Bernard Berenson and his wife-to-be, Mary Costelloe.

1901

Gertrude fails her exams and cannot graduate with her medical school class. She and Leo spend the summer in Spain and North Africa and join Etta Cone in Paris on August 29. In October, Leo returns to Florence, and Gertrude returns to Baltimore, where she continues her neurology research.

1902

Gertrude travels to Italy in the spring to meet Leo. Mary Berenson describes her as "a fat, un-wieldy person, the color of mahogany…but with a grand, monumental head, plenty of brains & immense geniality—a really splendid woman."[10] In September, the Berensons invite Leo and Gertrude to stay with them at their country home outside London. The siblings stay in London into the winter, residing at 20 Bloomsbury Square.

Leo leaves London in late December and visits Paris. Determined to become an artist, he decides to stay and soon after

Plate 269

rents a studio and adjacent apartment at 27 rue de Fleurus.

1903

Gertrude returns to New York in February, staying with her friends Mabel Weeks, Harriet Clark, and Estelle Rumbold at the "White House," on 100th Street and Riverside Drive.

Before leaving Paris to spend the summer in Italy, Leo purchases his first Cézanne, *The Spring House* (ca. 1879; pl. 35, cat. 8), from Ambroise Vollard's gallery.

Gertrude returns to Europe in the spring. She arrives in Florence on June 21 and visits the Cones and the Berensons before heading to Rome with Leo. In the fall, Gertrude moves to Paris to live with Leo at 27 rue de Fleurus.

The first Salon d'Automne is held at the Petit Palais in Paris, October 31– December 6.

1904

Michael, Sarah, Allan, and Theresa Ehrman (1884–1961), a young woman who accompanies the Steins as their au pair, move to Paris in January. After living initially at 2 rue de Fleurus, the family

settles in 1905 at 58 rue Madame, close to Gertrude and Leo. A friend later recalled that Michael "had the notion of opening an antique shop" in Europe, "but due to his dislike of business responsibility it never materialized."[11]

The twentieth Salon des Indépendants is held in Paris, February 21–March 24.

In what will be her last visit to the United States for thirty years, Gertrude sails to New York in the spring to visit family and friends. She returns to Europe in June, accompanied by Etta Cone, and visits Leo in Florence.

Matisse has his first solo exhibition at Vollard's gallery, June 1–18.

The second Salon d'Automne opens at the Grand Palais on October 15 and contains retrospectives of Paul Cézanne, Odilon Redon, Pierre-Auguste Renoir, Pierre Puvis de Chavannes, and Henri de Toulouse-Lautrec.

On October 28, after Michael has informed them of a windfall in their account, Leo and Gertrude purchase seven paintings

from Vollard: two Cézannes (cat. 12, 14), two Gauguins (cat. 63, 64), two Renoirs (cat. 396, 412), and a Denis (cat. 61).

On December 16, 1904, Leo and Gertrude buy Cézanne's *Madame Cézanne with a Fan* (1878–88; pl. 2, cat. 10), a painting that Vollard had lent to the Salon d'Automne.

1905

Wishing to purchase a work by Édouard Manet, Leo and Gertrude enlist Mabel Weeks and another friend, Estelle Rumbold, to sell art they left in Baltimore. Weeks writes to Gertrude, "I'd hate to be confronted by all my past enthusiasms, and I fancy Paris makes one grow very fast."[12]

Leo and Gertrude purchase at least two canvases from the twenty-first Salon des Indépendants (March 24–April 30): Henri Manguin's *The Studio, the Nude Model* (1904–5; pl. 55, cat. 82) and Félix Vallotton's *Reclining Nude on a Yellow Cushion* (1904; pl. 10, cat. 438).

Leo and Gertrude acquire their first works by Picasso: *The Acrobat Family* (1905; pl. 22, cat. 291) and *Girl with a Basket of Flowers* (1905; pl. 9, cat. 232). That spring,

Plate 269
Postcard from Sarah Stein to Theresa Ehrman featuring a view of Fiesole, Italy, dated July 4, 1905. Theresa Ehrman papers and photographs, BANC MSS 2009.8.AR1.4, The Magnes Collection of Jewish Art and Life, The Bancroft Library, University of California, Berkeley. Transfer; Judah L. Magnes Museum; 2010

Plate 270

Plate 271

author Henri-Pierre Roché (1880-1959) informs Picasso that he "shall bring the American of whom I spoke to see you at your house tomorrow"; the American was presumably Leo, and Gertrude would meet Picasso shortly thereafter.[13]

The Steins and the Cone sisters attend the October 18 opening of the third Salon d'Automne at the Grand Palais. A few weeks later, Leo and Gertrude purchase their first Matisse painting, *Woman with a Hat* (1905; pl. 13, cat. 113). Manguin introduces Leo to Matisse soon after; Leo in turn introduces Matisse to Sarah and Michael, who will become lifelong friends and benefactors.

1906
Leo and Gertrude introduce Matisse and Picasso to each other, probably in March.

Matisse has a solo exhibition at Galerie Druet in Paris (March 19 - April 7). The catalogue lists fifty-five paintings; the works that the Stein family will acquire include *The Gypsy* (1905-6; pl. 29, cat. 118), *Houses (Fenouillet)* (1898-99; cat. 95), *La Japonaise: Woman beside the Water* (1905; pl. 140, cat. 108), *Landscape near Collioure* [Study for *Le Bonheur de vivre*] (1905; pl. 141, cat. 109), *Madame Matisse*

(The Green Line) (1905; pl. 88, cat. 110), *Madame Matisse in the Olive Grove* (1905; cat. 111), *Nude before a Screen* (1905; cat. 112), and *Yellow Pottery from Provence* (1905; cat. 114).

Matisse submits one work to the Salon des Indépendants (March 20 - April 30), the enormous and controversial *Le Bonheur de vivre*, also called *The Joy of Life* (1905-6; pl. 15, cat. 117). The painting is hung in Leo and Gertrude's studio after the exhibition closes; they pay for it the following year.

Ten days after the April 18 San Francisco earthquake, one of the most devastating in the history of the United States, Sarah, Michael, and Allan depart for California to assess the damage to their rental properties, bringing with them several works by Matisse, most notably *Madame Matisse (The Green Line)*. Among the many people to whom Sarah and Michael show the paintings—the first of Matisse's to be seen in America—is Alice Toklas.

After Alice declines their invitation to accompany them to Europe, Sarah and Michael sail back to France on November

7 with Alice's friend Annette Rosenshine (1880-1971). Rosenshine, "startled by the wild, loud, glaring colors" of Sarah's Matisses yet "eager to be part of the art movement about which Mrs. Stein was so enthusiastic,"[14] moves into an apartment in Sarah and Michael's building at 58 rue Madame.

In the same year that Picasso paints his portraits *Leo Stein* (1906; pl. 33, cat. 325) and *Allan Stein* (1906; pl. 179, cat. 324), he finishes his *Gertrude Stein* (1905-6; pl. 183, cat. 238). According to Gertrude, when someone suggested that she did not look like her portrait, Picasso replied, "she will."[15]

In order to accommodate all the requests to see their paintings, Leo and Gertrude open their studio to visitors for Saturday evening salons. The guests, Rosenshine would recall, "were an unusual crowd of varied nationalities. It was a comfortable, friendly room—a genuine expression of two cultivated civilized people."[16] Sarah and Michael also open their large living-dining room at 58 rue Madame to guests on Saturday evenings. According to Vollard, the Stein families were

Plate 270
Cover of the exhibition catalogue for the third Salon d'Automne at the Grand Palais des Champs Elysées, Paris (October 18 - November 25, 1905). Miscellaneous art exhibition catalog collection, 1915-1925, Archives of American Art, Smithsonian Institution, Washington, D.C.

Plate 271
Alice Toklas, San Francisco, ca. 1905. Photograph by Arnold Genthe. Department of Nineteenth-Century, Modern, and Contemporary Art, The Metropolitan Museum of Art, New York, gift of Edward Burns, 2011

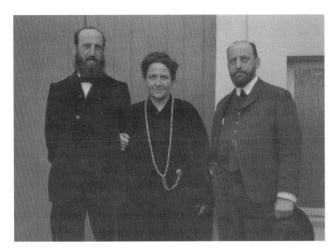

Plate 272

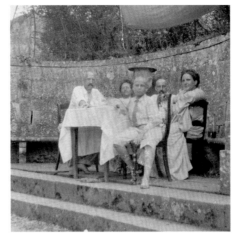

Plate 273

"the most hospitable people in the world."[17]

1907
Leo and Gertrude purchase Matisse's *Blue Nude: Memory of Biskra* (1907; pl. 27, cat. 139) from the Salon des Indépendants (March 20 – April 30).

Matisse and his wife travel to Italy in July and visit Leo and Gertrude at Casa Ricci in Fiesole.

While traveling with Harriet Lane Levy (1867-1950), a childhood friend of Sarah's from San Francisco, Alice Toklas meets Gertrude on September 9, her first day in Paris, and is "very much impressed… with [Gertrude's] certain physical beauty and enormous power… her presence and her wonderful eyes and incredibly beautiful voice."[18] Alice and Harriet take French lessons from Fernande Olivier, Picasso's companion.

In the fall, Gertrude and Leo see Picasso's large new canvas *The Bordello*, later retitled *Les Demoiselles d'Avignon* (1907; Museum of Modern Art, New York). They will purchase related studies (pls. 208-17, cat. 363-75).

The fifth Salon d'Automne (October 1-21) includes Vallotton's portrait *Gertrude Stein* (1907; pl. 206, cat. 441). Sarah and Michael purchase Matisse's *Red Madras Headdress* (1907; pl. 95, cat. 144) and *Le Luxe I* (1907; pl. 101, cat. 142), both in that year's Salon d'Automne.

1908
With Sarah's encouragement Matisse begins teaching an art class at the convent of Les Oiseaux on rue de Sèvres in Paris. The Académie Matisse opens in January with a group of about ten students, including Sarah, Hans Purrmann (1880-1966), Max Weber (1881-1961), and Annette Rosenshine, who would recall that "the students in the Matisse class were deadly serious and worked at a white heat…. On the days that Matisse would appear for criticism, the anxiety and tension were at a breaking point."[19]

The American photographer Edward Steichen, whom Sarah had introduced to Matisse the previous year, organizes Matisse's first exhibition in the United States, a watercolor show held April 6-25 at photographer Alfred Stieglitz's famed Little Galleries of the Photo-Secession at 291 Fifth Avenue in New York. After the opening, Michael writes to Gertrude: "Steichen told us they have a new game in swell N.Y. society…. They call it *Matisse*. Each guest is given some water colors and paper and they compete to see who can make the most bizarre arrangement."[20]

Michael and Sarah attend the May 16 Druet auction at Hôtel Drouot, where they purchase three works by Matisse, including *Still Life with Chocolate Pot* (1900-1902; pl. 133, cat. 104) and *Pont Saint-Michel* (1901-2; pl. 132, cat. 105). Michael writes to Leo and Gertrude: "The Matisses brought good prices except those we wanted, which naturally were the least popular."[21]

Before joining the family at Villa Bardi in Fiesole, Michael writes Gertrude that Druet's photographers "took the Bonheur [*Joy of Life*] out into the yard and photographed it and also took a colored plate and they also took the new Renoir nude…. I have also brought the Cézanne portrait here. The Vallotton portrait is back from Munich & we hung that also."[22]

Plate 274

Plate 275

After Annette Rosenshine returns to San Francisco in June, Gertrude hires Alice as her secretary. Rosenshine would later write, "Alice stepped into Gertrude's life when Leo failed to give Gertrude his support in her literary ambition."[23]

Among the works that the Steins lend to the sixth Salon d'Automne at the Grand Palais (October 1 – November 8) are Matisse's *Olive Trees at Collioure* (ca. 1906; pl. 59, cat. 134); *Blue Still Life* (1907; cat. 140); and *Pink Onions* (1906-7; pl. 117, cat. 138). Sarah buys at least one additional Matisse from the exhibition: *Sculpture and Persian Vase* (1908; pl. 151, cat. 146). Painter Morton Livingston Schamberg (1881-1918), who visited the Salon d'Automne three times, observes: "I am inclined to consider [Matisse's work] a very personal art rather than the part of a great movement.… The art doctrines evolved by the Steins (damn nice people…) and that outfit are to me the most awful nonsense. I think they as others have been completely upset by Matisse."[24]

1909

Gertrude's book *Three Lives* is published by the Grafton Press in New York. She later said that she had written it while under the spell of Cézanne's *Madame Cézanne with a Fan*: "Cézanne conceived the idea that in composition one thing was as important as another thing… it impressed me so much that I began to write *Three Lives* under this influence and this idea of composition."[25]

Gertrude and Leo purchase Picasso's *Three Women* (1908; pl. 186, cat. 251) from the artist soon after its completion. The painting would hang in the Steins' salon on rue de Fleurus until 1913.

Bernheim-Jeune acquires Matisse's *Tree or Landscape (Corsica)* (1898; cat. 94) from Leo and Gertrude on February 6, and they purchase Renoir's *Pears* (ca. 1890; cat. 399) from Bernheim-Jeune.

The Russian artist Lyubov Popova (1889-1924) requests permission to visit the Steins' collection on May 7 after learning of it from art collector Sergei Shchukin (1854-1936).

Picasso gives Gertrude his *Homage to Gertrude Stein* (1909; pl. 192, cat. 255), a painting that she would later affix to the ceiling above her bed.

Leo both lends to and purchases heavily from Elie Nadelman's (1882-1946) Druet exhibition (April 26 – May 8), which receives a great deal of attention. Gertrude would write in her 1909 notebooks that Nadelman had "a finicky choking sense of beauty. A profound sensitiveness to lyrical beauty."[26]

Leo and Gertrude purchase three works executed by Picasso during his summer sojourn in Horta de Ebro: *Head of a Woman (Fernande)* (1909; pl. 228, cat. 258); *The Reservoir, Horta de Ebro* (1909; pl. 229, cat. 256); and *Houses on a Hill, Horta de Ebro* (1909; pl. 230, cat. 257). Gertrude, who had Picasso's photographs of the Horta de Ebro landscape, would recall her response to critics of the paintings: "When people said that the few cubes in the landscapes looked like nothing but cubes, Gertrude Stein would laugh and say, if you had objected to these landscapes as being too realistic there would be some point in your objection."[27]

American writer Alice Woods Ullman (1870-1959) thanks Gertrude for a visit: "We had a very nice time chez vous yesterday.… But your pictures 'horrors!' …I like the nude on the white sheet

[Vallotton's *Reclining Nude on a Yellow Cushion* (1904; pl. 10, cat. 438)], and I saw the colour in the Matisse things, but the Spaniard's things mmm—I'm sure I do not at all know what."[28]

1910
Bernheim-Jeune holds a Matisse exhibition (February 14-22), to which the Steins lend heavily: of the sixty-five paintings on view, eighteen belong to Sarah and Michael, and seven to Leo and Gertrude, who also lend two drawings.

Parisian art dealers are aware of Leo's great interest in paintings by Renoir. When Sarah and Michael see an unfinished and very expensive Renoir nude at Bernheim-Jeune in May, Michael writes to Gertrude and Leo: "I told Fénéon [the dealer] that I was glad Leo had left for Florence, so that I would not have any financial problem to face. Price 25,000 fr. …Fénéon said he would gladly send the Renoir to Florence on approbation and I told him not on your life!!!!"[29]

William James writes to Gertrude: "How is the wonderful Matisse and his associates? Does he continue to *wear*?"[30]

Sarah, Michael, and Allan return to San Francisco on July 16 to be with Sarah's father, who is suffering from cancer. He dies on November 10. While in California, Michael decides to "sell all the Real Estate and in fact clean up…the houses have been a gold mine."[31] Harriet Lane Levy, Alice's roommate on rue Notre-Dame-des-Champs, returns to San Francisco as well, bringing with her some Picasso works on paper and the Matisse painting she bought at Michael's urging, *The Girl with Green Eyes* (1908; pl. 94). After Levy's departure, Gertrude invites Alice to live at 27 rue de Fleurus.

On October 29 Michael writes to Gertrude and Leo, warning them to keep their spending in check: "you folks don't want to be too lavish…because it will be rather a hard winter financially."[32] Sarah and Michael decide to stay in California over the winter, and ultimately through the following summer, to get their affairs in order.

1911
Picasso writes to Henri-Pierre Roché on April 7 asking for help with the translation of Gertrude's word portrait of him. Wishing to facilitate a meeting, he

writes, "Tomorrow we are going to the Cirque Medrano and Gertrude Stein will be with us."[33]

On September 9, Sarah, Michael, and Allan sail from New York, returning to Paris after more than a year in California.

In the fall, Gertrude finishes her 925-page novel *The Making of Americans*, her most ambitious and dense work.

1912
Sarah formally registers as a member of the First Church of Christian Science in Paris on January 4. It is through the church, in which she has already been involved for several years, that she meets and becomes close friends with Gabrielle Colaço-Osorio (1882-1961), the wealthy wife of French politician Anatole de Monzie (1876-1947). Gabrielle, Sarah, and Michael will later share a home.

On February 12, the Italian futurist artist Gino Severini (1883-1966) requests permission to visit rue de Fleurus with his colleague Umberto Boccioni (1882-1916) the following morning.[34]

Leo leaves for London in February out of a "desire for splendid isolation…to get

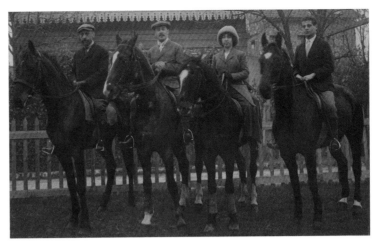

Plate 276

away even from familiar streets, museums, everything."[35] An undated letter to Gertrude reveals his frustration and the rising tension between the siblings: "I dislike…all forms of homosexuality so it must be understood that except when I am away from the house or gone to bed, you and Alice except when you are in one of your rooms, must be as Browning has it, 'of friends the nearest.' It is not sufficient for example that I should be upstairs in my rooms & that you should be on the piazza because I don't want to have the sensations either of a prisoner or a trespasser."[36]

While Leo is away in London, Gertrude makes her first major independent purchase: Picasso's *The Architect's Table* (1912; pl. 197, cat. 260), which features a painted version of Gertrude's calling card in the lower right corner.

Gertrude and Alice travel in Spain for several months beginning in May; Michael, Sarah, and Allan arrive at the Villa La Falaise in Brittany in June; Leo spends part of the summer in Fiesole.

Leo purchases two canvases by Renoir from Bernheim-Jeune on June 27 (cat. 393,

394). On August 29, Leo reports to Gertrude that "all the Renoirs & Cézannes, the Manet & Daumier [at rue de Fleurus] have been cleaned and varnished. I never had seen what the Cézanne landscape was like until it was cleaned. The light yellows & the sky have become something entirely different."[37]

Stieglitz publishes Gertrude's 1909 word portraits "Picasso" and "Matisse" in the August issue of *Camera Work*, his quarterly magazine devoted to photography and the activities of the New York gallery now known as 291. Gertrude would later say (inaccurately) that Stieglitz "was the first one that ever printed anything that I had done. And you can imagine what that meant to me or to any one."[38]

The Steins lend Matisse's *La Coiffure* (1907; pl. 19, cat. 141) and *Red Madras Headdress* to the *Second Post-Impressionist Exhibition* (October 5 – December 31), organized by Roger Fry at the Grafton Galleries in London.

Albert C. Barnes, an American inventor and art collector, meets Leo and Gertrude at rue de Fleurus on December 9.

1913

The Steins' Saturday salons continue to attract many visitors, including American expatriate artists. After attending one on January 4, Sylvia Salinger, a niece of Harriet Levy's living in Paris, writes: "Saturday night was the most interesting gathering I have seen so far at the Steins. Such a mixture I have never seen. There was one woman from Australia, who paints—a man from England…, a couple of young English boys—about twenty I think…, a man who is a sort of globetrotter…. He and I *discussed* Matisse."[39]

In a series of letters to Mabel Weeks, Leo describes his growing rift with Gertrude: "I have come to the end of something and perhaps the beginning of something else," he writes on February 4. "The presence of Alice was a godsend as it enabled the thing to happen without any explosion. As we have come to maturity we have come to find that there is practically nothing under the heavens that we don't either disagree about or at least regard with different sympathies."[40]

The International Exhibition of Modern Art, popularly known as the Armory

Plate 276
Michael Stein, Max Rosenberg, Sylvia Salinger, and Allan Stein on horseback, Robinson, France, ca. 1912–13.
Albert S. Bennett, New York

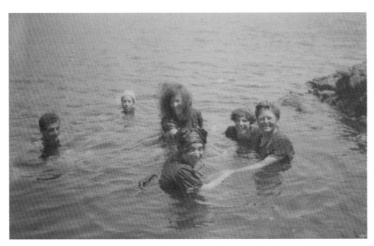

Plate 277

Show, opens in New York (February 17 - March 15). Among the Matisse works lent by the Steins are *Blue Nude: Memory of Biskra*, *Red Madras Headdress*, and *La Coiffure*. Although no Matisse or Picasso paintings are sold in New York, Albert Barnes describes the exhibition to Leo as "the sensation of the generation. Academic art received a blow from which it will never entirely recover."[41]

Pleased with the success of his first Matisse exhibition, held May 1-10 in Berlin, gallerist Fritz Gurlitt begins planning a second solo show, to which Sarah and Michael will lend many works.

Gertrude meets the American writer and photographer Carl Van Vechten (1880-1964), who will later become her literary executor.

Michael and Sarah spend the summer in the South of France at Agay, and Gertrude and Alice return to Spain. Leo rents the Villa di Doccia near Settignano, Italy, in July and in the fall announces his plans to live there permanently. "I was also very pleased that you do not object to your brother's migrating to Italy—and I very much hope you will sometimes come to visit him at the Villa

di Doccia," Gertrude's friend Florence Blood writes on October 11.[42] Gertrude believes that Leo's departure means that she and Alice will have to move.

Gertrude and Leo exchange notes regarding the division of their art collection. "This letter," begins one note from Leo, "which is necessarily of a certain volume was written in a state of cheerful calm & will not to the best of my intent & belief trouble any digestion."[43] At this time both Leo and Gertrude begin to sell certain pictures: on October 17, the dealer and gallery owner Daniel-Henry Kahnweiler agrees to acquire three Picassos from Gertrude—*Young Acrobat on a Ball* (1905; pl. 70, cat. 234), *Nude with a Towel* (1907; pl. 184, cat. 242), and *Three Women*—in exchange for *Man with a Guitar* (1913; pl. 234, cat. 264) and cash.

1914
News of changes to Leo and Gertrude's household continues to reach friends. "Mike wrote me that Leo is going to Italy to live and that you will probably take another apartment," writes Gertrude's friend Hortense Moses on January 1. "It will be hard to think of you anywhere

else than in that wonderfully attractive studio."[44] Claribel Cone receives a letter on January 12 in which Gertrude explains: "we have at last found what we wanted, an apartment on the balcony floor of the Palais Royal, 4, windows on the garden and we are very happy. We don't move until the middle of July."[45]

Leo informs Matisse that he is actively acquiring works by Renoir. In order to fund these purchases, he is selling works by El Greco, Picasso, and even Matisse.

The British author Clive Bell (1881-1964) confirms a visit with Gertrude, writing that he will be accompanied by the Irish artist Roderick O'Conor (1860-1940), "a remarkable person whom you will like, I think. He was a friend of Gauguin and has half a dozen of his pictures—in fact he, too, has a very interesting collection."[46]

Barnes writes Leo on February 9 after learning that Leo is selling paintings before moving to Italy: "Why, oh why, didn't you give me first chance at buying your early Picassos?…you can probably do better with me than with the dealers… but what the Hell do you care about money?"[47]

Plate 277
Allan Stein, Sylvia Salinger, Theresa Ehrman, Rachael Miller, Harriet Lane Levy, and Sarah Stein swimming at Agay, France, 1913. Albert S. Bennett, New York

Plate 278

Plate 279

Gertrude's *Tender Buttons*, a volume of prose poems, is published in London in June.

Leo leaves Paris on April 3 for the Villa di Doccia. "I'm going to Florence a simple minded person of the 'Old School' without a single Picasso hardly any Matisses only 2 Cezanne paintings and some aquarelles and 16 Renoirs," he tells Mabel Weeks on April 2. "Rather an amusing baggage for a leader in the great modern fight. But que voulez vous. The fight is already won and lost."[48] Leo's partner, Eugénie "Nina" Auzias (1882–1949), a Parisian artist's model with whom he has been involved for several years, plans to join him in August.

Gertrude and Alice decide not to move and instead renovate 27 rue de Fleurus, installing electricity, a fireplace, and a small portico linking the atelier to the rest of the apartment. The work is completed by June. Alice would later say: "Gertrude made a complete break. I don't know what Leo did, because I never saw him. No, she didn't want to hear about him."[49]

In June and July, Gertrude acquires her first paintings by Juan Gris (1887–1927),

whom she has known since around 1910, from Galerie Kahnweiler: *Glasses on a Table* (1913–14; pl. 241, cat. 67), *Book and Glasses* (1914; pl. 242, cat. 68), *Flowers* (1914; pl. 189, cat. 69), and *Glass of Beer and Playing Cards* (1913; cat. 66).

Germany declares war on France on August 3. Sarah, Michael, and Allan, in the South of France at the time, learn that the nineteen paintings that they had lent to a Matisse exhibition held the previous month at the Kunstsalon Fritz Gurlitt in Berlin have been confiscated. Many of the pictures are sold to Scandinavian collectors Christian Tetzen-Lund and Tryggve Sagen when the United States enters the war in 1917. For much of the war Sarah and Michael remain in the South of France; during this time Allan eventually completes his studies and serves in the U.S. Army. Gertrude and Alice are in London when the war begins and return to Paris in mid-October.

André Derain's wife, Alice, inquires on October 23 if Gertrude will buy a Picasso painting from her during a period of

financial hardship: "It would be a big help to me because André doesn't have a cent and it is impossible for me to send him any money."[50]

Picasso paints *Apple* (1914; pl. 238, cat. 382) for Gertrude in December, as a consolation for her having to part with Cézanne's *Five Apples* (1877–78; pl. 49, cat. 7) when she and Leo divided their collection the previous year. At the time Leo had written, "The Cézanne apples have a unique importance to me that nothing can replace…and I'm afraid you'll have to look upon the loss of the apples as an act of God."[51]

1915

Gertrude sells Matisse's *Woman with a Hat* to Sarah and Michael in February for $4,000.

In March, Gertrude and Alice travel to Mallorca, Spain, where they rent a house for a year.

Leo sails from Genoa to the United States on April 27. Unable to obtain a return passport during the war, he travels, visits family, and on the recommendation of Mabel Weeks, moves to Taos, New Mexico, where he buys a small house in

Plate 278
Gertrude Stein and Alice Toklas in the courtyard at 27 rue de Fleurus, Paris, ca. 1914. Department of Nineteenth-Century, Modern, and Contemporary Art, The Metropolitan Museum of Art, New York, gift of Edward Burns, 2011

Plate 279
Leo Stein, n.d. Yale Collection of American Literature, Beinecke Rare Book and Manuscript Library, Yale University, New Haven

Plate 280

the summer of 1918 and studies the Pueblo Indians. It is probably at this time that he begins acquiring Native American art, some of which is now in the collection of the Museum of the American Indian.

On October 16, Gertrude's poem "M. Vollard et Cézanne" is published in the *New York Sun*.

1916
Gertrude and Alice return to Paris from Spain by at least June 11. They join the war effort under the auspices of the American Fund for French Wounded, traveling the French countryside in their Ford van, "Auntie," which they acquire in early 1917 and name after Gertrude's aunt Pauline Stein. After the war, they will be awarded the Médaille de la Reconnaissance Française by the French government.

Michael gives notice for the apartment at 58 rue Madame to take effect in January. He writes to Gertrude, "Do you know anyone who would like to take [the apartment] so I could sell them all the fine new installations I made just before the war."[52]

In the fall, Matisse paints *Sarah Stein* (1916; pl. 83, cat. 152) and *Michael Stein* (1916; pl. 84, cat. 151), the only companion portraits he would ever make.

1917
Michael and Sarah return from the South of France to Paris on June 23, living at first at 58 rue Madame before moving to 14 rue de l'Assomption, Paris.

In mid-December, Matisse moves to Nice, where he will stay most of each year for the rest of his life.

1918
Michael and Sarah, who will spend much of the year in the countryside outside Paris, inform Gertrude that they have checked on the art at rue de Fleurus. They "decided that the Pavillon [*sic*] was better than that Atelier much more solid & with a joint wall against the main building. So we will put most of the pictures in the pavillon against the wall with a nail in the floor to prevent the stacks from slipping. The Cézanne portrait I took out of the frame and put in the clothes closet in the library as that closet is built into the wall and is so to speak a part of the wall."[53]

Sarah and Michael return to Paris by early October and soon move into a furnished flat at 248 boulevard Raspail.

World War I ends with the armistice on November 11.

1919
Anticipating Gertrude and Alice's imminent return to Paris, Michael writes on April 17: "I guess you all will be coming back soon, as I see in the papers that the AFFW [American Fund for French Wounded] goes out of business in May. Paris is more crowded than ever and the price of apartments is extraordinary."[54]

Gertrude sells two small paintings, Manet's *Ball Scene* (1873; pl. 48, cat. 81) and Cézanne's *Man with Pipe* (1896; cat. 13), to dealer Paul Rosenberg for 20,000 francs on October 15.

Finally able to get his passport reissued, Leo returns to Settignano, sailing on November 11.

Leo sells Matisse's *Le Bonheur de vivre* to Bernheim-Jeune.

Plate 280
Alice Toklas and Gertrude Stein in their Ford van, working for the American Fund for French Wounded, ca. 1917. Department of Nineteenth-Century, Modern, and Contemporary Art, The Metropolitan Museum of Art, New York, gift of Edward Burns, 2011

Plate 281

Plate 282

Plate 283

1920

While visiting in Paris in early spring, Leo stops in at 27 rue de Fleurus. Annette Rosenshine would recall that "shortly before he died, [Leo] wrote to me, 'Gertrude I never saw her after 1920. It was she who avoided me. When we might have passed each other in Paris she and Alice crossed the street.'"[55]

1921

Jacques Lipchitz (1891–1973) invites Gertrude and Alice to visit him on January 27. "I would like to show you my latest sculpture and to know your opinion, which is valuable to me."[56]

The birth of Picasso's son Paulo on February 4 provides occasion for the reconciliation of Gertrude and Picasso, who had evidently not been corresponding for a year or more. "Oh hell, let's be friends," Picasso says to Gertrude, ending their silence.[57] Gertrude implies that the estrangement may have been prompted by Picasso's resentment of Gertrude's support of Gris.[58]

Leo and Nina Auzias are married in February. They divide their time between the Villino Rosso in Settignano and 42 rue du Parc Montsouris, Paris.

Gertrude purchases Gris's *The Table in Front of the Window* (1921; pl. 244, cat. 70) from Galerie Simon on June 8. In 1924 she will buy his *Woman with Clasped Hands* (1924; pl. 246, cat. 71), and in 1926 she will purchase *Dish of Pears* (1926; cat. 73).

Needing money, Leo asks Barnes to help him sell paintings that he left in storage in New York. "Do about them whatever you think most advisable.… Perhaps I shall get a lot of money for the Renoirs."[59] Barnes tells him that he cannot find any buyers and purchases much of the work himself. Later that year, Leo sells his last Cézanne to the Durand-Ruel gallery.

1922

Gertrude meets André Masson and becomes a friend of Ernest Hemingway. In 1925 Hemingway will introduce her to F. Scott Fitzgerald.

By August 27 Michael and Sarah are living at 59 rue de la Tour, Paris, with Gabrielle Colaço-Osorio, now separated from her husband.

Michael facilitates a shipment of seven cases of art—containing mostly works by Favre and Matisse—belonging to Etta

and Claribel Cone, sending them on the steamer *Sonorah* from France to Baltimore on November 21.

Jo Davidson (1883–1952), a sculptor and close friend of Gertrude and Alice, completes his Buddha-like portrait, *Gertrude Stein* (1920–22; pl. 254). He would later explain that "to do a head of Gertrude was not enough—there was so much more to her than that."[60]

1923

Gertrude purchases three Masson paintings from Galerie Simon between February and June: *The Meal* (1922; pl. 247, cat. 85); *The Cardplayers* (1923; cat. 87), and *The Snack* (1922–23; cat. 86). She is one of the artist's first clients and the first American to buy his work. After seeing *The Meal* at Gertrude's home, Ernest Hemingway buys Masson's *The Throw of the Dice* (ca. 1920; John F. Kennedy Presidential Library and Museum, Boston) in May.

Allan Stein announces his engagement to Iona (Yvonne) Rochefort Daunt (1899–1962), a dancer with the Paris Opéra, "suddenly and informally one evening while I was there," writes Claribel to Etta Cone on August 13. "Sallie [Sarah]

Plate 281
Claribel Cone, Etta Cone, Jacqueline Colaço-Osorio, Michael Stein, and Gabrielle Colaço-Osorio, 59 rue de la Tour, Paris, ca. 1923. David and Barbara Block family archives

Plate 282
Jo Davidson at work on his sculpture of Gertrude Stein, Paris, ca. 1922. Photograph by Man Ray. Yale Collection of American Literature, Beinecke Rare Book and Manuscript Library, Yale University, New Haven

Plate 283
Yvonne Daunt Stein, Paris, ca. 1925. Photograph by Bert-Sabourin. David and Barbara Block family archives

Plate 284

was as surprised as anyone.... Sallie is so afraid however that it won't last."[61] The wedding takes place in Paris on April 24, 1924.

Matisse's daughter, Marguerite, is married to Georges Duthuit in Paris on December 10. Michael writes to Etta Cone, "Gabrielle [Colaço-Osorio], Sally and I were the only people at the luncheon at Laperousse's [sic] except the family and the witnesses."[62]

1924

Gertrude lends three Masson paintings purchased the previous year to a solo exhibition of the artist's work at Galerie Simon in February and buys a work on paper from the show.[63]

In March, Kahnweiler begins planning the publication of Gertrude's *A Birthday Book*, written for Picasso's son Paulo. Picasso never finishes the engravings that are to be used as illustrations, and the project is never realized.

En route to the French Riviera in August, with plans to visit Picasso, Gertrude and Alice stop at the Hotel Pernollet in Belley, in the Rhone Valley, and decide to stay there instead. They remain until October and return to the area for the next four summers.

1925

At Gertrude's request, Michael and Sarah arrange to sell some of her paintings to the Cones. On June 6, Michael writes Alice: "The Cones came last night and Sally at once got busy for Gertrude. She has sold 9,000 francs worth without the Favre pictures. Pretty snifty as Allan would say. I also spoke to them about the [Marie] Laurencin and they seem interested." On June 14 he reports: "The Laurencin is sold for 10,000 and they are going to look at the Favres next week. So far you have 19,000." Two days later: "The Favres are sold for 2,000 fr. altogether = 21,000."[64]

Gertrude introduces Le Corbusier to Anatole de Monzie, the French minister of education and fine arts, who will inaugurate Le Corbusier's controversial Pavillon de l'Esprit Nouveau (Pavilion of the New Spirit) at the International Exposition of Modern Decorative and Industrial Arts in Paris in July.

Sarah and Michael acquire the monumental Matisse painting *Tea* (1919; pl. 99, cat. 155) from Bernheim-Jeune on August 13. Years later, Sarah would explain how she successfully acquired the painting ahead of another interested client, who, according to a friend, "made the condition he would only take it if Matisse would change the face of the woman on the right to a conventional form. So [Sarah] grabbed it as it was."[65]

Gris inscribes his *Ship's Deck (Boat Deck)* (1924; cat. 76) to Gertrude and begins a series of sketches for textiles that Alice will use to upholster two chairs for the rue de Fleurus apartment.

Gertrude's *The Making of Americans* is published in Paris by Contact Editions; parts of it were printed the previous year in Ford Madox Ford's *Transatlantic Review*.

At the Salon d'Automne (September 17–November 2), Gertrude discovers the work of Pavel Tchelitchew (1898–1957), a Russian painter who had moved to Paris in 1923 to work with the Ballets Russes. She acquires his portrait of René Crevel (1925; pl. 190, cat. 433) and over the next few years develops a friendship with the artist. Tchelitchew will paint several portraits of Gertrude and Alice, and

Plate 284
Alice Toklas, Pavel Tchelitchew, and Gertrude Stein, France, ca. 1926. Yale Collection of American Literature, Beinecke Rare Book and Manuscript Library, Yale University, New Haven

Plate 285

Plate 286

Gertrude will publish a written portrait of the artist in *Dix Portraits* (1930).

1926
On May 7, Sarah and Michael, along with Gabrielle Colaço-Osorio, commission Le Corbusier to design a home for them in Vaucresson, about ten miles outside Paris.

Gertrude lectures in Cambridge (June 4) and Oxford (June 7).

Around this time, following the example of the Duchess of Clermont-Tonnerre (born Elisabeth de Gramont, 1875–1954), a writer and visitor to rue de Fleurus, Alice cuts Gertrude's hair in what would become Gertrude's signature style.

In December, Galerie Simon publishes Gertrude's text *A Book Concluding with As a Wife Has a Cow a Love Story*, accompanied by four lithographs by Gris (pl. 243).

1927
Concerning her own growing fame, Gertrude writes to Etta Cone on January 1, "I am getting to be a bigger lion and even I am beginning to think I must have had about enough but it is nice, I can't say I don't like it."[66]

Juan Gris's death on May 11 leaves Gertrude "heart broken."[67] In "The Life and Death of Juan Gris," her memorial portrait of the artist, published in *Transition* in July, she writes: "And this being so and it is so Juan Gris was a brother and comrade to every one being one as no one ever had been one. That is the proportion. One to any one number of millions."[68]

Leo travels to Vienna in May to visit a specialist for his deteriorating hearing.

Leo's book *The A-B-C of Aesthetics* is published by Boni and Liveright in New York.

Daniel Michael Stein (1927–2008), Sarah and Michael's grandson, is born to Allan and Yvonne on August 27.

As construction continues on their Le Corbusier villa, Les Terrasses, Michael writes to Etta Cone, "I have to simply live out at Garches now that the house is nearing completion and at night I am completely tired out."[69]

1928
Michael and Sarah move into Les Terrasses with Gabrielle and her daughter, Jacqueline, in the spring. The

ultramodern home has both shared and private living spaces for the two families.

A posthumous Juan Gris retrospective at Galerie Simon, Paris, June 4–16, includes four paintings lent by Gertrude.

1929
Leo presents a series of twelve lectures at New York's New School for Social Research from January through March. While in New York, he promotes the paintings of his friend Othone (Otakar) Coubine (1883–1969), arranging for the sale of two works.

In February, Gertrude and Alice adopt their first dog, the poodle Basket (I),[70] just before signing a summer lease on "the house of [their] dreams"[71] in Bilignin, France. They will return to the house every year for more than a decade.

American artist Stuart Davis (1892–1964) writes to Gertrude on June 1, asking "for favors. Elliot Paul told me that you were interested in one of my paintings, *Egg Beater*, and that you would buy it. I would consider it an honor to be in your collection and in addition to that my finances are missing on all cylinders [*sic*].

Plate 285
Yvonne Daunt Stein and Daniel Stein, 1927 or 1928. Estate of Daniel M. Stein

Plate 286
Leo Stein and Nina Auzias, Settignano, Italy, 1928. Department of Nineteenth-Century, Modern, and Contemporary Art, The Metropolitan Museum of Art, New York, gift of Edward Burns, 2011

Plate 287

Plate 288

Therefore I would like you to have the painting in question for your own price."[72]

Leo suffers serious financial losses as a result of the October stock market crash.

1930
In January, Gertrude and Alice publish *Lucy Church Amiably*, the first of Gertrude's books to be issued by their own imprint, The Plain Edition. Seeing her books in store windows gives Gertrude "a childish delight amounting almost to ecstasy."[73]

On his way to Tahiti, Matisse travels to the United States for the first time, arriving in New York on March 4. He goes on to visit Chicago, Los Angeles, and San Francisco.

Matisse visits Michael and Sarah at Les Terrasses on October 19.

Around this time, Allan and Yvonne are divorced; their son Daniel goes to live with Michael and Sarah at Les Terrasses; and Allan marries an Armenian woman, Roubina Alexanian (1909–2000).[74]

1932
In June, Francis Picabia (1879–1953), an artist with whom Gertrude has become

very close and for whom she would write many exhibition catalogue introductions, gives Gertrude and Alice a Mexican Chihuahua named Byron. When Byron dies the following spring, he is succeeded by a Chihuahua named Pépé, another gift from Picabia in May 1933. Pépé lives until around 1943.

Artist Louis Marcoussis (1878–1941), who met Gertrude and Alice many years earlier, begins making several drypoint portraits of the two women around this time.

1933
Gertrude's book *The Autobiography of Alice B. Toklas*, written over the course of six weeks at Bilignin in 1932 and excerpted in four issues of the *Atlantic Monthly* between May and August 1933, is published by Harcourt, Brace, New York, in the fall. The book becomes a surprise best seller and is a Book of the Month Club selection, although the fallout from it among artists and collectors is considerable. "Picasso and Matisse each told me what a damned liar [Gertrude] is, and I also put her down the same way for what she said about me in the book," Barnes writes Leo in late 1934. "Your explanation is better than theirs or mine—she

is so far away from reality that she doesn't know romance from history. She is meat for the newspapers here and nearly always with ridicule played to the limit."[75] In early 1935 the French historian and Gertrude's close friend Bernard Faÿ writes to Gertrude: "A gallant crusade made up of [Maria] Jolas, [Eugene] Jolas, [Tristan] Tzara, [André] Salmon, [Georges] Braque, and [Henri] Matisse, have published a special edition of 'Transition' to fight us. It's nice of the Jolases to spend whatever is left of their money and brains to advertise for us. These ladies and gentlemen are accusing you not to understand painting and me not to understand French. Coming from such great and clear minds, it's pretty good. I am not planning to answer. But it makes a good noise and it's lots of fun."[76]

1934
Four Saints in Three Acts, Virgil Thomson's opera based on Gertrude's text, debuts on February 8 at the Wadsworth Atheneum in Hartford, Connecticut, where Picasso's first American retrospective had opened two days earlier. Produced by John Houseman, designed

Plate 287
Dust jacket of the first edition of Gertrude Stein's *Autobiography of Alice B. Toklas* (New York: Harcourt, Brace, 1933), featuring a photograph by Man Ray. General Research Division, The New York Public Library, Astor, Lenox and Tilden Foundations

Plate 288
Francis Strain, *Four Saints in Three Acts*, 1934. Oil on canvas, 36 x 30 in. (91.4 x 76.2 cm). Courtesy Michael Rosenfeld Gallery, LLC, New York

Plate 289

Plate 290

Plate 291

by Florine Stettheimer, and choreographed by Frederick Ashton, the opera has its Broadway premiere at the 44th Street Theatre on February 20.

Gertrude lends a suite of fourteen paintings by the English aristocrat Francis Rose (1909-1979), an artist who has become a close friend of hers, to an exhibition of his work at the Marie Harriman Gallery in New York, December 7-29.

Gertrude and Alice arrive in New York on October 24 for an extended visit and lecture tour lasting until May 4, 1935. Their itinerary includes stops in Virginia, New York, and Chicago (where they see Thornton Wilder [1897-1975]), as well as a homecoming to Oakland. Eleanor Roosevelt hosts a tea reception at the White House on December 30. Random House publishes Gertrude's *Lectures in America* in 1935.

1935
In February, Michael writes to Gertrude regarding her limited funds: "You have not made a declaration [for income tax] for years because you did not have enough income above your personal exemption…you were living on capital by selling paintings which you owned."[77]

Sarah, Michael, their grandson Daniel, Gabrielle, and her daughter, Jacqueline, move to America after selling their Le Corbusier-designed home, Les Terrasses, sailing from France on July 6 and arriving in San Francisco on July 21. They live together at 433 Kingsley Avenue in Palo Alto, where Sarah hosts faculty and students from Stanford University and art enthusiasts. She continues her correspondence with Matisse.

1936
Grace McCann Morley, director of the San Francisco Museum of Art, organizes *Paintings, Drawings, and Sculpture by Henri Matisse* (January 11-February 24), an exhibition including twelve paintings and sculptures from Michael and Sarah's collection—among them *Woman with a Hat*—and eight works belonging to Harriet Lane Levy.

On February 8 Gertrude and Alice fly to England, where Gertrude delivers lectures at Cambridge and Oxford.

Random House publishes *The Geographical History of America*, Gertrude's musings on human nature and ideas about theater.

Cecil Beaton (1904-1980), a British photographer and friend of Gertrude and Alice, takes a series of photographs of the two women at his studio.

1937
Leo learns that Etta Cone has purchased a Delacroix once in his collection (*Perseus and Andromeda,* 1847; cat. 60). "That little thing of his did for me, outwear everything else I had. I consider Delacroix to be the one genuinely great painter since Rubens."[78]

Gertrude publishes *Everybody's Autobiography,* her second autobiography, with Random House.

Gertrude lends work to a solo exhibition of Picabia's work at Galerie de Beaune, Paris, November 19-December 2.

Gertrude informs Yale University on November 23 that she is happy to deposit the handwritten manuscripts of her work in its archives "for safe-keeping, available to such persons as may wish to study them,"[79] and sends them to Yale via Thornton Wilder.

Gertrude recommends Pierre Tal-Coat (1905-1985), a painter who has recently made several portraits of her, for an exhibition at the Arts Club of Chicago.

Plate 289
Alice Toklas and Gertrude Stein arrive in New York, 1934. Photograph by Carl Van Vechten. Yale Collection of American Literature, Beinecke Rare Book and Manuscript Library, Yale University, New Haven

Plates 290-91
Sarah, Daniel, and Michael Stein's passports, stamped on their return to United States, July 13, 1935. Estate of Daniel M. Stein

1938

After their landlord reclaims their apartment, Gertrude and Alice move from rue de Fleurus into a sunny flat at 5 rue Christine in the sixth arrondissement by early February. Janet Flanner (1892–1978), an American journalist and friend, thought "the move was a good thing, since the moving men had to count up for Miss Stein what she had never bothered to inventory."[80]

Tchelitchew completes *Phenomena* (1938), a major work that he gives to the Tretiakov Gallery. In the painting, Tchelitchew depicts Gertrude and Alice—with whom he had fallen out in 1928—as two grotesque figures incarnating evil.

Thanking Gertrude for sending the French version of her book *Picasso*, published that year, Michael writes on April 14: "It is fine and would sell like hotcakes in America in an English edition. I am getting along fine and everybody says I look better than I have for a long time."[81] On September 9, Michael dies of cancer at age seventy-three.

Shortly after Michael's death, Allan and Roubina travel to the United States to see Sarah. On October 7 Allan writes to Gertrude from Palo Alto: "We are with Sarah. She is doing as well as can be expected. We are giving her what little help we can. She has tried to write to you, but is unable to write to anyone as yet."[82]

1939

Once France and Britain declare war on Germany on September 3, Gertrude and Alice close their Paris apartment and head to Bilignin.

1940

Fleeing the war in Europe, Allan, Roubina, and their two-year-old son, Michael, move to Palo Alto in April. Their daughter, Gabrielle Rohena Stein (1940–1997), is born that year. A racehorse owner-trainer by trade, Allan continues racing horses in California until 1944, when he moves back to France with his family.

The United States Embassy sends Gertrude and Alice repeated notices advising all U.S. citizens to leave Europe. On June 14, Paris is taken by German forces.

1942

Gertrude and Alice move from Bilignin to nearby Culoz in the winter.

1944

Paris is liberated in August. In mid-December, Gertrude and Alice return home to find their rue Christine apartment and their collection of artworks intact, thanks in part to the influence of their friend Bernard Faÿ, who collaborated with the Nazis.

1945

Gertrude helps organize an exhibition of Francis Rose at Galerie Pierre Colle in Paris. O. N. Solbert, brigadier general of the U.S. Army, writes Gertrude on March 26: "I was delighted to hear you are sponsoring the first occasion on which the three countries have united in the cultural field since the German occupation."[83]

At the invitation of *Life* magazine, on June 19 Gertrude and Alice fly with American soldiers to Germany for a five-day tour.

Gertrude's third autobiography, *Wars I Have Seen*, is published by Random House.

Plate 292

Plate 293

Leo, who "hardly painted at all during the war [as] painting outside was forbidden," turns his attention to writing.[84] He and Nina, having suffered from food and coal shortages throughout the war such that "the luxury of coffee and milk and toast…[would leave them] in a state almost of exultation," decide to stay in Italy.[85]

Sarah lectures at the Stanford Gallery in Palo Alto on October 7 on the occasion of the opening of the exhibition *Modern French Painting*, to which she lends works by Matisse and Picasso.

1946
Barnes informs Leo of Picasso's growing fame in the United States: "The cult of Picasso in America has become disgusting, and the people most responsible for it are the nitwits, especially Alfred Barr, who run the Museum of Modern Art in New York," he writes on April 16. "In America at least, Matisse has taken a back seat and Picasso rides majestically in the forefront of the bandwagon."[86]

Gertrude undergoes an operation for cancer and dies at age seventy-two at the American Hospital at Neuilly on July 27. She is buried in Père Lachaise cemetery in Paris on October 22. Her headstone is designed by Francis Rose. Gertrude leaves her portrait by Picasso to the Metropolitan Museum of Art, New York, and the rest of her collection to her nephew Allan, with the stipulation that Alice is to have use of the estate until her own death.

1947
Leo's book *Appreciation: Painting, Poetry, and Prose* is published by Crown Publishers in July. Writing to his editor on July 21 concerning the positive reviews in the *New York Herald Tribune* and reporters' coverage of "highly speculative relations between Gertrude and myself," Leo says, "it would surprise… the American Public…if they knew how little I thought of Gertrude. She is in my opinion one of those fake intellectuals like Picasso who write in Jargon because they can't get enough effect with decent English."[87]

On July 29, Leo dies of complications from cancer surgery at age seventy-five.

Nina and some of Leo's friends organize a memorial exhibition of twenty-four of Leo's pictures at the Leonardo da Vinci club in Florence in November. Nina hopes they "may be able to judge from this exhibition how successful a possible exhibition in America might be."[88]

Sarah and Michael's grandson Daniel buys his first racehorse, an eleven-year-old gelding named Exploded. Daniel's gambling debts will precipitate the dispersion of Sarah's art collection: the following year, Sarah sells Matisse's *Woman with a Hat* to Mrs. Walter A. Haas.

1949
Leo's cousin Fred Stein urges Nina not to sell much of her furniture, books, and collections until she consults with a good attorney. On August 17 he writes, "I cannot believe that they are going to put you out of the house, and I don't believe that they can cramp you into one room in order that your landlord can store grain in the other room."[89] Soon after, Nina commits suicide.

Francis Rose paints *Homage to Gertrude Stein* (1949; pl. 263, cat. 431), a very large work that Alice hangs prominently in her rue Christine apartment.

Plate 292
Gertrude Stein and Basket II in the apartment at 5 rue Christine, Paris, ca. 1946. Photograph by Cecil Beaton. Department of Nineteenth-Century, Modern, and Contemporary Art, The Metropolitan Museum of Art, New York, gift of Edward Burns, 2011

Plate 293, cat. 78
Marie Laurencin, *Basket II*, **1946.** Oil on canvas, 21½ x 18½ in. (54.5 x 47 cm). Yale Collection of American Literature, Beinecke Rare Book and Manuscript Library, Yale University, New Haven

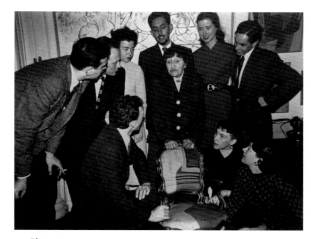

Plate 294

Plate 295

1950

By July, Sarah has moved from Palo Alto to 255 Buckingham Way, "a comfortable small apartment with a view of the ocean,"[90] in the Stonestown area of San Francisco.

1951

Allan dies on January 18 at the American Hospital in Neuilly at age fifty-five, leaving Gertrude's estate to his wife, Roubina, and his children.

1953

Sarah dies at age eighty-three in San Francisco on September 15.

1954

The Alice B. Toklas Cook Book is published and becomes famous for its hashish fudge recipe, given to Alice by a friend. Alice's second cookbook, *Aromas and Flavors of Past and Present*, is published in 1958; her memoir, *What Is Remembered*, follows in 1963.

Henri Matisse dies at age eighty-four in Nice on November 3.

1957

Alice converts to Catholicism on December 8, the Feast of the Immaculate Conception, making her confession and taking Holy Communion.

1959

"No there is [no] question of my selling any of the pictures," Alice writes to a friend on April 9. "These baseless rumours get about. I am off to the baths in Italy."[91]

1960

While Alice is away on a lengthy retreat in an Italian monastery, her landlord at rue Christine begins eviction proceedings. Around the same time, Allan Stein's heirs bring charges against Alice for selling two paintings and some drawings by Picasso in order to support herself. The Steins claim that the paintings in the apartment are neglected and unprotected, and in 1961 the collection is removed to a vault at the Chase Manhattan Bank in Paris.

1964

Alice is evicted from her rue Christine apartment and moves to 16 rue de la Convention, where she lives alone. In

December, Alice writes in a letter: "I am in the new apartment and a little lonesome for rue Christine. This is a modern house, and strangely for Paris, one is not allowed to tack anything into the walls, so the pictures have to be leaned against a piece of furniture."[92]

1967

At age eighty-nine, Alice Toklas dies in Paris on March 7 and is interred in Gertrude's tomb in Père Lachaise cemetery. In keeping with her wishes, her name is carved on the back of the headstone.

1968

A consortium of trustees of the Museum of Modern Art, New York, acquires artworks from the estate of Gertrude Stein. Two years later, the exhibition *Four Americans in Paris: The Collections of Gertrude Stein and Her Family* opens at the museum and travels to the Baltimore Museum of Art and the San Francisco Museum of Art.

Plate 294

Alice Toklas with a group of students in the apartment at 5 rue Christine, Paris, ca. 1950. Department of Nineteenth-Century, Modern, and Contemporary Art, The Metropolitan Museum of Art, New York, gift of Edward Burns, 2011

Plate 295

Installation view of *Four Americans in Paris: The Collections of Gertrude Stein and Her Family* at the Museum of Modern Art, New York (December 19, 1970–March 1, 1971). The Museum of Modern Art Archives, New York

Notes

1. Sarah Stein's middle name is inferred from many letters consulted at Baltimore Museum of Art Archives, Dr. Claribel and Miss Etta Cone Papers, in which Stein signed her letters "Sally Anne."

2. Gertrude Stein to Harriet Lane Levy, [1913], Yale Collection of American Literature, Beinecke Rare Book and Manuscript Library (hereafter, Beinecke YCAL), MSS 77, box 10, folder 134.

3. Toklas ca. 1955, 38. Date of interview in Potter 1970, 47.

4. Toklas ca. 1955, 24-25, 50.

5. Ibid., 8.

6. Ibid., 33.

7. Leo Stein to Fred Stein, December 20, 1894, Beinecke YCAL, MSS 78, box 1, folder 17.

8. Smith et al. 1994, 12.

9. Sarah Stein to Gertrude Stein, October 30, 1899, Beinecke YCAL, MSS 76, box 126, folder 2731.

10. Mary Costelloe Berenson diary, May 13, 1902, Harvard University Center for Renaissance Studies, Settignano, Italy, cited in Wineapple 1996, 168-69.

11. Annette Rosenshine Papers, 1885-1998 (bulk 1907-1971), Bancroft Library, University of California, Berkeley (hereafter, Rosenshine Papers), BANC MSS C-H 161, box 2:19.

12. Mabel Weeks to Gertrude Stein, March 14, 1905, in Gallup 1953, 27

13. See Cowling 2002, 362, for a more complete discussion of Leo and Gertrude's introduction to Picasso and the 1906 meeting of Matisse and Picasso.

14. Rosenshine Papers, BANC MSS C-H 161, box 2:15.

15. G. Stein 1990, 12.

16. Rosenshine Papers, BANC MSS C-H 161, box 3:7, 116-17.

17. Vollard 1936, 136.

18. Toklas ca. 1955, 15-16, 45.

19. Rosenshine Papers, BANC MSS C-H 161, box 3:7, 101-3.

20. Michael Stein to Gertrude Stein, undated [1908/1909?], Beinecke YCAL, MSS 76, box 125, folder 2716.

21. Undated [May 17, 1908], Beinecke YCAL, MSS 76, box 124, folder 2705.

22. Michael Stein to Gertrude Stein, May 22, 1908, Beinecke YCAL, MSS 76, box 125, folder 2716; Michael Stein to Gertrude Stein, June 1, 1908, Beinecke YCAL, MSS 76, box 125, folder 2716.

23. Rosenshine Papers, BANC MSS C-H 161, box 3:7.

24. Morton Livingston Schamberg, Paris, to Walter Pach, November 5, 1908, Walter Pach Papers, Archives of American Art, Smithsonian Institution, Washington, D.C., File: 4216: 806-7.

25. G. Stein 1971a, 15.

26. Quoted in Kirstein 1948, 192.

27. G. Stein 1990, 90.

28. Alice Woods Ullman to Gertrude Stein, December 23, 1909, cited in Gallup 1953, 48.

29. Michael Stein to Gertrude and Leo Stein, May 13, 1910, Beinecke YCAL, MSS 76, box 125, folder 2717.

30. William James to Gertrude Stein, May 25, 1910, Beinecke YCAL, MSS 76, box 112, folder 2294.

31. Michael Stein to Gertrude Stein, July 7, 1910, Beinecke YCAL, MSS 76, box 125, folder 2717.

32. Michael Stein to Gertrude Stein, October 29, 1910, Beinecke YCAL, MSS 76, box 125, folder 2717.

33. Lake and Ashton 1991, 38.

34. G. Severini to "Monsieur," February 12, 1912, Beinecke YCAL MSS 76, box 124, folder 2684.

35. Leo Stein to Gertrude Stein, [ca. 1912?], Beinecke YCAL, MSS 76, box 124, folder 2714.

36. Leo Stein to Gertrude Stein, n.d., Beinecke YCAL MS76, box 124, folder 2715.

37. Leo Stein to Gertrude Stein, August 29, 1912, Beinecke YCAL, MSS 76, box 124, folder 2713.

38. Frank et al. 1934, 280.

39. Salinger 1987, 52-53.

40. Leo Stein to Mabel Weeks, February 4, 1913, Beinecke YCAL, MSS 78, box 3, folder 55.

41. Albert Barnes to Leo Stein, March 30, 1913, Beinecke YCAL, MSS 76, box 97, folder 1839.

42. Florence Blood to Gertrude Stein, October 11, 1913, Beinecke YCAL, MSS 76, box 98, folder 1877.

43. Leo Stein to Gertrude Stein, [1913?], Beinecke YCAL, MSS 76, box 124, folder 2714.

44. Hortense Moses to Gertrude Stein, January 1, 1914, Beinecke YCAL, MSS 76, box 117, folder 2489.

45. Gertrude Stein to Claribel Cone, ca. late December 1913 [handwritten on back of envelope: "received Baltimore January 12, 1914"], Dr. Claribel and Miss Etta Cone Papers, Archives and Manuscripts Collections, The Baltimore Museum of Art (hereafter, BMA Cone Papers).

46. Clive Bell to Gertrude Stein, January 23, 1914, Beinecke YCAL, MSS 76, box 97, folder 1848.

47. Beinecke YCAL, MSS 76, box 97, folder 1839.

48. Leo Stein to Mabel Weeks, April 2, 1914 [27 rue de Fleurus stationery], Beinecke YCAL, MSS 78, box 3, folder 55.

49. Toklas ca. 1955, 115.

50. Alice Derain to Gertrude Stein, October 23, 1914, Beinecke YCAL, MSS 76, box 104, folder 2032. Cécile Debray suggests that the painting in question could have been *The Blue House* (1902; cat. 230), which was included in the spring 1914 Peau de l'Ours sale.

51. Leo Stein to Gertrude Stein, [1913?], Beinecke YCAL, MSS 76, box 124, folder 2714.

52. Michael Stein to Gertrude Stein, August 6, 1916, Beinecke YCAL, MSS 76, box 125, folder 2719.

53. Michael Stein to Gertrude Stein, April 12 [1918], Beinecke YCAL, MSS 76, box 125, folder 2721.

54. Michael Stein to Gertrude Stein, April 17, 1919, Beinecke YCAL, MSS 76, box 125, folder 2721.

55. Rosenshine Papers, BANC MSS C-H 161, box 3:7, 91-92.

56. Jacques Lipchitz to Gertrude Stein, January 25, 1921, Beinecke YCAL, MSS 76, box 114, folder 2379 (my translation).

57. G. Stein 1962, 179; cited in Mellow 1974, 244.

58. G. Stein 1990, 211.

59. L. Stein 1950, 86.

60. Davidson 1951, 174.

61. Claribel Cone to Etta Cone, August 13, 1923, BMA Cone Papers.

62. Michael Stein to Etta Cone, December 17, 1923, BMA Cone Papers.

63. The Galerie Simon exhibition catalogue lists the following three works from the collection of Gertrude Stein: no. 7, *Le Repas* (1922); no. 13, *Les Joueurs de cartes* (1922); no. 20, *Le Verre de vin* (1923). Cécile Debray notes that *Le Verre de vin* and *Le Repas* (here called *The Snack*, cat. 86) are the same painting.

64. Michael Stein to Alice Toklas, June 6 [1925]; Michael Stein to Gertrude Stein, June 14, 1925; Michael Stein to Gertrude Stein, June 16, 1925, all Beinecke YCAL, MSS 76, box 125, folder 2722.

65. Kimball 1948b, 29.

66. Cone Papers.

67. G. Stein 1990, 212.

68. G. Stein 1934, 49.

69. Michael Stein to Etta Cone, December 30, 1927, BMA Cone Papers.

70. Shortly after the death of Basket (I) on November 25, 1938, Gertrude and Alice acquired another poodle, Basket (II). Dydo and Rice 2003, 426n8.

71. G. Stein 1990, 229.

72. Stuart Davis to Gertrude Stein, June 1, 1929, Beinecke YCAL, MSS 76, box 103, folder 2021.

73. G. Stein 1990, 243.

74. Roubina Stein death notice. Estate of Daniel M. Stein.

75. Albert Barnes to Leo Stein, November 2, 1934, Beinecke YCAL, MSS 76, box 97, folder 1839.

76. Bernard Faÿ to Gertrude Stein, February 13, 1935, Beinecke YCAL, MSS 76, box 106, folder 2096.

77. Michael Stein to Gertrude Stein, February 8, 1935, Beinecke YCAL, MSS 76, box 125, folder 2723.

78. Leo Stein to Etta Cone, May 13, 1937, BMA Cone Papers.

79. Gertrude Stein to Andrew Keogh, Esq., librarian, Yale University, November 23, 1937, Beinecke YCAL, MSS 77, box 12, folder 183.

80. Flanner 1988, 187-88.

81. Michael Stein to Gertrude Stein, April 14, 1938, Beinecke YCAL, MSS 76, box 125, folder 2723.

82. Allan Stein to Gertrude Stein, October 7, 1938, Beinecke YCAL, MSS 76, box 124, folder 2705.

83. O. N. Solbert to Gertrude Stein, March 26, 1945, Beinecke YCAL, MSS 76, box 124, folder 2697.

84. Leo Stein to Chantal Quenneville, August 25, 1945, Beinecke YCAL, MSS 78, box 1, folder 14.

85. L. Stein 1950, 247. From a notebook headed "During the War," November 11, 1944.

86. Albert C. Barnes to Leo Stein, April 16, 1946, Beinecke YCAL, MSS 76, box 97, folder 1839.

87. Leo Stein to Hiram Haydn, July 21, 1947, Beinecke YCAL, MSS 78, box 1, folder 9.

88. Nina Stein to Fred Stein, October 30, 1947, Beinecke YCAL, MSS 78, box 5, folder 166.

89. Fred Stein to Nina Stein, August 17, 1949, Beinecke YCAL, MSS 78, box 5, folder 166.

90. Fiske Kimball to R. Sturgis Ingersoll, San Francisco, December 11, 1951, Kimball Papers, Philadelphia Museum of Art Archives.

91. Alice Toklas [to Mrs. Stern?], April 9, 1959, Alice B. Toklas Papers, Bancroft Library.

92. Alice Toklas [to Mrs. Stern?], December 20, 1964, Toklas Papers.

Sarah Stein's Notebook from the Académie Matisse
Janet Bishop and Carrie Pilto

Plate 296

In 1908, in the early days of the Académie Matisse, Sarah Stein wrote down many of Matisse's remarks to his class. First published as "A Great Artist Speaks to His Students" in Alfred H. Barr's 1951 book *Matisse: His Art and His Public*, Sarah's firsthand account has long provided insight into the artist's methods, theories, and aims as a teacher.[1] Sarah was enthusiastic about Barr's book plans, writing him in 1946, "I am already looking forward to your book on Matisse. I know that it will be invaluable to all lovers of art and a revelation to all who have much to learn."[2] Publication was delayed, however, and by 1950 Sarah was suffering from dementia. Her friend John Dodds, a professor at Stanford University, took over the correspondence on Sarah's behalf and sent Barr a copy of her notes.[3]

A mystery until now, the original source for "A Great Artist Speaks to His Students" is a small, black faux-leather-bound notebook newly discovered within the estate of Sarah's grandson, Daniel M. Stein. Excepting blank pages, it is reproduced here in its entirety (pls. 296–342).

Matisse, who spoke hardly any English, taught in French. Most of Sarah's notes are in English. The haphazard organization of the notebook suggests that she was simultaneously translating and transcribing as Matisse spoke, likely over the course of a number of classes. In a few instances, we catch glimpses of the artist teaching in the original French, with Sarah citing him in quotation marks alongside her English translation. Regarding drawing, for example, she writes: "'Il faut toujours chercher la volonté de la ligne.' One must always search for the *desire* of the line" (pl. 318). On color placement: "'Il faut de l'ordre.' *Order*, above all (in color)" (pl. 328).

Markings on the pages reveal that Sarah subsequently coded and reorganized her notes according to subject. A capital *P* overwritten in graphite or purple crayon indicates notes on painting; a large *S* specifies observations on sculpting; a capital *P* in green singles out critiques of pupils' work. Many of the sections are decisively crossed out, presumably to indicate that they had been transferred into a more polished version of the document.

The notebook contains several passages (shown in italics below) that were not in fact published in 1951. One such passage addresses the construction of the figure: *"You must put in at the very first (to leave room for them is a very difficult matter) all the details that you intend to include (the toes, fingers, etc.) otherwise, if you but draw the volumes and attempt further on to add these details, they will always show that they have been added"* (pl. 314). Another speaks to the use of photographs for painting, with Matisse encouraging his students to enrich their canvases beyond what can be captured by the camera: "Nature excites the imagination to representation. *A photograph would include only as much of this landscape as could be taken in by the plate but you certainly want* [to] add to this the spirit of the landscape in order to help its pictorial quality" (pls. 329, 333, 334). Sarah also transcribed a long citation by Cézanne on a double page near the end of the notebook (pl. 342). Cézanne's words, which appeared in print in 1904,[4] resonate in Matisse's advice to his students.

Finally, thanks to Sarah's unpublished annotations, it is possible to identify the students to whom a few of Matisse's critiques were addressed. To American painter Patrick Henry Bruce, for example, he said: "Choose two points, for instance, the darkest and lightest spots on the subject (in this case the model's black hair and the yellow straw of the stool). Consider every additional stroke in relation to these" (pl. 328). To German painter Hans Purrmann:

Plate 296–342
Notebook of Henri Matisse's teachings, transcribed by Sarah Stein, 1908.
6½ x 4¼ in. (16.5 x 10.8 cm). Estate of Daniel M. Stein

"You must make your color follow the form as your drawing does. Therefore your vermillion and white in this light should turn to garance [madder] and white—*violet*—in this cooler shadow. For this leg is round not broken by a corner (*as it was*). Thick paint does not give light; you must have the proper color combination. *Remember that a color may be indefinitely mixed with white on the palette, but at a certain stage it is rich, at another poor—and remember that you must not fail to consider this in considering its relation to the other colors*" (pls. 331, 332).

Sometime in the late 1930s or early 1940s,[5] Sarah shared another version of her notes, labeled "Matisse notes/roughly copied," with the San Francisco Museum of Art (now SFMOMA). Also discovered in the estate of Daniel M. Stein, these fifty-one sheets of loose-leaf paper written in longhand combine statements found in the 1908 notebook with others from a source that has yet to be found. Sarah's willingness to share her private notes from Matisse's class with American museums on both coasts reflects her commitment to pass on to others what she had learned firsthand from the master—part of her lifelong mission to further the understanding of modern art.

Plate 297

Plate 298

Plate 299

Plate 300

Plate 301

Plate 302

Plate 303

Plate 304

Plate 305

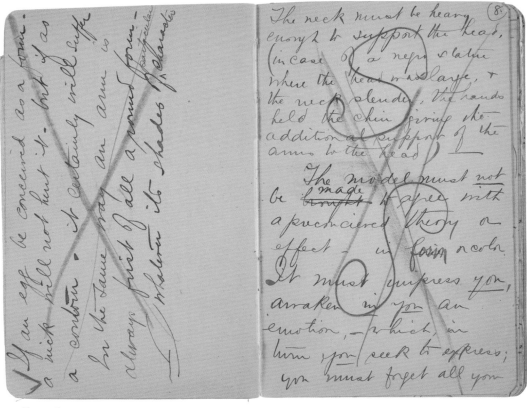

Plate 306

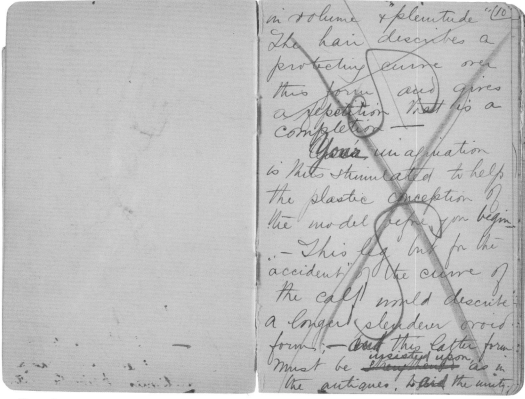

Plate 307

Plate 308

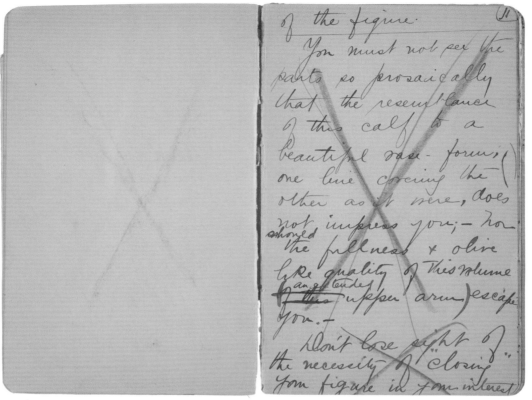

Plate 309

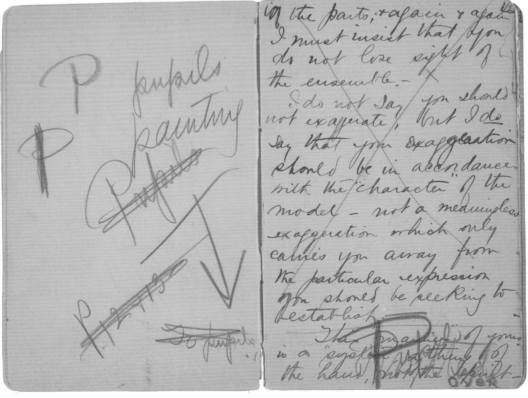

Plate 310

Plate 311

Plate 312

& give a sufficient
base to your form. (model)

Put in no holes that
hurt the ensemble (as the
thumb & fingers in hands
lying at side in sculpture),
express by masses in
relation to one another
& large sweeps of line
in relation. —

One must determine
the characteristic
forms of the different

parts (of the body), & the
direction of the contours
which will give this
form — In a man
standing erect — all
the parts must go
in a direction that
that sensation — the
legs work up into
the torso which flashes
down over them — It
must have a spinal column.
One can divide ones
work by opposing lines (axes)
which give the direction
of the parts, & thus build

Plate 313

You must put in at the
very first (to leave room
for details a very difficult
matter) all the details
that you intend to include
(the toes, fingers, etc)
+ then see, if you first
draw the volumes & attempt
further on to add these
details, they will always
show that they have been
added

It is surprising how high
the navel always seems. There
is always a slight depression
above it + the full position of
the abdomen comes below it

up the body in a
manner that at once
suggests its character
+ movement. It is general
well in an upright figure to make
the lines contours walk, remaining true to the parts
In addition to those
sensations one derives
from a drawing, a sculpture
must invite us to handle
it — as an object; — Just
so, the sculptor must feel
in making it the particular
demands (of the sculptor)
for volume + mass — The smaller
the bit of sculpture the
more the essentials of form

Plate 314

The Egyptians emphasized this feature.

The navel gives a distinct expression to the belly — as the spot corresponding the apple does — and its place must be accurately chosen with the consideration of this expression.

The pelvis has a distinct round of its own below the round of the belly. And the belly fits into another round which embraces the hips.

Begin lines.

must exist.) X 5

One must never forget the "constructive lines" (axes) of shoulders + pelvis — (nor of legs, arms, neck, + head) — this building up of the form gives its essential expression.

characteristics may always heighten the effect but the construction must exist first.

No lines go "wild" every line must have its function — (this one carries the eye up to the arm, note how it does)

Plate 315

√ The mechanics of construction is the establishment of the oppositions which cause the equilibrium of the directions (axes)

√ All the lines must close — around a center "la nine" — otherwise your drawing can not exist — (as a unit) for these "placing" lines carry the attention away — they do not arrest it

√ It was in the decadent periods of art that the artists chief interest lay in developing the small forms + details — in all the

Plate 316

great periods the essentials of form the big masses, & their relations, occupied him above all other consideration He did not elaborate until that was established not that the antique does not show that sensibility of the artist which was sometimes attributed only to the moderns. Only the sensibility was better controlled—

(It is then,

Plate 317

"Il faut toujours chercher la volonté de la ligne;— One must always search for the desire of the line — where it wishes to enter or where to die away — always always be sure of its source, — this must be done from the model—

To feel a central line in the direction of the general movement of the body & build about that is a great aid

For Drawing go back to Page ⑤6 just preceding this

then P 3

Plate 318

Plate 319

Plate 320

Plate 321

Plate 322

Plate 323

Plate 324

upon the chest they
tie. — this adds to
the determination + nervous
strength of the pose.
dont hesitate to
make his head round
+ outline it well against
the back-ground. it
is round as a ball,
+ black. —
The foot resting upon
the model stand making a
line sharp + straight
as a cut — give this
feature its importance. That
slightly drooping bulge
of flesh is just a trifle

Plate 325

that may be added but
the line alone counts.
in the character of the pose
Remember that the
foot encircles the lower
leg + dont make it a
silhouette even in drawing
the profile — the ankle
fades into body at the
ankle. The heel comes up
around it.
Ingres said never,
in drawing a head,
omit the ear — If I
do not insist upon
this, I do remind
you that the ear adds
enormously to the character
of the head, + it is

Plate 326

very important to strike it carefully & fully, not suggest it with a dot.
A sharply drawn silhouette
shading in the back—looks to prevent its looking like a silhouette cut out, & pastes on white paper

When painting, first look long & well at your model (or subject) & decide on your general color scheme—This must prevail—
("In this instance the dark young Italian model against a steel-grey muslin background suggests, in your palette, rose against blue). OVER
Don't add one spot...

Plate 327

contradiction to the (2) effect you have been trying to gain in your drawing—remember that volume & plenitude depend upon not cutting up your parts—
Choose your points—for instance, the darkest & lightest spots on the subject (in this case the model's black hair & the yellow stain of the stool) Consider every additional place in relation to these—You have... then P. 4

"Il faut de l'ordre"
Order—above all—(in color)—
Put 3 or 4 touches of color that you have understood upon the canvas, add another if you can—if you can't, put this aside & begin again.—
Construct by "rapports" (relations of color)—close & distant; equivalents of the relations that you see upon the model—then II

Plate 328

Plate 329

Plate 330

because against your bluish
back-ground it becomes warm - &
the former against the red
becomes cooler & darker -
(to Purrmann)
You must make your color
follow the form as you
drawing does- Then if
you vermillion & white in
this light should turn to
[orange] & white violet-
in this cooler shadow -
now this is round not broken
[...] by a corner as it was
Thick paint does not
give light, you must have
the proper colour combination

Plate 331

gradations in the light &
masses - with contrasts
in the shadows - & the
whole in relation to
one another - may be
used as a rule - but
the round (the volume,
the plenitude) must be
kept intact. (You may
represent your gradations by a single color)
"You need red to make
your blue & yellow " play"-
but put it where it
helps - not hurts, - in
the back-ground - perhaps."
& don't attempt to strengthen

P.6 green P 6
Remember that a color
may be indefinitely mixed
with white on the palette,
but at a certain stage it
is rich, at another poor.
And remember that you
must not fail to consider
this in considering its relation
to the other colors - (the rapports)

You put a black +
you at once create light
(de la lumière) around it

Plate 332

your forms with "high-lights"
it is better to make
the back-ground of the
proper relation (rapport)

Cézanne painted in
diagonal strokes so
all in relation
& constituting
a gradated harmony,
did he not? Yes, but
he never forgot his
"corner" relations either,
& many who have followed
him have observed the

Plate 333

Plate 334

It is not necessary 9
to make the whole
sky blue to give relief
to a white cloud – This
blue around the cloud.
throws the cloud forward
+ the sky back though
the sky itself is mostly
white (light in tone)

If you choose to make
this ground redder with
green (its comp. + farthest
rapprt) in the shadow
the green going through yellow
back to red fn – because of the
relations – the shadows & planes
will remain correct.

Had you not better 9
employ the former
method alone – then
your blue background
will require the warmer
shadow + this black
head against it a
warmer tone than this
dark blue you have chosen
etc, etc. your model
stand will take a
lighter warmer tone (it looks
like kinky creamy silk)
in relation to the greenish wall-
paper.
Corot chose his lightest
+ darkest spots + kept every tone
between these

Plate 335

The church must
be dark against
the light sky but
it need not remain
dark to suggest that
it is in shadow +
it must grade back to light in
order to define against it this dark
tree-trunk – Considering carefully
your color-relations, your planes
will construct – through the
rapports ____

Plate 336

Recent Still - Life
3. Theories of color —
Cezanne used blue
to make this yellow
tell; but he used
it with the discrimination
as he did in all other cases
that no one else has
been shown able to do.

The Neo-impressionists
took different centres of light. viz.
a yellow and a green,
put blue around the yellow,
red around the green &
faded the blue into the
red through purple, etc.

Plate 337

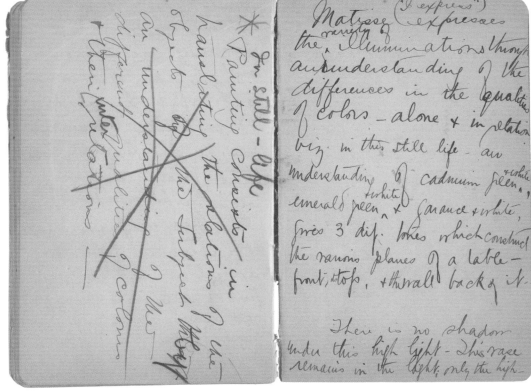

Matisse ("I express") expresses
the variety of illuminations through
an understanding of the
differences in the qualities
of colors — alone & in relation
viz. in this still life. an
understanding of cadmium green + white,
emerald green + white & garance + white,
gives 3 diff. tones which construct
the various planes of a table —
front, top, & the wall back of it.

There is no shadow
under this high light — this vase
remains in the light; only the high-

* In still - life
Painting consists in
harmonizing the relations of the
objects of the subject through
an understanding of their
different qualities of colors —
their interrelations —

Plate 338

light & light beneath it must
be in the proper color, relation. –

When the eyes become
tired & the rapport
seem all wrong – just
look at the object. –
("but this brass is yellow,")
frankly put a yellow
ochre, for instance, on a
light spot. & start out
from there – fresh, again –
to reconcile the various
parts.

Tb. copy the objects
in a naive mode – is
nothing – one must render

Plate 339

the emotion they awaken
in you; – the emotion
of the ensemble; – the inter
relation of the objects;
the specific character of
every one (modified by its
relation to the others) – ;
interlaced like a
cord – or a serpent –
(The tear-like quality
of this slender fat bellied
vase the various
volume of this copper must
touch you – what you may do it
A still life is as
difficult as an antique
& the proportions of the
various parts as important

Plate 340

Plate 341

Plate 342

Notes

1. The notes as published in Barr 1951 appear in French translation for the first time, with annotations, in Matisse 1972, 64-74. They were reprinted in English with a useful analysis in Flam 1995, 44-52.

2. Sarah Stein to Alfred H. Barr, Jr., August 8, 1946, in reply to Barr's request for photographs of her Matisse paintings, Alfred H. Barr, Jr. Papers, Museum of Modern Art Archives, NY, AHB 11.I.A.20.

3. John Dodds to Alfred H. Barr, Jr., June 28, 1950: "Some time ago I helped Mrs. Stein transcribe notes which she had taken in 1908 under Matisse, in the school." Dodds to Barr, July 30, 1950: "Since I have not yet been able to see Mrs. Stein, I ought at least to give you an interim report, and I enclose herewith the copy of her notes from the class." On August 8, 1950, Barr wrote to Dodds: "It's wonderful to have the notes Mrs. Stein took down from Matisse's remarks at the time of his class in 1908. I'm not sure I shall be able to use all of them, but I do hope to quote a great deal from them." Dodds replied to Barr on August 18, 1950: "I did tell her [Sarah] that I had sent you the Matisse notes, and she seemed pleased to know that they might be of some help to you. My own judgment would be that there is no reason why you should not make use of them as suits your needs." The manuscript Dodds sent Barr has been lost; MoMA's archives contain a typescript prepared by the museum for publication (MoMA Barr Papers, AHB 11.I.A.20). This typescript and subsequent published versions are faithful to Sarah's notebook entries except for section headings, added for clarity, and one small error: "Depressions and contours may hurt the volume" should read "Depressions in contours may hurt the volume."

4. The quotation appears in Bernard 1904, 23-24.

5. The stamps used on the envelope in which the San Francisco Museum of Art returned the loose-leaf manuscript to Sarah at her home in Palo Alto were issued on June 13, 1938. The roller cancel on the envelope does not contain a date but was used between the late 1930s and early 1940s.

The Stein Residences in Photographs

The selection of photographs that follows was culled from more than four hundred extant images of various Stein family residences. Many of the pictures were taken by the Steins and their associates to record the family's collections or mark new acquisitions. Because the art displayed on the walls of rue de Fleurus and rue Madame changed so frequently in the years prior to World War I, images of these residences have proven exceptionally useful in tracing the history of the Steins' evolving taste.

Although a number of these photographs have been reproduced elsewhere, the ensuing pages present simultaneous views of several walls of their residences—offering near-panoramic representations of the family's holdings at given moments in time. In some cases the analysis of the archival images in tandem with the newly reconstructed acquisition histories and provenance information compiled in the Catalogue of the Stein Collections in this volume has led to revised datings of previously published photographs.

The pictures reproduced here are from the following archives and collections: Dr. Claribel and Miss Etta Cone Papers, Archives and Manuscripts Collections, The Baltimore Museum of Art; The Bancroft Library, University of California, Berkeley; Cecil Beaton Studio Archive at Sotheby's, London; Albert S. Bennett, New York; David and Barbara Block family archives; Musée National d'Art Moderne, Centre Georges Pompidou, Paris; Department of Nineteenth-Century, Modern, and Contemporary Art, The Metropolitan Museum of Art, New York, gift of Edward Burns, 2011; Estate of Daniel M. Stein, courtesy William J. Ashton; and the Yale Collection of American Literature, Beinecke Rare Book and Manuscript Library. Complete credits for individual photographs appear on page 482.

The painstaking identification of the artworks and dating of the photographs was undertaken by Robert McD. Parker and Maxime Touillet, with input from the exhibition curators and Carrie Pilto.

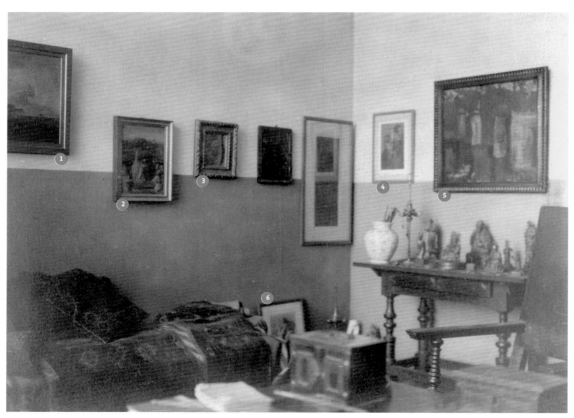

Plate 343 (east and south walls)

Rue de Fleurus, ca. 1904

Leo moves into 27 rue de Fleurus in Paris in early 1903, with Gertrude joining him the following fall. These three photographs of their atelier document their purchases from Ambroise Vollard's art gallery on October 28, 1904. Paul Cézanne's *Madame Cézanne with a Fan* (1878–88; pl. 2), bought from Vollard on December 16, 1904, is not yet hanging in the space.

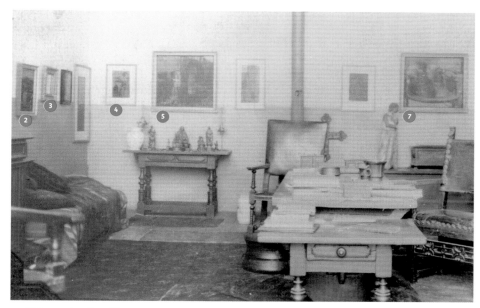

Plate 344 (south wall)

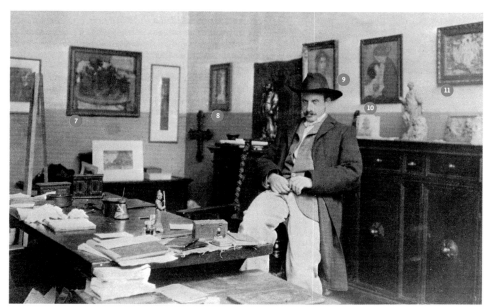

Plate 345 (south and west walls)

1 Unidentified landscape, possibly by **Philip Wilson Steer**
2 Unidentified Renaissance painting, possibly *Madonna and Child*
3 **Honoré Daumier,** *Head of an Old Woman*, 1856–60 (cat. 57)
4 Unidentified Japanese print depicting two women
5 **Paul Gauguin,** *Three Tahitian Women against a Yellow Background*, 1899 (pl. 8, cat. 63)

6 Reproduction of **Edgar Degas**'s *After the Bath* (cat. 59)
7 **Paul Gauguin,** *Sunflowers on an Armchair*, 1901 (cat. 64)
8 Unidentified painting, possibly by **Raoul du Gardier**
9 **Pierre-Auguste Renoir,** *Head of a Young Woman*, 1890 (pl. 53, cat. 396)
10 **Maurice Denis,** *Mother in Black*, 1895 (pl. 40, cat. 61)
11 **Paul Cézanne,** *Group of Bathers*, 1892–94 (cat. 12)

Rue de Fleurus, ca. 1906

Henri Matisse's *Woman with a Hat* (no. 20), which Leo and Gertrude purchase in fall 1905, is prominently displayed on the west wall of the atelier. On January 21, 1907, the siblings sell Pierre Bonnard's *Siesta* (no. 3) and Paul Gauguin's *Three Tahitian Women against a Yellow Background* (no. 10) to Ambroise Vollard.

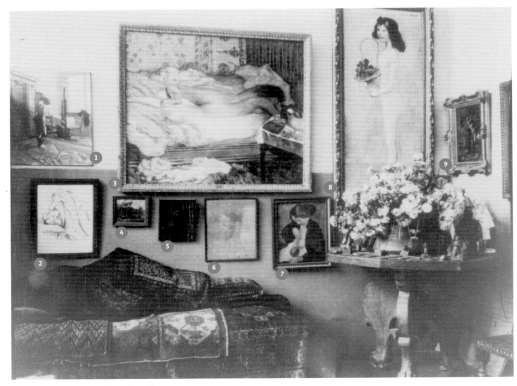

Plate 346 (east and south walls)

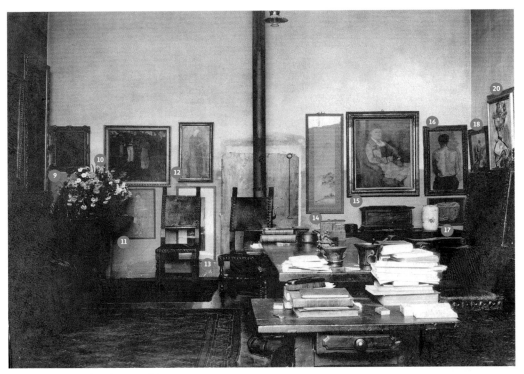

Plate 347 (south and west walls)

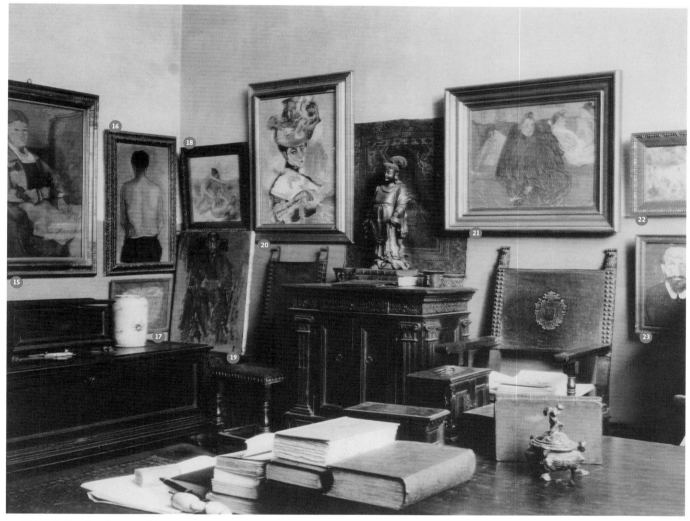

Plate 348 (south and west walls)

1 **Henri Charles Manguin,** *The Studio, the Nude Model,* 1904-5 (pl. 55, cat. 82)

2 **Paul Cézanne,** *Leaning Smoker,* 1890-91 (cat. 19)

3 **Pierre Bonnard,** *Siesta,* 1900 (pl. 14, cat. 3)

4 **Pierre-Auguste Renoir,** *Landscape,* ca. 1904 (cat. 404)

5 **Honoré Daumier,** *Head of an Old Woman,* 1856-60 (cat. 57)

6 **Pablo Picasso,** *Profile of a Young Boy,* 1905 (cat. 288)

7 **Maurice Denis,** *Mother in Black,* 1895 (pl. 40, cat. 61)

8 **Pablo Picasso,** *Girl with a Basket of Flowers,* 1905 (pl. 9, cat. 232)

9 **Eugène Delacroix,** *Perseus and Andromeda,* 1847 (cat. 60)

10 **Paul Gauguin,** *Three Tahitian Women against a Yellow Background,* 1899 (pl. 8, cat. 63)

11 **Pablo Picasso,** *The Milk Bottle,* 1905 (pl. 67, cat. 289)

12 Unidentified Renaissance painting, possibly *Madonna and Child with Saint John the Baptist*

13 Unidentified Japanese print

14 Unidentified Japanese mountain scene

15 **Paul Cézanne,** *Madame Cézanne with a Fan,* 1878-88 (pl. 2, cat. 10)

16 **Leo Stein,** *Man from the Back,* n.d.

17 Unidentified pre-Columbian textile

18 **Pierre-Auguste Renoir,** *Two Nudes,* ca. 1897 (cat. 412)

19 Unidentified painting, possibly by **Leo Stein**

20 **Henri Matisse,** *Woman with a Hat,* 1905 (pl. 13, cat. 113)

21 **Henri de Toulouse-Lautrec,** *In the Salon: The Divan,* ca. 1892-93 (pl. 28, cat. 437)

22 **Paul Cézanne,** *Bathers,* 1898-1900 (pl. 36, cat. 14)

23 **Leo Stein,** *Michael Stein,* n.d.

Rue de Fleurus, ca. 1907

Leo and Gertrude purchase Henri Matisse's *Margot* (no. 10) on October 22, 1906. These photographs of the atelier are taken sometime before the siblings exchange Paul Gauguin's *Sunflowers on an Armchair* (no. 2) and Maurice Denis's *Mother in Black* (no. 22) for a Renoir nude on April 27, 1908.

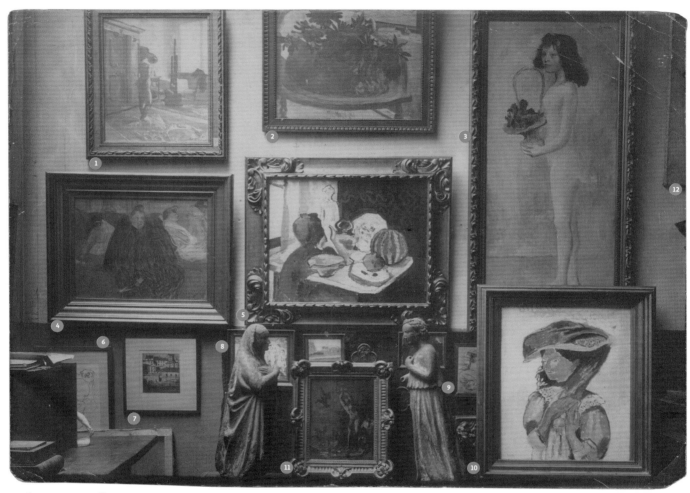

Plate 349 (east wall)

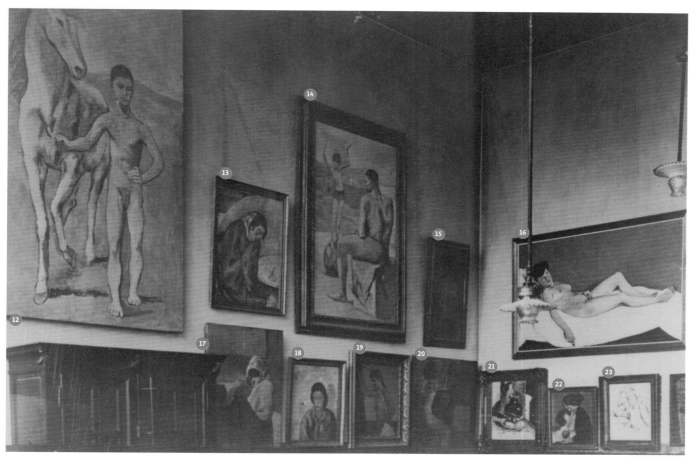

Plate 350 (east and south walls)

1 **Henri Charles Manguin,** *The Studio, the Nude Model,* 1904-5 (pl. 55, cat. 82)
2 **Paul Gauguin,** *Sunflowers on an Armchair,* 1901 (cat. 64)
3 **Pablo Picasso,** *Girl with a Basket of Flowers,* 1905 (pl. 9, cat. 232)
4 **Henri de Toulouse-Lautrec,** *In the Salon: The Divan,* ca. 1892-93 (pl. 28, cat. 437)
5 **Henri Matisse,** *Dishes and Melon,* 1906-7 (pl. 60, cat. 136)
6 **Henri Matisse,** *Pensive Nude in Folding Chair,* 1906 (cat. 179)
7 **Charles Meryon,** *The Morgue, Paris,* 1854 (cat. 213)
8 **Paul Cézanne,** *Bathers,* 1897 (cat. 27)
9 **Pierre-Auguste Renoir,** *Two Bathers,* 1895 (from *L'Estampe Originale*)
10 **Henri Matisse,** *Margot,* 1906 (pl. 61, cat. 122)
11 **Eugène Delacroix,** *Perseus and Andromeda,* 1847 (cat. 60)
12 **Pablo Picasso,** *Boy Leading a Horse,* 1905-6 (pl. 20, cat. 236)

13 **Pablo Picasso,** *Dozing Drinker,* 1902 (cat. 227)
14 **Pablo Picasso,** *Young Acrobat on a Ball,* 1905 (pl. 70, cat. 234)
15 **Leo Stein,** *Man from the Back,* n.d.
16 **Félix Vallotton,** *Reclining Nude on a Yellow Cushion,* 1904 (pl. 10, cat. 438)
17 **Pablo Picasso,** *Crouching Woman,* 1902 (cat. 226)
18 **Pablo Picasso,** *Woman with Bangs,* 1902 (pl. 65, cat. 225)
19 **Félix Vallotton,** *Nude Woman Leaning against a Tree,* 1906 (cat. 440)
20 **Pablo Picasso,** *Two Women Seated at a Bar,* 1902 (pl. 66, cat. 229)
21 **Henri Matisse,** *Yellow Pottery from Provence,* 1905 (cat. 114)
22 **Maurice Denis,** *Mother in Black,* 1895 (pl. 40, cat. 61)
23 **Paul Cézanne,** *Leaning Smoker,* 1890-91 (cat. 19)

Rue de Fleurus, ca. 1910

Elie Nadelman's unframed drawing of a woman's face (no. 37), which Leo purchases from a Nadelman exhibition in spring 1909, leans against the west wall of the atelier. In January 1910 Leo and Gertrude lend Paul Cézanne's *Madame Cézanne with a Fan* (1878–88; pl. 2) to a Cézanne exhibition at Galerie Bernheim-Jeune, which may explain why the canvas, usually prominently displayed on the south or west walls, is not on view.

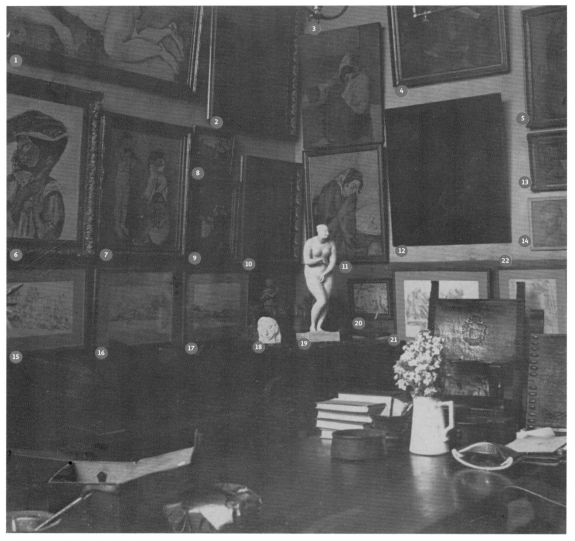

Plate 351 (east and south walls)

1 **Henri Matisse,** *Blue Nude: Memory of Biskra*, 1907 (pl. 27, cat. 139)

2 Likely **Leo Stein,** *Man from the Back*, n.d.

3 **Pablo Picasso,** *Crouching Woman*, 1902 (cat. 226)

4 **Pablo Picasso,** *Landscape with Two Figures*, 1908 (pl. 185, cat. 244)

5 Unidentified Renaissance painting, possibly *Madonna and Child with Saint John the Baptist*

6 **Henri Matisse,** *Margot*, 1906 (pl. 61, cat. 122)

7 **Henri Matisse,** *Music* (Sketch), 1907 (pl. 62, cat. 143)

8 **Henri Matisse,** *Houses (Fenouillet)*, 1898–99 (cat. 95)

9 **Henri Matisse,** *The Convalescent Woman (The Sick Woman)*, 1899 (cat. 97)

10 Likely **Félix Vallotton,** *Nude Woman Leaning against a Tree*, 1906 (cat. 440)

11 **Pablo Picasso,** *Dozing Drinker*, 1902 (cat. 227)

12 **El Greco,** *Saint Francis in Meditation*, ca. 1585 (cat. 65)

13 **Pablo Picasso,** *Glasses and Fruit*, 1908 (pl. 224, cat. 249)

14 **Pablo Picasso,** *Head of a Boy*, 1905 (pl. 72, cat. 294)

15 **Paul Cézanne,** *The Coach House*, 1890–95 (cat. 20)

16 **Paul Cézanne,** *Mont Sainte-Victoire*, 1890 (cat. 18)

17 **Paul Cézanne,** *Waterfront Landscape*, 1878–80 (cat. 15)

18 **Pablo Picasso,** *Mask of a Woman*, 1908 (pl. 221, cat. 389)

19 **Elie Nadelman,** *Standing Female Figure*, ca. 1907 (cat. 215)

20 **Paul Cézanne,** *Bathers*, 1897 (cat. 27)

21 **Paul Cézanne,** *Olive Grove*, ca. 1900 (cat. 25)

22 **Paul Cézanne,** *Footpath in the Woods*, 1882–84 (cat. 16)

23 **Pablo Picasso,** *Two Women Seated at a Bar*, 1902 (pl. 66, cat. 229)

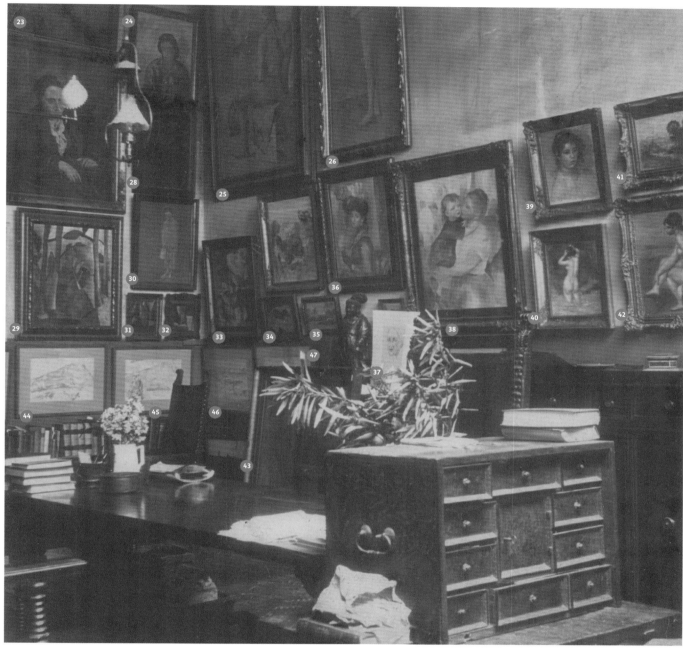

Plate 352 (south and west walls)

24 **Pablo Picasso**, *Woman with Bangs*, 1902 (pl. 65, cat. 225)

25 **Pablo Picasso**, *Young Acrobat on a Ball*, 1905 (pl. 70, cat. 234)

26 **Pablo Picasso**, *Girl with a Basket of Flowers*, 1905 (pl. 9, cat. 232)

27 **Pablo Picasso**, *Gertrude Stein*, 1905–6 (pl. 183, cat. 238)

28 **Pablo Picasso**, *Bust of a Man*, 1908 (pl. 222, cat. 243)

29 **Pablo Picasso**, *La Rue-des-Bois*, 1908 (pl. 226, cat. 245)

30 **Pablo Picasso**, *The Milk Bottle*, 1905 (pl. 67, cat. 289)

31 **Pablo Picasso**, *Still Life with Fruit and Glass*, 1908 (cat. 253)

32 **Pablo Picasso**, *Glasses and Fruit*, 1908 (pl. 225, cat. 250)

33 **Pierre-Auguste Renoir**, *The Hat Pinned with Flowers*, 1898 (cat. 413)

34 **Pierre-Auguste Renoir**, *Pears*, ca. 1890 (cat. 399)

35 **Pierre-Auguste Renoir**, *Landscape*, ca. 1900–1905 (cat. 406)

36 **Pierre-Auguste Renoir**, *Girl in Gray-Blue*, ca. 1889 (cat. 395)

37 **Elie Nadelman**, *Head of a Woman*, ca. 1906 (pl. 63, cat. 214)

38 **Pierre-Auguste Renoir**, *Washerwoman and Child*, 1887 (pl. 54, cat. 394)

39 **Pierre-Auguste Renoir**, *Head of a Young Woman*, 1890 (pl. 53, cat. 396)

40 **Pierre-Auguste Renoir**, *Bather*, ca. 1890 (cat. 398)

41 **Pierre-Auguste Renoir**, *Landscape*, 1890 (cat. 397)

42 **Pierre-Auguste Renoir**, *Seated Bather*, ca. 1882 (pl. 39, cat. 393)

43 **Pablo Picasso**, *Landscape* (La Rue-des-Bois or Paris), 1908 (cat. 246)

44 **Paul Cézanne**, *Mont Sainte-Victoire*, ca. 1900 (cat. 23)

45 **Paul Cézanne**, *Mont Sainte-Victoire*, ca. 1900 (cat. 24)

46 **Paul Cézanne**, *The Chaîne de l'Etoile Mountains*, 1885–86 (cat. 17)

47 Unidentified watercolor, possibly **Paul Cézanne**, *Trees*, ca. 1900 (cat. 21)

Rue de Fleurus, between summer 1912 and fall 1913

Hanging on the atelier walls are Pablo Picasso's *Le Journal* (no. 8) and *The Small Glass* (no. 30), which Gertrude acquires in May 1912. Gertrude sells Picasso's *Young Acrobat on a Ball* (no. 24), still visible here, to Kahnweiler in October 1913.

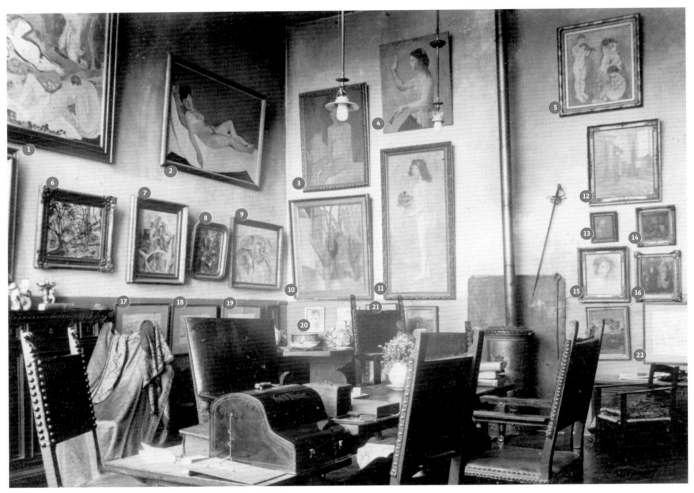

Plate 353 (east and south walls)

1 **Henri Matisse,** *Le Bonheur de vivre,* also called *The Joy of Life,* 1905–6 (pl. 15, cat. 117)

2 **Félix Vallotton,** *Reclining Nude on a Yellow Cushion,* 1904 (pl. 10, cat. 438)

3 **Pablo Picasso,** *Seated Nude,* 1905 (pl. 71, cat. 233)

4 **Pablo Picasso,** *Lady with a Fan,* 1905 (pl. 68, cat. 235)

5 **Henri Matisse,** *Music* (Sketch), 1907 (pl. 62, cat. 143)

6 **Henri Matisse,** *Olive Trees at Collioure,* ca. 1906 (pl. 59, cat. 134)

7 **Pablo Picasso,** *The Reservoir, Horta de Ebro,* 1909 (pl. 229, cat. 256)

8 **Pablo Picasso,** *Le Journal,* 1912 (cat. 259)

9 **Pablo Picasso,** *Houses on a Hill, Horta de Ebro,* 1909 (pl. 230, cat. 257)

10 **Pablo Picasso,** *Landscape* (La Rue-des-Bois or Paris), 1908 (cat. 246)

11 **Pablo Picasso,** *Girl with a Basket of Flowers,* 1905 (pl. 9, cat. 232)

12 **Henri Charles Manguin,** *The Studio, the Nude Model,* 1904–5 (pl. 55, cat. 82)

13 **Honoré Daumier,** *Head of an Old Woman,* 1856–60 (cat. 57)

14 **Pablo Picasso,** *Glasses and Fruit,* 1908 (pl. 224, cat. 249)

15 **Pierre-Auguste Renoir,** *Head of a Young Woman,* 1890 (pl. 53, cat. 396)

16 **Édouard Manet,** *Ball Scene,* 1873 (pl. 48, cat. 81)

17 **Paul Cézanne,** *Mont Sainte-Victoire,* ca. 1900 (cat. 24)

18 **Paul Cézanne,** *Mont Sainte-Victoire,* 1890 (cat. 18)

19 Unidentified watercolor by **Paul Cézanne**

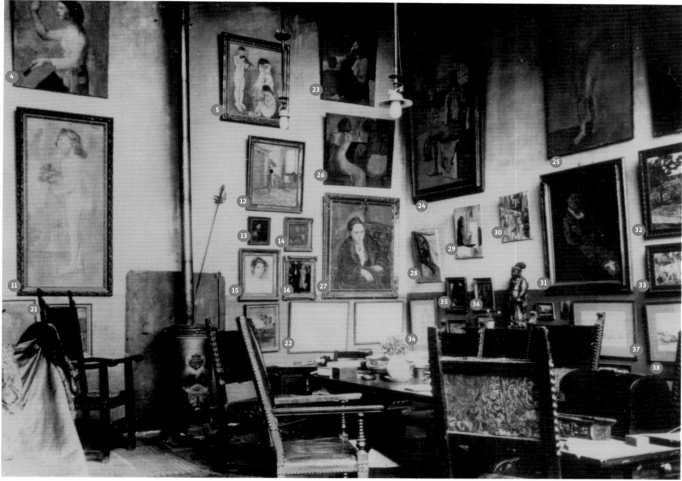

Plate 354 (south and west walls)

Rue de Fleurus, between June 1914 and spring 1915

The photographs of the atelier on these and the following pages are taken after Leo's final departure from Rue de Fleurus in April 1914 and Gertrude and Alice's renovations to the space the following June. Visible are Pablo Picasso's *Man with a Guitar* (no. 1 on page 372), which Gertrude acquires in fall 1913, and Henri Matisse's *Woman with a Hat* (no. 6), which Gertrude will sell to Michael in February 1915. Gertrude does not immediately transfer the Matisse work, however, because it is covered by her insurance.

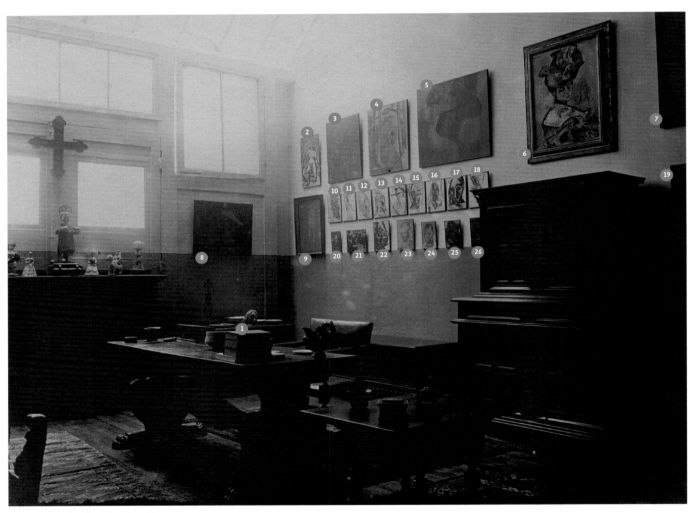

Plate 355 (north and east walls)

1 **Pablo Picasso,** *Mask of a Woman*, 1908 (pl. 221, cat. 389)
2 **Pablo Picasso,** Study for *The Dryad (Nude in a Forest)*, 1908 (pl. 219, cat. 252)
3 **Pablo Picasso,** *La Rue-des-Bois*, 1908 (cat. 247)
4 **Pablo Picasso,** *La Rue-des-Bois*, 1908 (pl. 226, cat. 245)
5 **Pablo Picasso,** *Two Women Seated at a Bar*, 1902 (pl. 66, cat. 229)
6 **Henri Matisse,** *Woman with a Hat*, 1905 (pl. 13, cat. 113)
7 **Pablo Picasso,** *Lady with a Fan*, 1905 (pl. 68, cat. 235)
8 **Pablo Picasso,** *Landscape with Two Figures*, 1908 (pl. 185, cat. 244)
9 **Pablo Picasso,** *The Milk Bottle*, 1905 (pl. 67, cat. 289)
10 **Pablo Picasso,** Study for *Nude with Drapery*, 1907 (pl. 213, cat. 371)
11 **Pablo Picasso,** Study for *Nude with Drapery*, 1907 (pl. 217, cat. 375)

12 **Pablo Picasso,** Study for *Nude with Drapery*, 1907 (cat. 369)
13 **Pablo Picasso,** Study for *Nude with Drapery*, 1907 (cat. 368)
14 **Pablo Picasso,** Study for *Nude with Drapery*, 1907 (pl. 214, cat. 372)
15 **Pablo Picasso,** Study for *Nude with Drapery*, 1907 (pl. 211, cat. 366)
16 **Pablo Picasso,** Study for *Nude with Drapery*, 1907 (cat. 367)
17 **Pablo Picasso,** *Head of a Woman in Brown and Black*, 1907 (pl. 210, cat. 365)
18 **Pablo Picasso,** Study for *Nude with Drapery*, 1907 (pl. 216, cat. 374)
19 **Pablo Picasso,** *The Blue House*, 1902 (cat. 230)
20 **Pablo Picasso,** *Leo Stein*, 1906 (pl. 33, cat. 325)
21 **Pablo Picasso,** *Café Scene*, 1900 (cat. 224)
22 **Pablo Picasso,** *Pitcher, Jar, and Lemon*, 1907 (pl. 208, cat. 362)

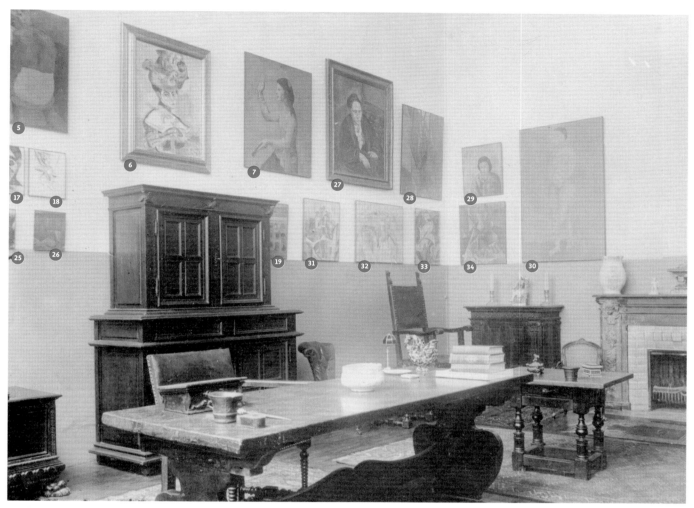

Plate 356 (east and south walls)

23 **Pablo Picasso,** *Head of a Boy,* 1905 (pl. 72, cat. 294)

24 **Pablo Picasso,** *Self-Portrait,* 1906 (pl. 81, cat. 239)

25 **Paul Cézanne,** *Man with Pipe,* 1892–96 (cat. 13)

26 **Pablo Picasso,** *Glasses and Fruit,* 1908 (pl. 224, cat. 249)

27 **Pablo Picasso,** *Gertrude Stein,* 1905–6 (pl. 183, cat. 238)

28 **Pablo Picasso,** *Landscape* (La Rue-des-Bois or Paris), 1908 (cat. 246)

29 **Pablo Picasso,** *Woman with Bangs,* 1902 (pl. 65, cat. 225)

30 **Pablo Picasso,** *Nude with Joined Hands,* 1906 (pl. 74, cat. 237)

31 **Pablo Picasso,** *The Reservoir, Horta de Ebro,* 1909 (pl. 229, cat. 256)

32 **Pablo Picasso,** *Houses on a Hill, Horta de Ebro,* 1909 (pl. 230, cat. 257)

33 **Pablo Picasso,** *Landscape,* 1907 (cat. 358)

34 **Pablo Picasso,** *Vase, Gourd, and Fruit on a Table,* 1908 (pl. 227, cat. 254)

Rue de Fleurus, between June 1914 and spring 1915 (continued)

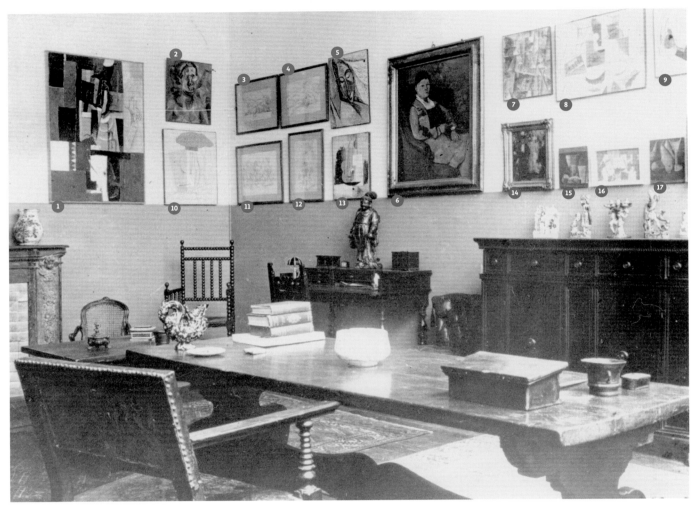

Plate 357 (south and west walls)

1 **Pablo Picasso**, *Man with a Guitar*, 1913 (pl. 234, cat. 264)
2 **Pablo Picasso**, *Head of a Woman (Fernande)*, 1909 (pl. 228, cat. 258)
3 **Paul Cézanne**, *Mont Sainte-Victoire*, 1890 (cat. 18)
4 **Paul Cézanne**, *Mont Sainte-Victoire*, 1900 (cat. 22)
5 **Pablo Picasso**, *Head of a Sleeping Woman* (Study for *Nude with Drapery*), 1907 (pl. 218, cat. 241)
6 **Paul Cézanne**, *Madame Cézanne with a Fan*, 1878-88 (pl. 2, cat. 10)
7 **Pablo Picasso**, *The Small Glass*, 1912 (cat. 261)
8 **Pablo Picasso**, *Guitar on a Table*, 1912 (pl. 232, cat. 263)
9 **Pablo Picasso**, *Segment of Pear, Wineglass, and Ace of Clubs*, 1914 (cat. 379)
10 **Pablo Picasso**, *Student with a Pipe*, 1914 (pl. 233, cat. 265)
11 **Paul Cézanne**, *Olive Grove*, ca. 1900 (cat. 25)
12 **Paul Cézanne**, *Footpath in the Woods*, 1882-84 (cat. 16)
13 **Pablo Picasso**, *Violin*, 1912 (pl. 231, cat. 262)
14 **Édouard Manet**, *Ball Scene*, 1873 (pl. 48, cat. 81)
15 **Pablo Picasso**, *Glasses and Fruit*, 1908 (pl. 225, cat. 250)
16 **Pablo Picasso**, *Segment of Pear, Bunch of Grapes, and Pipe*, 1914 (cat. 381)
17 **Pablo Picasso**, *Still Life with Fruit and Glass*, 1908 (cat. 253)
18 **Paul Cézanne**, *Bathers*, 1898-1900 (pl. 36, cat. 14)
19 **Pablo Picasso**, *Le Journal*, 1912 (cat. 259)
20 **Pablo Picasso**, *Girl with a Basket of Flowers*, 1905 (pl. 9, cat. 231)
21 **Pablo Picasso**, *The Architect's Table*, 1912 (pl. 197, cat. 260)
22 **Pablo Picasso**, *Seated Nude*, 1905 (pl. 71, cat. 233)
23 **Pablo Picasso**, *Profile of a Young Boy*, 1905 (cat. 288)
24 **Pablo Picasso**, *Head of a Sailor* (Study for *The Sailor*), 1906-7 (cat. 240)

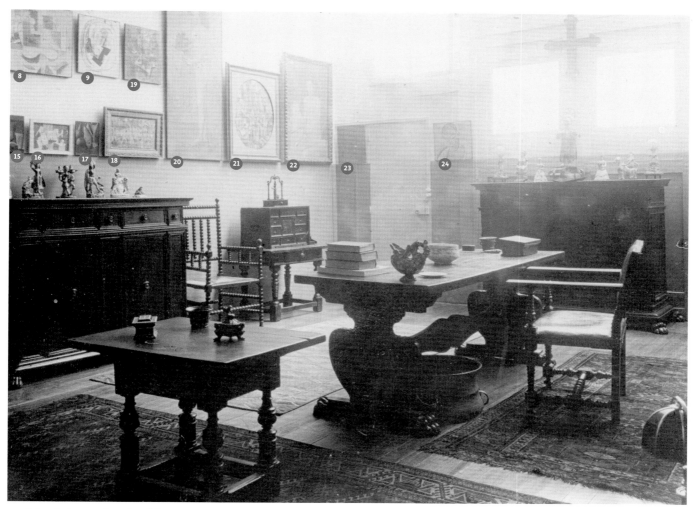

Plate 358 (west and north walls)

Rue de Fleurus, 1922

Man Ray photographs Gertrude and Alice in their atelier in 1922.

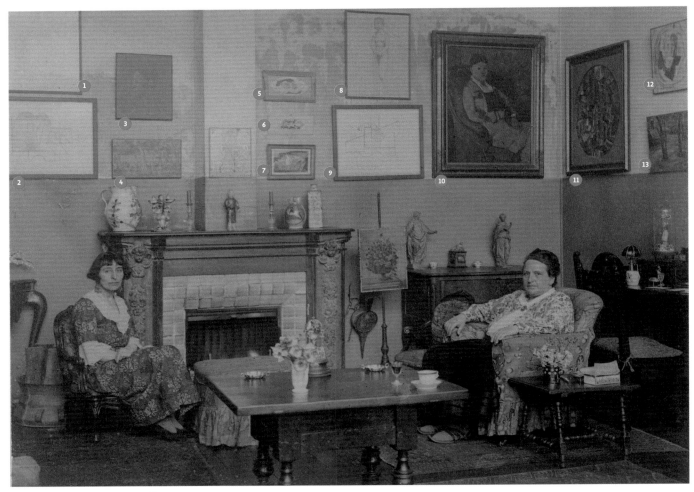

Plate 359 (south and west walls)

1 **Pablo Picasso,** *Two Standing Nudes,* 1906 (cat. 342)
2 **Pablo Picasso,** *Study of a Violin,* 1912 (cat. 378)
3 **Pablo Picasso,** *Profile of a Young Boy,* 1905 (cat. 288)
4 **Paul Cézanne,** *Bathers,* 1898–1900 (pl. 36, cat. 14)
5 Unidentified still life, possibly by **Georges Braque** (cat. 4)
6 Unidentified still life, possibly by **Georges Braque** (cat. 5)
7 Unidentified still life, possibly by **Georges Braque** (cat. 6)
8 **Pablo Picasso,** *Standing Nude, Hands Clasped,* 1906 (cat. 333)
9 **Pablo Picasso,** *Guitar on a Table,* 1912 (cat. 377)
10 **Paul Cézanne,** *Madame Cézanne with a Fan,* 1878–88 (pl. 2, cat. 10)
11 **Pablo Picasso,** *The Architect's Table,* 1912 (pl. 197, cat. 260)

12 **Pablo Picasso,** *Segment of Pear, Wineglass, and Ace of Clubs,* 1914 (cat. 379)
13 Unidentified landscape, possibly by **Dora Maar**
14 **Pablo Picasso,** *Nude with Joined Hands,* 1906 (pl. 74, cat. 237)
15 **Juan Gris,** *Book and Glasses,* 1914 (pl. 242, cat. 68)
16 **Pablo Picasso,** *Student with a Pipe,* 1914 (pl. 233, cat. 265)
17 **Pablo Picasso,** *Landscape with Two Figures,* 1908 (pl. 185, cat. 244)
18 **Pablo Picasso,** *Guitar on a Table,* 1912 (pl. 232, cat. 263)
19 **Pablo Picasso,** *Le Journal,* 1912 (cat. 259)
20 **Pablo Picasso,** *The Small Glass,* 1912 (cat. 261)
21 **Pablo Picasso,** *Guitarist with Sheet Music,* 1913 (pl. 188, cat. 390)

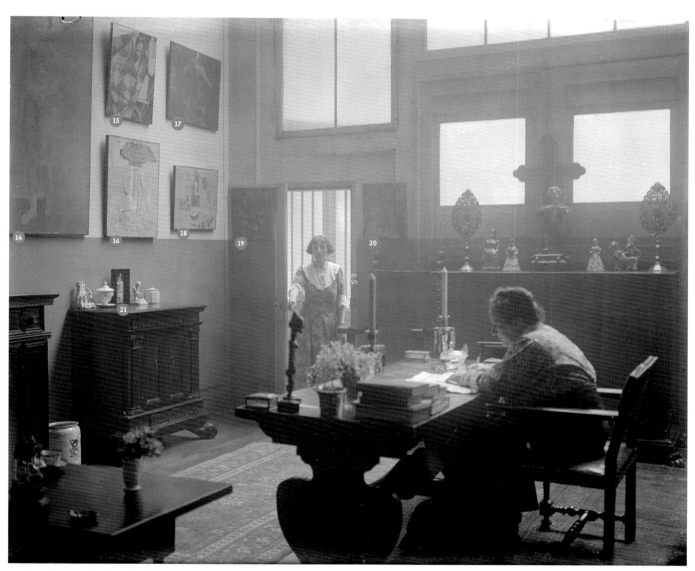

Plate 360 (west and north walls)

Rue de Fleurus, 1933–1934

This photograph of the atelier was reproduced in the March 30, 1934, edition of *Gazette des beaux-arts*, where it was noted as representing the atelier in its current state. Francis Picabia's portrait of Gertrude from the prior year (no. 22) hangs on the west wall.

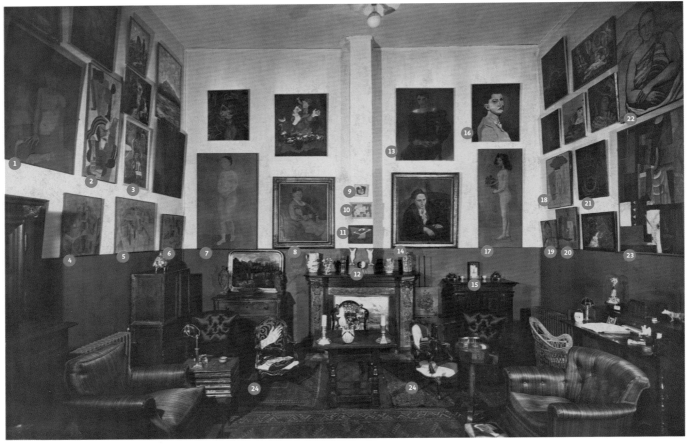

Plate 361 (east, south, and west walls)

1 **Pablo Picasso,** *Seated Nude,* 1905 (pl. 71, cat. 233)
2 **Pablo Picasso,** *Woman with a Guitar,* 1914 (pl. 235, cat. 266)
3 **Francis Rose,** *Portrait of Alice B. Toklas,* 1932 (cat. 418)
4 **Pablo Picasso,** *The Reservoir, Horta de Ebro,* 1909 (pl. 229, cat. 256)
5 **Pablo Picasso,** *Houses on a Hill, Horta de Ebro,* 1909 (pl. 230, cat. 257)
6 **Pablo Picasso,** *Guitar on a Table,* 1912 (pl. 232, cat. 263)
7 **Pablo Picasso,** *Nude with Joined Hands,* 1906 (pl. 74, cat. 237)
8 **Paul Cézanne,** *Madame Cézanne with a Fan,* 1878–88 (pl. 2, cat. 10)
9 **Pablo Picasso,** *Guitar,* 1918 (pl. 239, cat. 383)
10 **Pablo Picasso,** *Segment of Pear, Bunch of Grapes, and Pipe,* 1914 (cat. 381)
11 **Juan Gris,** *Dish of Pears,* 1926 (cat. 73)
12 **Pablo Picasso,** *Head,* 1928 (pl. 240, cat. 391)
13 Unidentified portrait, possibly by **Francis Rose**

14 **Pablo Picasso,** *Gertrude Stein,* 1905–6 (pl. 183, cat. 238)
15 **Pablo Picasso,** *Guitarist with Sheet Music,* 1913 (pl. 188, cat. 390)
16 Unidentified portrait, possibly by **Francisco Riba-Rovira**
17 **Pablo Picasso,** *Girl with a Basket of Flowers,* 1905 (pl. 9, cat. 232)
18 **Pablo Picasso,** *Student with a Pipe,* 1914 (pl. 233, cat. 265)
19 **Pablo Picasso,** *Head of a Sailor* (Study for *The Sailor*), 1906–7 (cat. 240)
20 **Pablo Picasso,** *Violin,* 1912 (pl. 231, cat. 262)
21 **Francis Picabia,** *Pa,* 1932 (pl. 249, cat. 219)
22 **Francis Picabia,** *Gertrude Stein,* 1933 (pl. 250, cat. 220)
23 **Pablo Picasso,** *Man with a Guitar,* 1913 (pl. 234, cat. 264)
24 **Pablo Picasso and Alice Toklas,** Upholstery for armchairs, ca. 1930
 (pl. 204, cat. 392)

Rue Madame, 1906

In 1904 Sarah and Michael take up residence at 58 rue Madame in Paris. This photograph of their main room was taken after their purchase of Henri Matisse's *Fruit Trees in Blossom* (no. 3) on April 10, 1906, and before the renovation of the space later that year.

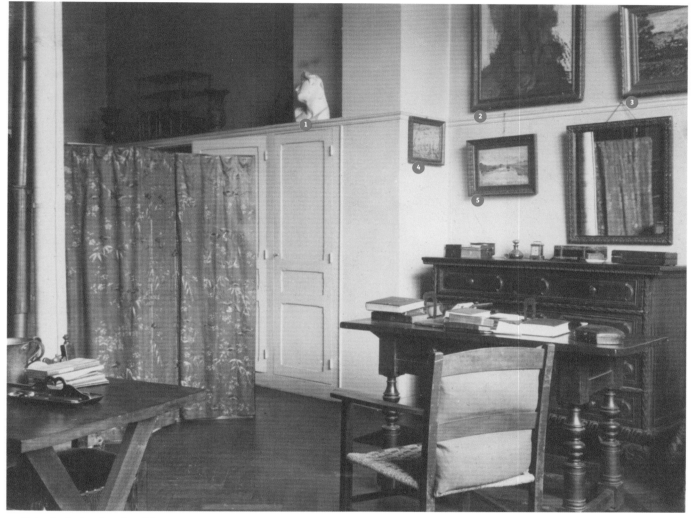

Plate 362 (east and south walls)

1 Plaster copy of **Michelangelo**'s *Dying Slave*
2 **Henri Matisse**, *Faith, the Model*, ca. 1901 (pl. 135, cat. 102)
3 **Henri Matisse**, *Fruit Trees in Blossom*, 1898 (cat. 92)
4 **Paul Cézanne**, *Bathers*, 1897 (cat. 27)
5 **Henri Matisse**, *Canal du Midi*, 1898 (pl. 57, cat. 91)

Rue Madame, 1907

These photographs were taken to record the renovated main room at rue Madame, which Sarah had nearly finished decorating in January 1907. Felix Vallotton's nude (no. 4), hanging on the north wall, will be replaced by Henri Matisse's *Le Luxe I* (1907; pl. 101) before the year's end.

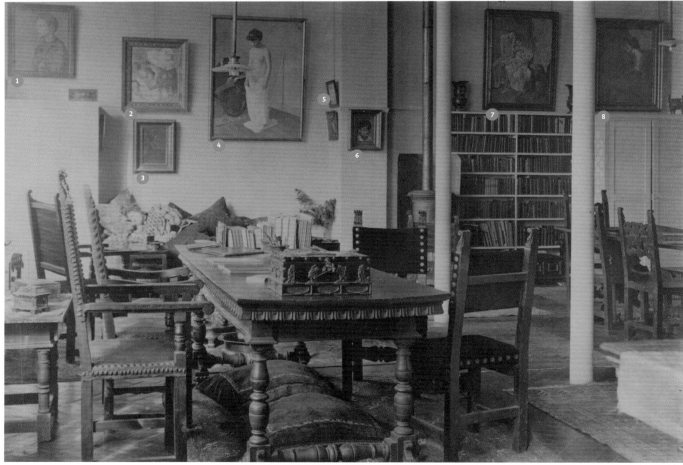

Plate 363 (north wall)

1 **Pablo Picasso,** *Allan Stein*, 1906 (pl. 179, cat. 324)
2 **Pierre-Auguste Renoir,** *The Hat Pinned with Flowers*, 1898 (cat. 413)
3 **Paul Gauguin,** *Head of a Tahitian Girl*, ca. 1892 (cat. 62)
4 **Félix Vallotton,** *Standing Nude Holding Her Chemise with Two Hands*, 1904 (pl. 180, cat. 439)
5 **Paul Cézanne,** *Bathers*, 1897 (cat. 27)
6 Unidentified portrait of a man
7 **Pablo Picasso,** *The Acrobat Family*, 1905 (pl. 22, cat. 291)

8 **Pablo Picasso,** *Melancholy Woman*, 1902 (pl. 176, cat. 231)
9 **Henri Matisse,** *Canal du Midi*, 1898 (pl. 57, cat. 91)
10 **Paul Cézanne,** *Bathers*, ca. 1892 (pl. 129, cat. 11)
11 **Henri Matisse,** *Still Life with Blue Jug*, ca. 1900–1903 (pl. 131, cat. 106)
12 **Henri Charles Manguin,** *La Coiffure*, 1905 (pl. 18, cat. 83)
13 **Pablo Picasso,** *Strolling Player and Child*, 1905 (pl. 178, cat. 290)
14 **Henri Matisse,** Sketch for *Marguerite Reading*, 1906 (pl. 152, cat. 123)
15 **Pablo Picasso,** *Soup*, 1902 (pl. 177, cat. 228)

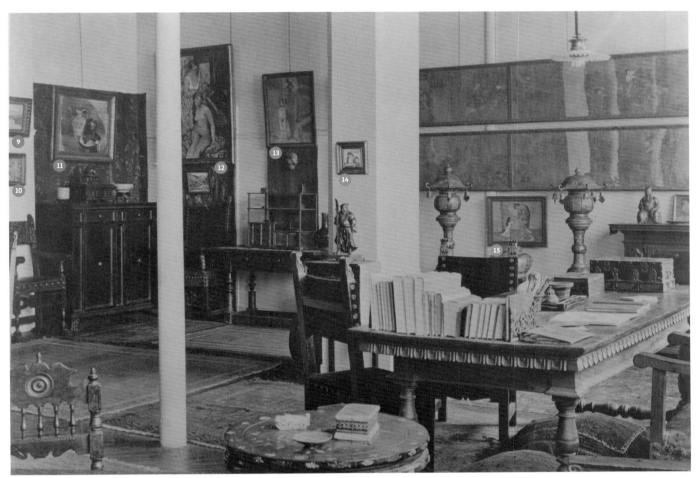

Plate 364 (east and south walls)

Rue Madame, winter 1907–1908

By December 1907 the north wall of the main room is dominated by Henri Matisse's *Le Luxe I* (no. 8). Hanging nearby is Matisse's drawing *Sailboat in the Harbor at Collioure* (no. 5), which is inscribed to Allan and dated November 7, 1907. The east wall now pays homage to Matisse as well, and guests at the dining table are seated at eye level with the newly acquired *Blue Still Life* (no. 20).

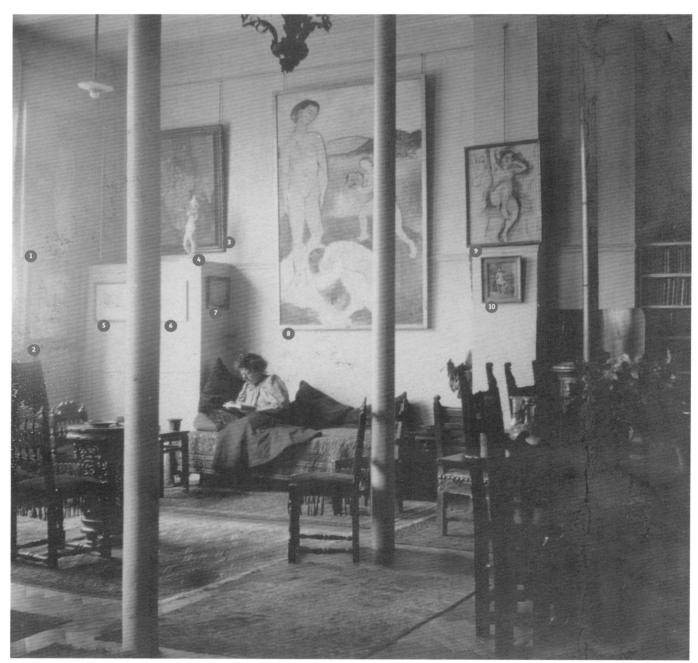

Plate 365 (north wall)

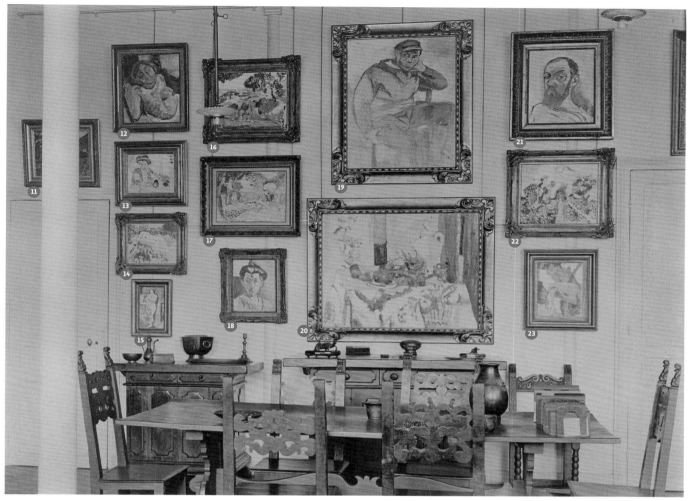

Plate 366 (east wall)

1 **Félix Vallotton,** *Standing Nude Holding Her Chemise with Two Hands,* 1904 (pl. 180, cat. 439)
2 **Pierre-Auguste Renoir,** *The Hat Pinned with Flowers,* 1898 (cat. 413)
3 **Pablo Picasso,** *The Acrobat Family,* 1905 (pl. 22, cat. 291)
4 **Henri Matisse,** *Madeleine I,* 1901 (cat. 197A)
5 **Henri Matisse,** *Sailboat in the Harbor at Collioure,* 1905 (cat. 162)
6 **Henri Matisse,** *Reclining Nude,* ca. 1906 (pl. 146, cat. 167)
7 **Paul Cézanne,** *Bathers,* 1897 (cat. 27)
8 **Henri Matisse,** *Le Luxe I,* 1907 (pl. 101, cat. 142)
9 **Henri Matisse,** *Seated Nude,* ca. 1906 (pl. 148, cat. 168)
10 **Henri Matisse,** *Nude,* ca. 1901–3 (cat. 158)
11 **Henri Matisse,** *Fruit Trees in Blossom,* 1898 (cat. 92)

12 **Henri Matisse,** *The Gypsy,* 1905–6 (pl. 29, cat. 118)
13 **Henri Matisse,** *Woman in a Kimono,* ca. 1906 (pl. 90, cat. 135)
14 **Henri Matisse,** *Nude Reclining Woman,* 1906 (cat. 125)
15 **Henri Matisse,** *Nude before a Screen,* 1905 (cat. 112)
16 **Henri Matisse,** *Landscape at Collioure,* 1906 (cat. 121)
17 **Henri Matisse,** Sketch for *Le Bonheur de vivre,* 1905–6 (pl. 142, cat. 116)
18 **Henri Matisse,** *Madame Matisse (The Green Line),* 1905 (pl. 88, cat. 110)
19 **Henri Matisse,** *The Young Sailor I,* 1906 (pl. 157, cat. 133)
20 **Henri Matisse,** *Blue Still Life,* 1907 (cat. 140)
21 **Henri Matisse,** *Self-Portrait,* 1906 (pl. 138, cat. 131)
22 **Henri Matisse,** *Madame Matisse in the Olive Grove,* 1905 (cat. 111)
23 **Henri Matisse,** *La Pudeur (L'Italienne),* 1906 (cat. 126)

Rue Madame, ca. early 1908

Important acquisitions made during the second half of 1907—including Henri Matisse's *La Coiffure* (no. 10), *Pink Onions* (no. 1), and *Red Madras Headdress* (no. 21)—now hang in the main room. The artist's small bronze sculptures also appear for the first time. Purchases made from the May 1908 Fayet sale are not visible in these photographs; they will subsequently hang on the south wall.

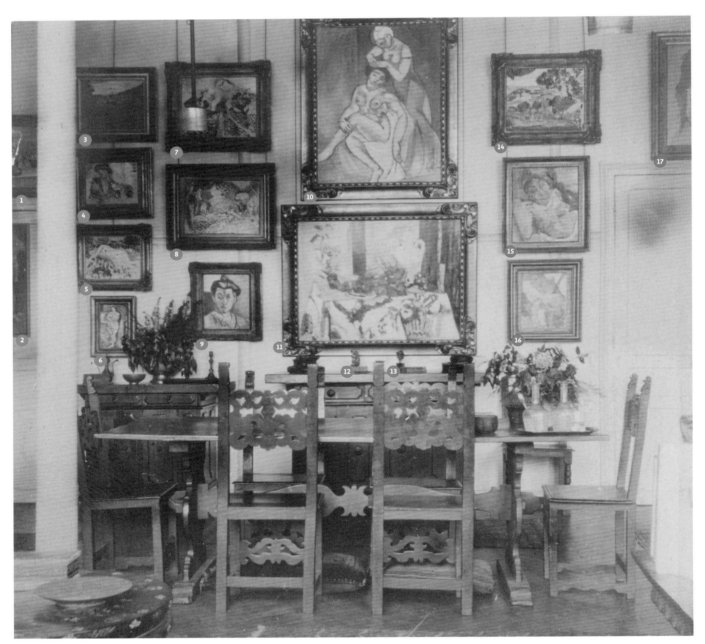

Plate 367 (east wall)

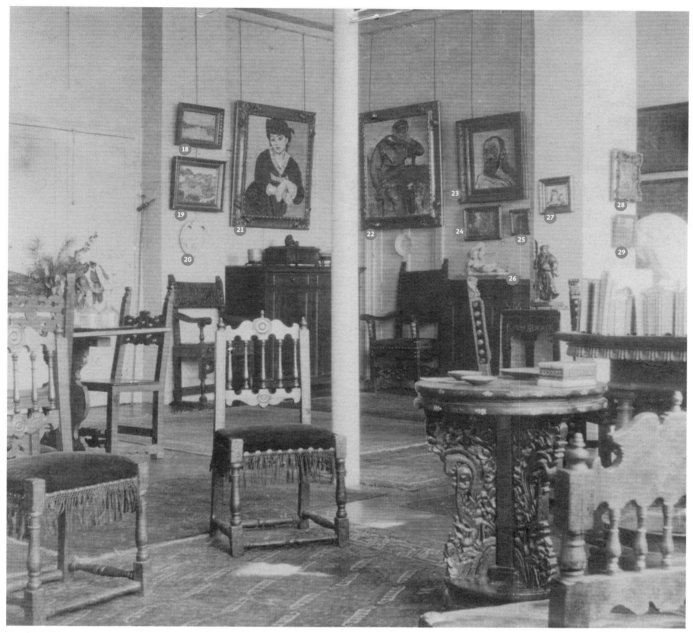

Plate 368 (east and south walls)

1 **Henri Matisse**, *Pink Onions*, 1906-7 (pl. 117, cat. 138)

2 **Henri Matisse**, *Male Nude*, 1900-1901 (pl. 136, cat. 100)

3 **Henri Matisse**, *Fruit Trees in Blossom*, 1898 (cat. 92)

4 **Henri Matisse**, *Woman in a Kimono*, ca. 1906 (pl. 90, cat. 135)

5 **Henri Matisse**, *Nude Reclining Woman*, 1906 (cat. 125)

6 **Henri Matisse**, *Nude before a Screen*, 1905 (cat. 112)

7 **Henri Matisse**, *Madame Matisse in the Olive Grove*, 1905 (cat. 111)

8 **Henri Matisse**, Sketch for *Le Bonheur de vivre*, 1905-6 (pl. 142, cat. 116)

9 **Henri Matisse**, *Madame Matisse (The Green Line)*, 1905 (pl. 88, cat. 110)

10 **Henri Matisse**, *La Coiffure*, 1907 (pl. 19, cat. 141)

11 **Henri Matisse**, *Blue Still Life*, 1907 (cat. 140)

12 **Henri Matisse**, *Small Crouching Nude without an Arm*, 1908 (cat. 206)

13 **Henri Matisse**, *Small Head with Comb*, 1907 (cat. 205)

14 **Henri Matisse**, *Landscape at Collioure*, 1906 (cat. 121)

15 **Henri Matisse**, *The Gypsy*, 1905-6 (pl. 29, cat. 118)

16 **Henri Matisse**, *La Pudeur (L'Italienne)*, 1906 (cat. 126)

17 **Henri Matisse**, *Marguerite*, 1901 (pl. 154, cat. 101)

18 **Henri Matisse**, *Canal du Midi*, 1898 (pl. 57, cat. 91)

19 **Henri Matisse**, *Landscape: Broom*, 1906 (pl. 143, cat. 119)

20 **Henri Matisse**, Painted ceramic plate (with three nudes), ca. 1907 (cat. 210)

21 **Henri Matisse**, *Red Madras Headdress*, 1907 (pl. 95, cat. 144)

22 **Henri Matisse**, *The Young Sailor I*, 1906 (pl. 157, cat. 133)

23 **Henri Matisse**, *Self-Portrait*, 1906 (pl. 138, cat. 131)

24 **Paul Cézanne**, *Bathers*, ca. 1892 (pl. 129, cat. 11)

25 **Paul Cézanne**, *Portrait of Paul, the Artist's Son*, ca. 1880 (pl. 128, cat. 9)

26 **Henri Matisse**, *Reclining Nude I (Aurora)*, 1907 (cat. 204A)

27 **Henri Matisse**, Sketch for *Marguerite Reading*, 1906 (pl. 152, cat. 123)

28 **Pierre-Auguste Renoir**, *Reader*, ca. 1895 (cat. 403)

29 **Pierre-Auguste Renoir**, *Landscape*, ca. 1904 (cat. 404)

Rue Madame, between January 1909 and late 1911

Henri Matisse's *Seascape (La Moulade)* (no. 8) hangs on the door leading from the main room to the kitchen after it is acquired on January 12, 1909. Sarah and Michael's purchase of Matisse's monumental *Interior with Aubergines* (1911; pl. 162) in late 1911 will necessitate a rehanging of the south wall.

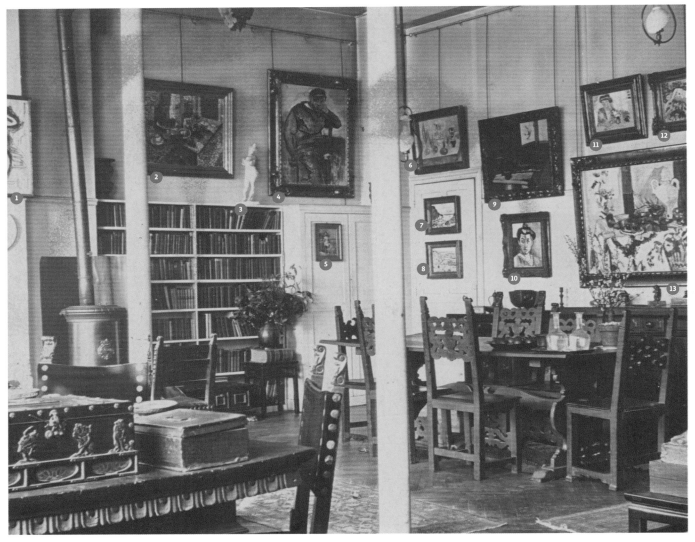

Plate 369 (north and east walls)

1 **Henri Matisse,** *Seated Nude,* ca. 1906 (pl. 148, cat. 168)
2 **Henri Matisse,** *Sideboard and Table,* 1899 (pl. 130, cat. 98)
3 **Henri Matisse,** *Madeleine I,* 1901 (cat. 197A)
4 **Henri Matisse,** *The Young Sailor I,* 1906 (pl. 157, cat. 133)
5 **Henri Matisse,** *Nude,* ca. 1901–3 (cat. 158)
6 **Henri Matisse,** *Pink Onions,* 1906–7 (pl. 117, cat. 138)
7 **Henri Matisse,** *Seascape (Beside the Sea),* 1906 (pl. 145, cat. 128)
8 **Henri Matisse,** *Seascape (La Moulade),* 1906 (pl. 144, cat. 129)
9 **Henri Matisse,** *Sculpture and Persian Vase,* 1908 (pl. 151, cat. 146)
10 **Henri Matisse,** *Madame Matisse (The Green Line),* 1905 (pl. 88, cat. 110)
11 **Henri Matisse,** *Woman in a Kimono,* ca. 1906 (pl. 90, cat. 135)
12 **Henri Matisse,** *Nude Reclining Woman,* 1906 (cat. 125)
13 **Henri Matisse,** *Blue Still Life,* 1907 (cat. 140)
14 **Henri Matisse,** *Marguerite,* 1901 (pl. 154, cat. 101)
15 **Henri Matisse,** *Landscape: Broom,* 1906 (pl. 143, cat. 119)
16 **Henri Matisse,** *André Derain,* 1905 (pl. 137, cat. 107)
17 **Henri Matisse,** *La Japonaise: Woman beside the Water,* 1905 (pl. 140, cat. 108)

18 **Henri Matisse,** *Red Madras Headdress,* 1907 (pl. 95, cat. 144)
19 **Henri Matisse,** *The Gypsy,* 1905–6 (pl. 29, cat. 118)
20 **Henri Matisse,** *Madame Matisse in the Olive Grove,* 1905 (cat. 111)
21 **Henri Matisse,** *Self-Portrait,* 1906 (pl. 138, cat. 131)
22 **Henri Matisse,** Sketch for *Le Bonheur de vivre,* 1905–6 (pl. 142, cat. 116)
23 **Henri Matisse,** *Reclining Nude I (Aurora),* 1907 (cat. 204B)
24 **Henri Matisse,** *Nude before a Screen,* 1905 (cat. 112)
25 **Henri Matisse,** *The Serf,* 1900–1903 (cat. 198)
26 **Pierre-Auguste Renoir,** *Reader,* ca. 1895 (cat. 403)
27 **Pierre-Auguste Renoir,** *Landscape,* ca. 1904 (cat. 404)
28 **Henri Matisse,** *La Coiffure,* 1907 (pl. 19, cat. 141)
29 **Henri Matisse,** *Landscape near Collioure* [Study for *Le Bonheur de vivre*], 1905 (pl. 141, cat. 109)
30 **Henri Matisse,** *Still Life with Chocolate Pot,* 1900–1902 (pl. 133, cat. 104)
31 **Henri Matisse,** *Pont Saint-Michel,* 1901–2 (pl. 132, cat. 105)
32 **Henri Matisse,** *Fruit Trees in Blossom,* 1898 (cat. 92)

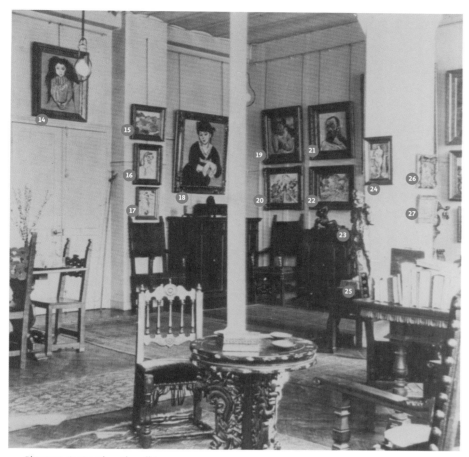

Plate 370 (east and south walls)

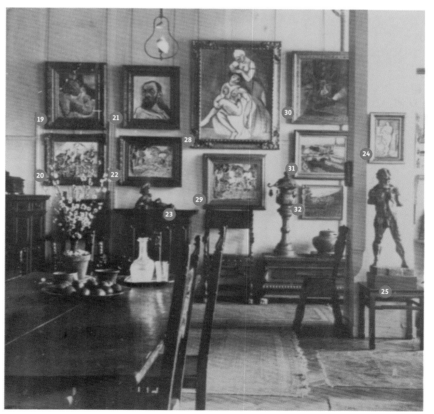

Plate 371 (south wall)

Rue Madame, between December 1911 and July 1914

In a letter to Claribel Cone from December 1911, Michael recounts that the Steins' recent purchase of a very large canvas has forced them to rehang their main room (see cat. 149). The work in question, Henri Matisse's *Interior with Aubergines* (no. 15), can be seen here on the south wall. Nearly three years later, in July 1914, nineteen of Sarah and Michael's Matisses are shipped to the Kunstsalon Fritz Gurlitt in Berlin for an exhibition. The works are confiscated during World War I and never return to their owners.

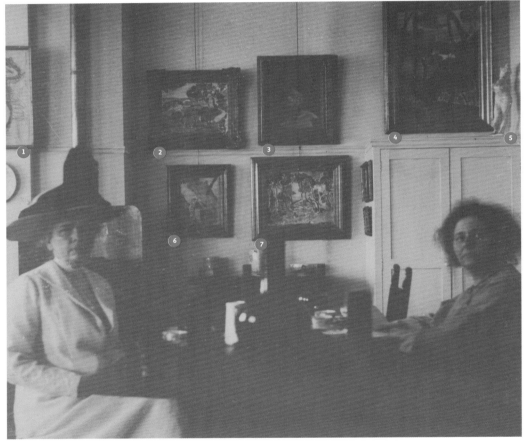

Plate 372 (north wall)

1 **Henri Matisse**, *Seated Nude*, ca. 1906 (pl. 148, cat. 168)

2 **Henri Matisse**, *Landscape at Collioure*, 1906 (cat. 121)

3 **Henri Matisse**, *Woman with Black Hair*, ca. 1902 (cat. 99)

4 **Henri Matisse**, *View of Collioure*, 1907 (pl. 158, cat. 145)

5 **Henri Matisse**, *Madeleine I*, 1901 (cat. 197A)

6 **Henri Matisse**, *La Pudeur (L'Italienne)*, 1906 (cat. 126)

7 **Henri Matisse**, *Landscape near Collioure* [Study for *Le Bonheur de vivre*], 1905 (pl. 141, cat. 109)

8 **Henri Matisse**, *Fontainebleau Forest (Autumn Landscape)*, 1909 (pl. 161, cat. 147)

9 **Henri Matisse**, *Sculpture and Persian Vase*, 1908 (pl. 151, cat. 146)

10 **Henri Matisse**, *Marguerite*, 1901 (pl. 154, cat. 101)

11 **Henri Matisse**, *Woman in a Kimono*, ca. 1906 (pl. 90, cat. 135)

12 **Henri Matisse**, *Madame Matisse (The Green Line)*, 1905 (pl. 88, cat. 110)

13 **Henri Matisse**, *Red Madras Headdress*, 1907 (pl. 95, cat. 144)

14 **Henri Matisse**, *Reclining Nude I (Aurora)*, 1907 (cat. 204B)

15 **Henri Matisse**, *Interior with Aubergines*, 1911 (pl. 162, cat. 149)

16 **Henri Matisse**, *Nude before a Screen*, 1905 (cat. 112)

17 **Henri Matisse**, *The Serf*, 1900-1903 (cat. 198)

18 **Pierre-Auguste Renoir**, *Reader*, ca. 1895 (cat. 403)

19 **Pierre-Auguste Renoir**, *Landscape*, ca. 1904 (cat. 404)

20 **Henri Matisse**, *La Coiffure*, 1907 (pl. 19, cat. 141)

21 **Henri Matisse**, *Self-Portrait*, 1906 (pl. 138, cat. 131)

22 **Henri Matisse**, *Pink Onions*, 1906-7 (pl. 117, cat. 138)

23 **Henri Matisse**, *Still Life with Blue Jug*, ca. 1900-1903 (pl. 131, cat. 106)

24 **Henri Matisse**, *Still Life with Chocolate Pot*, 1900-1902 (pl. 133, cat. 104)

25 **Henri Matisse**, *La Japonaise: Woman beside the Water*, 1905 (pl. 140, cat. 108)

26 **Henri Matisse**, *André Derain*, 1905 (pl. 137, cat. 107)

27 **Henri Matisse**, *Landscape: Broom*, 1906 (pl. 143, cat. 119)

28 **Henri Matisse**, *Male Nude*, 1900-1901 (pl. 136, cat. 100)

29 **Henri Matisse**, *Nude in a Landscape*, 1906 (pl. 91, cat. 124)

30 **Henri Matisse**, *Ajaccio*, 1898 (cat. 90)

31 **Henri Matisse**, *Marguerite in Three Poses*, 1906 (pl. 153, cat. 165)

32 **Henri Matisse**, *Nude*, ca. 1901-3 (cat. 158)

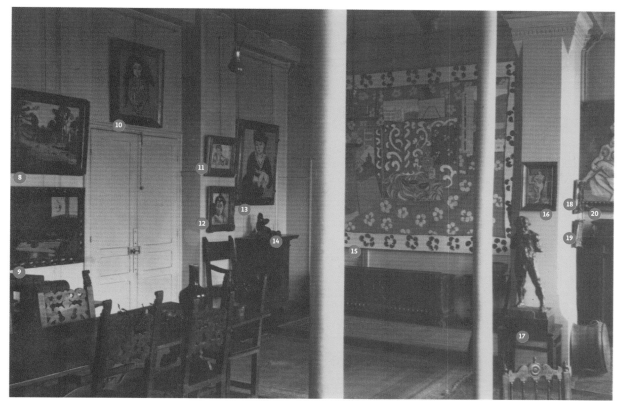

Plate 373 (east and south walls)

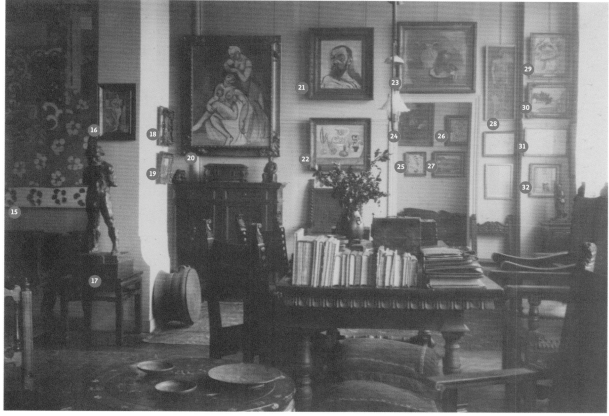

Plate 374 (south wall)

Rue de la Tour, between August 1922 and spring 1928

From 1922 to 1928 Sarah and Michael live at 59 rue de la Tour in Paris, where they share an apartment with Gabrielle Colaço-Osorio and her daughter Jacqueline. A substantial portion of Sarah and Michael's collection has been lost during World War I. Henri Matisse's 1916 portraits of the collectors (nos. 1, 2) hang prominently in one of the salons.

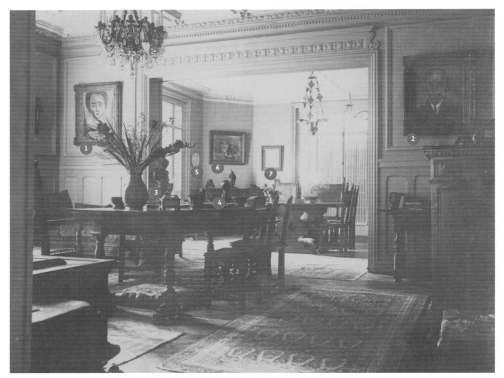

Plate 375 (salons)

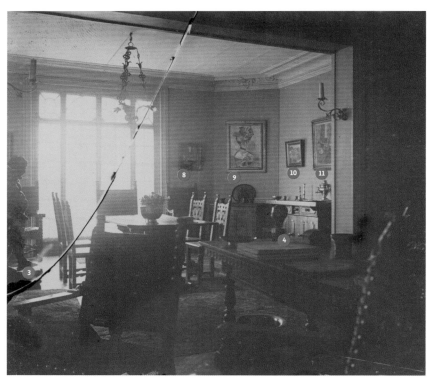

Plate 376 (salons)

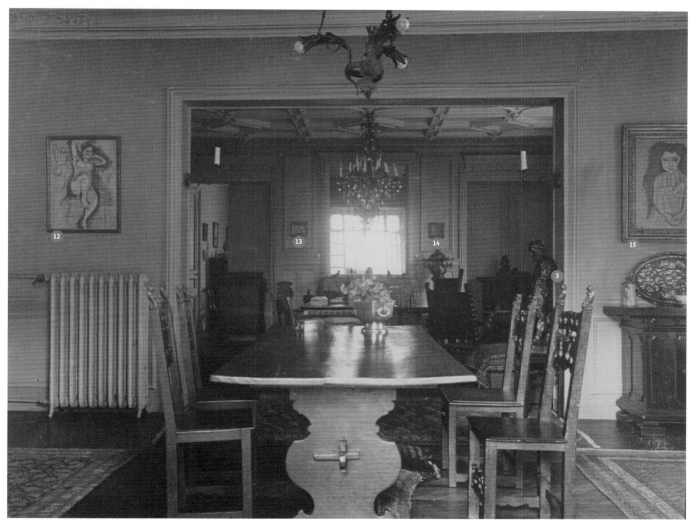

Plate 377 (salons)

1 **Henri Matisse,** *Sarah Stein*, 1916 (pl. 83, cat. 152)
2 **Henri Matisse,** *Michael Stein*, 1916 (pl. 84, cat. 151)
3 **Henri Matisse,** *The Serf*, 1900-1903 (cat. 198)
4 **Henri Matisse,** *Head of a Child (Pierre Matisse)*, 1904-5 (cat. 200)
5 **Henri Matisse,** Painted ceramic plate (with three nudes), ca. 1907 (cat. 210)
6 **Henri Matisse,** *Still Life with Blue Jug*, 1900-1903 (pl. 131, cat. 106)
7 **Henri Matisse,** *La Pudeur (L'Italienne)*, 1906 (cat. 126)
8 **Henri Matisse,** *Nude in a Forest*, 1909-12 (cat. 150)

9 **Henri Matisse,** *Woman with a Hat*, 1905 (pl. 13, cat. 113)
10 **Henri Matisse,** *Landscape: Broom*, 1906 (pl. 143, cat. 119)
11 **Henri Matisse,** *Sideboard and Table*, 1899 (pl. 130, cat. 98)
12 **Henri Matisse,** *Seated Nude*, ca. 1906 (pl. 148, cat. 168)
13 **Henri Matisse,** Sketch for *Marguerite Reading*, 1906 (pl. 152, cat. 123)
14 **Paul Cézanne,** *Portrait of Paul, the Artist's Son*, ca. 1880 (pl. 128, cat. 9)
15 **Henri Matisse,** *Marguerite*, 1901 (pl. 154, cat. 101)

Villa Stein–de Monzie, between spring 1928 and July 1935

In May 1926 Sarah and Michael Stein, together with Gabrielle Colaço-Osorio, commission Le Corbusier to design a villa for them in Vaucresson, outside Paris. The two families move in to the completed structure in spring 1928. These photographs show the Steins' artworks and furniture in dialogue with their new, ultramodern living room. (For additional pictures of the villa, see pls. 118-27.)

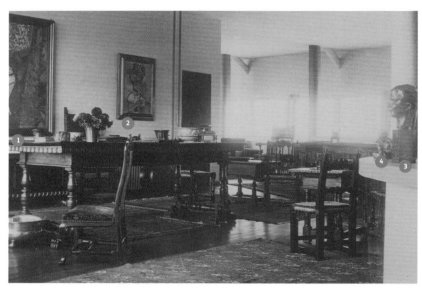

Plate 378 (living room)

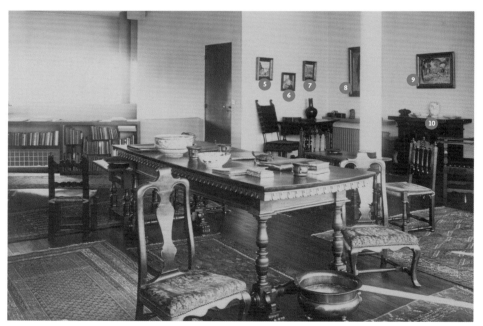

Plate 379 (living room)

1 **Henri Matisse,** *Tea*, 1919 (pl. 99, cat. 155)	6 **Henri Matisse,** *Girl Reading*, ca. 1925 (pl. 170, cat. 156)
2 **Henri Matisse,** *Woman with a Hat*, 1905 (pl. 13, cat. 113)	7 **Henri Matisse,** *Seascape (La Moulade)*, 1906 (pl. 144, cat. 129)
3 **Henri Matisse,** *Head of a Child (Pierre Matisse)*, 1904-5 (cat. 200)	8 **Henri Matisse,** *Marguerite*, 1901 (pl. 154, cat. 101)
4 **Henri Matisse,** *Woman Leaning on Her Hands*, 1905 (cat. 201)	9 **Henri Matisse,** Sketch for *Le Bonheur de vivre*, 1905-6 (pl. 142, cat. 116)
5 **Henri Matisse,** *Seascape (Beside the Sea)*, 1906 (pl. 145, cat. 128)	10 **Henri Matisse,** Painted ceramic vase, ca. 1907 (pl. 160, cat. 211)

Kingsley Avenue, between September 1935 and the late 1940s

Sarah and Michael Stein leave France for Palo Alto in 1935, taking up residence at 433 Kingsley Avenue. Nearly all of the artworks in these photographs will remain in Sarah's hands through the late 1940s, when she gives away a number of pieces to friends and sells others to retire the debts of her grandson Daniel.

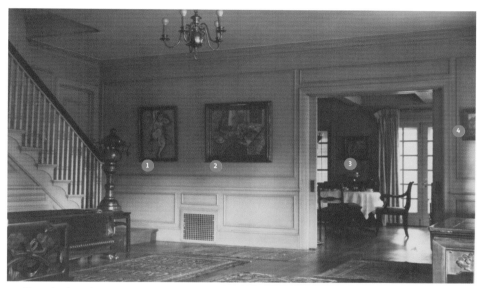

Plate 380 (entry)

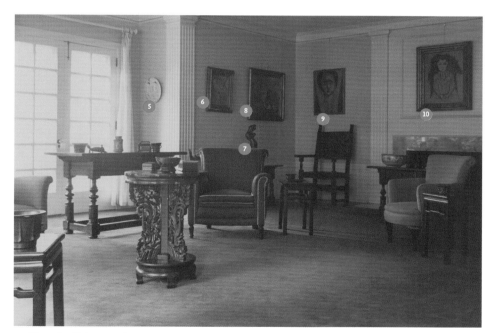

Plate 381 (living room)

1 **Henri Matisse,** *Seated Nude,* ca. 1906 (pl. 148, cat. 168)
2 **Henri Matisse,** *Sideboard and Table,* 1899 (pl. 130, cat. 98)
3 **Henri Matisse,** *Woman in a Kimono,* ca. 1906 (pl. 90, cat. 135)
4 **Henri Matisse,** *Landscape with Cypresses and Olive Trees near Nice,* 1918 (pl. 165, cat. 154)
5 **Henri Matisse,** Painted ceramic plate (with three nudes), ca. 1907 (cat. 210)

6 **Henri Matisse,** *La Pudeur (L'Italienne),* 1906 (cat. 126)
7 **Henri Matisse,** *Madeleine I,* 1901 (cat. 197B)
8 **Henri Matisse,** *Still Life with Blue Jug,* ca. 1900-1903 (pl. 131, cat. 106)
9 **Henri Matisse,** *Sarah Stein,* 1916 (pl. 83, cat. 152)
10 **Henri Matisse,** *Marguerite,* 1901 (pl. 154, cat. 101)

Rue Christine, ca. 1938

In early 1938 Alice and Gertrude take an apartment at 5 rue Christine in Paris. Cecil Beaton photographs Gertrude around this time. The salon contains the most iconic artworks, some of which are hung on mirrors.

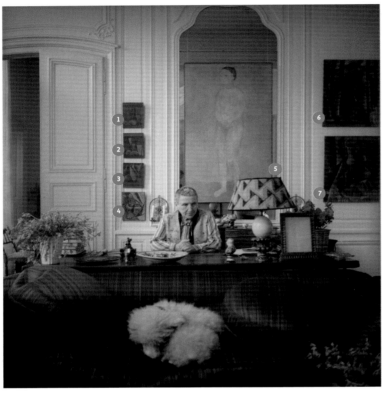

Plate 382 (salon)

Plate 383 (salon)

1 **Pablo Picasso,** *Glasses and Fruit*, 1908 (pl. 224, cat. 249)
2 **Pablo Picasso,** *Glasses and Fruit*, 1908 (pl. 225, cat. 250)
3 **Pablo Picasso,** *Still Life with Fruit and Glass*, 1908 (cat. 253)
4 **Pablo Picasso,** *Pitcher, Jar, and Lemon*, 1907 (pl. 208, cat. 362)
5 **Pablo Picasso,** *Nude with Joined Hands*, 1906 (pl. 74, cat. 237)
6 **Pablo Picasso,** *La Rue-des-Bois*, 1908 (pl. 226, cat. 245)
7 **Pablo Picasso,** *Vase, Gourd, and Fruit on a Table*, 1908 (pl. 227, cat. 254)
8 **Juan Gris,** *Woman with Clasped Hands*, 1924 (pl. 246, cat. 71)
9 **Juan Gris,** *The Table in Front of the Window*, 1921 (pl. 244, cat. 70)

10 **Pablo Picasso,** *Self-Portrait*, 1906 (pl. 81, cat. 239)
11 **Pablo Picasso,** *Gertrude Stein*, 1905-6 (pl. 183, cat. 238)
12 **Paul Cézanne,** *Madame Cézanne with a Fan*, 1878-88 (pl. 2, cat. 10)
13 **Pablo Picasso,** *Guitarist with Sheet Music*, 1913 (pl. 188, cat. 390)
14 **Pablo Picasso,** *Head of a Woman in Brown and Black*, 1907 (pl. 210, cat. 365)
15 **Pablo Picasso,** Study for *Nude with Drapery*, 1907 (pl. 213, cat. 371)
16 **Pablo Picasso,** Study of head for *Nude with Drapery*, 1907 (cat. 368)
17 **Pablo Picasso,** Study for *Nude with Drapery*, 1907 (cat. 367)
18 **Pablo Picasso,** *Apple*, 1914 (pl. 238, cat. 382)

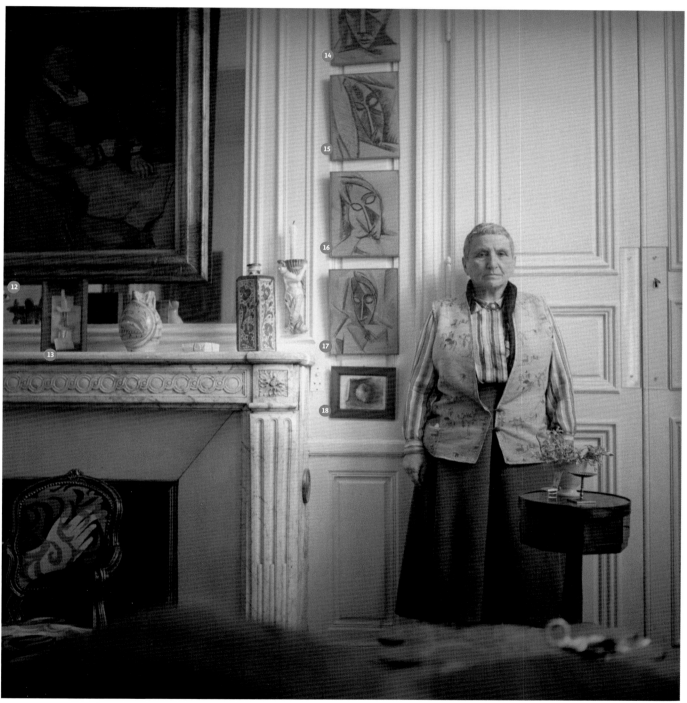

Plate 384 (salon)

Catalogue of the Stein Collections
Robert McD. Parker

The following inventory documents the artworks that were owned by Gertrude Stein, Leo Stein, Michael Stein, Sarah Stein, and Alice Toklas. For practical purposes, the list has been confined primarily to holdings in Western avant-garde art substantiated by archival documentation.

Given the scope of this exhibition and limited catalogue space, certain aspects of the Steins' collecting habits are not captured here. The inventory does not purport to offer a complete accounting of the numerous works on paper possessed by family members. Instead, the decision has been made to focus on the drawings for which we have documentary or photographic evidence of Stein provenance and the prints that are illustrated in this volume and/or included in the accompanying exhibition (see the list of works in the exhibition on pages 458-67). In addition, no attempt has been made to record Leo's collection of Native American artifacts (gold, stone, and ceramic objects), which was purchased by Thea Heye before 1928 and is now part of the Smithsonian Institution's National Museum of the American Indian. The photographs of the Stein residences on pages 360-93 of this volume attest to the Steins' interest in other types of decorative objects and non-Western art. Their collections of Renaissance-style antiques, Asian art, and old and rare books are among the categories not addressed here.

The list that follows is organized alphabetically by artist. Within each artist's output, the artworks are presented by medium in the following order: paintings, works on paper (in which drawings precede graphics), sculpture, and other. The works are then ordered by creation date, based on the relevant catalogue raisonné and augmented by the most recent scholarship. Established dates precede circa dates; if a work was executed over a period of time, it is classified by the year of completion (final year in the date range). The only exception to this rule is the section devoted to Picasso; for ease of identification, the works within each medium are ordered according to the sequence established by Christian Zervos in his multivolume publication *Pablo Picasso*, even if the dating of individual works has shifted in light of subsequent research.

Titles, with few exceptions, have been translated into English. Where possible, the preferred naming conventions of the current owner have been honored.

Medium and dimensions have been provided by the owners or custodians of the works, augmented in some cases by firsthand observation by members of the exhibition team. For works on paper, the dimensions correspond to the sheet size unless otherwise indicated.

If an artwork appears in a catalogue raisonné or authoritative exhibition catalogue, the relevant publication is identified by author name, followed by the number assigned to the work therein. See the References section on pages 468-79 of this volume for full citations.

The plate references provided for each artwork include both dedicated color illustrations and archival photographs of the Stein residences in which the work appears.

The provenance record for each artwork focuses mainly on the life of the object as it entered and exited the Steins' collections. Additional provenance from the periods before and after the Steins' acquisition of a given work has been provided on a limited basis, in cases where such information is not readily available to scholars. The use of the term *acquired* indicates a firm acquisition date with a cited reference or supporting archival document.

In the notes for each artwork, the presence of the symbol + followed by a number directs the reader to a legend of additional information and documentation, which can be found at the conclusion of this section (pages 455-57).

Archives, exhibitions, and publications are cited in the notes in abbreviated form. Full citations are provided in the References section on pages 468-79.

Finally, the creation of a document of this scale requires many hands and many heads. Janet Bishop, Cécile Debray, Carrie Pilto, and Rebecca Rabinow shared their research and offered invaluable input. Maxime Touillet and Hilary Floe assisted in researching and compiling the information.

CHRISTIAN BÉRARD

French, born 1902, Paris; died 1949, Paris

1. *Gertrude Stein*, 1928
Ink on paper
13½ x 10½ in. (34.3 x 26.7 cm)
Yale Collection of American Literature, Beinecke
Rare Book and Manuscript Library, Yale University,
New Haven

Provenance

Gertrude Stein, Paris (until 1946; thereafter, her estate[1]
and Alice Toklas); Yale Collection of American
Literature, Beinecke Rare Book and Manuscript Library,
Yale University[2]

Notes

1. Potter 1970, 155.
2. Gift of Alice B. Toklas and Allan Stein, Beinecke
YCAL records.

EUGENE BERMAN

American, born 1899, Saint Petersburg, Russia;
died 1972, Rome

2. *Portrait of Alice B. Toklas*,[1] ca. 1930
India ink on paper
24⅞ x 18¾ in. (55.9 x 43.2 cm)
Charles E. Young Research Library, UCLA Library
Special Collections

Provenance

Alice B. Toklas, Paris (until 1945); private collection
(after 1945[2]); Charles E. Young Research Library, UCLA
Library Special Collections

Notes

1. An unfinished drawing of Gertrude Stein is on the
verso. Charles E. Young Research Library, UCLA
Library Special Collections. This work is one of at
least three representing Gertrude Stein that Gilbert
Harrison gave to UCLA in 1974.
2. Potter 1970, 155. The work was "given to an Air Force
colonel just after the war," according to Margaret
Potter (to Donald Gallup, November 2, 1970, MoMA
Archives, Potter 2).

PIERRE BONNARD

French, born 1867, Fontenay-aux-Roses, France;
died 1947, Le Cannet, France

3. *Siesta*, 1900
Oil on canvas, signed lower right
42⅞ x 52 in. (109 x 132 cm)
National Gallery of Victoria, Melbourne, Australia,
Felton Bequest, 1949
Dauberville (1992) 227
Plates 14, 346

Provenance

Leo and Gertrude Stein, Paris (after November 1905[1]
until January 1907 [pl. 346]); Ambroise Vollard,
Paris (acquired January 21, 1907[2]); Galerie Bernheim-
Jeune, Paris; Lord Kenneth Clark, Hythe, England;
Mrs. S. Kaye, London; Lefevre Gallery, London;
National Gallery of Victoria (1949)[3]

Notes

1. The painting exhibited in the 1905 Salon d'Automne
as no. 152, "Sommeil," can now be identified as the
present work. In his critique of the salon, Charles
Morice (1905f, 381) wrote: "[In] Bonnard's Siesta—that
woman sprawled out—the human appearance recedes
to the level of things, and it is an exaggerated, truly
false still life" (translation by Erin Hyman). See Rebecca
Rabinow's discussion of the work in this volume, 39.
2. Vollard agenda entry for January 21, 1907. +1
3. Additional provenance provided in *Bonnard: The Late
Paintings* (Paris 1984, 110).

GEORGES BRAQUE

French, born 1882, Argenteuil, France; died 1963, Paris

PAINTING

4. *Still Life*, n.d.
Current location unknown
Plate 359

Provenance

Gertrude Stein, Paris (until at least March 1937[1,2])

Notes

1. One of three Braque still lifes listed in the Lloyds of
London insurance policy dated March 12, 1937 (Ransom
Center), issued to Gertrude Stein at 27 rue de Fleurus;
the three works hang over the fireplace in a 1922
photograph by Man Ray of Alice Toklas and Gertrude
Stein in the atelier (pl. 359).
2. It is believed that Gertrude Stein sold her three works
by Braque over the course of 1937, when she was also
in the process of selling *Seated Nude* by Picasso (1905;
cat. 233). +2

5. *Still Life*, n.d.
Current location unknown
Plate 359

Provenance

Gertrude Stein, Paris (until at least March 1937[1,2])

Notes

1. One of three Braque still lifes listed in the Lloyds of
London insurance policy dated March 12, 1937 (Ransom
Center), issued to Gertrude Stein at 27 rue de Fleurus;
the three works hang over the fireplace in a 1922
photograph by Man Ray of Alice Toklas and Gertrude
Stein in the atelier (pl. 359).
2. It is believed that Gertrude Stein sold her three
works by Braque over the course of 1937, when she
was also in the process of selling *Seated Nude* by
Picasso (1905; cat. 233). +2

6. *Still Life*, n.d.
Current location unknown
Plate 359

Provenance

Gertrude Stein, Paris (until at least March 1937[1,2])

Notes

1. One of three Braque still lifes listed in the Lloyds of
London insurance policy dated March 12, 1937 (Ransom
Center), issued to Gertrude Stein at 27 rue de Fleurus;
the three works hang over the fireplace in a 1922
photograph by Man Ray of Alice Toklas and Gertrude
Stein in the atelier (pl. 359).
2. It is believed that Gertrude Stein sold her three
works by Braque over the course of 1937, when she
was also in the process of selling *Seated Nude* by
Picasso (1905; cat. 233). +2

PAUL CÉZANNE

French, born 1839, Aix-en-Provence, France; died 1906,
Aix-en-Provence, France

PAINTING

7. *Five Apples*, 1877-78
Oil on canvas
4⅞ x 10¼ in. (12.4 x 26 cm)
Mr. and Mrs. Eugene V. Thaw
Rewald (1996) 334; Venturi 191
Plate 49

Provenance

Maxime Maufra (until November 13, 1907); Galerie
Bernheim-Jeune, Paris (November 13, 1907,[1] until
December 17, 1907); Leo [and Gertrude] Stein, Paris
(acquired December 17, 1907,[1] and probably owned
jointly until 1913/1914[2]); thereafter, Leo Stein, Paris and
Settignano, Italy (until at least May/June 1921[3,4]);
Durand-Ruel, New York (acquired 1921[4]); Carl Weeks,
Des Moines

Notes

1. Galerie Bernheim-Jeune client list with dates of sales
and purchases: no. 16258, "Cézanne, Nature morte." +8
2. One of two paintings by Cézanne that Leo took with
him to Italy. See Rewald 1996, 226 (no. 334), in which
Rewald cites two letters: Leo Stein to Mabel Weeks,
April 2, 1914; and Joseph Durand-Ruel to his brother
Georges, April 8, 1921, noting: "One small Cézanne,
fruit, is insignificant but fine."
3. The painting appears as no. 20, "Cézanne," with a
noted price of $1,000, on a list of artworks that Leo
Stein wished to sell in April 1921. However, it was one
of at least three works that were instead purchased by
Durand-Ruel. The price offered for the Cézanne by
Durand-Ruel was $800. +5

4. Durand-Ruel, New York, records of works belonging to Leo Stein in 1921, including a stock book reference as no. 20, Cézanne, accompanied by a photograph, with dimensions and additional annotation: "ph a. 1254." Archives Durand-Ruel, Paris.

8. *The Spring House,* ca. 1879
Oil on canvas
23⅝ x 19¹¹⁄₁₆ in. (60 x 50 cm)
The Barnes Foundation, Merion, Pennsylvania
Rewald (1996) 406; Venturi 310
Plates 35, 354

Provenance

Ambroise Vollard, Paris[1]; Leo Stein, Paris (acquired spring 1903[2] and owned [pl. 354] until May 1914[3,4]); Albert C. Barnes, Merion, Pennsylvania (acquired May 1914[5])

Notes

1. Vollard Archives photo no. 205, Stock Book A (1899-ca. April 1904), no. 3668, "Cézanne, 61 x 50 cm, 100 [francs]."
2. Leo acquired the painting before traveling to Italy in spring 1903. See Rebecca Rabinow in this volume, 45n13.
3. One of four works that Jos Hessel proposed to purchase from Leo and Gertrude Stein in 1912 but that were sold later to different collectors. Leo sold *The Spring House* to Barnes in May 1914. +11
4. In a letter dated November 26, 1914, to Gertrude Stein, in which Felix Fénéon writes about the Stein works that Galerie Bernheim-Jeune handled during the year, the present work is likely that cited as: "*Le Moulin* de Cézanne lui [to Leo] a été restituée contre reçu le 13 mai 1914." Beinecke YCAL, MSS 76, box 98, folder 1866. If identified correctly, the work was sold to Barnes the following day.
5. Barnes sent payment for the work on May 14, 1914: "(no. 2989): Julien [i.e, Julian] Stein, Cézanne landscape—$2882" (Jayne Warman, e-mail message to author, June 2009, based on her research at the BFA). Julian Stein (1880-1937) was Leo and Gertrude's cousin, the son of Samuel Stein and Annie Heidelberger.

9. *Portrait of Paul, the Artist's Son,* ca. 1880
Oil on canvas
6¾ x 6 in. (17.1 x 15.2 cm)
The Henry and Rose Pearlman Foundation; on long-term loan to Princeton University Art Museum
Rewald (1996) 464
Plates 128, 368, 377

Provenance

Ambroise Vollard, Paris; George Viau, Paris (until March 1907); Michael and Sarah Stein, Paris and Palo Alto, California (acquired March 21-22, 1907,[1,2] and owned jointly[3] [pls. 368, 377] until 1938); thereafter, Sarah Stein, Palo Alto (until at least February 1947[4]); Stendahl Gallery, Los Angeles (until 1954); James Vigeveno, Ojai, California; Lilienfeld Gallery, New York

Notes

1. Sales catalogue, Galerie Durand-Ruel, Paris, "Collection de M. George Viau," March 21-22, 1907, lot no. 17, as "*Tete* Cézanne." The work was purchased for 1,100 francs; the handwritten name of the purchaser is illegible but begins with an *S,* according to the *procès-verbal* of the sale (AdvP D48390). This is apparently Michael Stein; see note 2 below.

2. Annette Rosenshine (n.d., 97) describes attending the sale and refers to a newspaper article wherein it is discussed.
3. Paris 1910b, no. 41 (as "*Tête d'enfant*"). Rewald 1996, 563.
4. Following a 1947 visit with Sarah Stein, Fiske Kimball wrote: "There is one Cézanne, a little portrait head of his son as a boy." +9

10. *Madame Cézanne with a Fan,* 1878-88
Oil on canvas
36¼ x 28¾ in. (92.5 x 73 cm)
Foundation E. G. Bührle Collection, Zurich
Rewald (1996) 606; Venturi 369
Plates 2, 347, 348, 354, 357, 359, 376, 384

Provenance

Ambroise Vollard, Paris[1]; Leo and Gertrude Stein, Paris (acquired December 16, 1904,[2,3] and owned jointly [pls. 347, 348, 354] until 1913/1914); thereafter, Gertrude Stein, Paris (1913/1914 and owned [pls. 357, 359, 376, 384] until 1943[3,4]); César de Hauke (by January 1944[3,4]); Emil Georg Bührle, Zurich (acquired 1952[3])

Notes

1. Purchased from the artist as "Femme a l'eventail asisse dans fauteuil rouge," 92 x 73 cm, for 300 francs. Vollard Archives, MS 421 (4, 5), folio 77.
2. Sold by Vollard to Leo Stein, no. 4061, for 8,000 francs. Vollard Archives, MS 421 (4, 10), fol. 44.
3. Saint-Pierre 2009, 255-57.
4. The work is referred to in the tax files for Gertrude Stein's estate and in the recorded calculations for the payment of an "Impôt de Solidarité Nationale" dated June 10, 1947. This document includes an account at the Société Générale de Crédit Industriel et Commercial (today Banque CIC), valued at 600,000 francs, that represents part of the proceeds from the sale of a Cézanne painting Gertrude had acquired in 1905. AdvP 1600 W/1957 (E 12.959: Dossier: Déclaration du Patrimoine, p. IV[i/iv]).

11. *Bathers,* ca. 1892
Oil on canvas
8¹¹⁄₁₆ x 13 in. (22 x 33 cm)
Musée d'Orsay, Paris, on deposit at the Musée des Beaux-Arts, Lyon
Rewald (1996) 749; Venturi 587
Plates 129, 364, 368

Provenance

Ambroise Vollard, Paris(?)[1,2]; Michael and Sarah Stein, Paris (before November 1907 [pl. 364] until later [pl. 368]); Auguste Pellerin, Paris; Jean-Victor Pellerin, Paris; Musée d'Orsay

Notes

1. According to documents in the Musée d'Orsay, the works bears the following inscriptions: 305, 76, 381; as well as a label bearing the number 5250. Anne Roquebert, Musée d'Orsay, e-mail message to author, February 2010.
2. The label (no. 5250) is perhaps a Vollard inventory number; however, the corresponding stock book has not yet been located.

12. *Group of Bathers,* 1892-94
Oil on canvas
12 x 16 in. (30.5 x 40.6 cm)
The Barnes Foundation, Merion, Pennsylvania
Rewald (1996) 753; Venturi 590
Plate 345

Provenance

Ambroise Vollard, Paris[1]; Leo and Gertrude Stein, Paris (acquired October 28, 1904,[2] and probably owned jointly [pl. 345] until 1913/1914); thereafter, Leo Stein, Paris and Settignano, Italy (until later); Albert C. Barnes, Merion, Pennsylvania (probably by 1916[3])

Notes

1. Purchased from the artist as "Baigneurs," 30 x 40 cm, for 200 francs. Vollard Archives, MS 421 (4, 5), folio 107.
2. One of seven works that Leo Stein purchased from Vollard on October 28, 1904, this work corresponds to stock no. 4363. +10
3. The last letter regarding the purchase of this Cézanne is probably that between Albert C. Barnes and Leo Stein from January 19, 1916, BFA, AR.ABC.1916.85(1).

13. *Man with Pipe,* 1892-96
Oil on canvas
10¼ x 8 in. (26.1 x 20.2 cm)
National Gallery of Art, Washington, D.C., gift of the W. Averell Harriman Foundation in memory of Marie N. Harriman
Rewald (1996) 711; Venturi 566
Plates 354, 355

Provenance

Ambroise Vollard, Paris; Leo and Gertrude Stein, Paris (owned jointly[1] [pl. 354] until 1913/1914); Gertrude Stein, Paris (1913/1914 [pl. 355] until October 1919); Paul Rosenberg, Paris (October 15, 1919[2]); Marie Harriman Gallery, New York (at least by 1934[3]); Mr. and Mrs. W. Averell Harriman, New York; National Gallery of Art, Washington, D.C., gift of the W. Averell Harriman Foundation in memory of Marie N. Harriman

Notes

1. One of four works that Jos Hessel proposed to purchase from Leo and Gertrude Stein in 1912 but that were sold later to different collectors. Gertrude sold *Man with Pipe* to Rosenberg in October 1915. +11

2. Handwritten receipt from Gertrude Stein to Paul Rosenberg, Paris, October 15, 1919, MoMA Archives, Paul Rosenberg Papers.
3. Philadelphia 1934, no. 36 (as "Study for the Card Players, ca. 1891-92, Marie Harriman Gallery, New York City").

14. *Bathers,* 1898-1900
Oil on canvas
10⅝ x 18⅛ in. (27 x 46 cm)
The Baltimore Museum of Art: The Cone Collection, formed by Dr. Claribel Cone and Miss Etta Cone of Baltimore, Maryland
Rewald (1996) 861; Venturi 724; Vollard Archives, photo no. 191
Plates 36, 348, 354, 358, 359

Provenance

Ambroise Vollard, Paris[1]; Auguste Pellerin, Paris; Ambroise Vollard, Paris[2]; Leo and Gertrude Stein, Paris (acquired October 28, 1904,[2] until 1913/1914 [pls. 348, 354]); thereafter, Gertrude Stein, Paris (1913/1914,[3] and owned [pls. 358, 359] until August 1926[4,5]); Etta Cone, Baltimore (August 1926[5] and then by bequest, 1949,[6] to the Baltimore Museum of Art)

Notes

1. Purchased from the artist as "'Baigneurs,' 27 x 46 cm," for 150 francs. Vollard Archives, MS 421 (4, 5), folio 107.
2. One of seven works that Leo Stein purchased from Vollard on October 28, 1904, this work corresponds to stock no. 4364. +10
3. Rewald 1996 (no. 861) establishes early provenance as noted and lists this work as one of three paintings (including *Madame Cézanne with a Fan* [Rewald 1996, no. 606] and *Man with Pipe* [Rewald 1996, no. 711]) that Gertrude Stein retained after the 1913-14 split of the collection.
4. In a series of letters dated July 1926 from Michael Stein to Gertrude Stein, he inquires about obtaining Gertrude's authorization to remove the present work from the safe deposit at the bank to have a frame made. BMA Cone Papers, and Beinecke YCAL, MSS, 76, box 125, folders 2716-24. Also, according to correspondence from Michael Stein in midsummer and early autumn 1926, he was in Paris orchestrating the sale of two works that the Cone sisters bought from Gertrude through him: the present example, purchased by Etta in August, and Félix Vallotton's *Gertrude Stein* (1907; cat. 441), purchased by Claribel in October. BMA Cone Papers, box 6, series 7-8.
5. B. Richardson 1985, 176.
6. BMA curatorial records.

WORKS ON PAPER

15. *Waterfront Landscape,*[1] 1878-80
Graphite and watercolor on paper
12¼ x 18¾ in. (31 x 47.5 cm)
Private collection, New York
Rewald (1983) 95; Venturi 907
Plates 352, 354

Provenance

Ambroise Vollard, Paris[2] (perhaps until January 1909); Leo and Gertrude Stein, Paris (perhaps January 1909,[3] and probably owned jointly [pls. 352, 354] until 1913/1914[4]); Galerie Thannhauser, Lucerne; Dr. and Mrs. F. H. Hirschland, New York (at least by November 1934[5]); Wildenstein, New York (until 1984); private collection, New York[6]

Notes

1. On the verso are two pencil studies, one of a female head in profile, the other of four ducks.
2. Vollard Archives, photo no. 119.
3. Perhaps one of nine Cézanne watercolors that Vollard sold to Leo on January 18, 1909. +3
4. Rewald 1983, 178. See also +4.
5. Philadelphia 1934, no. 52 (as "Landscape with Hill").
6. Rewald 1983, no. 95.

16. *Footpath in the Woods,* 1882-84
Watercolor and graphite on paper
18½ x 12¼ in. (47 x 31 cm)
Current location unknown
Rewald (1983) 170; Venturi 838; Vollard Archives, photo no. 157
Plates 351, 354, 357

Provenance

Princesse Murat, Paris; Leo and Gertrude Stein, Paris (probably owned jointly [pls. 351, 354] until 1913/1914); thereafter, Gertrude Stein, Paris (1913/1914 until later [pl. 357]); Paul Cassirer, Berlin; Harries von Siemens, Berlin; private collection, Munich[1]

Notes

1. Provenance as indicated in Rewald 1983, no. 170.

17. *The Chaine de l'Etoile Mountains,* 1885-86
Watercolor and graphite on paper
12⅜ x 19⅛ in. (31.4 x 48.6 cm)
The Barnes Foundation, Merion, Pennsylvania
Rewald (1983) 247; Venturi 908
Plate 352

Provenance

Ambroise Vollard, Paris (perhaps until January 1909); Leo and Gertrude Stein, Paris (perhaps January 1909[1] and probably owned jointly [pl. 352] until 1913/1914); thereafter, Leo Stein, Paris and Settignano, Italy (until May 1921); Albert C. Barnes, Merion, Pennsylvania (acquired May 1921[2])

Notes

1. Perhaps one of nine Cézanne watercolors that Vollard sold to Leo on January 18, 1909. +3
2. Among the seven works by Cézanne belonging to Leo that were offered for sale in 1921, this is one of a group of five watercolors purchased by Barnes. +5

18. *Mont Sainte-Victoire,* 1890
Watercolor on paper
11 x 17½ in. (28 x 44.5 cm)
Current location unknown
Rewald (1983) 288; Venturi 1563
Plates 351, 353, 357

Provenance

Ambroise Vollard, Paris[1] (perhaps until January 1909); Leo and Gertrude Stein, Paris (perhaps January 1909[2] and probably owned jointly [pls. 351, 353] until 1913/1914[3]); thereafter, Gertrude Stein, Paris (1913/1914 until later [pl. 357]); Paul Rosenberg, Paris[4]

Notes

1. Archives Vollard, photo no. 151.
2. Perhaps one of nine Cézanne watercolors that Vollard sold to Leo on January 18, 1909. +3
3. Rewald 1983, 178. See also +4.
4. +6

19. *Leaning Smoker,* 1890-91
Watercolor and graphite on paper
18⅝ x 14⅛ in. (47.3 x 35.9 cm)
The Barnes Foundation, Merion, Pennsylvania
Rewald (1983) 381; Venturi 1087
Plates 346, 350

Provenance

Ambroise Vollard, Paris(?)[1]; Leo and Gertrude Stein, Paris (by January 1907 [pl. 346] and owned jointly [pl. 350] until 1913/1914[2]); thereafter, Leo Stein, Paris and Settignano, Italy (until May 1921); Albert C. Barnes, Merion, Pennsylvania (acquired May 1921[3])

Notes

1. Vollard Archives, photo no. 221.
2. Rewald 1983, 178. See also +4.
3. Among the seven works by Cézanne belonging to Leo Stein that were offered for sale in 1921, *Leaning Smoker* was listed separately from the five other watercolors purchased by Barnes as a "drawing." +5

20. *The Coach House,* 1890-95
Watercolor and graphite on paper
12⅜ x 19¹⁄₁₆ in. (31.4 x 48.4 cm)
The Barnes Foundation, Merion, Pennsylvania
Rewald (1983) 394
Plate 351

Provenance

Ambroise Vollard, Paris[1] (perhaps until January 1909); Leo and Gertrude Stein, Paris (perhaps January 1909,[2] and owned jointly [pl. 351] until 1913/1914[3]); thereafter, Leo Stein, Paris and Settignano, Italy (until May 1921); Albert C. Barnes, Merion, Pennsylvania (acquired May 1921[4])

Notes

1. Vollard Archives, photo no. 122.
2. Perhaps one of nine Cézanne watercolors that Vollard sold to Leo on January 18, 1909. +3
3. One of several works not noted in Rewald 1983 as having been in the collection of Leo and Gertrude Stein that have since been confirmed to have been so. +4
4. Among the seven works by Cézanne belonging to Leo Stein that were offered for sale in 1921, this is one of a group of five watercolors purchased by Barnes. +5

21. _Trees_, ca. 1900 (possibly earlier)
Watercolor and graphite on paper
12³⁄₁₆ x 18¹¹⁄₁₆ in. (31 x 47.5 cm)
The Barnes Foundation, Merion, Pennsylvania
Rewald (1983) 525; Venturi 1012
Plate 352

Provenance

Ambroise Vollard, Paris[1] (perhaps until January 1909); Leo and Gertrude Stein, Paris (perhaps January 1909,[2] and probably owned jointly [pl. 352] until 1913/1914); thereafter, Leo Stein, Paris and Settignano, Italy (until May 1921); Albert C. Barnes, Merion, Pennsylvania (acquired May 1921[3])

Notes

1. Vollard Archives, photo no. 61.
2. Perhaps one of nine Cézanne watercolors that Vollard sold to Leo on January 18, 1909. +3
3. Among the seven works by Cézanne belonging to Leo Stein that were offered for sale in April 1921, this is one of a group of five watercolors purchased by Barnes. +5

22. _Mont Sainte-Victoire_, ca. 1900
Watercolor and graphite on paper
12¼ x 18¾ in. (31.1 x 47.9 cm)
Musée du Louvre, Paris, on deposit at the Musée d'Orsay, Paris (RF 31171)
Rewald (1983) 502; Venturi 1562
Plate 357

Provenance

Ambroise Vollard, Paris[1] (perhaps until January 1909); Leo and Gertrude Stein, Paris (perhaps January 1909,[2] and probably owned jointly until 1913/1914[3]); thereafter, Gertrude Stein, Paris (1913/1914 until later [pl. 357]); Paul Rosenberg, Paris[4]; Baron Kojiro Matsukata, Kobe, Japan, and Paris; Cabinet des Dessins, Musée du Louvre; on deposit, Musée d'Orsay[5]

Notes

1. Vollard Archives, photo no. 148.
2. Perhaps one of nine Cézanne watercolors that Vollard sold to Leo on January 18, 1909. +3
3. Rewald 1983, 178. See also +4.
4. +6
5. Rewald 1983, no. 502.

23. _Mont Sainte-Victoire_, ca. 1900
Watercolor and graphite on paper
12³⁄₈ x 19¹⁄₈ in. (31.5 x 48.5 cm)
The Barnes Foundation, Merion, Pennsylvania
Rewald (1983) 496; Venturi 1020
Plate 352

Provenance

Ambroise Vollard, Paris[1] (perhaps until January 1909); Leo and Gertrude Stein, Paris (perhaps January 1909,[2] and probably owned jointly [pl. 352] until 1913/1914); thereafter, Leo Stein, Paris and Settignano, Italy (until May 1921); Albert C. Barnes, Merion, Pennsylvania (acquired May 1921[3])

Notes

1. Vollard Archives, photo no. 90.
2. Perhaps one of nine Cézanne watercolors that Vollard sold to Leo on January 18, 1909. +3
3. Among the seven works by Cézanne belonging to Leo Stein that were offered for sale in April 1921, this is one of a group of five watercolors purchased by Barnes. +5

24. _Mont Sainte-Victoire_, ca. 1900
Watercolor and graphite on paper
12½ x 19 in. (31.8 x 48.3 cm)
The Barnes Foundation, Merion, Pennsylvania
Rewald (1983) 504; Venturi 1028
Plates 352, 353

Provenance

Ambroise Vollard, Paris (perhaps until January 1909); Leo and Gertrude Stein, Paris (perhaps January 1909,[1] and owned jointly [pls. 352, 353] until 1913/1914[2]); thereafter, Leo Stein, Paris and Settignano, Italy (until May 1921); Albert C. Barnes, Merion, Pennsylvania (acquired May 1921[3])

Notes

1. Perhaps one of nine Cézanne watercolors that Vollard sold to Leo on January 18, 1909. +3
2. One of several works not noted in Rewald 1983 as having been in the collection of Leo and Gertrude Stein that have since been confirmed to have been so. +4
3. Among the seven works by Cézanne belonging to Leo Stein that were offered for sale in April 1921, this is one of a group of five watercolors purchased by Barnes. +5

25. _Olive Grove_, ca. 1900
Watercolor and graphite on paper
16⅛ x 22¹⁄₁₆ in. (41 x 56 cm)
Current location unknown
Rewald (1983) 522; Venturi 1017
Plates 351, 357

Provenance

Ambroise Vollard, Paris (perhaps until January 1909); Leo and Gertrude Stein, Paris (perhaps January 1909,[1] and owned jointly [pl. 351] until 1913/1914[2]); thereafter, Gertrude Stein, Paris (1913/1914 until later[3] [pl. 357]); Paul Rosenberg, Paris[4]; Alfred Flechtheim, Berlin; Elsa Essberger, Hamburg; private collection, Hamburg[5]

Notes

1. Perhaps one of nine Cézanne watercolors that Vollard sold to Leo on January 18, 1909. +3
2. Rewald 1983, 178. See also +4.
3. +6
4. Fonds Rosenberg: 3346 Cézanne Grands Arbres (538), Documentation Center, Musée d'Orsay, Paris.
5. Rewald 1983, no. 522.

26. _Large Bathers_, 1896-97
Lithograph
16¾ x 20¼ in. (42.6 x 51.5 cm)
Current location unknown
Venturi 1157
[See pl. 50 for an example not owned by the Steins]

Provenance

Perhaps Ambroise Vollard, Paris[1]; Leo and Gertrude Stein, Paris[1,2]; Michael and Sarah Stein, Paris (perhaps by 1937[3])

Notes

1. Perhaps the Cézanne lithograph sold by Ambroise Vollard to "Stein" on February 6, 1906, for 50 francs. Vollard Archives, MS 421 (5, 1), folio 23.
2. Potter 1970, 155-56.
3. Possibly one of two Cézanne lithographs listed in a 1937 inventory of Michael and Sarah Stein's collection. +7

27. _Bathers_, 1897
Lithograph
9½ x 11³⁄₈ in. (24.1 x 28.9 cm)
Current location unknown
Venturi 1156
Example A: Plates 362, 363, 365
Example B: Plates 349, 351
[See pl. 51 for an example not owned by the Steins]

Provenance
Example A:
Perhaps Ambroise Vollard, Paris[1]; Michael and Sarah Stein, Paris (owned[2] [pls. 362, 363, 365] until at least 1937[3])[4]

Example B:
Perhaps Ambroise Vollard, Paris[1]; Leo and Gertrude Stein, Paris (owned[2] [pl. 349] until at least May 1912 [pl. 351])[4]

Notes
1. Perhaps the Cézanne lithograph sold by Ambroise Vollard to "Stein" on February 6, 1906, for 50 francs. Vollard Archives, MS 421 (5, 1), folio 23.
2. Potter 1970, 155
3. Possibly one of two Cézanne lithographs listed in a 1937 inventory of Michael and Sarah Stein's collection. +7
4. It is not known if one lithograph of bathers (small plate) was exchanged within the family or if Michael and Sarah owned one version and Leo and Gertrude, another.

OTHONE (OTAKAR) COUBINE
Czech, born 1883, Boskovice, Austria-Hungary; died 1969, Marseille, France

PAINTING

28. *Girl at Piano,* n.d.
Oil on canvas, signed lower right
28¾ x 36¼ in. (73 x 92.1 cm)
Stephen Mazoh, Rhinebeck, New York

Provenance
Leo Stein, Settignano, Italy; probably Fred M. Stein family, New York [and their descendants, Baltimore]; Stephen Mazoh, Rhinebeck, New York[1]

Notes
1. One of forty-four Coubines owned by Leo Stein and sent to Manhattan Storage, probably in May 1947. A handwritten label affixed to the stretcher reads: #30-3, Coll. Stein. +12

29. *Girl Sewing,* n.d.
Oil on canvas
36¼ x 28¾ in. (92.1 x 73 cm)
Stephen Mazoh, Rhinebeck, New York

Provenance
Leo Stein, Settignano, Italy; probably Fred M. Stein family, New York [and their descendants, Baltimore]; Stephen Mazoh, Rhinebeck, New York[1]

Notes
1. One of forty-four Coubines owned by Leo Stein and sent to Manhattan Storage, probably in May 1947. A handwritten label affixed to the stretcher reads: #30-2, Coll. Stein. +12

30. *Landscape,* n.d.
Oil on canvas
22 x 18½ in. (55.9 x 47 cm)
Stephen Mazoh, Rhinebeck, New York

Provenance
Leo Stein, Settignano, Italy; probably Fred M. Stein family, New York [and their descendants, Baltimore]; Stephen Mazoh, Rhinebeck, New York[1]

Notes
1. One of forty-four Coubines owned by Leo Stein and sent to Manhattan Storage, probably in May 1947. A handwritten label affixed to the stretcher reads: S-8, Coll. Stein. +12

31. *Landscape,* n.d.
Oil on canvas, signed lower right
21½ x 25¾ in. (54.6 x 65.4 cm)
Stephen Mazoh, Rhinebeck, New York

Provenance
Leo Stein, Settignano, Italy; probably Fred M. Stein family, New York [and their descendants, Baltimore]; Stephen Mazoh, Rhinebeck, New York[1]

Notes
1. One of forty-four Coubines owned by Leo Stein and sent to Manhattan Storage, probably in May 1947. A handwritten label affixed to the stretcher reads: #15-5, Coll. Stein. +12

32. *Landscape,* n.d.
Oil on canvas, signed lower right
20 x 24 in. (50.8 x 61 cm)
Stephen Mazoh, Rhinebeck, New York

Provenance
Leo Stein, Settignano, Italy; probably Fred M. Stein family, New York [and their descendants, Baltimore]; Stephen Mazoh, Rhinebeck, New York[1]

Notes
1. One of forty-four Coubines owned by Leo Stein and sent to Manhattan Storage, probably in May 1947. A handwritten label affixed to the stretcher reads: #12-4, Coll. Stein. +12

33. *Landscape,* n.d.
Oil on canvas, signed lower right
20 x 24 in. (50.8 x 61 cm)
Stephen Mazoh, Rhinebeck, New York

Provenance
Leo Stein, Settignano, Italy; probably Fred M. Stein family, New York [and their descendants, Baltimore]; Stephen Mazoh, Rhinebeck, New York[1]

Notes
1. One of forty-four Coubines owned by Leo Stein and sent to Manhattan Storage, probably in May 1947. A handwritten label affixed to the stretcher reads: #12-1, Coll. Stein. +12

34. *Landscape,* n.d.
Oil on canvas, signed lower right
20 x 24 in. (50.8 x 61 cm)
Stephen Mazoh, Rhinebeck, New York

Provenance
Leo Stein, Settignano, Italy; probably Fred M. Stein family, New York [and their descendants, Baltimore]; Stephen Mazoh, Rhinebeck, New York[1]

Notes
1. One of forty-four Coubines owned by Leo Stein and sent to Manhattan Storage, probably in May 1947. A handwritten label affixed to the stretcher reads: #12-3, Coll. Stein. +12

35. *Landscape,* n.d.
Oil on canvas, signed lower right
21¼ x 25¾ in. (54 x 65 cm)
Stephen Mazoh, Rhinebeck, New York

Provenance
Galerie Bernheim-Jeune, Paris (purchased from the artist October 3, 1927[1]); [Leo] Stein, [Settignano, Italy] (purchased on December 8, 1927[1,2]); probably Fred M. Stein family, New York [and their descendants, Baltimore]; Stephen Mazoh, Rhinebeck, New York[3]

Notes
1. Galerie Bernheim-Jeune client list with dates of sales and purchases: invoice no. 25039, photo no. 6.551. +8 Bernheim-Jeune invoice no. 25039 appears on stretcher.
2. One of at least six paintings by Coubine that Leo purchased in December 1927. Leo Stein to Othone Coubine, December 10, 1927, Beinecke YCAL, MSS 78, box 1, folder 3.
3. One of forty-four Coubines owned by Leo Stein and sent to Manhattan Storage, probably in May 1947. A handwritten label affixed to the stretcher reads: #15-6 Coll. Stein. +12

36. *Landscape,* n.d.
Oil on canvas, signed lower right
19¾ x 24 in. (50.2 x 61 cm)
Stephen Mazoh, Rhinebeck, New York

Provenance
Leo Stein, Settignano, Italy; probably Fred M. Stein family, New York [and their descendants, Baltimore]; Stephen Mazoh, Rhinebeck, New York[1]

Notes
1. One of forty-four Coubines owned by Leo Stein and sent to Manhattan Storage, probably in May 1947. A handwritten label affixed to the stretcher reads: #12-2, Coll. Stein. +12

37. *Landscape,* n.d.
Oil on canvas, signed lower right
21½ x 25½ in. (54.6 x 64.8 cm)
Stephen Mazoh, Rhinebeck, New York

Provenance
Leo Stein, Settignano, Italy; probably Fred M. Stein family, New York [and their descendants, Baltimore]; Stephen Mazoh, Rhinebeck, New York[1]

Notes
1. One of forty-four Coubines owned by Leo Stein and sent to Manhattan Storage, probably in May 1947. A handwritten label affixed to the stretcher reads: #15-9, Coll. Stein. +12

38. *Landscape,* n.d.
Oil on canvas, signed lower right
23⅞ x 28¾ in. (60.6 x 73 cm)
Stephen Mazoh, Rhinebeck, New York

Provenance
Leo Stein, Settignano, Italy; probably Fred M. Stein family, New York [and their descendants, Baltimore]; Stephen Mazoh, Rhinebeck, New York[1]

Notes
1. One of forty-four Coubines owned by Leo Stein and sent to Manhattan Storage, probably in May 1947. A handwritten label affixed to the stretcher reads: #20-9, Coll. Stein. +12

39. *Landscape,* n.d.
Oil on canvas, signed lower right
24 x 28¾ in. (61 x 73 cm)
Stephen Mazoh, Rhinebeck, New York

Provenance
Leo Stein, Settignano, Italy; probably Fred M. Stein family, New York [and their descendants, Baltimore]; Stephen Mazoh, Rhinebeck, New York[1]

Notes
1. One of forty-four Coubines owned by Leo Stein and sent to Manhattan Storage, probably in May 1947. A handwritten label affixed to the stretcher reads: #20-8, Coll. Stein. +12

40. *Landscape,* n.d.
Oil on canvas, signed lower right
23¾ x 28¾ in. (60.3 x 73 cm)
Stephen Mazoh, Rhinebeck, New York

Provenance
Leo Stein, Settignano, Italy; probably Fred M. Stein family, New York [and their descendants, Baltimore]; Stephen Mazoh, Rhinebeck, New York[1]

Notes
1. One of forty-four Coubines owned by Leo Stein and sent to Manhattan Storage, probably in May 1947. A handwritten label affixed to the stretcher reads: #20-6, Coll. Stein. +12

41. *Landscape,* n.d.
Oil on canvas, signed lower right
20 x 24 in. (50.8 x 61 cm)
Stephen Mazoh, Rhinebeck, New York

Provenance
Leo Stein, Settignano, Italy; probably Fred M. Stein family, New York [and their descendants, Baltimore]; Stephen Mazoh, Rhinebeck, New York[1]

Notes
1. One of forty-four Coubines owned by Leo Stein and sent to Manhattan Storage, probably in May 1947. A handwritten label affixed to the stretcher reads: #12-5, Coll. Stein. +12

42. *Landscape,* n.d.
Oil on canvas, signed lower right
21½ x 25¾ in. (54.6 x 65.4 cm)
Stephen Mazoh, Rhinebeck, New York

Provenance
Leo Stein, Settignano, Italy; probably Fred M. Stein family, New York [and their descendants, Baltimore]; Stephen Mazoh, Rhinebeck, New York[1]

Notes
1. One of forty-four Coubines owned by Leo Stein and sent to Manhattan Storage, probably in May 1947. A handwritten label affixed to the stretcher reads: #15-2, Coll. Stein. +12

43. *Landscape,* n.d.
Oil on canvas, signed lower right
19⅞ x 24⅛ in. (50.5 x 61.3 cm)
Stephen Mazoh, Rhinebeck, New York

Provenance
Leo Stein, Settignano, Italy; probably Fred M. Stein family, New York [and their descendants, Baltimore]; Stephen Mazoh, Rhinebeck, New York[1]

Notes
1. One of forty-four Coubines owned by Leo Stein and sent to Manhattan Storage, probably in May 1947. A handwritten label affixed to the stretcher reads: #12-6, Coll. Stein. +12

44. *Landscape,* n.d.
Oil on canvas, signed lower right
20 x 24 in. (50.8 x 61 cm)
Stephen Mazoh, Rhinebeck, New York

Provenance
Leo Stein, Settignano, Italy; probably Fred M. Stein family, New York [and their descendants, Baltimore]; Stephen Mazoh, Rhinebeck, New York[1]

Notes
1. One of forty-four Coubines owned by Leo Stein and sent to Manhattan Storage, probably in May 1947. A handwritten label affixed to the stretcher reads: #12-7, Coll. Stein. +12

45. *Landscape,* n.d.
Oil on canvas, signed lower right
21½ x 25¾ in. (54.6 x 65.4 cm)
Stephen Mazoh, Rhinebeck, New York

Provenance
Leo Stein, Settignano, Italy; probably Fred M. Stein family, New York [and their descendants, Baltimore]; Stephen Mazoh, Rhinebeck, New York[1]

Notes
1. One of forty-four Coubines owned by Leo Stein and sent to Manhattan Storage, probably in May 1947. A handwritten label affixed to the stretcher reads: #15-7, Coll. Stein. +12

46. *Landscape,* n.d.
Oil on canvas, signed lower right
18¼ x 21¾ in. (46.3 x 55.2 cm)
Stephen Mazoh, Rhinebeck, New York

Provenance
Leo Stein, Settignano, Italy; probably Fred M. Stein family, New York [and their descendants, Baltimore]; Stephen Mazoh, Rhinebeck, New York[1]

Notes
1. One of forty-four Coubines owned by Leo Stein and sent to Manhattan Storage, probably in May 1947. A handwritten label affixed to the stretcher reads: #10-3, Coll. Stein. +12

47. *Landscape,* n.d.
Oil on canvas
29 x 36¼ in. (73.7 x 92.1 cm)
Stephen Mazoh, Rhinebeck, New York

Provenance
Leo Stein, Settignano, Italy; probably Fred M. Stein family, New York [and their descendants, Baltimore]; Stephen Mazoh, Rhinebeck, New York[1]

Notes
1. One of forty-four Coubines owned by Leo Stein and sent to Manhattan Storage, probably in May 1947. A handwritten label affixed to the stretcher reads: #30-4, Coll. Stein. +12

48. *Landscape (Montagne de Lure),* n.d.
Oil on canvas, signed lower right
21¼ x 25¾ in. (54 x 65.4 cm)
Stephen Mazoh, Rhinebeck, New York

Provenance
Leo Stein, Settignano, Italy; probably Fred M. Stein family, New York [and their descendants, Baltimore]; Stephen Mazoh, Rhinebeck, New York[1]

Notes
1. One of forty-four Coubines owned by Leo Stein and sent to Manhattan Storage, probably in May 1947. A handwritten label affixed to the stretcher reads: #15-10, Coll. Stein. +12

49. *Portrait of a Woman,* n.d.
Oil on canvas, signed at lower right
28¾ x 23¾ in. (73 x 60.3 cm)
Stephen Mazoh, Rhinebeck, New York

Provenance
Leo Stein, Settignano, Italy; probably Fred M. Stein family, New York [and their descendants, Baltimore]; Stephen Mazoh, Rhinebeck, New York[1]

Notes
1. One of forty-four Coubines owned by Leo Stein and sent to Manhattan Storage, probably in May 1947. A handwritten label affixed to the stretcher reads: #20-10, Coll. Stein. +12

50. *Still Life with Statue, Vase, and Flowers,* n.d.
Oil on canvas, signed at lower right
18⅜ x 21¾ in. (46.7 x 55.2 cm)
Stephen Mazoh, Rhinebeck, New York

Provenance
Leo Stein, Settignano, Italy; probably Fred M. Stein family, New York [and their descendants, Baltimore]; Stephen Mazoh, Rhinebeck, New York[1]

Notes
1. One of forty-four Coubines owned by Leo Stein and sent to Manhattan Storage, probably in May 1947. A handwritten label affixed to the stretcher reads: #10-2, Coll. Stein. +12

51. *Landscape,* before May 1929
Oil on canvas, signed
19¾ x 24 in. (50.2 x 61 cm)
Stephen Mazoh, Rhinebeck, New York

Provenance
Leo Stein, Settignano, Italy; probably Fred M. Stein family, New York [and their descendants, Baltimore]; Stephen Mazoh, Rhinebeck, New York[1]

Notes
1. One of forty-four Coubines owned by Leo Stein and sent to Manhattan Storage, probably in May 1947. A handwritten label affixed to the stretcher reads: #12-9, Coll. Stein. +12

52. *Orchard with Purple Heather,* mid-1920s?
Oil on canvas
23¾ x 28¾ in. (60.3 x 73 cm)
Stephen Mazoh, Rhinebeck, New York

Provenance
Leo Stein, Settignano, Italy; Fred M. Stein family, New York (1970[1]); Stephen Mazoh, Rhinebeck, New York[2]

Notes

1. Potter 1970, 156.
2. One of forty-four Coubines owned by Leo Stein and sent to Manhattan Storage, probably in May 1947. A handwritten label affixed to the stretcher reads: #20-7, Coll. Stein. +12

53. *Landscape,* 1927
Oil on canvas, signed at lower right
23¾ x 28¾ in. (60.3 x 73 cm)
Stephen Mazoh, Rhinebeck, New York

Provenance

Leo Stein, Settignano, Italy; probably Fred M. Stein family, New York [and their descendants, Baltimore]; Stephen Mazoh, Rhinebeck, New York[1]

Notes

1. One of forty-four Coubines owned by Leo Stein and sent to Manhattan Storage, probably in May 1947. A handwritten label affixed to the stretcher reads: #20-4, Coll. Stein. +12

54. *Landscape,* 1928
Oil on canvas, signed at lower right
23¾ x 28¾ in. (60.3 x 73 cm)
Stephen Mazoh, Rhinebeck, New York

Provenance

Leo Stein, Settignano, Italy; probably Fred M. Stein family, New York [and their descendants, Baltimore]; Stephen Mazoh, Rhinebeck, New York[1]

Notes

1. One of forty-four Coubines owned by Leo Stein and sent to Manhattan Storage, probably in May 1947. A handwritten label affixed to the stretcher reads: #20-5, Coll. Stein. +12

55. *Landscape,* 1929
Oil on canvas, signed
18¼ x 21¾ in. (46.3 x 55.2 cm)
Stephen Mazoh, Rhinebeck, New York

Provenance

Leo Stein, Settignano, Italy; probably Fred M. Stein family, New York [and their descendants, Baltimore]; Stephen Mazoh, Rhinebeck, New York[1]

Notes

1. One of forty-four Coubines owned by Leo Stein and sent to Manhattan Storage, probably in May 1947. A handwritten label affixed to the stretcher reads: #10-4, Coll. Stein. +12

56. *Landscape,* ca. 1929
Oil on canvas, signed lower right
29 x 36¼ in. (73.7 x 92 cm)
Stephen Mazoh, Rhinebeck, New York

Provenance

Leo Stein, Settignano, Italy; probably Fred M. Stein family, New York [and their descendants, Baltimore]; Stephen Mazoh, Rhinebeck, New York[1]

Notes

1. One of forty-four Coubines owned by Leo Stein and sent to Manhattan Storage, probably in May 1947. A handwritten label affixed to the stretcher reads: #30-1, Coll. Stein. +12

HONORÉ DAUMIER
French, born 1808, Marseille, France; died 1879, Valmondois, France

57. *Head of an Old Woman,* 1856–60
Oil on panel
8⅝ x 6½ in. (21.9 x 16.5 cm)
The Henry and Rose Pearlman Foundation; on long-term loan to Princeton University Art Museum
Maison I-108
Plates 343, 344, 346, 353, 354

Provenance

Ambroise Vollard, Paris (until August 1904[1]); Leo Stein, Paris (acquired August 24, 1904,[1] until[2] [pls. 343, 344, 346, 353, 354] probably at least April 1924[3]; Fred M. Stein[3])

Notes

1. Possibly the work Vollard bought on March 17, 1904. Vollard Archives, MS 421 (4) 10, folio 4. Leo's purchase (for 600 francs) recorded in Vollard inventory A, no. 4096 (Gallery Archives, National Gallery of Art).
2. Surely the work that appears as "no. 19 Daumier" and is noted "? hard to estimate" on a list of artworks that Leo Stein wished to sell in April 1921. +5
3. One of at least four artworks placed on consignment with Durand-Ruel, New York, by Leo Stein in May/June 1921 and returned to him in care of his cousin Fred M. Stein, New York, on April 7, 1924, the present work is listed in the Durand-Ruel records as no. 19; depot no. 8101. Archives Durand-Ruel. +5

JO DAVIDSON
American, born 1883, New York; died 1952, Tours, France

58. *Bilignin,* ca. 1930
Watercolor on paper
7⅝ x 11¼ in. (20 x 28 cm)
Yale Collection of American Literature, Beinecke Rare Book and Manuscript Library, Yale University, New Haven

Provenance

Gertrude Stein, Paris (until 1946; thereafter, her estate[1]); Yale Collection of American Literature, Beinecke Rare Book and Manuscript Library, Yale University

Notes

1. Potter 1970, 156.

EDGAR DEGAS
French, born 1834, Paris; died 1917, Paris

59. *After the Bath*[1,2]
Plate 343

Notes

1. This reproduction of Degas's pastel of a nude reclining on the back of a chaise longue (Lemoisne no. 1232) appears as plate no. 19, "Femme renversée sur le dossier d'une chaise longue et se frottant les reins avec une serviette enroulée, 1896," in *Degas: Vingt dessins, 1861–1896* (Paris: Goupil & Co., 1897).
2. Mahonri Young recalled that when he was an art student in Paris Leo Stein invited him to the rue de Fleurus atelier to see "a large green-covered volume, a portfolio of twenty exquisite sketches by Degas." Cited in Wineapple 1996, 196.

EUGÈNE DELACROIX
French, born 1798, Saint-Maurice, France; died 1863, Paris

60. *Perseus and Andromeda,* 1847
Oil on paper mounted on wood panel
16⅝ x 13¹⁄₁₆ in. (42.2 x 33.2 cm)
The Baltimore Museum of Art: The Cone Collection, formed by Dr. Claribel Cone and Miss Etta Cone of Baltimore, Maryland
Johnson 306
Plates 346, 347, 349

Provenance

Eugène Delacroix (until February 1864[1]); Jadin, Paris (until March 1893[2]); M. T. Shiff (acquired March 1893,[3] until March 1905[4]); Leo [and Gertrude] Stein, Paris (probably spring 1905,[4,5] and probably owned jointly[6] [pls. 346, 347, 349] until 1913/1914); Leo Stein, Paris (until at least April 1921[7] and probably April 1924[8]); Fred M. Stein, New York (from April 1924[8]); Howard S. Gans, New York (until April 2/May 13, 1937[9]); Etta Cone, Baltimore (acquired April 2/May 13, 1937,[9] until 1949); Baltimore Museum of Art

Notes

1. Delacroix atelier sale, Hôtel Drouot, Paris, February 17–19, 1864, lot no. 64.
2. Sales catalogue, Hôtel Drouot, Paris, March 29, 1893, lot no. 15.

3. Schiff [*i.e.*, Shiff] is noted in the March 29, 1893, sale as the buyer for 1,120 francs in the auctioneer's records in Paris. AdvP D48E3.78.

4. M. T. Shiff, his sale, March 21-22, 1905, lot no. 187. Purchased for 1,900 francs. *Chronique des Arts*, no. 15 (April 15, 1905), 119.

5. Leo is thought to have seen the work at auction and later purchased it from a dealer. Wineapple 1996, 225. Although Wineapple cites Leo's acquisition at the time of the 1904 Salon d'Automne, the date is obviously sometime in spring 1905.

6. The work was certainly in the collection of Leo and Gertrude at rue de Fleurus by September 2, 1905, as noted in a letter of that date. Emma Lootz Erving to Gertrude Stein, September 2, 1905, Beinecke YCAL, MSS 76, box 105, folder 2084.

7. The painting appears as no. 31, Delacroix, with a noted value of "1,000 (pupil Andrieu)," on a list of artworks that Leo Stein wished to sell in April 1921. +5

8. One of at least four artworks placed on consignment with Durand-Ruel, New York, by Leo Stein in May/June 1921 and returned to him in care of his cousin Fred M. Stein, New York, on April 7, 1924, the present work is listed in the Durand-Ruel records as no. 31; depot no. 8100. Archives Durand-Ruel. See +5

9. In a letter dated April 2, 1937, from Howard S. Gans in New York to Etta Cone in Baltimore, Gans confirms the shipment of the Delacroix that Etta soon thereafter purchased. "I wrote Leo on Tuesday to tell him all about the matter so that he might be prepared to give me an immediate answer on receipt of a cable from me in case you decide that you would like to have the Delacroix as well as the Picassos and the Lautrecs, or any of them." BMA Cone Papers, box 1c, series 2. Gans was related to Leo Stein by marriage to Fred M. Stein's sister Bird. It is impossible from the present records to know whether Leo's relatives simply handled these art transactions on Leo's behalf or were the actual owners of the artworks.

MAURICE DENIS

French, born 1870, Granville, France; died 1943, Paris

61. *Mother in Black*, 1895
Oil on canvas, signed with monogram and dated upper right
18½ x 15¼ in. (47 x 38.7 cm)
Private collection
Plates 40, 345, 346, 350

Provenance

Ambroise Vollard, Paris (February 1899[1]); Arsène Alexandre, Paris[2]; Ambroise Vollard, Paris (until October 28, 1904); Leo [and Gertrude] Stein, Paris (acquired October 28, 1904,[3] until April 27, 1908 [pls. 345, 346, 350]); Ambroise Vollard, Paris (acquired April 27, 1908[4]); private collection, Paris (and ca. 1930 by descent to his child or children until May 2005[5]); Galerie Hopkins-Custot, Paris; private collection

Notes

1. Purchased from the artist by Ambroise Vollard, as *Mère alaitant un enfant*, for 150 francs. Vollard Archives, MS 421 (4, 5), folio 65.

2. Information provided by Galerie Hopkins-Custot, Paris, June 2007.

3. One of seven works that Leo Stein purchased from Vollard on October 28, 1904, this work corresponds to stock no. 3942. +10

4. Leo Stein exchanged this painting, as well as Gauguin's *Sunflowers on an Armchair* (cat. 64) and cash, in order to acquire a study of a female nude by Renoir (*Bather*, cat. 398). +13

5. Sales catalogue, Christie's, Paris, May 24, 2005, lot no. 12 (ill.).

PAUL GAUGUIN

French, born 1848, Paris; died 1903, Atuona, French Polynesia

PAINTING

62. *Head of a Tahitian Girl*, ca. 1892
Oil on canvas
16⅛ x 10⅝ in. (41 x 27 cm)
Current location unknown
Wildenstein 448
Plate 363

Provenance

Michael and Sarah Stein, Paris (by December 1907 [pl. 363] until perhaps after July 1908); perhaps Galerie Kahnweiler, Paris (after July 1908[1]); Paco Durrio, Paris (by July 1928[2] until probably 1930/1931[3]); Dr. Lichtenhan, Basel (probably 1930/1931[3] until 1935); Mr. and Mrs. Roland Ziegler, Overwil-Basel (acquired 1935, until at least May 1970[4]); Geiser Collection, Basel (by 1995)

Notes

1. It is thought that the Gauguin left the Stein collection through an exchange in 1907-8. Evidently Matisse was trying to help Michael and Sarah Stein acquire his painting *La Coiffure* (1907; cat. 141) by finding a dealer or a buyer for their Gauguin, *Head of a Tahitian Girl.* This is cited in two sources. As recounted by Daniel-Henry Kahnweiler (1969, 18), Matisse asked Kahnweiler if he would buy *La Coiffure* from the artist and then sell it to the Steins, accepting their Gauguin head as part of the payment. Although the exact dates of the final transaction and exchange are unclear, the Steins did acquire *La Coiffure*, and *Head of a Tahitian Girl* apparently left the collection around this time. On July 18, 1908, Félix Fénéon responded to Matisse's proposal to exchange a Gauguin "tête d'Océanien[ne]" (presumably the Stein picture) for a young girl in red by Renoir (AMP). If the work in question is the Steins' Gauguin, presumably the Kahnweiler transaction had not yet taken place.

2. Kunsthalle Basel 1928, no. 81 (as "Maori-Kopf...F. Durrio, Paris"). The work belonged to Picasso's friend Francisco Durrieu de Madron (1868-1940), the Basque sculptor and ceramist also known as Francisco or Paco Durrio.

3. Dr. Lichtenhan reportedly purchased approximately ninety works from the Durrio collection in 1930/1931. Rudolf Reber, e-mail message to author, October 4, 2009.

4. In a letter dated May 11, 1970, to Carolyn Lanchner, Jacqueline Ziegler writes: "In fact, the picture was his [Roland Ziegler's] wedding present to me. He bought it from an art dealer in Basle [*sic*] in 1935, Dr. Lichtenhan." MoMA Archives, Cur. Exh. #950.

63. *Three Tahitian Women against a Yellow Background*, 1899
Oil on canvas
26¾ x 28¹⁵⁄₁₆ in. (68 x 73.5 cm)
The State Hermitage Museum, Saint Petersburg
Plates 8, 343, 344, 347

Provenance

Ambroise Vollard, Paris (October 17, 1900,[1] until October 28, 1904); Leo Stein, Paris (acquired October 28, 1904,[2] until [pls. 343, 344, 347] January 21, 1907); Ambroise Vollard, Paris (acquired January 21, 1907,[3] until probably May 1910); Ivan Morosov, Moscow (probably acquired May 13, 1910[4]); Museum of Modern Western Painting, Moscow (1919); State Museum of Modern Western Art, Moscow (1923); State Hermitage Museum (1948)[5]

Notes

1. Purchased from Daniel de Monfreid (on behalf of Gauguin) for 200 francs. Vollard Archives, MS 421 (4, 5), folio 21.

2. One of seven works that Leo Stein purchased from Vollard on October 28, 1904. +10

3. Vollard agenda entry for January 21, 1907. +1

4. Probably the sale recorded by Vollard on May 13, 1910, as "Morosoff 10,000 [francs] reçu pour Gaug remis." Vollard Archives, MS 421 (5, 5), folio 75.

5. The full provenance, including the Vollard archival references, is published in the catalogue of *Cézanne to Picasso: Ambroise Vollard, Patron of the Avant-garde* (Rabinow et al. 2006), no. 99, 366.

64. *Sunflowers on an Armchair*, 1901
Oil on canvas
26¹¹⁄₁₆ x 29¹¹⁄₁₆ in. (68 x 75.5 cm)
The Foundation E. G. Bührle Collection, Zurich
Wildenstein 602
Plates 344, 345, 349

Provenance

Ambroise Vollard, Paris[1] (until October 28, 1904); Leo Stein, Paris (acquired October 28, 1904,[2] until [pls. 344, 345, 349] April 27, 1908); Ambroise Vollard, Paris (acquired April 27, 1908[3]); Halvorsen, Copenhagen; Thannhauser, Berlin; Josef Stransky, New York; Wildenstein, New York; Sam Salz, New York; Oscar Homolka; Foundation E. G. Bührle Collection, Zurich

Notes

1. Purchased from the artist as "Nature Morte. Fleurs sur fauteuil avec tableau marine dans le fond," for 200 francs. Vollard Archives, MS 421 (4, 5), folio 1.

2. One of seven works that Leo Stein purchased from Vollard on October 28, 1904. +10

3. Leo Stein exchanged this painting, as well as Maurice Denis's *Mother in Black* (1895; cat. 61) and cash, in order to acquire a study of a female nude by Renoir (*Bather*, cat. 398). +13 Earlier, in December 1907, he had entered into negotiations with Félix Fénéon of Bernheim-Jeune to trade his Toulouse-Lautrec (*In the Salon: The Divan*, ca. 1892-93; cat. 437), along with a Gauguin (possibly the present work), for two Renoirs. G. Stein and Picasso 2005, 49n1.

EL GRECO (DOMÉNIKOS THEOTOKÓPOULOS)

Spanish, born Candia, Crete, 1541; died 1614, Toledo, Spain

65. *Saint Francis in Meditation,* ca. 1585
Oil on canvas
39⅝ x 34¾ in. (100 x 88 cm)
Current location unknown
Plate 351

Provenance

Leo Stein, Paris (owned[1,2] [pl. 351] until February 10, 1914); Durand-Ruel, Paris (acquired February 10, 1914[1,3])

Notes

1. Legrendre, Hartmann, and Gloeckner 1937, 389.
2. In correspondence dated December 7, 1910, to Gertrude Stein, Jacob Moses writes about a pending visit by Faris Pitt, who is in charge of the Walters Collection: "Who knows but that he may offer a 'real Greco' price for the 'St. Francis' Meditation'? It looks fine on the wall and we are very fond of it." Beinecke YCAL, MSS 76, folder 2488, box 117. Yet given the sale of Leo's work to Durand-Ruel in 1914, the reference may relate to another work attributed to the artist.
3. Durand-Ruel Archives. References in the Durand-Ruel Archives for this work—no. 10490, photograph 7843, 1 x 0.88 m—indicate: "Greco. 'Saint François d'Assise.'"

JUAN GRIS

Spanish, born 1887, Madrid; died 1927, Boulogne-Billancourt, France

PAINTING

66. *Glass of Beer and Playing Cards,* 1913
Oil on canvas, signed and dated on verso
9⁷⁄₁₆ x 7½ in. (24 x 19 cm)
Musée des Beaux-Arts de Dijon, Granville gift
Cooper 48

Provenance

Galerie Kahnweiler, Paris; Gertrude Stein, Paris (possibly by June 1914[1]); Rolf de Maré, Paris (by 1923[2,3]); Galerie Renou et Colle, Paris; Valentine Gallery, New York; Pierre and Kathleen Granville (until 1969)[4]; Musée des Beaux-Arts de Dijon (gift in 1969[5])

Notes

1. Of the four works created by Gris in or before 1914 that belonged to Gertrude Stein, one may be the present example, referred to in a letter from Daniel-Henry Kahnweiler to Gertrude. +14
2. Cooper 1977, no. 48, lists the provenance as noted.
3. The painting belonged to the Swedish collector and leader of the Ballets Suédois in Paris Rolf de Maré at least by 1923. Asplund 1923, ill. pl. 32.

4. The work was lent to a Cubism exhibition in 1953 by an unknown owner ("Collection particulière, Paris"). Paris 1953, no. 127.
5. Acquisition date provided by the online collection database Ministère de la culture, France [culture.gouv.fr/Joconde], accessed June 3, 2010.

67. *Glasses on a Table,* 1913-14
Oil and pasted paper on canvas, signed on verso
24⅛ x 15⅛ in. (61.3 x 38.4 cm)
Private collection
Cooper 68
Plate 241

Provenance

Galerie Kahnweiler, Paris (1914); Gertrude Stein, Paris (possibly June 1914[1,2] until 1946; thereafter, her estate[3]); André Meyer, New York (December 14, 1968,[4] until 1980[5])[6]

Notes

1. Of the four works created by Gris in or before 1914 that belonged to Gertrude Stein, one may be the present example, referred to in a letter from Daniel-Henry Kahnweiler to Gertrude. +14
2. Likely one of three works by Gris that Carl Van Vechten reported seeing in the dining room at rue de Fleurus during a visit with Gertrude and Alice on July 5, 1914. Edward Burns, e-mail message to author, November 9, 2009. See also +16
3. One of eight works by Gris recorded in the estate of Gertrude Stein and evaluated in a French tax document dated February 22, 1947, and one of a group of the artist's works mentioned in correspondence dated November 13, 1955, from Alice Toklas. +15
4. Purchased from the Museum of Modern Art Syndicate, 1968
5. His sale, Sotheby Parke Bernet, Inc., New York, October 22, 1980, lot. no. 39 (ill.).
6. Esteban Leal 2005, no. 38.

68. *Book and Glasses,* 1914
Oil, pasted paper, and wax crayon on canvas mounted on panel
25¹¹⁄₁₆ x 19¹³⁄₁₆ in. (65.3 x 50.3 cm)
Private collection, New York
Cooper 83
Plates 242, 360

Provenance

Galerie Kahnweiler,[1] Paris (1914); Gertrude Stein, Paris (July 1914,[2,3] and owned [pl. 360] until 1946; thereafter, her estate[4]); E.V. Thaw, Inc., New York (December 14, 1968[5,6,7]); S. Tarica, Paris; Mr. and Mrs. B.F. Goulandris, Lausanne, Switzerland; private collection, New York

Notes

1. The verso of the work bears the Kahnweiler inventory no. 2086. Work examined September 9, 2009.
2. Cooper 1977, no. 83. Douglas Cooper (1971) originally proposed a June acquisition date, which he later revised.
3. Likely one of three works by Gris that Carl Van Vechten reported seeing in the dining room at rue de Fleurus during a visit with Gertrude and Alice on July 5, 1914. Edward Burns, e-mail message to author, November 9, 2009. +16
4. In 1954 Alice Toklas referred to this work as "the early dark Gris still life" in need of "serious and immediate attention." Alice Toklas to Donald Gallup, October 12, 19, and 21, 1954, in Toklas 1973, 309-10.
5. Purchased through the Museum of Modern Art Syndicate, 1968.

6. The verso of the work also bears a MoMA "Estate" number, 70.1216, which corresponds to Stein collection number 36: "Gris, Nature morte (à la bouteille)." Work examined September 9, 2009; and MoMA Archives, M. Potter Papers, Exh. 950, untitled box, folder 4A, corr. D-H.
7. One of eight works by Gris recorded in the estate of Gertrude Stein and evaluated in a French tax document dated February 22, 1947, and one of a group of the artist's works mentioned in correspondence from Alice Toklas dated November 13, 1955. +15

69. *Flowers,* 1914
Oil, pasted paper, and graphite on canvas, signed on verso
21¾ x 18¼ in. (55.3 x 46.4 cm)
Private collection
Cooper 95
Plate 189

Provenance

Galerie Kahnweiler, Paris (1914[1]); Gertrude Stein, Paris (by June 1914[2,3] and owned[4,5] until 1946; thereafter, her estate[6]); Nelson A. Rockefeller, New York (December 14, 1968[7]); E.V. Thaw, Inc., New York; Harold Diamond, New York[8]

Notes

1. Galerie Kahnweiler inventory number: K. 2090.
2. Cooper 1977, no. 95. Douglas Cooper claims that it was the third work by Gris to enter Gertrude Stein's collection. Cooper 1971, unpaged.
3. Likely one of three works by Gris that Carl Van Vechten reported seeing in the dining room at rue de Fleurus during a visit with Gertrude and Alice on July 5, 1914. Edward Burns, e-mail message to author, November 9, 2009.
4. Surely one of the works referred to in an August 10, 1917, letter from Gris. +16
5. One of at least four works from the collection of Gertrude Stein lent to the Juan Gris retrospective at Galerie Simon in June 1928 (Paris 1928). +17
6. One of eight works by Gris recorded in the estate of Gertrude Stein and evaluated in a French tax document dated February 22, 1947, and one of a group of the artist's works mentioned in correspondence from Alice Toklas dated November 13, 1955. +15
7. Purchased through the Museum of Modern Art Syndicate, 1968.
8. Additional ownership information provided by Rebecca Rabinow.

70. *The Table in Front of the Window,* 1921
Oil on canvas, signed and dated lower right
25⅝ x 39½ in. (65 x 100 cm)
Beverly and Raymond Sackler
Cooper 366
Plates 244, 383

Provenance

Galerie Simon, Paris[1]; Gertrude Stein, Paris (probably June 1921[2] and owned[3] [pl. 383] until 1946; thereafter, her estate[4]); E.V. Thaw, Inc., New York (December 14, 1968[5]); Stephen Hahn, Inc., New York (until 1973); Beverly and Raymond Sackler (acquired 1973[6])

Notes

1. Galerie Simon inventory number: K.6552.
2. Cooper 1977, no. 366.
3. One of at least four works from the collection of Gertrude Stein lent to the Juan Gris retrospective at Galerie Simon in June 1928 (Paris 1928). +17

4. One of eight works by Gris recorded in the estate of Gertrude Stein and evaluated in a French tax document dated February 22, 1947, and one of a group of the artist's works mentioned in correspondence from Alice Toklas dated November 13, 1955. +15
5. Purchased through the Museum of Modern Art Syndicate, 1968.
6. Esteban Leal 2005, no. 113.

71. *Woman with Clasped Hands*, 1924
Oil on canvas, signed and dated lower right
32 x 23⅝ in. (81.3 x 60 cm)
Ikeda Museum of Twentieth-Century Art Foundation, Shizuoka, Japan
Cooper 456
Plates 246, 383

Provenance
Galerie Simon, Paris[1]; Gertrude Stein, Paris (acquired in autumn 1924,[2] until [pl. 383] 1946; thereafter, her estate[3]); E.V. Thaw, Inc., New York (December 14, 1968[4]); Mr. Eiichi Ikeda (February 19, 1975,[5] until present)

Notes
1. Galerie Simon inventory number: K.8385.
2. Acquisition date provided by Cécile Debray.
3. One of eight works by Gris recorded in the estate of Gertrude Stein and evaluated in a French tax document dated February 22, 1947, and one of a group of the artist's works mentioned in correspondence from Alice Toklas dated November 13, 1955. +15
4. Purchased through the Museum of Modern Art Syndicate, 1968.
5. Susumu Yamamoto, e-mail message to author, June 4, 2010.

72. *The Green Cloth*, 1925
Oil on canvas, signed and dated lower left
28¾ x 36¼ in. (73 x 92 cm)
Private collection, New York
Cooper 522

Provenance
Galerie Simon, Paris[1]; Gertrude Stein (acquired June 1925[2] and owned[3] until 1946; thereafter, her estate[4]); private collection, New York (December 14, 1968,[5] until present[6])

Notes
1. Galerie Simon inventory number: K.8941.
2. Gertrude acquired the present work through an exchange of André Masson's *The Snack* (1922–23; cat. 86) and 1,000 francs. +18
3. One of at least four works from the collection of Gertrude Stein lent to the Juan Gris retrospective at Galerie Simon in June 1928 (Paris 1928). +17
4. One of eight works by Gris recorded in the estate of Gertrude Stein and evaluated in a French tax document dated February 22, 1947, and one of a group of the artist's works mentioned in correspondence from Alice Toklas dated November 13, 1955. +15

5. Acquired by David Rockefeller from the estate of Gertrude Stein through the Museum of Modern Art Syndicate in 1968. +19
6. Esteban Leal 2005, no. 137.

73. *Dish of Pears*, 1926
Oil on canvas, signed and dated lower right
10⅝ x 13¾ in. (26.9 x 34.9 cm)
Current location unknown
Cooper 598
Plate 361

Provenance
Galerie Simon, Paris[1]; Gertrude Stein, Paris (acquired autumn 1926 and owned[2] [pl. 361] until 1946; thereafter, her estate[3])

Notes
1. Galerie Simon inventory number: K.9700.
2. One of at least four works from the collection of Gertrude Stein lent to the Juan Gris retrospective at Galerie Simon in June 1928 (Paris 1928). +17
3. One of eight works by Gris recorded in the estate of Gertrude Stein and evaluated in a French tax document dated February 22, 1947, and one of a group of the artist's works mentioned in correspondence from Alice Toklas dated November 13, 1955. +15

WORKS ON PAPER

74. *The Clown*, drawing for Armand Salacrou's *Le Casseur d'assiettes* (The Plate Breaker), 1924
Ink and graphite on paper, signed and inscribed lower left
9⅞ x 7½ in. (25.1 x 19.1 cm)
Katrina B. Heinrich-Steinberg, Rancho Mirage, California
Plate 245

Provenance
Gertrude Stein, Paris (acquired 1924[1]); Louise and Lionel Steinberg, Palm Springs, California (by 1970[2]); Lionel Steinberg and Katrina Heinrich-Steinberg (until 1999[3]); thereafter, Katrina Heinrich-Steinberg, Rancho Mirage, California

Notes
1. The work was a gift from the artist to Gertrude Stein and is inscribed: "A Gertrude Stein/Tres amicalement, /Juan Gris/1924." Alice Toklas received a similar drawing in 1924 (see cat. 75).
2. Potter 1970, 157 (ill. 69).
3. Lionel Steinberg died in 1999.

75. *Man with Hat*, drawing for Armand Salacrou's *Le Casseur d'assiettes* (The Plate Breaker), 1924
Ink and graphite on paper, signed and inscribed lower left
9⅞ x 7½ in. (25.1 x 19.1 cm)
Current location unknown

Provenance
Alice Toklas, Paris (acquired 1924,[1] until[2] probably 1968); Gilbert A. and Anne B. Harrison (until May 2008); Galería Guillermo de Osma, Madrid (acquired May 2008[3])

Notes
1. The work was a gift from the artist to Alice Toklas and is inscribed: "A Alice Toklas/Tres amicalement /Juan Gris/1924." Gertrude Stein received a similar drawing in 1924 (see cat. 74).
2. Toklas writes in an April 1949 letter that she owns a pen-and-ink drawing by Gris of *Le Casseur d'assiettes* created for a limited edition of Salacrou's play: "My dear I've just gone in and looked at it and it's a pen and ink drawing! *Tant pis* only would you think it horrid of me if I asked you to leave it to Yale University Library for the G.S. collection." Alice Toklas to L. Elizabeth Hansen, April 14, 1949, in Toklas 1973, 154.
3. Sales catalogue, Sotheby's, New York, 2008, lot no. 320. Provenance as indicated.

76. *Ship's Deck (Boat Deck)*, 1924
Watercolor and pasted paper
8½ x 11¾ in. (21.6 x 29.9 cm)
Current location unknown

Provenance
Gertrude Stein, Paris (acquired 1925,[1] until 1946; thereafter, her estate); Nelson A. Rockefeller, New York (acquired 1968[2])

Notes
1. The work was a gift from the artist to Gertrude Stein and is inscribed: "A Gertrude Stein/son ami Juan Gris 1925."
2. Purchased through the Museum of Modern Art Syndicate, 1968.

MARIE LAURENCIN
French, born 1885, Paris; died 1956, Paris

PAINTING

77. *Group of Artists*, 1908
Oil on canvas, signed and dated lower left
25½ x 31⅞ in. (64.8 x 81 cm)
The Baltimore Museum of Art: The Cone Collection, formed by Dr. Claribel Cone and Miss Etta Cone of Baltimore, Maryland
Plate 207

Provenance
Gertrude Stein, Paris[1] (probably until June 1925); Claribel and Etta Cone, Baltimore (purchased June 14, 1925[2,3]); Baltimore Museum of Art (1950)

Notes
1. Gertrude claimed to have acquired the first picture that the artist ever sold. G. Stein 1990, 62.
2. Although Kahnweiler proposed to Gertrude an exchange involving the present work, it was actually Michael and Sarah who sold the work for her and received payment from Claribel Cone. +20; +18
The purchase price is noted as $2,150 in Mellow 1974 (346) and 10,000 francs in Claribel Cone's 1925 notebook. +21
3. Purchase date established in B. Richardson 1985, 175.

78. *Basket II*, 1946[1]
Oil on canvas, signed upper right
21½ x 18½ in. (54.5 x 47 cm)
Yale Collection of American Literature, Beinecke
Rare Book and Manuscript Library, Yale University,
New Haven
Plate 293

Provenance

Alice Toklas, Paris (until 1949[1,2]); Yale Collection of
American Literature, Beinecke Rare Book and
Manuscript Library, Yale University (1949[2,3])

Notes

1. The painting of Basket II appears in several
photographs of rue Christine in spring–summer 1946:
in one, Gertrude holds the painting (Beinecke YCAL,
MSS 76, folder 3638); in another, the "portrait" of
Basket II hangs on a door in the living room (Horst P.
Horst, *Self-Portrait with Gertrude Stein, Paris* [1946;
private collection]).
2. Following Gertrude's example, Alice Toklas added
to the collection of papers and artworks that Gertrude
gave to the Yale Collection of American Literature,
Beinecke Rare Book and Manuscript Library. In a letter
dated July 19, 1949, to L. Elizabeth Hansen, Toklas writes
about Donald Gallup, curator of the Yale Collection of
American Literature: "He is taking back with him my
little early Picasso and the portrait of the poodle by
Marie Laurencin and the red tape to get them out of
the country." Toklas 1973, 171–73.
3. Gift of Alice B. Toklas, Beinecke YCAL records.

DORA MAAR

French, born 1907, Tours, France; died 1997, Paris

PAINTING

79. *View of the Seine*, n.d.
Oil on canvas
33¼ x 40½ in. (84.2 x 103.1 cm)
Yale Collection of American Literature, Beinecke
Rare Book and Manuscript Library, Yale University,
New Haven

Provenance

[Gertrude Stein and] Alice Toklas, Paris[1,2]; Yale
Collection of American Literature, Beinecke Rare
Book and Manuscript Library, Yale University[2]

Notes

1. The artwork appears in a photograph of the entry
hallway of 5 rue Christine taken ca. 1945–55,
Department of Nineteenth-Century, Modern, and
Contemporary Art, The Metropolitan Museum of Art,
New York, gift of Edward Burns, 2011.
2. Gift of Alice B. Toklas, Beinecke YCAL records.

80. *Portrait of Alice B. Toklas*, ca. 1952
Oil on canvas
40 x 55 in. (99 x 140 cm)
Yale Collection of American Literature, Beinecke
Rare Book and Manuscript Library, Yale University,
New Haven

Provenance

Alice Toklas, Paris (ca. 1952[1]); Yale Collection
of American Literature, Beinecke Rare Book and
Manuscript Library, Yale University[2]

Notes

1. In a letter dated March 29, 1952, Alice Toklas writes
to Carl Van Vechten: "Dora Maar is putting Basket [II]
into the portrait which pleases me a lot—she is
coming to make some more drawings of him—it is to
be hoped she will give me one of them" (Toklas
1973, 254). The letter suggests that the inclusion of the
pet poodle was a late addition to the portrait, and thus
that the painting was either finished or nearly finished
and then revised by the artist in March 1952. The
completed artwork appears in a May/June 1952 photo
of Alice visiting with cast members of *Four Saints in
Three Acts*, Department of Nineteenth-Century,
Modern, and Contemporary Art, The Metropolitan
Museum of Art, New York, gift of Edward Burns, 2011.
2. Gift of Alice B. Toklas, Beinecke YCAL records.

ÉDOUARD MANET

French, born 1832, Paris; died 1883, Paris

81. *Ball Scene*, 1873
Oil on canvas
13¾ x 10⅝ in. (34.9 x 27 cm)
Private collection
Plates 16, 48, 353, 354, 357

Provenance

Édouard Manet (until 1883[1]); Cherfils, Paris (until
probably 1892[2]); Leo and Gertrude Stein, Paris
(by February 1909,[3] and owned jointly[4] [pls. 353, 354]
until 1913/1914); thereafter, Gertrude Stein, Paris
(1913/1914 until [pl. 357] October 1919); Paul Rosenberg,
Paris (acquired October 15, 1919[5]); Halfdan Mustad,
Oslo (by 1932[6])

Notes

1. Posthumous inventory in 1883 of the artist's atelier:
no. 58, "Esquisse de Bal masqué, 150 francs." Jamot and
Wildenstein 1932, 107.
2. Probably Alphonse Cherfils, the collector from Pau,
who died in 1892.
3. The artwork appears just to the left of Pierre-Auguste
Renoir's *Girl in Gray-Blue* in pl. 16, which was taken
between November 1908 and February 1909. A letter
from Gertrude Stein dated March 14, 1905, suggests
that she and Leo are trying to buy a Manet. BMA Cone
Papers, box 6, series 7-8, and original document from
Beinecke YCAL.

4. One of four works that Jos Hessel proposed to
purchase from Leo and Gertrude Stein in 1912 but that
were later sold to different collectors. +11
5. Gertrude sold the present work along with Cézanne's
Man with Pipe (1892–96; cat. 13) for 20,000 francs
on October 15, 1919. Handwritten receipt from Gertrude
Stein to Paul Rosenberg, Paris, October 15, 1919,
MoMA Archives, Paul Rosenberg Papers.
6. Jamot and Wildenstein, 19 (no. 217).

HENRI CHARLES MANGUIN

French, born 1874, Paris; died 1949, Saint-Tropez, France

PAINTING

82. *The Studio, the Nude Model*, 1904–5
Oil on canvas, signed lower right
24¾ x 21 in. (65 x 54 cm)
Collection of Mr. and Mrs. E. David Coolidge III
Sainsaulieu 129
Plates 55, 346, 349, 353, 354

Provenance

Leo [and Gertrude] Stein, Paris (April 1905,[1,2] and
perhaps owned jointly[3] [pls. 346, 349, 353, 354] until
1913/1914); Leo Stein, Paris (1913/1914 until[4] at least
April 1924[5,6]); Fred M. Stein, New York (from April
1924[5]); J. Solomon, New York (by 1970[7]); Sotheby's,
New York, March 11, 1998, lot no. 55

Notes

1. Surely the painting that Leo bought (along with a
Vallotton, cat. 438) from the 1905 Salon des Indépendants,
shown in the salon as no. 2648 (see Sainsaulieu 1980,
no. 129, 78–79). Leo refers to the acquisition as "a
successful study of the nude by Manguin, really school
of Matisse, but of a kind of Matisse that I had not yet
seen; otherwise I should not have been so well pleased
with this Matisse at second-hand." L. Stein 1996, 158.
2. Henri Manguin account book indicates that the work
(no. 15) was sold to Leo Stein in April 1905 for 250
francs. Claude Holstein-Manguin, e-mail message to
Cécile Debray and the author, November 23, 2009,
and Cécile Debray, e-mail message to author,
December 16, 2009.
3. Druet 1910, no. 33 (as "L'Atelier. Appartient à M. Léo
Stein").
4. The work appears as no. 34, noted as having "no
value," on a list of artworks that Leo Stein wished to
sell in April 1921. +5
5. One of at least four works placed on consignment
with Durand-Ruel, New York, by Leo Stein in
May/June 1921 and returned to him in care of his
cousin Fred M. Stein, New York, on April 7, 1924, the
present work is surely that listed in the Durand-Ruel
records as no. 34: "Femme nue, interieur"; depot no.
8099. Archives Durand-Ruel, Paris. +5
6. Although Sainsaulieu 1980, no. 129, lists Gertrude
Stein subsequently as an individual owner of this work,
one may, based on the information cited in notes 4
and 5 above, more likely conclude that Leo retained this
work after he and Gertrude divided their joint
collection in 1913–14, especially since the work does not
appear in the later photographs of Gertrude's collec-
tion that are presently known.
7. The verso displays the following labels: Museum of
Modern Art loan label "Solomon, J. 70.1067" and a
white label bearing the number 6197. Other, less
legible numbers on the verso are perhaps "73_ _ 9 S."
Fred Baker, e-mail message to author, May 10, 2010.

83. *La Coiffure*, 1905
Oil on canvas
45⅝ x 35¹/₁₆ in. (116 x 89 cm)
Collection Couturat
Sainsaulieu 134
Plates 18, 364

Provenance

[Leo and/or] Michael and Sarah Stein, Paris (acquired February 1906,[1] until[2] [pl. 364] October 1916); Galerie Bernheim-Jeune, Paris (acquired October 1916,[3] until May 1935); G. Couturat, Paris (acquired May 1935[4]); private collection, Lausanne (ca. 1950[3])

Notes

1. Henri Manguin account book indicates the work (no. 50) as being sold to Stein (no first name) in February 1906 for 600 francs. Claude Holstein-Manguin, e-mail message to Cécile Debray and the author, November 23, 2009, and Cécile Debray, e-mail message to author, December 16, 2009. In early photographs of the Stein residences, the painting is known to appear only at rue Madame, which suggests that even if Leo "purchased" the work, it was soon thereafter acquired by Michael Stein.
2. Druet 1910, no. 3 (as "La Coiffure. Appartient à M. Michel Stein").
3. Provenance information established by Sainsaulieu 1980, no. 134.
4. Claude Holstein-Manguin, e-mail message to Cécile Debray and the author, December 1, 200[9].

84. *Study of Reclining Nude*, 1905
Oil on panel, signed lower right
13 x 16⅛ in. (33 x 41 cm)
Private collection, France
Sainsaulieu 138
Plate 56

Provenance

Leo Stein, Paris (acquired February 1907[1,2]); Lucie Manguin, France (ca. 1950[3])

Notes

1. Henri Manguin account book indicates the work (no. 6) was sold to Stein (no first name) in February 1907 for 100 francs. Claude Holstein-Manguin, e-mail message to Cécile Debray and the author, November 23, 2009, and Cécile Debray, e-mail message to author, December 16, 2009. Note that the painting measures slightly larger than a traditional number six canvas, the largest size of which, a portrait size, measures 16 x 12¹³/₁₆ in. (40.5 x 32.5 cm); thus, it is likely painted on a portrait-format canvas that has been oriented horizontally, rather than a traditional number six (landscape or marine) canvas.
2. After Leo's acquisition of this work, little is known.
3. Provenance information established by Sainsaulieu 1980, no. 138.

ANDRÉ MASSON

French, born 1896, Balagne, France; died 1987, Paris

PAINTING

85. *The Meal*, 1922
Oil on canvas, signed lower right
32¼ x 26⅜ in. (82 x 67 cm)
Private collection, Madrid
Masson 1922*20
Plate 247

Provenance

Galerie Simon, Paris[1]; Gertrude Stein (likely by April 1923,[2] until at least March 1924[3]); private collection, Paris (by 1976[4]); Galerie Louise Leiris, Paris[5]

Notes

1. Galerie Simon, Paris: photo no. 10501.
2. One of two works by Masson that Gertrude Stein refers to in a letter of perhaps April 1923 to Henry McBride: "I have a new Picasso I traded for an old and two new Masson's." +22
3. Simon 1924, no. 7 (noted as "Appartient à Mlle Gertrude Stein," and dated 1922).
4. Rubin and Lanchner 1976, 93.
5. Ownership noted in Masson, Masson, and Loewer 2010, no. 1922*20.

86. *The Snack*, 1922–23
Oil on canvas, signed lower left
29⅝ x 31⅞ in. (65 x 81 cm)
Private collection
Masson 1923*35

Provenance

Galerie Simon,[1] Paris (May 25, 1923,[2] until June 1923[2]); Gertrude Stein, Paris (June 1923, and owned[3] probably until June 1925[4]); private collection, United States[5]; Galerie K., Paris[5]; private collection, Paris (by 2004[5])[6]

Notes

1. Galerie Simon (photo nos. 10519/7774).
2. Levaillant 1990, 30.
3. Simon 1924, no. 20 (as "Le Verre de vin, Appartient à Mlle Gertrude Stein," and dated 1923).
4. Likely the work that Gertrude traded in order to acquire *The Green Cloth* by Gris (1925; cat. 72). +18
5. Sales catalogue, Tajan, Paris, December 9, 2004: sale no. 4514, lot no. 31. The work was bought in.
6. Provenance established in Masson, Masson, and Loewer 2010, no. 1923*35.

87. *The Cardplayers*, 1923[3]
Oil on canvas, signed lower right
31⅞ x 23⅝ in. (81 x 60 cm)
Private collection
Masson 1923*21

Provenance

Galerie Simon, Paris[1]; Gertrude Stein, Paris (likely by April 1923[2] until at least March 1924[3]); Galerie Simon, Paris[4]; Galerie de Beaune, Paris[4]; Walter P. Chrysler Jr. (by 1941[4] until at least 1950[5]); Galerie Louise Leiris, Paris (by 1970[6]); private collection[7]

Notes

1. Galerie Simon, Paris, photo no. 10504.
2. One of two works by Masson that Gertrude Stein refers to in a letter of perhaps April 1923 to Henry McBride: "I have a new Picasso I traded for an old and two new Masson's [*sic*]." +22
3. Simon 1924, no. 13 (noted as "Appartient à Mlle Gertrude Stein," and dated 1922). Note that Masson, Masson, and Loewer 2010 dates the work to 1923.
4. Richmond 1941, no. 107 (ill.).
5. In a letter dated January 4, 1950, Edward H. Dwight wrote to Mr. Lamont Moore noting the present work in the collection of Walter P. Chrysler Jr. BMA Cone Papers, box 6: series 7-8. This is one of at least two works by Masson formerly in the collection of Gertrude Stein acquired by Chrysler.
6. Potter 1970, 159, citing Galerie Louise Leiris to Margaret Potter, July 22, 1970; see MoMA Archives, Margaret Potter Papers, Exh. 950.

7. Provenance established in Masson, Masson, and Loewer 2010, no. 1923*21.

88. *Man in a Tower*, 1924
Oil on canvas, signed on verso
37⅜ x 24 in. (95 x 60.8 cm)
Solomon R. Guggenheim Museum, New York, Estate of Karl Nierendorf, by purchase
Masson 1924*24
Plate 248

Provenance

Galerie Simon,[1] Paris (1924); Gertrude Stein, Paris (acquired 1924); Galerie de Beaune,[1] Paris; Walter P. Chrysler Jr. (by January 1941)[2]; Karl Nierendorf, New York (until 1947; thereafter his estate[3]); Solomon R. Guggenheim Museum, New York (acquired 1948)[4]

Notes

1. The verso of the work bears a Galerie Simon photo no. (10586) and label, and a stamp of the Galerie de Beaune. Guggenheim Collections Research Report prepared by Megan Fontanella, June 23, 2010.
2. Walter P. Chrysler Jr. is known to have acquired at least two works by Masson formerly in the collection of Gertrude Stein. The present work was exhibited in Richmond 1941, no. 108 (as "Man Holding a Rope, 1924, 24 x 37¼ in. [dimensions reversed]"). There is no additional information in the archives at the Chrysler Museum of Art, Norfolk, Virginia, regarding the identification of this work (Laura Christiansen, e-mail message to author, June 4, 2010). Of the two other known versions of Masson's *Man in a Tower*, neither corresponds in dimension as closely as the Guggenheim painting, which is also the only example in which the man is actually holding a rope (Camille Morando, e-mail message to author, June 7, 2010). Both facts suggest that this painting was in the Chrysler collection.
3. Karl Nierendorf died in 1947 without a will, and his estate passed into the custody of the State of New York. Guggenheim Collections Research Report prepared by Megan Fontanella, June 23, 2010.
4. Rudenstine 1976, 506.

HENRI MATISSE

French, born 1869, Le Cateau-Cambrésis, France; died 1954, Nice, France

PAINTING

89. *Open Door, Brittany*, 1896
Oil on canvas
13⅞ x 11¼ in. (35 x 28.5 cm)
Current location unknown
Dauberville (1995) 7 (Bernheim-Jeune photo no. 1419, October 1916)

Provenance

Leo Stein, Paris[1,2]; Michael and Sarah Stein, Paris (owned jointly[3] until 1938; thereafter, Sarah Stein, Palo Alto, until at least February 1947[4]); Allan and Roubina Stein (until 1951); thereafter, Roubina Stein[5]

Notes

1. Dauberville 1995, no. 7.
2. Sales catalogue, Hôtel Drouot, Paris, June 5, 1912, probably the Matisse work sold by Druet as lot no. 52: "La Porte ouverte, 36 x 28 cm."
3. Thought to be "Open Door 5518" among the works lent by Michael and Sarah Stein to San Francisco 1936. Sarah Stein to Henri Matisse, January 7, 1936, AMP and SFMOMA Archives (+28).
4. Following a 1947 visit with Sarah Stein, Fiske Kimball wrote, "There is a beautiful gray doorway, half open, of *1896!*" +9
5. Appears in an undated Sotheby's inventory of Roubina Stein's collection, AMP, information communicated to Carrie Pilto, February 2008.

90. *Ajaccio*, 1898
Oil on canvas
11 x 14¼ in. (27.9 x 36.2 cm)
Current location unknown
Dauberville (1995) 40 (Bernheim-Jeune photo no. 1420, October 1916, as "Le village")
Plate 374

Provenance

Michael and Sarah Stein, Paris and Palo Alto (owned jointly [pl. 374] until at least 1928[1] and until perhaps 1935/January 1936[2]); Mr. and Mrs. Philip N. Lilienthal, Atherton, California; Mr. and Mrs. Philip N. Lilienthal III

Notes

1. The work appears in a photograph of the dining room of Villa Stein–de Monzie taken sometime between 1928 and 1935, David and Barbara Block family archives.
2. It is possible that the Lilienthals acquired the work at the time they purchased *La Japonaise: Woman beside the Water* (1905; cat. 108), by January 1936, shortly after the Steins returned to California in July 1935.

91. *Canal du Midi*, 1898
Oil on cardboard
9½ x 14⅛ in. (24 x 36 cm)
Collection of Carmen Thyssen-Bornemisza, on loan to the Museo Thyssen-Bornemisza, Madrid
Dauberville (1995) 38 (as "Paysage vers 1900") (Bernheim-Jeune photo no. 1430[1], October 1916)
Plates 57, 362, 364, 368

Provenance

Galerie Bernheim-Jeune, Paris; Galerie Druet, Paris (by 1906[2]); Leo and Gertrude Stein, Paris (perhaps by spring 1906[2]); Michael and Sarah Stein, Paris and Palo Alto (ca. 1906/early 1907 [pl. 362], and owned jointly [pls. 364, 368] until 1938; thereafter, Sarah Stein, Palo Alto, until 1949); Mr. and Mrs. Lionel Steinberg, Palm Springs (purchased 1949); Christie's, London, June 1997[3]

Notes

1. An undated photograph of the work exists with the Bernheim-Jeune number 1430 on the verso. PMG Archives, MA 5020, box 133.19.

2. Perhaps one of two works (nos. 27, 28) presented under the title "Paysage du Canal du Midi" in Paris 1906. Tomás Llorens, in a 2010 online text, suggests that Leo and Gertrude acquired the work from this Galerie Druet exhibition. Museo Thyssen-Bornemisza [museothyssen.org], accessed June 3, 2010.
3. Sales catalogue, Christie's, London, June 24, 1997 (Part II), lot no. 147, which states that the work is Druet no. 2886.

92. *Fruit Trees in Blossom*, 1898
Oil on canvas
Approximately 15 x 18⅛ in. (38 x 46 cm)
Current location unknown
Plates 362, 366, 367, 371

Provenance

Michael and Sarah Stein, Paris (likely acquired April 10, 1906,[1] possibly until [pls. 363, 366, 367, 371] lent July 1914[2]—from 1914 to 1917[?] left in safekeeping with Greta and Oskar Moll, Berlin, until allegedly confiscated by gallery owner Fritz Gurlitt, sold in a fictitious auction in 1917, and bought by Gurlitt himself; claimed in 1919 by Hans Purrmann on behalf of the Steins and sold); Tryggve Sagen, Oslo, or Christian Tetzen-Lund, Copenhagen (ca. 1920–22)[3]; Collection Renand[4]

Notes

1. The painting is probably Druet stock no. 1939, noted as "vendu M. Steine [Stein], 10 avril 1906, 120 francs." AMP.
2. Gurlitt exhibition (Berlin 1914) pamphlet, no. 1 (as "Obstbäume in Korsika, 1897") and November 1916 document, pl. 116 (as "Arbres fruitiers Corse [fruit trees in Corsica], 46 x 38 [cm.; dimensions reversed], 1897, $150.00"). +24
3. Monrad 1999b, 146.
4. AMP.

93. *Small Door of the Old Mill*, 1898
Oil on canvas, signed lower right
18⅞ x 14⅛ in. (48 x 36 cm)
Current location unknown
Dauberville (1995) 26 (Bernheim-Jeune photo no. 350, February 1914)

Provenance

Leo Stein, Paris (at least by February 1910,[1,2] until February 12, 1914); Galerie Bernheim-Jeune, Paris (acquired on February 12, 1914,[3] until June 22, 1915); Henri Matisse (reacquired June 22, 1915)[4]; Hôtel Drouot, Paris, November 24, 1951, lot no. 205[5]; private collection, Paris[6]

Notes

1. Likely the work exhibited in Paris 1910a as no. 12 ("La porte, 1899, App. à M.L.D.S. [Mr. Leo D. Stein]").

2. Probably the work referred to in a May 14, 1910, letter from Michael Stein to Leo and Gertrude Stein at Casa Ricci, noting: "We brought home with us your little Matisse landscape." BMA Cone Papers, box 6, series 7-8.
3. Dauberville 1995, no. 26. In November 1913, Félix Fénéon writes to Leo Stein that Galerie Bernheim-Jeune wishes to borrow a large number of works from his collection for the 1914 Rome exhibition *Secessione*. This is likely the work lent as as no. 11: "La porta." Beinecke YCAL, MSS 76, box 98, folder 1866.
4. Dauberville 1995, no. 26.
5. AMP.
6. Likely Paris 1957, no. 124 (as "La porte du jardin, 1898, 46 x 38,…Signé dans l'angle inférieur droit. Collection particulière, Paris").

94. *Tree or Landscape (Corsica)*, 1898
Oil on canvas, signed lower right
14¹⁵⁄₁₆ x 18⅛ in. (38 x 46 cm)
Current location unknown
Dauberville (1995) 15 (Bernheim-Jeune photo nos. 2591, June 1919, and 11189; inv. nos. 7139, 21613)[2]

Provenance

Galerie Druet, Paris; Leo Stein, Paris (acquired November 27, 1908,[1] until February 6, 1909); Galerie Bernheim-Jeune, Paris (February 6, 1909,[2] until March 13, 1914); E. Mayrisch (acquired March 13, 1914, for 1,400 francs); Galerie Bernheim-Jeune, Paris (June 1, 1919, until July 27, 1919); Léon Marseille (acquired July 27, 1919)[3]; Madame Desjardins, Paris (at least by June 1931,[4] likely until at least 1957[5]); Philippe Fontaine, Paris[6]; Lefevre Gallery, London (before 1987[6])

Notes

1. Druet stock no. 1942 is noted as being sold to Leo Stein on November 27, 1908, for 250 francs. AMP.
2. Paris 1910a, no. 3 (as "Jardin près d'Ajaccio," without recorded ownership).
3. Provenance subsequent to Leo's ownership and until July 1919 is established by Dauberville 1995, no. 15. A photograph of this work is inscribed "photo Mme Hass" and bears the Bernheim-Jeune inventory number 21613 and photograph number 2591. AMP.
4. When the work was exhibited (as no. 4) in Paris 1931, Madame Desjardins, Paris, was noted as the owner.
5. Sales catalogue, Christie's, London, July 3, 1979, lot no. 40. According to this source, the work was exhibited in Paris 1957, likely no. 125 (as "Paysage de corse, 1898, huile sur toile. H. 0,40; L. 0,47. Signé dans l'angle inférieur droit. Collection particulière, Paris").
6. Sales catalogue, Sotheby's, New York, May 12, 1987, Part II, lot no. 293.

95. *Houses (Fenouillet),*[1] 1898-99
Oil on cardboard (later mounted to hardboard and plywood panels)
9⁷⁄₁₆ x 14 in. (24 x 35.5 cm)
The Barnes Foundation, Merion, Pennsylvania
Plate 351

Provenance
Leo and Gertrude Stein, Paris (owned jointly [pl. 351] until 1913/1914; thereafter, Leo Stein, until May 1921[2]); Albert C. Barnes, Merion, Pennsylvania (acquired May 1921[3])

Notes
1. Paris 1906, no. 29 (as "Les Maisons [Fenouillet]").
2. One of seven paintings by Matisse that Leo Stein offered for sale in 1921, likely no. 23, valued at $200: "[Matisse] 200 houses." +5
3. One of five works (totaling $800) that Alfred C. Barnes purchased from Leo Stein in May 1921. Barnes to Stein, April 30, 1921, BFA, AR.ABC.1921.109, cited by Karen Butler in Bois forthcoming. +5

96. *Small Jar,*[1] 1898-99
Oil on paper (later mounted to paperboard and panel)
5³⁄₈ x 7³⁄₁₆ in. (13.7 x 18.3 cm)
The Barnes Foundation, Merion, Pennsylvania

Provenance
Leo and Gertrude Stein, Paris (by February 1909,[2] and owned jointly until 1913/1914; thereafter, Leo Stein, until May 1921[3]); Albert C. Barnes, Merion, Pennsylvania (acquired May 1921[4])

Notes
1. Identified by Karen Butler and Claudine Grammont (Bois forthcoming) as no. 51 in Paris 1906.
2. The work appears in a photograph of rue de Fleurus taken between November 1908 and February 1909 (pl. 16, where it hangs directly above Pierre-Auguste Renoir's *Girl in Gray-Blue*). See also Potter 1970, 91 (where the photo is dated to ca. 1907).
3. One of seven works by Matisse that Leo Stein offered for sale in 1921, likely no. 18, valued at $100. +5
4. One of five works (totaling $800) that Alfred C. Barnes purchased from Leo Stein in May 1921. Barnes to Stein, April 30, 1921, BFA, AR.ABC.1921.109, cited by Karen Butler in Bois forthcoming. +5

97. *The Convalescent Woman (The Sick Woman),* 1899
Oil on canvas
16⁵⁄₁₆ x 15¹⁄₈ in. (41.4 x 38.4 cm)
The Baltimore Museum of Art: The Cone Collection, formed by Dr. Claribel Cone and Miss Etta Cone of Baltimore, Maryland
Dauberville (1995) 28 (Bernheim-Jeune photo no. 351, February 1914)
Plate 351

Provenance
Galerie Druet, Paris; Michael and Sarah Stein, Paris (purchased December 1908[1]); Leo Stein, Paris (by at least February 1910,[2] until [pl. 351] at least February 12, 1914,[3] or later); Galerie Bernheim-Jeune, Paris (February 12, 1914)[4]; Etta Cone, Baltimore (acquired either 1923[5] or 1925[6])

Notes
1. AMP.
2. Likely Paris 1910a, no. 11 (as "1899, La Malade," among the works "App. à M.L.D.S. [Mr. Leo D. Stein]").
3. Dauberville 1995, no. 28, notes the work's sale by Leo Stein.
4. Dauberville (ibid.) claims that Galerie Bernheim-Jeune acquired the work in 1914; however, Brenda Richardson (1985, 173-75) notes that "the painting was photographed by Bernheim-Jeune in 1914, but its sale was apparently not handled by the dealer." She believes the work was "among the group of Matisses released for sale by Leo in about 1913." If this is the case, the sale would correspond to Leo's departure from rue de Fleurus. It is likely that this work was lent to the 1914 Rome exhibition *Secessione* (no. 11, as "La malata"). Félix Fénéon to Leo Stein, November 1913, Beinecke YCAL, MSS 76, box 98, folder 1866.
5. B. Richardson (1985, 173) believes the work may have been acquired in 1923 for 4,000 francs.
6. BMA records indicate that on the verso of the stretcher is painted "1899" (supposedly the creation date) and that it also bears a 1925 *douane*, or customs, stamp, indicating the transit of the painting to be either received or lent.

98. *Sideboard and Table,* 1899
Oil on canvas
26⁵⁄₈ x 32½ in. (67.5 x 82.5 cm)
Kunsthaus Zürich, gift of the Holenia Trust in memory of Joseph H. Hirshhorn with support from Rolf and Margit Weinberg
Plates 130, 369, 376, 380

Provenance
Michael and Sarah Stein, Paris and Palo Alto (before December 1911 [pl. 369], and owned jointly[1] [pls. 376, 380] until 1938; thereafter Sarah Stein, Palo Alto, until[2] September 1953); Dumbarton Oaks, Washington, D.C. (by 1970 until at least 1974[3]); Kunsthaus Zürich (acquired 1998[4])

Notes
1. Thought to be "Pointilliste still life 5521" among the works loaned by Michael and Sarah Stein to San Francisco 1936. Sarah Stein to Henri Matisse, January 7, 1936, AMP and SFMOMA Archives (+28).
2. +9
3. Potter 1970, 159, ill. pl. 3. The work was still in the Dumbarton Oaks collection as of 1974. AMP.
4. Klemm 2007, 148.

99. *Woman with Black Hair,* ca. 1900
Oil on canvas
17½ x 14½ in. (45 x 38 cm)
Current location unknown
Bernheim-Jeune inv. no. 17166
Plate 372

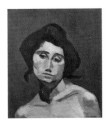

Provenance
Galerie Bernheim-Jeune, Paris (acquired February 27, 1909[1]); Michael [and Sarah] Stein, Paris (acquired March 2, 1909,[2] and probably owned jointly[3] [pl. 372] until 1938; thereafter, Sarah Stein, Palo Alto and San Francisco); Stendahl Gallery, Los Angeles (ca. 1950)[4]; Mr. and Mrs. Andrew M. Cole (by 1952 until at least 1962[5,6])

Notes
1. Sales catalogue, Drouot, Paris, February 27, 1909, lot no. 30 (as "Matisse (H). Tête de Femme. Toile. Haut., 45 cent.; larg., 38 cent. Non signée" and annotated: "380 Bernheim-Jeune"). The *procès-verbal* confirms that lot no. 30 was purchased by Bernheim-Jeune for 380 francs. AdvP: D42E3 110.
2. Galerie Bernheim-Jeune client list with dates of sales and purchases: no. 17166. +8
3. Thought to be "Portrait Study 5517" among the works lent by Michael and Sarah Stein to San Francisco 1936. Sarah Stein to Henri Matisse, January 7, 1936, AMP and SFMOMA Archives (+28).
4. A photograph in the Pierre Matisse Gallery Archives indicates: "His Italian Maid, Oil, 18½ x 15¼ in., 1901, Stendahl Art Gallery, Earl L. Stendahl, No. 8107-5." PMG Archives, MA 5020, box 133, folder 2.
5. Stendahl Galleries records indicate the work was sold to "Cole." April Dammann, e-mail message to Carrie Pilto, May 10, 2010.
6. San Francisco 1952, no. 4 (as "Portrait Study," lent by Mr. and Mrs. Andrew Cole, 1952) and San Francisco 1962. +28

100. *Male Nude,* 1900-1901
Oil on canvas
32⁵⁄₁₆ x 11⁷⁄₁₆ in. (82 x 29 cm)
Musée Cantini, Marseille
Dauberville (1995) 35 (Bernheim-Jeune photo no. 1421, October 1916)
Plates 136, 367, 374

Provenance

Jean Biette (acquired in 1902[1]); Henri Matisse; Michael and Sarah Stein, Paris (by autumn 1908 [pl. 367], until [pls. 367, 374] 1947); Stanley Steinberg, San Francisco (purchased 1947,[2] and owned until 1970[4]); Richard L. Feigen & Co., New York (by 1982,[5] until at least January 1985[6]); Musée Cantini, Marseille (acquired 1990[7])

Notes

1. According to Wanda de Guébriant, AMP, Jean Biette acquired this work from Matisse and later exchanged it for another of Matisse's paintings, a view of Notre-Dame (Dauberville 1995, no. 47).
2. Stanley Steinberg, e-mail message to Carrie Pilto, March 30, 2011. The acquisition is referred to in Steinberg 2010.
3. San Francisco 1952, no. 9 (as "Standing Nude," lent by Dr. Stanley Steinberg). +28
4. Potter 1970, 159 (as "Male Nude…private collection, San Francisco").
5. Zurich 1982, no. 7.
6. Stockholm 1984, no. 4 (as loaned by "Richard L. Feigen & Co., New York").
7. Anonymous sale for 4,200,000 francs, Ader Picard Tajan, Paris, March 20, 1990, lot no. 59.

101. *Marguerite*, 1901
Oil on wood
28 x 21¾ in. (71.1 x 55.3 cm)
Private collection, San Francisco
Dauberville (1995) 179 (Bernheim-Jeune photo no. 1429, October 1916)
Plates 154, 367, 370, 373, 377, 379, 381

Provenance

Michael and Sarah Stein, Paris and Palo Alto (in or after 1906, and owned jointly [pls. 367, 370, 373, 379, 381] until 1938; thereafter, Sarah Stein, Palo Alto, until at least February 1947[1]); Mr. and Mrs. Lionel Steinberg, Palm Springs (ca. 1947-49), until at least 1952[2]; Mrs. Madeleine Haas Russell, San Francisco (by 1962[3] until 1999); private collection, San Francisco

Notes

1. Following a 1947 visit with Sarah Stein, Fiske Kimball described the work as "a beautiful, strange young girl also, half length, very fine." +9
2. San Francisco 1952, no. 13 (as "Marguerite Matisse," lent by Mr. and Mrs. Lionel Steinberg, Fresno). +28
3. Exhibited in San Francisco 1962. +28

102. *Faith, the Model,* ca. 1901
Oil on canvas
31 x 17½ in. (78.7 x 44.5 cm)[1]
Fine Arts Museums of San Francisco, bequest of Aurelie Henwood to the de Young Museum in memory of Lucille and Gardner Dailey
Dauberville (1995) 36 (Bernheim-Jeune photo no. 36, October 1916 and Ref. no. [PZ 297])
Plates 135, 362

Provenance

Sarah and Michael Stein, Paris and Palo Alto (by 1906 [pl. 362], and owned jointly until[1,2] 1938; thereafter, Sarah Stein, Palo Alto, until probably November 1948[2]); Dr. Maurice Galanté (perhaps acquired November 1948, until 1949[3]); Sarah Stein, Palo Alto (reacquired in 1949[3]); Stendahl Gallery, Los Angeles[4]; Gardner Dailey, San Francisco (by at least 1952[5]); Aurelie Henwood (until 1992)

Notes

1. The painting was altered sometime between 1916 and 1930. When photographed in 1916 (Dauberville 1995, no. 36), the work included additional canvas at left and right. These side areas are no longer visible in a 1930 photograph by Francis Yerbury (David and Barbara Block family archives), which shows the cropped work hanging in Villa Stein-de Monzie.
2. Likely the painting listed as "Female Model" and valued at $1,000 in the 1937 inventory of Michael and Sarah Stein's collection. +7
3. Galanté recalls that Sarah Stein gave him the painting in November 1948 and that, under pressure from her grandson Daniel M. Stein, he returned it in 1949. Galanté to Carrie Pilto, April 13, 2010.
4. According to Stendahl Galleries records, the work was purchased from the Stein family for $1,500; the transaction date is unknown. April Dammann, e-mail message to Carrie Pilto, May 10, 2010.
5. San Francisco 1952, no. 2 (as "Figure Study," lent by Mr. Gardner Dailey). +28

103. *Pot of Flowers,* ca. 1901
Oil on canvas
23⅝ x 28¾ in. (60 x 73 cm[1])
Current location unknown

Provenance

Ambroise Vollard, Paris (June 1904)[1]; Michael and Sarah Stein, Paris (September 16, 1909,[2,3] until lent July 1914[4]—from 1914 to 1917[?] left in safekeeping with Greta and Oskar Moll, Berlin, until allegedly confiscated by gallery owner Fritz Gurlitt, sold in a fictitious auction in 1917, and bought by Gurlitt himself; claimed in 1919 by Hans Purrmann on behalf of the Steins and sold ca. 1920); Tryggve Sagen, Norway (ca. 1920[4] until 1927); likely Consul Peter Krag, Paris and Oslo (ca. 1927); Mrs. Sigri Welhaven, Oslo[5]

Notes

1. Likely the painting purchased from Matisse for 150 francs (Vollard Archives, MS 421 (4, 5), folio 12) and recorded in Vollard's Stock Book B (no. 3412) as "'Nature morte. Pot de fleurs sur une table,' 60 x 73 cm"; also probably the work exhibited in Paris 1904 as no. 29: "Primevères."
2. Probably the above-mentioned work sold to "Stein" for 2,000 francs on September 16, 1909. Vollard Archives, MS 421 (5, 4), folio 170. "Le bouquet de fleurs 'Les Primevères' qui était chez Vollard, a été enfin retrouvé et acheté par Mme Stein qui le désirait tant." Henri Matisse to Sergei Shchukin, draft, AMP.
3. Likely the work exhibited in Paris 1910a as no. 15: "Primevère," 1902, among the works listed as "App. à M.M.S. [Mr. Michael Stein]."
4. Gurlitt exhibition (Berlin 1914) pamphlet, no. 4 (as "Première [sic], 1902") and November 1916 document (pl. 116) as "Primevere (pot de fleur) (Pot of flowers) 73 x 60 [cm; dimensions reversed], 1902, $900.00." Monrad (1999b, 145) indicates this work as having entered the collection of Tryggve Sagen. +24
5. Perhaps former collection Mrs. Sigri Welhaven, Oslo. AMP

104. *Still Life with Chocolate Pot,* 1900-1902
Oil on canvas
28¾ x 23⅜ in. (73 x 59.4 cm)
Musée National d'Art Moderne, Centre Georges Pompidou, gift of Alex Maguy-Glass, 2002
Plates 133, 371, 374

Provenance

Gustave Fayet (until May 16, 1908); Michael and Sarah Stein, Paris (acquired May 16, 1908,[1,2] until [pls. 371, 374] lent July 1914[3]—from 1914 to 1917[?] left in safekeeping with Greta and Oskar Moll, Berlin, until allegedly confiscated by gallery owner Fritz Gurlitt, sold in a fictitious auction in 1917, and bought by Gurlitt himself; claimed in 1919 by Hans Purrmann on behalf of the Steins and sold ca. 1920); Tryggve Sagen, Oslo (ca. 1920 until 1927); likely Consul Peter Krag, Paris and Oslo (ca. 1927); Mrs. Sigri Welhaven[4], Oslo (by 1930[5]); Alex Maguy-Glass (acquired in 1968[5]); gift of Alex Maguy-Glass to Musée National d'Art Moderne, Paris (2002[5])

Notes

1. Gustave Fayet's sale, Hôtel Drouot, Paris, May 16, 1908, lot no. 32 (as "Nature morte: Cafetière, 73 x 60 cm, signee en bas, à gauche"). Michael Stein to Leo and Gertrude Stein, undated [May 17, 1908], Beinecke YCAL, MSS 76, box 124, folder 2705.
2. Perhaps exhibited in Paris 1910a (as no. 13, "Nature morte," 1900 among the works "App. à M.M.S. [Mr. Michael Stein]").
3. Gurlitt exhibition (Berlin 1914) pamphlet, no. 2 (as "Stilleben Mit Kaffeekanne, 1899") and November 1916 document (pl. 116) as "Nature Morte cafetiere (still life coffe[e] pot) 73 x 60 [cm], 1899, $350.00." +24
4. Mrs. Sigri Welhaven (1894-1991) was married to Peter Krag.
5. Musée National d'Art Moderne documents.

105. *Pont Saint-Michel,* 1901-2
Oil on canvas
18¼ x 22 in. (46.7 x 55.9 cm)
Isabelle and Scott Black Collection
Plates 132, 371

Provenance

Gustave Fayet, Paris (until May 16, 1908); Michael and Sarah Stein, Paris (acquired May 16, 1908,[1] until [pl. 371] lent July 1914[2]—from 1914 to 1917[?] left in safekeeping with Greta and Oskar Moll, Berlin, until allegedly confiscated by gallery owner Fritz Gurlitt, sold in a fictitious auction in 1917, and bought by Gurlitt himself; claimed in 1919 by Hans Purrmann on behalf of the Steins and sold ca. 1920); Tryggve Sagen, Oslo (ca. 1920 until 1927); Consul Peter Krag, Paris and Oslo (ca. 1927); Mrs. Sigri Welhaven, Oslo; private collection, Scandinavia[3]

Notes

1. Gustave Fayet's sale, Hôtel Drouot, Paris, May 16, 1908; lot no. 29: "Pont Saint-Michel, 46 x 55 cm." Michael Stein to Leo and Gertrude Stein, undated [May 17, 1908], Beinecke YCAL, MSS 76, box 124, folder 2705.
2. Gurlitt exhibition (Berlin 1914) pamphlet, no. 3 (as "Pont Saint Michel, 1902") and November 1916 document (pl. 116) as "Pont Saint Michel (Saint Michel bridge Paris) 55 x 46 [cm; dimensions reversed], 1902, $400.00." +24

3. Provenance from 1919 to present from sales catalogue, Christie's, London, *Impressionist and Modern Paintings and Sculpture*, June 24, 1991, lot no. 14. Peter Krag is noted as the late husband of Sigri Welhaven, from whom the anonymous Scandinavian seller acquired the painting.

106. *Still Life with Blue Jug*, ca. 1900–1903
Oil on canvas
23 x 25 in. (58.4 x 63.5 cm)
San Francisco Museum of Modern Art, bequest of Matilda B. Wilbur in honor of her daughter, Mary W. Thacher
Dauberville (1995) 170 (Bernheim-Jeune photo no. 1426, October 1916)
Plates 131, 364, 374, 375, 381

Provenance

Galerie Druet, Paris (until March 1906[1]); Curt von Mutzenbecher (acquired March 19, 1906[1]); Michael and Sarah Stein, Paris and Palo Alto (at least by December 1907 [pl. 364], and owned jointly[2] [pls. 374–75, 381] until at least 1937[3]); Mr. and Mrs. Brayton Wilbur, Burlingame, California (at least by December 1949,[4] until later[5,6]); San Francisco Museum of Modern Art, 2008

Notes

1. Druet sold this work to: "Curt von Mutzenbecher 19 mars 1906, pour 275 F[rench] F[rancs]" (AMP). A Druet label on the verso reads "Galerie Druet/114 Faub. St. Honoré, Paris, N. 2869," with the last digit partially visible. Kate Mendillo, e-mail message to author, March 15, 2010.
2. Perhaps exhibited in Paris 1910a as no. 13 ("Nature morte," App. à M.M.S. [Mr. Michael Stein]).
3. Listed as "Blue Still Life" and valued at $3,000 in the 1937 inventory of Michael and Sarah Stein's collection. +7
4. One of the two works noted in a letter dated December 14, 1949, from Dorothy Miller to Alfred H. Barr Jr., indicating that Mr. and Mrs. Wilbur had purchased "two of Mrs. Stein's Matisses. One is a ~~very~~ small painting, '*Woman at a Table*.' The other is a still life mostly in blues [*Still Life with Blue Jug*]." MoMA Archives, AHB 11.I.A.20.
5. San Francisco 1952, no. 7 (as "Study in Blue," lent by Mr. and Mrs. Brayton Wilbur, Burlingame). +28
6. San Francisco Museum of Modern Art, by bequest of Matilda B. Wilbur, 2008.

107. *André Derain*, 1905
Oil on canvas
15½ x 11⅜ in. (39.4 x 29 cm)
Tate, London, purchased with assistance from the Knapping Fund, the Art Fund and the Contemporary Art Society and private subscribers, 1954
Plates 137, 370, 374

Provenance

André Derain (summer 1905[1]); Galerie Druet, Paris, (October 30, 1908, until October 31, 1908[1]); Michael and Sarah Stein, Paris (October 31, 1908,[1,2] until [pls. 370, 374] lent July 1914[3]—from 1914 to 1917[?] left in safekeeping with Greta and Oskar Moll, Berlin, until allegedly confiscated by gallery owner Fritz Gurlitt, sold in a fictitious auction in 1917, and bought by Gurlitt himself; claimed in 1919 by Hans Purrmann on behalf of the Steins and sold ca. 1922); Christian Tetzen-Lund, Copenhagen (ca. 1922 until at least May 19, 1925[4]); Galerie Pierre Loeb, Paris (December 1927 until July 1928[4]); William Rees Jefferys, Sussex (July 1928 until November 1954[5])

Notes

1. Monrad 1999a, 257. Listed as Druet stock no. 4715. AMP.
2. Likely exhibited in Paris 1910a as no. 28: "Portrait," "App. à M.M.S. [Mr. Michael Stein]."
3. Gurlitt exhibition (Berlin 1914) pamphlet, no. 7 (as "Männerbildnis, 1905") and November 1916 document (pl. 116) as "'Portrait d'homme' (male head), 39 x 28 cm, 1905, $300.00." +24
4. His sale, May 19, 1925, V. Winkel & Magnussen, lot no. 86, as "Buste d'un maroquin" (bought in). Monrad 1999a, 257.
5. His sale, November 26, 1954, Christie's, London, lot no. 113.

108. *La Japonaise: Woman beside the Water*, 1905
Oil and graphite on canvas
13⅞ x 11⅛ in. (35.2 x 28.2 cm)
The Museum of Modern Art, New York, purchase and partial anonymous gift, 1983
Plates 140, 370, 374

Provenance

Galerie Druet, Paris (1906[1,2]–08); Michael and Sarah Stein, Paris and Palo Alto (at least by April/May 18, 1908,[3] until [pls. 370, 374] 1935); Mr. and Mrs. Philip N. Lilienthal, Atherton, California (1935/January 1936 until 1983)[4]; Museum of Modern Art, New York (1983[4])

Notes

1. Salon d'Automne, 1905 (no. 714).
2. Shown in Druet 1906 as no. 6: "La Japonaise au bord de l'eau, toile 32 x 29" and given the Druet inventory number 3323. Flam 2005, 34.
3. The sale date of May 18, 1908, is recorded in the Druet account records: "vendu 18 mai [19]08 à m. Steine [Stein] 58 Rue Madame" (AMP). However, the painting is believed to be one of several Matisse works that Inez Haynes Irwin mentioned in her journal entry for April 18, 1908, when she visited Michael and Sarah Stein's atelier: "Some of them, which I had taken for landscapes, were in fact portraits. Others, which I had taken for portraits, were in fact landscapes." Quoted in Fourcade and Monod-Fontaine 1993, 425, anthology no. 17; translated by Erin Hyman. The work is exhibited in Paris 1910a as no. 27, "App. à M.M.S. [Mr. Michael Stein]."
4. Purchased from the Steins in 1935 and owned until 1983, according to MoMA curatorial records.

109. *Landscape near Collioure* [Study for *Le Bonheur de vivre*], 1905
Oil on canvas
18⅛ x 21⅝ in. (46 x 54.9 cm)
Statens Museum for Kunst, Copenhagen, gift of Johannes Rump, 1928
Plates 141, 371, 372

Provenance

Galerie Druet, Paris; Michael and Sarah Stein, Paris (after April 1906[1,2] until [pls. 371–72] lent July 1914[3,4]—from 1914 to 1917[?] left in safekeeping with Greta and Oskar Moll, Berlin, until allegedly confiscated by gallery owner Fritz Gurlitt, sold in a fictitious auction in 1917, and bought by Gurlitt himself; claimed in 1919 by Hans Purrmann on behalf of the Steins[4] and sold ca. 1922); Christian Tetzen-Lund, Copenhagen (ca. 1922 until May 1925[5]); Ny Carlsberg Foundation (May 1925[5] until 1927[6]); Johannes Rump (1927[6] until donation on January 19, 1928); Statens Museum for Kunst, Copenhagen (1928)[7]

Notes

1. Paris 1906, no. 13 (as "Etude du tableau exposé aux Indépendants"). Monrad 1999a, 283.
2. The verso of the work bears a "Druet" label with the following handwritten information: "2884 Matisse Croquis grand tableau." Communicated by Dorthe Aagesen, Statens Museum for Kunst, Copenhagen, April 27, 2010.
3. Paris 1910a, no. 31 (as "Etude pour 'le Bonheur de vivre'" [Monrad (1999a, 283)], App. à M.M.S. [Mr. Michael Stein]). This work bears a label from the exhibition, with the following handwritten information: "1905 Etude pour le Bonheur de Vivre." Communicated by Dorthe Aagesen, April 27, 2010.
4. Gurlitt exhibition (Berlin 1914) pamphlet, no. 5 (as "Sudliche Landschaft, 1905") (Monrad 1999a, 283) and November 1916 document (pl. 116) as "Paysage du Midi (landscape trees) 55 x 46 [cm; dimensions reversed], 1905, $600.00." +24
5. His sale, Copenhagen, May 18–19, 1925, lot 88a.
6. Acquired through exchange.
7. Provenance completed with information from Monrad 1999a, 283, augmented by Fourcade and Monod-Fontaine 1993, no. 18.

110. *Madame Matisse (The Green Line)*, 1905
Oil on canvas
16 x 12¾ in. (40.5 x 32.5 cm)
Statens Museum for Kunst, Copenhagen, gift of The Engineer J. Rump and Wife Fund, 1928
Plates 88, 366, 367, 369, 373

Provenance

Galerie Druet, Paris; Michael and Sarah Stein, Paris (by April 28, 1906,[1,2] until [pls. 366–67, 369, 373] lent July 1914[3]—from 1914 to 1917[?] left in safekeeping with Greta and Oskar Moll, Berlin, until allegedly confiscated by gallery owner Fritz Gurlitt, sold in a fictitious auction in 1917, and bought by Gurlitt himself; claimed in 1919 by Hans Purrmann on behalf of the Steins and sold ca. 1922); Christian Tetzen-Lund,[4] Copenhagen (ca. 1922 until June 10, 1936[5]); Statens Museum for Kunst[6]

Notes

1. Paris 1906, no. 3 (as "Portrait") (Wanda de Guébriant, conversation with Carrie Pilto, February 17, 2011). Purchased from Galerie Druet in March–April 1906 (Monrad 1999a, 259). One of the three small paintings that Michael and Sarah brought with them to San Francisco shortly after the earthquake in 1906, departing Paris on April 28. Described by Annette Rosenshine (n.d.); see Janet Bishop's essay in this volume, 131.
2. Paris 1910a, no. 29 (as "Portrait de Mme M.," App. à M.M.S. [Mr. Michael Stein]). The work's verso bears a label for the exhibition with the following information written by hand: "1905…Portrait de Mme Matisse." Communicated by Dorthe Aagesen, Statens Museum for Kunst, Copenhagen, April 27, 2010.
3. Gurlitt exhibition (Berlin 1914) pamphlet, no. 6 (as "Frauenbildnis, 1905") and November 1916 document (pl. 116) as "Portrait de femme (female head), 41 x 33 [cm], 1905, $600.00." +24
4. The verso of the work bears three Christian Tetzen-Lund collection stamps. Communicated by Dorthe Aagesen, see note 2.
5. His sales, May 19, 1925, V. Winkel & Magnussen, lot no. 89 (bought in); May 28, 1934, V. Winkel & Magnussen, lot no. 10 (bought in); June 10, 1936, V. Winkel & Magnussen, lot no. 6 was purchased for the J. Rump Collection, Statens Museum for Kunst. Monrad 1999a, 259.
6. Provenance established by Monrad 1999a, 259.

111. *Madame Matisse in the Olive Grove,* 1905
Oil on canvas, signed top left
18½ x 21¾ in. (47 x 55 cm)
Private collection, Denmark
Plates 366, 367, 370, 371

Provenance
Michael and Sarah Stein, Paris (acquired spring 1906[1] and owned jointly [pls. 366-67, 370, 371] until lent July 1914[2]—from 1914 to 1917[?] left in safekeeping with Greta and Oskar Moll, Berlin, until allegedly confiscated by gallery owner Fritz Gurlitt, sold in a fictitious auction in 1917, and bought by Gurlitt himself; claimed in 1919 by Hans Purrmann on behalf of the Steins[2] and sold ca. 1922); Christian Tetzen-Lund, Copenhagen (ca. 1922 until June 10, 1936[3]); Axel Bruun, perhaps as an agent for Carl Schepler (June 10, 1936[3])

Notes
1. Paris 1906, no. 11 (as "Promenade dans les Oliviers," and purchased from the gallery by Michael and Sarah Stein, 1906). Grammont 2005, 277.
2. Gurlitt exhibition (Berlin 1914) pamphlet, no. 8 (as "Ölbäume, 1905") (Monrad 1999a, 256) and November 1916 document (pl. 116) as "Oliviers (olive trees) 55 x 46 [cm; dimensions reversed], 1905, $600.00." +24
3. His sale, May 19, 1925, V. Winkel & Magnussen Auctioneers of Fine Art, lot no. 89 (bought in); his sale, June 10, 1936, V. Winkel & Magnussen Auctioneers of Fine Art, lot no. 200; purchased by Axel Bruun, presumably on behalf of Carl Schepler. Monrad 1999a, 256.

112. *Nude before a Screen,* 1905
Oil on canvas, signed upper right
13 x 7½ in (33 x 19 cm)
Current location unknown
Dauberville (1995) 64 (Bernheim-Jeune photo no. 1427, October 1916)
Plates 366, 367, 370, 371, 373, 374

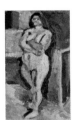

Provenance
Galerie Druet, Paris[1]; Michael and Sarah Stein, Paris (acquired by April 28, 1906,[2] until[3] at least 1937[4]); Robert Ardrey and Helen Johnson Ardrey, Norman, Oklahoma (by 1970 until 1973-74); Chozo Yoshi, Tokyo (acquired 1973-74, subsequently sold)

Notes
1. Paris 1906, no. 8 (as "Etude de Nu"). Wanda de Guébriant, conversation with Carrie Pilto, February 17, 2011.

2. One of the three small paintings Michael and Sarah brought with them to San Francisco shortly after the earthquake in 1906. Cauman 2000a, 24; Potter 1970, 160; described by Annette Rosenshine (n.d.); see Janet Bishop's essay in this volume, 131.
3. When the Steins returned to Paris from San Francisco, they installed this painting in the rue Madame apartment (see plates listed above).
4. Listed as "Nude and Screen" and valued at $1,000 in the 1937 inventory of Michael and Sarah Stein's collection. +7

113. *Woman with a Hat,* 1905
31¾ x 23½ in. (80.7 x 59.7 cm)
San Francisco Museum of Modern Art, bequest of Elise S. Haas
Plates 13, 16, 347, 348, 355, 356, 376, 378

Provenance
Leo [and Gertrude] Stein, Paris (autumn 1905,[1,2] and owned jointly [pl. 347-48] until 1913/1914); Gertrude Stein, Paris (1913/1914 until [pls. 355, 356] February 1915[3]); Michael and Sarah Stein, Paris and Palo Alto (acquired February 1915,[3] and owned jointly[4] [pls. 376, 378] until 1938; thereafter, Sarah Stein, Palo Alto, until January 1948[5]); Mr. and Mrs. Walter A. Haas, San Francisco (acquired January 6, 1948,[5] until 1979; thereafter, Elise S. Haas until 1990); San Francisco Museum of Modern Art (1991)

Notes
1. Leo Stein purchased at the 1905 Salon d'Automne (no. 717).
2. Paris 1910a, no. 32 (as "Femme au chapeau, App. à M.L.D.S. [Mr. Leo D. Stein]."
3. In a letter dated February 12, 1915, from Michael Stein to Gertrude Stein, Michael buys the "Femme au chapeau" from Gertrude for $4,000. Gallup 1953, 106-7.
4. Paris 1931, no. 9 (as "La Femme au chapeau, Collection de Monsieur Michel Stein, Vaucresson"). The verso of the work bears a label for this exhibition: "Appartenant à Mr. Michel Stein à Vaucresson."
5. Per a handwritten note from the records of Elise S. Haas, purchased January 6, 1948, for $20,000. SFMOMA Permanent Collection Object File: 91.161.

114. *Yellow Pottery from Provence,* 1905
Oil on canvas
21⅞ x 18⅜ in. (55.6 x 46.7 cm)
The Baltimore Museum of Art: The Cone Collection, formed by Dr. Claribel Cone and Miss Etta Cone of Baltimore, Maryland
Plate 350

Provenance
Galerie Druet, Paris[1]; Leo and Gertrude Stein, Paris (after April 7, 1906[1,2] until at least October 1906 [pl. 350]); possibly Oskar and Greta Moll, Berlin (after October 1906)[2]; Etta Cone, Baltimore (from 1906 until 1950)[2]; Baltimore Museum of Art (1950)

Notes
1. Paris 1906 as no. 48, based on an archival photograph that bears Matisse's annotation: "48…aubergines et poterie jaune." Flam 2005, 37.
2. The work appears on the walls of rue de Fleurus, although its early ownership has not been established. Flam (2005, 37) has suggested that Leo acquired it for 200 francs and sold it to the Cone sisters soon thereafter. Grammont (in Flam 2005, 277) believes this painting was purchased by the Steins and sold to Oskar and Greta Moll after the close of the spring 1906 Druet exhibition. A third scenario is proposed by Brenda Richardson (B. Richardson 1985, 158n35), who asserts that the work was purchased by Etta Cone and loaned "to the Steins to hang until she [returned and] could practically retrieve the picture and give it a home."

115. Sketch for *Le Bonheur de vivre,* 1905-6
Oil on cardboard (later mounted to plywood panel)
4¹³⁄₁₆ x 7¹¹⁄₁₆ in. (12.2 x 19.5 cm)
The Barnes Foundation, Merion, Pennsylvania

Provenance
Leo and Gertrude Stein, Paris (by February 1909,[1] and owned jointly until 1913/1914; thereafter, Leo Stein until May 1921[2,3]); Albert C. Barnes, Merion, Pennsylvania (acquired May 1921)[3]

Notes
1. The work appears in a photograph of rue de Fleurus taken between November 1908 and February 1909 (pl. 16, where it hangs directly above the upper left corner of Pierre-Auguste Renoir's *Girl in Gray-Blue*). See also Potter 1970, 91 (where the photo is dated ca. 1907).
2. One of seven works by Matisse that Leo Stein offered for sale in 1921, likely no. 21, valued at $100: "Matisse 100 landscape." +5
3. One of five works (totaling $800) that Alfred C. Barnes purchased from Leo Stein in May 1921. Barnes to Stein, April 30, 1921, BFA, AR.ABC.1921.109, cited by Karen Butler in Bois forthcoming. +5

116. Sketch for *Le Bonheur de vivre,* 1905-6
Oil on canvas
16 x 21½ in. (40.6 x 54.6 cm)
San Francisco Museum of Modern Art, bequest of Elise S. Haas
Plates 142, 366, 367, 370, 371, 379

Provenance
Michael and Sarah Stein, Paris and Palo Alto (by October-November 1908 [pls. 366, 367], and owned jointly[1,2] [pls. 370-71, 379] until 1938; thereafter, Sarah Stein, Palo Alto, until 1948[3]); Mr. and Mrs. Walter A. Haas, San Francisco (acquired by 1948[3,4] until 1979; thereafter Elise S. Haas until 1990); San Francisco Museum of Modern Art, 1991

Notes
1. The work bears a label from Paris 1910a confirming it as "Esquisse pour 'le Bonheur de vivre'" (no. 30), listed as "App. à M.M.S. [Mr. Michael Stein]." Kate Mendillo, e-mail message to author, March 15, 2010.

2. Listed as "The Joy of Life" and valued at $4,000 in the 1937 inventory of Michael and Sarah Stein's collection. +7

3. According to a receipt from Sarah Stein, $6,000 received from Elise S. Haas as payment in full. SFMOMA Permanent Collection Object File: 91.160.

4. In a December 1951 letter, Fiske Kimball writes about sales from the collection of Sarah Stein: "They [Mr. and Mrs. Walter Haas] have…the Matisse oil sketch (say 20 by 30 inches) of Matisse's big 'Joie de vivre,' which Barnes has and which also formerly belonged to the Steins." Fiske Kimball to R. Sturgis Ingersoll, December 11, 1951, PMA Kimball Papers.

117. *Le Bonheur de vivre*, **also called** *The Joy of Life*, 1905–6
Oil on canvas
69½ x 94¾ in. (176.5 x 240.7 cm)
The Barnes Foundation, Merion, Pennsylvania
Dauberville (1995) 69 (Bernheim-Jeune photo no. 369, March 1914)
Plates 15, 353

Provenance

Leo [and Gertrude] Stein, Paris (acquired between May 6 and June 6, 1906,[1,2] and owned jointly [pl. 353] until 1913/1914; thereafter, Leo Stein, Paris, and sent to Galerie Bernheim-Jeune, Paris, probably in March 1914[3,4] until August 1919[5]); Paul Guillaume, Paris (August 1919[5]); Christian Tetzen-Lund, Copenhagen (after August 1919 until January 27, 1923[6]); Albert C. Barnes, Merion, Pennsylvania (acquired January 27, 1923[6])

Notes

1. Exhibited at the 1906 Salon des Indépendants (as no. 2289, "Le bonheur de vivre"). On May 6, 1906, Leo wrote to Matisse about acquiring *Le Bonheur de vivre* but was waiting to hear about the consequences of the San Francisco earthquake (Flam 2003, 231n27). By June 6, 1906, Henri Manguin wrote to Matisse about the presence of the latter's "large painting in his [Stein's] studio" (AMP).

2. In a letter postmarked May 22, 1908, Michael Stein wrote to Gertrude Stein (at Villa Bardi, in Florence): "Tomorrow Druet is coming to photograph Bonheur de Vivre in the atelier." In a second letter, dated June 1, 1908, he wrote: "Photographed the bonheur de vivre and Renoir (a new nude) and then brought the cezanne portrait to rue de fleurus and the Vallotton portrait is back from Munich." Beinecke YCAL, MSS 76, box 125, folder 2716. The Vallotton portrait of Gertrude Stein was lent to the 1908 Munich Secession exhibition as no. 206.

3. The Bernheim-Jeune photograph of *Le Bonheur de vivre* dates from March 1914; at least one Bernheim-Jeune stock number (21670) is thought to reference this work. +25

4. In a letter dated November 26, 1914, Félix Fénéon wrote to Gertrude that the painting had not yet returned from the 1914 Salon Triennal, Brussels. Beinecke YCAL, MSS 76, box 98, folder 1866. The work is listed in the catalogue for the Brussels 1914 exhibition: "Matisse (Henri), Route de Clamart, 92, Issy-les-Moulineaux, et chez MM. Bernheim Jeune et Cie, rue Richepance, 15, Paris. [no.] 371. La Joie de vivre, panneau décoratif." No indication of ownership is noted.

5. Margaret Duthuit's notes taken from Bernheim-Jeune ledger book, Cahier III, "21670. Leo Stein, Août 1919, vendu Paul Guillaume" (AMP), likely records the sale of this work. Cited by Karen Butler in Bois forthcoming.

6. Barnes's acquisition from Christian Tetzen-Lund provided by Karen Butler, ibid.

118. *The Gypsy*, 1905–6
Oil on canvas, signed lower left
21⅝ x 18⅛ in. (55 x 46 cm)
Musée National d'Art Moderne, Centre Georges Pompidou, on loan to the Musée de l'Annonciade, Saint-Tropez
Plates 29, 366, 367, 370, 371

Provenance

Galerie Druet, Paris (probably before March 1906[1]); Michael and Sarah Stein, Paris (by November 1908[2] [pls. 366, 367] until [pls. 370, 371] lent July 1914[3]—from 1914 to 1917[?] left in safekeeping with Greta and Oskar Moll, Berlin, until allegedly confiscated by gallery owner Fritz Gurlitt, sold in a fictitious auction in 1917, and bought by Gurlitt himself; claimed in 1919 by Hans Purrmann on behalf of the Steins and sold); Tryggve Sagen, Oslo (likely ca. 1920 until 1927)[4]; Georges Bernheim, Paris (by October 17, 1928); Georges Grammont, Paris (ca. 1936-55); Musée de l'Annonciade, Saint-Tropez (by bequest, 1955)[5]

Notes

1. Paris 1906, no. 2 (as "La Gitane").

2. Paris 1910a, no. 37 (as "Gitane, App. à M.M.S. [Mr. Michael Stein]."

3. Gurlitt exhibition (Berlin 1914) pamphlet, no. 9 (as "Die Zigeunerin, 1906") and November 1916 document (pl. 116) as "La gitane (female torse [torso]), 55 x 46 cm [cm], 1906, $400.00." +24

4. Monrad (1999b, 144, 146) indicates that this work was owned by Tryggve Sagen.

5. Additional provenance information established by Fourcade and Monod-Fontaine 1993, no. 27.

119. *Landscape: Broom*, 1906
Oil on panel
12 x 15⅝ in. (30.5 x 39.7 cm)
San Francisco Museum of Modern Art, bequest of Elise S. Haas
Dauberville (1995) 58 (Bernheim-Jeune photo no. 1428 from 1916)
Plates 143, 368, 370, 374

Provenance

Michael and Sarah Stein, Paris and Palo Alto (acquired September 1907,[1] and owned jointly[2] [pls. 143, 368, 370, 374] until at least 1937[3]); Mrs. Sigmund [Rosalie Meyer] Stern (by 1948[4] and probably until 1956); Mr. and Mrs. Walter A. Haas, San Francisco (at least by 1962[5] until 1979; thereafter, Elise S. Haas until 1990); San Francisco Museum of Modern Art (1991)

Notes

1. Druet stock no. 3218 (as "Les Genêts-Panneau 32 x 40 [cm] Vendu à M. Stein, 17 Sept 1907") (Jack Flam to Jill Dawsey, February 13, 2005). According to the Druet stock records, the work sold for 250 francs (AMP).

2. Paris 1910a no. 36 (as "Genêts, App. À M. M. S. [Mr. Michael Stein]").

3. Listed as "Landscape Les Genets" and valued at $2,000 in the 1937 inventory of Michael and Sarah Stein's collection. +7

4. Per a handwritten note from the records of Elise S. Haas, purchased by Mrs. Stern in 1948 for $2,500 or $3,000. SFMOMA Permanent Collection Object File: 91.164.

5. Exhibited in San Francisco 1962. +28

120. *Landscape, Collioure*,[4] 1906
Oil on canvas
18⅜ x 15⅜ in. (46.7 x 39.1 cm)
Current location unknown

Provenance

Galerie Druet, Paris (autumn 1906[1] until January 1907); Michael and Sarah Stein, Paris (acquired January 29, 1907,[1,2] and owned until at least March 1910[3])

Notes

1. Purchased from the artist. Druet inventory no. 3224, "paysage-toile 46 x 35," cited in Flam 2005, 40, no. 140.

2. "Paysage, toile, 46 x 35, vendu M. Steine [Stein], 29 janvier 1907, 500 francs." AMP.

3. Flam (2005, 40, no. 140) identifies the present work as no. 35: "1906…Paysage de Collioure" in Paris 1910a, where it is listed as "App. à M.M.S. [Mr. Michael Stein]."

4. The view depicted is Sailfort peak in the Albères chain.

121. *Landscape at Collioure*, 1906
Oil on canvas
18 x 21¾ in. (46.2 x 55.2 cm)
Private collection
Plates 366, 367, 372

Provenance

Michael and Sarah Stein, Paris (probably acquired in 1907[1] [pls. 366, 367], until [pl. 372] lent July 1914[2]—from 1914 to 1917[?] left in safekeeping with Greta and Oskar Moll, Berlin, until allegedly confiscated by gallery owner Fritz Gurlitt, sold in a fictitious auction in 1917, and bought by Gurlitt himself; claimed in 1919 by Hans Purrmann on behalf of the Steins and sold ca. 1922); Christian Tetzen-Lund, Copenhagen (ca. 1922 until May 19, 1925[3]); Le Centaure; Collection Burthoul (until March 1950[4]); Philippe Dotremont, Uccle-Bruxelles (1951 until 1956); New Gallery, New York (until January 1962); David and Peggy Rockefeller, New York (until at least 1970); private collection, New York[5]

Notes

1. Flam 2005, 41, no. 196.

2. Surely this is the work recorded in the Gurlitt (Berlin 1914) exhibition pamphlet as no. 10, "Landschaft von Collioure, 1906," and in a November 1916 document (pl. 116), where it is listed as "Paysage de Collioure (landscape), 55 x 46 [cm; dimensions reversed], 1906, $600.00." +24 There has long been confusion over the identification of no. 10, "Landschaft von Collioure, 1906," derived from what is now believed to be an erroneous illustration in the Gurlitt exhibition pamphlet. Another Collioure work (*The Bridge of Collioure*, Dauberville 1995, no. 105) that was probably never lent to the exhibition was illustrated; notably, this image bears no catalogue reference. Additional confusion arose over the fact that Matisse's *Autumn Landscape* (Berlin 1914, no. 19, "Herbststilleben, 1909"; see cat. 147) was illustrated with the wrong caption number, number 10.

3. His sale, May 19, 1925, V. Winkel & Magnussen, no. 88a.
4. Sales catalogue, Galerie Georges Giroux, Brussels, *Collection Burthoul*, March 11, 1950, no. 52 (ill.).
5. Provenance established by Monrad 1999a, 263–64.

122. *Margot*, 1906

Oil on canvas
31⅞ x 25⅝ in. (81 x 65 cm)
Kunsthaus Zürich
Dauberville (1995) 83 (Bernheim-Jeune photo no. 370, March 1914)
Plates 61, 349, 351

Provenance

Galerie Druet, Paris (until October 1906[1]); Leo [and Gertrude] Stein, Paris (acquired October 22, 1906,[2] and probably owned jointly [pls. 349, 351] until March/November 1914); Bernheim-Jeune, Paris (by March/November 1914[3]); Oskar and Greta Moll, Paris and Berlin (perhaps 1914[4] until September 1925); Kunsthaus Zürich (acquired after September 1925[4,5])

Notes

1. Druet stock no. 3228: "Femme au chapeau—toile 65 x 81 [dimensions reversed]."
2. Grammont 2005, 281. This information, as well as the amount "650 francs," is listed in the Druet Account Sheets, AMP, courtesy Claudine Grammont, e-mail message to author, February 11, 2010.
3. Two works were purchased from Leo Stein by Galerie Bernheim-Jeune by November 1914: "Margot et le Paysage de Collioure que nous lui avons acheté, ont été payés par nous à Michael Stein par les instructions de Leo D. Stein." Félix Fénéon to Gertrude Stein, November 26, 1914, Beinecke YCAL, MSS 76, box 98, folder 98. See also cat. 134, note 5, and +25.
4. Kropmanns 1997, 79–92. Claudine Grammont suggests that the painting was purchased by the Molls from Bernheim-Jeune, perhaps in 1914. Grammont, e-mail message to author, May 12, 2010.
5. Zurich 1925. Of the eight works lent by the Molls, three Matisse works were for sale: no. 287 (*Boy with Butterfly Net* [1907; pl. 156]); no. 288 (*Bathers* [1907], both now Minneapolis Institute of Arts; and no. 289, the present work. Claudine Grammont, e-mail message to author, May 12, 2010.

123. Sketch for *Marguerite Reading*, 1906

Oil on canvas
5¼ x 5¼ in. (13.3 x 14 cm)
Private collection
Plates 152, 364, 368, 377

Provenance

Michael and Sarah Stein, Paris and Palo Alto (before December 1907 [pl. 364], possibly a gift by the artist, and owned jointly [pls. 368, 377] probably until at least 1937[1]); Brayton Wilbur, Burlingame, California; Earl Stendahl, Los Angeles; Pierre Matisse, New York (by 1993)[2]; private collection

Notes

1. Listed as "Marguerite (Sketch)" and valued at $500 in the 1937 inventory of Michael and Sarah Stein's collection. +7
2. Provenance established by Fourcade and Monod-Fontaine 1993, no. 34.3.

124. *Nude in a Landscape*, 1906

Oil on panel, signed twice: once, lower left; once, lower right
15¾ x 12⅝ in. (40 x 32 cm)
V. Madrigal Collection, New York
Dauberville (1995) 68 (Bernheim-Jeune photo no. 1424, October 1916)
Plates 91, 374

Provenance

Galerie Druet, Paris (acquired autumn 1906, until January 1907)[1]; Michael and Sarah Stein, Paris (acquired January 1907,[1] until at least September 1911 [pl. 374] and probably until at least 1937[2]); John W. Dodds, Stanford, California[3]; Wally F. Findlay Galleries International, Inc., Chicago (by 1970[4] until at least 1985[5]); V. Madrigal Collection, New York

Notes

1. The painting, for which Amélie Matisse modeled, was bought by Druet in fall 1906 and inventoried as no. 3222: "etude de nu-carton 41,5 x 32,5 [cm]." Michael and Sarah Stein acquired it on January 29, 1907. Flam 2005, 40, no. 132.
2. Perhaps the painting by Matisse listed as "Nude Under Tree" and valued at $1,500 in the 1937 inventory of Michael and Sarah Stein's collection. +7
3. "Dodds" appears on a label on the verso of the work.
4. Potter 1970, 160.
5. Moderna Museet 1985, no. 11, lent by "Wally Findlay Galleries International."

125. *Nude Reclining Woman*, 1906

Oil on canvas, signed lower left
12½ x 15 in. (31.8 x 38.1 cm)
Private collection
Dauberville (1995) 61 (Bernheim-Jeune photo no. 1422, October 1916)
Plates 366, 367, 369

Provenance

Michael and Sarah Stein, Paris and Palo Alto (by November 1908 [pls. 366, 367] and owned [pl. 369] jointly, until at least 1937[1]); Mr. and Mrs. Lionel Steinberg, Fresno, California, by 1952[2]; Madeleine Haas Russell, San Francisco (by 1962[3] until[4] 1999); private collection

Notes

1. Listed as "Reclining Nude" and valued at $1,000 in the 1937 inventory of Michael and Sarah Stein's collection. +7
2. San Francisco 1952, no. 14 (as "Reclining Nude," lent by Mr. and Mrs. Lionel Steinberg, Fresno). +28
3. Exhibited as "Nude in Meadow" in San Francisco 1962. +28
4. Potter 1970, 161.

126. *La Pudeur (L'Italienne)*, 1906

Oil on panel, signed lower right
16½ x 12¾ in. (42 x 32 cm)
Current location unknown
Dauberville (1995) 62 (Bernheim-Jeune photo no. 1431, October 1916)
Plates 366, 367, 372, 375, 381

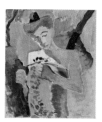

Provenance

Galerie Druet (until January 29, 1907)[1]; Sarah and Michael Stein, Paris and Palo Alto (purchased January 29, 1907, and owned [pl. 366, 367, 372, 375] until at least September 1935 [pl. 381]); M. Knoedler & Co., Inc., New York; Sidney Janis Gallery, New York; Dr. and Mrs. Norman Laskey, Mount Kisco, New York (by 1953 until at least November 1969[2]); Sidney Janis Gallery, New York (May 1972); J. Irwin and Xenia S. Miller (May 1972 until June 24, 2008[3])

Notes

1. Druet stock no. 3219: "Italienne—carton 32,5 x 41,5" (dimensions reversed). Sold to Michael and Sarah Stein on January 29, 1907, for 275 francs. Druet account list from the AMP provided by Claudine Grammont, April 13, 2010.
2. Hudson River Museum 1969, no. 48.
3. Their estate sale, Christie's, London, June 24, 2008, lot no. 12.

127. *The Sea Seen from Collioure*, 1906

Oil on canvas
15³⁄₁₆ x 18⅛ in. (38.5 x 46 cm)
The Barnes Foundation, Merion, Pennsylvania
Bernheim-Jeune label "16143R" titled "La Mer vue à Collioure" on verso

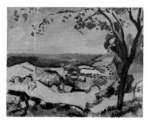

Provenance

Galerie Druet, Paris (acquired October 2, 1906[1]); Gustave Fayet, Paris (October 4, 1906,[2] until June 14, 1907); Bernheim-Jeune, Paris[3] (acquired June 14, 1907,[3] until September 10, 1907); Leo Stein, Paris (acquired September 10, 1907,[3,4,5] until December 1912); Albert C. Barnes, Merion, Pennsylvania (December 1912[6])

Notes

1. Presented at the Salon d'Automne 1906 as no. 1175 and acquired from the artist on October 2, 1906, for 250 francs. See Claudine Grammont, in Bois forthcoming.
2. Grammont (ibid.) cites a Druet account listing (AMP) that identifies the painting as: "no. 3143, 'paysage' no. 1175, s.d'automne, vendu Fayet, 4 oct. 1906, 600 francs."

3. Galerie Bernheim-Jeune client list with dates of sales and purchases: no. 15922, "Matisse, La mer, vue de Collioure, 38 x 46 cm, [Acheté à] Fayet, 14.6.07, ['Vendu à' Leo Stein], 10.9.07." +8 The Bernheim-Jeune number 15922 is possibly erroneous. The back of the painting bears the inscription "16143" in blue crayon as well as a Bernheim-Jeune label with the number 16143R.

4. One of two works from "1906," both titled "Paysage de Collioure" (nos. 43, 45) exhibited in Paris 1910a. See also cat. 134, notes 3 and 4.

5. One of four works that Jos Hessel proposed to purchase from Leo and Gertrude Stein in July 1912 but that were sold later to different collectors. +11

6. Barnes Foundation archives indicate that the painting was purchased from Leo Stein, through Durand-Ruel, in December 1912 for 900 francs, frame included (888 francs for the painting and 12 francs for the frame). At this time, Barnes also purchased *Dishes and Melon* (cat. 136). Wattenmaker and Distel 1993, 308.

128. *Seascape (Beside the Sea)*, 1906
Oil on cardboard mounted on panel
9⅝ x 12¾ in. (24.5 x 32.4 cm)
San Francisco Museum of Modern Art, bequest of Mildred B. Bliss
Plates 145, 369, 379

Provenance
Galerie Druet, Paris[1]; Michael and Sarah Stein, Paris and Palo Alto (acquired November 1908[2,3] and owned jointly [pls. 369, 379] until at least 1937[4]); Mr. and Mrs. Robert Woods Bliss, Washington, D.C. (at least by 1962[5]); thereafter, Mildred B. Bliss; her bequest to the San Francisco Museum of Art (September 1969)[6]

Notes
1. Druet stock no. 3217: "Marine-carton 24 x 32 [cm]." Cited in Flam 2005, 41, no. 110. Jack Flam dates this work to summer 1906 and therefore discredits the possibility that it is one of two views of Collioure exhibited in Druet 1906 (nos. 36 or 37).

2. Acquired on November 26, 1908, by Michael and Sarah Stein (ibid.). According to the Druet stock records "vendu M. Steine [Stein], 26 nov. [19]08, 250 francs." AMP.

3. Paris 1910a, no. 39 (as "Marine, App. à M.M.S. [Mr. Michael Stein]"). The exhibition label remains affixed to the painting's verso, indicating: 39/Marine. SFMOMA Permanent Collection Object File: 69.67.

4. One of two paintings by Matisse titled "Sea-Scape Collioure I, II [each valued at] $1,500.00" in the 1937 inventory of Michael and Sarah Stein's collection. +7

5. Exhibited in San Francisco 1962. +28

6. Provenance established by Fourcade and Monod-Fontaine 1993, no. 12.

129. *Seascape (La Moulade)*, 1906
Oil on cardboard mounted on panel
10¼ x 13¼ in. (26.1 x 33.7 cm)
San Francisco Museum of Modern Art, bequest of Mildred B. Bliss
Plates 144, 369, 379

Provenance
Galerie Druet, Paris (acquired October 1906,[1] until January 1909); Michael and Sarah Stein, Paris and Palo Alto (acquired January 1909[2] and owned jointly[3] [pls. 369, 379] until at least 1937[4]); Mr. and Mrs. Robert Woods Bliss, Washington, D.C. (by at least 1962)[5]; thereafter, Mildred B. Bliss; her bequest to the San Francisco Museum of Art (September 1969)[6]

Notes
1. Druet stock number 3216: "Marine—carton 25 x 32." Cited in Flam 2005, 41, no. 114. See also cat. 128, note 1.

2. Sold to Michael and Sarah Stein on January 12, 1909. Jack Flam to Jill Dawsey, February 13, 2005. The transaction was completed on January 19, 1909, for 350 francs. AMP.

3. Paris 1910a, no. 38 (as "1906, Marine, App. à M.M.S. [Mr. Michael Stein]"). The exhibition label remains affixed to the painting's verso, indicating: 38/Marine. Carrie Pilto, SFMOMA.

4. One of two paintings by Matisse entitled "Sea-Scape Collioure I, II," each valued at $1,500 in the 1937 inventory of Michael and Sarah Stein's collection. +7

5. Exhibited in San Francisco 1962. +28

6. Provenance established by Fourcade and Monod-Fontaine 1993, no. 14.

130. *Seated Nude*, 1906
Oil on paperboard (later mounted to cradled panel)
12¾ x 16 in. (32.4 x 40.6 cm)
The Barnes Foundation, Merion, Pennsylvania

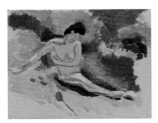

Provenance
Leo and Gertrude Stein, Paris (probably autumn 1906 or winter 1907,[1] and owned jointly until 1913/1914; thereafter, Leo Stein until May 1921[2]); Albert C. Barnes, Merion, Pennsylvania (acquired May 1921[3])

Notes
1. Acquisition dates provided by Karen Butler in Bois forthcoming.

2. One of seven works by Matisse that Leo Stein offered for sale in 1921, listed as no. 30 and valued at $500. +5

3. One of five works (totaling $800) that Alfred C. Barnes purchased from Leo Stein in May 1921. Barnes to Stein, April 30, 1921, BFA, AR.ABC.1921.109, cited by Karen Butler in Bois forthcoming. +5 Butler notes that the circled number 30 on the verso corresponds to the list noted above.

131. *Self-Portrait*, 1906
Oil on canvas
21⅝ x 18⅛ in. (55 x 46 cm)
Statens Museum for Kunst, Copenhagen, gift of Johannes Rump, 1928
Plates 138, 366, 368, 370, 371, 374

Provenance
Michael and Sarah Stein, Paris (1906[1] until[2,3] [pls. 366, 368, 370, 371, 374] lent July 1914[4]—from 1914 to 1917[?] left in safekeeping with Greta and Oskar Moll, Berlin, until allegedly confiscated by gallery owner Fritz Gurlitt, sold in a fictitious auction in 1917, and bought by Gurlitt himself; claimed in 1919 by Hans Purrmann on behalf of the Steins and sold ca. 1922); Christian Tetzen-Lund, Copenhagen (ca. 1922 until 1924); Ny Carlsberg Foundation (acquired and deposited in the Ny Carlsberg Glyptotek, Copenhagen, October 1924); Johannes Rump, Copenhagen (acquired by exchange, November 1926); Statens Museum for Kunst, Copenhagen (gift of Johannes Rump, 1928)[5]

Notes
1. Monrad 1999a, 286.

2. Paris 1907-8, no. 64 (as "Henri-Matisse,…Son portrait," without reference to any owner).

3. In a 1913 visit to Madame, C. Lewis Hind remarked having seen the present work, Matisse's "tête de son autoportrait." Cited in Fourcade and Monod-Fontaine 1993, 433-34, anthology no. 38.

4. Gurlitt exhibition (Berlin 1914) pamphlet, no. 13 (as "Selbstbildnis, 1907") and November 1916 document (pl. 116) as "Portrait de l'artiste (portrait of the artist), 55 x 46 [cm], 1907, $600.00." +24

5. Provenance established by Monrad 1999a, 286.

132. *Standing Figure*, 1906
Oil on paperboard (later mounted to cradled panel)
12¹³⁄₁₆ x 7⅝ in. (32.5 x 19.3 cm)
The Barnes Foundation, Merion, Pennsylvania

Provenance
Leo and Gertrude Stein, Paris (probably autumn 1906 or winter 1907,[1] and owned jointly until 1913/1914; thereafter, Leo Stein, Paris and Settignano, until May 1921[2]); Albert C. Barnes, Merion, Pennsylvania (acquired May 1921[3])

Notes
1. Acquisition dates provided by Karen Butler in Bois forthcoming.

2. One of seven works by Matisse that Leo Stein offered for sale in 1921, listed as no. 22 and valued at $100: "[Matisse] 100 figure." +5

3. One of five works (totaling $800) that Alfred C. Barnes purchased from Leo Stein in May 1921. Barnes to Stein, April 30, 1921, BFA, AR.ABC.1921.109, cited by Karen Butler in Bois forthcoming. +5 Butler notes that the circled number 22 on the verso corresponds to the list noted above.

133. *The Young Sailor I*, 1906
Oil on canvas
39¼ x 32¼ in. (100 x 78.5 cm)
Private collection
Plates 157, 366, 368, 369

Provenance
Michael and Sarah Stein, Paris (early 1907,[1] and owned[2,3] [pls. 366, 368, 369] until lent July 1914[4]—from 1914 to 1917[?] left in safekeeping with Greta and Oskar Moll, Berlin, until allegedly confiscated by gallery owner Fritz Gurlitt, sold in a fictitious auction in 1917, and bought by Gurlitt himself; claimed in 1919 by Hans Purrmann on behalf of the Steins and sold ca. 1920[4]); Tryggve Sagen, Oslo (ca. 1920 until 1927); Consul Peter Krag, Paris and Oslo (ca. 1927[5]); Mrs. Sigri Welhaven, Oslo (until July 1979[6])[7]; private collection

Notes

1. Cauman (2000b, 28) has dated the acquisition of this work by Michael and Sarah Stein to autumn 1906; however, other scholars establish the date as early 1907 (Flam 2005, 41, no. 175). The earliest known photograph of the work in the Steins' rue Madame apartment dates from winter 1907-8 (pl. 366).

2. In the catalogue of the 1908 Salon d'Automne, painting no. 902 is listed as "Jeune marin" without indication of lender or owner; it is thought to be the present work (Fourcade and Monod-Fontaine 1993, no. 45). It is worth noting that the Steins are credited for lending other works to this same exhibition (cat. 140 and 138).

3. Lent to an exhibition that traveled to Odessa and Kiev from December 1909 to February 1910 (no. 396). See cat. 140, note 3.

4. Gurlitt exhibition (Berlin 1914) pamphlet, no. 12 (ill., as "Bildnis eines Seemanns, 1907") and November 1916 document (pl. 116) as "Portrait d'un Marin (portrait of sailor) 100 x 81 [cm], 1907, $1000.00" (+24). According to Fourcade and Monod-Fontaine (1993, 212), the work was possibly offered in the 1916 Den franske Udstilling i Kunstnerforbundet sale in Oslo (as no. 31).

5. Berlin 1930, no. 18 (as "Sitzender Matrose, 1907," without indication of owner). +26 When the present work was exhibited in Paris 1931, Krag was noted in the exhibition catalogue as the owner: no. 14, "Collection de Monsieur le Consul Krag, Paris; Ancienne collection de Monsieur Stein, Paris."

6. Sales catalogue, Christie's, London, July 3, 1979, lot no. 99 (ill.); as noted, at the time Mr. Peter Krag was the late husband of Mrs. Sigri Welhaven.

7. Provenance established by Fourcade and Monod-Fontaine 1993, no. 45.

134. *Olive Trees at Collioure,* ca. 1906
Oil on canvas
17½ x 21¾ in. (44.5 x 55.2 cm)
The Metropolitan Museum of Art, New York, Robert Lehman Collection, 1975
Plates 59, 353

Provenance

Leo and Gertrude Stein, Paris (acquired either autumn 1906 or more likely autumn 1907[1,2] and owned jointly[3,4] [pl. 353] until at least March/November 1914[5]); Galerie Bernheim-Jeune, Paris (March/November 1914[5]); Oskar and Greta Moll, Paris and Berlin (perhaps as early as 1914[6]); Robert Lehman, New York (acquired in Paris, May/June 1949[7])

Notes

1. Perhaps one of the two Collioure landscapes (the other is *The Sea Seen from Collioure* [1906; cat. 127]) that Leo Stein referred to in 1947 as having been bought "at the end of the summer of 1906, shortly after they were painted." Cited in Wattenmaker and Distel 1993, 236. However, Henri Matisse's personal notes contain a reference dated Friday, December 6, 1907, listing the present work among the year's sales to Leo Stein: "à Leo Stein: La Musique/le paysage aux grands arbres [the present work]/le tableau No. III (femme bleu)." AMP.

2. Exhibited at the Salon d'Automne of 1908 as no. 894: "Paysage aux Oliviers," lent by "M.L.S. [Mr. Leo Stein]."

3. One of two works, both titled "Paysage de Collioure" (nos. 43, 45), exhibited in Paris 1910a; both works are listed as "App. à M.L.D.S. [Mr. Leo Daniel Stein]." Both *The Sea Seen from Collioure* and *Olive Trees at Collioure* bear Paris 1910a exhibition labels according to Wattenmaker and Distel 1993, 308n2.

4. Leo Stein lent a Matisse landscape to Grafton 1910-11—no. 77: "Paysage"—as did his friend Bernard Berenson. Although it is impossible to determine which painting Leo lent—he owned eight Matisse "landscapes" by 1910 (two traditional landscapes, two with figures, three depicting structures, and one marine)—it was most likely either *The Sea Seen from Collioure* or *Olive Trees at Collioure.*

5. By November 1914 Galerie Bernheim-Jeune had purchased from Leo Stein Matisse's "Margot [see cat. 122] et le Paysage de Collioure que nous lui avons acheté, ont été payés par nous à Michael Stein par les instructions de Leo D. Stein." Félix Fénéon to Gertrude Stein, November 26, 1914, Beinecke YCAL, MSS 76, box 98, folder 98. Since Leo had sold one of his Collioure landscapes to Barnes in December 1912, it is clear that the landscape Bernheim-Jeune purchased in 1914 is the present work. +25

6. Kropmanns 1997, 79-92. Claudine Grammont suggests that the painting may have been purchased by the Molls from Bernheim-Jeune in 1914; she confirms that it was not exhibited in Gurlitt 1914 (Grammont, e-mail message to the author, May 12, 2010). The painting appears in a photograph (dated by Kropmanns to ca.1917-18) of the Berlin apartment of the Molls (ibid., 89).

7. The Metropolitan Museum of Art, New York, Robert Lehman Collection curatorial files retain a shipping receipt from June 3, 1949 from Lenars & Co, Paris.

135. *Woman in a Kimono,* ca. 1906
Oil on panel
12⅜ x 15½ in. (31.5 x 39.5 cm)
Private collection, on loan to The Courtauld Gallery, London
Dauberville (1995) 63 (Bernheim-Jeune photo no. 1433, October 1916)
Plates 90, 366, 367, 369, 373, 380

Provenance

Michael and Sarah Stein, Paris and Palo Alto (probably acquired before May 1906,[1] and owned jointly [pls. 366, 367, 369, 373, 380] until 1938; thereafter, Sarah Stein, Palo Alto, until 1950); Stanley Steinberg, San Francisco (1950[2,3] until November 7, 1979); private collection

Notes

1. Acquisition date of before May 1906 conveyed by Claudine Grammont, e-mail message to Cécile Debray, February 3, 2010. The AMP has no specific acquisition information for this picture, which has no Druet number attached to it in AMP records; the AMP does contain a note from Amélie Matisse noting that she posed for this picture in a green shawl. Wanda de Guébriant, conversation with Carrie Pilto, February 17, 2011. Likely one of the three small paintings that Michael and Sarah brought with them to San Francisco shortly after the earthquake in 1906, departing Paris on April 28. Matches a description in Rosenshine n.d.; see Janet Bishop's essay in this volume, 131.

2. Acquired by Lionel Steinberg on behalf of his brother, Stanley Steinberg, while the latter was stationed overseas with the United States Army. Stanley Steinberg, e-mail message to Carrie Pilto, March 29, 2011.

3. San Francisco 1952, no. 15 (as "Woman and Still Life," lent by Dr. Stanley Steinberg). +28

136. *Dishes and Melon,* 1906-7[1,3]
Oil on canvas
25⁹⁄₁₆ x 31⅞ in. (65 x 81 cm)
The Barnes Foundation, Merion, Pennsylvania
Plates 60, 349

Provenance

[Galerie Druet, Paris (possibly acquired October 1906); Gustave Fayet, Paris (possibly acquired October 4, 1906)][1,2]; Leo and Gertrude Stein, Paris (acquired before April 1908[3] [pl. 349], and owned jointly until December 1912[4]); Albert C. Barnes, Merion, Pennsylvania (acquired in December 1912[4])

Notes

1. Early acquisition information proposed by Karen Butler and based upon a creation date of fall 1906. See Butler and Grammont in Bois forthcoming.

2. By October 4, 1906, Fayet had acquired nine Matisse still life paintings from Druet. Grammont suggests that the present work may be Druet no. 1979, based on the Druet account sheets; however, the lack of dimensions prevents a conclusive identification. Claudine Grammont, e-mail message to author, May 25, 2010.

3. The painting was probably the work exhibited at Bernheim-Jeune 1907 as no. 35: "Assiettes et melon," dated 1907 in the catalogue and without recorded ownership. The work appears in archival photographs dating between October 1906 and April 1908 of the Steins' apartment at rue de Fleurus (for example, pl. 349).

4. The price paid for *Dishes and Melon* is recorded as 3,500 francs, with an 80-franc frame included. Wattenmaker and Distel 1993, 308. See also cat. 127, note 6.

137. *Flower Piece,*[1] 1906-7
Oil on canvas
21⅞ x 18¼ in (55.6 x 46.4 cm)
The Barnes Foundation, Merion, Pennsylvania

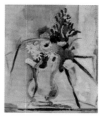

Provenance

Galerie Druet, Paris; Gustave Fayet, Paris (until April 10, 1907[2]); Bernheim-Jeune, Paris (acquired April 10, 1907, until April 16, 1907[2,3]); Leo Stein, Paris (acquired April 16, 1907,[2,3] and owned[4] until May 1921[5]); Albert C. Barnes, Merion, Pennsylvania (acquired May 1921[6])

Notes

1. Possibly included in the Matisse exhibition that opened at Galerie Druet, Paris, on October 5, 1906. The date of this work has not yet been firmly established.

2. Perhaps the work referred to in Manguin's correspondence to Matisse, June 11, 1907, which notes that the Steins had bought from Félix Fénéon (who acquired it from Fayet) a Matisse pot of flowers, "harmonious in the greens," that was at the past Salon d'Automne (Grammont 2005, 282). In the 1906 Salon d'Automne, no. 1174, it appeared as "Fleurs."

3. Galerie Bernheim-Jeune client list with dates of sales and purchases: no. 15922. +8

4. Paris 1910a, no. 42 (as "1906, Fleurs" and listed as "App. à M.L.D.S. [Mr. Leo D. Stein]"). +8

5. One of seven works by Matisse that Leo Stein offered for sale in 1921, listed as no. 33, initially valued at $1,000 and reduced to $500. +5

6. Barnes acquired the work in for $500. BFA, AR.ABC.1921.109.

138. *Pink Onions,* 1906–7
Oil on canvas, signed lower left
18⅛ x 21⅝ in. (46 x 55 cm)
Statens Museum for Kunst, Copenhagen, gift of
Johannes Rump, 1928
Plates 117, 367, 369, 374

Provenance

Sarah and Michael Stein, Paris (acquired probably autumn 1907,[1,2] until [pls. 367, 369, 374] lent July 1914[3]—from 1914 to 1917[?] left in safekeeping with Greta and Oskar Moll, Berlin, until allegedly confiscated by gallery owner Fritz Gurlitt, sold in a fictitious auction in 1917, and bought by the German painter Emil Rudolf Weis; reclaimed in 1919 by Hans Purrmann[4] for the Steins and sold ca. 1922); Christian Tetzen-Lund,[5] Copenhagen (ca. 1922 until October 1924); Ny Carlsberg Foundation, Copenhagen (October 1924 until November 1926); Johannes Rump, Copenhagen (acquired by exchange, November 1926); Statens Museum for Kunst, Copenhagen (gift of Johnannes Rump, January 19, 1928)[6]

Notes

1. Monrad 1999a, 288–89. Matisse's personal notes contain a reference listing the present work among the year's sales to Leo Stein (AMP). This may also be the still life cited in a letter of September 15, 1907, to Manguin. +27
2. Exhibited Salon d'Automne, 1908, no. 903, as "Nature morte, aux oignons" and owner listed as "M.M.S. [Monsieur Michael Stein]."
3. Gurlitt exhibition (Berlin 1914) pamphlet, no. 14 (as "Die Zwiebeln, 1907") and November 1916 document (pl. 116) as "Les Oignons (onions on a table), 55 x 46 [cm; dimensions reversed], 1907, $600.00." +24
4. Hans Purrmann wrote in 1946 that he reclaimed the painting from Emil Rudolf Weis for Michael and Sarah Stein. Fourcade and Monod-Fontaine 1993, 439, anthology no. 44.
5. The verso of the work bears the Christian Tetzen-Lund collection stamp. Communicated by Dorthe Aagesen, Statens Museum for Kunst, Copenhagen, on April 27, 2010.
6. Provenance established by Monrad 1999a, 288–89.

139. *Blue Nude: Memory of Biskra,* 1907
Oil on canvas
36¼ x 55¼ in. (92.1 x 140.4 cm)
The Baltimore Museum of Art: The Cone Collection, formed by Dr. Claribel Cone and Miss Etta Cone of Baltimore, Maryland
Plates 27, 351

Provenance

Leo [and Gertrude] Stein, Paris (spring 1907,[1,2] and probably owned jointly [pl. 351] until 1913/1914[3]); Alphonse Kann, Paris and Saint-Germain-en-Laye, France; Georges de Zayas, Paris; Marius de Zayas Gallery, New York (ca. 1920); John Quinn, New York (acquired December 1920,[4] until 1924); Dr. Claribel and Etta Cone, Baltimore (acquired October 28, 1926,[5] until September 1929; thereafter, Etta Cone, Baltimore, until August 1949); Baltimore Museum of Art

Notes

1. Purchased from the 1907 Salon des Indépendants, where it was no. 5247 (as "Tableau no. III"). Matisse's personal notes contain a reference listing the present work among the year's sales to Leo Stein. AMP.

2. In a journal entry of April 18, 1908, Inez Haynes Irwin remarked on having seen this painting of "la femme nue à la hanche hypertrophiée" among others in the collection of Gertrude and Leo Stein. Quoted in Fourcade and Monod-Fontaine 1993, 435, anthology no. 42.
3. Listed in New York 1913 as no. 411, "Lent by Leo Stein."
4. Purchased for $4,500.
5. Posthumous sale of John Quinn. Sales catalogue, *Tableaux modernes provenant de la collection John Quinn,* Hôtel Drouot, Paris, October 28, 1926, no. 61. Purchased at the sale by Michael Stein on behalf of Claribel Cone for 120,760 francs. Confirmed in B. Richardson 1985, 176.

140. *Blue Still Life,* 1907
Oil on canvas
35¼ x 46 in. (89.5 x 116.8 cm)
The Barnes Foundation, Merion, Pennsylvania
Plates 366, 367, 369

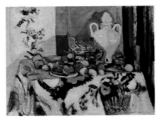

Provenance

Michael and Sarah Stein, Paris (probably between the end of summer 1907 and April 1908[1,2,3] until [pls. 366, 367, 369] lent July 1914[4]—from 1914 to 1917[?] left in safekeeping with Greta and Oskar Moll, Berlin, until allegedly confiscated by gallery owner Fritz Gurlitt, sold in a fictitious auction in 1917, and bought by Gurlitt himself; claimed in 1919 by Hans Purrmann on behalf of the Steins and sold ca. 1922); Christian Tetzen-Lund (ca. 1922 until January 1925); Albert C. Barnes, Merion, Pennsylvania (January 1925[5,6])

Notes

1. Probable dates of acquisition in Karen Butler in Bois forthcoming.
2. Lent to the 1908 Salon d'Automne, where it was exhibited as no. 895: "Nature morte au camaïeu bleu" and listed as "Appartient à M.M.S. [Monsieur Michael Stein]." Monrad 1999a, 267.
3. In a photograph of rue Madame showing the Michael Stein family seated at their dining table in the company of Matisse and Hans Purrmann (Potter 1970, 41, dated late 1907; one of six photographs sent by Matisse to Etta Cone in letters of September 19 and November 16, 1935, BMA Cone Papers), the frame of *Blue Still Life* appears without the canvas. This photograph was taken either while *Blue Still Life* was on display at the 1908 Salon d'Automne or possibly during the winter 1909–10, when the Steins may have lent *Blue Still Life* and *The Young Sailor I* (1906; cat. 133) to an exhibition in Odessa-Kiev.
4. Gurlitt exhibition (Berlin 1914) pamphlet, no. 11 (ill., as "Blaues stilleben, 1907") and November 1916 document (pl. 116) as "Nature morte bleue (still life with table), 116 x 89 [cm; dimensions reversed], 1907, $2,000.00." Of the nineteen Matisse works the Steins tried to reclaim, this is the highest value given to a single work. +24
5. Paul Guillaume in Paris acted as an agent. Monrad 1999a, 267.
6. Barnes purchased the work on January 19, 1925. See Karen Butler in Bois forthcoming.

141. *La Coiffure,* 1907
Oil on canvas
45⅝ x 35 in. (116 x 89 cm)
Staatsgalerie Stuttgart
Plates 19, 367, 371, 373, 374

Provenance

Galerie Bernheim-Jeune, Paris (received shipment of the painting July 1907[1]); Michael and Sarah Stein (by 1908[2] [pl. 367], and owned[3] [pls. 371, 373, 374] until lent July 1914[4,5,6]—from 1914 to 1917[?] left in safekeeping with Greta and Oskar Moll, Berlin, until allegedly confiscated by gallery owner Fritz Gurlitt, sold in a fictitious auction in 1917, and bought by Gurlitt himself; claimed in 1919 by Hans Purrmann on behalf of the Steins and sold ca. 1920); Tryggve Sagen, Oslo (ca. 1920 until 1927[6]); Consul Peter Krag, Paris and Oslo (perhaps ca. 1927[6,7]); Ragnar Moltzau, Olso (until 1959[7]); Staatsgalerie Stuttgart (1959[7])

Notes

1. In a letter dated July 8, 1907, Matisse wrote to Félix Fénéon about a format 50 canvas for which the artist asks 900 francs; the painting, referred to as "la coiffure ou la toilette," was sent to Galerie Bernheim-Jeune on July 13, 1907. Cited in Flam 2005, 46, no. 190.
2. Evidently Matisse was trying to help Michael and Sarah Stein acquire *La Coiffure* by finding a dealer or a buyer for their Gauguin, *Head of a Tahitian Girl* (ca. 1892; cat. 62); this is cited in two sources: (a) As recounted by Daniel-Henry Kahnweiler in his introduction to *Painted Lace* (Kahnweiler 1955, 18), Matisse asked Kahnweiler if he would buy *La Coiffure* from him and then sell it to the Steins, accepting their Gauguin head as part of the payment. Although the exact dates of the final transaction and exchange are unclear, the Steins did acquire *La Coiffure* around the time that *Head of a Tahitian Girl* left their collection. (b) On July 18, 1908, Fénéon responded to Matisse's proposal to exchange a Gauguin "tête d'Océanien[ne]" (presumably the Stein picture) for a young girl in red by Renoir (AMP). If the work in question is the Steins' Gauguin, presumably the Kahnweiler transaction had not yet taken place. It is possible that *La Coiffure* hung at rue Madame, perhaps as early as autumn 1907, before the negotiations were finalized (see pl. 364).
3. Lent to Berlin 1909, in which it was exhibited as "Die Friseuse." See Karen Butler and Claudine Grammont's description of this exhibition in Bois forthcoming.
4. Listed in the catalogue for the New York Armory Show (New York 1931) as no. 403, "Lent by Michael Stein."
5. Gurlitt exhibition (Berlin 1914) pamphlet, no. 17 (ill., as "Morgentoilette, 1907") and November 1916 document (pl. 116), as "La Coiffeuse (two female figures, 116 x 89 [cm], 1907, $1200.00." +24
6. Acquisition dates here are based on the purchase of other Matisse works from the Stein collection that Krag purchased from Sagen ca. 1927.
7. Provenance information provided by Staatsgalerie Stuttgart, Dr. Ina Conzen to the author, May 10, 2010.

142. *Le Luxe I,* 1907
Oil on canvas
82⅝ x 54⅜ in. (209.9 x 138.1 cm)
Musée National d'Art Moderne, Centre Georges Pompidou, Paris
Plates 101, 365

Provenance

Michael and Sarah Stein, Paris (acquired by the end of December 1907[1] [pl. 365], perhaps until 1917[2,3]); Henri Matisse, Paris (possibly acquired in 1917, until[4] 1945); Musée National d'Art Moderne, Centre Georges Pompidou (1945)[5]

Notes

1. After it was exhibited at the 1907 Salon d'Automne as "Le luxe, esquisse" (no. 758), the painting hung in the apartment of Michael and Sarah Stein at 58 rue Madame. Henri Matisse's personal notes contain a reference dated Friday, December 6, 1907, listing the present work among the year's sales to Michael Stein. AMP.
2. In a journal entry of April 18, 1908, Inez Haynes Irwin remembers this painting from her visit with Michael and Sarah Stein: "The three figures, one standing, one crouching on the ground, one holding flowers in the background, all nude." Quoted in Fourcade and Monod-Fontaine 1993, 444, anthology no. 53; translated by Erin Hyman.
3. Photographs of the rue Madame apartment taken between spring 1909 and December 1911 (Albert S. Bennett, New York) show *Le Luxe I* still hanging on the wall. It is not known when Matisse reacquired the painting; however, Michael and Sarah sold at least one large work from their collection back to the artist in 1917. Maxime Touillet; Claudine Grammont, e-mail message to author, May 25, 2010.
4. Paris 1937, no. 37 (as "Luxe, 1906, appartient à l'artiste)."
5. Purchased from the artist by the Musée National d'Art Moderne, Centre Georges Pompidou. Provenance established by Fourcade and Monod-Fontaine 1993, no. 53.

143. *Music* **(Sketch),** 1907
Oil and charcoal on canvas
29 x 24 in. (73.7 x 61 cm)
The Museum of Modern Art, New York, gift of A. Conger Goodyear in honor of Alfred H. Barr, Jr., 1962
Plates 62, 351, 353, 354

Provenance

Galerie Bernheim-Jeune, Paris (acquired July 13, 1907[1]); Leo [and Gertrude] Stein, Paris (purchased out of the Salon d'Automne of 1907,[2,3] and owned jointly [pls. 351, 353, 354] until possibly February 1914[4]); Galerie Bernheim-Jeune, Lausanne, November 1914[4]; Marius de Zayas, New York (by 1920[5]); John Quinn, New York (April 21, 1920,[6] until 1924; thereafter his estate until January 1926); A. Conger Goodyear, New York (January 1926[7] until 1962); Museum of Modern Art, New York (gift of A. Conger Goodyear, 1962)

Notes

1. In a letter dated July 8, 1907, Matisse writes to Félix Fénéon about a format 20 canvas for which the artist asks 400 francs; the painting was sent to Galerie Bernheim-Jeune on July 13, 1907. Flam 2005, 46, no. 192.
2. Exhibited in the 1907 Salon d'Automne (October) as no. 757bis: "La Musique (esquisse)." This is likely the work "toile no. 20, La Musique, 400f" cited in a draft or copy of a letter dated July 8, 1907, from Matisse to Fénéon about works Matisse is sending from Collioure. AMP. These documents amend the previous assumption that the work was owned by Michael and Sarah Stein.
3. See +27 for letter from Matisse to Manguin. "Music" mentioned in the letter is surely the present work.

4. Lent to the 1914 Rome exhibition *Secessione* as no. 3: "La musica." Félix Fénéon to Leo Stein, November 1913, Beinecke YCAL, MSS 76, box 98, folder 1866. Bernheim-Jeune purchased at least two Stein Matisse works in February 1914, in advance of the exhibition; however, it is not known when or to whom Leo sold this particular painting. Bernheim-Jeune handled the work's dispersal after Leo and Gertrude's separation of 1913–14. +25
5. One of two Matisse works (the other is *Blue Nude: Memory of Biskra* [1907; cat. 139]) that left Leo and Gertrude's collection and entered the New York gallery of Marius de Zayas by 1920.
6. Purchased for $1,100. Fourcade and Monod-Fontaine 1993, no. 52, 226–27.
7. Purchased for $1,800. Ibid.

144. *Red Madras Headdress,* 1907
Oil on canvas
39⅜ x 31¾ in. (100 x 80.6 cm)
The Barnes Foundation, Merion, Pennsylvania
Plates 95, 368, 370, 373

Provenance

Galerie Bernheim-Jeune, Paris (received shipment of the painting July 1907[1]); Michael and Sarah Stein, Paris (acquired autumn 1907,[2,3] until[4] [pls. 368, 370, 373] lent July 1914[5]—from 1914 to 1917[?] left in safekeeping with Greta and Oskar Moll, Berlin, until allegedly confiscated by gallery owner Fritz Gurlitt, sold in a fictitious auction in 1917, and bought by Gurlitt himself; claimed in 1919 by Hans Purrmann on behalf of the Steins and sold ca. 1922); Christian Tetzen-Lund, Copenhagen (ca. 1922 until January 1925); Albert C. Barnes, Merion, Pennsylvania (January 1925[6,7])

Notes

1. In a July 8, 1907, letter to Fénéon, Matisse writes about a format 40 canvas for which the artist asks 800 francs. The painting, referred to as "tête d'expression," was sent to Galerie Bernheim-Jeune on July 13, 1907. Unable to acquire the work at the time, Fénéon writes Matisse on September 30, 1907, requesting permission to purchase the painting from the Salon d'Automne for the 800 francs Matisse originally suggested. AMP.
2. Exhibited in the 1907 Salon d'Automne as no. 757: "Tête d'expression," with no recorded owner. Matisse's personal notes contain a reference listing the present work among the year's sales to Leo Stein. AMP.
3. See +27 for letter from Matisse to Manguin. Of the mentioned works, the "large" painting is likely either the present work or *Le Luxe I* (1907; cat. 142), both of which were acquired by the Steins in the fall of 1907.
4. New York 1913, no. 401, "Lent by Michael Stein."
5. Gurlitt exhibition (Berlin 1914) pamphlet, no. 15 (ill., as "Porträt, 1907") and November 1916 document (pl. 116), as "Portrait au Madras rouge (portrait with red headdress), 100 x 81 [cm], 1907, $1200.00." +24
6. Paul Guillaume acted as an intermediary in this transaction. Monrad 1999a, 265.
7. Barnes purchased on January 19, 1925. Karen Butler in Bois forthcoming.

145. *View of Collioure,* 1907
Oil on canvas, signed lower right
36¼ x 25⅞ in. (92 x 65.5 cm)
The Metropolitan Museum of Art, New York, Jacques and Natasha Gelman Collection, 1998
Plates 158, 372

Provenance

Michael and Sarah Stein, Paris (1907/1908[1] until [pl. 372] lent July 1914[2]—from 1914 to 1917[?] left in safekeeping with Greta and Oskar Moll, Berlin, until allegedly confiscated by gallery owner Fritz Gurlitt, sold in a fictitious auction in 1917, and bought by Gurlitt himself; claimed in 1919 by Hans Purrmann on behalf of the Steins and sold ca. 1922); Christian Tetzen-Lund (ca. 1922 until at least May 19, 1925[3,4]); Marie Cuttoli, Paris; Helena Rubenstein, Paris and New York (at least by July 1937[5] until April 1966[6]); E. V. Thaw & Co., New York; Jacques and Natasha Gelman, New York; Metropolitan Museum of Art (bequeathed 1998)[7]

Notes

1. Exhibited at the Salon d'Automne in October 1907 as either no. 759 or 759b, both titled "Paysage (esquisse)." Noted as having been purchased by Michael and Sarah Stein in 1907/1908, Monrad 1999a, 270.
2. Gurlitt exhibition (Berlin 1914) pamphlet, no. 16 (as "Collioure Zwischen Baumen, 1907") and November 1916 document (pl. 116) as "Collioure à travers les arbres (landscape foliage), 92 x 65 [cm], 1907, $800.00." +24
3. His sale, May 19, 1925, V. Winkel & Magnussen Auctioneers of Fine Art, lot no. 90 (bought in).
4. Another Matisse work bought in from Christian Tetzen-Lund's 1925 sale, the portrait *André Derain* (1905; cat. 107), was purchased by Galerie Pierre Loeb, Paris, in December 1927, and it is plausible that the present work may have returned to Paris in the same way.
5. Paris 1937, no. 44 (as "Collioure à travers les arbres, 1905. Coll. Helena Rubinstein").
6. Her sale (part I), Sotheby Parke-Bernet, New York, April 20, 1966, no. 48 (ill.).
7. Provenance established by Monrad 1999a, 270.

146. *Sculpture and Persian Vase,* 1908
Oil on canvas
23⅞ x 29 in. (60.6 x 73.7 cm)
The National Museum of Art, Architecture, and Design, Oslo
Dauberville (1995) 85 (Bernheim-Jeune photo no. 1185, stock no. 16732[1])
Plates 151, 369, 373

Provenance

Galerie Bernheim-Jeune, Paris (July 7, 1908,[1] until October 1, 1908[2]); Michael and Sarah Stein (acquired October 1, 1908,[3] and owned [pls. 369, 373] until lent July 1914[4]—from 1914 to 1917[?] left in safekeeping with Greta and Oskar Moll, Berlin, until allegedly confiscated by gallery owner Fritz Gurlitt, sold in a fictious auction in 1917, and bought by Gurlitt himself; exhibited in Oslo in 1918[5]; claimed in 1919 by Hans Purrmann on behalf of the Steins and sold ca. 1922); Christian Tetzen-Lund, Copenhagen (ca. 1922 until at least May 28, 1934[6,7]); The National Museum of Art, Architecture, and Design, Oslo[8]

Notes

1. Purchased from the artist with the frame for 660 francs. The Bernheim-Jeune inventory no. 16732 is recorded on the stretcher. Nils Messel, National Museum of Art, Architeture and Design, Oslo, e-mail message to author, February 5, 2010.
2. Presented at the 1908 Salon d'Automne as no. 896: "Nature morte, bronze à l'oeillet."

3. A copy of a one-page typed document bearing the stamp of Galerie Bernheim-Jeune and showing a list of clients with recorded dates of sales and purchases (see +8) has created some confusion over the ownership of this work. On that document the purchaser in 1908 is erroneously listed as Madame Martin Stein. When the work was exhibited in Paris 1910a (as no. 55, "Bronze, 1908") it was listed as "App. à M.M.S." Early photographic evidence depicts *Sculpture and Persian Vase* hanging in Michael and Sarah Stein's rue Madame apartment (pl. 369).

4. Gurlitt exhibition (Berlin 1914) pamphlet, no. 18 (as "Stilleben mit bronzen, 1908") and November 1916 document (pl. 116) as "Nature Morte, Le Bronze (Still life with bronze), 73 x 60 [cm; dimensions reversed], 1908, $800.00." +24

5. Lent to a 1918 exhibition in Oslo, where the work was not illustrated and its owner not listed. Nils Messel, National Museum of Art, Architeture and Design, Oslo, e-mail message to author, February 5, 2010.

6. His sale, May 19, 1925, V. Winkel & Magnussen, lot no. 84 (bought in); his sale, May 28, 1934, V. Winkel & Magnussen, lot no. 11.

7. Purchased by the Friends of the Norwegian National Gallery and presented to the Nasjionalgalleriet, Oslo. Monrad 1999a, 271.

8. Provenance established by Monrad 1999a, 271.

147. *Fontainebleau Forest (Autumn Landscape)*, 1909
Oil on canvas, signed
23⅝ x 29 in. (60 x 73.5 cm)
Private collection
Plates 161, 373

Provenance

Michael and Sarah Stein, Paris (acquired before February 1910,[1] until [pl. 373] lent July 1914[2]—from 1914 to 1917[?] left in safekeeping with Greta and Oskar Moll, Berlin, until allegedly confiscated by gallery owner Fritz Gurlitt, sold in a fictitious auction in 1917, and bought by Gurlitt himself; claimed in 1919 by Hans Purrmann on behalf of the Steins and sold ca. 1920); Tryggve Sagen, Oslo (ca. 1920 until 1927)[2,3]; Consul Peter Krag, Paris and Oslo (ca. 1927[3] until at least 1931[4,5])

Notes

1. Paris 1910a, no. 57 (as "1909, Paysage d'automne, App. à M.M.S. [Mr. Michael Stein]."
2. *Autumn Landscape* is illustrated in the Gurlitt (Berlin 1914) exhibition pamphlet; however, the erroneous caption refers to no. 10, which is a 1906 Collioure landscape (now identified as cat. 121). The work is actually no. 19: "Herbststilleben, 1909." It also appears in a November 1916 document (pl. 116), as "Paysage d'automne (landscape autumn effect) 73 x 60 [cm; dimensions reversed], 1909, $800.00" (+24). Monrad (1999b, 145) indicates this work as having entered the collection of Tryggve Sagen.
3. Thannhauser (Berlin 1930) is noted as having exhibited this work, listing it in the catalogue as no. 8, "Herbstlandschaft," without indication of owner. See +26. However, Krag is believed to have already been the owner of at least one other work by Matisse (no. 18) lent to this exhibition; therefore, it is likely, that Krag also acquired the present work ca. 1927 (along with several other Matisse paintings) through transactions with Tryggve Sagen.
4. Paris 1931, no. 19 (as "Collection de Monsieur le Consul Krag, Paris").
5. Sales catalogue, Christie's, London, December 2, 1985, lot no. 14 (ill.).

148. *Portrait of Sarah Stein*, 1908–11
Oil on canvas
Approximately 25 x 19¼ in. (63.5 x 50 cm)
Current location unknown

Provenance

Michael and Sarah Stein, Paris[1,2]; private collection (by 1970[1,2])

Notes

1. Potter 1970, 162. The work is not illustrated in the catalogue for the 1970 MoMA exhibition but appears in an installation photograph of the exhibition.
2. Wanda de Guébriant has suggested that this may be the "Tête de femme" that appears in an undated Sotheby's inventory of Roubina Stein's collection. AMP, information communicated to Carrie Pilto, February 2008.

149. *Interior with Aubergines*, 1911
Distemper on canvas, signed lower right (partial signature visible)
82⅜ x 96⅞ in. (212 x 246 cm)
Musée Grenoble, gift of the artist, 1922
Dauberville (1995) 168 (Bernheim-Jeune photo no. 1518, November 1916)
Plates 162, 373, 374

Provenance

Sarah and Michael Stein, Paris (acquired late 1911,[1] until [pls. 373–74] probably 1917[2]); Henri Matisse, Paris (probably reacquired in 1917,[2] until June 1922[3]); Musée de Grenoble (gift of the artist in June 1922[3])

Notes

1. Michael wrote Claribel Cone that he had just acquired this picture, "a very large new 'decoration,' about 8 feet by 10," that would require them to completely reorganize their apartment. The undated letter was "received [in] Baltimore Jan. 5, 1912." BMA Cone Papers, and Grammont 2005, 287.
2. Repurchase by the artist is now dated to 1917, as proposed by Wanda de Guébriant. See G. Stein and Picasso 2008, 188n2. Previously, scholars dated this transaction and the gifting to the Musée de Grenoble to 1922: "The painted frame was still on the picture when it was photographed in December 1916. At that time it belonged to the Michael Steins, who had acquired it in 1912 (Bernheim-Jeune photo no. 1518, taken in December 1916). In 1922 Matisse bought it back in order to give it to the Musée de Peinture et de Sculpture in Grenoble, and the frame may have been removed when the painting was shipped then. In any case, by 1935 the painted frame was no longer on the painting and its fate remains a mystery." Flam 1986, 497n16.
3. Given by the wife and daughter of Henri Matisse. Fourcade and Monod-Fontaine 1993, no. 90.

150. *Nude in a Forest*, 1909–12
Oil on canvas, signed lower left
16½ x 12¾ in. (41.9 x 32.4 cm)
Solomon R. Guggenheim Museum, New York
Dauberville (1995) 103 (Bernheim-Jeune photo no. 62, October 1913, and no. 557, June 1914)
Plate 376

Provenance

Galerie Bernheim-Jeune, Paris (acquired October 9, 1913,[1] until October 13, 1916[1]); Michael [and Sarah] Stein, Paris and Palo Alto (acquired October 13, 1916,[1] and owned jointly [pl. 376] until at least 1937[2] and before May 1952[3]); Mr. and Mrs. Tevis Jacobs, San Francisco (by May 1952[3] until[4,5] 1984); Solomon R. Guggenheim Museum, New York (acquired 1984[6])

Notes

1. Dauberville 1995, no. 103, 476, lists an erroneous acquisition date from the artist but supplies a purchase price of 850 francs. The correct date can be found on a Galerie Bernheim-Jeune client list that records sales and purchases: no. 20029 (+8). The verso of the painting bears the Bernheim-Jeune inventory no. 20029.
2. Likely the painting listed as "Nude in Forest" and valued at $1,500 in the 1937 inventory of Michael and Sarah Stein's collection. +7
3. The painting passed directly from Sarah Stein to the Jacobses. Object file, Solomon R. Guggenheim Museum, Megan Fontanella, e-mail message to author, June 15, 2010. Also, San Francisco 1952, no. 18 (as lent by Mr. and Mrs. Tevis Jacobs).
4. San Francisco 1962. +28
5. Potter 1970, 162.
6. Purchased from the estate of the former owner. Megan Fontanella, e-mail message to the author, June 15, 2010.

151. *Michael Stein*, 1916
Oil on canvas, signed lower left
26½ x 19⅞ in. (67.3 x 50.5 cm)
San Francisco Museum of Modern Art, Sarah and Michael Stein Memorial Collection, gift of Nathan Cummings
Dauberville (1995) 184 (Bernheim-Jeune photo no. 1576, January 1917)
Plates 84, 375

Provenance

Michael and Sarah Stein, Paris and Palo Alto (1916 and owned jointly [pl. 375] until 1938; thereafter Sarah Stein, Palo Alto and San Francisco,[1] until September 1953); Nathan Cummings, Chicago (February 1954 until January 1955); San Francisco Museum of Modern Art[2]

Notes

1. In a December 1951 letter, Fiske Kimball writes about sales from the collection of Sarah Stein: "She [Sarah Stein] has left only two Matisse oils, the portraits of Mike and of herself, which I published in our Bulletin (both now taken to the bank for safekeeping), and a big drawing of herself by Matisse, with dedication, 1906 [sic], beside a few lithographs." Fiske Kimball to R. Sturgis Ingersoll, December 11, 1951, PMA Kimball Papers.

2. According to Elise S. Haas, "when we were in Europe in '53 we went to Venice one day, and went to Harry's Bar. A large man got up and embraced me in the middle of the floor, which rather startled me. It was Nate Cummings of Chicago, who was the man I had in mind to buy the portrait of Mike…. 'I have spoken to Tevis Jabobs [Sarah's attorney] already and told him that when Sarah dies I would like to buy her portrait and present it to the San Francisco Museum of Art as a nucleus for a Sarah and Michael Stein Memorial Collection. Why don't you buy Mike's and do the same?' He said, 'It's a deal,' and we shook hands on it." Haas 1972, 108.

152. *Sarah Stein*, 1916
Oil on canvas
28½ x 22¼ in. (72.4 x 56.5 cm)
San Francisco Museum of Modern Art, Sarah and Michael Stein Memorial Collection, gift of Elise S. Haas
Dauberville (1995) 183 (Bernheim-Jeune photo no. 1577, January 1917)
Plates 83, 375, 381

Provenance

Michael and Sarah Stein, Paris and Palo Alto (1916, and owned jointly [pls. 375, 381] until 1938; thereafter Sarah Stein, Palo Alto and San Francisco,[1] until September 1953); Mr. and Mrs. Walter A. Haas, San Francisco[2] (1954 until January 1955); San Francisco Museum of Modern Art[3]

Notes

1. In a December 1951 letter Fiske Kimball writes about sales from the collection of Sarah Stein: "She [Sarah Stein] has left only two Matisse oils, the portraits of Mike and of herself, which I published in our Bulletin (both now taken to the bank for safekeeping), and a big drawing of herself by Matisse, with dedication, 1906 [sic], beside a few lithographs." Fiske Kimball to R. Sturgis Ingersoll, December 11, 1951, PMA Kimball Papers.

2. Purchased by Elise S. Haas "as a nucleus for a Sarah and Michael Stein Memorial Collection" at the San Francisco Museum of Art. Haas 1972, 108.

3. Accessioned by SFMA 1954. Written notice of transfer from Elise S. Haas is dated January 11, 1955, and acceptance by SFMA is dated January 20, 1955. SFMOMA Permanent Collection Object File: 54.1117.

153. *The Bay of Nice*, 1918
Oil on canvas
35⅜ x 28 in. (89.9 x 71.1 cm)
Private collection
Plate 98

Provenance

Michael and Sarah Stein, Paris and Palo Alto (at least by July 1935,[1] and owned jointly[2,3] until 1938; thereafter, Sarah Stein, Palo Alto); Mr. and Mrs. Leon Russell (probably late 1940s, and at least by 1952)[4]; thereafter, Madeleine Haas Russell (until 1999); private collection

Notes

1. Appears in photographs of the Villa Stein-de Monzie, where Sarah and Michael resided from spring 1928 until July 1935, David and Barbara Block family archives.

2. San Francisco 1936, no. 20 (ill., as "Nice, 1919, Lent by Mr. and Mrs. Michael Stein"). +28

3. Listed as "Sea-Scape Nice" and valued at $8,000 in the 1937 inventory of Michael and Sarah Stein's collection. +7

4. According to Sarah's friend Elise S. Haas, Maurice Galanté "rang me up one day and said, 'I hear your cousin, Mrs. Madeleine Russell is interested in Matisse's 'Promenade des Anglais' at Nice, and Sarah is willing to sell it, if Mrs. Russell still wants it.' Of course I rang up Madeleine and she was delighted to have it." Haas 1972, 110. San Francisco 1952, no. 22 (as "Landscape—Nice," lent by Mr. and Mrs. Leon Russell). Pierre Matisse to J. H. Hume, president of the SFMA Board of Trustees, December 27, 1962, PMG Archives, MS 5020, box 77, folder 16.

154. *Landscape with Cypresses and Olive Trees near Nice*, 1918
Oil on board
10⅝ x 13½ in. (27 x 34.3 cm)
Ann and Gordon Getty, San Francisco
Plates 165, 380

Provenance

Michael and Sarah Stein, Paris and Palo Alto (owned jointly [pl. 380] until 1938; thereafter, Sarah Stein, Palo Alto[1]); Stendahl Gallery, Los Angeles[2]; Sir Antony and Lady Hornby, England (by April 1963), before or after Lefevre Gallery, London[3]; Ann and Gordon Getty, San Francisco

Notes

1. A photograph in the Pierre Matisse Gallery Archives indicates: "Oil on canvas, 13¾ x 10¾, Stendahl Art Gallery, Earl L. Stendahl, No. 8107-4." PMG Archives, MA 5020, box 133, folder 1.

2. Stendahl Galleries records. April Dammann, e-mail message to Carrie Pilto, May 10, 2010.

3. Ownership as indicated in the following sources: sales catalogue, Christie's, London, June 27, 1995, part II, lot no. 160 (ill.); and London 1963, no. 80: "Paysage environs de Nice, 1918. Oil on canvas. 14½ x 17½. Signed Henri Matisse." The present work is illustrated in the 1995 sales catalogue, which notes a provenance of "Lefevre Gallery, London (121/53)" and refers to the 1963 exhibition. The Tate catalogue lists the work among the loans of "Sir Antony and Lady Hornby, England." Despite slight variations in dimensions and medium, both sources are thought to refer to the same work. At present, it is unclear whether the work was first acquired by the Hornbys or by Lefevre Gallery, London.

155. *Tea*, 1919
Oil on canvas, signed lower left
55¼ x 83¼ in. (140.3 x 211.3 cm)
Los Angeles County Museum of Art, bequest of David L. Loew in memory of his father, Marcus Loew
Bernheim-Jeune inv. no. 21767
Plates 99, 378

Provenance

Josse and Gaston Bernheim, Paris (acquired November/December 1919[1]); Galerie Bernheim-Jeune, Paris (May 18[2] until July 30, 1920); [Mr. and Mrs.] Paul Ebstein, Paris (by July 30, 1920[2]); Lell[3]; Bernheim-Jeune, Paris (until August 1925); Michael and Sarah

Stein, Paris and Palo Alto (August 13, 1925,[3] until [pl. 378] 1938; thereafter, Sarah Stein, Palo Alto, until late 1948/early 1949[4]); Stendahl Gallery, Los Angeles (by February 1949[4,5] until 1954); David L. Loew, Beverly Hills (November 1954 until 1973); Los Angeles County Museum of Art (bequest of David L. Loew in memory of his father, Marcus Loew, 1973)[6]

Notes

1. This painting was acquired in late autumn 1919. Dauberville 1995, no. 348, records the purchase date as November 17, 1919, but publishes a facsimile of the receipt for the work dated December 15, 1919.

2. The painting was acquired from Josse and Gaston Bernheim by Galerie Bernheim-Jeune on May 18, 1920 (Fourcade and Monod-Fontaine 1993, no. 151). That October the canvas was included in an exhibition at Bernheim-Jeune as no. 18: "Le thé, Appartient à Mme P. E."

3. Galerie Bernheim-Jeune client list with dates of sales and purchases, no. 21767, shows the work was purchased from "Lell" without indication of date. +8

4. "The great *Le Thé* of ca. 1920 had just arrived and been hung at Stendahl's. In N[ew] Y[ork] he had said they are asking $35,000 (at which it was unsold) but we could have it for 25,000 cash in advance which he needed for the deal." Fiske Kimball to R. Sturgis Ingersoll, +23

5. A photograph in the visual records of the Pierre Matisse Gallery Archives indicates: "Stendahl Art Gallery, Earl L. Stendahl." PMG Archives, MA 5020, box 133, folder 1. According to Stendahl Galleries records, the work was purchased from the Steins for $15,000. April Dammann, e-mail message to Carrie Pilto, May 10, 2010.

6. Provenance established by Fourcade and Monod-Fontaine 1993, no. 151.

156. *Girl Reading*, ca. 1925
Oil on canvas, signed lower right
14 x 19½ in. (35.6 x 49.5 cm)
Private collection
Plates 170, 379

Provenance

Michael and Sarah Stein, Paris and Palo Alto (owned jointly from 1925 [pl. 379] until at least 1937[1]); Mr. and Mrs. Brayton Wilbur, Burlingame, California (by December 1949,[2] and owned[3] until at least 1970[4]); Mr. and Mrs. Carter P. Thacher (at least by 1983[5] and until 2006; thereafter Carter P. Thacher until 2009); private collection

Notes

1. Inscribed on verso: "A Madame M. Stein/cordialement Henri Matisse/Juillet 1925." Janet Bishop, e-mail message to author, July 1, 2010. Listed as "Girl at Table" and valued at $3,000 in the 1937 inventory of Michael and Sarah Stein's collection. +7

2. Likely one of the two works (the other is *Woman at a Table*) noted in the December 14, 1949, letter referenced in cat. 106, note 4. See caption, pl. 170, in this volume.

3. San Francisco 1952, no. 24 (as lent by Mr. and Mrs. Brayton Wilbur, Burlingame, California).

4. Potter 1970, 44.

5. A letter from Brayton Wilbur, Jr., to Pierre Schneider, August 1, 1983, indicates that the painting was then owned by C. P. Thacher. Copy, SFMOMA Permanent Collection Object File: 2008.21.

157. *Cap d'Antibes Road,* 1926
Oil on canvas
19⅞ x 24 in. (50.5 x 61 cm)
Private collection
Plate 166

Provenance

Michael and Sarah Stein, Paris and Palo Alto[1]; Henri Matisse (by 1945,[2] until 1954); Jean Matisse (1954 until ca. 1973); Marie Matisse (ca. 1973 until 2001); private collection (2001 until present)

Notes

1. Potter 1970, 44. In researching Stein provenance of this painting for the *Four Americans in Paris* catalogue, Margaret Potter wrote to Lucile Golson, "I have been able to track down the small picture of a large tree photographed by Dr. Dodds in Sarah's garden, of which Gerry [Nordland] sent me a slide…. It was published in a book of 1948 as 'Antibes Road' of 1926, collection Henri Matisse. So that also went back." Potter to Golson, April 1, 1970, MoMA Archives, Potter papers 4.
2. "V & A London, 1945: #6 Cap d'Antibes 1925, lent by the artist," handwritten note, MoMA Archives, Potter papers 6.

WORKS ON PAPER

158. *Nude,* ca. 1901-3
Pencil on paper
11 x 9 in. (27.9 x 22.9 cm)
Private collection
Plates 365, 369, 374

Provenance

Michael and Sarah Stein, Paris (owned jointly by December 1907 [pls. 365, 369, 374], probably until at least 1937[1]; thereafter, Sarah Stein, Palo Alto and San Francisco); Dr. and Mrs. Harold Rosenblum, Sausalito, California (by 1953[2] and owned until 1989[2])

Notes

1. Perhaps the work by Matisse listed as "Nude Seated (Sketch)" and valued at $500 in the 1937 inventory of Michael and Sarah Stein's collection. +7
2. According to a conversation (May 12, 2009) with a descendant, Sarah gave the work to Dr. Rosenblum during a medical visit in San Francisco. Sarah Stein died in 1953. The work passed by descent in 1989.

159. *Grounded Fishing Boat,* 1905
Reed pen and ink on paper, laid on paper, laid on card
17½ x 13¼ in. (44.4 x 31.7 cm)
The Art Institute of Chicago, gift of Mr. Joel Starrels, 1961

Provenance

Leo Stein, Paris and Settignano, Italy[1]; Cesar de Hauke, Paris (by 1954, until at least April 1956); Zwemmer Gallery, London; Joel Starrels (until 1961); Art Institute of Chicago[2]

Notes

1. The mat bears an inscription identifying the work as having been in the collection of Leo Stein. Art Institute of Chicago website [http://www.artic.edu/aic/collections/artwork/87624?search_id=3], accessed February 26, 2011.
2. Provenance details obtained from the object file at the Art Institute of Chicago.

160. *Landscape (Collioure),* 1905
Reed pen and ink on paper
12⅛ x 18 in. (30.8 x 45.7 cm)
The Barnes Foundation, Merion, Pennsylvania

Provenance

Leo and Gertrude Stein, Paris (owned jointly[1] until 1913/1914; thereafter, Leo Stein until May 1921[2]); Albert C. Barnes, Merion, Pennsylvania (acquired May 1921[3])

Notes

1. One of two drawings that Leo Stein lent to Paris 1910a, this may be no. 76. Karen Butler in Bois forthcoming.
2. One of seven works by Matisse belonging to Leo Stein that were offered for sale in 1921, this is likely no. 29: "Matisse drawing," valued at $200. +5
3. Alfred Barnes purchased from Leo Stein for $100, according to a letter of May 9, 1921. BFA, AR.ABC.1921.109, cited by Karen Butler in Bois forthcoming.

161. *Madame Matisse in the Olive Grove,* 1905
Ink on paper, signed lower right
8 x 10½ in. (20.3 x 26.7 cm)
Frances and Michael Baylson, Philadelphia
Plate 139

Provenance

Michael and Sarah Stein, Paris and Palo Alto (perhaps by 1907,[1] and owned jointly until 1938; thereafter, Sarah Stein, Palo Alto, until at least February 25, 1947[2]); Mr. and Mrs. Lionel Steinberg, Palm Springs (by 1970[3]; thereafter, by descent); Frances and Michael Baylson, Philadelphia

Notes

1. Matisse's painting of the same subject hangs in the Stein apartment on rue Madame, as early as 1907 (see pl. 366).
2. Noted by Fiske Kimball as "a beautiful little drawing like Van Gogh, but delicate, of Madame Matisse walking in the garden, special favorite of his, which she [Sarah Stein] selected when he begged her to give him the samovar in Le Thé [*Tea*] in return for a drawing." +9
3. Potter 1970, 159.

162. *Sailboat in the Harbor of Collioure,* 1905
Brush and ink on paper, inscribed on mount
6⅛ x 8¹⁄₁₆ in. (15.5 x 20.4 cm)
Current location unknown
Plate 365

Provenance

Allan Stein, Paris (acquired November 7, 1907,[1] until 1951; thereafter, Roubina Stein until October 1989[2])

Notes

1. The mount is inscribed: "A. Allain [Allan] Stein/son ami H. Matisse 7 nov. 07." Potter 1970, 160. In New York 1970, the work was exhibited and listed as private collection, without further indications.
2. Appears in an undated Sotheby's inventory of Roubina Stein's collection, and noted as having been among the Matisse works stolen in October 1989. AMP, information communicated to Carrie Pilto, February 2008.

163. *Figure in a Landscape,* 1905-6
Watercolor and graphite on paper laid on paper, signed lower left
6⅞ x 10 in. (17.5 x 25.4 cm)
Private collection

Provenance

Gustave Fayet, Paris; Michael and Sarah Stein, Paris and Palo Alto (probably acquired May 16, 1908,[1] and owned jointly until at least 1937[2]); Mr. and Mrs. Tevis Jacobs, San Francisco (gift of Sarah Stein at least by 1952,[3] until November 2000[4]); private collection

Notes

1. Likely the Matisse watercolor that Michael Stein acquired from the sale of the Gustave Fayet collection, Hôtel Drouot, Paris, May 16, 1908, lot no. 72, as Matisse "Baigneuses, aquarelle, 17 x 25 cm, signé en bas à gauche." Michael Stein to Leo and Gertrude Stein, undated [May 17, 1908], Beinecke YCAL, MSS 76, box 124, folder 2705. Note, however, that the title of the work in the sales catalogue refers to more than one bather.
2. Surely the work by Matisse listed as "Watercolor Landscape" and valued at $500 in the 1937 inventory of Michael and Sarah Stein's collection. +7
3. San Francisco 1952, no. 27 (as lent by Mr. and Mrs. Tevis Jacobs, San Francisco).
4. Sales catalogue, Sotheby's, New York, November 10, 2000, lot no. 308. Tevis Jacobs (1906-1974) was a partner in a legal firm with Oscar Samuels, the brother of Sarah Samuels Stein.

164. *Postcard with a sketch of The Artist's Family,* 1906
Ink on paper
3¼ x 4½ in. (8.3 x 11.4 cm)
Cary and Jan Lochtenberg
Plate 89

Provenance

Allan Stein, Paris (acquired July 1906,[1] probably until 1951; thereafter, his estate); Stephen Hahn, Santa Barbara; Cary and Jan Lochtenberg, New York[2] (at least by 2001[3])

Notes

1. Postcard, Henri Matisse to Allan Stein, July 4, 1906, inscribed: "De Henri Matisse à Allain [Allan] Stein Cordial souvenir de toute la famille Matisse de vous et de vos chers parents."
2. Hahn's sale to the Lochtenbergs established in Carrie Pilto's telephone conversations with Cary Lochtenberg and Mrs. Stephen Hahn, both March 17, 2009.
3. Klein 2001, 88n56.

165. *Marguerite in Three Poses,* 1906
Ink on paper, signed lower right
10 x 15⅝ in. (25.4 x 39.7 cm)
San Francisco Museum of Modern Art, bequest of
Elise S. Haas
Plates 153, 374

Provenance
Michael and Sarah Stein, Paris and Palo Alto (owned
jointly by 1914 [pl. 374], until 1938; thereafter, Sarah
Stein, Palo Alto); Mr. and Mrs. Walter A. Haas, San
Francisco (by at least 1952[1] until 1979; thereafter, Elise
S. Haas until 1990); San Francisco Museum of Modern
Art (bequest of Elise S. Haas, 1991)

Notes
1. San Francisco 1952, no. 37 (as "Three Girls," lent by
Mr. and Mrs. Walter A. Haas, San Francisco). +28

166. *Madame Matisse Pinning Her Hat,* ca. 1906
Ink on paper
11⅝ x 7⅝ in. (29.5 x 19.4 cm)
Yale Collection of American Literature, Beinecke
Rare Book and Manuscript Library, Yale University,
New Haven

Provenance
Gertrude Stein, Paris (in or after 1906[1]); Yale
Collection of American Literature, Beinecke Rare
Book and Manuscript Library, Yale University

Notes
1. "Matisse, as a gesture of friendship, made a drawing
of his wife in this typical act and presented it to
Gertrude" (Mellow 1974, 9). From *The Autiobiography of
Alice B. Toklas*: "Gertrude Stein always liked the way
she [Madame Matisse] pinned her hat to her head and
Matisse once made a drawing of his wife making this
characteristic gesture and gave it to Miss Stein.... She
always placed a large black hat-pin well in the middle
of the hat and the middle of the top of her head and
then with a large firm gesture, down it came" (G. Stein
1990, 36).

167. *Reclining Nude,* ca. 1906
Ink on paper, signed lower right
12¾ x 15½ in. (32.4 x 39.4 cm)
Anne and Stephen Rader, USA
Plates 146, 365

Provenance
Michael and Sarah Stein, Paris and Palo Alto (possibly
by April 1906,[1] and owned jointly until 1938; thereafter,
Sarah Stein, Palo Alto and San Francisco); Walter
Stein, Port Washington, New York (at least by 1970[2]
until November 1981[3]); John Berggruen Gallery,
San Francisco; Clarence J. Woodard (1982 until May
1998[4]); Anne and Stephen Rader, USA

Notes
1. The work was taken to San Francisco by Sarah and
Michael Stein in late April 1906. See Janet Bishop's
essay in this volume, 131-33. It also appears in photos
of rue Madame dating to ca. 1907-8 (pl. 365).
2. Potter 1970, pl. 14, 162. Likely one of the works that
Walter Stein purchased from the estate of Sarah
Stein. Walter Stein to Pierre Matisse Gallery, June 1,
1970, PMG Archives, MA 5020, box 120, folder 25.
3. Sold from his estate at auction for $2,200. Sales
catalogue, Sotheby's, New York, *Impressionist and
Modern Drawings and Watercolors*, November 6, 1981,
lot no. 515.
4. Sales catalogue, Christie's, New York, *Twentieth
Century Works on Paper*, May 13, 1998, lot no. 108. The
catalogue erroneously describes Walter Stein as
having received the drawing by descent from Michael
and Sarah Stein, but he was not a relative. It is not
known how he acquired the work.

168. *Seated Nude,* ca. 1906
Pastel and ink on vellum
29⅜ x 21½ in. (74.3 x 54.6 cm)
Collection Jan Krugier
Dauberville (1995) 181 (Bernheim-Jeune photo. no. 1434,[5]
October 1916)
Plates 148, 365, 369, 372, 377, 380

Provenance
Michael and Sarah Stein, Paris and Palo Alto (acquired
from the artist[1] by 1908 [pl. 365], and owned jointly
until at least 1937[2]); Mr. and Mrs. Tevis Jacobs, San
Francisco (gift of Sarah Stein by 1952,[3] until November
2000[4]); private collection

Notes
1. Diane Moore, daughter of Mr. and Mrs. Tevis
Jacobs, recounts that her parents were told that Sarah
acquired it from Matisse in exchange for a paisley
shawl that Sarah owned. Conversation with Janet
Bishop and Carrie Pilto, Davis, California, July 16, 2009.
2. Likely the work by Matisse listed as "Pastel," $1,000,
in the 1937 inventory of Michael and Sarah Stein's
collection. +7
3. San Francisco 1952, no. 26 (as lent by Mr. and Mrs.
Tevis Jacobs). +28
4. Sales catalogue, Sotheby's, New York, November 9,
2000 (Part I), lot no. 51.
5. An undated photograph of the work exists with the
reference on the verso: 1434. PMG Archives, MA 5020,
box 133.20.

169. *Woman Leaning on Her Elbow,* 1906-7
Ink on paper
10¼ x 8¼ in. (26 x 21 cm)
San Francisco Museum of Modern Art, bequest of
Elise S. Haas
Plate 147

Provenance
Michael and Sarah Stein, Paris and Palo Alto; Mr. and
Mrs. Walter A. Haas,[1] San Francisco (by at least 1952[2]
until 1979; thereafter Elise S. Haas until 1990); San
Francisco Museum of Modern Art (bequest of Elise S.
Haas, 1991)

Notes
1. The work is inscribed "To Elise from Sarah with
love." SFMOMA Permanent Collection Object File:
91.162.
2. San Francisco 1952, no. 33 (as lent by Mr. and Mrs.
Walter A. Haas, San Francisco). +28

170. *Studies of Allan Stein,* 1907
Brush and ink on paper
21½ x 17½ in. (54.6 x 44.5 cm)
Current location unknown

Provenance
Michael and Sarah Stein, Paris and Palo Alto (in or
after May 1907,[1] and probably owned jointly until 1938;
thereafter, probably Sarah Stein, Palo Alto and San
Francisco); Allan Stein, Paris (likely by gift or descent,
and owned until 1951; thereafter, Roubina Stein[2])

Notes
1. Likely the drawing inscribed: "A Allan Stein en sou-
venir de les onze ans affectueusement mai 1907 Henri
Matisse." Potter 1970, 161.
2. Appears in an undated Sotheby's inventory of
Roubina Stein's collection. AMP, Information
communicated to Carrie Pilto, February 2008.

171. Sketch for Ceramic Design, ca. 1907
Graphite on paper
8⅞ x 6⅞ in. (22.5 x 17.5 cm)
San Francisco Museum of Modern Art, gift of Charles
Lindstrom

Provenance
Michael and Sarah Stein, Paris and Palo Alto (owned
jointly until 1938; thereafter, Sarah Stein, Palo Alto,
until April 1941[1]); Charles Lindstrom (acquired 1941,[1]
until 1962); San Francisco Museum of Modern Art (gift
of Charles Lindstrom, 1962)

Notes
1. Given to Charles Lindstrom by Sarah Stein in 1941
accompanied by a letter dated April 4. SFMOMA
Permanent Collection Object File: 62.429.

172. *Pig,* ca. 1908
Pencil on paper
8 x 12 in. (20 x 51 cm), estimated size
Current location unknown

Provenance

Michael and Sarah Stein, Paris[1]; Allan Stein (until 1951; thereafter, Roubina Stein until at least 1970[1,2])

Notes

1. Potter 1970, 162.
2. Appears in an undated Sotheby's inventory of Roubina Stein's collection. AMP, information communicated to Carrie Pilto, February 2008.

173. **Postcard with a sketch of** *The Painter's Family,* 1911

Pen and brown ink on paper
3⁹⁄₁₆ x 5½ in. (9 x 14 cm)
National Gallery of Art, Washington, D.C., Collection of Mr. and Mrs. Paul Mellon

Provenance

Michael and Sarah Stein, Paris and Palo Alto (owned jointly until 1938; thereafter, Sarah Stein, Palo Alto); John W. Dodds, Stanford, California (by 1976[1]); Mr. and Mrs. Paul Mellon, Upperville, Virginia; National Gallery of Art, Washington, D.C. (1995)

Notes

1. Sale, Sotheby Parke-Bernet, New York, October 21, 1976, lot no. 162, bought in.

174. *Untitled,* 1913

Ink on paper, signed, dated, with a dedication to Sarah Stein
11 x 8 in. (27.9 x 20.3 cm)
Current location unknown
Dauberville (1995) 140 (Bernheim-Jeune photo. no. 1425⁴, October 1916)

Provenance

[Michael and] Sarah Stein, Paris (1913[1] until 1938; thereafter, Sarah Stein, Palo Alto); Dr. Alvin C. Eurich, New York (by 1962[2] until at least 1970[3])[4]

Notes

1. The work bears an inscription: "à MMe M. Stein/Cordialement/Henri Matisse/1913."
2. San Francisco 1962. +28
3. Potter 1970, 163.
4. An undated photograph of the work exists with the reference on the verso: 1425. PMG Archives, MA 5020, box 133.26.

175. *Study of Sarah Stein,* 1916

Graphite on paper, signed and dated, with a dedication to Sarah Stein
19⅛ x 12⅝ in. (48.6 x 32.1 cm)
San Francisco Museum of Modern Art, gift of Mr. and Mrs. Walter A. Haas
Dauberville (1995) 182 (Bernheim-Jeune photo. no. 1530, November 1916)
Plate 164

Provenance

Michael and Sarah Stein, Paris and Palo Alto (1916[1] and owned jointly until 1938; thereafter Sarah Stein, Palo Alto, until probably September 1953[2]); Mr. and Mrs. Walter Haas, San Francisco (until 1962[3]); San Francisco Museum of Modern Art (gift of Mr. and Mrs. Walter A. Haas, 1962)[4]

Notes

1. The work bears the inscription: "a Mad.e Michel Stein/hommage respectueux/Henri Matisse 1916."
2. In a December 1951 letter, Fiske Kimball writes about sales from the collection of Sarah Stein: "She has left only two Matisse oils, the portraits of Mike and of herself, which I published in our Bulletin (both now taken to the bank for safekeeping), and a big drawing of herself by Matisse, with dedication, 1906 [sic], beside a few lithographs." Fiske Kimball to R. Sturgis Ingersoll, December 11, 1951, PMA Kimball Papers. The only remaining Matisse drawing to fit the above description is the 1916 portrait of Sarah Stein; the erroneous date is apparently a typographical error.
3. A "Pencil Sketch of Sarah Stein" was in the collection of Sarah Stein in 1952. Dr. Grace Morley to Wells Fargo Bank and Union Trust Co., September 9, 1952, SFMOMA Archives, Collector and Donor Correspondence, Office of the Director Records 1935–1958.
4. George D. Culler, director of SFMA from 1961 to 1965, to Pierre Matisse, July 19, 1962, PMG Archives, MA 5020, box 77, folder 16.

176. **Untitled portrait of woman; verso, subject unknown,** ca. 1918

Ink on paper [on recto and verso]
14½ x 10¼ in. (36.8 x 26 cm)
Current location unknown

Provenance

Michael and Sarah Stein, Paris and Palo Alto (owned jointly until 1938; thereafter, Sarah Stein, Palo Alto); Mrs. Rose Rabow, San Francisco (at least by 1962[1])

Notes

1. San Francisco 1962. +28

177. *Mrs. Allan Stein (Yvonne Daunt),* 1924

Current location unknown

Provenance

Yvonne Daunt (Mrs. Allan Stein, later Mrs. Carleton Graves), Paris and San Francisco (1924[1]); George Block, San Francisco (probably until at least November 1976[2]); Mr. and Mrs. Lionel Steinberg (Mrs. Katrina Heinrich-Steinberg), Palm Springs (until 1999[3])

Notes

1. The work is inscribed: "A Made Yv. Daunt-Stein/respectueusement/Henri-Matisse 1924." Carrie Pilto, e-mail message to author, March 3, 2011.
2. "Mrs. [Walter A.] Haas called to report that Mr. George Bloc[k] [husband of Jacqueline Colaço-Osorio] …showed her a Matisse charcoal sketch Portrait of Yvonne [Daunt Stein] for possible purchase." Mike [McCone] to Henry [Hopkins], November 18, 1976, Elise S. Haas Papers, SFMOMA Archives.
3. Reported to have disappeared or been stolen at the time of Lionel Steinberg's death in 1999. Katrina Heinrich-Steinberg, e-mail message to Carrie Pilto, April 15, 2010.

178. *Mrs. Allan Stein (Yvonne Daunt),* 1924

Charcoal on paper
25 x 19 in. (63.5 x 48.3 cm)
Trina and Billy Steinberg, Los Angeles
Plate 163

Provenance

[Allan Stein and] Yvonne Daunt Stein (later Mrs. Carleton Graves), Paris and San Francisco (1924[1]); Daniel Michael Stein (by inheritance from the above in 1963[2]); Mr. and Mrs. Lionel Steinberg, Palm Springs (by 1970[3]); Trina and Billy Steinberg, Los Angeles

Notes

1. The work bears the following inscription: "aux epoux Allan Stein Daunt/souvenir amical/Henri Matisse 24."
2. Estate of Yvonne I. R. Graves, San Francisco. Distributee's receipt per terms of decree, March 19, 1963.
3. Potter 1970, 163.

179. *Pensive Nude in Folding Chair,* 1906

Lithograph
17¹¹⁄₁₆ x 11 in. (45 x 28 cm)
The Museum of Modern Art, New York, given anonymously in memory of Leo and Nina Stein
Plate 349

Provenance

Leo and Gertrude Stein, Paris (before April 1908 [pl. 349] and probably owned jointly until 1913/1914); Museum of Modern Art, New York (acquired by gift, 1950)

180. *Harbor at Collioure,* 1907

Lithograph
7⅞ x 10⁹⁄₁₆ in. (20 x 26.8 cm)
The Museum of Modern Art, New York, given in memory of Leo and Nina Stein

Provenance

[Leo and] Gertrude Stein, Paris[1] (in or after 1907 and probably owned until at least 1913/1914); Museum of Modern Art, New York (acquired by gift, 1950[2])

Notes

1. Inscribed "hommage à Mademoiselle Stein/Henri-Matisse." Potter 1970, 160.
2. Ibid.

181. *Black Eyes,* 1913

Transfer lithograph
19¹¹⁄₁₆ x 12¹⁵⁄₁₆ in. (50 x 32.9 cm)
The Museum of Modern Art, New York, gift of Mrs. Saidie A. May

Provenance

Michael and Sarah Stein, Paris and Palo Alto[1]; Museum of Modern Art (gift of Mrs. Saidie A. May, 1932)

Notes

1. Potter 1970, 163.

182. *Head of a Girl,* 1913
Lithograph, signed lower right: Henri Matisse
19³⁄₁₆ x 13 in. (50.3 x 33 cm)
Iris & B. Gerald Cantor Center for Visual Arts at Stanford University, gift of Mrs. Michael Stein, 1953
Duthuit-Matisse and Duthuit 413

Provenance
Michael and Sarah Stein, Paris and Palo Alto (probably owned jointly until 1938; thereafter, Sarah Stein, Palo Alto, until 1953); Iris & B. Gerald Cantor Center for Visual Arts at Stanford University (gift of Mrs. Michael Stein, 1953)[1]

Notes
1. +29

183. *Irène Vignier,* 1914
Monotype
6¹⁄₈ x 2¼ in. (15.6 x 5.7 cm)
Trina and Billy Steinberg, Los Angeles
Duthuit-Matisse and Duthuit 335

Provenance
Michael and Sarah Stein, Paris and Palo Alto[1]; Mr. and Mrs. Lionel Steinberg, Palm Springs (by 1970[2]); Trina and Billy Steinberg, Los Angeles

Notes
1. Potter 1970, 163.
2. Ibid.

184. *The Yellow Dress with the Black Ribbon,* 1922
Lithograph
21¾ x 14¹⁄₈ in. (55.2 x 35.9 cm)
Iris & B. Gerald Cantor Center for Visual Arts at Stanford University, gift of Mrs. Michael Stein, 1953
Duthuit-Matisse and Duthuit 424

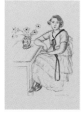

Provenance
Michael and Sarah Stein, Paris and Palo Alto (probably owned jointly until 1938; thereafter, Sarah Stein, Palo Alto, until 1953); Iris & B. Gerald Cantor Center for Visual Arts at Stanford University (gift of Mrs. Michael Stein, 1953)[1]

Notes
1. +29

185. *Girl Seated at a Table with Vase of Flowers,* 1923
Lithograph
11⁹⁄₁₆ x 14¼ in. (29.4 x 36.2 cm)
Iris & B. Gerald Cantor Center for Visual Arts at Stanford University, gift of Mrs. Michael Stein, 1953
Duthuit-Matisse and Duthuit 439
Plate 167

Provenance
Michael and Sarah Stein, Paris and Palo Alto (probably owned jointly until 1938; thereafter, Sarah Stein, Palo Alto, until 1953); Iris & B. Gerald Cantor Center for Visual Arts at Stanford University (gift of Mrs. Michael Stein, 1953)[1]

Notes
1. +29

186. *Girl with an Organdy Collar, No. 2,* 1923
Lithograph
13½ x 10¹⁄₈ in. (34.3 x 25.7 cm)
Iris & B. Gerald Cantor Center for Visual Arts at Stanford University, gift of Mrs. Michael Stein, 1953
Duthuit-Matisse and Duthuit 429
Plate 168

Provenance
Michael and Sarah Stein, Paris and Palo Alto (probably owned jointly until 1938; thereafter, Sarah Stein, Palo Alto until 1953); Iris & B. Gerald Cantor Center for Visual Arts at Stanford University (gift of Mrs. Michael Stein, 1953)[1]

Notes
1. +29

187. *Little Aurore,* 1923
Lithograph
10¼ x 12¼ in. (26 x 31.1 cm)
Stanley Steinberg, San Francisco
Plate 172

Provenance
Michael and Sarah Stein, Paris and Palo Alto (probably owned jointly until 1938; thereafter, Sarah Stein, Palo Alto, until mid-1940s); Stanley Steinberg (mid-1940s)[1]

Notes
1. Stanley Steinberg (2010) recalls that he and Sarah Stein first met in summer 1942, and that their visits continued for five years. +29

188. *Woman Reading,* 1923
Lithograph
25¼ x 19¾ in. (64.1 x 50.2 cm)
Mills College Art Museum, gift of Mrs. Michael Stein, 1945
Duthuit-Matisse and Duthuit 437
Plate 169

Provenance
Michael and Sarah Stein,[1,2] Paris and Palo Alto (probably owned jointly until 1938; thereafter, Sarah Stein, Palo Alto, until 1945); Mills College Art Museum (gift of Mrs. Michael Stein, 1945)[3]

Notes
1. Inscribed in Matisse's hand on recto (under sig. lower right): "à Madame Michael Stein." Stacie Daniels, e-mail message to Amanda Glesmann, March 3, 2011.
2. Probably one of six lithographs listed among the dozen works noted as being lent by Mr. and Mrs. Michael Stein to *Modern Art: Eighty-Fifth Anniversary Exhibition* at Mills College (Oakland 1937); the present work is likely no. 49 ("Girl reading, 1922–1923, Lithograph, 21 x 15½ inches, Collection Mr. and Mrs. Michael Stein").
3. +29

189. *Nude with Blue Cushion,* 1924
Lithograph
29¼ x 21⁷⁄₈ in. (74.3 x 55.5 cm)
Iris & B. Gerald Cantor Center for Visual Arts at Stanford University, gift of Mrs. Michael Stein, 1953
Duthuit-Matisse and Duthuit 442
Plate 175

Provenance
Michael and Sarah Stein, Paris and Palo Alto (probably owned jointly until 1938; thereafter, Sarah Stein, Palo Alto, until 1953); Iris & B. Gerald Cantor Center for Visual Arts at Stanford University (gift of Mrs. Michael Stein, 1953)[1]

Notes
1. +29

190. *Odalisque in Striped Pantaloons,* 1925
Lithograph
24¾ x 19¾ in. (62.9 x 50.2 cm)
Mills College Art Museum, gift of Mrs. Michael Stein, 1945
Duthuit-Matisse and Duthuit 455
Plate 173

Provenance
Michael and Sarah Stein, Paris and Palo Alto (probably owned jointly until 1938; thereafter, Sarah Stein, Palo Alto, until 1945); Mills College Art Museum (gift of Mrs. Michael Stein, 1945)[1]

Notes
1. +29

191. *Reclining Odalisque (with Red Satin Culottes),* 1925
Lithograph
11¹⁄₁₆ x 13¹³⁄₁₆ in. (28.1 x 35.8 cm)
Iris & B. Gerald Cantor Center for Visual Arts at Stanford University, gift of Mrs. Michael Stein, 1953
Duthuit-Matisse and Duthuit 456
Plate 171

Provenance
Michael and Sarah Stein, Paris and Palo Alto (probably owned jointly until 1938; thereafter, Sarah Stein, Palo Alto, until 1953); Iris & B. Gerald Cantor Center for Visual Arts at Stanford University (gift of Mrs. Michael Stein, 1953)[1]

Notes
1. +29

192. *Seated Nude with Tulle Jacket,* 1925
Lithograph
19⅟₁₆ x 14⁷⁄₁₆ in. (48.1 x 37.4 cm)
Iris & B. Gerald Cantor Center for Visual Arts at Stanford University, gift of Mrs. Michael Stein, 1953
Duthuit-Matisse and Duthuit 465
Plate 174

Provenance

Michael and Sarah Stein, Paris and Palo Alto (probably owned jointly until 1938; thereafter, Sarah Stein, Palo Alto, until 1953); Iris & B. Gerald Cantor Center for Visual Arts at Stanford University (gift of Mrs. Michael Stein, 1953)[1]

Notes

1. +29

193. *Woman Leaning on Her Elbow,* 1925
Etching
10⅜ x 8¾ in.
San Francisco Museum of Modern Art, gift of Mr. and Mrs. Michael Stein

Provenance

Michael and Sarah Stein, Paris and Palo Alto, until 1937; San Francisco Museum of Modern Art (gift of Mrs. Michael Stein, 1937)[1]

Notes

1. One of two Matisse etchings received from Michael and Sarah Stein, December 13, 1937, per San Francisco Museum of Art receipt, SFMOMA Permanent Collection Object File.

194. Illustrations for Stéphane Mallarmé's *Poésies,*
1932
Illustrated book with twenty-nine etchings, signed and dedicated (numbered V)
Current location unknown

Provenance

Michael and Sarah Stein, Paris (acquired February 1933,[1] until at least February 1947[2])

Notes

1. Sarah Stein to Henri Matisse, February 8, 1933, in which Sarah thanks Matisse for the "ensemble of illustrations for Mallarmé's poems," AMP.
2. Following a 1947 visit with Sarah Stein, Fiske Kimball wrote, "She has…the volume of Mallarmé illustrated by apposite drawings already existing, which he [Matisse] asked her to select with him, & which is a '*collaborator's* copy,' # V, signed and dedicated." +9

195. *Fairy in a Luminous Hat, Souvenir of Mallarmé,*
1933
Etching
22¹³⁄₁₆ x 15¾ in. (58 x 40 cm), signed lower right, inscribed lower left[1]
San Francisco Museum of Modern Art, bequest of Elise S. Haas
Duthuit-Matisse and Duthuit 234

Provenance

Michael and Sarah Stein, Paris and Palo Alto (owned jointly until 1938; thereafter, Sarah Stein, Palo Alto); Mr. and Mrs. Walter A. Haas, San Francisco (by at least 1952[2] until 1979; thereafter, Elise S. Haas until 1991); San Francisco Museum of Modern Art (bequest of Elise S. Haas, 1991)

Notes

1. Inscription in Matisse's hand, lower left, recto: "à Sarah & Michel [Michael] Stein / affectueusement"; signed lower right: "Henri Matisse / Etat."
2. San Francisco 1952, no. 62 (as "Lent by Mr. and Mrs. Walter A. Haas, San Francisco"). +28

196. *Jazz,* 1947
Twenty hand-printed colored stencils with text on paper
16⅝ x 25⅝ in. (42.2 x 65.1 cm)
Department of Special Collections, Stanford University Libraries

Provenance

Sarah Stein, Palo Alto and San Francisco (gift of the artist, 1948[1]); Department of Special Collections, Stanford University Libraries[2]

Notes

1. Inscribed on half-title "a Madame Sarah Stein, hommage respecteuesement affectueux, Henri Matisse, Fev. 48."
2. Acquired for Stanford University Libraries, date unknown.

SCULPTURE

197A and 197B. *Madeleine I,* 1901 (cast ca. 1925[1])
Bronze
21½ x 7⅝ in. (54.6 x 17.2 cm)
Dr. Stanley Steinberg, San Francisco
Duthuit and de Guébriant 8
197A: Plaster version: plates 365, 369, 372
197B: Bronze version: plates 124, 381
[See pl. 134 for an example not owned by the Steins]

Provenance

Michael and Sarah Stein, Paris and Palo Alto (bronze acquired in or after 1925[1,2] and owned jointly until at least 1937[3]; thereafter, Sarah Stein, Palo Alto); Dr. Stanley Steinberg, San Francisco[1]

Notes

1. Duthuit and de Guébriant 1997, no. 8: "Epreuve no. 1. Fonte Valsuani, vers 1925. Patine brune. Signée et numérotée Henri Matisse 1/10 sur le devant de la terrasse, à droite. Cachet *Cire—C. Valsuani—perdue.*"
2. Michael and Sarah Stein owned a plaster [pls. 365, 369, 372] and a bronze [pls. 124, 381] version of this statue. The plaster version was acquired in or after 1907.
3. Surely the work by Matisse listed as "Madeleine" and valued at $2,000 in the 1937 inventory of Michael and Sarah Stein's collection. +7

198. *The Serf,* 1900-1903 (cast ca. 1908[4])
Bronze
36 x 12 x 13½ in. (91.5 x 30.5 x 34.3 cm)
The Art Institute of Chicago, Edward E. Ayer Endowment in memory of Charles L. Hutchinson, 1949.202
Duthuit and de Guébriant 6
Plates 370, 371, 373-77
[See pl. 58 for an example not owned by the Steins]

Provenance

Michael and Sarah Stein, Paris and Palo Alto (in or after 1908 and owned jointly [pls. 370-71, 373-77] until 1938; thereafter, Sarah Stein, Palo Alto, until at least February 1947[1]); Stendahl Gallery, Los Angeles[2]; Art Institute of Chicago (acquired 1949[3])[4]

Notes

1. Following a 1947 visit with Sarah Stein, Fiske Kimball wrote: "There is very much sculpture, the full length *Slave,* somewhat smaller than life—the first cast." +9
2. According to Stendahl Galleries records, the work was purchased from Michael Stein for $1,500. April Dammann, e-mail message to Carrie Pilto, May 10, 2010.
3. "Chicago will buy the Slave (1st bronze) for $2500—a price which Stendahl already regrets quoting them." Kimball to Ingersoll, +23
4. Duthuit and de Guébriant 1997, no. 6: "Epreuve no. 1. Fonte Bingen et Costenoble, vers 1908. Patine brune. Inscription Le Serf à l'avant, dans l'épaisseur de la terrasse. Signée et numérotée *Henri Matisse 1/10* sur la terrasse, derrière le pied gauche. Cachet *A. Bingen & Costenoble* fondeurs, Paris à l'arrière droit, dans l'épaisseur de la terrasse."

199. *The Serf,* 1900-1903 (cast 1908[1])
Bronze
36⅛ x 11¼ x 13¹⁄₁₆ in. (91.8 x 28.6 x 33.2 cm)
The Baltimore Museum of Art: The Cone Collection, formed by Dr. Claribel and Miss Etta Cone of Baltimore, Maryland
Duthuit and de Guébriant 6
[See pl. 58 for an example not owned by the Steins]

Provenance

Leo Stein, Paris (purchased from the artist September 30, 1908,[1] and owned until 1931); Etta Cone,[2] Baltimore (acquired 1931); Baltimore Museum of Art[1]

Notes

1. Duthuit and de Guébriant 1997, no. 6: "Epreuve no. 2. Fonte Bingen et Costenoble, 1908. Patine brune. Inscription *Le Serf* à l'avant, dans l'épaisseur de la terrasse. Signée et numérotée *Henri Matisse 2/10* sur la terrasse, derrière le pied gauche. Pas de cachet de fondeur." The sculpture is depicted in a photograph of the atelier rue de Fleurus dated between March 1912 and March 1914, Department of Nineteenth-Century, Modern, and Contemporary Art, The Metropolitan Museum of Art, New York, gift of Edward Burns, 2011.
2. Before the present work was acquired by Etta Cone, her sister Claribel had seen another version in the Parisian gallery of Paul Guillaume. In a notebook entry dated June 29, 1925, Claribel notes: "I saw one example of Matisse's Serf for which they asked $1750." BMA Cone Papers.

200. *Head of a Child (Pierre Matisse),* 1904-5
Bronze
6⁷⁄₁₆ x 4⁵⁄₁₆ x 4⅝ in. (16.4 x 11 x 11.8 cm)
Current location unknown
Duthuit and de Guébriant 16[3]
Plates 375, 376, 378

Provenance

Michael and Sarah Stein, Paris and Palo Alto (owned jointly [pls. 375, 376, 378] until 1938; thereafter, Sarah Stein, Palo Alto, until[1] at least 1952[2]); current location unknown

Notes

1. In Fiske Kimball's remarks about the Matisse sculptures that he saw in the collection of Sarah Stein during a 1947 visit, he mentions "several heads, including one of Pierre Matisse as a boy," the present example. +9

2. A "small bronze of Pierre Matisse" was in the collection of Sarah Stein in 1952. Dr. Grace Morley to Wells Fargo Bank and Union Trust Co., September 9, 1952, Collector and Donor Correspondence, Office of the Director Records 1935–1958, SFMOMA Archives. The cast is not identified in the Matisse sculpture catalogue raisonné (Duthuit and de Guébriant 1997).

3. Etta and Claribel Cone owned two versions of this sculpture (épreuve no. 5, Fonte Costenoble, Patinebrun foncé, ca. 1912; épreuve no. 6, Fonte Godard, 1922). It has been suggested that the sisters purchased the two sculptures using the "Steins" as intermediaries (Duthuit and de Guébriant 1997, no. 16). John Richardson (1992, 173, 182) posits that the Cones bought both works from the artist, one in summer 1922 and another in perhaps autumn 1929.

201. *Woman Leaning on Her Hands,* 1905 (cast ca. 1908[1])
Bronze
4⅞ x 9⅜ x 6⅜ in. (12.4 x 23.8 x 16.2 cm)
The Norton Simon Museum of Art, Los Angeles
Duthuit and de Guébriant 17
Plates 124, 378

Provenance
Michael and Sarah Stein, Paris and Palo Alto (acquired in 1908[1] and owned jointly until at least 1928 [pls. 124, 378]); M. Knoedler & Co., New York; Mr. and Mrs. Norton Simon, Los Angeles (from 1955); Norton Simon Museum of Art[2]

Notes
1. A version of this sculpture, perhaps the same, appears in the rue de Fleurus atelier of Leo and Gertrude in an archival photograph dated ca. 1909–14, Department of Nineteenth-Century, Modern, and Contemporary Art, The Metropolitan Museum of Art, New York, gift of Edward Burns, 2011.
2. Duthuit and de Guébriant 1997, no. 17: "Epreuve no. 0. Fonte Bingen et Costenoble, vers 1908. Signée *HM* sur la cuisse gauche, non numérotée. Pas de cachet de fondeur."

202. *Head of a Young Girl (Marguerite),* 1906 (cast 1929[1])
Bronze
6¼ in. (15.88 cm) high
Duthuit and de Guébriant 25
Private collection

Provenance
Miss Etta Cone, Baltimore (purchased in October 1929[2]); Michael and Sarah Stein, Paris and Palo Alto (received after October 1929[2,3] and owned jointly until 1938; thereafter, Sarah Stein, Palo Alto, probably until at least February 1947[4]); Mr. and Mrs. Tevis Jacobs, San Francisco[1]; private collection

Notes
1. Duthuit and de Guébriant 1997, no. 25, 62–65: "Epreuve no. 6. Fonte Valsuani, 1929. Patine brune. Signée H. Matisse et numérotée 8 en bas à gauche, dans la chevelure. Cachet Cire-C. Valsuani—perdue à l'arrière, sur omoplate gauche."
2. Etta Cone purchased two versions of this sculpture in October 1929: épreuve no. 5 (Fonte Valsuani, 1929. Patine foncée) and épreuve no. 6 (Fonte Valsuani, 1929. Patine brune); she sent épreuve no. 6 to Sarah Stein as a gift. J. Richardson 1992, 182.

3. The version of *Head of a Young Girl (Marguerite)* exhibited in New York 1970 was épreuve no. 5 (now in the Baltimore Museum of Art, The Cone Collection), and therefore does not have a Stein provenance. See Potter 1970, 160.
4. In Fiske Kimball's remarks about the Matisse sculptures that he saw in the collection of Sarah Stein during a 1947 visit, he mentions "several heads," one of which is probably the present work. +9

203. *Small Head with Upswept Hair,* 1906–7 (cast ca. 1930[2])
Bronze
3⅞ in. (9.8 cm) high
Current location unknown
Duthuit and de Guébriant 28

Provenance
Michael and Sarah Stein, Paris and Palo Alto (owned jointly until 1938; thereafter, Sarah Stein, Palo Alto, probably until at least February 1947[1]); Dr. and Mrs. Harry Bakwin, New York (ca. 1970); Ruth Bakwin, New York; private collection[2]

Notes
1. In Fiske Kimball's remarks about the Matisse sculptures that he saw in the collection of Sarah Stein during a 1947 visit, he mentions "several heads," one of which is probably the present work. +9
2. Duthuit and de Guébriant 1997, no. 28: "Fonte Valsuani, vers 1930. Signée et numérotée *HM 5/10.* Pas de cachet de fondeur."

204A and 204B. *Reclining Nude I (Aurora),*[4]
1907 (cast ca. 1908[3])
Bronze
13⁹⁄₁₆ x 19⅝ x 11 in. (34.4 x 49.9 x 27.9 cm)
Current location unknown
Duthuit and de Guébriant 30
204A: Plaster version: plate 368
204B: Bronze version: plates 123, 370, 371, 373
[See pl. 150 for a bronze example not owned by the Steins]

Provenance
Michael and Sarah Stein, Paris and Palo Alto (owned jointly[1] [pls. 123, 370, 371, 373] until 1938; thereafter, Sarah Stein, Palo Alto, until sold December 1951[2]); Ruth Haas Lilienthal, California; Mr. and Mrs. Philip N. Lilienthal, Atherton, California[3]

Notes
1. Michael and Sarah's cast (épreuve no. 2), last known in the Lilienthal collection. Thought to be "Aurora, bronze, 5525" among the loans by Michael and Sarah Stein to San Francisco 1936. Sarah Stein to Henri Matisse, January 7, 1936, AMP and SFMOMA Archives (see +28).
2. In a December 1951 letter, Fiske Kimball writes about sales from the collection of Sarah Stein: "I talked to…the executor, Tevis Jacobs, a nice guy whom I was able to help with some advice…a friend of his had just been offered Mrs. Stein's bronze (of course the first cast) of Matisse's reclining nude, more than half life size, for $3900. I said, 'Grab it'… so he did." Kimball to R. Sturgis Ingersoll, December 11, 1951, PMA Kimball Papers. Although the present work is not the first cast, it is the only remaining Matisse sculpture in her collection matching this description.

3. Duthuit and de Guébriant 1997, no. 30: "Epreuve no. 2. Fonte Bingen-Costenoble, vers 1908. Patine brune (traces d'oxydation). Signée et numérotée *Henri Matisse 2/10,* à l'arrière sur la terrasse. Cachet *Bingen & Costenoble Fondeurs, Paris* à l'arrière dans l'épaisseur de la terrasse."
4. A plaster or terracotta example (Duthuit and de Guébriant 1997, no. 29) appears at rue Madame in an archival photograph that dates after November 1907 and before May 1908 (pl. 367). The present location of this version is unknown.

205. *Small Head with Comb,* 1907 (cast ca. 1907)[3]
Bronze
3¼ in. (8.3 cm) high
Current location unknown
Duthuit and de Guébriant 33[4]
Plates 124, 367

Provenance
Michael and Sarah Stein, Paris and Palo Alto (by winter 1908 [pl. 367], and owned jointly [pl. 124] until 1938; thereafter, Sarah Stein, Palo Alto and San Francisco,[1] until probably 1953[2]); Walter Stein, Port Washington, New York (probably acquired after 1953[2])[3]

Notes
1. In Fiske Kimball's remarks about the Matisse sculptures that he saw in the collection of Sarah Stein during a 1947 visit, he mentions "several heads," one of which is probably the present work. +9
2. Likely one of the works that Walter Stein purchased from the estate of Sarah Stein. Walter Stein to Pierre Matisse Gallery, June 1, 1970, PMG Archives, MA 5020, box 120, folder 25.
3. Duthuit and de Guébriant 1997, no. 33: "Epreuve no. 2. Fonte Bingen et Costenoble, vers 1907. Patine dorée. Pas de cachet de fondeur."
4. The Cone sisters owned two versions ("Epreuve no. 6. Fonte Godard, 1922. Patine brun foncé; Epreuve no. 7. Fonte Godard, 1922. Patine brun très foncé") of this sculpture, at least one purchased in summer 1922 (J. Richardson 1992, 173). Michael and Sarah Stein's friend Madame de Monzie owned an example that she acquired in 1926 ("Epreuve no. 8. Fonte Godard, 1922. Patine foncée").

206. *Small Crouching Nude without an Arm,* 1908 (cast ca. 1908[2])
Bronze
4¾ in. (12 cm) high
Private collection
Duthuit and de Guébriant 38[5]
Plate 367

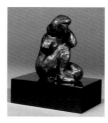

Provenance
Michael and Sarah Stein, Paris[1] and Palo Alto (by winter 1908 [pl. 367], and owned jointly[3] until 1938; thereafter, Sarah Stein, Palo Alto, until 1953); Daniel Stein, Palo Alto (by descent); Mr. and Mrs. Lionel Steinberg, Palm Springs, and by descent (until November 1986)[4]; Waddington Galleries, London; private collection[2]

Notes

1. Margaret Potter (1970, 163 [ill.]) cites a story told by Sarah Stein in which the plaster for the present object suffered losses.

2. Duthuit and de Guébriant 1997, no. 38, épreuve no. 1. A bronze version of the sculpture appears in a photograph of rue Madame (pl. 367), securely dated to winter 1907–8.

3. A version of this sculpture, perhaps the same cast, appears in the rue de Fleurus atelier of Leo and Gertrude in a vintage photograph dated ca. 1909–14, Department of Nineteenth-Century, Modern, and Contemporary Art, The Metropolitan Museum of Art, New York, gift of Edward Burns, 2011.

4. Sold, Sotheby's, New York, November 19, 1986, lot no. 123.

5. Etta and Claribel Cone purchased two versions ("Epreuve no. 6, Fonte Godard, 1922; Epreuve no. 7, Fonte Godard") of this sculpture from the artist, at least one in summer 1922. J. Richardson 1992, 173.

207. *Study of a Foot*, ca. 1909
Painted plaster[1]
13½ in. (34.3 cm) high
Dr. and Mrs. Maurice Galanté
Duthuit and de Guébriant 43[1]
Plate 149

Provenance

Michael and Sarah Stein, Paris and Palo Alto (likely a gift from the artist,[1] and owned jointly until 1938; thereafter, Sarah Stein, Palo Alto, until 1948); Maurice Galanté (acquired 1948)[2]

Notes

1. Previously unknown plaster cast, associated with Duthuit and de Guébriant 1997, no. 43, probably painted to resemble bronze. Wanda de Guébriant, e-mail message to Carrie Pilto, August 26, 2010.

2. Provenance and acquisition date based on information provided by current owner to Carrie Pilto.

208. *Figure with Cushion*, 1918 (cast ca. 1925[1])
Bronze
5⅛ in. (13 cm) high
Rosenbach Museum and Library, Philadelphia
Duthuit and de Guébriant 62[2]

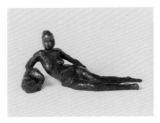

Provenance

Michael and Sarah Stein, Paris (owned jointly until 1928); Philip H. Rosenbach, Philadelphia (acquired in 1928); Rosenbach Museum & Library[1]

Notes

1. Duthuit and de Guébriant 1997, no. 62: "Epreuve no. 3. Fonte Valsuani, vers 1925. Signée et numérotée Henri Matisse *3/10* à l'extérieur du polochon, vers l'arrière. Cachet *Cire—C. Valsuani—perdue* sur le polochon."

2. The Cone sisters owned two versions ("Epreuve no. 1. Fonte Valsuani, vers 1925. Patine claire; Epreuve no. 2. Fonte Valsuani, vers 1925. Patine claire") of this sculpture, the latter purchased from the artist in 1925. Ibid.

OTHER

209. Painted ceramic tile (Dancing Faun or Dancing Nude), 1907
Glazed earthenware tile, signed lower left: "HM"
5 x 3¾ (12.7 x 9.5 cm)[3]
Current location unknown
Neff 1974, fig. 29

Provenance

Michael and Sarah Stein, Paris and Palo Alto (after spring 1907[1] until 1938; thereafter, Sarah Stein, Palo Alto, until early 1940s); John W. Dodds, Stanford, California (gift of Sarah Stein, early 1940s,[2] and owned until 1979[3])

Notes

1. John Hallmark Neff (1974, 46) dates the earliest Matisse ceramics to spring 1907 but concerning the present work states: "The freedom of this tile belies its early provenance, particularly when compared to… the tentative hatchings here identified with Matisse's earliest efforts in applying glaze."

2. Neff 1974, 220–21.

3. Presented at Sotheby's, New York, October 22, 1976, lot no. 320, and sold at Sotheby Parke-Bernet, New York, January 19, 1979, lot no. 36. According to both sales catalogues, the work was noted as a gift to the seller from Sarah Stein, who died in 1953, and as having been exhibited in San Francisco 1962.

210. Painted ceramic plate (with three nudes), ca. 1907
Current location unknown
Plates 368, 375, 381

Provenance

Michael and Sarah Stein, Paris and Palo Alto (after spring 1907[1] and by 1908 [pl. 368], and owned jointly [pl. 375] until 1938; thereafter, Sarah Stein, Palo Alto [pl. 381], probably until at least 1947[2]); perhaps Stendahl Gallery, Los Angeles (if so, before February 1949[3])

Notes

1. John Hallmark Neff (1974, 46) dates the earliest Matisse ceramics to spring 1907.

2. Following a 1947 visit with Sarah Stein, Fiske Kimball wrote: "She has also his ceramics, about 5 pieces, all, or almost all he ever made, fired for her" (+9). In fact, Neff (1974, appendix A) demonstrates the existence of many additional Matisse ceramics that had been previously unknown.

3. Perhaps one of the five ceramic pieces by Matisse that Earl Stendahl acquired from Sarah Stein and had sold by February 1949. +23

211. Painted ceramic vase, ca. 1907
Signed bottom perimeter: Henri Matisse, "M" in a circle, and "cE"
9⁷⁄₁₆ x 7⅞ in. (24 x 20 cm)
Trina and Billy Steinberg, Los Angeles
Plates 160, 379

Provenance

Michael and Sarah Stein, Paris and Palo Alto (owned jointly [pl. 379] until 1938; thereafter, Sarah Stein, Palo Alto, until 1949); Mr. and Mrs. Lionel Steinberg, Palm Springs (acquired in April 1949,[1,2] and owned jointly until 1999; thereafter, Trina and Billy Steinberg [by descent])

Notes

1. Provenance information established by Potter 1970, ill. plate 11, 161.

2. Presented as a wedding gift to Lionel and Louise Steinberg in 1949. The Steinbergs were married on April 10, 1949, and their wedding gift book lists entry no. 25: "Mrs. Sarah Stein, 433 Kingsley Rd., Palo Alto, Calif., Matisse-Vase." Photocopy of the above provided to author, June 2010.

212. Painted ceramic plate, ca. 1908
Signed on verso: Henri Matisse with "M" in circle
9¼ in. (23.5 cm) diameter
Philadelphia Museum of Art: purchased with Museum funds, 1949
Plate 159

Provenance

Michael and Sarah Stein, Paris and Palo Alto (owned jointly until 1938; thereafter, Sarah Stein, Palo Alto, probably until at least 1947[1]); Stendahl Gallery, Los Angeles (acquired before February 1949); Philadelphia Museum of Art (acquired by February 1949)[2]

Notes

1. Following a 1947 visit with Sarah Stein, Fiske Kimball wrote: "She has also his ceramics, about 5 pieces, all, or almost all he ever made, fired for her" (+9). In fact, Neff (1974, appendix A) demonstrates the existence of many additional Matisse ceramics that had been previously unknown.

2. One of the ceramic pieces by Matisse that Earl Stendahl acquired from Sarah Stein and had sold by February 1949. +23

CHARLES MERYON
French, born 1821, Paris; died 1868, Charenton-le-Pont, France

213. *The Morgue, Paris*, 1854
Etching and drypoint; state three of seven
8¾ x 7¹³⁄₁₆ in. (22.2 x 19.8 cm)
Current location unknown
Plate 349

Provenance

Leo and Gertrude Stein, Paris (by April 1908 [pl. 349])

ELIE NADELMAN
American, born 1882, Warsaw; died 1946, New York

WORKS ON PAPER

214. *Head of a Woman*, ca. 1906
Pen and ink on paper, signed lower right, "E. Nadelman"
11¾ x 7½ in. (29.9 x 19.1 cm)
Private collection, courtesy James Reinish & Associates, Inc.
Plates 63, 352

Provenance

Leo [and Gertrude] Stein, Paris (likely acquired April–May 1909,[1,2] until at least 1910[3] [pl. 352]); Gerard Boulad, Montreal (ca. 1978); Sotheby's, New York, September 23, 1981, lot no. 195; Forum Gallery, New York; Hirschl & Adler Galleries, New York; private collection, Massachusetts[4]

Notes

1. Paris 1909 (Galerie Druet) exhibition catalogue; also visible in archival photographs of the exhibition. Lincoln Kirstein Papers, *MGZEB 99 1221, Nadelman 2 folder, reprinted in Haskell 2003, 31.
2. Likely one of the Nadelman drawings exhibited in Paris 1909 that Leo Stein purchased. +30
3. Possibly one of the Nadelman drawings that Leo lent or returned to the artist in 1910 for possible reproduction in the 1914 portfolio *Vers l'unité plastique* (owners not cited). +30
4. Provenance subsequent to Stein ownership provided by Parrish & Reinish, Inc., e-mail message to Carrie Pilto, July 7, 2009.

SCULPTURE

215. *Standing Female Figure*, ca. 1907
Plaster[5]
Approx. 30 in. (76 cm) high
Current location unknown
Plate 351
[For related bronze, see plate 64]

Provenance

Leo [and Gertrude] Stein, Paris (acquired 1907 or later[1,2] and perhaps owned jointly [pl. 351] until 1913/1914); thereafter, Gertrude Stein, Paris (1913/1914[3] until ca. 1927[4])

Notes

1. Fernande Olivier to Alice Toklas, June 27, 1909, transcribed in Olivier 2001, 238. For quotation, see caption for plate 64 in this volume.
2. A larger plaster variation of the same standing nude was exhibited in Paris 1909 and appears in photographs of the exhibition; information about its provenance is unknown. Lincoln Kirstein Papers.
3. Haskell 2003, 42-43.
4. Gertrude Stein provided Nadelman with the plaster sculpture from which to make bronze casts. Beinecke YCAL, MSS 76, series II, box 117, folder 2500. The plaster version is thought to be lost (Spear 1973-74, 42n20).
5. Several bronze casts are known (Kirstein 1973, 294). The example at the Whitney (pl. 64) was a gift of the Elie Nadelman estate; the version at the Weatherspoon Art Museum was given by Anne and Benjamin Cone, 1972. It is not known whether any of the bronzes has a Stein provenance.

216. *Woman Raising Her Arms*, 1908-9
Plaster[4]
Approx. 56 in. (142.2 cm) high
Current location unknown

Provenance

Leo Stein, Paris (by April 1909[1,2] until at least March/April 1912[3])

Notes

1. Of the twenty-nine Nadelman plaster sculptures exhibited in Paris 1909, two were listed as being owned by Leo Stein, including the present work, no. 5 (as "Femme levant les bras").
2. An undated photograph by Druet of a plaster version may represent the Stein sculpture. Kirstein 1970, 18 (ill. k, as "Suppliant Woman, plaster for bronze; Photo Druet, Bronze, Coll. Nadelman Estate").
3. The work appears behind Michael Stein in a photograph of the rue de Fleurus atelier taken ca. 1912 (pl. 25).

4. A bronze cast (measuring 56½ x 18¾ x 31½ in. [143.5 x 47.6 x 80 cm)] from the Nadelman estate is illustrated in Haskell 2003, 32.

217. *Head*, before April 1909
Plaster

Provenance

Leo Stein, Paris (by April 1909[1])

Notes

1. One of two plaster sculptures exhibited in Paris 1909 that were listed as being owned by Leo Stein; the present work is no. 2 ("Tête"). The work appears with two other heads in the installation photograph of Paris 1909 (Haskell 2003, 31, fig. 18).

FRANCIS PICABIA
French, born 1879, Paris; died 1953, Paris

PAINTING

218. *Ida*, 1932
Oil on canvas
25⁹⁄₁₆ x 21⁵⁄₁₆ in. (65 x 54.2 cm)
Nahmad Collection

Provenance

Gertrude Stein, Paris (until 1946; thereafter, her estate until at least 1949[1,2]); [anonymous sale, Maître Laurin, Paris, 1957; Christie's, London, June 25, 2008, lot no. 542[3]]; Nahmad Collection

Notes

1. Paris 1949, no. 63 (one of two works [with no. 64: *Pa*] noted as "Gertrude Stein Collection").
2. One of six works by Picabia noted in a June 1951 account of the estate of Gertrude Stein. +31
3. Sales catalogue, Christie's, London, June 25, 2008, lot no. 542, cites only the 1957 sale; no other provenance information given.

219. *Pa*, 1932
Oil on canvas
25⁹⁄₁₆ x 21¼ in. (65 x 54 cm)
Mike Kelley, Los Angeles
Plates 249, 361

Provenance

Gertrude Stein, Paris (by March 1934 [pl. 361], until 1946; thereafter, her estate[1,2]); Gabrielle Stein Tyler, Pittsburgh; Concept Art Gallery, Pittsburgh; Michael Werner Gallery, New York and Cologne (2002)[3]; Patrick Painter Inc., Los Angeles (2008); Mike Kelley, Los Angeles

Notes

1. Paris 1949, no. 64 (one of two works [with no. 63: *Ida*] noted as "Gertrude Stein Collection").
2. The present work is perhaps *Two Heads*, one of six works by Picabia noted in a June 1951 account of the estate of Gertrude Stein. +31
3. Ownership information after 1946 provided by Justine Birbil, e-mail message to Carrie Pilto, March 23, 2011.

220. *Gertrude Stein*, 1933
Oil on canvas, signed lower right
45¾ x 23¾ in. (116.2 x 60.3 cm)
Yale Collection of American Literature, Beinecke Rare Book and Manuscript Library, Yale University, New Haven
Borràs 612
Plates 250, 361

Provenance

Gertrude Stein and Alice Toklas, Paris (by March 1934 [pl. 361], and probably owned jointly[1] until 1946[2]); Yale Collection of American Literature, Beinecke Rare Book and Manuscript Library, Yale University[2]

Notes

1. The artwork appears in prewar and postwar photographs by Cecil Beaton of Gertrude Stein standing in the hallway, or "gallery," of the apartment at 5 rue Christine. The Cecil Beaton Studio Archive at Sotheby's, London, and Department of Nineteenth-Century, Modern, and Contemporary Art, The Metropolitan Museum of Art, New York, gift of Edward Burns, 2011.
2. Gift of Alice B. Toklas, Beinecke YCAL records.

221. *Gertrude Stein*, 1937 or later
Oil on canvas
29½ x 24 in. (74.9 x 61 cm)
Private collection, courtesy Concept Art Gallery, Pittsburgh
Borràs 669[1]
Plate 252

Provenance

Gertrude Stein, Paris (until 1946; thereafter, her estate); private collection, Paris (by 1970[2]); current owner (by descent[2])

Notes

1. Borràs 1985, no. 669, fig. 852.
2. Potter 1970, 164. The work remained in the Stein family, according to archival records (Margaret Potter to Donald Gallup, November 2, 1970, MoMA Archives, Margaret Potter Papers, 2).

WORKS ON PAPER

222. *Church in Lucey (France)*
Pastel and charcoal on paper, signed lower right
12¼ x 9⅜ in. (31.1 x 23.8 cm)
Current location unknown

Provenance

Gertrude Stein, Paris (probably until 1946[1]); private collection (until May 1960); Mrs. Gerdy DuBoisky, New York (acquired May 1960[2]; by descent in 1989, until September 2004)[3]

Notes

1. The work depicts the church in Lucey, France, that was the subject of Gertrude's book *Lucy Church Amiably*, published in 1930. The pastel may have been a

gift by the artist during or after a visit to the country house that Gertrude and Alice Toklas rented in nearby Bilignin. The church is depicted from a similar vantage point in an undated photograph with Gertrude in the foreground. Beinecke YCAL, MSS 76, box 148, folder 3474.

2. Anonymous sale, Sotheby Parke-Bernet Galleries, New York, May 18, 1960, lot no. 24.

3. Entire provenance as established by Christie's, New York, September 29, 2004, lot no. 76 (ill.).

223. *Louis XIV*, 1936
Charcoal on paper; titled, signed, and dated
Current location unknown
Borràs 663[1]

Provenance
Gertrude Stein, Paris (until 1946; thereafter, her estate[2])

Notes
1. Borràs 1985, no. 663, fig. 846.
2. One of six works by Picabia noted in a June 1951 account of the estate of Gertrude Stein. +31

PABLO PICASSO

Spanish, born 1881, Málaga, Spain; died 1973, Mougins, France

PAINTING

224. *Café Scene*, 1900
Oil on panel
16¼ x 19¼ in. (41 x 49 cm)
Yale Collection of American Literature, Beinecke Rare Book and Manuscript Library, Yale University, New Haven
Zervos I 33
Plate 355

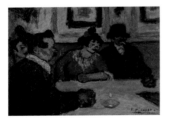

Provenance
Gertrude Stein and Alice Toklas, Paris (in or after 1908[1,2]); thereafter[3] [pl. 355], Alice Toklas, Paris (until 1951[2,3]); Yale Collection of American Literature, Beinecke Rare Book and Manuscript Library, Yale University (by 1951[3])

Notes
1. G. Stein 1990, 10.
2. Alice Toklas wrote to Samuel Steward on May 27, 1949: "A Swiss editor came to see what he would choose for his book *Picasso before Picasso*(!). There's a little café scene he did in '02 or '03 that a friend gave me in '08—one of the rare ones under the influence of Toulouse-Lautrec—which I produced with considerable pride." Toklas 1973, 165.
3. On March 23, 1948, Alice Toklas proposed a gift to Yale in her letter to Donald G. Gallup: "Now, I have a small gift for Yale. Do you remember the little early Picasso—the *Café Scene*—under the influence of

Toulouse-Lautrec—that is in the dining room—you may remember that it is mine (Pierre Loeb—knowing this—said to me once—You know whenever you are ready to sell your collection I am ready to buy it)" (Toklas 1973, 108–9). The Picasso painting was gifted by Toklas to the Gertrude Stein and Alice B. Toklas Papers in the Yale Collection of American Literature, Beinecke Rare Book and Manuscript Library, Yale University, by 1951.

225. *Woman with Bangs*, 1902
Oil on canvas
24⅛ x 20¼ in. (61.3 x 51.4 cm)
The Baltimore Museum of Art: The Cone Collection, formed by Dr. Claribel Cone and Miss Etta Cone of Baltimore, Maryland
Zervos I 118
Plates 65, 350, 352, 356

Provenance
Leo and Gertrude Stein, Paris (in or after April 1908 [pl. 350], and owned jointly [pl. 352] until 1913/1914); Gertrude Stein, Paris (1913/1914 until [pl. 356] 1929-30[1,2]); Etta Cone, Baltimore (1929-30[1,2] until 1950); Baltimore Museum of Art (1950)

Notes
1. Brenda Richardson (1985, 183) notes that the work was acquired from Gertrude Stein in Paris ca. 1929-30(?); neither the exact date nor the amount of the transaction are recorded. However, by May 1930 the work was published in an exhibition catalogue *The Cone Collection of Modern Paintings and Sculpture* (Baltimore 1930), 2, no. 43 (ill., as "Portrait-Picasso").
2. In 1950 the work entered the Cone Collection at the Baltimore Museum of Art, according to BMA records (BMA 1950.268).

226A. *Crouching Woman*, 1902 (recto); 1905 (verso)[A]
Oil on canvas
35⁷⁄₁₆ x 27¹⁵⁄₁₆ in. (90 x 71 cm)
Staatsgalerie Stuttgart
Zervos I 119; verso, Zervos I 296
Plates 350, 351, 354

Provenance
Leo and Gertrude Stein, Paris (in or after 1906[1], but at least by April 1908 [pl. 350], and owned jointly [pls. 351, 354] until 1913/1914); [Gertrude Stein, Paris; Galerie Gaspari, Munich; Dr. Fritz Nathan, Zurich (by 1955)[2]][1]

A. The present work is the recto of *Mother and Child (Acrobats)* (1905; cat. 226 B).

Notes
1. Daix and Boudaille 1966 (VII 2).
2. Munich 1955, no. 8 (ill., noted as "Mädchen an der Mauer, Dr. Nathan, Zürich").

226B. *Mother and Child (Acrobats)*, 1905 (verso); 1902 (recto)[A]
Gouache on canvas
35⁷⁄₁₆ x 27¹⁵⁄₁₆ in. (90 x 71 cm)
Staatsgalerie Stuttgart
Zervos I 296; recto, Zervos I 119

Provenance
Leo and Gertrude Stein, Paris (in or after 1906[1], but at least by April 1908, and owned jointly until 1913/1914); [Gertrude Stein, Paris; Galerie Gaspari, Munich; Dr. Fritz Nathan, Zurich (by 1955)[2]][1]

A. The present work is the verso of *Crouching Woman* (1902; cat. 226 A), which appears in several photographs. This side has never been on view.

Notes
1. Daix and Boudaille 1966 (VII 2).
2. Munich 1955, no. 8 (ill., noted as "Mädchen an der Mauer, Dr. Nathan, Zürich").

227. *Dozing Drinker*, 1902
Oil on canvas
31½ x 24⁷⁄₁₆ in. (80 x 60.5 cm)
Kunstmuseum Bern, Stiftung Othmar Huber, Bern, Inv. Nr. G 79.048
Zervos I 120
Plates 350, 351

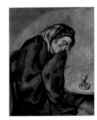

Provenance
Gertrude Stein, Paris (in or after 1906[1] until [pl. 350] at least 1910 [pl. 351]); Dr. Troplowitz, Hamburg; Kunsthalle, Hamburg, confiscated by the Nazi regime in 1937 and sold in 1939[2]; Othmar Huber, Glarus (1953[3])

Notes
1. Daix and Boudaille 1966 (VII 3) establishes early provenance and acquisition date.
2. Sales catalogue, Galerie Fischer, Lucerne, June 30, 1939, no. 116 (ill.).
3. Milan 1953, no. 2 (ill., as "La bevitrice" from "Collezione Othmar Huber, Glarus").

228. *Soup*, 1902
Oil on canvas
15⅛ x 18⅛ in. (38.4 x 46 cm)
Art Gallery of Ontario, gift of Margaret Dunlap Crang, 1983
Zervos I 131
Plates 177, 364

Provenance

Michael and Sarah Stein, Paris [pl. 364] (and possibly owned by Leo and Gertrude Stein[1] at some point); Karl/Klaus Sternheim, Paris (by 1932[2])

Notes

1. Daix and Boudaille 1966 (VII 11) indicates ownership by Gertrude Stein and is apparently one of few sources to do so for this painting.
2. Zervos 1932 (I 131), published in June, notes the owner as Karl Sternheim. The credit line under the reproduction of this work in *Cahiers d'Art* VII (June 1932), 162, gives Klaus Sternheim as the owner.

229. *Two Women Seated at a Bar,* 1902
Oil on canvas
31½ x 36 in. (80 x 91.4 cm)
Hiroshima Museum of Art
Zervos I 132
Plates 66, 350, 352, 354-56

Provenance

Leo and Gertrude Stein, Paris (at least by April 1908 [pl. 350], and owned jointly [pl. 352] until 1913/1914); Gertrude Stein [pls. 355, 356], Paris (1913/1914 until 1935[1]); Walter P. Chrysler Jr. (by May 1938[2,3])

Notes

1. Portland 1956, no. 88 (ill., provenance notes "Gertrude Stein, Paris, France, 1935").
2. Lerch 1938, 44 (ill.).
3. In an interview, Walter P. Chrysler Jr. recalls a conversation with Gertrude Stein and the acquisition of this painting: "I forget now what picture she chose from my collection but I remember very well the picture I chose from her collection—Picasso's *Two Women at the Bar*. I bought it…for $450.00." Hemphill 1978, 38.

230. *The Blue House,* 1902
Oil on canvas
20⅜ x 16⅜ in. (51.7 x 41.6 cm)
Current location unknown
Zervos XXI 280
Plate 355, 356

Provenance

Galerie Berthe Weill, Paris (at least by November 1902,[1] until 1906); André Level for La Peau de l'Ours (1906 until March 2, 1914[2]); Gertrude Stein, Paris (acquired after 1914 [pls. 355, 356], until 1946; thereafter, her estate[3,4]); André Meyer, New York (December 14, 1968[4] until October 1980[5,6])

Notes

1. Exhibited in Berthe Weill's first show of works by Picasso, November 15 - December 15, 1902, as no. 17, and believed to have been purchased in 1906 by Clovis Sagot, acting as agent for Level and his collectors. Fitzgerald 1995, 274n32.
2. Included in the infamous Peau de l'Ours sale in 1914, this work was sold for 550 francs. Sales catalogue, Hôtel Drouot, Paris, *Collection de la Peau de l'Ours,* March 2, 1914, lot no. 66 (as "Les maisons espagnoles" for "550"). Annotated version of catalogue, MMA-Watson.
3. On May 6, 1949, Alice Toklas writes to Allison Delarue: "If they do not interest you as painting you will enjoy them as souvenirs of Gertrude—the nude was the first Picasso she bought (1905) and the blue landscape is one of the very few landscapes of that period—if not the only one." Toklas 1973, 160-61. The

works have been identified by Edward Burns as Picasso's *Girl with a Basket of Flowers* (1905; pl. 9, cat. 232) and *The Blue House.*
4. Purchased through the Museum of Modern Art Syndicate, 1968.
5. His sale, Sotheby Parke Bernet, Inc., New York, October 22, 1980, no. 40 (ill.).
6. The work was later offered for sale and exhibited as follows: sales catalogue, Drouot-Montaigne, April 16, 1989, lot no. 15 (ill.), and Paris 1989b (ill.).

231. *Melancholy Woman,* 1902
Oil on canvas
39⅜ x 27¼ in. (100 x 69.2 cm)
Detroit Institute of Arts, bequest of Robert H. Tannahill
Zervos I 133
Plates 176, 363

Provenance

Michael and Sarah Stein, Paris (by November 1906[1,2] [pl. 363]); [Galerie Kahnweiler, Paris][2]; Paul Guillaume (1929[3]); Valentine Dudensing, New York[4]; Robert H. Tannahill, Grosse Pointe Farms, Michigan (1934 until 1970)[4]; Detroit Institute of Arts (bequest of Robert H. Tannahill, 1970)[4]

Notes

1. Possibly acquired through Leo and Gertrude Stein, Paris, although no records confirm their ownership.
2. Raynal 1921, no. 10 (ill.) does not indicate the owner. The photograph was provided by Galerie Simon.
3. New York 1936, no. 13 (as "Woman seated with fichu (La Mélancolie)…Lent Anonymously." No provenance listing appears, only a bibliographic reference to George Waldemar, *La grande peinture contemporaine à la Collection Paul Guillaume,*" Paris, 1929, 117.
4. Information provided by the online collection database Detroit Institute of Arts [dia.org], accessed June 3, 2010.

232. *Girl with a Basket of Flowers,* 1905
Oil on canvas
61 x 26 in. (154.9 x 66 cm)
Fractional gift to the Museum of Modern Art, New York, by a private collector
Zervos I 256
Plates 9, 346, 349, 352-54, 358, 361

Provenance

Clovis Sagot, Paris; Leo and Gertrude Stein, Paris (acquired in 1905,[1,2,3] and owned jointly [pls. 349, 352-54] until 1913/1914); Gertrude Stein, Paris (1913/1914 until [pls. 358, 361] 1946; thereafter, her estate); David and Peggy Rockefeller, New York (December 14, 1968[4]); Museum of Modern Art, New York (fractional gift of a private collector)

Notes

1. Purchased for 150 francs. G. Stein 1990, 43.
2. Barcelona 1992, 162-63, dates the acquisition to between October 18 and November 2, 1905.
3. Likely one of the two Picasso works, with *The Acrobat Family* (1905; cat. 291), that Leo mentions in a letter dated November 29, 1905, to Mabel Foote Weeks. Beinecke YCAL, MSS 78, box 1, folder 51-69.
4. Acquired by David Rockefeller from the estate of Gertrude Stein through the Museum of Modern Art Syndicate in 1968. +19

233. *Seated Nude,* 1905
Oil on cardboard mounted on panel, signed lower right
41¾ x 30 in. (106 x 76 cm)
Musée National d'Art Moderne, Centre Georges Pompidou, on loan to Musée National Picasso, Paris
Zervos I 257
Plates 71, 353, 358, 361

Provenance

Leo and Gertrude Stein, Paris (in or after 1905, and owned jointly until [pl. 353] 1913/1914); Gertrude Stein, Paris (in 1913/1914 until later [pls. 358, 361]); Pierre Matisse Gallery, New York (1932 until at least November 1937[1]); Walter P. Chrysler Jr., New York (by 1941[2]–1950[3])

Notes

1. Zervos 1932 (I 257) and New York 1937, no. 18. Pierre Matisse sent the Picasso painting to the Wadsworth Atheneum in February 1937 (Pierre Matisse to Mr. A. Everett Austin, director of the Wadsworth Atheneum, February 4, 1937) and by November 1937 offered to sell the work, in which he had partial ownership: "I own the picture with a friend of mine in Paris who wants the picture disposed of as quickly as possible" (Pierre Matisse to Austin, November 12, 1937). PMG Archives, MA 5020, box 77.28. It is unclear whether Gertrude Stein was still a partial owner or whether Pierre Matisse was owner with a third, unnamed party.
2. Richmond 1941, no. 153 (as "Nude in Grey… Collection: Gertrude Stein, Paris; Pierre Matisse Gallery, New York").
3. Sales catalogue, Parke-Bernet Galleries, Inc., New York, *Modern Paintings, Drawings, Sculptures from the Collection of Walter P. Chrysler, Jr.,* pt. 2, February 16, 1950, Picasso, lot no. 64 (ill., as "Nu gris, tempera on cradled board: 42 x 29½ in., Collection of Gertrude Stein; from the Pierre Matisse Gallery, New York." Annotated copy, Chrysler Museum of Art, Jean Outland Chrysler Library, Norfolk. Annotation: 4,500 [US dollars] with an indecipherable name starting with an "M" and ending in "et."

234. *Young Acrobat on a Ball,* 1905
Oil on canvas
57⅝ x 37⅜ in. (146.4 x 94.9 cm)
Pushkin State Museum of Fine Arts, Moscow
Zervos I 290
Plates 70, 350, 352, 354

Provenance

Leo and Gertrude Stein, Paris (in or after 1906 [pl. 350], and owned jointly [pls. 352, 354] until October 1913/January 1914); Galerie Kahnweiler (October 1913/January 1914[1a,b]); Ivan Morosov, Moscow (1913[2] until 1918); State Museum of Modern Western Art, Moscow (1918 until 1948); Pushkin State Museum of Fine Arts (1948)[3]

Notes

1a. One of three works that Daniel-Henry Kahnweiler purchased through the exchange of money and Picasso's *Man with a Guitar* (1913; cat. 264). +35
1b. Label on verso of painting: "Galerie Kahnweiler no. 1491."
2. Daix and Boudaille 1966 (XII.19) indicates the purchase price in 1913 as 16,000 francs.
3. Information provided by the online collection database Pushkin State Museum of Fine Arts [museum.ru], accessed June 3, 2010.

235. *Lady with a Fan*, 1905
Oil on canvas
39½ x 31⅞ in. (100.3 x 81 cm)
National Gallery of Art, Washington, D.C., gift of the
W. Averell Harriman Foundation in memory of Marie
N. Harriman
Zervos I 308
Plates 68, 353–56

Provenance

Leo and Gertrude Stein, Paris (in or after 1905, and
owned jointly [pls. 353, 354] until 1913/1914); Gertrude
Stein, Paris (1913/1914 until [pls. 355, 356] June 1931[1]);
Marie and W. Averell Harriman, New York (by June
1931[2,3] until 1972); National Gallery of Art,
Washington, D.C. (gift of the W. Averell Harriman
Foundation in memory of Marie N. Harriman, 1972)[4]

Notes

1. Barcelona 1992, 262, dates the sale to 1931 and cites
Alice Toklas, who wrote that the painting was sold in
1931 to pay for the publication of Gertrude's book *Lucy
Church Amiably* (1930).
2. Purchased in June 1931 through Paul Rosenberg,
according to NGA records.
3. Paris 1932, no. 36 (as "La Femme à l'Eventail,
Collection Marie Harriman, New-York").
4. Information provided by the online collection
database National Gallery of Art [nga.gov], accessed
June 3, 2010.

236. *Boy Leading a Horse*, 1905–6
Oil on canvas
86⅞ x 57⅝ in. (220.7 x 131.1 cm)
The Museum of Modern Art, New York, The William
S. Paley Collection, 1964
Zervos I 264
Plates 20, 350

Provenance

Ambroise Vollard, Paris; Leo and Gertrude Stein, Paris
(by 1907 [pl. 350], and owned jointly until 1913/1914[1]);
[Galerie Simon, Paris?]; Paul von Mendelssohn-
Bartholdy, Berlin (acquired by 1934/1935 and sold
August 31, 1935); Justin K. Thannhauser, Berlin (August
31, 1935, until August 28, 1936[2]); William S. Paley
(acquired August 28, 1936,[2] until 1964); Museum of
Modern Art, New York (The William S. Paley
Collection, 1964)

Notes

1. As noted above, the work appears in a photograph
of rue de Fleurus in which Picasso's *Three Women* (sold
to the Russian collector Sergei Shchukin in October
1913; see cat. 251, note 1) still hangs on the walls of the
Steins' apartment. No photographic evidence is known
of the present work in later views of the apartment
when, after 1913/1914, the collection was split and
Gertrude and Alice continued to live at rue de Fleurus
after Leo's departure to Italy in spring 1914. In pano-
ramic views of the apartment dated prior to February
1915, this large-format painting of a boy leading a
horse is not present among Gertrude's important collec-
tion of Picasso works (see, for example, pls. 353, 354).
It is likely that the present painting was one of the works
sold at the time the collection was being divided in
1913/1914 or shortly thereafter.
2. The work was sold by Justin K. Thannhauser through
Seigfried Rosengart, a business partner in Lucerne,
to Albert Skira in Geneva, who purchased the painting
on August 28, 1936, on behalf of William S. Paley.
Information provided by the online collection database
Museum of Modern Art [moma.org], accessed June 3,
2010.

237. *Nude with Joined Hands*, 1906
Oil on canvas
60½ x 37⅛ in. (153.7 x 94.3 cm)
The Museum of Modern Art, New York,
The William S. Paley Collection, 1990
Zervos I 327
Plates 74, 354, 356, 360, 361, 382

Provenance

Leo and Gertrude Stein, Paris (in or after 1906, and
owned jointly until [pl. 354] 1913/1914); Gertrude Stein,
Paris (1913/1914 until [pls. 356, 360, 361, 382] 1946;
thereafter, her estate); William S. Paley, New York
(December 14, 1968[1] until 1990); Museum of Modern
Art, New York (The William S. Paley Collection, 1990)

Notes

1. Purchased through the Museum of Modern Art
Syndicate, 1968.

238. *Gertrude Stein*, 1905–6
Oil on canvas
39⅜ x 32 in. (100 x 81.3 cm)
The Metropolitan Museum of Art, New York, bequest
of Gertrude Stein, 1946
Zervos I 352
Plates 183, 198, 352, 354, 356, 361, 383

Provenance

Gertrude Stein, Paris (gift of the artist in autumn 1906,[1]
and owned [pls. 352, 354, 356, 361, 383] until 1946;
thereafter, her estate); Metropolitan Museum of Art
(bequest of Gertrude Stein, 1946)

Notes

1. The painting hung in the atelier at rue de Fleurus
and later at rue Christine. Gertrude took the painting
to Bilignin (October 1939 until November 1942) and
then to Culoz, near Belley, Ain, France (November
1942 until December 1944), and then brought the work
back to Paris to hang in her rue Christine apartment
until her death.

239. *Self-Portrait*, 1906
Oil on canvas mounted on honeycomb panel
10½ x 7¾ in. (26.7 x 19.7 cm)
The Metropolitan Museum of Art, New York, Jacques
and Natasha Gelman Collection, 1998
Zervos I 371
Plates 81, 198, 353, 355, 383

Provenance

Leo and Gertrude Stein, Paris (in or after 1906, and
owned jointly [pl. 353] until 1913/1914); Gertrude Stein,
Paris (1913/1914 until [pls. 355, 383] 1946; thereafter, her
estate); André Meyer (December 14, 1968,[1] until
October 22, 1980[2]); Lynn Epstein Tescher, New York
(October 22, 1980, until May 7, 1986)[3]; Jacques and
Natasha Gelman, Mexico City and New York (May 7,
1986, until 1998)[3]; Metropolitan Museum of Art
(bequest of Natasha Gelman, 1998)[3]

Notes

1. Purchased through the Museum of Modern Art
Syndicate, 1968.
2. His sale, Sotheby Parke Bernet, *Highly Important
Paintings, Drawings, and Sculpture from The André Meyer
Collection*, October 22, 1980, lot no. 33 (ill.) (as "Picasso,
Head of a Young Man [Self-Portrait]").
3. New York 2010, no. 39.

240. *Head of a Sailor* (**Study for** *The Sailor*), 1906–7
Oil on canvas
15¾ x 16½ in. (41 x 39 cm)
Current location unknown
Zervos II* 6
Plate 358, 361

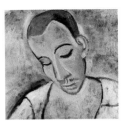

Provenance

Leo and Gertrude Stein, Paris (owned jointly until
1913/1914); Gertrude Stein, Paris (1913/1914 until[1] [pls.
358, 361] 1946; thereafter, her estate); David and
Peggy Rockefeller, New York (December 14, 1968[2]);
J. Seward Johnson (until 1981[3]); Stanley J. Seeger,
New York (until November 1993[4])

Notes

1. Zervos 1942 (II* 6).
2. Acquired by David Rockefeller from the estate of
Gertrude Stein through the Museum of Modern Art
Syndicate, 1968. +19
3. Sales catalogue, Christie's, New York, November 3,
1981, lot no. 37.
4. Sales catalogue, Sotheby's, New York, November 4,
1993, lot no. 415 (ill.)

241. *Head of a Sleeping Woman* (**Study for** *Nude with
Drapery*), 1907
Oil on canvas
24¼ x 18¾ in. (61.4 x 47.6 cm)
The Museum of Modern Art, New York, Estate of John
Hay Whitney, 1983
Zervos II* 44
Plates 218, 354, 357

Provenance

Leo and Gertrude Stein, Paris (in or after 1907, and
owned jointly until [pl. 354] 1913/1914); Gertrude Stein,
Paris (1913/1914, and owned until[1] [pl. 357] 1946;
thereafter, her estate); Mr. and Mrs. John Hay Whitney,
New York (December 14, 1968,[2] until 1983); Museum
of Modern Art, New York (Estate of John Hay
Whitney, 1983)

Notes

1. G. Stein 1938, between 72–75 (ill.), listed as "Coll.
Miss Gertrude Stein."
2. Purchased through the Museum of Modern Art
Syndicate, 1968.

242. *Nude with a Towel*, 1907
Oil on canvas
45⅝ x 35 in. (116 x 89 cm)
Private collection
Zervos II* 48
Plate 184

Provenance

Leo and Gertrude Stein, Paris (in or after 1907, until
October 1913); Galerie Kahnweiler (October 1913[1a,b]
until June 1921); Oscar Miestchaninoff (June 1921[2]);
Galerie Jeanne Bucher, Paris (before 1928[3]); vicomte
and vicomtesse Charles de Noailles, Paris (1928[3]
until at least 1960/61[4]); private collection

Notes

1a. One of three works that Daniel-Henry Kahnweiler purchased through the exchange of money and Picasso's *Man with a Guitar* (1913; cat. 264). +35
1b. Label on verso of painting: "Galerie Kahnweiler no. 1492."
2. Sales catalogue, Hôtel Drouot, Paris, June 13–14, 1921, lot. no. 87 (ill.). Annotated catalogue, Thomas J. Watson Library, the Metropolitan Museum of Art, New York; Private Archives, Inventory records of the collection de Noailles. The work was bought at the auction by Mr. Oscar Mie[s]tchaninoff for 1,500/1,450 francs. See Gee 1981, Appendices, 46, no. 162.
3. Purchased by exchange of one painting and two drawings by Picasso and one painting by Juan Gris valued at 120,000 francs. Private Archives, Inventory records of the collection de Noailles.
4. Paris 1960, no. 553 (owner listed as "Paris, Mme la Vicomtesse de Noailles").

243. *Bust of a Man*, 1908
Oil on canvas
24½ x 17⅛ in. (62.2 x 43.5 cm)
The Metropolitan Museum of Art, New York, bequest of Florene M. Schoenborn, 1995
Zervos II** 76
Plates 222, 352

Provenance

Leo and Gertrude Stein, Paris (acquired from the artist ca. 1908, until [pl. 352] 1913/1914)[1]; Galerie Kahnweiler, Paris (stock no. 1888; by 1914, until November, 18, 1921[2]); Henri-Pierre Roché, Paris (1921 until January 4, 1926[3]); Galerie Pierre [Pierre Loeb], Paris (by 1926, until at least 1932)[5]; Walter P. Chrysler Jr., New York and Warrenton, Virginia (by 1936,[4] until at least 1942)[5]

Notes

1. Although the painting appears in photographs of the Stein atelier at 27 rue de Fleurus, the work is not listed as belonging to Gertrude Stein in Paris 1932, no. 44 (as "Tête d'homme, Ancienne collection H.-P. Roché, Paris") and Zurich 1932, no. 37 (as "Negerkopf verkäuflich"). Additionally, her name does not appear in the provenance for this work in New York 1937, no. 6 (ill., as "Tête Nègre, 1907–1908" and having been lent by "Walter P. Chrysler, Jr., New York"), although her name is noted as owner of several other exhibited works. The date and details of Gertrude's acquisition of this work are not presently known.
2. Sales catalogue, Hôtel Drouot, Paris, *Vente de biens allemands ayant fait l'objet d'une mesure de Séquestre de Guerre: Collection Henry Kahnweiler, Tableaux modernes, deuxième vente*, November 18, 1921, lot no. 197, purchased by Léonce Rosenberg for Henri-Pierre Roché. See Gee 1981, appendices, 42, no. 116.
3. Henri-Pierre Roché notes on January 4, 1926, that his Picasso sold for 17,500 francs. Henri-Pierre Roché Archives, Ransom Center. Based on the few possible Picasso works that would bring such a price in Roché's collection, it is thought to be the present work.
4. New York 1936, no. 29 (as lent by Walter P. Chrysler Jr.).
5. Provenance as noted, and for subsequent owners, see New York 2010, no. 46.

244. *Landscape with Two Figures*, 1908
Oil on canvas
23⅝ x 28¾ in. (60 x 73 cm)
Musée National Picasso, Paris
Zervos II* 79
Plates 185, 351, 355, 360

Provenance

Gertrude Stein, Paris (at least before February 1914 [pl. 351], until later [pls. 355, 360]); Pablo Picasso, Paris (at least by 1939,[1,2] until 1973; thereafter, his estate)

Notes

1. Raynal 1921, no. 35 (ill.), does not indicate the owner. The photograph was provided by Galerie Simon.
2. New York 1939, no. 80 (ill.), 66 (as "Landscape with Figures…Lent by the artist").

245. *La Rue-des-Bois,* 1908
Oil on canvas
28¾ x 23⅝ in. (73 x 60 cm)
Private collection
Zervos II* 82
Plates 226, 352, 355, 382

Provenance

Leo and Gertrude Stein, Paris (acquired from the artist in autumn 1908,[1] and owned jointly until [pl. 352] 1913/1914); Gertrude Stein, Paris (1913/1914 until[2] [pls. 355, 382] 1946; thereafter, her estate); André Meyer, New York (December 14, 1968[3]–October 1980[4])

Notes

1. Potter 1984, 263, and G. Stein and Picasso 2008, 60n2.
2. Zervos 1942 (II* 82).
3. Purchased through the Museum of Modern Art Syndicate, 1968.
4. His sale, Sotheby's, New York, *Highly Important Paintings, Drawings, and Sculpture from the André Meyer Collection*, October 22, 1980, no. 41 (ill.).

246. *Landscape* (La Rue-des-Bois or Paris), 1908
Oil on canvas
39⅝ x 32 in. (100.8 x 81.3 cm)
The Museum of Modern Art, New York, gift of Mr. and Mrs. David Rockefeller
Zervos II* 83
Plates 352, 353, 356

Provenance

Leo and Gertrude Stein, Paris (acquired in autumn 1908,[1] and owned jointly until [pls. 353, 353] 1913/1914); Gertrude Stein, Paris (1913/1914 until[2] [pl. 356] 1946; thereafter, her estate); David and Peggy Rockefeller, New York (December 14, 1968,[3] until 1974); Museum of Modern Art, New York (gift of Mr. and Mrs. David Rockefeller, 1974)

Notes

1. Potter 1984, 263, and G. Stein and Picasso 2008, 60n2.
2. Zervos 1942 (II* 83).
3. Acquired by David Rockefeller from the estate of Gertrude Stein through the Museum of Modern Art Syndicate, 1968. +19

247. *La Rue-des-Bois,* 1908
Oil on canvas
28½ x 23⅜ in. (72.5 x 59.5 cm)
Museo del Novecento e Case Museo, Milan
Zervos II* 86
Plate 355

Provenance

Leo and Gertrude Stein, Paris (acquired in autumn 1908,[1] and owned jointly until 1913); Gertrude Stein, Paris (1913 until [pl. 355] 1946[2]; thereafter, her estate); Riccardo Jucker, Milan (after October 1955[3])

Notes

1. Potter 1984, 263, and G. Stein and Picasso 2008, 60n2.
2. Zervos 1942 (II* 86).
3. Probably purchased after Paris 1955. There are two versions of the catalogue for this exhibition, with different catalogue numbers. In the definitive exhibition catalogue, this work (Zervos II* 86) was illustrated and listed as no. 16, "Paysage," but was misidentified as Zervos II* 82. The work was sold in 1957 to Riccardo Jucker, Milan, with Galerie Louise Leiris, Paris, acting as agent. Edward Burns, e-mail message to Cécile Debray, June 10, 2010.

248. *Green Bowl and Black Bottle*, 1908
Oil on canvas
24 x 19⅞ in. (61 x 50.5 cm)
The State Hermitage Museum, Saint Petersburg
Zervos II* 89
Plate 223

Provenance

Leo [and Gertrude] Stein, Paris (in or after 1908, until 1912[1]); Sergei Shchukin, Moscow (1912 until 1918[2,3]); State Museum of New Western Art, Moscow (1918 until 1948); State Hermitage Museum, Saint Petersburg (1948)[4]

Notes

1. London 1912, no. 60 (ill., as "Nature Morte, Lent by M. Leo Stein").
2. Appears in the Picasso Room of Sergei Shchukin's house in Moscow, 1913. Költzsch 1993, 73.
3. Daix and Rosselet 1979, no. 173.
4. Information provided by the online collection database State Hermitage Museum [hermitagemuseum.org], accessed June 3, 2010.

249. *Glasses and Fruit,* 1908
Oil on cradled panel
10⅝ x 8⅜ in. (27 x 21 cm)
Museum Ludwig, Cologne
Zervos II* 97
Plates 224, 351, 353–56, 382

Provenance

Leo and Gertrude Stein, Paris (in or after 1908, and owned jointly until [pls. 351, 353] 1913/1914); Gertrude Stein, Paris (1913/1914 until [pls. 355, 356, 382] at least 1942[1]); private collection, New York[2]; André Stassart, Liège, Belgium[2] (by 1978[3]); private collection, Liège[2]

Notes

1. Zervos 1942 (II* 97), published in September, lists this work as "Coll. Mlle Gertrude Stein."
2. Daix and Rosselet 1979, no. 207, lists the provenance as referenced.
3. Paris 1978, no. 44 (ill.; caption reads: "Picasso: Verre et Fruit [1908] Galerie Stassart").

250. *Glasses and Fruit,* 1908
Oil on panel
10⅝ x 8½ in. (27 x 21.6 cm)
Museo Thyssen-Bornemisza, Madrid
Zervos II* 98
Plates 225, 352, 357, 358, 382

Provenance

Leo and Gertrude Stein, Paris (in or after 1908, and owned jointly until [pl. 352] 1913/1914); Gertrude Stein, Paris (1913/1914 until[1] [pls. 357, 358, 382] 1946; thereafter, her estate); Nelson A. Rockefeller, New York (December 14, 1968[2])

Notes

1. Zervos 1942 (II* 98).
2. Purchased through the Museum of Modern Art Syndicate, 1968.

251. *Three Women,* 1908
Oil on canvas
78¾ x 70⅛ in. (200 x 178 cm)
The State Hermitage Museum, Saint Petersburg
Zervos II* 108
Plate 186

Provenance

Leo and Gertrude Stein, Paris (acquired early 1909,[1] and probably owned jointly until 1913[2a,b]); Galerie Kahnweiler, Paris (1913[2a,b]); Sergei Shchukin, Moscow (1913[1] until 1918); State Museum of New Western Art, Moscow (1918 until 1948); State Hermitage Museum, Saint Petersburg (1948)[3]

Notes

1. Purchased from the artist. It seems that around 1911 Leo tried to sell the painting to Sergei Shchukin; as the latter wrote: "Cher Monsieur, J'ai reçu votre lettre du 26 novembre et je vous remercie beaucoup pour votre proposition de me ceder le grand tableau de Picasso 'Les trois femmes.' Mais je trouve aussi le tableau trop encombrant, la plan chez moi est déjà trop prise et je ne pense pas acheter des grands tableaux." Sergei Shchukin (Moscow) to Leo Stein, November 17/30, 1912, Beinecke YCAL, MSS 76, box 128, folder 2786. On May 29, 1913, the painting was sent to Daniel-Henry Kahnweiler, who sold the work to Shchukin soon thereafter. G. Stein and Picasso 2008, 55n1.
2a. Gertrude accepts the sale of this work in October 1913 as one of three works that Daniel-Henry Kahnweiler purchased through the exchange of money and Picasso's *Man with a Guitar* (1913; cat. 264). +35
2b. Label on verso of painting: "Galerie Kahnweiler no. 1490."
3. Information provided by the online collection database State Hermitage Museum [hermitagemuseum.org], accessed June 3, 2010.

252. Study for *The Dryad (Nude in a Forest),* 1908
Gouache, ink, and graphite on card laid on cradled panel
24⅝ x 14½ in. (62.5 x 37 cm)
Private collection
Zervos II* 112
Plates 219, 355

Provenance

Leo and Gertrude Stein, Paris (in or after 1908, and owned jointly until 1913/1914); Gertrude Stein, Paris (1913/1914 and later [pl. 355]); Galerie Simon,[1] Paris (inv. no. 6454, photo no. 415); Galerie Flechtheim,[1] Paris (inv. no. 4610, photo no. 721) (acquired by 1922[1]); René Gaffé, Brussels (by 1963)

Notes

1. Sales catalogue, Christie's, New York, *The Collection of René Gaffé, Property from the Estate of Madame René Gaffé,* November 6, 2001, sale no. 9854, lot no. 5.

253. *Still Life with Fruit and Glass,* 1908
Tempera on wood
10⅝ x 8⅜ in. (27 x 21.1 cm)
The Museum of Modern Art, New York, Estate of John Hay Whitney
Zervos II* 123
Plates 352, 354, 357, 358, 382

Provenance

Leo and Gertrude Stein, Paris (acquired from the artist and owned jointly until [pls. 352, 354] 1913/1914); Gertrude Stein, Paris (1913/1914 until [pls. 357, 358, 382] 1946; thereafter, her estate); Mr. and Mrs. John Hay Whitney, New York (December 14, 1968[1] until 1983); Museum of Modern Art, New York (Estate of John Hay Whitney in 1983[2])

Notes

1. Purchased through the Museum of Modern Art Syndicate, 1968.
2. Washington, D.C. 1983, no. 56.

254. *Vase, Gourd, and Fruit on a Table,* 1908
Oil on canvas
28¾ x 23⅝ in. (73 x 60 cm)
Yale University Art Gallery, New Haven, John Hay Whitney, B.A. 1926, M.A. (Hon.) 1956, Collection
Zervos II* 126
Plates 227, 356, 382

Provenance

Leo [and Gertrude] Stein, Paris (in or after 1908, and owned jointly until 1913/1914[1]); Gertrude Stein, Paris (1913/1914 until [pls. 356, 382] 1946; thereafter, her estate); John Hay Whitney, New York (December 14, 1968,[2] until 1982); Yale University Art Gallery (1982[3])

Notes

1. New York 1913, no. 345 (as "Nature morte No. 1") or 346 (as "Nature morte No. 2"), both "lent by Leo Stein."
2. Purchased through the Museum of Modern Art Syndicate, 1968.
3. Information provided by the online collection database Yale University Art Gallery [ecatalogue.art.yale.edu], accessed June 3, 2010.

255. *Homage to Gertrude Stein,* 1909
Tempera on panel
8¼ x 10¾ in. (21 x 27.3 cm)
Charles E. Young Research Library, UCLA Special Collections
Online Picasso Project 09.180
Plate 192

Provenance

Gertrude Stein, Paris (1909[1] until 1946; thereafter, her estate [and Alice Toklas?]); private collection, New York (by 1970[2]); Gilbert Harrison; UCLA Special Collections (1998[3])

Notes

1. "The figuration of the women and the angels allows the date of this little panel to be given fairly certainly as spring 1909. It is quite likely that this tribute was painted for St. Gertrude's Day, 17 March." Daix and Rosselet 1979, no. 248.
2. Potter 170.
3. UCLA object record, provided to Janet Bishop, September 26, 2008.

256. *The Reservoir, Horta de Ebro,* 1909
Oil on canvas
24⅛ x 20⅛ in. (61.5 x 51.1 cm)
Promised gift of Mr. and Mrs. David Rockefeller to the Museum of Modern Art, New York
Zervos II* 157
Plates 229, 353, 356, 361

Provenance

Leo and Gertrude Stein, Paris (purchased from the artist in autumn 1909,[1] and owned jointly until [pl. 353] 1913/1914); Gertrude Stein, Paris (1913/1914 until[2] [pls. 356, 361] 1946; thereafter, her estate); David and Peggy Rockefeller, New York (December 14, 1968,[3] until 1991); Museum of Modern Art, New York (promised gift of Mr. and Mrs. David Rockefeller, 1991)

Notes

1. Daix and Rosselet, no. 280, and J. Richardson 1996, 142 (cf. 454n11).
2. Illustrated in Transition 1928, "by Courtesy of Miss Gertrude Stein." Cécile Debray, e-mail message to the author, June 10, 2010.
3. Purchased through the Museum of Modern Art Syndicate, 1968.

257. *Houses on a Hill, Horta de Ebro,* 1909
Oil on canvas
25⅝ x 31⅞ in. (65 x 81 cm)
Nationalgalerie, Museum Berggruen, Staatliche Museen, Berlin
Zervos II* 161
Plates 230, 353, 356, 361

Provenance

Leo and Gertrude Stein, Paris (purchased from the artist in autumn 1909,[1] and owned jointly until [pl. 353] 1913/1914); Gertrude Stein, Paris (1913/1914 until[2] [pls. 356, 361] 1946; thereafter, her estate); Nelson A. Rockefeller, New York (December 14, 1968[3])

Notes

1. Daix and Rosselet 1979, no. 280, and J. Richardson 1996, 142 (cf. 454n11).
2. Illustrated in *Transition*, no. 11, 1928, "by Courtesy of Miss Gertrude Stein."
3. Purchased through the Museum of Modern Art Syndicate, 1968.

258. *Head of a Woman (Fernande),* 1909
Oil on canvas
23⅞ x 20¼ in. (60.6 x 51.3 cm)
The Art Institute of Chicago, Joseph Winterbotham Collection
Zervos II* 167
Plates 228, 357

Provenance

Leo and Gertrude Stein, Paris (acquired from the artist in 1909,[1] and owned jointly until 1913/1914); Gertrude Stein, Paris (1913/1914 until [pl. 357] later); Dr. Gottlieb Friedrich von Reber, Lausanne (by 1926,[2] until at least 1932); René Gaffé, Brussels (by 1937); Valentine Dudensing Gallery, New York (in 1940); Art Insitute of Chicago (1940)

Notes

1. Daix and Rosselet 1979, no. 287, and J. Richardson 1996, 142 (cf. 454n11) and 134 (ill.).
2. Einstein 1926, no. 266 (as "Bildnis einer Frau, 1909, Lugano, Sammlung Reber").

259. *Le Journal*, 1912
Oil on canvas
18 x 14¾ in. (45.7 x 37.5 cm)
Current location unknown
Zervos II* 316
Plates 353, 358, 360

Provenance
[Leo and] Gertrude Stein, Paris (May 1912,[1,2] and owned jointly until [pl. 353] 1913/1914); Gertrude Stein, Paris (1913/1914 until [pls. 358, 360] 1946; thereafter, her estate); Mr. and Mrs. John Hay Whitney (December 14, 1968, until 1999[3,4])

Notes
1. Purchased from the artist: "Two days later, on May 3 [1912], Picasso confirmed an appointment with her [Gertrude] for the following Monday [May 6, 1912]. Gertrude bought two smallish but extremely fine still lifes: *The Little Glass* [1912; cat. 261] and *Still Life with Newspaper* [the present work]." J. Richardson 1996, 223. It is now believed that Gertrude and Leo began to divide their collection in October 1913. Although they both made individual purchases before this date, it is believed they were sharing financial resources and it is nearly impossible to distinguish the actual owner until after the collection is split.
2. See letters from Picasso to Gertrude Stein dated May 1, 3, and 8, 1912. G. Stein and Picasso 2008, 115–17.
3. Purchased through the Museum of Modern Art Syndicate, 1968.
4. Their sale, Sotheby's, New York, May 10, 1999, lot no. 32 (ill.).

260. *The Architect's Table*, 1912
Oil on canvas mounted on panel
28⅝ x 23½ in. (72.7 x 59.7 cm)
The Museum of Modern Art, New York,
The William S. Paley Collection, 1971
Zervos II* 321
Plates 197, 358, 359

Provenance
Galerie Kahnweiler, Paris; Gertrude Stein, Paris (March/April 1912[1,2] until [pls. 358, 359] 1946; thereafter, her estate); Mr. and Mrs. William S. Paley, New York (December 14, 1968[3] until 1971); Museum of Modern Art, New York (The William S. Paley Collection, 1971)

Notes
1. In a letter dated March 28, 1912, Daniel-Henry Kahnweiler agrees to sell to Gertrude Stein one painting by Picasso—*The Architect's Table*—for 1,200 francs ("payable half now, half after your return to Paris in the fall"). He agreed to deliver the painting on Saturday, March 30, 1912, at six o'clock in the evening. In a letter of April 1, 1912, Kahnweiler acknowledges a letter from Gertrude Stein, received the day before, containing a check for 600 francs in accordance with the sale agreement as noted above. Kahnweiler to Gertrude Stein, March 28 and April 1, 1912, Beinecke YCAL, MSS 76, series II, box 112, folder 2310.

2. According to Brenda Wineapple (1996, 346), this was Gertrude's "first independent purchase."
3. Purchased through the Museum of Modern Art Syndicate, 1968.

261. *The Small Glass*, 1912
Oil on canvas
18¼ x 15⅛ in. (46 x 38 cm)[1]
Current location unknown
Zervos II* 323
Plates 354, 357, 360

Provenance
[Leo and] Gertrude Stein, Paris (May 1912,[2,3] and owned jointly until [pl. 354] 1913/1914); Gertrude Stein, Paris (1913/1914[3] until [pls. 357, 360] probably 1946; thereafter, her estate)

Notes
1. Zervos reproduced the work as noted here; as seen in the plates cited above, it hangs in the Stein apartment inverted.
2. Purchased from the artist: "Two days later, on May 3 [1912], Picasso confirmed an appointment with her [Gertrude] for the following Monday [May 6, 1912]. Gertrude bought two smallish but extremely fine still lifes: *The Little Glass* [the present work] and *Still Life with Newspaper* [1912; cat. 259]." J. Richardson 1996, 223.
3. See letters from Picasso to Gertrude Stein dated May 1, 3, and 8, 1912. G. Stein and Picasso 2008, 115–17.

262. *Violin*, 1912
Oil, sand, and charcoal on canvas
21½ x 17 in. (54.6 x 43.2 cm)
Private collection
Zervos II** 368[A]
Plates 231, 354, 357, 361

Provenance
[Leo and] Gertrude Stein, Paris (in or after 1912 [pl. 354], and owned jointly until 1913/1914); Gertrude Stein, Paris (1913/1914 until[1] [pls. 357, 361] 1946; thereafter, her estate); André Meyer, New York (December 14, 1968,[2] until October 1980[3]); private collection

A. A similar drawing of a violin from this period is in the Philadelphia Museum of Art from the Louise and Walter Arensberg Collection, 1950 (1950.134.167).

Notes
1. Zervos 1942 (II** 368).
2. Purchased through the Museum of Modern Art Syndicate, 1968.
3. His sale, Sotheby Parke-Bernet, Inc., New York, October 22, 1980, lot no. 34 (ill.).

263. *Guitar on a Table*, 1912
Oil, sand, and charcoal on canvas
20⅛ x 24¼ in. (51.1 x 61.6 cm)
Hood Museum of Art, Dartmouth College, Hanover, New Hampshire; gift of Nelson A. Rockefeller, Class of 1930
Zervos II** 373
Plates 232, 357, 358, 360, 361

Provenance
[Leo and] Gertrude Stein, Paris (gift of the artist to Gertrude in 1913, until [pls. 357, 358, 360, 361] 1946[1]; thereafter, her estate); Marlborough Gallery, London (1968 until 1970); Nelson A. Rockefeller, New York (by 1970 to 1975[2]); Hood Museum of Art, Dartmouth College, Hanover, New Hampshire (1975[2])

Notes
1. Zervos 1942 (II** 373).
2. Information provided by the online collection database Hood Museum of Art [hoodmuseum. dartmouth.edu], accessed June 3, 2010.

264. *Man with a Guitar*, 1913
Oil and encaustic on canvas
51¼ x 35 in. (130.2 x 88.9 cm)
Private collection
Zervos II** 436
Plates 234, 357, 361

Provenance
Galerie Kahnweiler, Paris; Gertrude Stein, Paris (October 1913/January 15, 1914[1] until [pls. 357, 361] 1946; thereafter, her estate); André Meyer, New York (December 14, 1968,[2] until later)

Notes
1. Gertrude acquired *Man with a Guitar* from Daniel-Henry Kahnweiler through the exchange of three earlier works: *Young Acrobat on a Ball* (1905; cat. 234); *Three Women* (1908; cat. 251); and *Nude with a Towel* (1907; cat. 242). +35
2. Purchased through the Museum of Modern Art Syndicate, 1968.

265. *Student with a Pipe*, 1914
Gesso, sand, pasted paper, oil, and charcoal on canvas
28¾ x 23⅛ in. (73 x 58.7 cm)
The Museum of Modern Art, New York,
Nelson A. Rockefeller Bequest
Zervos II** 444
Plates 233, 357, 360, 361

Provenance
Gertrude Stein, Paris (in or after March 1914 [pl. 357] until [pls. 360, 361] 1946; thereafter, her estate); Nelson A. Rockefeller, New York (December 14, 1968[1] until 1979); Museum of Modern Art, New York (Nelson A. Rockefeller Bequest, 1979)

Notes
1. Purchased through the Museum of Modern Art Syndicate, 1968.

266. *Woman with a Guitar*, 1914
Oil, sand, and charcoal on canvas
45½ x 18⅝ in. (115.6 x 47.3 cm)
The Museum of Modern Art, New York, gift of Mr. and Mrs. David Rockefeller, 1975
Zervos II** 448
Plates 235, 361

Provenance
Galerie Kahnweiler, Paris; Gertrude Stein, Paris (in or after 1914 until [pl. 361] 1946; thereafter, her estate); David and Peggy Rockefeller, New York (December 14, 1968,[1] until 1975); Museum of Modern Art, New York (gift of Mr. and Mrs. David Rockefeller, 1975)

Notes
1. Acquired by David Rockefeller from the estate of Gertrude Stein through the Museum of Modern Art Syndicate in 1968. +19

267. *Still Life with Fruit, Glass, and Newspaper,* 1914
Oil and sand on canvas
13⅝ x 16½ in. (34.5 x 42 cm)
Kreeger Museum, Washington, D.C.
Zervos II** 530
Plate 236

Provenance

Gertrude Stein, Paris (in or after 1914 until at least 1932[1]); G. David Thompson, Pittsburgh[2]; Knoedler and Company, New York (by 1962[3])

Notes

1. Zurich 1932, no. 87 (as "Stilleben mit Zeitung, Mlle Gertrud Stein, Paris").
2. Daix and Rosselet 1979, no. 781.
3. New York 1962, no. 22 (as "Still Life with Grapes, Pear and Newspaper on a Table, M. Knoedler and Co., Inc., New York").

268. *Still Life with Bottle of Rum,* 1914
Oil and charcoal on canvas
15 x 18⅛ in. (38.1 x 46 cm)
Nancy and Robert Blank, New York
Zervos II** 535; Daix and Rosselet 780
Plate 237

Provenance

Gertrude Stein, Paris (in or after 1914 until 1946; thereafter, her estate); Mr. and Mrs. John Hay Whitney (December 14, 1968[1]-99[2]); Nancy and Robert Blank, New York (May 1999)

Notes

1. Purchased through the Museum of Modern Art Syndicate, 1968.
2. Their sale, Sotheby's, New York, May 10, 1999, lot no. 29 (as "Nature morte à la bouteille de rhum").

269. *Still Life,* 1922
Oil on canvas
32⅛ x 39⅝ in. (81.6 x 100.3 cm)
The Art Institute of Chicago, Ada Turnbull Hertle Endowment
Zervos XXX 286

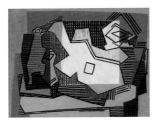

Provenance

Gertrude Stein, Paris (acquired possibly in exchange for an earlier work by the artist, late winter 1923,[1] until 1946; thereafter, her estate, until at least 1948[2]); Knoedler and Company, New York (July 1949[3,4] until 1953); Art Institute of Chicago (1953)[5]

Notes

1. Likely the "new Picasso" that Gertrude Stein refers to in a letter of perhaps April 1923 to Henry McBride: "I have a new Picasso I traded for an old and two new Masson's." +22 Laurence Madeline suggests that the acquisition was a gift, based on correspondence from February 15, 1923. G. Stein and Picasso 2008, 272.

2. Alice Toklas proposes the sale of several works to Donald G. Gallup in a letter of March 23, 1948: "Now I have his [Allan Stein's] consent to sell a picture and if your museum is prepared—as I think you once said they might be—will you please tell me what is the next step for me to take. I want to sell the latest Picasso here—the brightly colored cubist in the little salon. Picasso told me that it was worth 10,000. When I wanted to sell it last summer I had an offer for it for that price in francs—but then I wanted dollars for Carl's publishing. There will be a way of getting the picture over. It is eighty-one centimetres by one metre." Toklas 1973, 108.
3. Letter dating the purchase of the work to July 1949 and its resale to the Art Institute of Chicago in 1953 from Richard Finnegan at Knoedler, September 1975, AIC, curatorial records.
4. Knoedler photo no. A 4217.
5. Art Institute of Chicago online collection database [artic.edu], accessed July 2009.

WORKS ON PAPER

270. *Head of a Bearded Man,* 1902-3
Charcoal on paper, signed upper right
12 x 8½ in. (30.5 x 21.6 cm)
Current location unknown[3]
Zervos XXII 34

Provenance

Leo and Gertrude Stein, Paris[1,2] (probably owned jointly until 1913/1914); Gertrude Stein, Paris (probably 1913/1914, until later); Leon Anthony Arkus, Pittsburgh (by 1970)

Notes

1. The only record of Stein provenance is the inclusion in Potter 1970, 164.
2. Neither Zervos nor Palau i Fabre 1981 nor OPP have provenance information that might corroborate ownership by the Stein family.
3. An undated letter from Sam Salz, Inc., New York, indicates that the present work had at some point been in a private collection in England and in the collection of Gerald Corcoran without further indications or information. MoMA Archives, Margaret Potter Papers, Potter, 9d.

271. *Crouching Nude with Green Stocking,* 1902[A]
Graphite and watercolor on paper, signed lower left[3]
10⅞ x 7⅞ in. (27.7 x 20 cm)
Current location unknown
Daix and Boudaille VII 16[A]

Provenance

Gertrude Stein, Paris; André Schoeller, Paris; Mme L., Paris[1]; private collection[2]; Stanley J. Seeger, New York (probably 1988[3] until November 1993[4])

A. This work relates closely to Zervos XXII 340 in the collection of Museu Picasso, Barcelona (MPB110.036).

Notes

1. Daix and Boudaille 1966 (VII 16) cites early provenance.
2. Sales catalogue, Ader, Picard, Tajan, Paris, June 22, 1988, lot no. 20, indicates previous owners as: "Collection particulière, Collection d'un grand amateur."

3. Sales catalogue, Christie's, London, November 29, 1988, lot no. 355, as former collection "Gertrude Stein, Paris; André Schoeller, Paris." The 1993 Sotheby's, New York, sale indicates that the 1988 Christie's, London, sale precedes the Seeger ownership of this work.
4. His sale, Sotheby's, New York, November 4, 1993, lot no. 403 (ill.)

272. *Nude with Crossed Legs,*[A] 1903
Pastel on paper mounted on canvas
22⁷⁄₁₆ x 16¹⁵⁄₁₆ in. (57 x 43 cm)
Collection Louis and Evelyn Franck, on deposit with Fondation Socindec
Zervos I 181

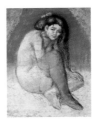

Provenance

Leo and Gertrude and/or Michael and Sarah Stein, Paris; Galerie Beyeler, Basel[1]

A. This work appears in a photograph of an unknown location in an album of photographs owned by Annette Rosenshine. Annette Rosenshine papers, BANC PIC 1964.049-.050—ALB, The Bancroft Library, University of California, Berkeley.

Notes

1. Online Picasso Project 03:063 lists the work formerly in the inventory of Galerie Beyeler, Basel.

273. *Family at Supper,* 1903
Pen and ink with watercolor on paper
12⅝ x 17½ in. (32.1 x 44.5 cm)
Collection Albright-Knox Art Gallery, Buffalo, Room of Contemporary Art Fund, 1941
Zervos VI 563

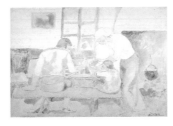

Provenance

Gertrude Stein, Paris; Galerie Kate Pens, Paris; Peter Watson, London; French Art Galleries, New York; Albright-Knox Gallery, Buffalo (by 1941)[1]

Notes

1. Provenance based on Daix and Boudaille 1966 (IX 13).

274. *Nude Woman Standing in Profile,* 1903
Signed and dated lower left
9⅝ x 6½ in. (24.5 x 16.5 cm)
Current location unknown
Zervos VI 564

Provenance
Leo and Gertrude Stein, Paris (in or after 1905, and owned jointly until 1913/1914); Gertrude Stein, Paris (1913/1914 until 1946[1]; thereafter, her estate and Alice Toklas until 1954[2]); Ragnar Moltzau, Oslo (by 1956)[3]

Notes
1. G. Stein 1938, 3 (ill.).
2. Paris 1954, no. 1 (ill.).
3. Oslo 1956, no. 3 (as "Femme nue debout, de profil," lent by "Ragnar Moltzau, Oslo").

275. *The Beggar's Meal,* 1903-4
Watercolor
9⅝ x 13⅝ in. (24.5 x 34.5 cm)
Current location unknown
Zervos VI 684

Provenance
Probably Leo and Gertrude Stein, Paris (in or after 1905, until 1913/1914); Gertrude Stein, Paris (1913/1914 until at least 1938[1]); Jacques Seligmann, New York (1954)[2]

Notes
1. G. Stein 1938, between 38-43 (ill.), listed as "Coll. Miss Gertrude Stein." All other works listed as such remained in the Gertrude Stein collection until 1946 and were part of her estate.
2. Zervos 1954 (VI 684).

276. *The Acrobat,* 1904
Ink on paper, signed lower left
9¼ x 6⅛ in. (23.5 x 15.5 cm)
Current location unknown
Zervos VI 602

Provenance
Leo and Gertrude Stein, Paris (in or after 1905, and owned jointly until 1913/1914); Gertrude Stein, Paris (1913/1914 until 1946; thereafter, her estate and Alice Toklas[1]); Galerie Louise Leiris, Paris (1954)[2]

Notes
1. Paris 1954, no. 7 (ill.).
2. Zervos 1954 (VI 602).

277. Study for *Young Acrobat on a Ball,* 1904
Ink on paper, signed upper left
10 x 6⅛ in. (25.5 x 15.5 cm)
Current location unknown
Zervos VI 603

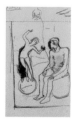

Provenance
Leo and Gertrude Stein, Paris (in or after 1905, and owned jointly until 1913/1914); Gertrude Stein, Paris (1913/1914 until 1946; thereafter, her estate and Alice Toklas[1]); Galerie Louise Leiris, Paris (1954[2]); Saidenberg Gallery, New York[3]; Sidney E. Cohn (until 1992)[3]

Notes
1. Paris 1954, no. 9 (ill.).
2. Zervos 1954 (VI 603).

3. Cohn estate sale, Sotheby's, New York, *Modern Paintings, Drawings and Sculpture from the Estate of Sidney E. Cohn,* May 13-14, 1992, lot no. 8, as having been purchased through Saidenberg Gallery, New York.

278. Study for *Young Acrobat on a Ball,* 1904
Ink on paper, signed lower right
10¼ x 6⁵⁄₁₆ in. (26 x 16 cm)
Current location unknown
Zervos VI 604

Provenance
Leo and Gertrude Stein, Paris (in or after 1905, and owned jointly until 1913/1914); Gertrude Stein, Paris (1913/1914 until 1946; thereafter, her estate and Alice Toklas[1]); Galerie Louise Leiris, Paris (1954[2])

Notes
1. Paris 1954, no. 8 (ill.).
2. Zervos 1954 (VI 604).

279. *The Promenade,* 1904
Ink on paper
15¾ x 12 in. (40 x 30.5 cm)
Current location unknown
Zervos VI 618

Provenance
Leo and Gertrude Stein, Paris (in or after 1905, and owned jointly until 1913/1914); Gertrude Stein, Paris (1913/1914 until 1946; thereafter, her estate and Alice Toklas[1]); Galerie Louise Leiris, Paris (1954[2])

Notes
1. Paris 1954, no. 3.
2. Zervos 1954 (VI 618).

280. *Danse barbare,* 1904
Pen and India ink on paper laid on card
9¼ x 12 in. (23.5 x 30.5 cm)
Current location unknown
Zervos VI 619

Provenance
Leo and Gertrude Stein, Paris (in or after 1905, and owned jointly until 1913/1914); Gertrude Stein, Paris (1913/1914 until 1946; thereafter, her estate and Alice Toklas[1]); Galerie Louise Leiris, Paris (1954[2])

Notes
1. Paris 1954, no. 6.
2. Zervos 1954 (VI 619).

281. *Une très belle danse barbare,* 1904 (letter ca. 1905)
Ink on paper
11¼ x 15⅞ in. (28.6 x 40.3 cm)
Private collection
Zervos VI 621
Plate 79

Provenance
Leo Stein, Paris; Curt Valentin, New York (by 1949,[1] until at least 1954[2]); Perry T. Rathbone (1954 until 2000); private collection

Notes
1. Princeton 1949, no. 10 (ill., as "Caricature, Letter to Leo Stein [signed in 1948]" and "Collection of Curt Valentin").
2. Zervos 1954 (VI 621).
3. According to private sources, the work was bequeathed to Perry T. Rathbone by Curt Valentin.

282. *Cuckold,* 1904
Ink on paper
8¼ x 8¹¹⁄₁₆ in. (21 x 22 cm)
Current location unknown
Zervos VI 622

Provenance
Leo and Gertrude Stein, Paris (in or after 1905, and owned jointly until 1913/1914); Gertrude Stein, Paris (1913/1914 until 1946; thereafter, her estate and Alice Toklas[1]); Galerie Louise Leiris, Paris (1954[2])

Notes
1. Paris 1954, no. 5.
2. Zervos 1954 (VI 622).

283. *The Concierge,* 1904
Ink on paper
11⁷⁄₁₆ x 15⅜ (29 x 39 cm)
Current location unknown
Zervos VI 624

Provenance
Leo and Gertrude Stein, Paris (in or after 1905, and owned jointly until 1913/1914); Gertrude Stein, Paris (1913/1914 until 1946; thereafter, her estate and Alice Toklas[1]); Galerie Louise Leiris, Paris (1954[2])

Notes
1. Paris 1954, no. 4.
2. Zervos 1954 (VI 624).

284. *La Belle qui passe,* 1904
Ink on paper
11½ x 15¾ in. (29.2 x 40 cm)
The Museum of Modern Art, New York, gift of Mr. and Mrs. Daniel Saidenberg
Zervos VI 625

Provenance
Leo and Gertrude Stein, Paris (in or after 1906, and owned jointly until 1913/1914); Gertrude Stein, Paris (1913/1914 until[1] 1946; thereafter, her estate and Alice Toklas[2]); Galerie Louise Leiris, Paris (1954[3]); Curt Valentin Gallery, New York (acquired 1954[4]); Mr. and Mrs. Daniel Saidenberg, New York (by 1970[5] until 1977); Museum of Modern Art, New York, gift of Mr. and Mrs. Daniel Saidenberg, 1977

Notes
1. G. Stein 1938, 169 (ill.).
2. Paris 1954, no. 2.
3. Zervos 1954 (VI 625).
4. *La Belle qui passe* is listed as no. 52463, 20 x 40 cm, 1904, $250 on a page titled "Dessins de Picasso," probably from 1954, in the business records of Curt Valentin. MoMA Archives, Curt Valentin Papers, Series VII, "Business Records," Subseries A.1, "Kahnweiler bills (1952-54)."
5. Potter 1970, 164.

285. *The Couple*, 1904
Charcoal on paper, signed lower left
13⁹/₁₆ x 10¹/₁₆ in. (34.5 x 25.5 cm)
Current location unknown
Zervos VI 661

Provenance

Leo and Gertrude Stein, Paris (in or after 1905, and owned jointly until 1913/1914); Gertrude Stein, Paris (1913/1914 until 1946; thereafter, her estate and Alice Toklas¹); Galerie Louise Leiris, Paris (1954²)

Notes

1. Paris 1954, no. 10 (ill.).
2. Zervos 1954 (VI 661).

286. *Mother and Child*, 1904
Sepia wash on paper, signed and dated lower right
14¼ x 10¼ in. (36.2 x 26 cm)
Current location unknown

Provenance

Leo Stein, Paris; Mr. and Mrs. Cornelius J. Sullivan, New York (possibly by 1933,¹ until 1937²)

Notes

1. Mrs. Cornelius J. Sullivan owned at least eight Picasso works on paper that had formerly belonged to Leo Stein, at least four of which were exhibited in Springfield 1933: nos. 123, 124, 176, 177.
2. His estate and her property sale, American Art Association, New York, April 29 - May 1, 1937, lot no. 201 (ill.) (as "Mother and Child," formerly "Collection of Leo Stein").

287. Study for *The Actor*, 1904-5
Graphite on paper
19 x 12½ in. (48.3 x 31.8 cm)
Private collection
Zervos VI 681
Plate 69

Provenance

Leo and Gertrude Stein, Paris (in or after 1905, and owned jointly until 1913/1914); Gertrude Stein, Paris (1913/1914 until 1946; thereafter, her estate and Alice Toklas¹); Galerie Louise Leiris, Paris²; Curt Valentin, New York; Nelson A. Rockefeller, New York (by 1957³); Harold Diamond, New York; Sidney Cohn, New York (until May 1992); Stanley J. Seeger (until November 1993)

Notes

1. Paris 1954, no. 19 (ill.).
2. Zervos 1954 (VI 681).
3. Oslo 1956, no. 12 (ill., as "Etude pour 'L'Acteur' et deux portraits de Fernande," 1905, 38.5 x 32.5 [cm], Z.VI 681, "Private collection, New York"); and New York 1957, no. 24 (ill., as "Study for 'The Actor' with profiles of Fernande," lent by "Nelson A. Rockefeller, New York").

288. *Profile of a Young Boy*, 1905
Ink and gouache on cardboard
17½ x 14³/₈ in. (44.5 x 36.5 cm)
Current location unknown
Zervos I 216
Plates 346, 353, 354, 358, 359

Provenance

Leo and Gertrude Stein, Paris (in or after 1905 [pl. 346], and owned jointly until [pls. 353, 354] 1913/1914); Gertrude Stein, Paris (1913/1914 until [pls. 358, 359] later¹); Pablo Picasso, Paris (probably before 1932¹ and until 1973; thereafter, his estate²)

Notes

1. Zervos 1932 (I 216) does not indicate the current owner.
2. Picasso Succession no. 12060.

289. *The Milk Bottle*, 1905
Gouache on cardboard
24⁵/₈ x 17¾ in. (62.5 x 45.1 cm)
The Museum of Fine Arts, Houston, gift of Oveta Culp Hobby
Zervos I 227
Plates 67, 347, 352, 354

Provenance

Leo and Gertrude Stein, Paris (acquired by late 1906 or early 1907¹ [pl. 347], and owned jointly until [pl. 352] 1913/1914); Gertrude Stein, Paris (1913/1914 until [pl. 355] later); Pierre Matisse Gallery, New York (until 1945³); Mrs. Oveta Culp Hobby, Houston (by 1970,² until 1984³); Museum of Fine Arts, Houston (by 1984³)

Notes

1. Wineapple 1996, 207-8.
2. Potter 1970, 164.
3. Information provided by Rebecca A. Dunham, Museum of Fine Arts, Houston.

290. *Strolling Player and Child*,ᴬ 1905
Gouache and pastel on cardboard
27¾ x 20½ in. (70.5 x 52 cm)
The National Museum of Art, Osaka
Zervos I 295
Plate 178

Provenance

Michael and Sarah Stein, Paris (by 1907ᴬ); Stephen C. Clark, New York (1931/32¹,² until 1960³,⁴); thereafter, Mrs. Stephen C. Clark⁵); Mrs. Robert P. Hutchins, Manchester, Vermont (1970⁶); Susan Clark Lefferts, Middleburg, Virginia (until 1976⁷); Gallery Knoedler, New York, and Nichido Gallery, Japan (1976); The National Museum of Art, Osaka (1978)

A. This work appears in a photograph of an unknown location in an album of photographs owned by Annette Rosenshine. Annette Rosenshine papers, BANC PIC 1964.049-.050—ALB, The Bancroft Library, University of California, Berkeley.

Notes

1. New York 1931, no. 19 (ill., as "Deux Harlequins, Lent anonymously").
2. Zervos 1932 (I 295) notes the owner as "Collection Clark, New York."
3. New Haven 1960, no. 192 (ill.; "Lent by Stephen C. Clark").
4. Stephen Carlton Clark (August 29, 1882 - September 17, 1960).
5. New York 1966, no. 126 ("Lent by Mrs. Stephen C. Clark").

6. Potter 1970, 166.
7. Sales catalogue, Sotheby's, New York, October 20, 1976, lot no. 10 (ill.), as "Property of Susan Clark Lefferts, Middleburg, Virginia."

291. *The Acrobat Family*, 1905
Watercolor, gouache, and ink on paper
41 x 29½ in. (104 x 75 cm)
Gothenburg Museum of Art, Sweden
Zervos I 299
Plates 22, 363, 365

Provenance

Clovis Sagot, Paris; Leo and Gertrude Stein, Paris (owned jointly in 1905,¹⁻⁴ and possibly owned later by Michael and Sarah Stein, Paris [pls. 363, 365]); Conrad Pineus, Gothenburg, Sweden (until 1922)

Notes

1. L. Stein 1996, 169, describes the present work and notes that it was acquired from Clovis Sagot in 1905.
2. Cowling et al. 2002, 363, dates the acquisition of this work to spring 1905 at the moment when "Leo Stein discovers the work of Picasso at the Galeries Serrurier (February 25 - March 6, 1905) and buys *Acrobat's Family with a Monkey* from Clovis Sagot."
3. Barcelona 1992, 162-63, dates the acquisition to between October 18 and November 2, 1905, and claims this to be "the first work to be purchased by Leo and Gertrude Stein."
4. The present work clearly appears to have been acquired by November 1905, and is likely one of the two Picasso works, with *Girl with a Basket of Flowers* (1905; pl. 9, cat. 232), that Leo mentions in a letter dated November 29, 1905, to Mabel Weeks. Beinecke YCAL, MSS 78, box 1, folder 51-69.

292. *Monkey*, 1905
Pen and black ink and brush and black wash on paper
7¹⁵/₁₆ x 7³/₈ in. (20.1 x 18.8 cm)
The Baltimore Museum of Art, Baltimore, Maryland, bequest of Dr. Grace McCann Morley, New Delhi, India, in Memory of Sarah Stein

Provenance

Michael and Sarah Stein, Paris (probably until 1938; thereafter, Sarah Stein, Palo Alto)¹,²; Grace McCann Morley²

Notes

1. The Steins owned the gouache of this subject: *The Acrobat's Family* (1905; cat. 291), which was purchased by Leo and Gertrude and later hung in the rue Madame apartment of Michael and Sarah. This sketch, thought to have belonged to Michael and Sarah, is one of three sections of a single sheet from 1905, which on both sides reveals preliminary studies for the gouache. This larger sheet of drawings was divided in three parts at an unknown date but has been reassembled by the Baltimore Museum and is now exhibited in a single frame. In its reconstituted form, one side displays

several studies of a monkey, including the present example, as well as two framed sketches for the acrobat's family. The other depicts two preparatory sketches from 1905: *Mother Kissing Child with Standing Woman* and *Circus Family with Violinist* (both Baltimore Museum of Art).
2. The present ink drawing is the only one of these three parts with a known Stein provenance (it was later gifted to Grace McCann Morley). However, it was exhibited in the New York 1970 exhibition as having been part of the collection of Michael and Sarah Stein alongside *Mother Kissing Child with Standing Woman* and *Circus Family with Violinist*. Potter 1970, 165.

293. *The Jester's Family*, 1905
Ink, colored pencil, and wash on paper
6½ x 4⅞ in. (16.5 x 12.4 cm)
Current location unknown
Zervos XXII 158

Provenance

Fernande Olivier, Paris (acquired from the artist[1]); Sarah Stein, Paris (1911[2] until at least February 1947[3] and before December 1951[4]); Mrs. Robert Woods Bliss, Washington, D.C.

Notes

1. The work is inscribed at top right: "Pour Fernande, Pablo."
2. J. Richardson 1991, 343.
3. Following a 1947 visit to Sarah Stein in Palo Alto, Fiske Kimball described her collection: "I recall… beautiful Picasso drawings and prints of the *Saltimbanques* & Harlequin period, especially one of Fernande with the baby they never had—marvelously drawn, as only Raphael could draw a child & Madonna (I am sure consciously)—with Harlequin-Picasso playing a guitar [*sic*] in the background. This drawn by Picasso for Fernande after a quarrel, & later given by Fernande to Sarah Stein." +9
4. Fiske Kimball discusses the recent sales from the collection of Sarah Stein in a letter dated December 11, 1951, to Sturgis Ingersoll: "The beautiful Raphael-like drawing by Picasso (blue period), with himself as a harlequin and Fernande with the baby they never had, went by the board to rescue Danny." PMA Kimball Papers.

294. *Head of a Boy*, 1905
Opaque matte paint on composition board
9⅝ x 7⁵⁄₁₆ in. (24.6 x 18.6 cm)
The Cleveland Museum of Art, bequest of Leonard C. Hanna, Jr.
Zervos I 303
Plates 72, 351, 355

Provenance

Leo and Gertrude Stein, Paris (acquired from the artist, and owned jointly until [pl. 351] 1913/1914); Gertrude Stein, Paris (1913/1914 and probably until [pl. 355] at least November 1937[1,2]); Horst Bohrmann, Berlin[3]

Notes

1. George 1931 illustrates six Picasso drawings between 58 and 59, of which two are owned by Gertrude. For the present work, the caption information is printed in French ("Tête d'homme") and English ("A Man's Head. [Photo Gal. Simon]").
2. New York 1937, no. 4 (ill., as "Tete de Garçon, 1905; Collection Gertrude Stein").
3. Daix and Boudaille 1966 (XV 7).

295. *Equitation*, 1905
Pen on paper
12½ x 16 in. (31.8 x 40.7 cm)
Current location unknown
Zervos XXII 261

Provenance

Gertrude Stein and Alice Toklas, Paris (until 1946[1]; thereafter, Alice Toklas[2]); Galerie Rosengart, Lucerne[1]; J. Westheimer, Cincinnati[3]

Notes

1. A similar work (Zervos XXII 263), possibly from the collection of Gertrude Stein, was later sold to Galerie Rosengart. Both works relate to the series of four drawings of horses and riders (Zervos XXII 258, 259, 260, and 262) in the Cone collection.
2. On March 23, 1948, Alice Toklas wrote to Donald Gallup: "[T]here are two lovely drawings that belong to me—a nude on a horse—and two nudes—one with a fan—do you remember them. Well I want Yale to have them and if I can get them over the sooner the better." Toklas 1973, 109. The two drawings are identified here for the first time as Zervos XXII 261 (the present work) and Zervos VI 875 (*Two Standing Nudes* [1906; cat. 342]).
3. Daix and Boudaille 1966 (XII 12) establishes the provenance of the work's first three owners.

296. *Equestrienne*, 1905
Pen on paper, signed lower left
9¼ x 12 in. (23.5 x 30.5 cm)
Current location unknown
Zervos XXII 263

Provenance

Possibly Gertrude Stein, Paris[1]; Galerie Rosengart, Lucerne; private collection, Switzerland[2]

Notes

1. A similar work (Zervos XXII 261) from the collection of Gertrude Stein was later sold to Galerie Rosengart; although unproven to date, Stein ownership is possible. Both works relate to the series of four drawings of horses and riders (Zervos XXII 258, 259, 260, and 262) in the Cone Collection.
2. Daix and Boudaille 1966 (XII 13) cites Galerie Rosengart as the earliest known provenance.

297. *Two Men Posing*, 1905
Ink on paper
9⁷⁄₁₆ x 12⅝ in. (24 x 32 cm)
Current location unknown
Zervos VI 629 [This work is the verso of *Four Nude Men*, unidentified]

Provenance

Leo and Gertrude Stein, Paris (in or after 1905, and owned jointly until 1913/1914); Gertrude Stein, Paris (1913/1914 until 1946; thereafter, her estate and Alice Toklas[1]); Galerie Louise Leiris, Paris (1954[2]); Picard Collection (by 1970[3])

Notes

1. Paris 1954, no. 12 (as "Quatre hommes nus, au verso, deux hommes posant").
2. Zervos 1954 (VI 629).
3. Potter 1970, 166.

298. *Standing Nude*, 1905
Graphite on paper, signed in 1937
24¹¹⁄₁₆ x 18¹⁄₁₆ in. (62.7 x 45.9 cm)
The Museum of Art, Rhode Island School of Design, Providence, gift of Mrs. Murray S. Danforth
Zervos VI 645

Provenance

Leo and Gertrude Stein, Paris (in or after 1905[2] until 1913/1914); Leo Stein, Settignano (1913/1914 until ca. 1937[1]); unknown American intermediary; Pierre Matisse, New York (ca. 1937–43[1,2]); Museum of Art, Rhode Island School of Design (1943[3])

Notes

1. A document for this work indicates the information as recorded here. MoMA Archives, Potter 9b.
2. According to Emily Peters at RISD: "On the original intake form, there is a reference to a July 8, 1943 letter from Pierre Matisse stating that he bought the drawing through an American intermediary from Leo Stein, who had it probably since the date of execution, about 1905…. Apparently it was unsigned at the time Matisse bought the drawing from Stein; Matisse took the drawing to Picasso and asked him to sign it, which he did." Emily Peters, e-mail message to author, November 2009.
3. Princeton 1949, no. 8 (ill., as "Standing Nude [signed in 1937]" lent by "Rhode Island School of Design").

299. *Study of Men, Woman, and Bull*, 1905
Ink on paper
13³⁄₁₆ x 10¼ in. (33.5 x 26 cm)
Current location unknown
Zervos VI 655

Provenance

Leo and Gertrude Stein, Paris (in or after 1905, and owned jointly until 1913/1914); Gertrude Stein, Paris (1913/1914 until 1946; thereafter, her estate and Alice Toklas[1]); Galerie Louise Leiris, Paris (1954[2]); Nelson Rockefeller Collection[3]

Notes

1. Paris 1954, no. 17.
2. Zervos 1954 (VI 655).
3. According to Margaret Potter Papers at MoMA Archives (Potter, 9d), the work was "purchased by N[elson] A. R[ockefeller] from Curt Valentin."

300. *Acrobats with Monkey*, 1905
Ink on paper, signed lower left
11¼ x 7¼ in. (28.5 x 18.5 cm)
Olivier Berggruen, New York
Zervos VI 656

Provenance

Leo and Gertrude Stein, Paris (in or after 1905, and owned jointly until 1913/1914); Gertrude Stein, Paris (1913/1914 until 1946[1]; thereafter, her estate and Alice Toklas[2]); Galerie Louise Leiris, Paris (1954[3]), the Hanover Gallery, London[4]; Ella Winter, London (before 1961[4])

Notes

1. The Picasso drawing is one of two illustrations reproduced in *Formes* (George 1931, 56; see also cat. 313); captions for both read: "Gertrude Stein Collection." The illustrations accompany an article titled "Fifty Years of Picasso and the Death of the Still-Life" by Waldemar George.
2. Paris 1954, no. 24 (ill.).
3. Zervos 1954 (VI 656).
4. Sales catalogue, Sotheby's, London, June 20, 2006, lot no. 138, lists the former owner(s) as noted.

301. *Two Men*, 1905
Pen and ink on paper laid on board, signed lower left
9⅛ x 12½ in. (23.2 x 31.8 cm)
Current location unknown
Zervos VI 658; Online Picasso Project 05.357

Provenance

Leo and Gertrude Stein, Paris (in or after 1905, and owned jointly until 1913/1914); Gertrude Stein, Paris (1913/1914 until 1946; thereafter, her estate and Alice Toklas[1]); Galerie Louise Leiris, Paris (1954[2]), Galerie des Etats-Unis, Cannes (by 1961[3]); Dr. Paul Brody, Nice[3]

Notes

1. Paris 1954, no. 16 (ill.).
2. Zervos 1954 (VI 658).
3. Online Picasso Project 05.357 notes the former owner(s) as listed above.

302. *The Fencer*, 1905
Ink on paper
9½ x 12⅝ in. (24 x 32 cm)
Current location unknown
Zervos VI 659 [this work is possibly the verso of *The Dance* (cat. 303)]

Provenance

Leo and Gertrude Stein, Paris (in or after 1905, and owned jointly until 1913/1914); Gertrude Stein, Paris (1913/1914 until 1946; thereafter, her estate and Alice Toklas[1]); Galerie Louise Leiris, Paris (1954[2])

Notes

1. Paris 1954, no. 14 (as "La danse, au verso, l'escrimeur").
2. Zervos 1954 (VI 659).

303. *The Dance*, 1905
Ink on paper
9½ x 12⅝ in. (24 x 32 cm)
Current location unknown
Zervos VI 724 [this work is possibly the recto of *The Fencer* (cat. 302)]

Provenance

Leo and Gertrude Stein, Paris (in or after 1905, and owned jointly until 1913/1914); Gertrude Stein, Paris (1913/1914 until 1946; thereafter, her estate and Alice Toklas[1]); Galerie Louise Leiris, Paris (1954[2])

Notes

1. Paris 1954, no. 14 (as "La danse, au verso, l'escrimeur").
2. Zervos 1954 (VI 724).

304. *Three Nude Men*, 1905
Ink on paper
9¼ x 12⅜ in. (23.5 x 31.5 cm)
Current location unknown
Zervos VI 664

Provenance

Leo and Gertrude Stein, Paris (in or after 1905, and owned jointly until 1913/1914); Gertrude Stein, Paris (1913/1914 until 1946; thereafter, her estate and Alice Toklas until 1954[1]); Galerie Louise Leiris, Paris (1954[2])

Notes

1. Paris 1954, no. 22.
2. Zervos 1954 (VI 664).

305. *Self-Portrait and Nudes*, 1905
Ink on paper
9½ x 12⅝ in. (24 x 32 cm)
Current location unknown
Zervos VI 666 [verso was once *Three Men Posing* (cat. 306)]

Provenance

Leo and Gertrude Stein, Paris (in or after 1905, and owned jointly until 1913/1914); Gertrude Stein, Paris (1913/1914 until 1946; thereafter, her estate and Alice Toklas[1]); Galerie Louise Leiris, Paris (1954[2]); H. Arnold Steinberg, Montreal (by 1970[3])

Notes

1. Paris 1954, no. 13 (sheet now divided: recto, "Portrait de Picasso et nus" [the present work]; verso, "Trois hommes posant" [1905; cat. 306]).
2. Zervos 1954 (VI 666).
3. Potter 1970, 166.

306. *Three Men Posing*, 1905
9½ x 12⅝ in. (24 x 32 cm)
Ink on paper
Current location unknown
Zervos VI 671 [recto was once *Self-Portrait and Nudes* (cat. 305)]

Provenance

Leo and Gertrude Stein, Paris (in or after 1905, and owned jointly until 1913/1914); Gertrude Stein, Paris (1913/1914 until 1946; thereafter, her estate and Alice Toklas until 1954[1]); Galerie Louise Leiris, Paris (1954[2])

Notes

1. Paris 1954, no. 13 (sheet now divided: recto, "Portrait de Picasso et nus" [1905; cat. 305]; verso, "Trois hommes posant" [the present work]).
2. Zervos 1954 (VI 671).

307. *Three Men Running*, 1905
Ink on paper
9 x 12³⁄₁₆ in. (23 x 31 cm)[2]
Current location unknown
Zervos VI 668

Provenance

Leo and Gertrude Stein, Paris (in or after 1905, and owned jointly until 1913/1914); Gertrude Stein, Paris (1913/1914 until 1946; thereafter, her estate and Alice Toklas, at least until 1954[1]); Galerie Louise Leiris, Paris (1954[2]); Peter Simonsen, Oslo (by 1956[3])

Notes

1. Paris 1954, no. 21.
2. Zervos 1954 (VI 668).
3. Oslo 1956, no. 11 (ill., as "Trois hommes," 1905, lent by "Peter Simonsen, Oslo").

308. *Leo Stein*, 1905
Ink on tracing paper, signed upper right
6¼ x 4½ in. (15.9 x 11.4 cm)
Philadelphia Museum of Art: The Louis E. Stern Collection, 1963
Zervos VI 673
Plate 80

Provenance

Leo [and Gertrude] Stein, Paris (probably owned jointly until 1913/1914; thereafter, Leo Stein)[1]; Curt Valentin, New York; Louis E. Stern,[2] New York (by 1952)[3]

Notes

1. One of five Picasso portraits of Leo Stein (drawings on paper) noted in an undated inventory of his collection. Beinecke YCAL, MSS 78, box 13, folder 347.
2. Louis E. Stern (1886–1962).
3. Philadephia 1964, no. 120 (as former "Collections Leo Stein; Curt Valentin, New York [sold February–March, 1952]").

309. *Leo Stein*, ca. 1905–6
Ink on paper, signed upper right
6¾ x 4¼ in. (17.15 x 10.8 cm)
Current location unknown
Zervos VI 674

Provenance

Leo [and Gertrude] Stein, Paris (probably owned jointly until 1913/1914; thereafter, Leo Stein[1]); Curt Valentin, New York (1954[2]); Mrs. Jerome B. Rocherolle, Stamford (by 1970[3])

Notes

1. One of five Picasso portraits of Leo Stein (drawings on paper) noted in an undated inventory of his collection. Beinecke YCAL, MSS 78, box 13, folder 347.
2. Zervos 1954 (VI 674) lists the owner as "Coll. Curt Valentin." One of the three portraits of Leo Stein, works on paper, that were still owned by Curt Valentin in 1954.
3. Potter 1970, 28 (ill.), "Collection Mrs. Jerome B. Rocherolle, Stamford, Connecticut," and 167.

310. *Leo Stein*, 1905
Ink on paper, signed upper right
12½ x 9⅜ in. (31.8 x 23.8 cm)
Castellani Art Museum of Niagara University Collection, gift of Dr. and Mrs. Armand J. Castellani, 1998
Zervos VI 675
Plate 78

Provenance

Leo [and Gertrude] Stein, Paris (probably owned jointly until 1913/1914; thereafter, Leo Stein[1,2]); Buchholz Gallery, New York (1949[3])/Curt Valentin, New York (1954[4]); Justin K. Thannhauser, New York (until September 26, 1961[5]); David Douglas Duncan (by September 26, 1961[5])

Notes

1. One of five Picasso portraits of Leo Stein (drawings on paper) noted in an undated inventory of his collection. Beinecke YCAL, MSS 78, box 13, folder 347.

2. Sales catalogue, Sotheby's, London, June 3, 1982, lot no. 117, lists provenance as: "Michael and Sarah Stein, San Francisco; Curt Valentin, New York; J. K. Thannhauser, New York; Mr. David Douglas Duncan." The provenance listed in this sales catalogue appears to be an error because, as noted above, this work appears in an inventory of Leo Stein's collection.
3. Princeton 1949, no. 11 (ill., as "Leo Stein, 1905 [signed in 1948]…Collection of the Buchholz Gallery").
4. Zervos 1954 (VI 675) lists the owner as "Coll. Curt Valentin." One of the three portraits of Leo Stein, works on paper, that were still owned by Curt Valentin in 1954.
5. Sales catalogue, Christie's, London, June 27, 1989, lot no. 149A, provenance listed as: "Curt Valentin, New York; Justin K. Thannhauser, New York (40296), by whom given to David Douglas Duncan on 26 September 1961." The work was acquired by Dr. and Mrs. Armand J. Castellani at this sale. Kathleen Fraas, Castellani Art Museum, conversation with Carrie Pilto, April 4, 2011.

311. *Leo Stein (Sitting and Smoking)*, ca. 1905
Ink on paper
Current location unknown
Zervos VI 678

Provenance

Leo [and Gertrude] Stein, Paris (probably owned jointly until 1913/1914; thereafter, Leo Stein[1]); Curt Valentin, New York (1954[2])

Notes

1. One of five Picasso portraits of Leo Stein (drawings on paper) noted in an undated inventory of his collection. Beinecke YCAL, MSS 78, box 13, folder 347.
2. Zervos 1954 (VI 678) lists the owner as "Coll. Curt Valentin." One of the three portraits of Leo Stein, works on paper, that were still owned by Curt Valentin in 1954.

312. *Leo Stein*, 1905
Ink on paper laid on card
6¼ x 5¾ in. (16 x 14.5 cm)
Current location unknown
Zervos VI 680

Provenance

Leo [and Gertrude] Stein, Paris (probably owned jointly until 1913/1914; thereafter, Leo Stein[1]); [Bucholz Gallery, New York/Curt Valentin, New York; Saidenberg, New York[3]]; Mrs. Alma Morgenthau, New York (1954[2,3]); Anne Wertheim Werner, New York (until 1996[3])

Notes

1. One of five Picasso portraits of Leo Stein (drawings on paper) noted in an undated inventory of his collection. Beinecke YCAL, MSS 78, box 13, folder 347.
2. Zervos 1954 (VI 680).
3. Sales catalogue, Christie's, New York, November 11, 1996, lot no. 261, as "Property from the Estate of Anne Wertheim Werner."

313. *Family of Harlequins,* 1905
Ink on paper
7 x 8⅞ in. (17.8 x 22.5 cm)
Private collection, Los Angeles
Zervos VI 690

Provenance

Leo and Gertrude Stein, Paris (in or after 1905, and owned jointly until 1913/1914); Gertrude Stein, Paris (1913/1914 until 1946[1]; thereafter, her estate and Alice Toklas[2]); Georges E. Seligmann [and Edna H. Seligmann], New York (1947 until 1982[2]); private collection, London; private collection, Los Angeles

Notes

1. The Picasso drawing is one of two illustrations reproduced in *Formes* (George 1931, 56; see also cat. 300); captions for both read: "Gertrude Stein Collection." The illustrations accompany an article titled "Fifty Years of Picasso and the Death of the Still-Life" by Waldemar George.
2. Sales catalogue, Sotheby's, New York, November 4, 1982, "Drawings and Paintings Collected by Georges E. Seligmann: Property from the Estate of Mrs. Edna H. Seligmann," lot no. 12. See +32

314. *Sheet of Studies,* 1905
Ink on paper
6½ x 4½ in. (16.5 x 11.5 cm)
Current location unknown
Zervos VI 695

Provenance

Leo and Gertrude Stein, Paris (in or after 1905, and owned jointly until 1913/1914); Gertrude Stein, Paris (1913/1914 until 1946; thereafter, her estate and Alice Toklas until 1954[1]); Galerie Louise Leiris, Paris (1954[2])

Notes

1. Paris 1954, no. 11.
2. Zervos 1954 (VI 695).

315. *Six Circus Horses with Riders,* 1905
Pen and black ink on paper laid on cardboard
9¾ x 12⅞ in. (24.7 x 32.7 cm)
The National Gallery of Art, Washington, D.C., gift of Walter H. and Leonore Annenberg, in Honor of the 50th Anniversary of the National Gallery of Art
Zervos VI 716[A]

Provenance

Leo Stein, Paris[1,2]; Henry Kleeman (1949)[2,3]; Bucholz Gallery, New York/Curt Valentin,[2,3] New York; Curtis O. Baer[4]; by descent to Dr. and Mrs. George Baer[5]; National Gallery of Art, Washington, D.C. (gift of Walter H. and Leonore Annenberg, in Honor of the 50th Anniversary of the National Gallery of Art, 1990)[5]

A. A similar study of horses (cat. 316) remained in the collection of Gertrude Stein and was exhibited in Paris 1954 (no. 18).

Notes

1. One of at least nineteen drawings by Picasso noted in an undated inventory of Leo Stein's collection. Beinecke YCAL, MSS 78, box 13, folder 347.
2. Cambridge 1958, no. 53 (as "Sketches of Six Circus Horses, Some with Riders," former "Collections: Leo Stein; Henry Kleeman; acquired through Curt Valentin").

3. Princeton 1949, no. 4 (as "Horsemen," lent by "Collection of Henry Kleemann"); and Iowa City 1951, no. 212 (as "Studies of Horses. Lent by Buchholz Gallery, Inc., New York").
4. Atlanta 1985, no. 90.
5. Information provided by the online collection database National Gallery of Art [nga.gov], accessed June 3, 2010.

316. *Study of Horses,* 1905
Ink on paper
11⅝ x 16⅛ in. (29.5 x 41 cm)
Current location unknown
Zervos VI 717[A]

Provenance

Leo and Gertrude Stein, Paris (in or after 1905, and owned jointly until 1913/1914); Gertrude Stein, Paris (1913/1914 until 1946; thereafter, her estate and Alice Toklas[1]), Galerie Louise Leiris, Paris (1954[2])

A. A similar study of horses (cat. 315) was formerly in the collection of Leo Stein.

Notes

1. Paris 1954, no. 18.
2. Zervos 1954 (VI 717).

317. *Nude Woman Arranging Her Hair,* 1905
Ink on paper, signed lower left
9½ x 6⅛ in. (24 x 15.5 cm)
Current location unknown
Zervos VI 737

Provenance

Leo and Gertrude Stein, Paris (in or after 1905, and owned jointly until 1913/1914); Gertrude Stein, Paris (1913/1914 until 1946; thereafter, her estate and Alice Toklas[1]); Galerie Louise Leiris, Paris (1954[2]); Ragnar Moltzau, Oslo (by 1956[3])

Notes

1. Paris 1954, no. 20 (ill.).
2. Zervos 1954 (VI 737).
3. Oslo 1956, no. 8 (ill., as "Femme nue, se coiffant," 1905, lent by "Ragnar Moltzau, Oslo").

318. *Woman with Arms Raised,* 1905
Ink on paper, signed lower left
15⅝ x 10⅞ in. (39.7 x 27.6 cm)
Current location unknown
Zervos VI 739

Provenance

Gertrude Stein, Paris; Perls Galleries, New York; Walter P. Chrysler Jr., New York (probably until at least 1954[1])[2]; Hugo Gallery, New York[3]; Gustav Zumsteg, Zurich (at least by March 1959[4] until later, perhaps 1988[4]); Christie's, London, June 22, 1993, lot no. 151; Christie's, London, July 2, 1998, lot. no. 249

Notes

1. Zervos 1954 (VI 739).
2. Entire provenance established by Richmond 1941, no. 210 (as "Nu aux bras levés…Collection: Gertrude Stein, Paris; Perls Galleries, New York").
3. Earlier provenance corroborated and additional provenance as indicated, sales catalogue, Christie's, London, July 2, 1998, lot. no. 249.

4. Paris 1959, no. 182 (as "Femme nue debout, Dessin à la plume, H. 0,60; L. 0,43; Signé en bas, à gauche: Picasso. Collection Gustav Zumsteg, Zurich"). The work is illustrated and noted as "Collection Gustav Zumsteg, Zurich" in Daix, Boudaille, and Rosselet 1988, 90.

319. *Two Studies of Female Nudes*, ca. 1905-6
Pen and black ink on paper
11 x 15¹⁵⁄₁₆ in. (28 x 40.5 cm)
Princeton University Art Museum. Museum purchase, Laura P. Hall Memorial Fund
Zervos VI 740

Provenance

Leo and Gertrude Stein, Paris; Klooman Galleries; Dan Fellows Platt[1,2] (before 1938); Princeton University Art Museum (before 1949[3])

Notes

1. Princeton 1972, no. 69, establishes the provenance as noted: "Gertrude Stein, Leo Stein; Klooman Galleries; Dan Fellows Platt (Lugt 750a)."
2. Dan Fellows Platt (1873-1938).
3. Princeton 1949, no. 6 (ill., as "Le Bain," lent by "Princeton University").

320. *Two Giants*, 1905
India ink on paper
12⅝ x 8⅝ in. (32 x 21.9 cm)
Current location unknown
Zervos VI 797

Provenance

Leo and Gertrude Stein, Paris (in or after 1905, and owned jointly until 1913/1914); Gertrude Stein, Paris (1913/1914 until 1946; thereafter, her estate and Alice Toklas[1]); Galerie Louise Leiris, Paris (1954[2]); Jan Krugier, Geneva (by 1970[3])

Notes

1. Paris 1954, no. 23.
2. Zervos 1954 (VI 797).
3. Potter 1970, 166 (as "Collection Jan Krugier, Geneva").

321. *Guillaume Apollinaire*, 1905
India ink on paper
12¼ x 9½ in. (31.1 x 24.1 cm)
Private collection, Paris
Zervos XX 286

Provenance

Gertrude Stein, Paris; Lionel Prejger, Paris[1]

Notes

1. Daix and Boudaille 1966 (XII 24) establishes early provenance.

322. *Head of a Woman in Profile,* 1905
Pen and black ink, brush and gray wash on paper
7³⁄₁₆ x 5½ in. (18.2 x 13.9 cm)
The Baltimore Museum of Art: The Cone Collection, formed by Dr. Claribel Cone and Miss Etta Cone of Baltimore, Maryland
Zervos XXII 126

Provenance

Perhaps Michael and Sarah Stein, Paris[1]; Leo and Gertrude Stein, Paris (probably owned jointly until 1913/1914); Gertrude Stein, Paris (1913/1914 until probably 1931[2]); Etta Cone, Baltimore (by 1934[3] until 1950); Baltimore Museum of Art (1950)

Notes

1. Potter 1970, 165.
2. *Formes* (George 1931) illustrated six Picasso drawings between pages 58 and 59, of which two were owned by Gertrude. The caption information for the present work is printed in French ("Femme. Dessin. [Col. Gertrude Stein]") and English ("Woman. Drawing. [Gertrude Stein. Collection]"). For this reason, the work is probably not one of the fourteen unidentified Picasso drawings acquired by Etta Cone in 1930. See +33
3. Published as part of the Cone collection by Cone 1934.

323. *Nude with Hair Pulled Back*, 1905
Gouache on cardboard, signed lower right
21⅝ x 19¹¹⁄₁₆ in. (55 x 50 cm)
Current location unknown
Zervos I 259

Provenance

Leo and Gertrude Stein, Paris (until before 1932[1,2]); Galerie Vildrac, Paris (before 1982[3]); private collection[4] (until 1999[3])

Notes

1. Raynal 1921, no. 26 (ill.), does not indicate the owner. The photograph was provided by Galerie Simon.
2. Zervos 1932 (I 259) lists provenance as "Anc. coll. Stein. Paris."
3. Sales catalogue, Christie's, New York, November 9, 1999, lot no. 515 (ill.), notes provenance as: "Gertrude Stein, Paris; Galerie Vildrac, Paris; Anon sale, Sotheby's, New York, 20 May 1982, lot 214; acquired at the sale by the present owner."
4. Daix 2003, fig. nos. 40, 49, 166 (as "Nu à la chevelure tirée, collection particulière").

324. *Allan Stein*, 1906
Gouache on cardboard
29⅛ x 23½ in. (74 x 59.7 cm)
The Baltimore Museum of Art: The Cone Collection, formed by Dr. Claribel Cone and Miss Etta Cone of Baltimore, Maryland
Zervos I 35
Plates 179, 363

Provenance

Michael and Sarah Stein, Paris (probably acquired after November 1906,[1] and owned jointly until [pl. 363] 1938; thereafter, Sarah Stein, Palo Alto, until at least February 1947[2]); Allan Stein, Palo Alto (until August 1949[3]); Etta Cone, Baltimore (August 1949[3] until 1950); Baltimore Museum of Art (1950)

Notes

1. The work is thought to have been commissioned as a July 1906 birthday gift to Sarah (Sarah Samuels Stein was born July 26, 1870). As the Steins were absent from Paris between May and November 1906, the acquisition was likely after this date. Potter 1970, 168.
2. In a letter dated February 25, 1947, Fiske Kimball describes his visit with Sarah Stein: "The Picasso's fewer [than the number of Matisse works], but wonderful—above all the half length of Mrs. Stein's son Allen [*sic*] (Gertrude's executor)—even finer than Eddie Warburg's somewhat similar portrait of a boy, blue period—very spiritual and strong at the same time." PMA Kimball Papers.
3. Purchased in August 1949 and by 1950, the Cone Collection at the Baltimore Museum of Art. Carlson 1976, 56-57.

325. *Leo Stein*, 1906
Opaque watercolor on cardboard
9¾ x 6¾ in. (24.8 x 17.2 cm)
The Baltimore Museum of Art: The Cone Collection, formed by Dr. Claribel Cone and Miss Etta Cone of Baltimore, Maryland
Zervos I 250
Plates 33, 355

Provenance

Leo [and Gertrude] Stein, Paris (acquired as a gift from the artist to Leo after 1906,[1] until 1913/1914[2]); Gertrude Stein, Paris (1913/1914 until [pl. 355] September 14, 1932[3]); Etta Cone, Baltimore (acquired September 14, 1932,[1,3] until 1950); Baltimore Museum of Art (1950)

Notes

1. Purchased in September 1932 and by 1950 in the Cone Collection at the Baltimore Museum of Art. Carlson 1976, 58-59.
2. On February 13, 1955, Alice Toklas wrote to Donald Gallup: "Leo's portrait was a gift from Picasso to Leo. At the division he [Leo] didnt want it (he was bitter even about that) so it remained at the rue de Fleurus until Gertrude sold it to the Cones." Toklas 1973, 315-16.
3. Brenda Richardson (1985, 186) notes the exact date of acquisition: September 14, 1932.

326. Study for *Boy Leading a Horse*, 1905-6
Watercolor on paper, signed lower right
19¾ x 12¹⁵⁄₁₆ in. (50.1 x 32.8 cm)
The Baltimore Museum of Art: The Cone Collection, formed by Dr. Claribel Cone and Miss Etta Cone of Baltimore, Maryland
Zervos XXII 270

Provenance

Michael and Sarah Stein, Paris (in or after 1906 until 1925); Etta Cone, Baltimore (possibly in 1925[1] and before 1934,[2] until 1950); Baltimore Museum of Art (1950)

Notes

1. Possibly exhibited in Baltimore 1925 as no. 88 ("Horse and Boy [wash drawing]"), as cited in Carlson 1976, 44-45.
2. Cone 1934, plate 109(b); by 1950, the Cone Collection at the Baltimore Museum of Art, according to BMA records.

327. Study for *The Watering Place*, 1906
Charcoal on paper
11⅝ x 18 in. (29.5 x 45.7 cm)
Current location unknown
Zervos XXII 266[A]

Provenance

Leo Stein, Paris; J. B. Neumann, New York[1]; Adolph and Sam A. Lewisohn, New York (until May 1939[2]); Walter P. Chrysler Jr., New York (acquired in May 1939[2]); Roland, Browse and Delbanco, London (1970[3]); Philippe Altenloh, Brussels (before 1981[4]); Stanley J. Seeger (1981[4] until 1993[5])

A. This work relates to Picasso's *The Watering Place* (Zervos I 265), which was acquired for the Dial collection in 1923 and is now in the Metropolitan Museum of Art. Two related studies (Zervos VI 269 and VI 270) are in the Cone Collection, Baltimore Museum of Art.

Notes

1. In a letter dated February 23, 1930, Leo Stein (42 avenue du Parc Montsouris, Paris) writes to Mabel Weeks: "I don't know any of the NY dealers except for J. B. Neumann who sold some Picassos for me." Beinecke YCAL, MSS 78, box 3, folders 51-59.
2. Their sale, Parke-Bernet Galleries, New York, May 16, 1939, *From the collection of the late Adolph Lewisohn and from the collection of Sam A. Lewisohn*, lot no. 214 (ill.), accompanied "With a MS. authentication stating 'Ce dessin est bien de moi,' signed by Picasso and dated 'Paris, 28 Mars '38,' which will be given to the purchaser."
3. Zervos 1970 (XXII 266).
4. Sales catalogue, Sotheby's, London, April 1, 1981, lot no. 171.
5. His sale, Sotheby's, New York, November 4, 1993, lot. no. 412 (ill.), establishes the earlier provenance as noted here.

328. *Seated Female Nude*, 1906
Pen and ink on paper
16 x 11⁹⁄₁₆ in. (40.6 x 29.3 cm)
Current location unknown
Zervos VI 460[A]

Provenance

Leo and Gertrude Stein, Paris (in or after 1906, and owned jointly until 1913/1914); Gertrude Stein, Paris (1913/1914 until 1946; thereafter, her estate and Alice Toklas[1]); Mr. and Mrs. Georges E. Seligmann (possibly in 1947[1] until probably 1998[2]); Leon Mandell III[3] and/or the Leon Mandell III Trust until 2005[1]

A. Composition in reverse of a similar drawing (also in the Stein collection) of a seated male nude, Study for *Two Youths* (1906; cat. 329), a preparatory work for the painting *Two Youths* (1900; National Gallery of Art, Washington, D.C.).

Notes

1. Sales catalogue, Sotheby's, New York, November 3, 2005, lot no. 242 (ill.), indicates that the work is accompanied by a letter from Alice Toklas. It is not known whether this work was among the other works Mr. and Mrs. Georges E. Seligmann acquired from Alice Toklas in 1947 (cf. Sotheby's, New York, November 4, 1982; see +32). The present work is not one of the six works in the 1982 Seligmann sale.
2. Georges E. Seligmann (1896-1998).
3. Leon Mandell III (1928-2002) was Mrs. Edna H. Seligmann's son from a previous marriage.

329. Study for *Two Youths*,[1] ca. 1906
Crayon on paper
10⅛ x 6⅞ in. (25.7 x 17.5 cm)
Current location unknown

Provenance

[Leo and] Gertrude Stein, Paris (perhaps owned jointly until 1913/1914); Gertrude Stein, Paris (1913/1914 until 1946; thereafter, her estate); Nelson A. Rockefeller, New York (1970[2])

A. Composition in reverse of similar drawing also in the Stein collection, *Seated Female Nude* (1906, cat. 328).

Notes

1. *Two Youths* (1906; National Gallery of Art, Washington, D.C.).
2. Potter 1970, 168.

330. Study for *Woman with Loaves*,[1] 1906
Graphite on paper, signed lower right
23¾ x 15¾ in. (60.3 x 40 cm)
Current location unknown

Provenance

Leo and Gertrude Stein, Paris (in or after 1906, until 1908[2]); Mrs. Moses H. Cone (acquired in 1908[2]); Dr. and Mrs. Allan Roos (as noted in 1951[2])

Notes

1. *Woman with Loaves* (1906; Philadelphia Museum of Art).
2. New Haven and Baltimore 1951, no. 28 (as "Lent by Dr. and Mrs. Allan Roos"). However, this information is disclaimed in a note in the Margaret Potter Papers written in the preparation for the exhibition *Four Americans in Paris* (New York 1970). MoMA Archives, Margaret Potter Papers, Potter 9b.

331. Study for *Woman Combing Her Hair*, 1906
Graphite and charcoal on paper
11⅞ x 8⅝ in. (30.2 x 21.9 cm)
Hegewisch Collection at the Hamburger Kunsthalle, Hamburg, Germany
Zervos VI 751
Plate 76

Provenance

Leo and Gertrude Stein, Paris (in or after 1906, and owned jointly until 1913/1914); Gertrude Stein, Paris (1913/1914 until 1946; thereafter, her estate and Alice Toklas[1]); Georges E. Seligmann [and Edna H. Seligmann], New York (1947 until 1982[1]); Klaus-Bernt Hegewisch, Hamburg

Notes

1. Sales catalogue, Sotheby's, New York, *Drawings and Paintings Collected by Georges E. Seligmann: Property from the Estate of Mrs. Edna H. Seligmann*, November 4, 1982, lot no. 9. See +32

332. *Head of Fernande*,[A] 1905-6
Gouache and watercolor on paper
23½ x 16 in. (59.8 x 40.5 cm)
Current location unknown

Provenance

Leo and Gertrude Stein, Paris; Mme Robert Grange, Paris; Galerie Rosengart, Lucerne[1]

A. This work on paper closely relates to two works owned by Leo and Gertrude Stein: Picasso's *Nude with Joined Hands* (1906; cat. 237) and *Standing Nude* (1905; cat. 298).

Notes

1. Barcelona 1992. Entire provenance established by this exhibition catalogue.

333. *Standing Nude, Hands Clasped*, 1906
Conté crayon on paper, signed lower left
24½ x 18⅝ in. (62.2 x 47.3 cm)
Current location unknown
Zervos VI 779
Plate 359

Provenance

Gertrude Stein, Paris [pl. 359]; Perls Galleries, New York; Walter P. Chrysler Jr. (by 1941,[1] and until before 1956[2]); Mr. and Mrs. Leigh B. Block, Chicago (at least by 1962[3])

Notes

1. Richmond 1941, no. 211 (as "Nu aux mains jointes, Collection: Gertrude Stein, Paris; Perls Galleries, New York").
2. Paris 1956 (ill., noted as "Autrefois collection Walter P. Chrysler Jr.").
3. New York 1962, no. 6 (as "Standing Nude…Mr. and Mrs. Leigh B. Block, Chicago").

334. *Head of a Woman*, 1906
Ink on paper
12 x 9¼ in. (30.5 x 23.5 cm)
Current location unknown
Zervos VI 788

Provenance

Leo and Gertrude Stein, Paris (in or after 1906, and owned jointly until 1913/1914); Gertrude Stein, Paris (1913/1914 until 1946; thereafter, her estate and Alice Toklas[2]); Georges E. Seligmann [and Edna H. Seligmann], New York (1947 until 1982[1,2])

Notes

1. New York 1962, no. 7 (as "Head of a Woman…Mr. and Mrs. Georges E. Seligmann, New York").
2. Sales catalogue, Sotheby's, New York, *Drawings and Paintings Collected by Georges E. Seligmann: Property from the Estate of Mrs. Edna H. Seligmann*, November 4, 1982, lot no. 13. See +32

335. *Nude Woman Standing*, 1906
India ink and watercolor on paper, signed upper right
8¼ x 5⅛ in. (21 x 13 cm)
Current location unknown
Zervos VI 836

Provenance

Leo and Gertrude Stein, Paris (in or after 1906, and owned jointly until 1913/1914); Gertrude Stein, Paris (1913/1914 until 1946; thereafter, her estate and Alice Toklas[1]); Galerie Louise Leiris, Paris (1954[2]); Justin K. Thannhauser, New York[3]

Notes

1. Paris 1954, no. 25 (ill.).
2. Zervos 1954 (VI 836).
3. Sales catalogue, Christie's, New York, November 10, 1994, part II, lot no. 186, lists former owner as noted here.

336. *Three Nudes with Arms Raised*, 1906
Ink on paper, signed lower left
11⅝ x 15¹⁵⁄₁₆ in. (29.5 x 40.5 cm)
Current location unknown
Zervos VI 845

Provenance

Leo and Gertrude Stein, Paris (in or after 1906, and owned jointly until 1913/1914); Gertrude Stein, Paris (1913/1914 until 1946; thereafter, her estate and Alice Toklas[1]); Galerie Louise Leiris (1954[2])

Notes

1. Paris 1954, no. 37 (ill.).
2. Zervos 1954 (VI 845).

337. *Mother and Child*,[1] 1906
Ink on paper, signed lower right
11¹³⁄₁₆ x 14⁹⁄₁₆ in. (30 x 37 cm)
Current location unknown
Zervos VI 846

Provenance

Leo and Gertrude Stein, Paris (in or after 1906, and owned jointly until 1913/1914); Gertrude Stein, Paris (1913/1914 until 1946; thereafter, her estate and Alice Toklas[1]); Galerie Louise Leiris, Paris (by 1954[2])

Notes

1. Paris 1954, no. 32 (ill.).
2. Zervos 1954 (VI 846).

338. *Flower*, 1906
Pencil on paper
12¼ x 9⅜ in. (31 x 24 cm)
Current location unknown
Zervos VI 862

Provenance

Leo and Gertrude Stein, Paris (in or after 1906, and owned jointly until 1913/1914); Gertrude Stein, Paris (1913/1914 until 1946; thereafter, her estate and Alice Toklas[1]); Galerie Louise Leiris, Paris (1954[2])

Notes

1. Paris 1954, no. 30.
2. Zervos 1954 (VI 862).

339. *Study of Hands*, 1906
Pencil on paper
7⅞ x 4¹⁵⁄₁₆ in. (20 x 12.5 cm)
Current location unknown
Zervos VI 863

Provenance

Leo and Gertrude Stein, Paris (in or after 1906, and owned jointly until 1913/1914); Gertrude Stein, Paris (1913/1914 until 1946; thereafter, her estate and Alice Toklas[1]); Galerie Louise Leiris, Paris (1954[2])

Notes

1. Paris 1954, no. 26.
2. Zervos 1954 (VI 863).

340. *Boy on Horseback*, 1906
Ink on paper
16 x 12¾ in. (41.5 x 30 cm)[2]
Current location unknown
Zervos VI 864

Provenance

Leo and Gertrude Stein, Paris (in or after 1906, and owned jointly until 1913/1914); Gertrude Stein, Paris (1913/1914 and 1946; thereafter, her estate and Alice Toklas[1]); Galerie Louise Leiris, Paris (1954[2]); Curt Valentin, New York, or Nelson A. Rockefeller, New York (by 1956)[3]

Notes

1. Paris 1954, no. 34.
2. Zervos 1954 (VI 864).
3. Oslo 1956, no. 32 (as "Garçon à cheval," 1906 [42 x 33 (cm), Zervos VI 864], lent by "Private collection, New York").

341. *Pigs*, 1906
Pencil and India ink
8⁷⁄₁₆ x 10¹³⁄₁₆ in. (21.5 x 27.5 cm)
Current location unknown
Zervos VI 873

Provenance

Leo and Gertrude Stein, Paris (in or after 1906,[1] and owned jointly until 1913/1914); Gertrude Stein, Paris (1913/1914 until 1946; thereafter, her estate and Alice Toklas[2]); Galerie Louise Leiris, Paris (by 1954[3])

Notes

1. "She [Gertrude Stein] was always fond of pigs, and because of this Picasso made and gave her some charming drawings of the prodigal son among the pigs." G. Stein 1990, 89.

2. Paris 1954, no. 29.
3. Zervos 1954 (VI 873).

342. *Two Standing Nudes*, 1906
Graphite on paper, signed lower right
25³⁄₁₆ x 18½ in. (64 x 47 cm)
Current location unknown
Zervos VI 875
Plate 359

Provenance

Gertrude Stein and Alice Toklas, Paris (possibly acquired in 1908,[1] and owned until [pl. 359] 1946; thereafter, Alice Toklas, Paris,[2] perhaps until 1954[3,4]); Galerie Berggruen/Galerie Louise Leiris,[3] Paris; César de Hauke, Paris (by May 1954[4,5]); Jacques Sarlie, New York (before 1960[6])

Notes

1. Acquisition date suggested by Edward Burns, who believes the present drawing was perhaps acquired at the same time as Picasso's *Café Scene* (1900; cat. 224), which Alice says was given to her in 1908. Edward Burns, e-mail message to author, May 26, 2010, and Toklas 1973, 164-67.
2. On March 23, 1948, Alice Toklas wrote to Donald Gallup: "[T]here are two lovely drawings that belong to me—a nude on a horse—and two nudes—one with a fan—do you remember them. Well I want Yale to have them and if I can get them over the sooner the better." Toklas 1973, 107-9. The two drawings are identified here for the first time as Zervos XXII 261 (*Equitation* [cat. 295]) and Zervos VI 875 (the present work).
3. Zervos 1954 (VI 875).
4. Paris 1954, no. 41 (ill., as collection "Collection César de Hauke").
5. Arles 1957, no. 13 (as "Deux nus debout [1906], mine de plomb sur papier, 63 x 46 cm [Z.VI 875]"). Although no lender is attributed, César de Hauke owned the work by 1954. Alice Toklas is among the noted lenders, however, and may have lent three works (nos. 19, 20, and 25) that were once owned by Gertrude and remained in her estate after 1946.
6. His sale, Sotheby's, London, October 12, 1960, lot no. 7 (ill.), for 3,800 British pounds to "Patch," based on published auction results. Provenance noted as former "Collection of Gertrude Stein; César de Hauke, Paris."

343. *The Swineherd,* 1906
Charcoal and ink on paper, signed upper right
8⅜ x 7¾ in. (21.3 x 19.7 cm)
The Museum of Modern Art, New York, gift of Mr. and Mrs. Daniel Saidenberg
Zervos VI 876

Provenance

Leo and Gertrude Stein, Paris (in or after 1906,[1] and owned jointly until 1913/1914); Gertrude Stein, Paris (1913/1914 until 1946; thereafter, her estate and Alice Toklas[2]); Galerie Louise Leiris, Paris (1954[3]); Curt Valentin Gallery, New York (acquired 1954[4]); Mr. and Mrs. Daniel Saidenberg, New York (by 1970[5] until 1977); Museum of Modern Art, New York (gift of Mr. and Mrs. Daniel Saidenberg, 1977)

Notes

1. "She [Gertrude Stein] was always fond of pigs, and because of this Picasso made and gave her some charming drawings of the prodigal son among the pigs." G. Stein 1990, 89.
2. Paris 1954, no. 28 (ill.).
3. Zervos 1954 (VI 876).

4. *The Swineherd* is listed as no. 52445, 21 x 20 [cm], 1906, $1,000 on a page entitled "Dessins de Picasso," probably from 1954 in the business records of Curt Valentin. MoMA Archives, Curt Valentin Papers, Series VII, "Business Records," Subseries A.1, "Kahnweiler bills (1952–54)."

5. Potter 1970, 168, pl. 34, and noted as "Collection Mr. and Mrs. Daniel Saidenberg, New York."

344. *Seated Nude, Seen from Back,* 1906
Ink on paper, signed lower left
16⅛ x 11¹³⁄₁₆ in. (41 x 30 cm)
Current location unknown
Zervos VI 878

Provenance
Leo and Gertrude Stein, Paris (in or after 1906, and owned jointly until 1913/1914); Gertrude Stein, Paris (1913/1914 until 1946; thereafter, her estate and Alice Toklas[1]); Galerie Louise Leiris, Paris (1954[2]); Mrs. Richard K. Weil, St. Louis (by May 1954[1])

Notes
1. Paris 1954, no. 36 (ill.).
2. Zervos 1954 (VI 878).

345. *Woman with Legs Raised,* 1906
Ink on paper
15¾ x 11⁷⁄₁₆ in. (40 x 29 cm)
Current location unknown
Zervos VI 879

Provenance
Leo and Gertrude Stein, Paris (in or after 1906, and owned jointly until 1913/1914); Gertrude Stein, Paris (1913/1914 until 1946; thereafter, her estate and Alice Toklas[1]); Galerie Louise Leiris, Paris (1954[2])

Notes
1. Paris 1954, no. 33.
2. Zervos 1954 (VI 879).

346. *Woman with Bare Torso,* 1906
Ink on paper, signed lower right
15⁹⁄₁₆ x 11⁷⁄₁₆ in. (39.5 x 29 cm)
Current location unknown
Zervos VI 880

Provenance
Leo and Gertrude Stein, Paris (in or after 1906, and owned jointly until 1913/1914); Gertrude Stein, Paris (1913/1914 until 1946; thereafter, her estate and Alice Toklas[1]); Galerie Louise Leiris, Paris (1954[2])

Notes
1. Paris 1954, no. 35 (ill.).
2. Zervos 1954 (VI 880).

347. *Reclining Nude,* 1906
Pen and ink on paper, signed lower right
12 x 16 in. (30.5 x 40.6 cm)
Current location unknown
Zervos VI 881

Provenance
Leo and Gertrude Stein, Paris (in or after 1906, and owned jointly until 1913/1914); Gertrude Stein, Paris (1913/1914 until 1946; thereafter, her estate and Alice Toklas[1]); Galerie Louise Leiris, Paris (1954[2]); Hilmar Reksten, Bergen, Norway (by 1956[3] until probably 1962[4])

Notes
1. Paris 1954, no. 39 (ill.).
2. Zervos 1954 (VI 881).
3. Oslo 1956, no. 28 (ill., as "Nu étendu, 1906 [31 x 41 (cm), Zervos VI 881] Hilmar Reksten, Bergen").
4. Sales catalogue, Sotheby's, London, *Impressionist and Modern Paintings, Drawings, and Sculpture,* July 4–5, 1962, lot no. 27, as formerly from "the Collections of Gertrude Stein and Alice B. Toklas. From Galerie Louise Leiris. Sold with a certificate from Daniel-Henry Kahnweiler, dated 24th May 1960." Owner not indicated.

348. *Three Nudes,* 1906
Ink on paper
12⁹⁄₁₆ x 9⅝ in. (31 x 41 cm)
Current location unknown
Zervos VI 882

Provenance
Leo and Gertrude Stein, Paris (in or after 1906, and owned jointly until 1913/1914); Gertrude Stein, Paris (1913/1914 until 1946; thereafter, her estate and Alice Toklas[1]); Galerie Louise Leiris, Paris (1954[2])

Notes
1. Paris 1954, no. 38.
2. Zervos 1954 (VI 882).

349. *Portrait of a Man,* 1906
Ink on paper
12⅝ x 9⅝ in. (32 x 24.5 cm)
Current location unknown
Zervos VI 884

Provenance
Leo and Gertrude Stein, Paris (in or after 1906, and owned jointly until 1913/1914); Gertrude Stein, Paris (1913/1914 until 1946; thereafter, her estate and Alice Toklas[1]); Galerie Louise Leiris, Paris (1954[2]); John S. Thatcher[3]; John K. Havemeyer (before 1995[3])

Notes
1. Paris 1954, no. 31 (ill.).
2. Zervos 1954 (VI 884).
3. Sales catalogue, Sotheby's, New York, November 9, 1995, lot no. 416, lists John S. Thatcher as the first private collector to acquire this work, after Gertrude Stein and Alice Toklas ownership.

350. *Standing Nude and Head in Profile,* 1906
Graphite on paper
12¼ x 9⅛ in. (31.5 x 23.5 cm)
Richard and Mary L. Gray, Chicago
Zervos VI 886
Plate 75

Provenance
Leo and Gertrude Stein, Paris (in or after 1906, and owned jointly until 1913/1914); Gertrude Stein, Paris (1913/1914 until 1946; thereafter, her estate and Alice Toklas[1]); Mr. and Mrs. Georges E. Seligmann (by 1947 until 1982[1]); Acquavella Gallery

Notes
1. Sales catalogue, Sotheby's, New York, *Drawings and Paintings Collected by Georges E. Seligmann: Property from the Estate of Mrs. Edna H. Seligmann,* November 4, 1982, lot no. 11. See +32

351. *Seated Woman,* 1906
Ink on paper, signed upper right
7⅞ x 5½ in. (20 x 14 cm)
Current location unknown
Zervos VI 1463

Provenance
Leo and Gertrude Stein, Paris (in or after 1906, and owned jointly until 1913/1914); Gertrude Stein, Paris (1913/1914 until 1946; thereafter, her estate and Alice Toklas[1]); Galerie Louise Leiris, Paris (1954[2]); Richard K. Weil, St. Louis (until at least 1986[3])

Notes
1. Paris 1954, no. 27 (ill.).
2. Zervos 1954 (VI 1463).
3. Basel 1986 no. 45 (ill., as "Femme assise, 1906, Collection Richard K. Weil, St. Louis").

352. *Profile Bust of Nude Woman,* 1906
Pen and black ink on paper
10¹³⁄₁₆ x 7⁵⁄₁₆ in. (27.4 x 18.6 cm)
The Baltimore Museum of Art: The Cone Collection, formed by Dr. Claribel Cone and Miss Etta Cone of Baltimore, Maryland
Zervos XXII 394

Provenance
Michael and Sarah Stein, Paris [and possibly Leo and Gertrude Stein, Paris] (before 1930[1]); Etta Cone, Baltimore (probably 1930,[1,2] until 1950); Baltimore Museum of Art (1950)

Notes
1. Perhaps one of the fourteen unidentified Picasso drawings acquired by Etta Cone in 1930. See +33
2. Cone 1934, pl. 107(a).

353. *Two Nudes,*[A] 1906
Charcoal on paper
24½ x 18 in. (62.2 x 45.7 cm)
The Museum of Fine Arts, Houston, gift of Oveta Culp Hobby
Plate 73

A. Similar in subject to Zervos XXII 409, 411; the latter is a gouache.

Provenance
Leo and Gertrude Stein, Paris (in or after 1906, and owned jointly until[1] 1913/1914); Gertrude Stein, Paris (1913/1914 until later); Pierre Matisse Gallery, New York[3]; Oveta Culp Hobby, Houston (before 1970,[2] until December 23, 1958[3]); Museum of Fine Arts, Houston (by December 23, 1958[3])

Notes

1. The artwork appears in a photograph of the atelier at rue de Fleurus taken ca. 1910. Department of Nineteenth-Century, Modern, and Contemporary Art, The Metropolitan Museum of Art, New York, gift of Edward Burns, 2011.
2. Potter 1970, 168-69.
3. Information provided by Rebecca A. Dunham, Museum of Fine Arts, Houston.

354. Study for *La Toilette*, 1906
Watercolor, signed lower left
10 x 6½ in. (25.5 x 16.5 cm)
Current location unknown
Zervos XXII 433

Provenance

Leo Stein, Paris; Mrs. Cornelius J. Sullivan, New York (at least by 1933,[1] until December 1939[2]); Walter P. Chrysler Jr., New York (December 1939[3,4])

Notes

1. Springfield 1933, no. 124. Mrs. Cornelius J. Sullivan owned at least eight Picasso works on paper that had formerly belonged to Leo Stein, at least four of which (nos. 123, 124, 176, 177) appear in Springfield 1933.
2. Her sale, Parke-Bernet Galleries, New York, December 6-7, 1939, no. 143 (as "Study for La Toilette," watercolor, 10 x 6½ in., formerly "Collection of Leo Stein, Paris").
3. Listed in "Recent Auction Prices," *American Art News*, December 16, 1939: "143 Pablo Picasso: Study for La Toilette, watercolor, Walter P. Chrysler, Jr., 1350 [US dollars]." Archival document, Jean Outland Chrysler Library, Norfolk, Chrysler Museum of Art.
4. Richmond 1941, no. 207 (as "Study for 'La Toilette,'" formerly collection of "Leo Stein, Paris; Mrs. Cornelius J. Sullivan, New York").

355. Letter to Leo Stein with study for *The Peasants*, 1906
Ink on paper
7 x 8⅞ in. (18 x 22.5 cm)
Yale Collection of American Literature, Beinecke Rare Book and Manuscript Library, Yale University, New Haven
Zervos XX 349

Provenance

Leo [and Gertrude] Stein, Paris (August 1906, and owned jointly until 1913/1914; thereafter, Gertrude Stein, Paris, until 1946; thereafter, her estate); Yale Collection of American Literature, Beinecke Rare Book and Manuscript Library, Yale University

356. *Reclining Nude Woman*, 1906
Black chalk with stumping on paper
18⅜ x 24½ in. (46.6 x 62.2 cm)
The Baltimore Museum of Art: The Cone Collection, formed by Dr. Claribel Cone and Miss Etta Cone of Baltimore, Maryland
Zervos XXII 463

Provenance

Michael and Sarah Stein, Paris [and possibly Leo and Gertrude Stein, Paris] (before 1930); Etta Cone (1930[1,2] until 1950); Baltimore Museum of Art (1950)

Notes

1. Purchased in 1930, according to BMA records, and published as part of the Cone collection in Cone 1934, plate 103(b).
2. Perhaps one of the fourteen unidentified Picasso drawings acquired by Etta Cone in 1930. See +33

357. *Head and Figure Studies*, 1906
Conté crayon on paper
24 x 17¾ in. (61 x 45.1 cm)
Museum of Fine Arts, Boston, Arthur Tracy Cabot Fund
Zervos XXII 467
Plate 77

Provenance

Leo Stein[1], Paris; Pierre Matisse Gallery, New York (until 1963)[2,3]; Werner Drewes, St. Louis (until February 13, 1963[3]); Museum of Fine Arts, Boston (Arthur Tracy Cabot Fund, 1963)

Notes

1. Likely one of at least nineteen drawings by Picasso noted in an undated inventory of Leo Stein's collection. Beinecke YCAL, MSS 78, box 13, folder 347.
2. Daix and Boudaille 1966 (XVI 21) establishes first two owners.
3. Information provided by the online collection database Museum of Fine Arts, Boston [mfa.org], accessed June 3, 2010.

358. *Landscape*, 1907
Gouache on paper
25⁹⁄₁₆ x 19¹¹⁄₁₆ in. (65 x 50 cm)
Current location unknown
Zervos II** 691
Plate 356

Provenance

Leo and Gertrude Stein, Paris (in or after 1907, and owned jointly until 1913/1914); Gertrude Stein, Paris (1913/1914 until [pl. 356] later); Galerie Simon, Paris[1]; Dr. Gottlieb Friedrich Reber, Lausanne (before 1939)[1]; Pablo Picasso (by 1970[2])

Notes

1. Galerie Simon inv. no. 8431. Sales catalogue, Christie's, London, June 29, 1981, lot no. 37 (ill.).
2. Potter 1970, unpaged (94), photograph of "Studio of Gertrude Stein, 27 Rue de Fleurus, Paris. Winter 1914/15." The work is noted as belonging to Picasso.

359. *Bust of a Young Man*, 1907
Ink on paper
12⅜ x 9¹⁄₁₆ in. (31.5 x 23 cm)
Current location unknown
Zervos VI 854

Provenance

Leo and Gertrude Stein, Paris (in or after 1907, and owned jointly until 1913/1914); Gertrude Stein, Paris (1913/1914 until 1946; thereafter, her estate and Alice Toklas[2]); Galerie Louise Leiris, Paris (1954[3])

Notes

1. G. Stein 1938, 13 (ill.).
2. Paris 1954, no. 40 (ill. cover).
3. Zervos 1954 (VI 854).

360. *Untitled (Head in Profile)*, 1907
Graphite on paper
5⅛ x 7⅛ in. (13 x 18 cm)
The Menil Collection, Houston
Zervos VI 907
Plate 220

Provenance

Leo and Gertrude Stein, Paris (in or after 1907, and owned jointly until 1913/1914); Gertrude Stein, Paris (1913/1914 until 1946; thereafter, her estate and Alice Toklas[1]); Galerie Louise Leiris, Paris (1954[2]), Curt Valentin Gallery, New York; Jan Mitchell, New York (until 1974[3]); Menil Foundation, Inc. (1974[3])

Notes

1. Paris 1954, no. 42.
2. Zervos 1954 (VI 907).
3. Sales catalogue, Sotheby's, New York, October 23, 1974, lot no. 127.

361. *Sketch of André Salmon*, 1907
Charcoal on paper
24¾ x 18¾ in. (63 x 47.6 cm)
The Menil Collection, Houston

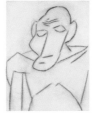

Provenance

Leo and Gertrude Stein, Paris (in or after 1908,[1] and owned jointly until 1913/1914); Gertrude Stein, Paris (1913/1914 until February 1921); Galerie Kahnweiler, Paris (February 1921 until later); David Thompson, Pittsburgh; Hannover Gallery, London (by 1958); Alexander Iolas, New York; Paul Rosenberg, New York; Sidney Janis Gallery, New York; John and Dominique de Menil, Houston (1959 until 1998); Menil Collection (in 1998)[2]

Notes

1. The drawing appears in the artist's atelier in the Bateau-Lavoir in a photograph dated 1908. Paris 1988, 545.

2. Entire provenance established by The Menil Collection, Houston. This is the only source for the Stein provenance.

362. *Pitcher, Jar, and Lemon*, 1907
Gouache on paper
11⅞ x 9⅜ in. (31.2 x 24.3 cm)
Gecht Family Collection
Daix and Rosselet 67[A]
Plates 208, 355, 382

Provenance

Leo and Gertrude Stein, Paris (probably acquired in autumn 1907,[1] and owned jointly until 1913/1914); Gertrude Stein, Paris (1913/1914 until [pls. 355, 382] 1946; thereafter, her estate and Alice Toklas[2]); David and Peggy Rockefeller, New York (December 14, 1968, until October 1972[3]); E. V. Thaw & Co., New York; Gecht Family Collection

A. One of at least fourteen works (sheet 1) from Picasso's Carnet 10—a sketchbook from June–July 1907 for *Les Demoiselles d'Avignon* and *Nude with Drapery*—which the Steins owned. +34

Notes

1. Purchased from the artist in autumn 1907. Seckel 1988, 260, and Daix and Rosselet 1979, no. 67.
2. Arles 1957, no. 20 (ill., plate no. 10, as "Broc, pot et citron," [été 1907], gouache et encre de chine sur papier rentoilé, 31 x 24 cm"). No owner is attributed, but Alice Toklas is among the noted lenders. Of the four possible loans by Toklas to this exhibition (nos. 13, 19, 20, 25), at least three remained in the collection of Gertrude Stein until her death and went into the Gertrude Stein estate, in which Alice Toklas had a life interest.
3. Exchanged for Picasso's Study for *Nude with Drapery* (1907; cat. 367). Potter 1984, vol. 1, 263.

363. *Nez quart de Brie* (**Study for** *Les Demoiselles d'Avignon* **or** *Nude with Drapery*), 1907
Graphite on paper
11⅞ x 9⅜ in. (31.2 x 24 cm)
Hegewisch Collection at the Hamburger Kunsthalle, Hamburg, Germany
Zervos VI 968[A]
Plate 209

Provenance

Leo and Gertrude Stein, Paris (probably acquired in autumn 1907,[1] and owned jointly until 1913/1914); Gertrude Stein, Paris (1913/1914 until 1946; thereafter, her estate and Alice Toklas[2]); Georges E. Seligmann [and Edna H. Seligmann], New York (1947 until 1982[2]); Klaus-Bernt Hegewisch, Hamburg

A. One of at least fourteen works (sheet 2) from Picasso's Carnet 10—a sketchbook from June–July 1907 for *Les Demoiselles d'Avignon* and *Nude with Drapery*—which the Steins owned. +34

Notes

1. Seckel 1988, 260.
2. Sales catalogue, Sotheby's, New York, *Drawings and Paintings Collected by Georges E. Seligmann: Property from the Estate of Mrs. Edna H. Seligmann*, November 4, 1982, lot no. 11. See +32

364. *Head of a Woman*, 1907
Black pencil on paper
12 x 9¾ in. (31 x 24 cm)
Current location unknown[A]

Provenance

Leo and Gertrude Stein, Paris (probably acquired in autumn 1907,[1] and owned jointly until 1913/1914); Gertrude Stein, Paris (1913/1914 and probably until 1946; thereafter, her estate and Alice Toklas); Georges E. Seligmann [and Edna H. Seligmann], New York (1947 probably until 1985[2]); unnamed owner(s)[3,4]

A. One of at least fourteen works (sheet 3) from Picasso's Carnet 10—a sketchbook from June–July 1907 for *Les Demoiselles d'Avignon* and *Nude with Drapery*—which the Steins owned. +34

Notes

1. Seckel 1988, 260.
2. Sales catalogue, Sotheby's, New York, May 15, 1985, lot no. 165, as former collection of "Leo and Gertrude Stein, Paris (acquired from the artist); Alice Toklas, 1947; Georges E. Seligmann, New York." The work closely relates to Carnet 10 drawing no. 2 (cat. 363) (Seckel 1988), another Stein collection work from this sketchbook that Georges and Edna Seligmann purchased from Alice Toklas.
3. Sales catalogue, Champin-Lombrail-Gauthier, Enghien, November 19, 1988, lot 45.
4. Paris 1989, no. 30 (ill., reversed).

365. *Head of a Woman in Brown and Black*, 1907
Watercolor and gouache on paper mounted on panel
12⅛ x 9⅜ in. (30.8 x 23.8 cm)
Private collection
Zervos XXVI 268; Daix and Rosselet 86[A]
Plates 210, 355, 356, 384

Provenance

Leo and Gertrude Stein, Paris (probably acquired in autumn 1907,[1] and owned jointly until 1913/1914); Gertrude Stein, Paris (1913/1914 until [pls. 355, 356, 384] 1946; thereafter, her estate and Alice Toklas[2]); Nelson A. Rockefeller (December 14, 1968[3])

A. One of at least fourteen works (sheet 4) from Picasso's Carnet 10—a sketchbook from June–July 1907 for *Les Demoiselles d'Avignon* and *Nude with Drapery*—which the Steins owned. +34

Notes

1. Purchased from the artist in autumn 1907. Seckel 1988, 260, and Daix and Rosselet 1979, no. 86.
2. Arles 1957, no. 19 (as "Tête de femme (été 1907), gouache et encre de chine sur papier rentoilé, 31 x 24 cm, [Zervos XXVI 268]"). No owner is attributed, but Alice Toklas is among the noted lenders. Of the four possible loans by Toklas to this exhibition (nos. 13, 19, 20, 25), at least three remained in the collection of Gertrude Stein until her death and went into the Gertrude Stein estate, in which Alice Toklas had a life interest.
3. Purchased through the Museum of Modern Art Syndicate, 1968.

366. **Study for** *Nude with Drapery*, 1907
Tempera and watercolor on paper mounted on board
12³⁄₁₆ x 9⁷⁄₁₆ in. (31 x 24 cm)
Private collection
Daix and Rosselet 87[A]
Plates 211, 355

Provenance

Leo and Gertrude Stein, Paris (probably acquired in autumn 1907,[1] and owned jointly until 1913/1914); Gertrude Stein, Paris (1913/1914 until [pl. 355] 1946; thereafter, her estate); Nelson A. Rockefeller, New York (December 14, 1968[2]); private collection, London (after 1968)

A. One of at least fourteen works (sheet 5) from Picasso's Carnet 10—a sketchbook from June–July 1907 for *Les Demoiselles d'Avignon* and *Nude with Drapery*—which the Steins owned. +34

Notes

1. Purchased from the artist in autumn 1907. Seckel 1988, 260, and Daix and Rosselet 1979, no. 87.
2. Purchased through the Museum of Modern Art Syndicate, 1968.

367. **Study for** *Nude with Drapery*, 1907
Oil wash on paper mounted on canvas
12¾ x 9¾ in. (32.4 x 24.8 cm)
Current location unknown
Daix and Rosselet 88[A]
Plates 355, 384

Provenance

Leo and Gertrude Stein, Paris (probably acquired in autumn 1907,[1] and owned jointly until 1913/1914); Gertrude Stein, Paris (1913/1914 until [pls. 355, 384] 1946; thereafter, her estate); E. V. Thaw & Co., New York (December 14, 1968[2]); David and Peggy Rockefeller, New York (by October 1972,[3] until later)

A. One of at least fourteen works (sheet 6) from Picasso's Carnet 10—a sketchbook from June–July 1907 for *Les Demoiselles d'Avignon* and *Nude with Drapery*—which the Steins owned. +34

Notes

1. Purchased from the artist in autumn 1907. Seckel 1988, 260, and Daix and Rosselet 1979, no. 88.
2. Purchased through the Museum of Modern Art Syndicate, 1968.
3. Acquired through the exchange of Picasso's *Pitcher, Jar, and Lemon* (1907; cat. 362). Potter 1984, vol. 1, 263.

368. **Study of Head for** *Nude with Drapery*, 1907
Oil on paper
12¼ x 9½ in. (31.1 x 24.1 cm)
Nationalgalerie, Museum Berggruen, Staatliche Museen, Berlin
Daix and Rosselet 89[A]
Plates 355, 384

Provenance

Leo and Gertrude Stein, Paris (probably acquired in autumn 1907,[1] and owned jointly until 1913/1914); Gertrude Stein, Paris (1913/1914 until [pl. 355] at least 1938/1939 [pl. 384]); private collection, New York[2]; private collection, Tokyo[2]

A. One of at least fourteen works (sheet 7) from Picasso's Carnet 10—a sketchbook from June–July 1907 for *Les Demoiselles d'Avignon* and *Nude with Drapery*—which the Steins owned. +34

Notes

1. Purchased from the artist in autumn 1907. Seckel 1988, 260, and Daix and Rosselet 1979, no. 89.
2. Daix and Rosselet 89. Provenance as referenced by these authors.

369. Study for *Nude with Drapery,* 1907
Watercolor on paper mounted on canvas, signed later, bottom left
12³⁄₁₆ x 9⁷⁄₁₆ in. (31 x 24 cm)
Current location unknown
Daix and Rosselet 90[A]
Plate 355

Provenance

Leo and Gertrude Stein, Paris (probably acquired in autumn 1907,[1] and owned jointly until 1913/1914); Gertrude Stein, Paris (1913/1914 until at least 1915 [pl. 355]); Jacques Kahn, Paris[3]; Perls Galleries, New York[2]; Mrs. Robert F. Windfohr [later to be Mrs. Charles D. Tandy, and known as Anne V. Burnett Tandy], Fort Worth, Texas (May 1951[2] until 1981[3])

A. One of at least fourteen works (sheet 8) from Picasso's Carnet 10—a sketchbook from June-July 1907 for *Les Demoiselles d'Avignon* and *Nude with Drapery*—which the Steins owned. +34

Notes

1. Purchased from the artist in autumn 1907. Seckel 1988, 260, and Daix and Rosselet 1979, no. 90.
2. Daix and Rosselet 1979, no. 90, establishes provenance and acquisition dates as referenced.
3. Sotheby's, New York, *Property from the Estate of Anne Burnett Tandy, Fort Worth, Texas,* November 6, 1981, lot no. 511. Provenance includes "Jacques Kahn, Paris" as noted.

370. *Head in Three-Quarter View,* 1907
Gouache and watercolor on paper
11¾ x 9¼ in. (29.9 x 23.5 cm)
San Francisco Museum of Modern Art, bequest of Elise S. Haas
Daix and Rosselet 91[A]
Plate 212

Provenance

Michael and Sarah Stein, Paris (acquired 1907;[1] thereafter, Sarah Stein, Palo Alto, from 1938 until 1949); [Mr. and Mrs. Walter Haas] Elise S. Haas, San Francisco (1949[2,3] until 1991); San Francisco Museum of Modern Art (bequest of Elise S. Haas, 1991)

A. One of at least fourteen works (sheet 9) from Picasso's Carnet 10—a sketchbook from June-July 1907 for *Les Demoiselles d'Avignon* and *Nude with Drapery*—which the Steins owned. +34

Notes

1. Daix and Rosselet 1979, no. 91.
2. Per handwritten note from the records of Elise S. Haas, purchased in 1949 for $800. SFMOMA Permanent Collection Object File: 91.178.
3. Fiske Kimball discusses the recent sales from the collection of Sarah Stein in a letter dated December 11, 1951, to Sturgis Ingersoll: "They [Mr. and Mrs. Walter Haas] have…one of the small Picasso heads of about 1908, studies for his 'Demoiselles d'Avignon' of which Alice Toklas has a life interest in the others." PMA Kimball Papers.

371. Study for *Nude with Drapery,* 1907
Watercolor and gouache on paper
12³⁄₁₆ x 9⁵⁄₈ in. (31 x 24.5 cm)
Museo Thyssen-Bornemisza, Madrid
Daix and Rosselet 92[A]
Plates 213, 355, 384

Provenance

Leo and Gertrude Stein, Paris (probably acquired autumn 1907,[1] until 1913/1914); Gertrude Stein, Paris (1913/1914 until [pls. 355, 384] 1946; thereafter, her estate); Mr. and Mrs. Lionel Steinberg, Palm Springs (1968[2]); Galerie Berggruen, Paris (by 1973[3] and probably until July 1974[4])

A. One of at least fourteen works (sheet 10) from Picasso's Carnet 10—a sketchbook from June-July 1907 for *Les Demoiselles d'Avignon* and *Nude with Drapery*—which the Steins owned. +34

Notes

1. Purchased from the artist in autumn 1907. Seckel 1988, 260, and Daix and Rosselet 1979, no. 92.
2. Received through the Museum of Modern Art Syndicate, 1968, in lieu of payment, according to a conversation between SFMOMA curators and the son of Mr. and Mrs. Lionel Steinberg in April 2009.
3. Daix and Rosselet 1979, no. 92.
4. Sales catalogue, Sotheby's, London, July 3, 1974, lot no. 84 (as "Tête, former collection of Leo and Gertrude Stein; Mr. and Mrs. Lionel Steinberg, Palm Springs, California").

372. Study for *Nude with Drapery,* 1907
Watercolor and graphite on paper mounted on canvas, signed lower left
12 x 9¼ in. (30.5 x 23.5 cm)
Collection Morton and Linda Janklow, New York
Zervos II** 674; Daix and Rosselet 82[A]
Plates 214, 355

Provenance

Leo and Gertrude Stein, Paris (in or after 1907, and owned jointly until 1913/1914); Gertrude Stein, Paris (1913/1914 until at least 1915 [pl. 355]); Galerie Pierre, Paris[1,3]; Helena Rubinstein (until April 1966[2,4])

A. One of at least fourteen works (sheet 11) from Picasso's Carnet 10—a sketchbook from June-July 1907 for *Les Demoiselles d'Avignon* and *Nude with Drapery*—which the Steins owned. +34

Notes

1. Daix and Rosselet 1979, no. 82.
2. Her sale, Sotheby's, New York, April 20, 1966, lot no. 39.
3. Of the numerous studies on paper for *Nude with Drapery* (1907; State Hermitage Museum, Saint Petersburg, Zervos II* 47), this is one of at least two works (see also cat. 374) of identical size owned by Galerie Pierre, Paris, in 1961, when Zervos vol. II** was published.
4. One of at least two Stein works in the Rubinstein collection. See cat. 374.

373. Study for *Nude with Drapery,* 1907
Watercolor and Conté crayon on cardboard
12³⁄₁₆ x 9⁹⁄₁₆ in. (30.9 x 24.3 cm)
The Baltimore Museum of Art: The Cone Collection, formed by Dr. Claribel Cone and Miss Etta Cone of Baltimore, Maryland
Zervos II* 45; Daix and Rosselet 83[A]
Plate 215

Provenance

Leo and Gertrude Stein, Paris (in or after 1907, and owned jointly until 1913/1914); Paul Rosenberg, Paris[1]; Etta Cone, Baltimore (by 1934[2] until 1950); Baltimore Museum of Art (1950)

A. One of at least fourteen works (sheet 12) from Picasso's Carnet 10—a sketchbook from June-July 1907 for *Les Demoiselles d'Avignon* and *Nude with Drapery*—which the Steins owned. +34

Notes

1. Probably sold to Rosenberg at some point after 1918, when he started to work with Picasso.
2. Published as part of the Cone collection in Cone 1934, plate 64. Earlier provenance established by BMA records.

374. Study for *Nude with Drapery,* 1907
Gouache on paper mounted on canvas
12 x 9¼ in. (30.5 x 23.5 cm)
Private collection
Zervos II** 676; Daix and Rosselet 84[A]
Plates 216, 355

Provenance

Leo and Gertrude Stein, Paris (in or after 1907, and owned jointly until 1913/1914); Gertrude Stein, Paris (1913/1914 until at least 1915 [pl. 355]); Galerie Pierre, Paris (1961)[1,2]; Helena Rubinstein, New York (before 1966[1,3])

A. One of at least fourteen works (sheet 13) from Picasso's Carnet 10—a sketchbook from June-July 1907 for *Les Demoiselles d'Avignon* and *Nude with Drapery*—which the Steins owned. +34

Notes

1. Sales catalogue, Sotheby's, New York, *Modern Paintings, Drawings and Sculpture from the Estate of Sidney E. Cohn,* May 13-14, 1992, lot no. 10 (ill.) establishes the provenance as referenced.
2. Of the numerous studies on paper for *Nude with Drapery* (1907; State Hermitage Museum, Saint Petersberg, Zervos II* 47), this is one of at least two works (see also cat. 372) of identical size owned by Galerie Pierre, Paris, in 1961, when Zervos vol. II** was published.
3. One of at least two Stein works in the Rubinstein collection. See cat. 372.

375. Study for *Nude with Drapery,* 1907
Oil wash on paper mounted on canvas, signed lower left
12¾ x 9¾ in. (32.4 x 24.8 cm)
Collection Michael and Judy Steinhardt, New York
Zervos XXVI 265; Daix and Rosselet 85[A]
Plates 217, 355

Provenance

Leo and Gertrude Stein, Paris (in or after 1907, until 1913/1914); Gertrude Stein, Paris (1913/1914 until [pl. 355] later); Perls Galleries, New York[1]; Herbert and Nannette Rothschild, New York (1952[2] and until at least 1983[1]); Judith Rothschild, New York (until 1993[3]; thereafter, the Judith Rothschild Foundation until at least 1997[2])

A. One of at least fourteen works (sheet 14) from Picasso's Carnet 10—a sketchbook from June-July 1907 for *Les Demoiselles d'Avignon* and *Nude with Drapery*—which the Steins owned. +34

Notes

1. Paris 1983, 72, indicates addition to provenance as noted.

2. New York 1962, no. 57 (noted as "Lent by the Collection of Herbert and Nannette Rothschild"); Providence 1966, no. 119; and Washington, D.C. 1996, no. 67 (ill.), which indicates the provenance as recorded here and notes the 1953 date of acquisition.

3. Judith Rothschild died in 1993.

376. *Head of a Woman,* 1909
Watercolor on paper
19¾ x 13 in. (50 x 33 cm)
Current location unknown
Zervos II* 146

Provenance

Leo and Gertrude Stein, Paris (in or after 1909, and owned jointly until 1913/1914); Gertrude Stein, Paris (1913/1914 and later); Roger Dutilleul, Paris (by 1942[1])[2]

Notes

1. Zervos 1942 (II* 146) lists the owner as "Coll. R. Dutilleul, Paris."

2. Arles 1957, no. 25 (as "Tête de femme [1909], gouache sur papier marouflé, 50 x 33 cm, (II* 146)." No owner is given. One of four possible loans to the exhibition by Alice Toklas (nos. 13, 19, 20, and 25 were all works once in the Gertrude Stein collection; three remained in the Gertrude Stein estate); however, the present work was by this point no longer in the estate.

377. *Guitar on a Table,*[4] 1912
Charcoal on paper
19¼ x 25¼ in. (49 x 64.2 cm)
Private collection
Online Picasso Project 12.286[A]
Plate 359

Provenance

Gertrude Stein, Paris (in or after 1912, and owned until [pl. 359] 1946; thereafter, her estate[1]); Nelson A. Rockefeller (December 14, 1968, and later); Marlborough Gallery, New York (by 1970,[2] until the mid-1970s[3]); private collection (until 2004[3]); private collection

A. A closely related guitar work on paper was noted: Sales catalogue, Phillips, New York, May 7, 2001, lot no. 29.

Notes

1. No. 70.980 [Stein estate or loan number].

2. New York 1970, no. 53 (ill., incorrectly as vertically oriented work; as "Marlborough Gallery, Inc., New York").

3. Sales catalogue, Sotheby's, New York, May 6, 2004, lot no. 139, with the provenance as follows: "Gertrude Stein, Paris; Nelson Rockefeller, New York; Berggruen Gallery; Marlborough Gallery, Inc., New York; acquired from the above by the present owner in the mid-1970s." No other sources indicate the Berggruen ownership.

4. The present work is related to Picasso's *Guitar on a Table* (1912; cat. 263), which also remained in Gertrude's collection throughout her life.

378. *Study of a Violin,*[A] 1912
Crayon and charcoal on paper
18⅝ x 24⅝ in. (47.3 x 62.5 cm)
Current location unknown
Plate 359

Provenance

Gertrude Stein, Paris (in or after 1912, and until [pl. 359] 1946; thereafter, her estate); Nelson A. Rockefeller, New York (December 14, 1968,[1] until later); Marlborough Gallery, New York (by 1970[2]).

A. A closely related violin drawing was published: Portland 1997, fig. 13 (ill., as *Violin,* 1912, charcoal on paper, 24½ x 18½ in.).

Notes

1. Purchased through the Museum of Modern Art Syndicate, 1968.

2. New York 1970, 171.

379. *Segment of Pear, Wineglass, and Ace of Clubs,* 1914
Collage: Pasted colored paper, distemper (gesso), gouache, and graphite on cardboard
17¹⁵⁄₁₆ x 15³⁄₁₆ in. (45.5 x 38.5 cm)
Yale University Art Gallery, New Haven, The John Hay Whitney, B.A. 1926, Hon. M.A., 1956, Collection
Zervos II** 486
Plates 357–59

Provenance

Gertrude Stein, Paris (acquired in or after 1914, until [pls. 357–59] 1946; thereafter, her estate); John Hay Whitney, New York (December 14, 1968,[1] until 1982[2]); Yale University Art Gallery (1982[2])

Notes

1. Purchased through the Museum of Modern Art Syndicate, 1968.

2. Information provided by the online collection database Yale University Art Gallery [ecatalogue.art.yale.edu], accessed June 3, 2010.

380. *Dice, Packet of Cigarettes, and Visiting Card,* 1914
Graphite and pasted paper on paper
5½ x 8¼ in. (14 x 21 cm)
Yale Collection of American Literature, Beinecke Rare Book and Manuscript Library, Yale University, New Haven
Zervos II** 490

Provenance

Gertrude Stein, Paris[3] (acquired in or after 1914); Mrs. Charles B. Goodspeed [later to be Mrs. Gilbert W. Chapman], Chicago and New York (before 1939[1,2] until at least 1970[3]); Yale Collection of American Literature, Beinecke Rare Book and Manuscript Library, Yale University[4]

Notes

1. Daix and Rosselet, no. 661.

2. New York 1940, no. 116 (ill.), 85 (as "Still Life with a Calling Card (The Package of Cigarettes)…Lent by Mrs. Charles B. Goodspeed").

3. Potter 1970, 171, 172 (ill.).

4. Gift of Elizabeth F. Chapman, Beinecke YCAL records.

381. *Segment of Pear, Bunch of Grapes, and Pipe,* 1914
Oil and sand (or sawdust[2]) on paper
8 x 11½ in. (21 x 30 cm)
Current location unknown
Zervos II** 497
Plates 357, 358, 361

Provenance

Gertrude Stein, Paris (in or after 1914, probably until [pls. 357, 358, 361] 1946; thereafter, her estate); private collection, New York (by 1970[1])

Notes

1. Potter 1970, 171.

2. Daix and Rosselet 1979, no. 679, indicates sawdust.

382. *Apple,* 1914
Watercolor on paper
5⅜ x 6⅞ in. (13.7 x 17.5 cm)
Private collection
Daix and Rosselet 801
Plates 238, 384

Provenance

Gertrude Stein and Alice Toklas, Paris (acquired at Christmas 1914,[1] until [pl. 384] 1946; thereafter, Gertrude Stein estate); private collection (December 14, 1968[2])

Notes

1. Inscription on verso: "Souvenir pour Gertrude et Alice/Picasso/Noel 1914." The work was a gift from the artist, Christmas 1914.

2. Purchased through the Museum of Modern Art Syndicate, 1968.

383. *Guitar,* 1918
Graphite, watercolor, and ink on paper
6¾ x 7½ in. (17.4 x 19.1 cm)
Private collection
Plates 239, 361

Provenance

Gertrude Stein, Paris (acquired April 26, 1918,[1] until [pl. 361] 1946; thereafter, her estate); Mr. and Mrs. David Rockefeller, New York (December 14, 1968,[2] until 1983[3]); private collection

Notes

1. The verso of the work bears the inscription: "Pour Gertrude Stein/son ami Picasso/Montrouge 26 avril 1918."

2. Purchased through the Museum of Modern Art Syndicate, 1968. No. 70.123.

3. Sold Sotheby's, New York, November 17, 1983, lot no. 350.

384. *Table with Guitar and Partition,* 1920
Gouache on paper mounted on cardboard[1]
9⅝ x 7¼ in. (24.45 x 18.42 cm)
Current location unknown
Zervos IV 82

Provenance

Gertrude Stein, Paris (acquired in or after 1920,[1] until later); Mr. and Mrs. Gilbert W. Chapman, New York (by 1970)[2]

Notes

1. It is known that Gertrude Stein owned the original gouache (Zervos IV 82). She may have also owned one or more of the colored *pochoirs* from an edition of 100 by Paul Rosenberg. These references are: Zervos, original, Juan-les-Pins, 1920, gouache, 27 x 21 cm.; pochoir, Edition Paul Rosenberg (edition of 100), circa 1920, 26.8 x 22 cm.

2. New York 1970, 172–73. Mr. and Mrs. Gilbert W. Chapman owned both a gouache, which was lent to the aforementioned exhibition, and a *pochoir* version of this work, which they donated in 1955 to the Yale University Art Gallery in memory of Gertrude Stein.

385. *Eagle, Red Background,*[A] 1907
Woodcut
5⅝ x 4½ in. (8.3 x 7.8 cm) impression
Current location unknown
Geiser and Baer 213 (*L'Aigle*)

Provenance

[Leo and] Gertrude Stein, Paris (probably owned jointly until 1913/1914); Gertrude Stein, Paris (1913/1914 until 1946[1,2]; thereafter, her estate and Alice Toklas); Nelson A. Rockefeller, New York (1970)[3].

A. According to Geiser and Baer 213: "Cette gravure était destinée au livre d'Apollinaire, *Le bestiaire*, qui par la suite, a été illustré par Raoul Dufy (Paris, 1911, Delplanche)."

Notes

1. Geiser and Baer 213 indicates: One proof, probably, on Ingres paper, with the eagle printed in black, with a red background. "Ancienne collection Gertrude Stein." A proof with the eagle printed in black, with a gray-violet background, was, according to this same source, formerly in the collection of Michael Stein (see related information for this work).
2. G. Stein 1938, 84 (ill.).
3. New York 1970, 168. The work was possibly acquired in 1968 through the Museum of Modern Art Syndicate, 1968.

386. *Eagle, Gray-Violet Background,*[A] 1907
Woodcut
5⅝ x 4½ in. (8.3 x 7.8 cm)
Current location unknown
Geiser and Baer 213 (*L'Aigle*)

Provenance

Michael and Sarah Stein, Paris (until at least 1937[1,2])

A. According to Geiser and Baer 213: "Cette gravure était destinée au livre d'Apollinaire, *Le bestiaire*, qui par la suite, a été illustré par Raoul Dufy (Paris, 1911, Delplanche)."

Notes

1. Geiser and Baer 213 indicates: One proof, probably, on Ingres paper, with the eagle printed in black, with a gray-violet background. "Ancienne collection Michael Stein." A proof with the eagle printed in black, with a red background, was, according to this same source, formerly in the collection of Gertrude Stein.
2. Surely one of the two works by Picasso listed as "2 Monotypes (Birds)" and valued together at $50 in a 1937 inventory of Michael and Sarah Stein's collection. +7

387. *Chick, Blue Background,*[A] 1907
Woodcut
3¹⁵⁄₁₆ x 3⅛ in. (10 x 8 cm) impression
Current location unknown
Geiser and Baer 214

Provenance

Leo and Gertrude Stein, Paris (owned jointly until 1913[1]); Gertrude Stein, Paris (1913 until 1946; thereafter, her estate and Alice Toklas); Mr. and Mrs. John Hay Whitney, New York (1970[2]).

A. According to Geiser and Baer 214: "Cette gravure était destinée au livre d'Apollinaire, *Le bestiaire*, qui par la suite, a été illustré par Raoul Dufy (Paris, 1911, Delplanche)."

Notes

1. Geiser and Baer 214 indicates: eight proofs, pulled by the artist (à la gouache), are known. One example reproduces the chick on a blue background and was noted to be in the "Collection Stein" without indication of exact ownership. The present work matches this description and remained in the collection of Gertrude Stein until her death and later her estate.
2. New York 1970, 167. The work was possibly acquired in 1968 through the Museum of Modern Art Syndicate, 1968.

SCULPTURE

388. *Head of a Picador with a Broken Nose,* original model 1904–5, this cast before 1925
Bronze
7⅝ x 5¹³⁄₁₆ x 5 in. (19.4 x 14.8 x 12.7 cm)
The Baltimore Museum of Art: The Cone Collection, formed by Dr. Claribel Cone and Miss Etta Cone of Baltimore, Maryland
Spies (2000) 3

Provenance

[Leo and] Gertrude Stein, Paris (acquired after 1905, and probably owned jointly until 1913/1914[1]); Gertrude Stein, Paris (1913/1914 until July 9, 1925); Etta Cone, Baltimore (July 9, 1925,[2] until 1950); Baltimore Museum of Art (1950)

Notes

1. In a letter (probably of January 14, 1914), Leo Stein writes to Gertrude Stein: "I shall not only propose but shall insist with happy cheerfulness that you make as clean a sweep of the Picassos as I have of the Renoirs with the exception of the drawings which I want to keep partly on account of their actual delightfulness and partly on account of the personal note.... You'll take the little still life, the gouache head and the little bronze." BMA Cone Papers, box 6, series 7–8.
2. Purchased for 5,000 francs from Gertrude Stein in Paris, as cited by Brenda Richardson (1985, 175). Claribel records two purchases from Gertrude in Paris on July 9, 1925: a bronze Picasso mask (the present work) for 5,000 francs and an African "Figure" for 3,000 francs.

389. *Mask of a Woman,* 1908
Terracotta
7 x 6⅝ x 7⅞ in. (17.8 x 16 x 12 cm)
Musée National d'Art Moderne, Centre Georges Pompidou, Paris, gift of Daniel-Henry Kahnweiler, 1957
Spies (2000) 22,1a
Plates 221, 351, 355

Provenance

Leo and Gertrude Stein, Paris (owned jointly until at least before February 1914 [pls. 351, 355]); Daniel-Henry Kahnweiler (until 1957); Musée National d'Art Moderne, Centre Georges Pompidou, Paris (gift of Daniel-Henry Kahnweiler, 1957)

390. *Guitarist with Sheet Music,* 1913
Paper construction
8⅝ x 4⅛ in. (22 x 10.5 cm)
Current location unknown
Daix and Rosselet 582; Spies (2000) 31
Plates 188, 360, 361, 384

Provenance

Gertrude Stein, Paris (in or after 1913, and owned until [pls. 360, 361, 384] 1946; thereafter, her estate and Alice Toklas until 1962[2]); private collection (by 1994[3])

Notes

1. Spies 2000 (31) records only the former collection of Gertrude Stein in the provenance.
2. In a letter dated August 3, 1962, to Alice Toklas, Russell Porter, her attorney, writes that he will "pick up the collage and give you a receipt for it, and it will be turned over to the administrator appointed by the court." Edward Burns believes the collage refers to the present work (e-mail message to author, May 24, 2010).
3. London 1994, no. 20 (ill., noted as "private collection").

391. *Head,* 1928
Brass and iron, painted, signed and dated on verso
7 x 4⁵⁄₁₆ x 3 in. (17.8 x 10.9 x 7.6 cm)
Private collection
Spies (2000) 66
Plate 240, 361

Provenance

Gertrude Stein, Paris (in or after 1928, and owned until[1] [pl. 361] 1946; thereafter, her estate and Alice Toklas until 1962[2])

Notes

1. The work is listed in an inventory of a Lloyd's of London insurance policy dated February 19, 1934. Stein Archives, Ransom Center.
2. In a letter dated August 3, 1962, to Alice Toklas, Russell Porter, her attorney, writes: "The purchaser is to retain the Picasso painted bronze; you are to retain the down payment." The work's current location and owner are unknown.

OTHER

392. Children's armchairs upholstered with petit point sewn by Alice Toklas over designs by Pablo Picasso, ca. 1930
Yale Collection of American Literature, Beinecke Rare Book and Manuscript Library, Yale University, New Haven
Plates 204, 361

Provenance

[Gertrude Stein and] Alice B. Toklas,[1] Paris (by March 1934 [pl. 361]); Yale Collection of American Literature, Beinecke Rare Book and Manuscript Library, Yale University

Notes

1. Gift of Alice B. Toklas, Beinecke YCAL records.

PIERRE-AUGUSTE RENOIR

French, born 1841, Limoges, France; died 1919, Cagnes-sur-Mer, France

PAINTING

393. *Seated Bather*, ca. 1882
Oil on canvas
21½ x 16½ in. (54.5 x 41.9 cm)
Private collection
Dauberville (2009) 1296; Daulte 399
Plates 39, 352

Provenance

Arsène Alexandre, Paris (until May 18, 1903[1]); M. Cognacq, Paris (until March 15, 1905); Bernheim-Jeune, Paris (acquired March 15, 1905[2]); Georges Petit, Paris (acquired March 15, 1905[2]); Galerie Bernheim-Jeune, Paris (acquired July 14, 1905,[2,3] until November 23, 1908); Leo Stein, Paris (acquired November 23, 1908,[2] until [pl. 352] May 21, 1921); Durand-Ruel (acquired May 21, 1921,[4,5] until September 23, 1926); Chester Dale, New York (acquired September 23, 1926, until 1937)

Notes

1. His sale (no. 52), Galerie Georges Petit, Paris.
2. Galerie Bernheim-Jeune client list with dates of sales and purchases: no. 14418. This document reveals that Bernheim-Jeune purchased the work from M. Cognacq and then sold it the same day to Georges Petit. +8
3. In a letter dated September 7, 1907, to Leo Stein—Félix Fénéon offers one or more of the four Renoirs—including the present work—that Bernheim-Jeune had acquired at the Arsène Alexandre sale on May 18, 1903. Beinecke YCAL, MSS 76, box 98, folder 1866.
4. This painting appears as no. 11, with a noted price of $1,000, on a list of artworks that Leo Stein wished to sell in April 1921. +36; +37, +5
5. Durand-Ruel, New York, stock book, listed among the works noted in the "Leo Stein Collection" as no. 11: "Woman Nude, Femme nue, 21 x 15⅞ [in.]" and annotated "ph.a-1256, L. NY 4660." Archives Durand-Ruel.

394. *Washerwoman and Child*, 1887
Oil on canvas
32 x 25¾ in. (81.3 x 65.4 cm)
The Barnes Foundation, Merion, Pennsylvania
Dauberville (2009) 972; Daulte 509
Plates 54, 352

Provenance

Georges Petit, Paris (until June 22, 1898); Bernheim-Jeune (acquired June 22, 1898, until December 5, 1899); Hart (acquired December 5, 1899, until February 21, 1908); Bernheim-Jeune (acquired February 21, 1908, until December 17, 1908)[1]; Leo Stein, Paris (acquired December 17, 1908,[1,2] until [pl. 352] June 2, 1921[3,4,5]); Albert C. Barnes, Merion, Pennsylvania (acquired June 2, 1921[5])

Notes

1. Galerie Bernheim-Jeune client list with dates of sales and purchases: no. 16412. +8
2. Leo discusses the Renoir in *Journey into the Self* (L. Stein 1950, 18–19).
3. Durand-Ruel, New York, stock book, listed among the works noted in the "Leo Stein Collection" as no. 16: "Woman & Child, 32 x 25½ [in.]" Archives Durand-Ruel.
4. The work appears as no. 16, with a noted price of $4,000, on a list of works that Leo Stein wished to sell in April 1921. +36; +37
5. Barnes purchased the painting for $5,000. Martha Lucy, e-mail message to author, June 2009; see also Lucy 2010.

395. *Girl in Gray-Blue*, ca. 1889
Oil on canvas
26 x 20½ in. (66 x 52 cm)
The Barnes Foundation, Merion, Pennsylvania
Plates 16, 352

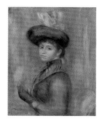

Provenance

Leo Stein, Paris (possibly in January 1907[1] and certainly by February 1909 [pl. 16], until [pl. 352] May 25, 1921[2,3]); Albert C. Barnes, Merion, Pennsylvania (acquired May 25, 1921[3])

Notes

1. See Rebecca Rabinow's essay in this volume, 39.
2. Durand-Ruel, New York, stock book, listed among the works noted in the "Leo Stein Collection" as no. 13: "Portr. of a woman bust, 26 x 20¼ [in.]" Archives Durand-Ruel.
3. The work appears as no. 13, with a noted price of $2,000, on a list of artworks that Leo Stein wished to sell in April 1921. +36 Barnes acquired it for $2,000 (Lucy 2010). See also +37.

396. *Head of a Young Woman*, 1890
Oil on canvas
16¼ x 12¾ in. (41.3 x 32.4 cm)
Private collection
Plates 53, 345, 352–54

Provenance

Ambroise Vollard, Paris (until October 28, 1904[1]); Leo Stein, Paris (acquired October 28, 1904,[2] until[3–5] [pls. 345, 352–54] 1922); Nelle E. Mullen (1922[5] until 1967); private collection (acquired November 1967)

Notes

1. Purchased from the artist for 200 francs. Vollard Archives, MS 421 (4, 5), folio 107.
2. One of seven works that Leo Stein purchased from Vollard on October 28, 1904, this pastel corresponds to stock no. 4365. +10
3. Durand-Ruel, New York, stock book, listed among the works noted in the "Leo Stein Collection" as no. 7: "Head of a Woman, 16⅛ x 12⅝ [in.]" Archives Durand-Ruel.

4. The painting appears as no. 7, with a noted price of $500, on a list of artworks that Leo Stein wished to sell in April 1921. +36; +37
5. Leo sold sixteen Renoirs between April and June 1921. Of these, Barnes purchased thirteen, and Durand-Ruel bought two. It is unclear who purchased the remaining Renoir (the present work), which is no. 7 on the May 9, 1921, list of sold works. +36; +37, +5 The sales catalogue—Samuel T. Freeman, Philadelphia, *The Mullen Collection…from the Estate of the Late Nelle E. Mullen*, November 15, 1967, lot no. 11—notes that Nelle E. Mullen acquired this painting directly from Leo. It is possible that she purchased it through an intermediary; it was not Durand-Ruel, however, whose 1921 purchases from Leo's collection are documented in a letter from Durand-Ruel, Paris. Correspondence copy dated June 23, 1970, to John Rewald, MoMA Archives, Margaret Potter Papers, 6.

397. *Landscape*, 1890
Oil on canvas
10¾ x 14¹¹⁄₁₆ in. (27.3 x 37.3 cm)
The Barnes Foundation, Merion, Pennsylvania
Plate 352

Provenance

Leo Stein, Paris (by February 1914 [pl. 352], until April 25, 1921[1,2]); Albert C. Barnes, Merion, Pennsylvania (acquired April 25, 1921[2])

Notes

1. Durand-Ruel, New York, stock book, listed among the works noted in the "Leo Stein Collection" as no. 5: "Landscape, 10⅝ x 14½ [in.]" Archives Durand-Ruel.
2. The painting appears as no. 5, with a noted price of $500, on a list of artworks that Leo Stein wished to sell in April 1921. +36; +37

398. *Bather*, ca. 1890
Oil on canvas
16¼ x 13¼ in. (41.3 x 33.7 cm)
The Barnes Foundation, Merion, Pennsylvania
Plate 352

Provenance

Ambroise Vollard, Paris[1]; Leo Stein, Paris (perhaps acquired April 27, 1908,[1,2,3] until [pl. 352] March 30, 1914); Albert C. Barnes, Merion, Pennsylvania (acquired March 30, 1914[4,5])

Notes

1. Likely the Renoir study ("une étude de Renoir femme nue") valued at 3,750 francs that Vollard sold and delivered to Leo Stein on April 27, 1908. Leo acquired the work in exchange for Maurice Denis's *Mother in Black* (1895; cat. 61), Paul Gauguin's *Sunflowers on an Armchair* (1901; cat. 64), and cash. +13

2. Probably the work referred to as a "new Renoir nude" that was photographed by Druet at rue de Fleurus. Michael Stein to Gertrude Stein, June 1, 1908, Beinecke YCAL, MSS 76, box 125, folder 2716.

3. The work is discussed in L. Stein 1996, 78.

4. Durand-Ruel, photo no. 23112: "Renoir, Baigneuse."

5. Barnes paid Leo 15,000 francs on March 30, 1914. BFA, AR.ABC.1914.117, cited in Lucy 2010.

399. *Pears,* ca. 1890
Oil on canvas
8⅞ x 12¼ in. (22.5 x 31.1 cm)
The Barnes Foundation, Merion, Pennsylvania
Bernheim-Jeune inv. no. 16818
Plate 352

Provenance

Bernheim-Jeune fils (until October 13, 1908[1]); Galerie Bernheim-Jeune, Paris (acquired October 13, 1908, until February 6, 1909); Leo Stein, Paris (acquired February 6, 1909,[1] until [pl. 352] April 25, 1921); Albert C. Barnes, Merion, Pennsylvania (acquired April 25, 1921[3])

Notes

1. Galerie Bernheim-Jeune client list with dates of sales and purchases: no. 16818 (+8). This inventory number also appears on the verso of the painting.

2. Durand-Ruel, New York, stock book, listed among the works noted in the "Leo Stein Collection" as no. 2: "Fruit, 8⅞ x 12¼ [in.]" Archives Durand-Ruel.

3. The painting appears as no. 2, with a noted price of $1,500, on a list of artworks that Leo Stein wished to sell in April 1921. +36; +37

400. *Peninsula of Saint-Jean,* 1893
Oil on canvas
25⅝ x 32⅛ in. (65.1 x 81.6 cm)
The Barnes Foundation, Merion, Pennsylvania
Durand-Ruel stock no. 6752, photo no. 3830[1]

Provenance

Galerie Durand-Ruel, Paris (acquired October 26, 1901,[1] until February 20, 1914); Leo Stein, Paris (acquired February 20, 1914,[2,3] until April 25, 1921); Albert C. Barnes, Merion, Pennsylvania (acquired April 25, 1921[3])

Notes

1. Archives Durand-Ruel, cited in Lucy 2010.

2. Archives Durand-Ruel. According to this source, Leo Stein purchased the work for 18,000 francs. +38. According to correspondence of May 1921, Leo paid 25,000 francs for the work. Albert C. Barnes to Leo Stein, May 9, 1921, BFA, AR.ABC.1921.109.

3. The work appears as no. 15, with a noted price of $5,000, on a list of artworks that Leo Stein wished to sell in April 1921. +36; +37

401. *Baby's Head,* ca. 1895
Oil on canvas, signed lower right
8¾ x 7¼ in. (22.2 x 18.4 cm)
The Barnes Foundation, Merion, Pennsylvania
Bernheim-Jeune inv. no. 19302

Provenance

Adrien Hébrard, Paris (until April 16, 1912[1]); Galerie Bernheim-Jeune, Paris (acquired April 16, 1912,[1] until June 27, 1912); Leo Stein, Paris (acquired June 27, 1912,[1,2] until May 25, 1921[3,4,5]); Albert C. Barnes, Merion, Pennsylvania (acquired May 25, 1921[5])

Notes

1. Galerie Bernheim-Jeune client list with dates of sales and purchases: no. 19302. +8

2. Possibly the Renoir head that Leo Stein mentions seeing "at Hessel's" in a letter to Gertrude dated August 29, 1912, sent from Florence. BMA Cone Papers, box 6, series 7-8.

3. Durand-Ruel, New York, stock book, listed among the works noted in the "Leo Stein Collection" as no. 4: "Head of a Child, 8⅝ x 7 [in.]" Archives Durand-Ruel.

4. The work appears as no. 4, with a noted price of $500, on a list of works that Leo Stein wished to sell in April 1921. +36; +37

5. Date and price ($500) cited in Lucy 2010.

402. *The Bay of Douarnenez,* ca. 1895
Oil on canvas
8⅝ x 15⅜ in. (22 x 39 cm)
Current location unknown

Provenance

Durand-Ruel, Paris (until February 11, 1914[1]); Leo Stein, Paris (February 11, 1914, until May 29, 1929[2]); Durand-Ruel, New York (acquired May 29, 1929[1]); Helin (acquired January 31, 1935[3])

Notes

1. Durand-Ruel stock no. 6779 (NY 4659), photo no. 3821. The only known image has been provided from the Durand-Ruel stock book. Archives Durand-Ruel. +38

2. The painting appears as no. 6, "landscape," with a noted price of $500, on a list of artworks that Leo Stein wished to sell in April 1921. +36 It was one of two Renoirs purchased by Durand-Ruel. +5; +37

3. Copies of documents from Durand-Ruel indicate that the painting was sold to Mr. Hélin on January 31, 1935 (perhaps Victor Hélin, Châteauroux), and include the Durand-Ruel Paris stock no. 13552. MoMA Archives, Margaret Potter Papers, Curator Exh. 950, Potter 6, 11.

403. *Reader,* ca. 1895
Oil on canvas, signed lower right
8¼ x 7 in. (21 x 17.8 cm)
The Baltimore Museum of Art: The Cone Collection, formed by Dr. Claribel Cone and Miss Etta Cone of Baltimore, Maryland
Plates 368, 370, 373, 374

Provenance

Michael and Sarah Stein, Paris (by November 1907 [pl. 368] until later [pls. 370, 373, 374]); Etta Cone (probably June 1925[1])

Notes

1. Possibly sold to Etta Cone by June 1925, as suggested in a letter from Claribel Cone cited in Rewald 1996, no. 464.

404. *Landscape,* ca. 1904
Oil on canvas
6¾ x 7¹⁵⁄₁₆ in. (17.1 x 20.2 cm)
The Baltimore Museum of Art: The Cone Collection, formed by Dr. Claribel Cone and Miss Etta Cone of Baltimore, Maryland
Plates 346, 368, 370, 373, 374

Provenance

Stein family, Paris (by January 1907, and probably owned jointly until later[1]); Etta Cone (by 1934[2])

Notes

1. Based on photographs, the painting appears to have first been in the collection of Leo and Gertrude Stein [pl. 346] and then with Michael and Sarah Stein [pls. 368, 370, 373, 374]. The exact ownership of the work during this period is undocumented.

2. Cone 1934, pl. 17.

405. *Landscape,* ca. 1900–1905
Oil on canvas
18 x 21¾ in. (45.7 x 55.2 cm)
The Barnes Foundation, Merion, Pennsylvania

Provenance
Galerie Bernheim-Jeune, Paris[1]; Leo Stein, Paris (until April 25, 1921[1,2]); Albert C. Barnes, Merion, Pennsylvania (acquired April 25, 1921[3])

Notes
1. It is thought that Leo purchased the work, listed as "spring landscape," from Bernheim-Jeune for 4,000 francs. BFA, AR. ABC.1921.109.
2. Durand-Ruel, New York, stock book, listed among the works noted in the "Leo Stein Collection" as no. 12: "Landscape, 17⅞ x 21⅝ [in.]" Archives Durand-Ruel.
3. The work appears as no. 12, with a noted price of $2,500, on a list of artworks that Leo Stein wished to sell in April 1921. +36; +37 A circled number 12 is written in pencil on the verso of the painting (Lucy 2010).

406. *Landscape,* ca. 1900–1905
Oil on canvas, signed lower right
8 x 12¼ in. (20.3 x 31.1 cm)
The Barnes Collection, Merion, Pennsylvania
Bernheim-Jeune inv. no. 16068
Plate 352

Provenance
Bernheim-Jeune fils (until May 18, 1907[1]); Galerie Bernheim-Jeune, Paris (acquired May 18, 1907, until December 14, 1908); Leo Stein, Paris (acquired December 14, 1908,[1] [pl. 352] until April 25, 1921[2]); Albert C. Barnes, Merion, Pennsylvania (acquired April 25, 1921[3])

Notes
1. Galerie Bernheim-Jeune client list with dates of sales and purchases: no. 1606. +8 A photograph in the same papers is annotated "S1 Landscape, BJ 16068" (identified in Lucy 2010).
2. Durand-Ruel, New York, stock book, listed among the works noted in the "Leo Stein Collection" as no. 1: "Landscape, 7⅞ x 12¼ [in.]" Archives Durand-Ruel.
3. The work appears as no. 1, with a noted price of $500, on a list of artworks that Leo Stein wished to sell in April 1921. +36; +37

407. *Femme aux seins dénudés (Gabrielle aux seins nus),* 1907
Oil on canvas
21⅝ x 18⅛ in. (55 x 46 cm)
Current location unknown

Provenance
Bernheim-Jeune, Paris; Leo Stein, Paris (purchased June 27, 1912[1])

Notes
1. Galerie Bernheim-Jeune stock no. 19305, photo no. 10749. Bernheim Jeune 1910; Galerie Bernheim-Jeune to the author, September 2009.

408. *Girl Darning,* ca. 1909
Oil on canvas
15¼ x 11⅜ in. (38.7 x 28.9 cm)
The Barnes Foundation, Merion, Pennsylvania

Provenance
Leo Stein, Paris (until April 25, 1921[1]); Albert C. Barnes, Merion, Pennsylvania (acquired April 25, 1921[2])

Notes
1. Durand-Ruel, New York, stock book, listed among the works noted in the "Leo Stein Collection" as no. 9: "Woman darning (reprisant), 15 x 11¼ [in.]" Archives Durand-Ruel. It is thought that Leo paid 2,000 francs for the work. BFA, AR.ABC.1921.109.
2. The work appears as no. 9, with a noted price of $600, on a list of works from the collection of Leo Stein that Albert C. Barnes proposed to buy in April 1921. +36; +37 A circled number 9 written in pencil appears on the verso of the painting (Lucy 2010).

409. *Landscape,* 1911
Oil on canvas
11¼ x 15½ in. (28.6 x 39.4 cm)
The Barnes Foundation, Merion, Pennsylvania

Provenance
Galerie Durand-Ruel, Paris (acquired January 17, 1912, until April 26, 1912); Leo Stein, Paris (acquired April 26, 1912,[1,2] until April 25, 1921); Albert C. Barnes, Merion, Pennsylvania (acquired April 25, 1921[3])

Notes
1. Durand-Ruel stock no. 9876, photo no. 7314. On April 26, 1912, Leo Stein purchased two Renoir landscapes—no. 9877 and the present work—from Durand-Ruel for 1,750 francs. Archives Durand-Ruel.

2. It is thought that Leo paid 1,000 francs for the present work (BFA, AR.ABC.1921.109).
3. The work appears as no. 8, with a noted price of $500, on a list of works from the collection of Leo Stein that Albert C. Barnes proposed to buy in April 1921. +36; +37 A circled number 8 is written in pencil on the verso of the painting. Provenance information provided by Martha Lucy; see Lucy 2010.

410. *Landscape,* ca. 1911
Oil on canvas
9 x 9 in. (22.9 x 22.9 cm)
The Barnes Foundation, Merion, Pennsylvania
Bernheim-Jeune inv. no. 19625[1]

Provenance
Laroche (until [June] 1912); Galerie Bernheim-Jeune,[1] Paris (acquired [June] 1912,[2] until February 12, 1914); Leo Stein, Paris (acquired February 12, 1914,[2] until May 25, 1921[3]); Albert C. Barnes, Paris (acquired May 25, 1921[4])

Notes
1. The Bernheim-Jeune stock number 19625 appears in blue on the verso. Martha Lucy, e-mail message to author, June 15, 2010.
2. Galerie Bernheim-Jeune client list with dates of sales and purchases: no. 19625. +8 The date of sale is indicated as "31.6.1912"; there is no other information to clarify if the error is in the date or the month.
3. Durand-Ruel, New York, stock book, listed among the works noted in the "Leo Stein Collection" as no. 3: "Landscape, 9 x 9 [in.]" Archives Durand-Ruel.
4. The work appears as no. 3, with a noted price of $800, on a list of works that Leo Stein wished to sell in April 1921. +36; +37

411. *Cup of Chocolate,* ca. 1912
Oil on canvas
21⅜ x 25½ in. (54.3 x 64.8 cm)
The Barnes Foundation, Merion, Pennsylvania
Plate 43

Provenance
Galerie Durand-Ruel, Paris (acquired October 22, 1912,[1] until February 11, 1914); Leo Stein, Paris (February 11, 1914,[1] until April 25, 1921); Albert C. Barnes, Merion, Pennsylvania (acquired April 25, 1921[2])

Notes
1. Durand-Ruel stock no. 10132, photo no. 7525. Archives Durand-Ruel. +38 These numbers are recorded on the verso of the painting (Lucy 2010).
2. The work appears as no. 14, with noted price of $7,500, on a list of works that Leo Stein wished to sell in April 1921. +36; +37 Provenance information provided by Martha Lucy; see Lucy 2010.

WORKS ON PAPER

412. *Two Nudes,* ca. 1897
Pastel with charcoal underdrawing on paper
18⅜ x 18 in. (46.7 x 45.7 cm)
The Barnes Foundation, Merion, Pennsylvania
Plates 347, 348

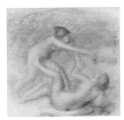

Provenance

Ambroise Vollard, Paris (until October 28, 1904); Leo Stein, Paris (acquired October 28, 1904,[1] until [pls. 347, 348] April 1921[2]); Albert C. Barnes, Merion, Pennsylvania (acquired April 1921[3])

Notes

1. One of seven works that Leo Stein purchased from Vollard on October 28, 1904, this pastel corresponds to stock no. 4366. There was an error in Vollard's bookkeeping, however, and he assigned the same inventory number again to a Daumier, *Trois Têtes* (ca. 1879; Hirshhorn Museum and Sculpture Garden), not purchased by Stein. +10
2. Durand-Ruel, New York, stock book, listed among the works noted in the "Leo Stein Collection" as no. 10: "Pastel two women, 18¼ x 18 [in.]." Archives Durand-Ruel.
3. The work appears as no. 10, with a noted price of $700, on a list of works that Leo Stein wished to sell in April 1921. +36; +37

413. *The Hat Pinned with Flowers,* 1898
Color lithograph
35⅝ x 24¹⁵⁄₁₆ in. (90.5 x 63.3 cm)
Current location unknown
Example A: plates 363, 365[1]
Example B: plate 352[1]
[See plate 52 for an example not owned by the Steins]

Provenance

Ambroise Vollard, Paris; [Leo and Gertrude or Michael and Sarah] Stein, Paris (acquired March 17, 1906,[2] until later)

Notes

1. Impressions of this lithograph appear at both rue de Fleurus and rue Madame. Two lithographs were purchased from Vollard: example A, rue Madame; example B, rue de Fleurus.
2. Two lithographs that Ambroise Vollard sold to "Stein" on March 17, 1906 ("2 litho de couleur femmes aux chapeaux de Renoir") for 160 francs. Vollard Archives, MS 421 (5, 1), folio 50.

FRANCISCO RIBA-ROVIRA

Spanish, born 1913, Barcelona, Spain; died 2002, Paris

414. *Gertrude Stein,* 1945
Oil on canvas, signed lower right
35⅝ x 28¼ in. (90.5 x 71.8 cm)
Collection of Alida and Christopher Latham
Plate 203

Provenance

Gertrude Stein, Paris (acquired from the artist); Robert Clyde Sweet (acquired 1945 or 1946[1]); Carleton Latham; Alida and Christopher Latham[2]

Notes

1. In a letter dated October 6, 1947, Alice Toklas wrote to Donald Gallup: "The Riba[-Rovira] portrait that Bob Sweet has you'll remember—Bob wont give it to you now but will bequeathe it (fifty years hence) to Y.U.L. if I write a very careful letter to him which I will." Toklas 1973, 79–82.
2. Provenance established in correspondence with the author from Edward Burns, November 23, 2009.

FRANCIS ROSE

British, born 1909, Farnham, England; died 1979, London

PAINTING

415. *The Grey Man,* n.d.
Current location unknown

Provenance

Gertrude Stein, Paris[1] (until probably 1946[2])

Notes

1. The artwork appears in a Cecil Beaton photograph taken ca. 1946 of Gertrude Stein standing in the hallway, or "gallery," of the apartment at 5 rue Christine. Department of Nineteenth-Century, Modern, and Contemporary Art, The Metropolitan Museum of Art, New York, gift of Edward Burns, 2011. Francis Rose described his work among the paintings displayed in the rue Christine salon: "The Pink Nude, Juan Gris's large portrait of a woman, and a cubist still life. Also hung there were Picasso's larger Spanish landscapes, his studies for the 'Demoiselles d'Avignon,' and later, my big picture 'The Grey Man.'" Rose 1968, 29.
2. The title does not appear in the list of sixty-eight works by Sir Francis Rose in a May 1950 inventory of Gertrude Stein's estate filed in 1951 in Baltimore (+40); nevertheless it is impossible to rule out the possibility that the work remained in her estate.

416. *Portrait of Woman,* n.d.
Oil on board
27¼ x 19½ in. (69.2 x 49.5 cm)
Current location unknown

Provenance

Gertrude Stein, Paris (at least by 1938;[1] thereafter, her estate); Daniel M. Stein; private collection (until May 2009[2])

Notes

1. The artwork appears in prewar and postwar photographs by Cecil Beaton of Gertrude Stein standing in the hallway, or "gallery," of the apartment at 5 rue Christine. The Cecil Beaton Studio Archive at Sotheby's, London.

2. Sold at auction in 2009 for $610 as "Portrait of a Woman." Bonhams & Butterfields, San Francisco, SoMA Estate Sale, Sunday, May 17, 2009, lot no. 06045, ill. The provenance as recorded in the auction catalogue is probably erroneous. The painting is noted as passing from Gertrude Stein "to Michael and Sarah Stein to Daniel Michael Stein," but Michael died in 1938 and Sarah in 1953. In fact, Gertrude's estate passed to Allan Stein, who died in 1951, and his descendants. Gertrude is known to have lent to a New York exhibition (Harriman, New York 1934) a work by Rose that was listed as no. 2: "Portrait of a Woman"; it is perhaps the present example.

417. *Bilignin,* ca. 1930
Oil on canvas
17¼ x 11 in. (43.8 x 27.9 cm)
Charles E. Young Research Library, UCLA Special Collections

Provenance

Gertrude Stein, Paris (probably by 1934[1] until later[2])

Notes

1. Likely the work exhibited as no. 12 in New York 1934. +39
2. The work appears in an undated Cecil Beaton photograph of Gertrude at Bilignin. The Cecil Beaton Studio Archive at Sotheby's, London.

418. *Portrait of Alice B. Toklas,* 1932
Oil on board, signed and dated lower left
29⅞ x 19 in. (75.9 x 48.3 cm)
Yale Collection of American Literature, Beinecke Rare Book and Manuscript Library, Yale University, New Haven

Provenance

[Gertrude Stein and] Alice Toklas, Paris (in 1932[1,2]); thereafter, Alice Toklas, Paris (until 1961[3]); Yale Collection of American Literature, Beinecke Rare Book and Manuscript Library, Yale University (1961[3])

Notes

1. The work is inscribed, signed, and dated: "To Alice Toklas/Francis Rose/1932."
2. Surely the "Portrait of Alice B. Toklas" exhibited as no. 6 in New York 1934. +39
3. Gift of Alice B. Toklas, 1961, Beinecke YCAL records.

419. *Couples in a Garden*, 1934
Oil on canvas
Current location unknown

Provenance

Gertrude Stein, Paris (by December 1934)[1]

Notes

1. Exhibited as no. 13 in New York 1934. +39

420. *The Eye of Rembrandt*, 1934
Oil on canvas
Current location unknown

Provenance

Gertrude Stein, Paris (by December 1934)[1]

Notes

1. Exhibited as no. 5 in New York 1934. +39

421. *Group*, 1934
Oil on canvas
Current location unknown

Provenance

Gertrude Stein, Paris (by December 1934)[1]

Notes

1. Exhibited as no. 9 in New York 1934. +39

422. *L'Harp solaire*, 1932
Oil on canvas, signed and dated lower center
28¾ x 23⅓ in. (73 x 59.7 cm)
Current location unknown

Provenance

Gertrude Stein, Paris (at least by 1946; thereafter, her estate until at least 1951[1]); Daniel M. Stein[2]; private collection (until May 2009[2])

Notes

1. Listed as "L'Harp Solaire" and valued at $15 in a May 1950 inventory of Gertrude Stein's estate filed in Baltimore in 1951. +40 Also see Ransom Center, box 275, folder 6.
2. Auction catalogue, Bonhams & Butterfields, San Francisco, SoMA Estate Sale, May 17, 2009, lot no. 06046, ill. The provenance as recorded in the auction catalogue is probably erroneous. The painting is noted as passing from Gertrude Stein "to Michael and Sarah Stein to Daniel Michael Stein," but Michael died in 1938 and Sarah in 1953. In fact, Gertrude's estate passed to Allan Stein, who died in 1951, and his descendants.

423. *Ibekia of America*, 1934
Oil on canvas
Current location unknown

Provenance

Gertrude Stein, Paris (by December 1934)[1]

Notes

1. Exhibited as no. 14 in New York 1934. +39

424. *Muse of Summer*, 1934
Oil on canvas
Current location unknown

Provenance

Gertrude Stein, Paris (by December 1934)[1]

Notes

1. Exhibited as no. 3 in New York 1934. +39

425. *Spirit of the Waterfall*, 1934
Oil on canvas
Current location unknown

Provenance

Gertrude Stein, Paris (by December 1934)[1]

Notes

1. Exhibited as no. 4 in New York 1934. +39

426. *Torso of a Man*, 1934
Oil on canvas
Current location unknown

Provenance

Gertrude Stein, Paris (by December 1934)[1]

Notes

1. Exhibited as no. 7 in New York 1934. +39

427. *Tréboul*, 1934
Oil on canvas
Current location unknown

Provenance

Gertrude Stein, Paris (by December 1934)[1]

Notes

1. Exhibited as no. 10 in New York 1934. +39

428. *Woodland Spring*, 1934
Oil on canvas
Current location unknown

Provenance

Gertrude Stein, Paris (by December 1934)[1]

Notes

1. Exhibited as no. 1 in New York 1934. +39

429. *Young Woman*, 1934
Oil on canvas
Current location unknown

Provenance

Gertrude Stein, Paris (by December 1934)[1]

Notes

1. Exhibited as no. 8 in New York 1934. +39

430. *Portrait of Gertrude Stein*, ca. 1930-35
Oil on canvas
31½ x 25¼ in. (80 x 64.1 cm)
Current location unknown

Provenance

Gertrude Stein (perhaps until 1939[1]); Allan and Roubina Stein, Paris (probably until 1951[1,2]); thereafter, Roubina Stein (perhaps until 1970[3])

Notes

1. In a letter dated October 6, 1947, to Donald Gallup, Alice Toklas wrote: "About Francis' portrait of me—of course you may have [it] if I can find one of Gertrude's to send at the same time. Francis did one of her—it wasnt very good as portrait or as painting which Gertrude gave to Allan (did you ever see it?). Allan definitely refuses to give it to Y.U.L." (in Toklas 1973, 79-80). Gertrude lent a work by Rose titled "Portrait of Gertrude Stein" to New York 1934 (as no. 11) and a painting titled "Miss Stein at Home" to London 1939 (as no. 26).

2. No "portrait of Gertrude Stein" appears among the sixty-eight works by Sir Francis Rose listed in a May 1950 inventory of Gertrude Stein's estate filed in 1951 in Baltimore.
3. The work was listed as "private collection" when lent in 1970; however, it is likely that the work remained in the Stein family by descent. Potter 1970, 173.

WORKS ON PAPER

431. *Homage to Gertrude Stein*, 1949
Oil, tempera, watercolor, and wax on paper; signed, dated, and titled
80¼ x 56¼ in. (203.8 x 142.9 cm)
England & Co. gallery, London
Plate 263

Provenance

Alice Toklas,[1] Paris (by May/June 1952[2])

Notes

1. Possibly the work Toklas refers to in a letter to Samuel Steward in Chicago about Sir Francis Rose: "He spent the summer in France near Lourdes where he went for a pilgrimage and he painted three or four pictures of it—quite masterly. And now he is doing a big picture a *Hommage à Gertrude*." Alice Toklas to Samuel Steward, December 31, 1946, in Toklas 1973, 44.
2. The artwork appears in a May/June 1952 photo of Alice visiting with cast members of *Four Saints in Three Acts*. Department of Nineteenth-Century, Modern, and Contemporary Art, The Metropolitan Museum of Art, New York, gift of Edward Burns, 2011.

PAVEL TCHELITCHEW
American, born 1898, Kaluga, Russia; died 1957, Grottaferrata, Italy

PAINTING

432. *Portrait of Alice B. Toklas*, 1924
Oil on canvas
29½ x 16 in. (74.9 x 40.6 cm)
Charles E. Young Research Library, UCLA Special Collections

Gertrude Stein and Alice Toklas, Paris (until 1947[1]); Galerie de Beaune, Paris[2]; Dr. Ralph Withington Church, Santa Barbara, California (by April 1947,[3] until January 1973[4]); Gilbert A. Harrison (acquired January 1973[4]); Charles E. Young Research Library, UCLA Special Collections (acquired by gift, 1973/1974)

1. New Haven and Baltimore 1951, no. 35 (noted as "Formerly in the collection of Gertrude Stein").
2. The verso of the painting is marked with an ink stamp of Galerie de Beaune. Genie Guerard, e-mail message to Amanda Glesmann, February 24, 2011.
3. Among three paintings that Alice Toklas sold to Ralph W. Church, as noted in a letter from Toklas to Church dated April 9, 1947. +41
4. Sales catalogue, Sotheby Parke-Bernet, New York, January 20, 1973, lot no. 86. The catalogue indicates that the work is inscribed with a dedication: "Alice Toklas, un souvenir de mon affection et de mes pensées à elle pour l'an 1924, beaucoup de bonheur, Pavel Tchelitchew."

433. *Three Heads (Portrait of René Crevel)*, 1925
Oil on canvas
18¾ x 14½ in. (47.6 x 36.8 cm)
Professor Boris Stavrovski, New York
Plate 190

Provenance

Gertrude Stein, Paris[1] (perhaps ca. 1926[2])

Notes

1. There is a brief mention of Gertrude Stein's acquisition of Tchelitchew's 1925 painted portrait of René Crevel in Soby 1942 (15), but the date and terms of acquisition are not specified.
2. A "Portrait de René Crevel" by Tchelitchew was exhibited as no. 48 in Paris 1926.

434. *Grapes*, 1927
Oil on canvas
17⅝ x 12⅝ in. (44.8 x 32.1 cm)
Current location unknown

Provenance

Gertrude Stein and Alice Toklas, Paris (until 1947[1]); Dr. Ralph Withington Church (by April 1947[2])

Notes

1. New Haven and Baltimore 1951, no. 36 (noted as "Formerly in the collection of Gertrude Stein").
2. Among three paintings that Alice Toklas sold to Ralph W. Church, as noted in a letter from Toklas to Church dated April 9, 1947. +41

WORKS ON PAPER

435. *Drawing Double Head*, 1927
India ink on paper
14³⁄₁₆ x 11 in. (36 x 28 cm)
Musée d'Art Moderne de Toulouse, gift of Anthony Denney, 1993

Provenance

Gertrude Stein, Paris[1]; Anthony Denney (ca. 1950 until 1993); Musée d'Art Moderne de Toulouse (gift of Anthony Denney in 1993)

Notes

1. Before posing for her portrait in 1929, Gertrude Stein is thought to have purchased drawings from Tchelitchew: "Miss Stein purchased drawings, one of which, framed, she hung in her dining room. Picasso stared at it, she observed, with genuine curiosity." Kirstein 1994, 43.

KRISTIANS TONNY

Dutch, born 1907, Amsterdam; died 1977

436. *Le Bâteau ivre*, 1927
Oil on canvas, signed and dated
21¼ x 25½ in. (54 x 64.8 cm)
Current location unknown

Provenance

Gertrude Stein[1] and Alice Toklas, Paris (until 1947); Dr. Ralph Withington Church (by April 1947[2])

Notes

1. New Haven and Baltimore 1951, no. 35 (noted as "Formerly in the collection of Gertrude Stein").
2. Among three paintings that Alice Toklas sold to Ralph W. Church, as noted in a letter from Toklas to Church dated April 9, 1947. +41

HENRI DE TOULOUSE-LAUTREC

French, born 1864, Albi, France; died 1901, Langon, France

437. *In the Salon: The Divan*, ca. 1892–93
Oil on cardboard, signed
23⅝ x 31½ in. (60 x 80 cm)
MASP, Museu de Arte de São Paulo Assis Chateaubriand, São Paulo, Brazil
Dortu P.502
Plates 28, 348, 349

Provenance

Leo and Gertrude Stein, Paris (at least by September 1905,[1,2] until [pls. 348, 349] at least December 1907); perhaps Galerie Bernheim-Jeune, Paris (after December 1907,[3] until at least November 1912[4]); perhaps Paul Rosenberg, Paris (by January 1914[5]); Collection Hodebert (by 1926[6]); Collection Wildenstein and Company, New York and Paris (by 1931[7] until 1952[7]); Museu de Arte de São Paulo (1952[8])

Notes

1. Leo saw Toulouse-Lautrec's work for the first time at the 1904 Salon d'Automne; he may have purchased the present work at that time (G. Stein and Picasso 2005, 49n1). Works by Toulouse-Lautrec and others were also exhibited in Paris 1905.
2. The work was certainly in the collection of Leo and Gertrude at rue de Fleurus by September 2, 1905. Emma Lootz Erving to Gertrude Stein, Beinecke YCAL, MSS 76, box 105, folder 2084.
3. Although Toulouse-Lautrec's *In the Salon: The Divan* was proposed to Galerie Bernheim-Jeune, it is not known how or when the gallery may have acquired the work. In December 1907 Leo entered into negotiations with Félix Fénéon to trade it, along with a Gauguin (possibly *Sunflowers on an Armchair* [1901; cat. 64]), for two Renoirs (G. Stein and Picasso 2005, 49n1). However, the Gauguin was not traded until April 27, 1908, in an exchange with Vollard.
4. Coquiot 1913, 85 (ill.). The book states that a majority of the works reproduced came from the collection of MM. Bernheim-Jeune.
5. Rosenberg 1914, no. 23 (as "Le Canapé," without owner listed). Listed in Galeries Rosenberg papers as "No. 339 (797), Le Canapé, 53 x 72 cm.; No. 2461 (781)." Photographic archives from Galeries Rosenberg at the Musée d'Orsay; Anne Roquebert, e-mail message to the author, September 11, 2009.
6. Joyant 1926, 153 (ill.).
7. New York 1931, no. 21 (ill.); also Jourdain 1952, no. 86 (ill.), 125.
8. A receipt from Wildenstein in the object file of the Museu de Arte de São Paulo records the date of sale as June 6, 1952.

FÉLIX VALLOTTON

Swiss, born 1865, Lausanne, Switzerland; died 1925, Paris

PAINTING

438. *Reclining Nude on a Yellow Cushion*, 1904
Oil on canvas, signed lower left
38³⁄₁₆ x 57½ in. (97 x 146 cm)
Sturzenegger Foundation, Museum zu Allerheiligen Schaffhausen, Switzerland
LRZ 540a; Ducrey 538
Plates 10, 350, 353

Provenance

Leo [and Gertrude] Stein, Paris (probably acquired April 1905,[1] and owned jointly[1] [pls. 350, 353] until at least 1913/1914); Bernheim-Jeune, Paris (1924); Josse Bernheim-Jeune (by 1931); Jean Dauberville, Paris (until November 1987[3]); Peter Silverman, New York; Sturzenegger Foundation, Museum zu Allerheiligen Schaffhausen, Switzerland (1995)[4]

Notes

1. The Vallotton painting that Leo bought (along with a Manguin, see cat. 82) from the 1905 Salon des Indépendants, shown in the salon as no. 4043: "Femme couchée" (Potter 1970, 25). In his discussion of the acquisition, Leo refers to Vallotton as "a talented and essentially witty painter." L. Stein 1996, 158.
2. Gertrude Stein wrote: "There was a big nude by Vallotton that felt like only it was not like the Odalisque of Manet.... Well Vallotton was a Manet for the impecunious. His big nude had all the hardness, the stillness and none of the quality of the Olympe of Manet and his portraits had the aridity but none of the elegance of David." G. Stein 1990, 10, 50.
3. Sale, Drouot, Paris, November 23, 1987, no. 11.
4. Ducrey 2005, no. 538 (as "Femme nue couchée sur un drap blanc").

439. *Standing Nude Holding Her Chemise with Two Hands*, 1904
Oil on canvas, signed lower left
50¾ x 37⅜ in. (129 x 95 cm)
Private collection, Switzerland
Ducrey 537
Plates 180, 363, 365

Provenance

[Leo[1] and/or] Michael and Sarah Stein, Paris (acquired in 1906,[1] and owned jointly[2,3] [pls. 363, 365]); Galerie Bernheim-Jeune, Paris[4]; Richard Bühler, Winterthur, Switzerland (1920 until September 1935[5])

Notes

1. Ducrey 2005, no. 537, "Femme nue retenant sa chemise à deux mains," states that Leo acquired the work from the artist in 1906; however, as noted above, archival photographs dated as early as November 1906/November 1907 show the work with Michael and Sarah's collection at rue Madame.
2. Michael and Sarah lent a Vallotton nude to Paris 1910d. Michael Stein to Leo and Gertrude Stein, May 18, 1910, BMA Cone Papers, box 6, series 7–8.
3. Likely work noted in Paris 1910d as no. 124: "Femme, A[ppartient à]. M. Stein."

4. Ducrey 2005, no. 537, associates Bernheim-Jeune stock no. 20759 with the work.

5. Ducrey 2005, no. 537, notes the sale of the collection of Richard Bühler, Winterthur, by Galerie Fischer, Lucerne, September 2, 1935, lot no. 9 (ill.).

440. *Nude Woman Leaning against a Tree*, 1906
Oil on canvas, signed and dated lower right
24⅛ x 19⅞ in. (61.3 x 50.5 cm)
The Baltimore Museum of Art: The Cone Collection, formed by Dr. Claribel Cone and Miss Etta Cone of Baltimore, Maryland
Ducrey 575
Plates 350, 351

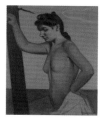

Provenance
Leo [and Gertrude] Stein, Paris (acquired 1906,[1] and probably owned jointly [pls. 350, 351] until November 1914); Bernheim-Jeune, Paris (by November 1914[2]); Etta Cone, Baltimore (before 1949)

Notes
1. Acquired from the artist. Ducrey 2005, no. 575.
2. By November 1914 the present work was at Galerie Bernheim-Jeune, Paris, as mentioned in a letter listing the paintings that Leo left with Bernheim-Jeune, apparently on consignment for sale. Galerie Bernheim-Jeune, Paris, to Gertrude Stein, November 26, 1914, Beinecke YCAL, MSS 76, box 98, folder 1866. In 1913/1914 Leo and Gertrude mutually decided to divide their collection and sell certain works for cash; however, it is impossible to determine who benefited from the sale of these works.

441. *Gertrude Stein*, 1907
Oil on canvas, signed upper left
39½ x 32 in. (100.3 x 81.3 cm)
The Baltimore Museum of Art: The Cone Collection, formed by Dr. Claribel Cone and Miss Etta Cone of Baltimore, Maryland
Ducrey 612
Plate 206

Provenance
[Leo and] Gertrude Stein, Paris (acquired before the 1907 Salon d'Automne,[1,2] and probably owned jointly[3] until 1913/1914); thereafter, Gertrude Stein, Paris (until October 26, 1926[4,5]); Dr. Claribel Cone, Baltimore (acquired October 26, 1926[4,5]); Baltimore Museum of Art (in 1950)

Notes
1. In *The Autobiography of Alice B. Toklas* (G. Stein 1990, 61–62), Gertrude Stein describes sitting for this portrait. Ducrey 2005, no. 612, states that the work was a gift from the artist to both Leo and Gertrude.
2. Salon d'Automne 1907, no. 1666 (as "Portrait de Mlle. S," no ownership indicated). In a letter to Leo, believed to have been written in the spring or early

summer 1907, the artist writes: "I would gladly exhibit the portrait of your sister at the Salon d'Automne." Félix Vallotton to Leo Stein, [spring/early summer 1907,] Beinecke YCAL, MSS 76, box 128, folder 2800.
3. In a letter dated June 1, 1908, Michael Stein wrote to Gertrude Stein, "the Vallotton portrait is back [at rue de Fleurus] from Munich," Beinecke YCAL, MSS 76, box 125, folder 2716. The portrait was lent to the 1908 Munich Secession exhibition as no. 206.
4. Gertrude sold the work to Claribel Cone, October 26, 1926, for 10,000 francs. B. Richardson 1985, 176.
5. According to correspondence from Michael Stein in midsummer and early autumn 1926, he was in Paris orchestrating the sale of two works that the Cone sisters bought from Gertrude through him: Cézanne's *Bathers* (1897; cat. 27), purchased by Etta in August 1926, and the present work, purchased by Claribel in October 1926. BMA Cone Papers, box 6, series 7–8.

MATHILDE VOLLMOELLER-PURRMANN
German, born 1865, Stuttgart; died 1943, Munich

442. *Still Life with Fruit*, ca. 1906–7[4]
Oil on canvas, signed, lower right
18 x 24 in. (45.7 x 60.1 cm)
San Francisco Museum of Modern Art, bequest of Esther Pollack
Plate 181

Provenance
Michael and Sarah Stein, Paris and Palo Alto (likely given by the artist ca. 1919,[1] and owned jointly until 1938; thereafter, Sarah Stein, Palo Alto); Sally Strauss Laurance, Carmel, California (until her death ca. 1960)[2]; Mr. and Mrs. Augustus Pollack, Carmel, California (from February 4, 1960; thereafter, Esther Pollack until 1991)[3]

Notes
1. Sarah Stein "remembered this work as a gift from the wife of Hans Purrman in repayment for some obscure but important favors." [Augustus Pollack] to Perrigrine Pollen, February 17, 1962, SFMOMA Permanent Collection Object File: 92.136.
2. Consignment from Mrs. Victor Jelenko (née Theresa Ehrman), sister of Sally Strauss Laurance, who must have been handling her sister's estate, to Augustus Pollack with attribution as "Hans Purrmann." SFMOMA Permanent Collection Object File: 92.136.
3. "The picture came from Sarah to Mrs. Laurance…. Mrs. Strauss recalled that Mrs. Stein told her the picture had been a gift from Mme. Hans Purrmann just after the end of the first world war when she came to Paris to liquidate the contents of Purrmann's confiscated studio." Augustus Pollack to Margaret Potter, August 31, 1970, SFMOMA Permanent Collection Object File: 92.136.
4. Attributed to Mathilde Vollmoeller-Purrmann by Purrmann-Haus. Adolf Leisen, e-mail message to Rebecca Rabinow, October 14, 2010.

Legend

+1 Vollard agenda entry, January 21, 1907: "Exchanged with Stein a canvas of Renoir [possibly cat. 395] … for a Gauguin [of] Tahitian characters standing [against a] yellow background [cat. 63] and a Bonnard female nude reclining [cat. 3] [from the] old Salon d'Automne. Renoir value four thousand francs." Vollard Archives, MS 421 (5, 2), folio 8; translated by Erin Hyman. For a discussion of this exchange, see Rebecca Rabinow's essay in this volume, 39.

+2 It is believed that Gertrude Stein sold her three works by Braque [cat. 4–6] over the course of 1937, when she was also in the process of selling *Seated Nude* by Picasso (1905; cat. 233). In February 1937 Pierre Matisse sent the painting to the Wadsworth Atheneum (Pierre Matisse to Mr. A. Everett Austin, director, Wadsworth Atheneum, February 4, 1937), and by November 1937 he offered to sell the Picasso work, in which he had partial ownership: "I own the picture with a friend of mine in Paris who wants the picture disposed of as quickly as possible" (P. Matisse to Austin, November 12, 1937). PMG Archives, MA 5020, box 77.28. It is unclear whether Gertrude Stein was still a partial owner or whether Pierre Matisse was owner with a third, unnamed party.

+3 Sale by Ambroise Vollard to "Mr. Stein" on January 18, 1909, recorded as nine Cézanne watercolors (4,800 francs), a small Cézanne lithograph (30 francs), and three lithographs and a drawing by Renoir (310 francs). Vollard Archives, MS 421 (5, 4), folio 7.

+4 Rewald (1983, 178) cites six Cézanne watercolors (Rewald nos. 95, 170, 288, 381, 502, 522) in the collection of Leo and Gertrude Stein. In fact, Leo and Gertrude acquired at least eleven watercolors before separating their collection in 1913–14; the additional works are Rewald nos. 247, 394, 496, 504, and 525. Five Cézanne watercolors remained in the collection of Leo Stein until they were acquired by Albert C. Barnes in 1921 (see +5). BFA, AR.ABC.1921.109.

+5 Thirty-four works belonging to Leo Stein that he wished to sell in 1921 were appraised in correspondence from Albert C. Barnes dated April 7, 1921. Barnes's list noted seventeen works by Renoir (one of which was a drawing), seven by Cézanne (six of which were watercolors), seven by Matisse (six paintings, one drawing), one Daumier, one Delacroix, and one Manguin. Barnes himself purchased twenty-nine of the works. A "detailed statement" of these twenty-nine purchases, including the prices paid, is listed in Barnes's correspondence to Leo dated May 9, 1921. BFA, AR.ABC.1921.109.

The seven works by Cézanne that appeared on the April 7, 1921, list were noted as nos. 20, 24, 25, 26, 27, 28, and 32. These numbers refer to one painting (no. 20, identified as *Five Apples* [1877–78; cat. 7], priced at $1,000 and offered and sold for $800); five watercolors (nos. 24–28, each priced at $200 and each sold for $100; see cat. 17, 20, 21, 23, 24); and *Leaning Smoker* (1890–91; cat. 19), also a watercolor but listed as a drawing (no.

32, priced at $500, and subsequently noted on a May 9, 1921, statement as "Cezanne, drawing, smoker" with a paid price of $200). All entered the collection of Albert C. Barnes with the exception of *Five Apples*, which Durand-Ruel purchased. BFA, AR.ABC.1921.109.

Of the seventeen works by Renoir that appeared on the April 7, 1921, list, Leo sold sixteen between April and June 1921. Of these, Barnes purchased thirteen: nine on April 25, 1921; three on May 25, 1921; one on June 2, 1921. BFA, AR.ABC.1921.109; see also Lucy 2010, 117–18.

At least three of the works that appeared on the April 7, 1921, list were purchased by Durand-Ruel: Cézanne's *Five Apples* and Renoir's *The Bay of Douarnenez* (ca. 1895; cat. 402) and *Seated Bather* (ca. 1882; cat. 393). BFA, AR.ABC.1921.109; Archives Durand-Ruel; and Durand-Ruel to John Rewald, June 23, 1970, in MoMA Archives, Margaret Potter Papers, 6.

Four of the works that appeared on the April 7, 1921, list were put on consignment with Durand-Ruel, New York, in May/June 1921: one Daumier (cat. 57), one Delacroix (cat. 60), one Manguin painting (cat. 82), and one Renoir drawing (current location unknown). All four were returned on April 7, 1924, to Leo's cousin Fred M. Stein in New York. BFA, AR.ABC.1921.109.

+6 One of at least three Cézanne watercolors (cat. 18, 22, 25) that Paul Rosenberg purchased from Gertrude after the 1913–14 division of the collection.

+7 An **inventory of Michael and Sarah Stein's collection, contained in correspondence from Grace McCann Morley to Mr. J. J. O'Brien of Messrs.** Cosgrove and Company, San Francisco, July 7, 1937, SFMOMA Archives.

+8 Undated copy of a one-page typed document with a list of clients and dates of sales and purchases, bearing the stamp of Galerie Bernheim-Jeune. MoMA Archives, Margaret Potter Papers, Curator Exh. 950, folder "Stein Research (C[arolyn]. L[anchner])."

+9 Following a visit with Sarah Stein in Palo Alto, Fiske **Kimball described her collection in detail in a letter to R.** Sturgis Ingersoll, February 25, 1947, **PMA Kimball Papers.**

+10 Leo Stein purchased seven works from Ambroise Vollard on October 28, 1904, for a total of 8,000 francs. They were recorded as nos. 3942 (Denis [cat. 61]), 4365 (Renoir [cat. 396]), 4364 (Cézanne [cat. 14]), 4363 (Cézanne [cat. 12]), 4366 (Renoir pastel [cat. 412]), 3305 (Gauguin [cat. 63 or 64]), and 3505 (Gauguin [cat. 63 or 64]). Vollard Archives, MS 421 (4, 10), folio 30.

+11 According to a letter dated July 14, 1912, from Leo Stein at rue de Fleurus to Gertrude Stein in Tangiers, Jos Hessel (1870–1941), first director of Galerie Bernheim-Jeune, offered to buy the following works from their collection: 15,000 francs for "the Cézanne landscape" (*The Spring House* [ca. 1879; cat. 8]); 8,000 for Manet's *Ball Scene* (1873; cat. 81); 2,000 for Cézanne's *Man with Pipe* (1892–96; cat. 13); 2,000 for the Matisse landscape "with tree on the right" (*The Sea Seen from Collioure* [1906; cat. 127]). BMA Cone Papers, box 6: series 7-8. The Steins declined to sell.

These four works were eventually sold: Leo sold the Matisse to Barnes in December 1912 and Cézanne's *The Spring House* to him in May 1914, and Gertrude sold the Manet and Cézanne's *Man with Pipe* to Paul Rosenberg in October 1919.

+12 Forty-four Coubines owned by Leo Stein were sent to Manhattan Storage, probably in May 1947. Fred Stein to Leo Stein in Settignano, Italy, undated telegram, among papers and letters from May 1947, Beinecke YCAL, MSS 78, box 5, folder 122. Twenty-nine are located in the collection of Stephen Mazoh.

+13 On April 27, 1908, Leo Stein acquired from Vollard the Renoir study of a female nude now known as *Bather* (ca. 1890; cat. 398), valued at 3,750 francs, in exchange for Maurice Denis's *Mother in Black* (1895; cat. 61), valued at 750 francs, and Paul Gauguin's *Sunflowers on an Armchair* (1901; cat. 64), valued at 2,500 francs, plus an additional cash payment of 750 francs. Vollard Archives, MS 421 (5, 3), F77.

+14 Gertrude Stein owned four works by Juan Gris (Cooper 1977, nos. 48, 68, 83, 95) that were created in or before 1914. The present example is perhaps one of the two paintings that she acquired in June 1914 and that were referred to in a letter, dated June 3, 1914, to Gertrude from Daniel-Henry Kahnweiler in which he acknowledges receiving a letter from her and confirms the sale of two paintings by Gris that he is delighted will enter her collection. He indicates that he will deliver these works to her the same day, along with a bill. Beinecke YCAL, MSS 76, series II, box 112, folder 2310.

+15 Eight works by Gris totaling 14,500 francs were recorded in the estate of Gertrude Stein and evaluated in a French tax document dated February 22, 1947 (AdvP Succession: Feb. 22, 1947). It should be noted that seven mixed-media paintings by Gris were listed in the inventory of Gertrude's estate filed in America in May 1948; a second American inventory, filed two years later, in May 1950, included two drawings by Gris that had been overlooked in the initial record, thus bringing the total number of works by Gris recorded in the inventories filed in America to nine. Alice Toklas confirmed the number of works on canvas, writing to Carl Van Vechten on November 13, 1955: "The Gris—there are only seven—of which three are in Berne—are not all of them in a condition to travel (collage)." Toklas 1973, 328.

+16 In a letter dated August 10, 1917, to Léonce Rosenberg, Gris indicates that Gertrude Stein acquired four of his still-life paintings through Kahnweiler. Léonce **Rosenberg Archives, 9600-438, Bibliothèque Kandinsky, Centre Georges Pompidou, Paris.**

+17 One of at least four works from the collection of Gertrude Stein lent to the Juan Gris retrospective at Galerie Simon in June 1928 (Paris 1928): no. 9, as "Bouquet" (*Flowers*, 1914; cat. 69); no. 29, as "L'Olivier" (*The Table in Front of the Window*, 1921; cat. 70); no. 52, as "Le Tapis vert" (*The Green Cloth*, 1925; cat. 72); and no. 53, as "Le Compotier de poires" (*Dish of Pears*, 1926; cat. 73).

+18 Gertrude Stein acquired *The Green Cloth* by Gris (1925; cat. 72) from Kahnweiler through the exchange of Masson's *The Snack* (1922–23; cat. 86) and **1,000 francs. The sizes of the two works are similar: the Masson, 25⁹⁄₁₆ x 31⁷⁄₈ inches, and the Gris, 28¾ x 36¼ inches. In a letter to Gertrude, Kahnweiler offered to sell a Gris painting in exchange for her Masson still life and 1,000 francs, stating "the price of the Gris being much higher than that of a Masson of the same size." Daniel-Henry Kahnweiler to Gertrude Stein, June 18, 1925, Beinecke YCAL, MSS 76, series II, box 112, folder 2310.**

+19 David Rockefeller acquired eight works (six by Picasso, two by Gris) from the estate of Gertrude Stein through the Museum of Modern Art Syndicate in 1968. Potter 1984, 258–60. For a brief description of the syndicate, see Edward Burns's essay in this volume, 263.

+20 Kahnweiler's initial offer appears in a June 6, 1925, letter to Gertrude in which he writes that he wishes to acquire her Laurencin painting (cat. 77) in exchange for the "Tapis vert" (*The Green Cloth*, 1925; cat. 72) by Juan Gris ("one of the two big pictures h**e painted just now") and 3,000 francs. This transaction did not take place, and Kahnweiler made a second offer on June 18, 1925, of an exchange of Gertrude's Masson still life for the Gris. See** +18.

+21 Purchased for 10,000 francs. Claribel Cone wrote in her 1925 notebook: "At lunch table gave Mike 6000 fr. part of what I owe him and Sallie for Gertrude's Marie Laurencin (10000) Still owe Mike and Sallie 5000 fr. as follows: 4000 fr. on 10000 for Marie Laurencin/Picasso/Fernande/1000 fr. for 3 Favres Paintings as follows/300 flowers-dahlias/300 Balcony/400 Still life much colored." BMA Cone Papers, Claribel Cone's 1925 notebook, 3.

+22 In a letter of perhaps April 1923 to Henry McBride, Gertrude writes: "I have a new Picasso I traded for an old and two new Masson's [*sic*]." The works by Masson have been identified as *The Cardplayers* (1923; cat. 87) and *The Meal* (1922; cat. 85). The Picasso is likely *Still Life* (1922; cat. 269). Beinecke YCAL, MSS 31, box 11, folder 307, 13r.

+23 In a letter to R. Sturgis Ingersoll dated February 6, 1949, Fiske **Kimball writes about Earl Stendahl's acquisitions of works by Matisse from Sarah Stein's collection. About the** five ceramic pieces by Matisse that Stendahl acquired and had sold by February 1949, he wrote: "He [Stendahl] also got the 5 pieces of ceramics—all Matisse made, beautiful. 4 already sold, including the best, 'L'après midi d'une [*sic*] faune' $750. I bought the remaining one—blue, with a head, $350—from surplus decorative objects." PMA Kimball Papers.

+24 Nineteen works by Matisse that Michael and Sarah Stein owned were shipped in June 1914 for inclusion in a July exhibition at Kunstsalon Fritz Gurlitt, 113 Potsdamer-Straße, Berlin. During World War I, the paintings were allegedly confiscated and later auctioned. The works are listed in the 1914 Gurlitt exhibition pamphlet, in a November 1916 document (pl. 116 in this volume), and in a document compiled in December 1917, which Michael later sent to his lawyer Jacob M. Moses in Baltimore (BMA Cone Papers, attachment to letter of February 27, 1925).

The Steins authorized their German friend Hans Purrmann to intervene on their behalf. He eventually negotiated the sale of the nineteen paintings to the Norwegian shipowner Tryggve Sagen and Danish collector Christian Tetzen-Lund. Monrad 1999b, 142–43.

+25 Leo and/or Gertrude were still selling works in spring 1914, which contradicts former notions that the separation of their collection was finalized before March 1914. Bernheim-Jeune handled the dispersal of at least four important Matisse paintings from Leo and Gertrude's collection after their separation of 1913–14: *Le Bonheur de vivre* (1905–6; cat. 117), *Music* (Sketch) (1907; cat. 143), *Margot* (1906; cat. 122), and *Olive Trees at Collioure* (ca. 1906; cat. 134).

+26 Of the nineteen works that Michael and Sarah Stein lent to the July 1914 exhibition at the Berlin gallery of Fritz Gurlitt, at least five were included in a Matisse exhibition sixteen years later at Galerien Thannhauser (Berlin 1930; as nos. 8, 10, 18, 20, 57). Hans Purrmann wrote an introduction for the catalogue.

+27 In a letter of September 15, 1907, to Henri Manguin, Matisse writes that he has sold to Stein a large painting (of which Manguin had seen a photo); a composition that he calls "Music"; a still life; and a landscape (AMP). Although Matisse's reference to a still life and a landscape is vague, he may be referring to the still life *Pink Onions* (1906-7; cat. 138) and the landscape *Olive Trees at Collioure* (ca. 1906; cat. 134), both of which Leo purchased in autumn 1907.

+28 Three exhibitions of the work of Henri Matisse at the San Francisco Museum of Art (now SFMOMA) are cited respectively as San Francisco 1936, San Francisco 1952, and San Francisco 1962. Reference sources in the SFMOMA Archives are as follows:

San Francisco 1936: List of **Received Works, February 26, 1936,** *Paintings, Drawings, and Sculpture by Henri Matisse,* **January 11 - February 24, 1936, Exhibition Records, San Francisco Museum of Modern Art Archives.**

San Francisco 1952: *Supplement to the Catalogue, Henri Matisse.*

San Francisco 1962: List of Lenders, *The Sarah and Michael Stein Collection,* March-April 1962, Exhibition Records, San Francisco Museum of Modern Art Archives.

+29 An inventory of Sarah and Michael Stein's collection made two years after their return to California indicates that they owned seventy Matisse lithographs and seven Matisse etchings (valued at $50 each), none of which were individually itemized. Grace McCann Morley to Mr. O'Brien of Messrs. Cosgrove and Company, July 7, 1937, SFMOMA Archives. The present list focuses on those prints that Sarah gave to Bay Area institutions or friends and that are included in the present exhibition: seven of the twelve lithographs given to Stanford University in 1953; two of the six lithographs given to Mills College, Oakland, in 1945 and 1946; one of the two etchings given to SFMA in 1937; and one of several prints given to her friend Stanley Steinberg in the 1940s.

+30 Leo Stein is reported to have purchased sixty-seven or more ("two thirds or three quarter" of approximately one hundred) Nadelman drawings exhibited in Paris 1909 (Galerie Druet). Kirstein 1973, 273-74, excerpt of André Gide's journal entry of April 25/26, 1909. See also Haskell 2003, 38. Only one of these drawings has been identified (*Head of a Woman,* ca. 1906; cat. 214).

Many of these drawings are thought to have been lent back or returned to the artist for possible reproduction in the 1914 portfolio *Vers l'unité plastique* (Kirstein 1948, 11). On May 19, 1910, Nadelman wrote: "Dear Mr. Stein, I would like to ask you a favor. They are going to publish an album of my drawings. I would like to include some that belong to you. Would it be possible to permit me to pick them up from rue de Fleurus to have them photographed, despite your absence." Another undated letter follows: "Dear Mr. Stein, I saw your brother, I received the drawings, thank you very much. A great pleasure awaits me—I will go to Italy and I will take advantage of this trip to come to see you *chez vous.*" Beinecke YCAL, MSS 76, series II, box 117, folder 2500; translations by Carrie Pilto. Copies of these letters provided by Cynthia Nadelman to Carrie Pilto, April 17, 2009.

Kirstein (1948, 18) indicates that some of Leo's Nadelman drawings were acquired by Joseph Brummer: "Gide wrote that Leo Stein bought two-thirds [or three quarters] of the drawings; Brummer later obtained many from Stein, and Nadelman had them back from Brummer for their American publication in 1921."

+31 The following six works by Picabia were noted in the Third Administration Accounting of the Estate of Gertrude Stein, dated June 22/26, 1951: *Portrait of a Woman* (perhaps cat. 220 or 221?), *Louis XIV* (1936; cat. 223), *Landscape, Trio, Woman with Leaves* (perhaps cat. 218?), and *Two Heads* (perhaps cat. 219?).

+32 Sales catalogue, Sotheby's, New York, *Drawings and Paintings Collected by Georges E. Seligmann: Property from the Estate of Mrs. Edna H. Seligmann,* November 4, 1982, indicates for this lot number: "A letter written in 1947 on the stationery of the Hotel Continental in Paris, signed Alice B. Toklas, confirming the provenance of this work, is affixed to the backing." The preface of the sales catalogue notes that the six drawings in the sale "were bought by Edna and Georges Seligmann on the same day in 1947 from the Gertrude Stein Collection in Paris."

+33 Perhaps this is one of fourteen unidentified Picasso drawings that Etta Cone acquired in 1930, as cited by Brenda Richardson (1985, 183, 186). She writes that Michael Stein in Vaucresson, Seine-et-Oise, received 50,000 francs from Etta Cone for "14 drawings" by Picasso. "It is not known which Picasso drawings were included in this group, nor whether the drawings in fact came from the collection of Michael Stein or, more likely, from Gertrude Stein."

+34 The Steins are known to have owned at least fourteen works from Picasso's Carnet 10 (June-July 1907), a sketchbook for *Les Demoiselles d'Avignon* (1907; **Museum of Modern Art, New York**), and *Nude with Drapery* (1907; **State Hermitage Museum, Saint Petersburg**). Michael and Sarah Stein owned one drawing from the sketchbook (cat. 370). Leo and Gertrude acquired thirteen of these works, probably in autumn 1907, according to Daix and Rosselet (1979). Current research indicates that most of these remained in the collection of Gertrude Stein until her death. Several are revealed in photographs of rue de Fleurus (pl. 355) and rue Christine (pl. 382). Two drawings from Carnet 10 (cat. 363 and 364) were never mounted on canvas and appear in no known photographs of rue de Fleurus and rue Christine. They remained in Gertrude Stein's estate and were dispersed in 1947.

+35 In an October 1913 letter, Daniel-Henry Kahnweiler agreed to purchase from Gertrude Stein three paintings by Picasso in exchange for cash and Picasso's *Man with a Guitar* (1913; cat. 264). The three paintings are: *Young Acrobat on a Ball* (1905; cat. 234); *Three Women* (1908-9; cat. 251); and "La femme avec le linge," or *Nude with a Towel* (1907; cat. 242). Kahnweiler to Gertrude Stein, October 17, 1913, Beinecke YCAL, MSS 76, series II, box 112, folder 2310. As Margaret Potter (1984, 263-64) notes, neither of the latter works appears in known photographs of Leo and Gertrude's rue de Fleurus apartment, and the identification of "La femme avec le linge" more likely refers to *Nude with a Towel* than *Nude with Drapery* (1907; State Hermitage Museum, **Saint Petersburg;** Zervos II*47), as once believed.

Kahnweiler's written offer is for 20,000 francs "in cash, as well as the new painting by Picasso titled *Man with a Guitar*" (translation by Erin Hyman). In the letter, Kahnweiler indicates that he includes a check for 20,000 francs payable on January 15, 1914. Although it is likely that the dealer's *check,* issued for the identical amount of the "cash" offer, represents the total amount of the monetary exchange involved in this transaction, there is also the possibility that the check was sent as a guarantee to secure the transaction or that later negotiations ensued. Given that Gertrude did exchange the three paintings for *Man with a Guitar* and the absence of any known proof of a counteroffer, it would appear that she accepted the terms of Kahnweiler's proposition noted here.

+36 This is one of seventeen Renoirs (fifteen paintings, one pastel, one drawing) on the list of thirty-four works that Leo wished to sell in 1921 that were appraised in correspondence from Albert C. Barnes dated April 7, 1921. **BFA, AR.ABC.1921.109. See also** +5.

+37 In a 1914 letter, Leo mentions taking sixteen Renoirs to Florence. Leo Stein to Mabel Weeks, April 2, 1914, Beinecke YCAL, MSS 78, box 3, folders 51-59. All remained with him until 1921, when he offered them for sale. BFA, AR.ABC.1921.109.

+38 In February 1914, Leo Stein purchased from Durand-Ruel, Paris, at least three Renoirs—*Cup of Chocolate* (ca. 1912; cat. 411), *The Bay of Douarnenez* (ca. 1895; cat. 402), and *Peninsula of Saint-Jean* (1893; cat. 400). Archives Durand-Ruel, Paris.

+39 Fourteen works were "loaned by Miss Gertrude Stein" to a December 1934 exhibition, *Sir Francis Rose,* at Marie Harriman Gallery (New York 1934). Gertrude wrote a one-page preface to the catalogue.

+40 Sixty-eight works by Sir Francis Rose were listed in a May 1950 inventory filed in the Third Administration Accounting of Gertrude Stein's Estate on June 22/26, 1951, in Baltimore.

+41 Among three paintings that Alice Toklas sold to Ralph W. Church, as noted in a letter from Toklas to Church dated April 9, 1947. The works were Tchelitchew's *Portrait of Alice B. Toklas* (1924; cat. 432) and *Grapes* (1927; cat. 434), and Kristians Tonny's *Le Bâteau ivre* (1927; cat. 436), and were sold with the consent of Allan Stein. Toklas 1973, 61-62.

Works in the Exhibition

This listing represents the San Francisco and New York presentations of *The Steins Collect: Matisse, Picasso, and the Parisian Avant-Garde* and reflects the information available at the time of publication. (The Paris presentation is documented in the French edition of the catalogue.) All works are exhibited at both American venues unless otherwise noted. In addition to the artworks below, the San Francisco and New York presentations include a selection of photographs by Cecil Beaton, George Platt Lynes, Man Ray, André Ostier, Ettore Sottsass, Carl Van Vechten, and Francis Yerbury, as well as studio photographs and snapshots, family albums, decorative arts, furniture, books, film clips, and ephemera courtesy of the following lenders: Albert S. Bennett, New York; Archives Françaises du Film–CNC; David and Barbara Block family archives; Fondation Le Corbusier, Paris; Hans Gallus; Mildred Gaw; Prelinger Archives; Estate of Daniel M. Stein, courtesy William J. Ashton; Stanley Steinberg, San Francisco; Yale Collection of American Literature, Beinecke Rare Book and Manuscript Library, Yale University; and anonymous private collectors. Our presentations also include materials from The Metropolitan Museum of Art's Department of Photographs and Thomas J. Watson Library, and Edward Burns's recent gift of his Gertrude Stein and Alice Toklas photographic archive, now housed in the museum's Department of Nineteenth-Century, Modern, and Contemporary Art; as well as the San Francisco Museum of Modern Art's Library and Archives.

BALTHUS (BALTHAZAR KLOSSOWSKI)
French, born 1908, Paris; died 2001, Rossinière, Switzerland

Moroccan Horseman and His Horse (pl. 194)
1949
Oil on canvas
23¼ x 25⅜ in. (58.9 x 64.2 cm)
Hirshhorn Museum and Sculpture Garden, Smithsonian Institution, Washington, D.C., gift of Joseph H. Hirshhorn, 1966

EUGENE BERMAN
American, born 1899, Saint Petersburg, Russia; died 1972, Rome

Gertrude Stein in Bilignin (pl. 191)
1929
Ink on paper
15¾ x 23⅝ in. (40 x 60 cm)
Private collection, Paris

PIERRE BONNARD
French, born 1867, Fontenay-aux-Roses, France; died 1947, Le Cannet, France

Siesta (pl. 14, cat. 3)
1900
Oil on canvas
42⅞ x 52 in. (109 x 132 cm)
National Gallery of Victoria, Melbourne, Australia, Felton Bequest, 1949

PAUL CÉZANNE
French, born 1839, Aix-en-Provence, France; died 1906, Aix-en-Provence, France

Bathers
1874–75
Oil on canvas
15 x 18⅛ in. (38.1 x 46 cm)
The Metropolitan Museum of Art, New York, bequest of Joan Whitney Payson, 1975

Five Apples (pl. 49, cat. 7)
1877–78
Oil on canvas
4⅞ x 10¼ in. (12.4 x 26 cm)
Mr. and Mrs. Eugene V. Thaw

Three Bathers (pl. 115)
1879–82
Oil on canvas
20½ x 21⅝ in. (52 x 55 cm)
Petit Palais, Musée des Beaux-Arts de la Ville de Paris
[San Francisco only]

Portrait of Paul, the Artist's Son (pl. 128, cat. 9)
ca. 1880
Oil on canvas
6¾ x 6 in. (17.1 x 15.2 cm)
The Henry and Rose Pearlman Foundation; on long-term loan to Princeton University Art Museum

Bathers (pl. 129, cat. 11)
ca. 1892
Oil on canvas
8¹¹⁄₁₆ x 13 in. (22 x 33 cm)
Musée d'Orsay, Paris, on deposit at the Musée des Beaux-Arts, Lyon

Bathers (pl. 51)
1897
Color lithograph
9½ x 11⅜ in. (24.1 x 28.9 cm)
San Francisco Museum of Modern Art, bequest of Harriet Lane Levy

Large Bathers (pl. 50)
ca. 1898
Color lithograph
18 x 20⅞ in. (45.7 x 53 cm)
San Francisco Museum of Modern Art, bequest of Harriet Lane Levy
[San Francisco only]

Large Bathers
ca. 1898
Color lithograph
19⅛ x 24¹⁵⁄₁₆ in. (48.6 x 63.3 cm)
The Metropolitan Museum of Art, Rogers Fund, 1922
[New York only]

Bathers (pl. 36, cat. 14)
1898–1900
Oil on canvas
10⅝ x 18⅛ in. (27 x 46 cm)
The Baltimore Museum of Art: The Cone Collection, formed by Dr. Claribel Cone and Miss Etta Cone of Baltimore, Maryland

Man with Crossed Arms (pl. 4)
ca. 1899
Oil on canvas
36¼ x 28⅝ in. (92 x 72.7 cm)
Solomon R. Guggenheim Museum, New York
[New York only]

JO DAVIDSON
American, born 1883, New York; died 1952, Tours, France

Gertrude Stein (pl. 254)
ca. 1920–22
Bronze
33 x 22 x 24 in. (83.8 x 55.9 x 61 cm)
The Metropolitan Museum of Art, New York, gift of
Dr. Maury P. Leibovitz, 1982

MAURICE DENIS
French, born 1870, Granville, France; died 1943, Paris

Mother in Black (pl. 40, cat. 61)
1895
Oil on canvas
18½ x 15¼ in. (47 x 38.7 cm)
Private collection
[New York only]

JUAN GRIS
Spanish, born 1887, Madrid; died 1927, Boulogne-
Billancourt, France

Glasses on a Table (pl. 241, cat. 67)
1913–14
Oil and pasted paper on canvas
24⅛ x 15⅛ in. (61.3 x 38.4 cm)
Private collection
[New York only]

Book and Glasses (pl. 242, cat. 68)
1914
Oil, pasted paper, and wax crayon on canvas mounted
on panel
25¹¹⁄₁₆ x 19¹³⁄₁₆ in. (65.3 x 50.3 cm)
Private collection, New York

Flowers (pl. 189, cat. 69)
1914
Oil, pasted paper, and graphite on canvas
21¾ x 18¼ in. (55.3 x 46.4 cm)
Private collection

The Table in Front of the Window (pl. 244, cat. 70)
1921
Oil on canvas
25⅝ x 39½ in. (65 x 100 cm)
Beverly and Raymond Sackler

The Clown, drawing for Armand Salacrou's *Le Casseur
d'assiettes* (The Plate Breaker) (pl. 245, cat. 74)
1924
Ink and graphite on paper
9⅞ x 7½ in. (25.1 x 19.1 cm)
Katrina B. Heinrich-Steinberg, Rancho Mirage,
California

Woman with Clasped Hands (pl. 246, cat. 71)
1924
Oil on canvas
32 x 23⅝ in. (81.3 x 60 cm)
Ikeda Museum of Twentieth-Century Art Foundation,
Shizuoka, Japan

Drawing for the cover of Gertrude Stein's *A Book
Concluding with As a Wife Has a Cow A Love Story*
ca. 1926
Graphite and pastel on paper
9⅝ x 7½ in. (24.5 x 19 cm)
Galerie Louise Leiris, Paris

JEAN HEIBERG
Norwegian, born 1884, Oslo; died 1976, Oslo

Nude (pl. 111)
1909
Oil on canvas
28⅜ x 21¼ in. (72 x 54 cm)
Drammens Museum, Norway

KITAGAWA HIDEMARO
Japanese, active ca. 1801–1818

Two Beauties and an Attendant by the Sea (pl. 87)
ca. 1801–18
Color woodblock print
14½ x 9½ in. (36.8 x 24.1 cm)
Stanley Steinberg, San Francisco

KATSUSHIKA HOKUSAI
Japanese, born 1760, Tokyo; died 1849, Tokyo

Ushibori in Hitachi Province (Joshu Ushibori), from the
series *Thirty-Six Views of Mount Fuji*
ca. 1831
Color woodblock print
9 x 13¾ in. (22.9 x 34.9 cm)
Stanley Steinberg, San Francisco

Watermill at Onden, from the series *Thirty-Six Views of
Mount Fuji* (pl. 85)
between 1826 and 1833
Color woodblock print
9¼ x 12¾ in. (23.5 x 32.4 cm)
Stanley Steinberg, San Francisco

UTAGAWA KUNISADA
Japanese, born 1786; died 1864

Standing Actor
ca. 1830s
Color woodblock print
26½ x 11½ in. (67.3 x 29.2 cm)
Stanley Steinberg, San Francisco

MARIE LAURENCIN
French, born 1885, Paris; died 1956, Paris

Group of Artists (pl. 207, cat. 77)
1908
Oil on canvas
25½ x 31⅞ in. (64.8 x 81 cm)
The Baltimore Museum of Art: The Cone Collection,
formed by Dr. Claribel Cone and Miss Etta Cone of
Baltimore, Maryland
[San Francisco only]

Apollinaire and His Friends (pl. 26)
1909
Oil on canvas
51⅛ x 76⅜ in. (130 x 194 cm)
Musée National d'Art Moderne, Centre Georges
Pompidou, on loan to Musée National Picasso, Paris

**LE CORBUSIER (CHARLES ÉDOUARD
JEANNERET)**
Swiss, born 1887, La Chaux-de-Fonds, Switzerland; died
1965, Roquebrune, France

Preliminary studies for the
Villa Stein-de Monzie (pl. 119)
1926
Ink and graphite on tracing paper
32¹¹⁄₁₆ x 25 ⁹⁄₁₆ in. (83 x 65 cm)
Fondation Le Corbusier, Paris (FLC 31480)

**LE CORBUSIER (CHARLES ÉDOUARD
JEANNERET) and PIERRE JEANNERET**
Swiss, born 1887, La Chaux-de-Fonds, Switzerland; died
1965, Roquebrune, France
Swiss, born 1896, Geneva; died 1967, Geneva

Axonometric projection of the front of
Villa Stein-de Monzie (northwest)
1927
Ink on tracing paper
23⅝ x 39¾ in. (60 x 101 cm)
Fondation Le Corbusier, Paris (FLC 10444)

Axonometric projection of the rear of
Villa Stein-de Monzie (southeast) (pl. 122)
1927
Graphite and colored pencil on gelatin print mounted
on paper
45¼ x 36⅝ in. (115 x 93 cm)
Fondation Le Corbusier, Paris (FLC 10445)
[San Francisco only]

Elevation of Villa Stein-de Monzie (east and west)
1927
Ink, graphite, and colored pencil on tracing paper
21¼ x 42½ in. (54 x 108 cm)
Fondation Le Corbusier, Paris (FLC 10421)
[San Francisco only]

Elevation of Villa Stein-de Monzie (north and south)
1927
Ink, graphite, and colored pencil on tracing paper
20⅞ x 41¾ in. (53 x 106 cm)
Fondation Le Corbusier, Paris (FLC 10420)
[San Francisco only]

Plans of the ground floor and main (second) floor of
Villa Stein-de Monzie (pl. 121)
1927
Ink and graphite on tracing paper
25³⁄₁₆ x 41⁵⁄₁₆ in. (64 x 105 cm)
Fondation Le Corbusier, Paris (FLC 10418)
[San Francisco only]

Plans of the third floor and fourth floor with roof terrace of Villa Stein-de Monzie (pl. 120)
1927
Ink and graphite on tracing paper
20 1/16 x 41 3/4 in. (51 x 106 cm)
Fondation Le Corbusier, Paris (FLC 10419)
[San Francisco only]

Preliminary presentation drawing for the north facade of Villa Stein-de Monzie
ca. 1927
Pastel on paper
17 1/8 x 29 5/16 in. (43.5 x 74.5 cm)
Fondation Le Corbusier, Paris (FLC 10588)
[San Francisco only]

Study for exterior colors of Villa Stein-de Monzie (north axonometric view)
ca. 1927
Gouache and graphite on tracing paper
14 13/16 x 15 9/16 in. (36 x 39.5 cm)
Fondation Le Corbusier, Paris (31513 A)
[San Francisco only]

Study for exterior colors of Villa Stein-de Monzie (south axonometric view)
ca. 1927
Gouache and graphite on tracing paper
14 7/16 x 10 1/16 in. (36.6 x 25.5 cm)
Fondation Le Corbusier, Paris (31315 B)
[San Francisco only]

North facade showing regulating lines, Villa Stein-de Monzie
ca. 1927
Gelatin print on paper
22 1/16 x 24 3/16 in. (56 x 63 cm)
Fondation Le Corbusier, Paris (FLC 10453)
[San Francisco only]

South facade showing regulating lines, Villa Stein-de Monzie
ca. 1927
Gelatin print on paper
22 1/16 x 24 13/16 in. (56 x 63 cm)
Fondation Le Corbusier, Paris (FLC 10454)
[San Francisco only]

Drawing for Steen: interior perspective of Villa Stein-de Monzie showing main (second) floor level, including living room with designs for furniture and a fireplace, and Henri Matisse's sculpture *Reclining Nude I (Aurora)*, 1907
1936
Graphite on tracing paper
25 9/16 x 43 5/16 in. (65 x 110 cm)
Fondation Le Corbusier, Paris (FLC 10495)

RUDOLF LEVY
German, born 1875, Stettin, Germany; died 1943

Nude on a Table (pl. 110)
1911
Oil on canvas
31 3/4 x 27 1/2 in. (80.5 x 69.8 cm)
Generaldirektion Kulturelles Erbe Rheinland-Pfalz, Landesmuseum Mainz, Germany

JACQUES LIPCHITZ
French, born 1891, Lithuania; died 1973, Capri, Italy

Gertrude Stein (pl. 253)
1920
Bronze
13 x 7 7/8 x 7 1/2 in. (33 x 20 x 19 cm)
Musée National d'Art Moderne, Centre Georges Pompidou, Paris

ÉDOUARD MANET
French, born 1832, Paris; died 1883, Paris

Ball Scene (pl. 48, cat. 81)
1873
Oil on canvas
13 3/4 x 10 5/8 in. (34.9 x 27 cm)
Private collection

HENRI CHARLES MANGUIN
French, born 1874, Paris; died 1949, Saint-Tropez, France

The Studio, the Nude Model (pl. 55, cat. 82)
1904-5
Oil on canvas
24 3/4 x 21 in. (65 x 54 cm)
Collection of Mr. and Mrs. E. David Coolidge III

La Coiffure (pl. 18, cat. 83)
1905
Oil on canvas
45 5/8 x 35 1/16 in. (116 x 89 cm)
Collection Couturat

Study of Reclining Nude (pl. 56, cat. 84)
1905
Oil on panel
13 x 16 1/8 in. (33 x 41 cm)
Private collection, France

LOUIS MARCOUSSIS
French, born 1883, Warsaw; died 1941, Cusset, France

Gertrude Stein (pl. 258)
1934
Drypoint and engraving, ninth state
14 1/16 x 10 3/16 in. (35.7 x 27.8 cm)
Bibliothèque Nationale de France, Paris
[New York only]

Gertrude Stein and Alice Toklas (pl. 256)
1934
Engraving, third state
14 9/16 x 13 9/16 in. (37.5 x 34.5 cm)
Bibliothèque Nationale de France, Paris
[New York only]

Gertrude Stein and Alice Toklas (pl. 257)
1934
Color engraving mounted on paper, fifth state
13 7/16 x 12 11/16 in. (33.5 x 32.5 cm)
Bibliothèque Nationale de France, Paris
[New York only]

Gertrude Stein (pl. 255)
ca. 1936
Graphite on paper
14 9/16 x 10 1/2 in. (37 x 26.7 cm)
Musée National d'Art Moderne, Centre Georges Pompidou, Paris, purchased in 1964
[San Francisco only]

ANDRÉ MASSON
French, born 1896, Balagne, France; died 1987, Paris

The Meal (pl. 247, cat. 85)
1922
Oil on canvas
32 1/4 x 26 3/8 in. (82 x 67 cm)
Private collection, Madrid

Man in a Tower (pl. 248, cat. 88)
1924
Oil on canvas
37 3/8 x 24 in. (95 x 60.8 cm)
Solomon R. Guggenheim Museum, New York, Estate of Karl Nierendorf, by purchase

HENRI MATISSE
French, born 1869, Le Cateau-Cambrésis, France; died 1954, Nice

Canal du Midi (pl. 57, cat. 91)
1898
Oil on cardboard
9 1/2 x 14 1/8 in. (24 x 36 cm)
Collection of Carmen Thyssen-Bornemisza, on loan to the Museo Thyssen-Bornemisza, Madrid

Sideboard and Table (pl. 130, cat. 98)
1899
Oil on canvas
26 5/8 x 32 1/2 in. (67.5 x 82.5 cm)
Kunsthaus Zürich, gift of the Holenia Trust in memory of Joseph H. Hirshhorn with support from Rolf and Margit Weinberg

Male Nude (pl. 136, cat. 100)
1900-1901
Oil on canvas
32 5/16 x 11 7/16 in. (82 x 29 cm)
Musée Cantini, Marseille

Still Life with Chocolate Pot (pl. 133, cat. 104)
1900-1902
Oil on canvas
28 3/4 x 23 3/8 in. (73 x 59.4 cm)
Musée National d'Art Moderne, Centre Georges Pompidou, Paris, gift of Alex Maguy-Glass, 2002

The Serf (pl. 58)
1900-1903
Bronze
36 1/8 x 14 7/8 x 13 in. (91.8 x 37.8 x 33 cm)
San Francisco Museum of Modern Art, bequest of Harriet Lane Levy

Still Life with Blue Jug (pl. 131, cat. 106)
ca. 1900-1903
Oil on canvas
23 x 25 in. (58.4 x 63.5 cm)
San Francisco Museum of Modern Art, bequest of Matilda B. Wilbur in honor of her daughter, Mary W. Thacher

Madeleine I (pl. 134)
1901
Bronze
21½ x 7⅝ in. (54.6 x 17.2 cm)
San Francisco Museum of Modern Art, bequest of
Harriet Lane Levy

Marguerite (pl. 154, cat. 101)
1901
Oil on cardboard
28 x 21¾ in. (71.1 x 55.3 cm)
Private collection, San Francisco
[New York only]

Faith, the Model (pl. 135, cat. 102)
ca. 1901
Oil on canvas
31 x 17½ in. (78.7 x 44.5 cm)
Fine Arts Museums of San Francisco, bequest of
Aurelie Henwood to the de Young Museum in
memory of Lucille and Gardner Dailey

Pont Saint-Michel (pl. 132, cat. 105)
1901–2
Oil on canvas
18¼ x 22 in. (46.7 x 55.9 cm)
Isabelle and Scott Black Collection
[New York only]

André Derain (pl. 137, cat. 107)
1905
Oil on canvas
15½ x 11⅜ in. (39.4 x 29 cm)
Tate, London, purchased with assistance from the
Knapping Fund, the Art Fund and the Contemporary
Art Society and private subscribers, 1954

Head of a Child (Pierre Matisse)
1905
Bronze
6¼ x 3¾ x 4½ in. (15.9 x 9.5 x 11.4 cm).
The Metropolitan Museum of Art, New York, The
Pierre and Maria-Gaetana Matisse Collection, 2002

La Japonaise: Woman beside the Water (pl. 140, cat. 108)
1905
Oil and graphite on canvas
13⅞ x 11⅛ in. (35.2 x 28.2 cm)
The Museum of Modern Art, New York, purchase and
partial anonymous gift, 1983

Landscape near Collioure [Study for *Le Bonheur de vivre*]
(pl. 141, cat. 109)
1905
Oil on canvas
18⅛ x 21⅝ in. (46 x 54.9 cm)
Statens Museum for Kunst, Copenhagen, gift of
Johannes Rump, 1928

Madame Matisse in the Olive Grove (pl. 139, cat. 161)
1905
Ink and graphite on paper
8⅛ x 10⅝ in. (20.6 x 26.6 cm)
Frances and Michael Baylson, Philadelphia

Woman Leaning on her Hands
1905
Bronze
4⅜ x 9⅝ x 7½ in. (11.1 x 24.5 x 19.1 cm)
The Metropolitan Museum of Art, New York, The
Pierre and Maria-Gaetana Matisse Collection, 2002
[New York only]

Woman with a Hat (pl. 13, cat. 113)
1905
Oil on canvas
31¾ x 23½ in. (80.7 x 59.7 cm)
San Francisco Museum of Modern Art, bequest of
Elise S. Haas

Sketch for *Le Bonheur de vivre* (pl. 142, cat. 116)
1905–6
Oil on canvas
16 x 21½ in. (40.6 x 54.6 cm)
San Francisco Museum of Modern Art, bequest of
Elise S. Haas

The Gypsy (pl. 29, cat. 118)
1905–6
Oil on canvas
21⅝ x 18⅛ in. (55 x 46 cm)
Musée National d'Art Moderne, Centre Georges
Pompidou, on loan to Musée de l'Annonciade,
Saint-Tropez
[San Francisco only]

Flowers (pl. 93)
1906
Oil on canvas
21⅝ x 18⅛ in. (54.9 x 46 cm)
Brooklyn Museum, gift of Marion Gans Pomeroy

Landscape: Broom (pl. 143, cat. 119)
1906
Oil on panel
12 x 15⅝ in. (30.5 x 39.7 cm)
San Francisco Museum of Modern Art, bequest of
Elise S. Haas

Margot (pl. 61, cat. 122)
1906
Oil on canvas
31⅞ x 25⅝ in. (81 x 65 cm)
Kunsthaus Zürich
[New York only]

Marguerite in Three Poses (pl. 153, cat. 165)
1906
Ink on paper
10 x 15⅝ in. (25.4 x 39.7 cm)
San Francisco Museum of Modern Art, bequest of
Elise S. Haas

Nude in a Landscape (pl. 91, cat. 124)
1906
Oil on panel
15¾ x 12⅝ in. (40 x 32 cm)
V. Madrigal Collection, New York

Nude in a Wood (pl. 92)
1906
Oil on board mounted on panel
16 x 12¾ in. (40.6 x 32.4 cm)
Brooklyn Museum, gift of George F. Of

Postcard with a sketch of *The Artist's Family* (pl. 89,
cat. 164)
1906
Ink on paper
3¼ x 4½ in. (8.3 x 11.4 cm)
Cary and Jan Lochtenberg

Reclining Nude
1906
Oil on canvas
12½ x 15 in. (31.8 x 38.1 cm)
Private collection
[New York only]

Seascape (Beside the Sea) (pl. 145, cat. 128)
1906
Oil on cardboard mounted on panel
9⅝ x 12¾ in. (24.5 x 32.4 cm)
San Francisco Museum of Modern Art, bequest of
Mildred B. Bliss

Seascape (La Moulade) (pl. 144, cat. 129)
1906
Oil on cardboard mounted on panel
10¼ x 13¼ in. (26 x 33.7 cm)
San Francisco Museum of Modern Art, bequest of
Mildred B. Bliss

Self-Portrait (pl. 138, cat. 131)
1906
Oil on canvas
21⅝ x 18⅛ in. (55 x 46 cm)
Statens Museum for Kunst, Copenhagen, gift of
Johannes Rump, 1928

Sketch for *Marguerite Reading* (pl. 152, cat. 123)
1906
Oil on canvas
5¼ x 5½ in. (13.3 x 14 cm)
Private collection

The Young Sailor I (pl. 157, cat. 133)
1906
Oil on canvas
39¼ x 32¼ in. (100 x 78.5 cm)
Private collection

Olive Trees at Collioure (pl. 59, cat. 134)
ca. 1906
Oil on canvas
17½ x 21¾ in. (44.5 x 55.2 cm)
The Metropolitan Museum of Art, New York, Robert
Lehman Collection, 1975
[New York only]

Reclining Nude (pl. 146, cat. 167)
ca. 1906
Ink on paper
12¾ x 15½ in. (32.4 x 39.4 cm)
Anne and Stephen Rader, USA

Seated Nude (pl. 148, cat. 168)
ca. 1906
Pastel and ink on vellum
29⅜ x 21½ in. (74.3 x 54.6 cm)
Collection Jan Krugier

Woman in a Kimono (pl. 90, cat. 135)
ca. 1906
Oil on panel
12⅜ x 15½ in. (31.5 x 39.5 cm)
Private collection, on loan to The Courtauld Gallery,
London

Pink Onions (pl. 117, cat. 138)
1906-7
Oil on canvas
18⅛ x 21⅝ in. (46 x 55 cm)
Statens Museum for Kunst, Copenhagen, gift of
Johannes Rump, 1928

Small Head with Striated Hair
1906-7
Bronze
6¼ x 2½ x 2¾ in. (15.9 x 6.4 x 7 cm)
San Francisco Museum of Modern Art, bequest of
Elise S. Haas
[San Francisco only]

Woman Leaning on Her Elbow (pl. 147, cat. 169)
1906-7
Ink on paper
10¼ x 8¼ in. (26 x 21 cm)
San Francisco Museum of Modern Art, bequest of
Elise S. Haas

Blue Nude: Memory of Biskra (pl. 27, cat. 139)
1907
Oil on canvas
36¼ x 55¼ in. (92.1 x 140.4 cm)
The Baltimore Museum of Art: The Cone Collection,
formed by Dr. Claribel Cone and Miss Etta Cone of
Baltimore, Maryland

Boy with Butterfly Net (pl. 156)
1907
Oil on canvas
69¾ x 45¹⁵⁄₁₆ in. (177.2 x 116.7 cm)
Minneapolis Institute of Arts, The Ethel Morrison Van
Derlip Fund

La Coiffure (pl. 19, cat. 141)
1907
Oil on canvas
45⅝ x 35 in. (116 x 89 cm)
Staatsgalerie Stuttgart

Flowers
1907
Oil on cardboard
13⅜ x 10¼ in. (34 x 26 cm)
San Francisco Museum of Modern Art, bequest of
Harriet Lane Levy
[San Francisco only]

Music (Sketch) (pl. 62, cat. 143)
1907
Oil and charcoal on canvas
29 x 24 in. (73.7 x 61 cm)
The Museum of Modern Art, New York, gift of A.
Conger Goodyear in honor of Alfred H. Barr, Jr., 1962

Reclining Nude I (Aurora) (pl. 150)
1907
Bronze
13¹⁄₁₆ x 19¾ x 11 in. (34.4 x 49.9 x 27.9 cm)
Raymond and Patsy Nasher Collection, Nasher
Sculpture Center, Dallas

View of Collioure (pl. 158, cat. 145)
1907
Oil on canvas
36¼ x 25⅞ in. (92 x 65.5 cm)
The Metropolitan Museum of Art, New York, Jacques
and Natasha Gelman Collection, 1998

Allan Stein (pl. 155)
ca. 1907
Oil on canvas
21⅝ x 18⅛ in. (55 x 46 cm)
Kaiserman Family

Painted ceramic vase (pl. 160, cat. 211)
ca. 1907
9⁷⁄₁₆ x 7⅞ in. (24 x 20 cm)
Trina and Billy Steinberg, Los Angeles

Sketch for ceramic design (cat. 171)
ca. 1907
Graphite on paper
8⅞ x 6⅞ in. (22.54 x 17.46 cm)
San Francisco Museum of Modern Art, gift of Charles
Lindstrom
[San Francisco only]

The Girl with Green Eyes (pl. 94)
1908
Oil on canvas
26 x 20 in. (66 x 50.8 cm)
San Francisco Museum of Modern Art, bequest of
Harriet Lane Levy
[San Francisco only]

Sculpture and Persian Vase (pl. 151, cat. 146)
1908
Oil on canvas
23⅞ x 29 in. (60.6 x 73.7 cm)
The National Museum of Art, Architecture, and
Design, Oslo

Painted ceramic plate (pl. 159, cat. 212)
ca. 1908
9¼ in. (23.5 cm) diameter
Philadelphia Museum of Art: purchased with Museum
funds, 1949

Bonjour Mademoiselle Levy
1909
Ink on paper
8½ x 5⅜ in. (22 x 13.7 cm)
San Francisco Museum of Modern Art, bequest of
Harriet Lane Levy
[San Francisco only]

Fontainebleau Forest (Autumn Landscape) (pl. 161, cat. 147)
1909
Oil on canvas
23⅝ x 29 in. (60 x 73.5 cm)
Private collection

Study of a Foot (pl. 149, cat. 207)
ca. 1909
Plaster
13½ in. (34.3 cm) high
Dr. and Mrs. Maurice Galanté

Postcard with a sketch of *The Painter's Family* (cat. 173)
1911
Pen and brown ink on postcard
3⁹⁄₁₆ x 5½ in. (9 x 14 cm)
National Gallery of Art, Washington, D.C., Collection
of Mr. and Mrs. Paul Mellon

Harriet Lane Levy
1913
Graphite on paper
11 x 8⁷⁄₁₆ in. (27.9 x 21.4 cm)
San Francisco Museum of Modern Art, bequest of
Harriet Lane Levy
[San Francisco only]

Head of a Girl (cat. 182)
1913
Lithograph
19³⁄₁₆ x 13 in. (50.3 x 33 cm)
Iris & B. Gerald Cantor Center for Visual Arts at
Stanford University, gift of Mrs. Michael Stein, 1953

Harriet Lane Levy
ca. 1913
Ink on paper
11 x 8⁷⁄₁₆ in. (27.9 x 21.4 cm)
San Francisco Museum of Modern Art, bequest of
Harriet Lane Levy
[San Francisco only]

Michael Stein (pl. 84, cat. 151)
1916
Oil on canvas
26½ x 19⅞ in. (67.3 x 50.5 cm)
San Francisco Museum of Modern Art, Sarah and
Michael Stein Memorial Collection, gift of Nathan
Cummings

Sarah Stein (pl. 83, cat. 152)
1916
Oil on canvas
28½ x 22¼ in. (72.4 x 56.5 cm)
San Francisco Museum of Modern Art, Sarah and
Michael Stein Memorial Collection, gift of Elise S.
Haas

Study of Sarah Stein (pl. 164, cat. 175)
1916
Graphite on paper
19⅛ x 12⅝ in. (48.6 x 32.1 cm)
San Francisco Museum of Modern Art, gift of Mr. and
Mrs. Walter A. Haas

The Bay of Nice (pl. 98, cat. 153)
1918
Oil on canvas
35⅜ x 28 in. (89.9 x 71.1 cm)
Private collection
[New York only]

Landscape with Cypresses and Olive Trees near Nice
(pl. 165, cat. 154)
1918
Oil on board
10⅝ x 13½ in. (27 x 34.3 cm)
Ann and Gordon Getty, San Francisco
[San Francisco only]

Tea (pl. 99, cat. 155)
1919
Oil on canvas
55¼ x 83¼ in. (140.3 x 211.3 cm)
Los Angeles County Museum of Art, bequest of David
L. Loew in memory of his father, Marcus Loew

The Yellow Dress with the Black Ribbon (cat. 184)
1922
Lithograph
21¾ x 14⅛ in. (55.2 x 35.9 cm)
Iris & B. Gerald Cantor Center for Visual Arts at
Stanford University, gift of Mrs. Michael Stein, 1953

Girl Seated at a Table with Vase of Flowers (pl. 167,
cat. 185)
1923
Lithograph
11⁹⁄₁₆ x 14¼ in. (29.4 x 36.2 cm)
Iris & B. Gerald Cantor Center for Visual Arts at
Stanford University, gift of Mrs. Michael Stein, 1953

Girl with an Organdy Collar, No. 2 (pl. 168, cat. 186)
1923
Lithograph
13½ x 10⅛ in. (34.3 x 25.7 cm)
Iris & B. Gerald Cantor Center for Visual Arts at
Stanford University, gift of Mrs. Michael Stein, 1953

Little Aurore (pl. 172, cat. 187)
1923
Lithograph
10¼ x 12¼ in. (26 x 31.1 cm)
Stanley Steinberg, San Francisco
[San Francisco only]

Woman Reading (pl. 169, cat. 188)
1923
Lithograph
25¼ x 19¾ in. (64.1 x 50.2 cm)
Mills College Art Museum, gift of Mrs. Michael Stein,
1945
[San Francisco only]

Nude with Blue Cushion (pl. 175, cat. 189)
1924
Lithograph
29¼ x 21⅞ in. (74.3 x 55.5 cm)
Iris & B. Gerald Cantor Center for Visual Arts at
Stanford University, gift of Mrs. Michael Stein, 1953

Mrs. Allan Stein (Yvonne Daunt) (pl. 163, cat. 178)
1924
Charcoal on paper
25 x 19 in. (63.5 x 48.3 cm)
Trina and Billy Steinberg, Los Angeles
[San Francisco only]

Odalisque in Striped Pantaloons (pl. 173, cat. 190)
1925
Lithograph
24¾ x 19¾ in. (62.9 x 50.2 cm)
Mills College Art Museum, gift of Mrs. Michael Stein,
1945
[San Francisco only]

Reclining Odalisque (with Red Satin Culottes) (pl. 171,
cat. 191)
1925
Lithograph
11¹⁄₁₆ x 13¹³⁄₁₆ in. (28.1 x 35.8 cm)
Iris & B. Gerald Cantor Center for Visual Arts at
Stanford University, gift of Mrs. Michael Stein, 1953

Seated Nude with Tulle Jacket (pl. 174, cat. 192)
1925
Lithograph
19¹⁄₁₆ x 14⁷⁄₁₆ in. (48.4 x 37.4 cm)
Iris & B. Gerald Cantor Center for Visual Arts at
Stanford University, gift of Mrs. Michael Stein, 1953

Woman Leaning on Her Elbow (cat. 193)
1925
Etching
3⅜ x 4¾ in. (8.6 x 12.1 cm)
San Francisco Museum of Modern Art, gift of Mr. and
Mrs. Michael Stein
[San Francisco only]

Girl Reading (pl. 170, cat. 156)
ca. 1925
Oil on canvas
14 x 19½ in. (35.6 x 49.5 cm)
Private collection

Cap d'Antibes Road (pl. 166, cat. 157)
1926
Oil on canvas
19⅞ x 24 in. (50.5 x 61 cm)
Private collection

Large Head (Henriette II)
1927
Bronze
13 x 9 x 12 in. (33 x 22.9 x 30.5 cm)
San Francisco Museum of Modern Art, bequest of
Harriet Lane Levy
[San Francisco only]

Fairy in a Luminous Hat, Souvenir of Mallarmé (cat. 195)
1933
Etching
14⅜ x 12⁹⁄₁₆ in. (36.5 x 31.9 cm)
San Francisco Museum of Modern Art, bequest of
Elise S. Haas
[San Francisco only]

Themes and Variations (Series L, variation 9)
1942
Crayon on paper
25⅜ x 18½ in. (64.5 x 47 cm)
San Francisco Museum of Modern Art, Sarah and
Michael Stein Memorial Collection, gift of the artist
[San Francisco only]

Portrait of F. Thomassin
1946
Charcoal on paper
16¼ x 12¼ in. (41.3 x 31.1 cm)
San Francisco Museum of Modern Art, Sarah and
Michael Stein Memorial Collection, gift of the artist
[San Francisco only]

Jazz (cat. 196)
1947
Twenty hand-printed colored stencils with text
on paper
16⅝ x 25⅝ in. (42.2 x 65.1 cm)
Department of Special Collections, Stanford
University Libraries
[San Francisco only]

ELIE NADELMAN
American, born 1882, Warsaw; died 1946, New York

Head of a Woman (pl. 63, cat. 214)
ca. 1906
Ink on paper
11¾ x 7½ in. (29.9 x 19.1 cm)
Private collection, courtesy James Reinish &
Associates, Inc.

Standing Female Figure (pl. 64)
ca. 1907
Bronze
29½ x 10½ x 9½ in. (74.9 x 26.7 x 24.1 cm)
Whitney Museum of American Art, New York, gift of
the Estate of Elie Nadelman

VILMOS PERLROTT-CSABA
Hungarian, born 1880, Békéscsaba, Hungary; died 1955,
Budapest

Female Nude (pl. 114)
1910
Oil on canvas mounted on board
20⅛ x 16⅛ in. (51 x 41 cm)
Rippl-Rónai Museum, Kaposvár, Hungary, bequest of
Ödön Rippl-Rónai

FRANCIS PICABIA
French, born 1879, Paris; died 1953, Paris

Pa (pl. 249, cat. 219)
1932
Oil on canvas
25⁹⁄₁₆ x 21¼ in. (65 x 54 cm)
Mike Kelley, Los Angeles

The Acrobats (pl. 251)
1935
Oil on panel
59 x 34⅝ in. (150 x 88 cm)
Private collection

Gertrude Stein (pl. 252, cat. 221)
1937 or later
Oil on canvas
29½ x 24 in. (74.9 x 61 cm)
Private collection, courtesy Concept Art Gallery,
Pittsburgh

PABLO PICASSO
Spanish, born 1881, Málaga, Spain; died 1973, Mougins,
France

Melancholy Woman (pl. 176, cat. 231)
1902
Oil on canvas
39⅜ x 27¼ in. (100 x 69.2 cm)
Detroit Institute of Arts, bequest of Robert H.
Tannahill

Soup (pl. 177, cat. 228)
1902
Oil on canvas
15⅛ x 18⅛ in. (38.4 x 46 cm)
Art Gallery of Ontario, gift of Margaret Dunlap Crang,
1983

Head of a Picador with a Broken Nose
1903
Bronze
7¾ x 5⅞ x 4½ in. (19.7 x 14.9 x 11.4 cm)
San Francisco Museum of Modern Art, gift of Marjory
W. Walker, Brooks Walker Jr., and John C. Walker
[San Francisco only]

Une très belle danse barbare (pl. 79, cat. 281)
1904 (letter ca. 1905)
Ink on paper
11¼ x 15⅞ in. (28.6 x 40.3 cm)
Private collection

Study for *The Actor* (pl. 69, cat. 287)
1904-5
Graphite on paper
19 x 12½ in. (48.3 x 31.8 cm)
Private collection
[New York only]

Cocks
1905
Gouache and watercolor on paper
9½ x 12½ in. (24.1 x 31.8 cm)
San Francisco Museum of Modern Art, bequest of
Harriet Lane Levy

Head of a Boy (pl. 72, cat. 294)
1905
Opaque matte paint on composition board
9⅝ x 7⁵⁄₁₆ in. (24.6 x 18.6 cm)
The Cleveland Museum of Art, bequest of Leonard C.
Hanna, Jr.
[New York only]

Lady with a Fan (pl. 68, cat. 235)
1905
Oil on canvas
39½ x 31⅞ in. (100.3 x 81 cm)
National Gallery of Art, Washington, D.C., gift of the
W. Averell Harriman Foundation in memory of Marie
N. Harriman

Leo Stein (pl. 78, cat. 310)
1905
Ink on paper
12½ x 9⅜ in. (31.8 x 23.8 cm)
Castellani Art Museum of Niagara University
Collection, gift of Dr. and Mrs. Armand J. Castellani,
1998

Leo Stein (pl. 80, cat. 308)
1905
Ink on tracing paper
6¼ x 4½ in. (15.9 x 11.4 cm)
Philadelphia Museum of Art: The Louis E. Stern
Collection, 1963

The Milk Bottle (pl. 67, cat. 289)
1905
Gouache on cardboard
24⅝ x 17¾ in. (62.5 x 45.1 cm)
The Museum of Fine Arts, Houston, gift of Oveta
Culp Hobby

Seated Nude (pl. 71, cat. 233)
1905
Oil on cardboard mounted on panel
41¾ x 30 in. (106 x 76 cm)
Musée National d'Art Moderne, Centre Georges
Pompidou, on loan to Musée National Picasso, Paris

Strolling Player and Child (pl. 178, cat. 290)
1905
Gouache and pastel on cardboard
27¾ x 20½ in. (70.5 x 52 cm)
The National Museum of Art, Osaka
[San Francisco only]

Boy Leading a Horse (pl. 20, cat. 236)
1905-6
Oil on canvas
86⅞ x 51⅝ in. (220.6 x 131.2 cm)
The Museum of Modern Art, New York,
The William S. Paley Collection, 1964

Gertrude Stein (pl. 183, cat. 238)
1905-6
Oil on canvas
39⅜ x 32 in. (100 x 81.3 cm)
The Metropolitan Museum of Art, New York, bequest
of Gertrude Stein, 1946

Untitled (Bathers)
1905-6
Ink on paper
12¼ x 17 in. (31.1 x 43.2 cm)
San Francisco Museum of Modern Art, bequest of
Harriet Lane Levy

Allan Stein (pl. 179, cat. 324)
1906
Gouache on cardboard
29⅛ x 23½ in. (74 x 59.7 cm)
The Baltimore Museum of Art: The Cone Collection,
formed by Dr. Claribel Cone and Miss Etta Cone of
Baltimore, Maryland

Head and Figure Studies (pl. 77, cat. 357)
1906
Conté crayon on paper
24 x 17¾ in. (61 x 45.1 cm)
Museum of Fine Arts, Boston, Arthur Tracy Cabot
Fund

Leo Stein (pl. 33, cat. 325)
1906
Opaque watercolor on cardboard
9¾ x 6¾ in. (24.8 x 17.2 cm)
The Baltimore Museum of Art: The Cone Collection,
formed by Dr. Claribel Cone and Miss Etta Cone of
Baltimore, Maryland

Nude with Joined Hands (pl. 74, cat. 237)
1906
Oil on canvas
60½ x 37⅛ in. (153.7 x 94.3 cm)
The Museum of Modern Art, New York, The William
S. Paley Collection, 1990

Self-Portrait (pl. 81, cat. 239)
1906
Oil on canvas mounted on honeycomb panel
10½ x 7¾ in. (26.7 x 19.7 cm)
The Metropolitan Museum of Art, New York, Jacques
and Natasha Gelman Collection, 1998

Standing Nude and Head in Profile (pl. 75, cat. 350)
1906
Graphite on paper
12¼ x 9⅛ in. (31.5 x 23.5 cm)
Richard and Mary L. Gray, Chicago

Two Nudes (pl. 73, cat. 353)
1906
Charcoal on paper
24½ x 18 in. (62.2 x 45.7 cm)
The Museum of Fine Arts, Houston, gift of Oveta
Culp Hobby

Head in Three-Quarter View (pl. 212, cat. 370)
1907
Gouache and watercolor on paper
11¾ x 9¼ in. (29.9 x 23.5 cm)
San Francisco Museum of Modern Art, bequest of
Elise S. Haas

Head of a Sleeping Woman (Study for *Nude with Drapery*)
(pl. 218, cat. 241)
1907
Oil on canvas
24¼ x 18¾ in. (61.4 x 47.6 cm)
The Museum of Modern Art, New York, Estate of John
Hay Whitney, 1983

Head of a Woman in Brown and Black (pl. 210, cat. 365)
1907
Watercolor and gouache on paper mounted on panel
12⅛ x 9⅜ in. (30.8 x 23.8 cm)
Private collection
[San Francisco only]

Pitcher, Jar, and Lemon (pl. 208, cat. 362)
1907
Gouache on paper
11⅞ x 9⅜ in. (31.2 x 24.3 cm)
Gecht Family Collection

Study for *Nude with Drapery* (pl. 211, cat. 366)
1907
Tempera and watercolor on paper mounted on board
12³⁄₁₆ x 9⁷⁄₁₆ in. (31 x 24 cm)
Private collection

Study for *Nude with Drapery* (pl. 213, cat. 371)
1907
Watercolor and gouache on paper
12³⁄₁₆ x 9⅝ in. (31 x 24.5 cm)
Museo Thyssen-Bornemisza, Madrid

Study for *Nude with Drapery* (pl. 214, cat. 372)
1907
Watercolor and graphite on paper mounted on canvas
12 x 9¼ in. (30.5 x 23.5 cm)
Collection Morton and Linda Janklow, New York
[New York only]

Study for *Nude with Drapery* (pl. 215, cat. 373)
1907
Watercolor and conté crayon on cardboard
12³⁄₁₆ x 9⁹⁄₁₆ in. (30.9 x 24.3 cm)
The Baltimore Museum of Art: The Cone Collection,
formed by Dr. Claribel Cone and Miss Etta Cone of
Baltimore, Maryland
[New York only]

Study for *Nude with Drapery* (pl. 216, cat. 374)
1907
Gouache on paper mounted on canvas
12 x 9¼ in. (30.5 x 23.5 cm)
Private collection
[New York only]

Study for *Nude with Drapery* (pl. 217, cat. 375)
1907
Oil wash on paper mounted on canvas
12¾ x 9¾ in. (32.4 x 24.8 cm)
Collection Michael and Judy Steinhardt, New York

Untitled (Head in Profile) (pl. 220, cat. 360)
1907
Graphite on paper
5⅛ x 7⅛ in. (13 x 18 cm)
The Menil Collection, Houston

Bust of a Man (pl. 222, cat. 243)
1908
Oil on canvas
24½ x 17⅛ in. (62.2 x 43.5 cm)
The Metropolitan Museum of Art, New York, bequest
of Florene M. Schoenborn, 1995

Glasses and Fruit (pl. 224, cat. 249)
1908
Oil on cradled panel
10⅝ x 8⅜ in. (27 x 21 cm)
Museum Ludwig, Cologne, Germany

Glasses and Fruit (pl. 225, cat. 250)
1908
Oil on panel
10⅝ x 8½ in. (27 x 21.6 cm)
Museo Thyssen-Bornemisza, Madrid

Green Bowl and Black Bottle (pl. 223, cat. 248)
1908
Oil on canvas
24 x 19⅞ in. (61 x 50.5 cm)
The State Hermitage Museum, Saint Petersburg

La Rue-des-Bois (pl. 226, cat. 245)
1908
Oil on canvas
28¾ x 23⅝ in. (73 x 60 cm)
Private collection

Study for *The Dryad (Nude in a Forest)* (pl. 219, cat. 252)
1908
Gouache, ink, and graphite on card laid on cradled
panel
24⅝ x 14½ in. (62.5 x 37 cm)
Private collection

Vase, Gourd, and Fruit on a Table (pl. 227, cat. 254)
1908
Oil on canvas
28¾ x 23⅝ in. (73 x 60 cm)
Yale University Art Gallery, John Hay Whitney, B.A.
1926, M.A. (Hon.) 1956, Collection

Three Women (pl. 186, cat. 251)
1908
Oil on canvas
78¾ x 70⅛ in. (200 x 178 cm)
The State Hermitage Museum, Saint Petersburg
[New York only]

Head of a Woman (Fernande) (pl. 228, cat. 258)
1909
Oil on canvas
23⅞ x 20¼ in. (60.6 x 51.3 cm)
The Art Institute of Chicago, Joseph Winterbotham
Collection

Homage to Gertrude Stein (pl. 192, cat. 255)
1909
Tempera on panel
8¼ x 10¾ in. (21 x 27.3 cm)
Charles E. Young Research Library, UCLA Special
Collections

The Architect's Table (pl. 197, cat. 260)
1912
Oil on canvas mounted on panel
28⅝ x 23½ in. (72.7 x 59.7 cm)
The Museum of Modern Art, New York, The William
S. Paley Collection, 1971

Guitar on a Table (pl. 232, cat. 263)
1912
Oil, sand, and charcoal on canvas
20⅛ x 24¼ in. (51.1 x 61.6 cm)
Hood Museum of Art, Dartmouth College, Hanover,
New Hampshire; gift of Nelson A. Rockefeller, Class
of 1930

Guitar on a Table (cat. 377)
1912
Charcoal on paper
19¼ x 25¼ in (49 x 64,2 cm)
Private collection

Violin (pl. 231, cat. 262)
1912
Oil, sand, and charcoal on canvas
21½ x 17 in. (54.6 x 43.2 cm)
Private collection

Man with a Guitar (pl. 234, cat. 264)
1913
Oil and encaustic on canvas
51¼ x 35 in. (130.2 x 88.9 cm)
Private collection
[New York only]

Apple (pl. 238, cat. 382)
1914
Watercolor on paper
5⅜ x 6⅞ in. (13.7 x 17.5 cm)
Private collection
[New York only]

Still Life with Bottle of Rum (pl. 237, cat. 268)
1914
Oil and charcoal on canvas
15 x 18⅛ in. (38.1 x 46 cm)
Nancy and Robert Blank, New York

Still Life with Fruit, Glass, and Newspaper (pl. 236, cat. 267)
1914
Oil and sand on canvas
13⅝ x 16½ in. (34.5 x 42 cm)
Kreeger Museum, Washington, D.C.

Student with a Pipe (pl. 233, cat. 265)
1914
Gesso, sand, pasted paper, oil, and charcoal on canvas
28¾ x 23⅛ in. (73 x 58.7 cm)
The Museum of Modern Art, New York, Nelson A.
Rockefeller Bequest, 1979

Woman with a Guitar (pl. 235, cat. 266)
1914
Oil, sand, and charcoal on canvas
45½ x 18⅝ in. (115.6 x 47.3 cm)
The Museum of Modern Art, New York, gift of Mr.
and Mrs. David Rockefeller, 1975

Guitar (pl. 239, cat. 383)
1918
Graphite, watercolor, and ink on paper
6¾ x 7½ in. (17.4 x 19.1 cm)
Private collection

HANS PURRMANN
German, born 1880, Speyer, Germany; died 1966, Basel

Model in Matisse's Studio (pl. 105)
1908
Oil on canvas
21⅞ x 18¼ in. (55.5 x 46.5 cm)
Private collection

Still Life with Vases, Oranges, and Lemons (pl. 104)
1908
Oil on canvas
31½ x 39⅛ in. (80 x 99.5 cm)
Nationalgalerie, Staatliche Museen, Berlin

Striding Man (pl. 106)
1909
Plaster of Paris
26 x 10⅝ x 13 in. (66 x 27 x 33 cm)
Private collection

PIERRE-AUGUSTE RENOIR
French, born 1841, Limoges, France; died 1919, Cagnes-sur-Mer, France

Study. Torso, Effect of Sunlight (pl. 7)
ca. 1876
Oil on canvas
31⅞ x 25⅝ in. (81 x 65 cm)
Musée d'Orsay, Paris, bequest of Gustave Caillebotte, 1894

Seated Bather (pl. 39, cat. 393)
ca. 1882
Oil on canvas
21½ x 16½ in. (54.5 x 41.9 cm)
Private collection
[New York only]

Head of a Young Woman (pl. 53, cat. 396)
1890
Oil on canvas
16¼ x 12¾ in. (41.3 x 32.4 cm)
Private collection

The Hat Pinned with Flowers (pl. 52)
1898
Color lithograph
35⅝ x 24¹⁵⁄₁₆ in. (90.5 x 63.3 cm)
The Metropolitan Museum of Art, New York, Harris Brisbane Dick Fund, 1931

FRANCISCO RIBA-ROVIRA
Spanish, born 1913, Barcelona; died 2002, Paris

Gertrude Stein (pl. 203, cat. 414)
1945
Oil on canvas
35⅝ x 28¼ in (90.5 x 71.8 cm)
Collection of Alida and Christopher Latham
[New York only]

FRANCIS ROSE
British, born 1909, Farnham, England; died 1979, London

Homage to Gertrude Stein (pl. 263)
1949
Oil, tempera, watercolor, and wax on paper
80¼ x 56¼ in. (203.8 x 142.9 cm)
England & Co. gallery, London

GERTRUDE STEIN
American, born 1874, Allegheny, Pennsylvania; died 1946, Neuilly, France

A Book Concluding with As a Wife Has a Cow a Love Story (pl. 243)
1926
Book with four illustrations by Juan Gris
9¹⁵⁄₁₆ x 7¹¹⁄₁₆ in. (25.2 x 19.5 cm)
The Metropolitan Museum of Art, New York, Harris Brisbane Dick Fund, 1930

A Village Are You Ready Yet Not Yet a Play in Four Acts
1928
Unbound book with seven illustrations by Élie Lascaux
7¹¹⁄₁₆ x 6⁵⁄₁₆ in. (19.5 x 16 cm)
Galerie Louise Leiris, Paris

Dix Portraits (Ten Portraits)
1930
Book with ten illustrations by Christian Bérard, Eugene Berman, Pablo Picasso, Pavel Tchelitchew, and Kristians Tonny
9 x 6½ in. (22.9 x 16.5 cm)
Spencer Collection, The New York Public Library
[New York only]

LEO STEIN (attributed to)
American, born 1872, Allegheny, Pennsylvania; died 1947, Settignano, Italy

Self-Portrait (pl. 37)
ca. 1906-8
Oil on canvas
31¹³⁄₁₆ x 17⅝ in. (80.8 x 44.7 cm)
Mr. and Mrs. Michel Ibre, Paris

SARAH STEIN
American, born 1870, San Francisco; died 1953, San Francisco

Standing Female Nude (pl. 113)
ca. 1908-11
Oil on canvas
22¼ x 13¼ in. (56.5 x 33.7 cm)
Dr. and Mrs. Maurice Galanté, San Francisco

Standing Male Nude (pl. 112)
ca. 1908-11
Oil on canvas
19 x 13 in. (48.3 x 33 cm)
Dr. and Mrs. Maurice Galanté, San Francisco

FLORINE STETTHEIMER
American, born 1871, Rochester; died 1944, New York

Maquettes for costumes and scenery for Gertrude Stein and Virgil Thomson's *Four Saints in Three Acts*
1934
Wire, crepe paper, thread, feathers, sequins, toile, velvet, cellophane, and other materials
Various dimensions
Florine Stettheimer Papers, Rare Book and Manuscript Library, Columbia University

FRANCES STRAIN
American, born 1898, Chicago; died 1962

Four Saints in Three Acts (pl. 288)
1934
Oil on canvas
36 x 30 in. (91.4 x 76.2 cm)
Courtesy Michael Rosenfeld Gallery, LLC, New York
[San Francisco only]

PIERRE TAL-COAT
French, born 1905, Finistère, France; died 1985, Eure, France

Gertrude Stein (pl. 262)
1934-35
Oil on plaster, transferred to particle board
66½ x 35⅜ in. (169 x 90 cm)
Musée d'Art Moderne de la Ville de Paris

PAVEL TCHELITCHEW
American, born 1898, Kaluga, Russia; died 1957, Grottaferrata, Italy

Three Heads (Portrait of René Crevel) (pl. 190, cat. 433)
1925
Oil on canvas
18¾ x 14½ in. (47.6 x 36.8 cm)
Professor Boris Stavrovski, New York

Gertrude Stein (pl. 259)
1930
Ink on paper
16¾ x 11⅜ in. (42.7 x 28.8 cm)
The Art Institute of Chicago, given in memory of Charles Barnett Goodspeed by Mrs. Charles B. Goodspeed

Gertrude Stein (pl. 260)
1931
Sepia and wash on paper
17⅝ x 10⁹⁄₁₆ in. (44.7 x 26.8 cm)
Yale University Art Gallery, New Haven, University Purchase Fund

Final sketch for *Phenomena* (pl. 261)
1938
Oil on canvas
35 x 45¾ in. (89 x 116.2 cm)
Hirshhorn Museum and Sculpture Garden, Smithsonian Institution, Washington, D.C., The Joseph H. Hirshhorn Bequest, 1981

HENRI DE TOULOUSE-LAUTREC
French, born 1864, Albi, France; died 1901, Langon, France

In the Salon: The Divan (pl. 28, cat. 437)
ca. 1892-93
Oil on cardboard
23⅝ x 31½ in. (60 x 80 cm)
MASP, Museu de Arte de São Paulo Assis Chateaubriand, São Paulo, Brazil

KITAGAWA UTAMARO
Japanese, born 1753, Kawagoe, Japan; died 1806, Tokyo

Kayoi [Komachi], from the series *Fashionable Renditions of the Seven Tales of Ono Komachi* (pl. 86)
1795
Color woodblock print
14⅜ x 9½ in. (36.5 x 24.1 cm)
Stanley Steinberg, San Francisco

FÉLIX VALLOTTON
Swiss, born 1865, Lausanne, Switzerland; died 1925,
Paris

Reclining Nude on a Yellow Cushion (pl. 10, cat. 438)
1904
Oil on canvas
38³⁄₁₆ in. x 57½ in. (97 x 146 cm)
Sturzenegger Foundation, Museum zu Allerheiligen
Schaffhausen, Switzerland
[San Francisco only]

Gertrude Stein (pl. 206, cat. 441)
1907
Oil on canvas
39½ x 32 in. (100.3 x 81.3 cm)
The Baltimore Museum of Art: The Cone Collection,
formed by Dr. Claribel Cone and Miss Etta Cone of
Baltimore, Maryland
[New York only]

MATHILDE VOLLMOELLER-PURRMANN
German, born 1876, Stuttgart; died 1943, Munich

Still Life with Fruit (pl. 181, cat. 442)
ca. 1906–7
Oil on canvas
18 x 24 in. (45.7 x 60.1 cm)
San Francisco Museum of Modern Art, bequest of
Esther Pollack

MAX WEBER
American, born 1881, Bialystok, Poland; died 1961, Great
Neck, New York

Sketch (pl. 30)
1906
Oil on canvas
7½ x 9½ in. (19.1 x 24.1 cm)
Galerie Salis & Vertes, Zurich

Apollo in Matisse's Studio (pl. 109)
1908
Oil on canvas
23 x 18 in. (58.4 x 45.7 cm)
Estate of Max Weber, courtesy Gerald Peters Gallery,
New York

Standing Nude (pl. 108)
1908
Oil on board
8¼ x 5⅛ in. (21 x 13 cm)
Estate of Max Weber, courtesy Gerald Peters Gallery,
New York

References

ARCHIVES CITED

When applicable, the abbreviated form used in citations appears in parentheses after the archive name.

Archives Durand-Ruel, Paris

Archives Matisse, Paris (AMP)

Archives of American Art, Smithsonian Institution, Washington, D.C. (Archives of American Art)

Archives of the Hungarian National Gallery, Budapest

Archives de la Ville de Paris (AdvP)

The Bancroft Library, University of California, Berkeley

Barnes Foundation Archives, Merion, Pennsylvania (BFA)

Alfred H. Barr Jr. Papers, The Museum of Modern Art Archives (MoMA Barr Papers)

David and Barbara Block family archives

Dr. Claribel and Miss Etta Cone Papers, Archives and Manuscripts Collections, The Baltimore Museum of Art (BMA Cone Papers)

Theresa Ehrman papers and photographs, The Magnes Collection of Jewish Art and Life, The Bancroft Library, University of California, Berkeley. Transfer; Judah L. Magnes Museum

Fondation Le Corbusier Archives

Fiske Kimball Papers, Philadelphia Museum of Art Archives (PMA Kimball Papers)

Library of the California Historical Society, San Francisco

Pierre Matisse Gallery Archives, Pierpont Morgan Library, The Morgan Library & Museum (PMG Archives)

Musée National d'Art Moderne, Centre Georges Pompidou, Paris

The Museum of Modern Art Archives, New York (MoMA Archives)

Harry Ransom Humanities Research Center, University of Texas, Austin (Ransom Center)

Léonce Rosenberg Archives, Bibliothèque Kandinsky, Centre Georges Pompidou, Paris

Annette Rosenshine Archives, Bancroft Library, University of California, Berkeley

Morgan Russell Archives and Collection, Montclair Art Museum, Montclair, N.J.

San Francisco Museum of Modern Art Archives (SFMOMA Archives)

Schlesinger Library, Radcliffe Institute, Harvard University, Cambridge, MA

Estate of Daniel M. Stein

Vollard Archives, Bibliothèque des Musées Nationaux / Musée d'Orsay, Paris (Vollard Archives)

Yale Collection of American Literature, Beinecke Rare Book and Manuscript Library, Yale University (Beinecke YCAL)

Charles E. Young Research Library, UCLA Special Collections

EXHIBITIONS CITED

Catalogues or other documentation of the following exhibitions are cited in the Catalogue of the Stein Collections on pages 394–457 of this volume.

Arles 1957
Picasso: Dessins, gouaches, aquarelles, 1898–1957, Musée Réattu, Arles, France, July 6 – September 2, 1957.

Baltimore 1925
An Exhibition of Modern French Art, Baltimore Museum of Art, January 9 – February 1, 1925.

Baltimore 1930
The Cone Collection of Modern Paintings and Sculpture, Baltimore Museum of Art, May–October 1930.

Barcelona 1992
Picasso: The Ludwig Collection: Paintings, Drawings, Sculptures, Ceramics, Prints, Museu Picasso, Barcelona, November 11, 1992 – January 31, 1993. Traveled.

Basel 1928
Paul Gauguin, Kunsthalle Basel, July–August 1928.

Basel 1986
Aus privaten Sammlungen, Galerie Beyeler, Basel, February 8 – April 19, 1986.

Berlin 1909
Ausstellung Henri Matisse, Paul Cassirer, Berlin, January 1–20, 1909.

Berlin 1914
Henri Matisse, Kunstsalon Fritz Gurlitt, Berlin, July–August 1914.

Berlin 1930
Henri Matisse, Galerien Thannhauser, Berlin, February 15 – March 19, 1930.

Cambridge 1958
Drawings from the Collection of Curtis O. Baer, Fogg Museum, Harvard University, Cambridge, MA, January 11 – February 15, 1958.

Céret 2005
Matisse-Derain: Collioure 1905, un été fauve. Musée Départemental d'Art Moderne de Céret, June–October, 2005. Traveled. Also Matamoros and Szymusiak 2005.

Iowa City 1951
Six Centuries of Master Drawings, Thirteenth Annual Fine Arts Festival, School of Fine Arts, State University of Iowa, Iowa City, summer 1951.

London 1910
Manet and the Post-Impressionists, Grafton Galleries, London, November 8, 1910 – January 15, 1911.

London 1912
Second Post-Impressionist Exhibition, Grafton Galleries, London, October 5 – December 31, 1912.

London 1939
An Exhibition of Paintings by Francis Rose, Mayor Gallery, London, January 1939.

London 1963
Private Views: Works from the Collections of Twenty Friends of the Tate Gallery, Tate Gallery, London, April 18 – May 19, 1963.

London 1994
Picasso: Sculptor/Painter—A Brief Guide, Tate Gallery, London, February 16 – May 8, 1994.

Madrid 2005
Juan Gris: Paintings and Drawings 1910-1927, Museo Nacional Centro de Arte Reina Sofía, Madrid, June 22 - September 19, 2005. Also Esteban Leal 2005.

Milan 1953
Pablo Picasso, Palazzo Reale, Milan, September 23 - December 31, 1953.

Munich 1955
Picasso 1900-1955: Malerei, Zeichnungen, Graphik, Haus der Kunst, Munich, October 25 - December 18, 1955. Traveled.

New Haven and Baltimore 1951
Pictures for a Picture of Gertrude Stein as a Collector and Writer on Art and Artists: An Exhibition, Yale University Art Gallery, New Haven, CT, February 11 - March 11, 1951; Baltimore Museum of Art, March 21 - April 21, 1951.

New York 1913
International Exhibition of Modern Art, Armory of the 69th Infantry, New York, February 15 - March 15, 1913.

New York 1931
Toulouse-Lautrec, Redon, Museum of Modern Art, New York, February 1 - March 2, 1931.

New York 1934
Sir Francis Rose, Marie Harriman Gallery, New York, December 7 - 29, 1934.

New York 1936a
Picasso: Blue and Rose Periods, 1901-1906, Jacques Seligmann & Co., New York, November 2-26, 1936.

New York 1936b
Picasso: Retrospective Exhibition, 1901-1934, Valentine Gallery, New York, October 26 - November 21, 1936.

New York 1937a
Twenty Years in the Evolution of Picasso, 1903-1923, Jacques Seligmann & Co., New York, November 1-20, 1937.

New York 1937b
Masterpieces of Modern Painting and Sculpture, Pierre Matisse Gallery, New York, January 5-30, 1937.

New York 1939
Picasso: Forty Years of His Art, Museum of Modern Art, New York, November 15, 1939 - January 7, 1940. Traveled.

New York 1951
Henri Matisse, Museum of Modern Art, New York, November 13, 1951 - January 13, 1952. Traveled. Also Barr 1951.

New York 1962a
Masters of Seven Centuries: Paintings and Drawings from the Fourteenth to Twentieth Century, Wildenstein and Co., New York, March 1-31, 1962.

New York 1962b
Picasso: An American Tribute, nine venues in New York, April 25 - May 12, 1962.

New York 1970
Four Americans in Paris: The Collections of Gertrude Stein and Her Family, Museum of Modern Art, New York, December 19, 1970 - March 1, 1971. Also Potter 1970.

New York 2006
Cézanne to Picasso: Ambroise Vollard, Patron of the Avant-Garde, Metropolitan Museum of Art, New York, September 13, 2006 - January 7, 2007. Traveled. Also Rabinow et al. 2006.

New York 2010
Picasso in the Metropolitan Museum of Art, Metropolitan Museum of Art, New York, April 27 - August 1, 2010. Also Tinterow and S. Stein 2010.

Oakland 1937
Modern Art: Eighty-Fifth Anniversary Exhibition, Mills College Art Gallery, April-May 1937.

Oslo 1956
Picasso, malerier, tegninger, grafikk, skulptur, keramikk, Kunstnernes Hus, Oslo, November-December 1956.

Paris 1904
Exposition des œuvres du peintre Henri Matisse, Galerie Vollard, Paris, June 1-18, 1904.

Paris 1905
Exposition de dessins, aquarelles, et peintures de Monsieurs Beaufrère Boudin, Dufy, Lautrec, et Van Dongen, Galerie B. Weill, February 25 - March 25, 1905.

Paris 1906
Exposition Henri Matisse, Galerie Druet, Paris, March 19 - April 7, 1906.

Paris 1907
Fleurs et natures mortes, Galerie Bernheim-Jeune, Paris, November 14-30, 1907.

Paris 1909
Exposition d'art plastique de Elie Nadelman, Galerie Druet, Paris, April 26 - May 8, 1909.

Paris 1910a
Exposition Matisse, Galerie Bernheim-Jeune, Paris, February 14 - March 5, 1910.

Paris 1910b
Exposition Cézanne, Galerie Bernheim-Jeune, Paris, January 10-22, 1910.

Paris 1910c
Exposition Manguin, Galerie Druet, Paris, May 30 - June 11, 1910.

Paris 1910d
Nus, Galerie Bernheim-Jeune, Paris, May 17-28, 1910.

Paris 1914
Exposition d'œuvres de Toulouse-Lautrec, Galeries Paul Rosenberg, Paris, January 20 - February 3, 1914.

Paris 1920
Exposition Henri Matisse, Galerie Bernheim-Jeune, Paris, October 15 - November 6, 1920.

Paris 1924
André Masson, Galerie Simon, Paris, February 25 - March 8, 1924.

Paris 1926
Œuvres de L. de Angelis, Ch. Bérard, E. Berman, L. Berman, P. Charbonnier, Thérèse Debains, J. F. Laglenne, P. Tchelitchev, K. Tonny, Galerie Druet, Paris, February 22 - March 5, 1926.

Paris 1928
Exposition rétrospective Juan Gris, Galerie Simon, Paris, June 4-16, 1928.

Paris 1931
Henri Matisse, exposition organisée au profit de l'Orphelinat des Arts, Galeries Georges Petit, Paris, June 16 - July 25, 1931.

Paris 1932
Exposition Picasso, Galerie Georges Petit, Paris, June 16 - July 30, 1932.

Paris 1949
Cinquante ans de plaisirs, Galerie René Drouin, Paris, March 4-26, 1949.

Paris 1953
Le Cubisme (1907-1914), Musée National d'Art Moderne, Paris, January 30 - April 9, 1953.

Paris 1954
Picasso: Dessins (1903-1907), Berggruen et Cie., Paris, May 25 - July 25, 1954.

Paris 1955
Picasso: Peintures (1900-1955), Musée des Arts Décoratifs, Paris, June-October 1955.

Paris 1956
Picasso: Dessins d'un demi-siècle, Berggruen et Cie., Paris, 1956.

Paris 1957
Depuis Bonnard, Musée National d'Art Moderne, Paris, March 23 - May 5, 1957.

Paris 1959
De Géricault à Matisse: Chefs-d'œuvre français des collections suisses, Petit Palais, Paris, March-May, 1959.

Paris 1960
Les sources du vingtième siècle: Les arts en Europe de 1884 à 1914, Musée National d'Art Moderne, Paris, November 4, 1960 - January 23, 1961.

Paris 1978
Société des artistes indépendants, quatre-vingt-neuvième exposition, Grand Palais, Paris, March 16 - April 9, 1978.

Paris 1983
Pablo Picasso, Foire Internationale d'Art Contemporain, Grand Palais, Paris, September 23 - October 2, 1983. Traveled.

Paris 1984
Bonnard: The Late Paintings, Musée National d'Art Moderne, Centre Georges Pompidou, Paris, February 23 - May 21, 1984. Traveled.

Paris 1988
Les Demoiselles d'Avignon: Carnet de dessins, Musée Picasso, Paris, January 26 - April 18, 1988.

Paris 1989a
Maîtres des XIXᵉ et XXᵉ Siècles, Galerie H. Odermatt, Paris, May 10 - July 29, 1989.

Paris 1989b
L'Europe des grand maîtres quand ils étaient jeunes (1870-1970), Musée Jacquemart André, Paris, September 21 - November 12, 1989.

Philadelphia 1934
Cézanne and French Painting, Pennsylvania Museum of Art (now Philadelphia Museum of Art), November 10 - December 10, 1934.

Portland 1956
Paintings from the Collection of Walter P. Chrysler, Jr., Portland Art Museum, Portland, OR, March 2, 1956 - April 14, 1957. Traveled.

Portland 1997
Seurat to Severini: Masterworks on Paper from the Robert and Maurine Rothschild Family Collection, Portland Museum of Art, Portland, ME, June 28 - October 5, 1997.

Princeton 1949
Loan Exhibition of Picasso Drawings, Princeton University Art Museum, Princeton, NJ, January 10-31, 1949.

Princeton 1972
Nineteenth- and Twentieth-Century French Drawings from the Art Museum, Princeton University: An Introduction, Princeton University Art Museum, Princeton, NJ, March 4 - April 9, 1972.

Providence 1966
The Herbert and Nannette Rothschild Collection: An Exhibition in Celebration of the Seventy-Fifth Anniversary of the Founding of Pembroke College in Brown University, Annmary Brown Memorial at Brown University, and the Museum of Art, Rhode Island School of Design, Providence, October 7 - November 6, 1966.

Richmond 1941
Collection of Walter P. Chrysler, Jr., Virginia Museum of Fine Arts, Richmond, January 16 - March 4, 1941. Traveled.

Rome 1914
Seconda esposizione internazionale d'arte della Secessione, Rome, 1914.

San Francisco 1936
Henri Matisse: Paintings, Drawings, Sculpture, San Francisco Museum of Art, January 11 - February 24, 1936.

San Francisco 1952
Henri Matisse, San Francisco Museum of Art, May 22 - July 6, 1952.

San Francisco 1962
The Sarah and Michael Stein Collection, San Francisco Museum of Art, March-April, 1962.

Springfield 1933
Catalog of the Opening Exhibition: In Honor of James Philip and Julia Emma Gray, Springfield Museum of Fine Arts, Springfield, MA, October 7 - November 2, 1933.

Stockholm 1984
Henri Matisse, Moderna Museet, Stockholm, November 3, 1984 - January 6, 1985. Also Öhman 1984.

Washington, D.C. 1983
The John Hay Whitney Collection, National Gallery of Art, Washington, D.C., May 29 - September 5, 1983.

Washington, D.C. 1996
Encounters with Modern Art: The Reminiscences of Nannette F. Rothschild; Works from the Rothschild Family Collections, National Gallery of Art, Washington, D.C., September 22, 1996 - January 26, 1997. Traveled.

Zurich 1925
Internationale Kunstausstellung, Kunsthaus Zürich, August 8 - September 23, 1925.

Zurich 1932
Picasso, Kunsthaus Zürich, September 11 - October 30, 1932.

Zurich 1982
Henri Matisse, Kunsthaus Zürich, October 15, 1982 - January 16, 1983. Traveled.

PUBLICATIONS CITED

Adriani 2001
Götz Adriani. *Henri Rousseau*. New Haven, CT, and London: Yale University Press, 2001.

Agee and Rose 1979
William C. Agee and Barbara Rose. *Patrick Henry Bruce: American Modernist*. Houston: Museum of Fine Arts, 1979.

Aldrich 1926
Mildred Aldrich. "Autobiography (Memoirs of a Breadwinner)." Typescript. 1926. Schlesinger Library, Radcliffe Institute, Harvard University, Cambridge, MA.

Anon., April 28, 1901
Anonymous. "They Have Fashioned the House Japan." *San Francisco Chronicle*, April 28, 1901.

Anon., June 1902
Anonymous. "Art, Music, and the Drama." *Cyclopedic Review of Current History and Modern Culture*, June 1902, 339-42.

Anon., March 7, 1903
Anonymous. "Propos du jour." *La Chronique des arts*, March 7, 1903, 73.

Anon., April 4, 1903
Anonymous. "Propos du jour." *La Chronique des arts*, April 4, 1903, 109.

Anon., August 8, 1903
Anonymous. "Propos du jour." *La Chronique des arts*, August 8, 1903, 225.

Anon., April 17, 1904
Anonymous. "Americans to the Fore at the Paris Salon." *New York Times*, April 17, 1904.

Anon., May 21, 1904
Anonymous. "Paris Letter; Toilettes and an Exhibition of Paintings at the French Capital." *Town and Country*, May 21, 1904, 30, 32.

Anon., March and April 1905
Anonymous. "Ephraim Keyser, Sculptor." *New Era*, March-April 1905, 397-99.

Anon., April 1905
Anonymous. "French Exhibitions." *Burlington Magazine*, April 1905, unpaged.

Anon. April 15, 1905
Anonymous. "Propos du jour." *La Chronique des Arts*, April 15, 1905, 119.

Anon., Fall 1907
Anonymous. "Le Salon d'Automne à Paris." *Le Télégramme*, Fall 1907. Reprinted in Fourcade and Monod-Fontaine 1993, 444.

Anon., January 12, 1908
Anonymous. "Chronique judiciaire des arts; entre marchands de tableaux." *L'Art moderne*, January 12, 1908, 13-14.

Anon., February 5, 1911
Anonymous. "Do Deadly Diseases Inspire Art's Masterpieces?" *San Francisco Examiner*, February 5, 1911.

Anon., April 8, 1911
Anonymous. "Dr. Claribel Cone, a Remarkable Woman." *Baltimore Evening Sun*, April 8, 1911.

Anon., August 23, 1914
Anonymous. "Have the Steins Deserted the 'Genius' Whom They Discovered?" *San Francisco Chronicle*, August 23, 1914.

Anon., January 12, 1919
Anonymous. "In the Current Week." *New York Times*, January 12, 1919.

Anon., July 28, 1935
Anonymous. "Kin of Writer Will Live Here: Gertrude Stein's Brother Arrives in Oakland." *Oakland Tribune* (?), July 28, 1935. Clipping courtesy of Library of the California Historical Society, San Francisco.

Anon., July 31, 1947
Anonymous. "Leo Stein, Author and Art Critic." *New York Times*, July 31, 1947.

Apollinaire 1905a
Guillaume Apollinaire. "Picasso, Painter and Draftsman." *La Revue immoraliste*, April 1905. Reprinted in Breunig 1972, 13-14.

Apollinaire 1905b
Guillaume Apollinaire. "Young Artists: Picasso the Painter." *La Plume*, May 15, 1905. Reprinted in Breunig 1972, 14-16.

Apollinaire 1907a
Guillaume Apollinaire. "Bernheim-Wagram." *Je dis tout*, July 25, 1907. Reprinted in Breunig 1972, 17-18.

Apollinaire 1907b
Guillaume Apollinaire. "The Salon d'Automne." *Je dis tout*, October 12, 1907. Reprinted in Breunig 1972, 18-30.

Asplund 1923
Karl Asplund. *Rolf de Marés Tavelsameling: Några anteckningar*. Stockholm: G. Tisells, 1923.

Bacou 1991
Roseline Bacou. "Paul Gauguin et Gustave Fayet." In *Gauguin: Actes du colloque Gauguin, Musée d'Orsay, 11-13 janvier 1989*, 13-31. Paris: Documentation Française, 1991.

Baldassari 1994
Anne Baldassari. *Picasso photographe, 1901-1916*. Paris: Réunion des Musées Nationaux, 1994.

Baldassari 2007
Anne Baldassari. "Horta de Ebro, 1909: Optiques, clichés et icônes du cubisme picassien." In *Picasso cubiste*, 119-47. Paris: Réunion des Musées Nationaux and Flammarion, 2007.

Bardazzi 2007
Francesca Bardazzi. "Fabbri and Loeser: Cézanne Collecting." In *Cézanne in Florence: Two Collectors and the 1910 Exhibition of Impressionism*. Milan: Electa and Palazzo Strozzi, 2007.

Barr 1951
Alfred H. Barr Jr. *Matisse: His Art and His Public*. New York: Museum of Modern Art, 1951.

Baumann et al. 1982
Felix Baumann, Margit Hahnloser-Ingold, and Klaus Schrenk. *Henri Matisse*. Zurich: Kunsthaus Zürich, 1982.

Bell 1912
Clive Bell. Introduction to *The Second Post-Impressionist Exhibition*. London: Grafton Galleries, 1912.

Belloli 1999
Lucy Belloli. "The Evolution of Picasso's Portrait of Gertrude Stein." *Burlington Magazine* 141 (January 1999): 12-18.

Bénédite 1904
Léonce Bénédite. "La Reconstruction du Musée du Luxembourg." *Les Arts de la vie*, February 1904, 106-12.

Benjamin 2001
Roger Benjamin. "Ingres chez les Fauves." *Fingering Ingres*. Edited by Susan Siegfried and Adrian Rifkin, 93-121. Oxford: Blackwell, 2001.

Benton 2007
Tim Benton. *The Villas of Le Corbusier and Pierre Jeanneret, 1920-1930*. Basel: Birkhäuser Architecture, 2007.

Berenson 1895
Bernard Berenson. *Lorenzo Lotto: An Essay in Constructive Art Criticism*. New York: G. P. Putnam's Sons, 1895.

Berenson 1908
Bernard Berenson. "De Gustibus." *Nation*, November 12, 1908, 461.

Berenson 1930a
Bernard Berenson. "Florentine Painters of the Renaissance" (1896). In *The Italian Painters of the Renaissance*. Rev. ed. Oxford: Clarendon, 1930.

Berenson 1930b
Bernard Berenson. "Painters of the Central Italian Renaissance" (1897). In *The Italian Painters of the Renaissance*. Rev. ed. Oxford: Clarendon, 1930.

Berenson 1964
Bernard Berenson. *The Selected Letters of Bernard Berenson*. Edited by Arthur Kilgore McComb. New York: Houghton Mifflin, 1964.

Bernard 1904
Émile Bernard. "Paul Cézanne." *L'Occident* 32 (July 1904): 17-30.

Bilski and Braun 2005
Emily Bilski and Emily Braun. *The Power of Conversation: Jewish Women and Their Salons*. New Haven, CT: Yale University Press, 2005.

Birnbaum 1960
Martin Birnbaum. *The Last Romantic: The Story of More than a Half-Century in the World of Art*. New York: Twayne, 1960.

Blanche 1938
Jacques-Emile Blanche. *Portraits of a Lifetime: The Late Victorian Era, the Edwardian Pageant, 1870-1914*. Translated by Walter Clement. New York: Coward-McCann, 1938.

Bloemink 1993
Barbara J. Bloemink. *Friends and Family: Portraiture in the World of Florine Stettheimer*. Katonah, NY: Katonah Museum of Art, 1993.

G. Boas 1928
George Boas. "The Aesthetic of Leo Stein." *Journal of Philosophy* 25 (May 24, 1928): 287-93.

N. Boas 1988
Nancy Boas. *The Society of Six: California Colorists*. San Francisco: Bedford Arts, 1988.

Boggs 1992
Jean Sutherland Boggs, ed. *Picasso and Things*. With essays by Marie-Laure Bernadac and Brigitte Léal. Cleveland: Cleveland Museum of Art; New York: Rizzoli, 1992.

Bois forthcoming
Yve-Alain Bois, ed. *Works by Henri Matisse in the Barnes Foundation* (tentative). New Haven, CT: Yale University Press; Merion, PA, and Philadelphia: Barnes Foundation, forthcoming.

Borràs 1985
Maria Lluïsa Borràs. *Picabia*. New York: Rizzoli, 1985.

Bouyer 1904
Raymond Bouyer. "Le Procès de l'art moderne au Salon d'Automne." *Revue politique et littéraire: Revue bleue*, November 5, 1904, 601-5.

Bouyer 1906
Raymond Bouyer. "Expositions et concours; divers salonnets." *Le Bulletin de l'art*, April 7, 1906, 109-10.

Braque et al. 1935
Georges Braque, Eugene Jolas, Henri Matisse, André Salmon, and Tristan Tzara. "Testimony against Gertrude Stein." *Transition* 23, supplement (February 1935).

Breeskin 1982
Adelyn Breeskin. *Anne Goldthwaite: A Catalogue Raisonné of the Graphic Work*. Montgomery, AL: Montgomery Museum of Fine Arts, 1982.

Breunig 1972
Leroy C. Breunig, ed. *Apollinaire on Art: Essays and Reviews, 1902-1918*. Translated by Susan Suleiman. New York: Viking, 1972.

Brooks 1958
Van Wyck Brooks. *The Dream of Arcadia: American Writers and Artists in Italy, 1760-1915*. New York: E. P. Dutton & Co., 1958.

Brown 1963
Milton W. Brown. *The Story of the Armory Show*. Greenwich, CT: Joseph H. Hirshhorn Foundation, 1963.

Burgess 1910
Gelett Burgess. "The Wild Men of Paris." *Architectural Record*, May 1910, 400-414.

Burns and Dydo 2004-5
Edward Burns and Ulla Dydo. "Listen to Me." *Luna Park* 2 (Winter 2004-5): 273-76.

Cachin 2000
Françoise Cachin. *Signac: Catalogue raisonné de l'œuvre peint*. Paris: Gallimard, 2000.

Calo 1994
Mary Ann Calo. *Bernard Berenson and the Twentieth Century*. Philadelphia: Temple University Press, 1994.

Camfield 1979
William C. Camfield. *Francis Picabia: His Art, Life, and Times*. Princeton, NJ: Princeton University Press, 1979.

Carlson 1976
Victor I. Carlson. *Picasso: Drawings and Watercolors, 1899-1907*. Baltimore: Baltimore Museum of Art, 1976.

Cauman 2000a
John Cauman. "Matisse and America, 1905-1933." PhD diss., City University of New York, 2000.

Cauman 2000b
John Cauman. "Henri Matisse, 1908, 1910, and 1912: New Evidence of Life." In *Modern Art and America: Alfred Stieglitz and His New York Galleries*, edited by Sarah Greenough, 83-95. Washington, D.C.: National Gallery of Art, 2000.

Child 1892
Theodore Child. *Art and Criticism: Monographs and Studies*. New York: Harper & Brothers, 1892.

Clement 1879
Clara Erskine Clement. *Artists of the Nineteenth Century and Their Works*. Vol. 2. Boston: Houghton, Osgood, 1879.

Compagnon 2009
Antoine Compagnon. *Le Cas Bernard Faÿ: Du Collège de France à l'indignité nationale*. Paris: Gallimard, 2009.

E. Cone 1934
Etta Cone. *The Cone Collection of Baltimore, Maryland: Catalogue of Paintings, Drawings, Sculpture of the Nineteenth and Twentieth Centuries*. Foreword by George Boas. Baltimore: Privately published, 1934.

E. T. Cone 1973
Edward T. Cone. "The Miss Etta Cones, the Steins, and M'sieu Matisse: A Memoir." *American Scholar* 42, no. 3 (Summer 1973): 441-60.

Cooper 1971
Douglas Cooper. "Gertrude Stein et Juan Gris." In *Gertrude Stein and Picasso and Juan Gris: Catalogue*. Ottawa: National Gallery of Canada, 1971.

Cooper 1977
Douglas Cooper. *Juan Gris: Catalogue raisonné de l'œuvre peint*. In collaboration with Margaret Potter. Paris: Berggruen, 1977.

Coquiot 1913
Gustave Coquiot. *H. de Toulouse-Lautrec*. Paris: Auguste Blaizot, 1912.

Courthion 1941
Pierre Courthion. "Bavardages." Unpublished manuscript, 1941. Matisse Archives, Paris.

Cousseau 1989
Henry-Claude Cousseau. *Atlan: Premières périodes, 1940-1954*. Nantes: Musée des Beaux-Arts; Paris: Adam Biro, 1989.

Cowart and Fourcade 1986
Jack Cowart and Dominique Fourcade. *Henri Matisse: The Early Years in Nice, 1916-1930*. Washington, D.C.: National Gallery of Art; New York: Harry N. Abrams, 1986.

Cowling 2002
Elizabeth Cowling. *Picasso: Style and Meaning*. New York: Phaidon, 2002.

Cox 1901
Kenyon Cox. "Books on Painting." *Nation*, November 7, 1901, 862-63.

Daix 1988
Pierre Daix. "L'Historique des *Demoiselles d'Avignon* révisé à l'aide des carnets de Picasso." In *Les Demoiselles d'Avignon*, 489-545. Paris: Réunion des Musées Nationaux, 1988.

Daix 2003
Pierre Daix. *Picasso: Trente ans après*. Neuchâtel, Switz.: Ides & Calendes, 2003.

Daix and Boudaille 1966
Pierre Daix and Georges Boudaille. *Picasso: The Blue and Rose Periods; A Catalogue Raisonné of the Paintings, 1900-1906*. Greenwich, CT: New York Graphic Society, 1966.

Daix, Boudaille, and Rosselet 1988
Pierre Daix, Georges Boudaille, and Joan Rosselet. *Picasso, 1900-1906: Catalogue raisonné de l'œuvre peint*. Neuchâtel, Switz.: Ides & Calendes, 1988.

Daix and Rosselet 1979
Pierre Daix and Joan Rosselet. *Le Cubisme de Picasso: Catalogue raisonné de l'œuvre peint, 1907-1916*. Neuchâtel, Switz.: Ides & Calendes, 1979.

Danchev 2005
Alex Danchev. *Georges Braque: A Life*. New York: Hamish Hamilton, 2005.

Dauberville 1992
Jean Dauberville, Henry Dauberville, Michel Dauberville, and Guy-Patrice Dauberville. *Bonnard: Catalogue raisonné de l'œuvre peint*. Paris: Bernheim-Jeune, 1992.

Dauberville 1995
Guy-Patrice Dauberville and Michel Dauberville. *Henri Matisse chez Bernheim-Jeune*. Paris: Bernheim-Jeune, 1995.

Dauberville 2009
Guy-Patrice Dauberville and Michel Dauberville. *Renoir: Catalogue raisonné des tableaux, pastels, dessins, et aquarelles*. Vol. 1, *1858-1881*. Paris: Éditions Bernheim-Jeune, 2007.

Dauberville 2010
Guy-Patrice Dauberville and Michel Dauberville. *Renoir: Catalogue raisonné des tableaux, pastels, dessins, et aquarelles*. Vol. 3, *1895-1902*. Paris: Éditions Bernheim-Jeune, 2010.

Daulte 1971
François Daulte. *Auguste Renoir: Catalogue raisonné de l'œuvre peint*. Lausanne: Éditions Durand-Ruel, 1971.

Davidson 1951
Jo Davidson. *Between Sittings*. New York: Dial, 1951.

Davis 1999
Norma S. Davis. *A Song of Joys: The Biography of Mahonri Mackintosh Young—Sculptor, Painter, Etcher*. Salt Lake City: Brigham Young University Art Museum, 1999.

Dawson 1996
Anne E. Dawson. "Idol of the Moderns: Renoir's Critical Reception in America, 1904-1940." PhD diss., Brown University, 1996.

Dennis 1984
Susan Murray Dennis. "The Circle Meets the Square: Le Corbusier's Villa Stein at Garches." Estate of Daniel M. Stein.

Draper 1929
Muriel Draper. *Music at Midnight*. New York: Harper & Brothers, 1929.

Ducrey 2005
Marina Ducrey. *Félix Vallotton, 1865-1925: L'Œuvre peint*. Milan: 5 Continents, 2005.

Du Mas 1932
Vivian Du Mas. "L'Occultisme dans l'art de Picabia." *Orbes* 3 (1932): 113-27.

Dusapin and Turrell 1997
Pascal Dusapin and James Turrell. *To Be Sung*. Arles, France: Théâtre de Caen and Actes Sud, 1997.

Duthuit and de Guébriant 1997
Claude Duthuit and Wanda de Guébriant, eds. *Henri Matisse: Catalogue raisonné de l'œuvre sculpté*. Paris: Claude Duthuit, 1997.

Duthuit-Matisse and Duthuit 1983
Marguerite Duthuit-Matisse and Claude Duthuit. *Henri Matisse: Catalogue raisonné de l'œuvre gravé établi.* With the collaboration of Françoise Garnaud. Paris: Claude Duthuit, 1983.

Dydo 2002-3
Ulla Dydo. "Picasso and Alice." *Nest,* no. 19 (Winter 2002-3): 14-21.

Dydo and Rice 2003
Ulla E. Dydo with William Rice. *Gertrude Stein: The Language That Rises, 1923-1934.* Evanston, IL: Northwestern University Press, 2003.

Edstrom 1937
David Edstrom. *The Testament of Caliban.* New York: Funk & Wagnalls, 1937.

Einstein 1926
Carl Einstein. *Die Kunst des 20 Jahrhunderts.* Berlin: Propyläen, 1926.

Eliel 2001
Carol S. Eliel, ed. *L'Esprit Nouveau: Purism in Paris, 1918-1925.* Los Angeles: Los Angeles County Museum of Art; New York: Harry N. Abrams, 2001.

Enright 1989
Robert Enright. "The Monumental Diarist: An Interview with Robert Motherwell." *Border Crossings* 8 (November 1989): 7-17.

Esteban Leal 2005
Paloma Esteban Leal. *Juan Gris: Paintings and Drawings, 1910-1927.* Madrid: Museo Nacional Centro de Arte Reina Sofía, 2005.

Faure 1905
Élie Faure. Introduction (dated October 15, 1905) to *Catalogue de peinture, dessin, sculpture, gravuer, architecture et art décoratif, exposés au Grand Palais des Champs-Élysées du 18 octobre 1905 au 25 novembre 1905.* Paris: Société du Salon d'Automne, 1905.

Fisher 2000
Paul Fisher. *Artful Itineraries: European Art and American Careers in High Culture, 1865-1920.* New York: Garland, 2000.

Fisk 1912
Edward Franklin Fisk. "Paris Diary." 1912. Archives of American Art, Smithsonian Institution, Washington, D.C.

Fitzgerald 1995
Michael Fitzgerald. *Making Modernism: Picasso and the Creation of the Market for Twentieth-Century Art.* New York: Farrar, Straus, & Giroux, 1995.

Fitzgerald 2006
Michael Fitzgerald. *Picasso and American Art.* New York: Whitney Museum of American Art; New Haven, CT: Yale University Press, 2006.

Flam 1986
Jack D. Flam. *Matisse: The Man and His Art, 1869-1918.* Ithaca, NY: Cornell University Press, 1986.

Flam 1995
Jack D. Flam. *Matisse on Art.* Rev. ed. Berkeley: University of California Press, 1995.

Flam 2003
Jack D. Flam. *Matisse and Picasso: The Story of Their Rivalry and Friendship.* Cambridge, MA: Icon, 2003.

Flam 2005
Jack D. Flam. "Matisse à Collioure: Évolution du style et datation des tableaux, 1905-1907." Translated by Jeanne Bouniort. In Matamoros and Szymusiak 2005, 30-47.

Flanner 1988
Janet Flanner. *Paris Was Yesterday, 1925-1939.* Edited by Irving Drutman. Boston: Mariner, 1988.

Ford 1993
Charles Henri Ford. Interview by Paul Cummings. In *Pavel Tchelitchew: Nature Transformed.* New York: Michael Rosenfeld Gallery, 1993.

Fourcade and Monod-Fontaine 1993
Dominique Fourcade and Isabelle Monod-Fontaine, eds. *Henri Matisse, 1904-1917.* With contributions by Claude Laugier and Eric de Chassey. Paris: Musée National d'Art Moderne, Centre Georges Pompidou, 1993.

Frank et al. 1934
Waldo Frank, Lewis Mumford, Dorothy Norman, Paul Rosenfeld, and Harold Ordway Rugg. *America and Alfred Stieglitz: A Collective Portrait.* Garden City, NY: Literary Guild, 1934.

Freeman 1990
Judi Freeman. *The Fauve Landscape.* Los Angeles: Los Angeles County Museum of Art; New York: Abbeville, 1990.

Frelinghuysen 1993
Alice Cooley Frelinghuysen. *Splendid Legacy: The Havemeyer Collection.* New York: Metropolitan Museum of Art, 1993.

Friedman 1998
Alice T. Friedman. "Being Modern Together." In *Women and the Making of the Modern House,* 92-125. New York: Harry N. Abrams, 1998.

Gallup 1948
Donald Gallup. "The Weaving of a Pattern: Marsden Hartley and Gertrude Stein." *Magazine of Art* 41 (November 1948): 256-61.

Gallup 1953
Donald Gallup, ed. *The Flowers of Friendship: Letters Written to Gertrude Stein.* New York: Alfred A. Knopf, 1953.

Garb 2001
Tamar Garb. "'To Kill the Nineteenth Century': Sex and Spectatorship with Gertrude and Pablo." In *Picasso's Les Demoiselles d'Avignon,* edited by Christopher Green, 55-73. London: Cambridge University Press, 2001.

Gathorne-Hardy 1963
Robert Gathorne-Hardy, ed. *Ottoline: The Early Memoirs of Lady Ottoline Morrell.* London: Faber & Faber, 1963.

Gee 1981
Malcolm Gee. *Dealers, Critics, and Collectors of Modern Painting: Aspects of the Parisian Art Market between 1910 and 1930.* New York: Garland, 1981.

Geiser and Baer 1992
Bernhard Geiser. *Picasso, peintre-graveur: Catalogue illustré de l'œuvre gravé et lithographié, 1899-1931.* Revised by Brigitte Baer. Bern, Switz.: Kornfeld, 1992.

George 1931
Waldemar George. "Fifty Years of Picasso and the Death of the Still-Life." *Formes,* no. 14 (April 1931). Collected in *Formes: An International Review of Plastic Art, 1929-1933.* New York: Arno, 1971, 56.

Gide 1905
André Gide. "Promenade au Salon d'Automne." *Gazette des beaux-arts* 34 (December 1905): 475-82.

Gide 1951
André Gide. *Journal, 1889-1939.* Vol. 1. Paris: Gallimard, 1951.

Giedion 1928
Sigfried Giedion. "Le Problème du luxe dans l'architecture moderne." *Cahiers d'art,* no. 5-6 (1928): 254-56.

Giroud 2007
Vincent Giroud. "Picasso and Gertrude Stein." *Metropolitan Museum of Art Bulletin* 64 (Winter 2007): 7-55.

Golson 1970
Lucile M. Golson. "The Michael Steins of San Francisco: Art Patrons and Collectors." In Potter 1970, 38-49.

Göpel 1961
Barbara Göpel and Erhard Göpel. *Leben und Meinungen des Malers Hans Purrmann, an Hand seiner Erzählungen, Schriften und Briefe zusammengestellt.* Wiesbaden, Germany: Limes, 1961.

Gottlieb 1984
Lennart Gottlieb. "Tetzen-Lunds samling—om dens historïe, indhold og betydning." *Kunst og Museum,* no. 19 (1984): 18-54.

Grammont 2005
Claudine Grammont. "Chronologie: L'Atelier du sud: Henri Matisse à Collioure, 1905-1914." In Matamoros and Szymusiak 2005, 270-84.

Greenough 2000
Sarah Greenough, ed. *Modern Art and America: Alfred Stieglitz and His New York Galleries.* Washington, D.C.: National Gallery of Art, 2000.

Gregg 1915
Frederick James Gregg. "What the New Art Has Done, and the Universally Disturbing Influence of the 'Moderns.'" *Vanity Fair*, April 1915, 30-31.

Grimal 1981
Claude Grimal. "Dr Gertrude et Ms Stein." *Cahiers du Musée National d'Art Moderne*, nos. 7-8 (1981): 372-85.

Grimal 1996
Claude Grimal. *Gertrude Stein: Le Sourire grammatical*. Paris: Belin, 1996.

Gris 1956
Juan Gris. *Letters of Juan Gris, 1913-1927*. Translated and edited by Douglas Cooper. London: Privately published, 1956.

Haas 1972
Elise Stern Haas. "The Appreciation of Quality." Interview by Harriet Nathan. Regional Oral History Office, Bancroft Library, University of California, Berkeley, 1972.

Hahn 1951
Paul Hahn. "Introducing Armand Salacrou." *Educational Theater Journal* 3, no. 1 (March 1951): 2-10.

Hapgood 1939
Hutchins Hapgood. *A Victorian in the Modern World*. New York: Harcourt, Brace, 1939.

Haselstein 2003
Ulla Haselstein. "Gertrude Stein's Portraits of Matisse and Picasso." *New Literary History* 34 (Autumn 2003): 723-43.

Haskell 2003
Barbara Haskell. *Elie Nadelman: Sculptor of Modern Life*. New York: Whitney Museum of American Art, 2003.

Hemingway 2009
Ernest Hemingway. *A Moveable Feast: The Restored Edition*. New York: Scribner, 2009.

Hemphill 1978
Chris Hemphill. "Walter P. Chrysler Jr.: How I Made $1.6 Million from a $450 Picasso." *Interview*, June 1978, 38.

Hind 1911
C. Lewis Hind. *The Post Impressionists*. London: Methuen, 1911.

Hitchcock and Johnson 1966
Henry-Russell Hitchcock and Philip Johnson. *The International Style*. New York: W. W. Norton, 1966.

Holland 1904
Clive Holland. "Lady Art Students' Life in Paris." *International Studio* 21 (January 1904): 225-33.

Imbert 1993
Dorothée Imbert. "Le Corbusier: The Landscape vs. the Garden." In *The Modernist Garden in France*. New Haven, CT: Yale University Press, 1993.

Irwin n.d.
Inez Haynes Irwin. "Adventures of Yesterday." Inez Haynes Gillmore Papers, 1872-1945, Schlesinger Library, Radcliffe Institute, Harvard University, Cambridge, MA, vols. 23-25, fols. 3-16.

James 1890
William James. *Principles of Psychology*. Vol. 1. New York: Henry Holt, 1890.

James 1902
William James. *The Varieties of Religious Experience: A Study in Human Nature*. London: Longmans, Green, 1902.

Jamot and Wildenstein 1932
Paul Jamot and Georges Wildenstein. *Manet*. In collaboration with Marie-Louise Bataille. Paris: Beaux-Arts, 1932.

Jean-Aubry 1907
G. Jean-Aubry. "La Peinture au Salon d'Automne." *L'Art moderne* 43 (October 27, 1907): 339-41.

Jelenko ca. 1965
Theresa [Ehrman] Jelenko. "My Life with the Steins." Transcript from dictation to Elise S. Haas, ca. 1965. Theresa Ehrman papers and photographs, The Magnes Collection of Jewish Art and Life, The Bancroft Library, University of California, Berkeley. Transfer; Judah L. Magnes Museum, MSS 92/810c, ctn. 6.

Johnson 1981-2002
Lee Johnson. *The Paintings of Eugène Delacroix: A Critical Catalogue*. Oxford: Oxford University Press, 1981-2002.

Joubert 1903
Louis Joubert. "Les Œuvres et les hommes." *Le Correspondant*, November 25, 1903, 810-28.

Jourdain 1952
Francis Jourdain. *Lautrec*. Paris: Pierre Tisné, 1952.

Joyant 1926
Maurice Joyant. *Henri de Toulouse-Lautrec, 1864-1901, peintre*. Paris: H. Floury, 1926.

Kahnweiler 1954
Daniel-Henry Kahnweiler. Preface to *Picasso: Dessins, 1903-1907*. Paris: Berggruen & Cie, 1954.

Kahnweiler 1955
Daniel-Henry Kahnweiler. Introduction to *Painted Lace*. Translated by Donald Gallup. G. Stein 1955, ix-xviii. Reprinted in Simon 1994, 17-27.

Kahnweiler 1963
Daniel-Henry Kahnweiler. "La Montée du cubisme." In *Confessions esthétiques*. Paris: Gallimard, 1963.

Kahnweiler 1965
Daniel-Henry Kahnweiler. Afterword to *Autobiographie d'Alice Toklas*, by Gertrude Stein, 185-89. Paris: Mazenod, 1965.

Kahnweiler 1969
Daniel-Henry Kahnweiler. *Juan Gris: His Life and Work*. Translated by Douglas Cooper. New York: Harry N. Abrams, 1969.

Kallen 1928
H. M. Kallen. "Adept's Alphabet." *Dial* 84 (February 1928): 146-49.

Karmel 2003
Pepe Karmel. *Picasso and the Invention of Cubism*. New Haven, CT: Yale University Press, 2003.

Katz 1978
Leon Katz. "Weininger and *The Making of Americans*." In "Gertrude Stein Issue." Special issue, *Twentieth-Century Literature* 24 (Spring 1978): 8-26.

Kimball 1948a
Fiske Kimball. "Matisse: Recognition, Patronage, Collecting." *Philadelphia Museum Bulletin* 43, no. 217 (1948): 34-47.

Kimball 1948b
Fiske Kimball. "Discovery from America: The Adventurous Americans Who Were among the First Collectors of Matisse." *Art News* 47 (April 1948): 29-31, 54-55.

Kirstein 1948
Lincoln Kirstein. *The Sculpture of Elie Nadelman*. New York: Museum of Modern Art, 1948.

Kirstein 1964
Lincoln Kirstein. *Pavel Tchelitchew*. Chronology by Parker Tyler. New York: Gallery of Modern Art, 1964.

Kirstein 1970
Lincoln Kirstein. *Elie Nadelman Drawings*. New York: Hacker, 1970.

Kirstein 1973
Lincoln Kirstein. *Elie Nadelman*. New York: Eakins, 1973.

Kirstein 1994
Lincoln Kirstein. *Tchelitchew*. Santa Fe: Twelvetrees Press, 1994.

Klein 2001
John Klein. *Matisse Portraits*. New Haven, CT: Yale University Press, 2001.

Klemm 2007
Christian Klemm. *Kunsthaus Zürich: The Masterpieces*. Translated by Fiona Elliot. Ostfildern, Germany: Hatje Cantz, 2007.

Klossowski 2001
Pierre Klossowski. *Tableaux vivants: Essais critiques, 1936-1983*. Edited by Patrick Mauriès. Paris: Promeneur, 2001.

Klüver and Martin 1989
Billy Klüver and Julie Martin. *Kiki et Montparnasse, 1900-1930*. Paris: Flammarion, 1989.

Költzsch 1993
Georg-W Költzsch, ed. *Morozov and Shchukin, the Russian Collectors: Monet to Picasso*. Cologne: DuMont, 1993.

Kostenevich and Semyonova 1993
Albert Kostenevich and Natalia Semyonova. *Collecting Matisse*. Paris: Flammarion, 1993.

Kropmanns 1997
Peter Kropmanns. "Matisse und die Molls, seine bedeutendsten deutschen Sammler." In *Oskar Moll: Gemälde und Aquarelle*, 79-92. Mainz, Germany: Landesmuseum; Cologne: Wienand, 1997.

Kropmanns 2000
Peter Kropmanns. "Matisse in Deutschland." PhD diss., Humboldt-Universität zu Berlin, 2000.

Kuklick 1981
Bruce Kuklick. Introduction to *Pragmatism*, by William James, ix-xvi. Indianapolis: Hackett, 1981.

Kushner 1990
Marilyn S. Kushner. *Morgan Russell*. New York: Hudson Hills, 1990.

Kyle 2001
Jill Anderson Kyle. "Paul Cézanne, 1911: Nature Reconstructed." In *Modern Art and America: Alfred Stieglitz and His New York Galleries*, edited by Sarah Greenough, 101-13. Washington, D.C.: National Gallery of Art, 2001.

Kyle 2009
Jill Anderson Kyle. "Cézanne, the 'Plastic,' and American Artist/Critics." In *Cézanne and American Modernism*, 64-77. Montclair, NJ: Montclair Art Museum, 2009.

Labrusse 1996
Rémi Labrusse. "Esthétique décorative et expérience critique: Matisse, Byzance et la notion d'Orient." PhD diss., Université Paris I Sorbonne, 1996.

Lake and Ashton 1991
Carlton Lake and Linda Ashton. *Henri-Pierre Roché: An Introduction*. Austin: Harry Ransom Humanities Research Center, University of Texas, Austin, 1991.

Lartigue 1981
Jacques-Henri Lartigue. *L'Émerveillé: Écrit à mesure, 1923-1931*. Paris: Stock, 1981.

Leclère 1905
Tristan Leclère. "De la Vénus de Giorgione à l'Olympia de Manet." *Les Arts de la vie*, July 1905, 39-46.

Le Corbusier 1929
Le Corbusier. "Tracés régulateurs." *L'Architecture vivante*, 2nd ser. (Spring-Summer 1929): 15-16.

Le Corbusier 1948
Le Corbusier. *New World of Space*. New York: Reynal & Hitchcock, 1948.

Lefèvre 1917
Frédéric Lefèvre. *La Jeune Poésie française: Hommes et tendances*. Paris: Rouart, 1917.

Legrendre, Hartmann, and Gloeckner 1937
Maurice Legrendre, A. Hartmann, and André Gloeckner. *Domenikos Theotokopoulos Called El Greco*. Paris: Hypérion, 1937.

Lerch 1938
John Lerch. "Walter P. Chrysler, Jr.'s Collection of Twentieth Century Masterpieces." *Country Life and the Sportsman*, May 1938, 45-47.

Levin 1978
Gail Levin. *Synchromism and American Color Abstraction, 1910-1925*. New York: George Braziller, 1978.

Levy n.d.
Harriet Lane Levy. "Recollections." Typescript. Bancroft Library, University of California, Berkeley, MSS C-H 11.

Lord 1994
James Lord. "Where the Pictures Were: Gertrude Stein and Alice B. Toklas." In *Six Exceptional Women: Further Memoirs*, 3-42. New York: Farrar, Straus, & Giroux, 1994.

Lucy 2010
Martha Lucy. "Late Renoir in the Collection of Albert C. Barnes and Leo Stein." In *Renoir in the Twentieth Century*, 110-21. Ostfildern, Germany: Hatje Cantz, 2010.

Luhan 1999
Mabel Dodge Luhan. *Intimate Memories*. Albuquerque: University of New Mexico Press, 1999.

Luhan and Stein 1996
Mabel Dodge Luhan and Gertrude Stein. *A History of Having a Great Many Times Not Continued to Be Friends: The Correspondence between Mabel Dodge and Gertrude Stein, 1911-1934*. Edited by Patricia Everett. Albuquerque: University of New Mexico Press, 1996.

Maison 1968
Karl Eric Maison. *Honoré Daumier: Catalogue Raisonné of the Paintings, Watercolors, and Drawings*. Greenwich, CT: New York Graphic Society, 1968.

Malcolm 2007
Janet Malcolm. *Two Lives: Gertrude and Alice*. New Haven, CT: Yale University Press, 2007.

Marguillier 1907
Auguste Marguillier. "Musées et collections." *Mercure de France*, March 1, 1907, 159-65.

Marx 1904
R. M. [Roger Marx]. "Petites Expositions; au Musée du Luxembourg." *La Chronique des arts et de la curiosité*, April 23, 1904, 134-35.

Masson 1975
André Masson. *Vagabond du surréalisme*. Paris: Saint-Germain-des-Prés, 1975.

Masson and Levaillant 1990
André Masson and Françoise Levaillant. *Les Années surréalistes: Correspondance, 1916-1942*. Paris: La Manufacture, 1990.

Masson et al. 2010
Guite Masson, Martin Masson, and Catherine Loewer, eds. *André Masson: Catalogue raisonné de l'œuvre peint, 1918-1941*. 3 vols. Vaumarcus, Switz.: ArtAcatos, 2010.

Matamoros and Szymusiak 2005
Joséphine Matamoros and Dominique Szymusiak, eds. *Matisse-Derain: Collioure 1905, un été fauve*. Paris: Gallimard, 2005.

Mathews 1984
Nancy Mowll Mathews, ed. *Cassatt and Her Circle: Selected Letters*. New York: Abbeville, 1984.

Matisse 1908
Henri Matisse. "Notes d'un peintre." *La Grande Revue* 2 (December 25, 1908): 731-45.

Matisse 1972
Henri Matisse. *Écrits et propos sur l'art*. Edited by Dominique Fourcade. Paris: Hermann, 1972.

Maus 1907
Octave Maus. "L'Art au Salon d'Automne." *Mercure de France*, January 1, 1907, 60-69.

McCarthy 1996
Laurette E. McCarthy. "Walter Pach: Artist, Critic, Historian, and Agent of Modernism." PhD diss., University of Delaware, 1996.

Meier-Graefe 1908
Julius Meier-Graefe. *Modern Art: Being a Contribution to a New System of Aesthetics*. 2 vols. Translated by Horace W. Simmonds and George W. Chrystal. London: William Heinemann; New York: G. P. Putnam's Sons, 1908.

Mellow 1974
James Mellow. *Charmed Circle: Gertrude Stein and Company*. London: Phaidon, 1974.

Mellquist 1942
Jerome Mellquist. *The Emergence of American Art*. New York: Charles Scribner's Sons, 1942.

Meyer 1953
Agnes E. Meyer. *Out of These Roots: The Autobiography of an American Woman*. Boston: Little, Brown, 1953.

Mielziner 1928
Jo Mielziner. "Arthur Carles: The Man Who Paints with Color." *Creative Art* 2 (February 1928).

Mikola 1972
András Mikola. *Colors and Lusters—Memoires of a Painter from Nagybánya*. Kolozsvár/Cluj, Romania: Dacia, 1972.

Miller 1949
Rosalind Miller. *Gertrude Stein: Form and Intelligibility*. New York: Exposition, 1949.

Modersohn-Becker 1983
Paula Modersohn-Becker: The Letters and Journals. Edited by Günter Busch and Liselotte von Reinken. Translated by Arthur S. Wensinger and Carole Clew Hoey. New York: Taplinger, 1983.

Moffett 1973
Kenworth Moffett. *Meier-Graefe as Art Critic*. Munich: Prestel, 1973.

Monod-Fontaine 1984
Isabelle Monod-Fontaine, ed. *Donation Louise et Michel Leiris: Collection Kahnweiler-Leiris*. Paris: Centre Georges Pompidou, 1984.

Monrad 1999a
Kasper Monrad, ed. *Henri Matisse: Four Great Collectors*. Copenhagen: Statens Museum for Kunst, 1999.

Monrad 1999b
Kasper Monrad. "Christian Tetzen-Lund: The Merchant with the Sharp Eye and Unlimited Ambition." In Monrad 1999a, 137-55.

Morch 1971
Albert Morch. "The Jacobs Case for Modern Art." *San Francisco Examiner*, October 31, 1971.

Morice 1905a
Charles Morice. "Art Moderne: Exposition d'œuvres de MM. Trachsel, Gérardin, Picasso." *Mercure de France*, March 15, 1905, 291-92.

Morice 1905b
Charles Morice. "Le XXIᵉ Salon des Indépendants." *Mercure de France*, April 15, 1905, 536-56.

Morice 1905c-e
Charles Morice. "Enquête sur les tendances actuelles des arts plastiques." *Mercure de France*, August 1, 1905, 346-59; August 15, 1905, 538-55; and September 1, 1905, 61-85.

Morice 1905f
Charles Morice. "Le Salon d'Automne." *Mercure de France*, December 1, 1905, 381.

Morice 1906
Charles Morice. "Le XXIIᵉ Salon des Indépendants." *Mercure de France*, April 15, 1906, 534-44.

Morrin n.d.
Peter Morrin. "Hofmann and Leo Stein." Unpublished manuscript.

Morrin et al. 1986
Peter Morrin, Judith Zilczer, and William C. Agee. *The Advent of Modernism*. Atlanta: High Museum of Art, 1986.

M.P.V. 1903
M.P.V. "Le Salon d'Automne." *Art et décoration*, supplement, November 1903, 1-2.

Neff 1974
John Hallmark Neff. "Matisse and Decoration, 1906-1914: Studies of the Ceramics and the Commissions for Paintings and Stained Glass: A Thesis." PhD diss., Harvard University, 1974.

Newman 1991
Sasha Newman, ed. *Félix Vallotton*. New Haven, CT: Yale University Art Gallery; New York: Abbeville, 1991.

New York 2001
Académie Matisse: Henri Matisse and His Nordic and American Pupils. New York: New York Studio School of Drawing, Painting, and Sculpture, 2001.

Nordland 1978
Gerald Nordland. *Richard Diebenkorn*. New York: Rizzoli, 1978.

Norman 1973
Dorothy Norman. *Alfred Stieglitz: An American Seer*. New York: Aperture, 1973.

Norris 1997
Margot Norris. "The 'Wife' and the 'Genius': Domesticating Modern Art in Stein's *Autobiography of Alice B. Toklas*." In *Modernism, Gender, and Culture*, edited by Lisa Rado, 79-99. New York: Garland, 1997.

Öhman 1984
Nina Öhman. *Henri Matisse: Moderna Museet*. Stockholm: Moderna Museet, 1984.

Olivier 1933
Fernande Olivier. *Picasso et ses amis*. Paris: Stock, 1933.

Olivier 1964
Fernande Olivier. *Picasso and His Friends*. Translated by Jane Miller. London: William Heinemann, 1964.

Olivier 1988
Fernande Olivier. *Souvenirs intimes*. Paris: Calmann-Levy, 1988.

Olivier 2001a
Fernande Olivier. *Loving Picasso: The Private Journal of Fernande Olivier*. Translated by Christine Baker and Michael Raeburn. New York: Harry N. Abrams, 2001.

Olivier 2001b
Fernande Olivier. *Picasso et ses amis*. Edited by Hélène Klein. Paris: Pygmalion/G. Watelet, 2001.

Online Picasso Project 2011
Online Picasso Project. Created and directed by Enrique Mallen, 1997-2011. Available at http://Picasso.tamu.edu.

Pach 1915
Walter Pach. "Current Comment: Why Matisse?" *Century Magazine*, February 1915, 633-36.

Pach 1938
Walter Pach. *Queer Thing, Painting: Forty Years in the World of Art*. New York: Harper & Brothers, 1938.

Pach 1956
Walter Pach. "Introducing the Paintings of George Of, 1876-1954." *Art News* 55 (October 1956): 36-38, 62-63.

Pach 1957
Walter Pach. "Submerged Artists." *Atlantic Monthly*, February 1957, 68-72.

Palau i Fabre 1981
Josep Palau i Fabre. *Picasso: The Early Years, 1881-1907*. Translated by Kenneth Lyons. New York: Rizzoli, 1981.

Patai 1961
Irene Patai. *Encounters: The Life of Jacques Lipchitz*. New York: Funk & Wagnalls, 1961.

Petersen 1920
Carl V. Petersen. "Henri Matisse: Den Stein'ske Samling hos Tetzen-Lund." *Politiken*, October 2, 1920. Reprinted in Gottlieb 1984.

Phéline and Baréty 2004
Christian Phéline and Marc Baréty, eds. *Matisse-Sembat Correspondance: Une Amitié artistique et politique, 1904-1922*. Lausanne, Switz.: Bibliothèque des arts, 2004.

Phillips 1983
Sandra Phillips. "The Art Criticism of Walter Pach." *Art Bulletin* 65 (March 1983): 106-22.

Picasso 1973
Pablo Picasso. *Picasso in Russland*. Edited by Felix Phillip Ingold. Zurich: Arche, 1973.

Picasso 1989
Pablo Picasso. *Écrits*. Edited by Marie-Laure Bernadac and Christine Piot. Paris: Réunion des Musées Nationaux and Gallimard, 1989.

Picasso 1998
Pablo Picasso. *Propos sur l'art*. Edited by Marie-Laure Bernadac and Androula Michaël. Paris: Gallimard, 1998.

Pip 1903
Pip. "Le Vernissage du Salon d'Automne." *La Nouvelle Revue*, November 1903, 271-72.

Polieri 1996
Jacques Polieri. *Atlan: Catalogue raisonné de l'œuvre complet*. Paris: Gallimard, 1996.

Potter 1970
Margaret Potter, ed. *Four Americans in Paris: The Collections of Gertrude Stein and Her Family*. New York: Museum of Modern Art, 1970.

Potter 1984
The David and Peggy Rockefeller Collection. Vol. 1, *European Works of Art*. Catalogue by Margaret Potter. New York: Privately published, 1984.

Pound 1954
Literary Essays of Ezra Pound. Edited by T. S. Eliot. New York: New Directions, 1954.

Purrmann 1922
Hans Purrmann. "From the Workshop of Henri Matisse." Translated by Kenneth Burke. *Dial*, July 1922, 32-40.

Purrmann 1946
Hans Purrmann. "Über Henri Matisse." *Werk* 33 (June 1946): 185-92.

Rabinow et al. 2006
Rebecca Rabinow, Douglas W. Druick, and Maryline Assante di Panzillo. *Cézanne to Picasso: Ambroise Vollard, Patron of the Avant-garde*. New York: Metropolitan Museum of Art; New Haven: Yale University Press, 2006.

Raynal 1921
Maurice Raynal. *Picasso*. Munich: Delphin, 1921.

Rewald 1983
John Rewald. *Paul Cézanne: The Watercolors; A Catalogue Raisonné*. Boston: Little, Brown, 1983.

Rewald 1989
John Rewald. *Cézanne and America: Dealers, Collectors, Artists, and Critics, 1891-1921*. Research assistance by Frances Weitzenhoffer. Princeton, NJ: Princeton University Press, 1989.

Rewald 1996
John Rewald. *The Paintings of Paul Cézanne: A Catalogue Raisonné*. In collaboration with Walter Feilchenfeldt and Jayne Warman. New York: Harry N. Abrams, 1996.

B. Richardson 1985
Brenda Richardson. *Dr. Claribel and Miss Etta: The Cone Collection of the Baltimore Museum of Art*. Baltimore: Baltimore Museum of Art, 1985.

J. Richardson 1964
John Richardson. *Picasso: Aquarelles et gouaches*. Basel: Phoebus, 1964.

J. Richardson 1991
John Richardson. *A Life of Picasso*. Vol. 1, *1881-1906*. New York: Random House, 1991.

J. Richardson 1996
John Richardson. *A Life of Picasso*. Vol. 2, *1907-1917*. New York: Random House, 1996.

Robertson and Yerbury 1929
Howard Robertson and F. R. Yerbury. "The Quest of the Ideal: The Villa at Garches by Le Corbusier and Jeanneret." *Architect and Building News* 10 and 17 (May 1929). Reprinted in *Travels in Modern Architecture, 1925-1930*, by Robertson and Yerbury, 76-83. London: Architectural Association, 1989.

Rose 1968
Sir Francis Rose. *Gertrude Stein and Painting*. London: Book Collecting & Library Monthly, 1968.

Rosenshine n.d.
Annette Rosenshine. "Life's Not a Paragraph." Typescript, final corrected version (undated). Bancroft Library, University of California, Berkeley, MSS C-H 161, box 3:7.

Rothenstein 1932
William Rothenstein. *Men and Memories: Recollections of William Rothenstein*. New York: Coward-McCann, 1932.

Roubaud 1983
Jacques Roubaud. "Gertrude Stein Grammaticus." In *Gertrude Stein, encore: Actes du colloque de Cerisy*, 45-49. Amiens, France: Trois Cailloux, 1983.

Rousseau 2001
Pascal Rousseau. "The Art of Light: Couleurs, sons et technologies de la lumière dans l'art des synchromistes." In *Made in USA: L'Art américain, 1908-1947*, 69-81. Paris: Réunion des Musées Nationaux, 2001.

Rubin and Lanchner 1976
William Stanley Rubin and Carolyn Lanchner. *André Masson*. New York: Museum of Modern Art, 1976.

Rudenstine 1976
Angelica Zander Rudenstine. *The Guggenheim Museum Collection: Paintings, 1880-1945*. New York: Solomon R. Guggenheim Foundation, 1976.

Saarinen 1958
Aline Saarinen. *The Proud Possessors*. New York: Random House, 1958.

Saint-Pierre 2009
Dominique Saint-Pierre. *Gertrude Stein, le Bugey, la guerre*. Bourg-en-Bresse, France: Musnier-Gilbert, 2009.

Sainsaulieu 1980
Marie-Caroline Sainsaulieu. *Henri Manguin: Catalogue raisonné de l'œuvre peint*. Neuchâtel, Switz.: Ides et Calendes, 1980.

Salinger 1987
Just a Very Pretty Girl from the Country: Sylvia Salinger's Letters from France, 1912-1913. Edited by Albert S. Bennett. Carbondale: Southern Illinois University Press, 1987.

Salzmann 1975
Siegfried Salzmann and Dorothea Salzmann. *Oskar Moll: Leben und Werk*. Munich: Bruckmann, 1975.

Samuels 1979
Ernest Samuels. *Bernard Berenson: The Making of a Connoisseur*. Cambridge, MA: Belknap Press of Harvard University Press, 1979.

Samuels 1987
Ernest Samuels. *Bernard Berenson: The Making of a Legend*. Cambridge, MA: Belknap Press of Harvard University Press, 1987.

Seckel 1988
Hélène Seckel. *Les Demoiselles d'Avignon*. Vol. 1. Paris: Editions de la Réunion des Musées Nationaux, 1988.

Seckel 1991
Hélène Seckel. "L'Académie Matisse." In *Paris—New York*, by Hélène Seckel, Daniel Abadie, and Alfred Pacquement, 316-20. Paris: Gallimard, 1991.

Shone 1976
Richard Shone. *Bloomsbury Portraits: Vanessa Bell, Duncan Grant, and Their Circle*. New York: E. P. Dutton, 1976.

Shone 1993
Richard Shone. "Matisse in England and Two English Sitters." *Burlington Magazine* 135 (July 1993): 479-84.

Simon 1984
Linda Simon. *Alice B. Toklas*. Paris: Seghers, 1984.

Simon 1994
Linda Simon. *Gertrude Stein Remembered*. Lincoln: University of Nebraska Press, 1994.

Simonson 1943
Lee Simonson. *Part of a Lifetime: Drawings and Designs, 1919-1940*. New York: Duell, Sloan & Pearce, 1943.

Smith et al. 1994
Lillian Wing Smith, Mabel Earle, and Louise Earle. "In Memoriam: Gertrude Stein." In Simon 1994, 10-13.

Soby 1942
James Thrall Soby. *Tchelitchew Paintings, Drawings*. New York: Museum of Modern Art, 1942.

Spear 1973-74
Athena Tacha Spear. "The Multiple Styles of Elie Nadelman: Drawings and Figure Sculptures, ca. 1905-1912." *Allen Memorial Art Museum Bulletin* 31, no. 1 (1973-74): 34-58.

Spies 2000
Werner Spies with Christine Piot. *Picasso sculpteur: Catalogue raisonné des sculptures*. Paris: Centre Georges Pompidou, 2000.

Sprigge 1954
Elizabeth Sprigge. "Journal in Search of Gertrude Stein." 1954. Yale Collection of American Literature, Beinecke Rare Book and Manuscript Library, Yale University, MSS 77, box 11, folder 307.

Spurling 1998
Hilary Spurling. *The Unknown Matisse: A Life of Henri Matisse; The Early Years, 1869-1908*. New York: Alfred A. Knopf, 1998.

Stavitsky 1990
Gail Stavitsky. *Gertrude Stein: The American Connection*. New York: Sid Deutsch Gallery, 1990.

Steichen 1963
Edward Steichen. *A Life in Photography*. Garden City, NY: Doubleday, 1963.

D. Stein and Karshan 1970
Donna M. Stein and Donald H. Karshan. *L'Estampe Originale: A Catalogue Raisonné*. New York: Museum of Graphic Art, 1970.

G. Stein 1912
Gertrude Stein. "Matisse" and "Picasso." *Camera Work*, August 1912, 23-25, 29-30.

G. Stein 1925
Gertrude Stein. *The Making of Americans, Being a History of a Family's Progress*. Paris: Contact, 1925.

G. Stein 1927
Gertrude Stein. "The Life of Juan Gris, the Life and Death of Juan Gris." *Transition*, no. 4 (July 1927): 160-62. Reprinted as "The Life and Death of Juan Gris" in G. Stein 1934, 48-50.

G. Stein 1930
Gertrude Stein. *Dix portraits*. English text with French translations by Georges Hugnet and Virgil Thompson. Paris: Éditions de la Montagne, 1930.

G. Stein 1933
Gertrude Stein. "G.M.P." In *Matisse, Picasso and Gertrude Stein with Two Shorter Stories*. Paris: Plain Edition, 1933.

G. Stein 1934
Gertrude Stein. *Portraits and Prayers*. New York: Modern Library, 1934.

G. Stein 1934a
Gertrude Stein. Preface to *Recent Paintings by Francis Picabia*. New York: Valentine Gallery, 1934.

G. Stein 1938
Gertrude Stein. *Picasso*. Paris: Floury, 1938.

G. Stein 1953
Gertrude Stein. *Unpublished Writings of Gertrude Stein: Bee Time Vine and Other Pieces [1917-1927]*. Yale Edition of the Unpublished Writings of Gertrude Stein, vol. 3. Edited by Carl Van Vechten. New Haven, CT: Yale University Press, 1953.

G. Stein 1955
Gertrude Stein. *Unpublished Writings of Gertrude Stein: Painted Lace and Other Pieces [1914-1937]*. Yale Edition of the Unpublished Writings of Gertrude Stein, vol. 5. Edited by Carl Van Vechten. New Haven, CT: Yale University Press, 1955.

G. Stein 1957
Gertrude Stein. *Lectures in America*. Boston: Beacon, 1957.

G. Stein 1962
Gertrude Stein. *Selected Writings of Gertrude Stein*. Edited by Carl Van Vechten. New York: Modern Library, 1962.

G. Stein 1970
Gertrude Stein. *Gertrude Stein on Picasso*. Edited by Edward Burns. New York: Liveright, 1970.

G. Stein 1971
Gertrude Stein. *Everybody's Autobiography*. New York: Cooper Square, 1971.

G. Stein 1971a
Gertrude Stein. "A Transatlantic Interview 1946." In *A Primer for the Gradual Understanding of Gertrude Stein*, edited by Robert Bartlett Haas, 15-35. Los Angeles: Black Sparrow, 1971.

G. Stein 1977
Gertrude Stein. *Dear Sammy: Letters from Gertrude Stein and Alice B. Toklas*. Edited with a memoir by Samuel M. Steward. Boston: Houghton Mifflin, 1977.

G. Stein 1978
Gertrude Stein. *Lectures en Amérique*. Translated by Claude Grimal. Paris: Christian Bourgois, 1978.

G. Stein 1984
Gertrude Stein. *Picasso*. New York: Dover, 1984.

G. Stein 1987
Gertrude Stein. *Interview transatlantique*. Paris: Transédition, 1987.

G. Stein 1990
Gertrude Stein. *The Autobiography of Alice B. Toklas*. New York: Vintage, 1990.

G. Stein 1993
Gertrude Stein. *A Stein Reader*. Edited by Ulla E. Dydo. Evanston, IL: Northwestern University Press, 1993.

G. Stein and Picasso 2008
Gertrude Stein and Pablo Picasso. *Pablo Picasso, Gertrude Stein: Correspondence*. Edited by Laurence Madeline. Translated by Lorna Scott Fox. London: Seagull, 2008.

G. Stein and Wilder 1996
Gertrude Stein and Thornton Wilder. *The Letters of Gertrude Stein and Thornton Wilder*. Edited by Edward Burns and Ulla E. Dydo, with William Rice. New Haven, CT: Yale University Press, 1996.

L. Stein 1916
Leo Stein. "Cézanne." *New Republic*, January 22, 1916, 297-98.

L. Stein 1918a
Leo Stein. "The Painting of Arthur B. Davies." *New Republic*, January 19, 1918, 338.

L. Stein 1918b
Leo Stein. "Renoir and the Impressionists." *New Republic*, March 30, 1918, 259-60.

L. Stein 1924
Leo Stein. "Pablo Picasso." *New Republic*, April 23, 1924, 229-30.

L. Stein 1927
Leo Stein. *The A-B-C of Aesthetics*. New York: Boni & Liveright, 1927.

L. Stein 1950
Journey into the Self: Being the Letters, Papers, and Journals of Leo Stein. Edited by Edmund Fuller. New York: Crown, 1950.

L. Stein 1996
Leo Stein. *Appreciation: Painting, Poetry, and Prose*. Lincoln: University of Nebraska Press, 1996.

L. A. Stein 1998
Laurie A. Stein. "The History and Reception of Matisse's *Bathers with a Turtle* in Germany, 1908-1939." *Saint Louis Art Museum Bulletin* 22, no. 3 (1998): 50-73.

S. Stein et al. 2009
Susan Alyson Stein, Asher Ethan Miller, and Colin B. Bailey. *The Annenberg Collection: Masterpieces of Impressionism and Post-Impressionism*. New York: Metropolitan Museum of Art, 2009.

Steinberg 2010
Stanley Steinberg. "Sarah Stein: The Woman Who Brought Matisse to San Francisco." Unpublished manuscript, e-mailed to SFMOMA, February 12, 2010.

Sterne 1965
Maurice Sterne. *Shadow and Light: The Life, Friends, and Opinions of Maurice Sterne*. Edited by Charlotte Leon Mayerson. New York: Harcourt Brace & World, 1965.

Stieglitz ca. 1922
Alfred Stieglitz. "Leo Stein." Ca. 1922. Alfred Stieglitz and Georgia O'Keeffe Papers, Yale Collection of American Literature, Beinecke Rare Book and Manuscript Library, Yale University, MSS 85, box 98, folder 1912.

Stimpson 1986
Catharine R. Stimpson. "The Somagrams of Gertrude Stein." In *The Female Body in Western Culture: Contemporary Perspectives*. Edited by Susan Rubin Suleiman, 30-43. Cambridge, MA: Harvard University Press, 1986.

Sutherland 1951
Donald Sutherland. *Gertrude Stein: A Biography of Her Work*. New Haven, CT: Yale University Press, 1951.

Taine 1875
Hippolyte Taine. *On Intelligence*. 2 vols. Translated by T. D. Haye. New York: H. Holt, 1875.

Taylor 1957
Francis Henry Taylor. "The Summons of Art." *Atlantic Monthly*, November 1957, 121-28.

Tinterow and S. Stein 2010
Gary Tinterow and Susan Alyson Stein, eds. *Picasso in the Metropolitan Museum of Art*. New York: Metropolitan Museum of Art, 2010.

Toklas ca. 1955
Alice B. Toklas. "Miss Alice B. Toklas Interview." Conducted by Roland E. Duncan. Undated typescript, ca. 1955. Bancroft Library, University of California, Berkeley, MSS X-X 16 FILM.

Toklas 1963
Alice B. Toklas. *What Is Remembered*. New York: Holt, Rinehart & Winston, 1963.

Toklas 1973
Alice B. Toklas. *Staying on Alone: Letters of Alice B. Toklas*. Edited by Edward M. Burns. New York: Liveright, 1973.

Toklas 2000
Alice Toklas. *Ma vie avec Gertrude Stein*. Monaco: Anatolia/Éditions du Rocher, 2000.

Transition 1927
Transition, no. 4 (July 1927).

Transition 1928
Transition, no. 11 (February 1928).

Tucker 1982
Paul Hayes Tucker. "Picasso, Photography, and the Development of Cubism." *Art Bulletin* 64 (June 1982): 288-99.

Tyler 1967
Parker Tyler. *The Divine Comedy of Pavel Tchelitchew*. New York: Fleet, 1967.

Vauxcelles 1904a
Louis Vauxcelles. "Le Salon d'Automne." *Gil Blas*, October 14, 1904, 1.

Vauxcelles 1904b
Louis Vauxcelles. "Le Salon d'Automne; le vernissage." *Gil Blas*, October 15, 1904, 1.

Vauxcelles 1908
Louis Vauxcelles. "Le Salon des Indépendants." *Gil Blas*, March 20, 1908.

Venturi 1936
Lionello Venturi. *Cézanne: Son art—son œuvre*. Paris: Paul Rosenberg, 1936.

Vollard 1936
Ambroise Vollard. *Recollections of a Picture Dealer*. Translated by Violet M. MacDonald. London: Constable, 1936.

Ward 1984
James Ward. "Le Corbusier's Villa Les Terrasses and the International Style." PhD diss., New York University, 1984.

Watson 2000
Steven Watson and Catherine Morris, eds. *An Eye on the Modern Century: Selected Letters of Henry McBride*. New Haven, CT: Yale University Press, 2000.

Wattenmaker and Distel 1993
Richard J. Wattenmaker and Anne Distel. *Great French Paintings from the Barnes Foundation*. New York: Knopf, 1993.

Weber 1951
Max Weber. "Lecture at the Museum of Modern Art," October 22, 1951. Max Weber Papers, Archives of American Art, Smithsonian Institution, Washington, D.C.

Weber 1958
Max Weber. "The Reminiscences of Max Weber." Oral History Research Office, Columbia University, 1958.

Werenskiold 1972
Marit Werenskiold. *De norske Matisse-elevene: Laeretid og gjennombrudd, 1908-1914*. Oslo: Gyldendal, 1972.

Widmaier Picasso 2003
Diana Widmaier Picasso, ed. *The Sculptures of Pablo Picasso*. Essay by Robert Rosenblum. New York: Gagosian Gallery; Toronto: Bowne, 2003.

Wildenstein 1964
Georges Wildenstein. *Gauguin*. Paris: Beaux-Arts, 1964.

Will 2011
Barbara E. Will. *Unlikely Collaboration: Gertrude Stein, Bernard Faÿ, and the Vichy Dilemma*. New York: Columbia University Press, 2011.

Wineapple 1996
Brenda Wineapple. *Sister Brother: Gertrude and Leo Stein*. New York: G. P. Putnam's Sons, 1996.

Wolanin 1983
Barbara A. Wolanin. *Arthur B. Carles (1882-1952): Painting with Color*. Philadelphia: Pennsylvania Academy of the Fine Arts, 1983.

A. Wright 2004
Alastair Wright. *Matisse and the Subject of Modernism*. Princeton, NJ: Princeton University Press, 2004.

W. H. Wright 1915
Willard Huntington Wright. *Modern Painting: Its Tendency and Meaning*. New York: John Lane, 1915.

New Haven and Baltimore 1951
Pictures for a Picture of Gertrude Stein as a Collector and Writer on Art and Artists: An Exhibition. New Haven, CT: Yale University Art Gallery; Baltimore: Baltimore Museum of Art, 1951.

Young 1940
Mahonri Young. "Notes from the Beginning." In *Mahonri Young: Retrospective Exhibition*. Andover, MA: Addison Gallery of American Art, Phillips Academy, 1940.

Young 1958
Mahonri Young. "The Reminiscences of Mahonri Young." Oral History Research Office, Columbia University, 1958.

Zervos 1928
Christian Zervos. "La Dernière Œuvre de Le Corbusier et Pierre Jeanneret." *Cahiers d'art*, no. 5-6 (1928): 256.

Zervos; Zervos 1932-1978
Christian Zervos. *Pablo Picasso*. 33 vols. Paris: Cahiers d'art, 1932-78.

Photography Credits

PLATES AND ESSAYS

9: © 2011 Estate of Pablo Picasso / Artists Rights Society (ARS), New York
10: © 2011 Fondation Félix Vallotton, Lausanne
13: © 2011 Succession H. Matisse / Artists Rights Society (ARS), New York
14: © 2011 Artists Rights Society (ARS), New York / ADAGP, Paris
15: © 2011 Succession H. Matisse / Artists Rights Society (ARS), New York
17: © 2011 Estate of Pablo Picasso / Artists Rights Society (ARS), New York
18: © 2011 Artists Rights Society (ARS), New York / ADAGP, Paris
19: © 2011 Succession H. Matisse / Artists Rights Society (ARS), New York
20: © 2011 Estate of Pablo Picasso / Artists Rights Society (ARS), New York
22: © 2011 Estate of Pablo Picasso / Artists Rights Society (ARS), New York
26: © 2011 Artists Rights Society (ARS), New York / ADAGP, Paris
27: © 2011 Succession H. Matisse / Artists Rights Society (ARS), New York
29: © 2011 Succession H. Matisse / Artists Rights Society (ARS), New York
30: © 2011 Estate of Max Weber, courtesy Gerald Peters Gallery
33: © 2011 Estate of Pablo Picasso / Artists Rights Society (ARS), New York
40: © 2011 Artists Rights Society (ARS), New York / ADAGP, Paris
45: © Estate of Florine Stettheimer
55: © 2011 Artists Rights Society (ARS), New York / ADAGP, Paris
56: © 2011 Artists Rights Society (ARS), New York / ADAGP, Paris
57: © 2011 Succession H. Matisse / Artists Rights Society (ARS), New York
58: © 2011 Succession H. Matisse / Artists Rights Society (ARS), New York
59: © 2011 Succession H. Matisse / Artists Rights Society (ARS), New York
60: © 2011 Succession H. Matisse / Artists Rights Society (ARS), New York
61: © 2011 Succession H. Matisse / Artists Rights Society (ARS), New York
62: © 2011 Succession H. Matisse / Artists Rights Society (ARS), New York
63: © Estate of Elie Nadelman
64: © Estate of Elie Nadelman
65: © 2011 Estate of Pablo Picasso / Artists Rights Society (ARS), New York
66: © 2011 Estate of Pablo Picasso / Artists Rights Society (ARS), New York
67: © 2011 Estate of Pablo Picasso / Artists Rights Society (ARS), New York
68: © 2011 Estate of Pablo Picasso / Artists Rights Society (ARS), New York
69: © 2011 Estate of Pablo Picasso / Artists Rights Society (ARS), New York
70: © 2011 Estate of Pablo Picasso / Artists Rights Society (ARS), New York
71: © 2011 Estate of Pablo Picasso / Artists Rights Society (ARS), New York
72: © 2011 Estate of Pablo Picasso / Artists Rights Society (ARS), New York
73: © 2011 Estate of Pablo Picasso / Artists Rights Society (ARS), New York
74: © 2011 Estate of Pablo Picasso / Artists Rights Society (ARS), New York
75: © 2011 Estate of Pablo Picasso / Artists Rights Society (ARS), New York
76: © 2011 Estate of Pablo Picasso / Artists Rights Society (ARS), New York
77: © 2011 Estate of Pablo Picasso / Artists Rights Society (ARS), New York
78: © 2011 Estate of Pablo Picasso / Artists Rights Society (ARS), New York
79: © 2011 Estate of Pablo Picasso / Artists Rights Society (ARS), New York
80: © 2011 Estate of Pablo Picasso / Artists Rights Society (ARS), New York
81: © 2011 Estate of Pablo Picasso / Artists Rights Society (ARS), New York
83: © 2011 Succession H. Matisse / Artists Rights Society (ARS), New York
84: © 2011 Succession H. Matisse / Artists Rights Society (ARS), New York
88: © 2011 Succession H. Matisse / Artists Rights Society (ARS), New York
89: © 2011 Succession H. Matisse / Artists Rights Society (ARS), New York
90: © 2011 Succession H. Matisse / Artists Rights Society (ARS), New York
91: © 2011 Succession H. Matisse / Artists Rights Society (ARS), New York
92: © 2011 Succession H. Matisse / Artists Rights Society (ARS), New York
93: © 2011 Succession H. Matisse / Artists Rights Society (ARS), New York
94: © 2011 Succession H. Matisse / Artists Rights Society (ARS), New York
95: © 2011 Succession H. Matisse / Artists Rights Society (ARS), New York
98: © 2011 Succession H. Matisse / Artists Rights Society (ARS), New York
99: © 2011 Succession H. Matisse / Artists Rights Society (ARS), New York
101: © 2011 Succession H. Matisse / Artists Rights Society (ARS), New York

103: © 2011 Succession H. Matisse / Artists Rights Society (ARS), New York
104: © 2011 Artists Rights Society (ARS), New York / VG Bild-Kunst, Bonn
105: © 2011 Artists Rights Society (ARS), New York / VG Bild-Kunst, Bonn
106: © 2011 Artists Rights Society (ARS), New York / VG Bild-Kunst, Bonn
108: © 2011 Estate of Max Weber, courtesy Gerald Peters Gallery
109: © 2011 Estate of Max Weber, courtesy Gerald Peters Gallery
117: © 2011 Succession H. Matisse / Artists Rights Society (ARS), New York
119: © 2011 Artists Rights Society (ARS), New York / ADAGP, Paris / F.L.C.
120: © 2011 Artists Rights Society (ARS), New York / ADAGP, Paris / F.L.C.
121: © 2011 Artists Rights Society (ARS), New York / ADAGP, Paris / F.L.C.
122: © 2011 Artists Rights Society (ARS), New York / ADAGP, Paris / F.L.C.
130: © 2011 Succession H. Matisse / Artists Rights Society (ARS), New York
131: © 2011 Succession H. Matisse / Artists Rights Society (ARS), New York
132: © 2011 Succession H. Matisse / Artists Rights Society (ARS), New York
133: © 2011 Succession H. Matisse / Artists Rights Society (ARS), New York
134: © 2011 Succession H. Matisse / Artists Rights Society (ARS), New York
135: © 2011 Succession H. Matisse / Artists Rights Society (ARS), New York
136: © 2011 Succession H. Matisse / Artists Rights Society (ARS), New York
137: © 2011 Succession H. Matisse / Artists Rights Society (ARS), New York
138: © 2011 Succession H. Matisse / Artists Rights Society (ARS), New York
139: © 2011 Succession H. Matisse / Artists Rights Society (ARS), New York
140: © 2011 Succession H. Matisse / Artists Rights Society (ARS), New York
141: © 2011 Succession H. Matisse / Artists Rights Society (ARS), New York
142: © 2011 Succession H. Matisse / Artists Rights Society (ARS), New York
143: © 2011 Succession H. Matisse / Artists Rights Society (ARS), New York
145: © 2011 Succession H. Matisse / Artists Rights Society (ARS), New York
146: © 2011 Succession H. Matisse / Artists Rights Society (ARS), New York
147: © 2011 Succession H. Matisse / Artists Rights Society (ARS), New York
148: © 2011 Succession H. Matisse / Artists Rights Society (ARS), New York
149: © 2011 Succession H. Matisse / Artists Rights Society (ARS), New York
150: © 2011 Succession H. Matisse / Artists Rights Society (ARS), New York
151: © 2011 Succession H. Matisse / Artists Rights Society (ARS), New York
152: © 2011 Succession H. Matisse / Artists Rights Society (ARS), New York
153: © 2011 Succession H. Matisse / Artists Rights Society (ARS), New York
154: © 2011 Succession H. Matisse / Artists Rights Society (ARS), New York
155: © 2011 Succession H. Matisse / Artists Rights Society (ARS), New York
156: © 2011 Succession H. Matisse / Artists Rights Society (ARS), New York
157: © 2011 Succession H. Matisse / Artists Rights Society (ARS), New York
158: © 2011 Succession H. Matisse / Artists Rights Society (ARS), New York
159: © 2011 Succession H. Matisse / Artists Rights Society (ARS), New York
160: © 2011 Succession H. Matisse / Artists Rights Society (ARS), New York
161: © 2011 Succession H. Matisse / Artists Rights Society (ARS), New York
162: © 2011 Succession H. Matisse / Artists Rights Society (ARS), New York
163: © 2011 Succession H. Matisse / Artists Rights Society (ARS), New York
164: © 2011 Succession H. Matisse / Artists Rights Society (ARS), New York
165: © 2011 Succession H. Matisse / Artists Rights Society (ARS), New York
166: © 2011 Succession H. Matisse / Artists Rights Society (ARS), New York
167: © 2011 Succession H. Matisse / Artists Rights Society (ARS), New York
168: © 2011 Succession H. Matisse / Artists Rights Society (ARS), New York
169: © 2011 Succession H. Matisse / Artists Rights Society (ARS), New York
170: © 2011 Succession H. Matisse / Artists Rights Society (ARS), New York
171: © 2011 Succession H. Matisse / Artists Rights Society (ARS), New York
172: © 2011 Succession H. Matisse / Artists Rights Society (ARS), New York
173: © 2011 Succession H. Matisse / Artists Rights Society (ARS), New York
174: © 2011 Succession H. Matisse / Artists Rights Society (ARS), New York
175: © 2011 Succession H. Matisse / Artists Rights Society (ARS), New York
180: © 2011 Fondation Félix Vallotton, Lausanne
182: © 2011 Man Ray Trust / Artists Rights Society (ARS), NY / ADAGP, Paris
183: © 2011 Estate of Pablo Picasso / Artists Rights Society (ARS), New York
184: © 2011 Estate of Pablo Picasso / Artists Rights Society (ARS), New York
185: © 2011 Estate of Pablo Picasso / Artists Rights Society (ARS), New York
186: © 2011 Estate of Pablo Picasso / Artists Rights Society (ARS), New York
192: © 2011 Estate of Pablo Picasso / Artists Rights Society (ARS), New York
193: © Van Vechten Trust
194: © 2011 Artists Rights Society (ARS), New York / ADAGP, Paris
196: © 2011 Artists Rights Society (ARS), New York / ADAGP, Paris
197: © 2011 Estate of Pablo Picasso / Artists Rights Society (ARS), New York

PHOTOGRAPHY

The following credits are grouped according to the section of the book in which the related works are reproduced, and are identified by plate number except where indicated. All copy photography was provided by the owners of the works named in the image captions, unless otherwise noted. Additional photography credits appear below. Staff photographers are not identified.

PLATES AND ESSAYS

3, 5, 6, 17, 52, 59, 81, 158, 183, 222, 243, 254: Image © The Metropolitan Museum of Art

7, 11, 12: Image © RMN / Droits réservés (Musée d'Orsay) / Hervé Lewandowski

8, 186, 223: Photograph © The State Hermitage Museum

9, 176, 234: Bridgeman Art Library International

15, 35, 43, 54, 60, 95: Photograph © 2011 reproduced with the Permission of The Barnes Foundation

19: Photo © Staatsgalerie Stuttgart

20, 62, 74, 197, 218, 233, 235: Digital Image © The Museum of Modern Art/Licensed by SCALA / Art Resource, NY

23-25, 201, 202, 205: Copy Photograph © The Metropolitan Museum of Art

26: © Collection Centre Pompidou, Dist. RMN / Jean-Claude Planchet

27, 33, 36, 65, 179, 206, 207, 215: Mitro Hood

28: João Musa

29, 101, 253: Image © Collection Centre Pompidou, Dist. RMN / Philippe Migeat

37, 184, 191, 196: Image © RMN / Droits réservés

39, 239: Private collection, Image © The Metropolitan Museum of Art

40: Courtesy Galerie Hopkins, Paris

48, 219: Courtesy Pyms Gallery, London

49: Brøndum & Co.

57, 213, 225: Image © Museo Thyssen-Bornemisza, Madrid

58, 83, 84, 94, 131, 134, 142-45, 170, 212: Ben Blackwell

64: Jerry Thompson

66: Bridgeman-Giraudon / Art Resource, NY

68: Image courtesy of the Board of Trustees, National Gallery of Art, Washington, D.C.; photo: Richard Carafelli

70: Image © Francis G. Mayer/CORBIS

71, 182, 221, 255: Image © Collection Centre Pompidou, Dist. RMN / Droits réservés

76, 209: Bildarchiv Preussischer Kulturbesitz / Art Resource, NY; photo: Nicolai Stephan

77: Photograph © 2011 Museum of Fine Arts, Boston

79: Bill Kipp

88, 117, 138, 141: Photo © SMK

89: Jason Mandella

91, 155, 161: Courtesy Archives Matisse, Paris

98, 102, 111, 112, 149, 154, 169: Ian Reeves

99: Digital Image © 2011 Museum Associates / LACMA / Art Resource, NY

103: Bildarchiv Preussischer Kulturbesitz / Art Resource, NY; photo: Klaus Goeken

104: Bildarchiv Preussischer Kulturbesitz / Art Resource, NY; photo: Klaus Goeken

113: Image © Drammens Museum, Norway; photo: Bjørn Johnsen

128: Bruce M. White

129: Image © RMN (Musée d'Orsay) / René-Gabriel Ojéda

132: Bernard C. Meyers

133, 198: Image © Collection Centre Pompidou, Dist. RMN / Georges Meguerditchian

136: Jean Bernard Photographe

137: Image © Tate, London, 2011

139: Jason Wierzbicki

140, 229: Digital Image © The Museum of Modern Art / Licensed by SCALA / Art Resource, NY; photo: Thomas Griesel

146: Susan Einstein

150: David Heald

151: Jacques Lathion

152: Ted Dillard

157, 226: Malcolm Varon, N.Y.C., ©2011

162: Photography © Musée de Grenoble

166: Jean-Louis Losi

180: Courtesy Fondation Félix Vallotton, Lausanne

185, 199: Image © Musée National Picasso, Dist. RMN

190: Courtesy Sotheby's, New York

194, 261: Lee Stalsworth

203: Photograph courtesy Smithsonian Institution. All rights reserved; photo: Matt Flynn

208: James Balodimas

210: Robert Lorenzson

214: Ellen Page Wilson

220: Image © Hester + Hardaway

224: Rheinisches Bildarchiv Köln

227, 260: Image © Yale University Art Gallery

228, 259: Photography © The Art Institute of Chicago

230: Bildarchiv Preussischer Kulturbesitz / Art Resource, NY; photo: Jens Ziehe

231: Fraser Marr

238: Malcolm Varon, N.Y.C., ©1982, 2011

244: Alan Zindman

247: Courtesy Oriol Galeria d'Art

252: Richard A. Stoner

262: Image © Musée d'Art Moderne / Roger-Viollet

263: Image © England & Co. gallery, London

CHRONOLOGY

271, 272, 278, 280, 286, 292, 294: Copy Photograph © The Metropolitan Museum of Art

THE STEIN RESIDENCES IN PHOTOGRAPHS

343-46, 353, 354, 356-58: Yale Collection of American Literature, Beinecke Rare Book and Manuscript Library, Yale University, New Haven

347, 355, 361: Department of Nineteenth-Century, Modern, and Contemporary Art, The Metropolitan Museum of Art, New York, gift of Edward Burns, 2011; Copy Photograph © The Metropolitan Museum of Art

348, 367: Dr. Claribel and Miss Etta Cone Papers, Archives and Manuscripts Collections, The Baltimore Museum of Art

349, 351, 352, 365, 368, 369: The Bancroft Library, University of California, Berkeley

350, 363, 364, 366, 370, 371: SFMOMA curatorial files, Department of Painting and Sculpture

359: Photograph by Man Ray. Private collection, San Francisco

360: Photograph by Man Ray. Musée national d'art moderne, Centre Georges Pompidou, Paris; Image © Collection Centre Pompidou, Dist. RMN / Droits réservés

362, 373, 374: Albert S. Bennett, New York

372, 378, 379, 381: Estate of Daniel M. Stein

375-77, 380: David and Barbara Block family archives

382, 384: Photograph by Cecil Beaton. Courtesy the Cecil Beaton Studio Archive at Sotheby's, London

383: Photograph by Cecil Beaton. Courtesy the Cecil Beaton Studio Archive at Sotheby's, London; Image © Collection Centre Pompidou, Dist. RMN / Georges Meguerditchian

CATALOGUE OF THE STEIN COLLECTIONS

Identified by catalogue number.

12, 17, 19-21, 23, 24, 95, 96, 115, 127, 130, 132, 137, 140, 160, 395, 397-401, 405, 406, 408-410, 412: Photograph © 2011 reproduced with the Permission of The Barnes Foundation

13, 179, 315: Image courtesy National Gallery of Art, Washington

22: Image © RMN (Musée d'Orsay) / Jean-Gilles Berizzi

57, 319: Bruce M. White

60, 97, 114, 292, 326, 352, 356, 404, 440: Photo: Mitro Hood

66: Image © Musée des Beaux-Arts de Dijon; photo: François Jay

75, 240, 259, 277, 280, 328, 334, 347: Courtesy Sotheby's, New York

89, 92, 94, 103, 111, 112, 148, 170, 172: Courtesy Archives Matisse, Paris

121: Malcolm Varon, N.Y.C., ©1982, 2011

125: Ian Reeves

126, 222, 301, 335: Image © Christie's Images Limited 2011

159, 269: Photography © The Art Institute of Chicago

226A, 226B: Photo © Staatsgalerie Stuttgart

227: Image © VEGAP, Barcelona

246: Digital Image © The Museum of Modern Art/Licensed by SCALA / Art Resource, NY

298: Image ©RISDM 43.011

361: Hickey-Robertson, Houston

379: Image © Yale University Art Gallery

Front cover: Ian Reeves

Back cover: Theresa Ehrman

Frontispiece: Department of Nineteenth-Century, Modern, and Contemporary Art, The Metropolitan Museum of Art, New York, gift of Edward Burns, 2011; Copy Photograph © The Metropolitan Museum of Art

Index

This catalogue is published by the San Francisco Museum of Modern Art in conjunction with the exhibition *The Steins Collect: Matisse, Picasso, and the Parisian Avant-Garde*, held at the San Francisco Museum of Modern Art, May 21 - September 6, 2011; the Réunion des Musées Nationaux-Grand Palais, Paris, October 3, 2011 - January 16, 2012; and The Metropolitan Museum of Art, New York, February 21 - June 3, 2012.

The Steins Collect: Matisse, Picasso, and the Parisian Avant-Garde is organized by the San Francisco Museum of Modern Art; the Réunion des Musées Nationaux-Grand Palais, Paris; and The Metropolitan Museum of Art, New York.

The exhibition is supported by an indemnity from the Federal Council on the Arts and the Humanities.

At the San Francisco Museum of Modern Art, presenting support is provided by the Mimi and Peter Haas Fund. Lead corporate support is provided by The Charles Schwab Corporation. Premier support is provided by the Evelyn D. Haas Exhibition Fund and the Koret Foundation. Major support is provided by Martha and Bruce Atwater; Gerson and Barbara Bakar; the Evelyn and Walter Haas, Jr. Fund; the Helen Diller Family Foundation, a supporting foundation of the Jewish Community Endowment Fund; and The Bernard Osher Foundation. Generous support is provided by the National Endowment for the Arts; Gay-Lynn and Robert Blanding; Jean and James E. Douglas Jr.; Ann and Robert S. Fisher; Gretchen and Howard Leach; Elaine McKeon; Deborah and Kenneth Novack, Thelma and Gilbert Schnitzer, The Schnitzer Novack Foundation; and Lydia and Douglas Shorenstein. Additional support is provided by Dolly and George Chammas and Concepción and Irwin Federman.

At The Metropolitan Museum of Art, the exhibition is made possible by The Philip and Janice Levin Foundation and the Janice H. Levin Fund. Additional support provided by The Daniel and Estrellita Brodsky Foundation. Education programs are made possible by The Georges Lurcy Charitable and Educational Trust.

Director of Publications: Chad Coerver
Managing Editor: Judy Bloch
Editor: Karen Jacobson
Editorial Coordinator: Amanda Glesmann
Editorial Associate: Erin Hyman
Research Assistants: Jennifer De La Cruz, Jared Ledesma
Indexer: Kathleen Preciado
Designers: Tracey Shiffman and Alex Kohnke with Deanne Oi, Shiffman & Kohnke

Printed and bound in Germany by Cantz

Hardcover edition published in association with Yale University Press, New Haven and London
www.yalebooks.com/art

Library of Congress Cataloging-in-Publication Data

The Steins collect : Matisse, Picasso, and the Parisian avant-garde / edited by Janet Bishop, Cécile Debray, and Rebecca Rabinow. — Hardcover ed.
 p. cm.
ISBN 978-0-300-16941-6 (hardcover) —
ISBN 978-0-918471-87-1 (pbk.) 1. Stein family—Art collections—Exhibitions. 2. Art, French—France—Paris—20th century—Exhibitions. I. Bishop, Janet C. II. Debray, Cécile. III. Rabinow, Rebecca A. IV. San Francisco Museum of Modern Art. V. Grand Palais (Paris, France) VI. Metropolitan Museum of Art (New York, N.Y.) VII. Title: Matisse, Picasso, and the Parisian avant-garde.
 N5220.S785S74 2011
 709.04'007479461—dc22

2011011783

FRONT COVER:
Henri Matisse, *Woman with a Hat*, 1905. Oil on canvas, 31¾ x 23½ in. (80.7 x 59.7 cm). San Francisco Museum of Modern Art, bequest of Elise S. Haas. © 2011 Succession H. Matisse / Artists Rights Society (ARS), New York. Photo: Ian Reeves

BACK COVER:
Gertrude and Leo Stein's atelier at 27 rue de Fleurus, Paris, ca. 1908-9. Photograph by Theresa Ehrman (detail). From left: Pablo Picasso, *Nude with Joined Hands* (1906), *Head of a Boy* (1905), *The Milk Bottle* (1905), and *Gertrude Stein* (1905-6); Henri Matisse, *Woman with a Hat* (1905), *Tree or Landscape (Corsica)* (1897), and *Olive Trees at Collioure* (ca. 1906). Dr. Claribel and Miss Etta Cone Papers, Archives and Manuscripts Collections, The Baltimore Museum of Art. Artworks by Matisse © 2011 Succession H. Matisse / Artists Rights Society (ARS), New York. Artworks by Picasso © 2011 Estate of Pablo Picasso / Artists Rights Society (ARS), New York

Photography credits appear on pages 480-82.